Mayflies (Ephemeroptera)

Dragonflies and Damselflies (Odonata)

Stoneflies (Plecoptera)

Ice Crawlers (Grylloblattodea)

Cockroaches and Termites (Blattodea)

Mantises (Mantodea)

Grasshoppers, Crickets, and Katydids (Orthoptera)

Walking Sticks (Phasmida)

Webspinners (Embiidina)

Earwigs (Dermaptera)

Barklice, Booklice, and Parasitic Lice (Psocodea)

True Bugs, Hoppers, Aphids, Scales, and Other Bugs (Hemiptera)

Thrips (Thysanoptera)

Fishflies and Alderflies (Megaloptera)

Snakeflies (Raphidioptera)

Nerve-winged Insects (Neuroptera)

Stylops (Strepsiptera)

Beetles (Coleoptera)

Fleas (Siphonaptera)

Flies, Gnats, and Midges (Diptera)

Scorpionflies (Mecoptera)

Caddisflies (Trichoptera)

Moths and Butterflies (Lepidoptera)

Ants, Wasps, and Bees (Hymenoptera)

California Natural History Guides

Phyllis M. Faber and Bruce M. Pavlik, General Editors

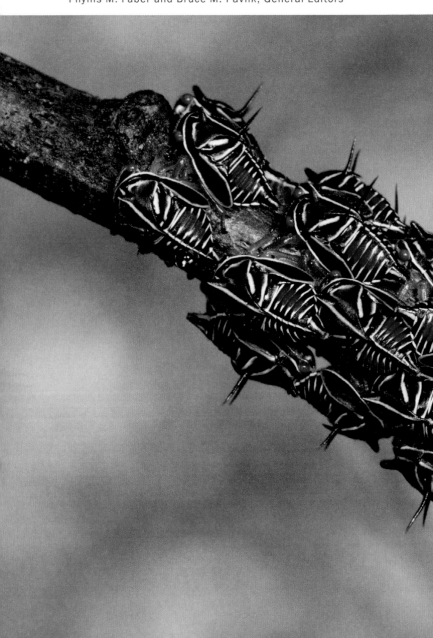

FIELD GUIDE
TO CALIFORNIA
INSECTS

SECOND EDITION

Kip Will
Joyce Gross
Daniel Rubinoff
Jerry A. Powell

UNIVERSITY OF CALIFORNIA PRESS

California Natural History Guides No. 111

University of California Press
Oakland, California

© 2020 by The Regents of the University of California

Library of Congress Cataloging-in-Publication Data

Names: Will, Kipling, 1964– author. | Gross, Joyce (Linda Joyce), author. | Rubinoff, Daniel (Entomologist), author. | Powell, Jerry A., author. | Powell, Jerry A. California insects. 1979

Title: Field guide to California insects / Kip Will, Joyce Gross, Daniel Rubinoff, Jerry A. Powell.

Other titles: California natural history guides ; 111.

Description: Second edition. | Oakland, California : University of California Press, [2020] | Series: California natural history guides ; no. 111 | Includes bibliographical references and index.

Identifiers: LCCN 2020016309 (print) | LCCN 2020016310 (ebook) | ISBN 9780520288737 (cloth) | ISBN 9780520288744 (paperback) | ISBN 9780520963573 (ebook)

Subjects: LCSH: Insects—California.

Classification: LCC QL475.C2 W55 2020 (print) | LCC QL475.C2 (ebook) | DDC 595.709794—dc23

LC record available at https://lccn.loc.gov/2020016309

LC ebook record available at https://lccn.loc.gov/2020016310

Manufactured in the United States of America

28 27 26 25 24 23 22 21 20
10 9 8 7 6 5 4 3 2 1

Cover illustrations, clockwise from upper left:
Pleasant Plant Bug *(Closterocoris amoenus)*, image by J. Gross.
California Tide-walker *(Thalassotrechus barbarae)*, image by J. Gross.
Brick-red Thick-headed Fly *(Myopa rubida)*, image by J. Gross.
Electra Buck Moth *(Hemileuca electra)*, image by Kirby Wolfe.

Title page, pp. ii–iii: Oak Treehopper *(Platycotis vittata)*, image by J. Gross.
Table of contents, p. vi: Little Bear *(Paracotalpa ursina)*, image by J. Gross.
Introduction, pp. xii–1: Lubberly Band-winged Grasshopper *(Agymnastus ingens)*, image by J. Gross.
Accounts, pp. 36–37: Common Snakefly *(Agulla sp.)*, image by J. Gross.

The publisher and the University of California Press Foundation gratefully acknowledge the generous support of the Ralph and Shirley Shapiro Endowment Fund in Environmental Studies.

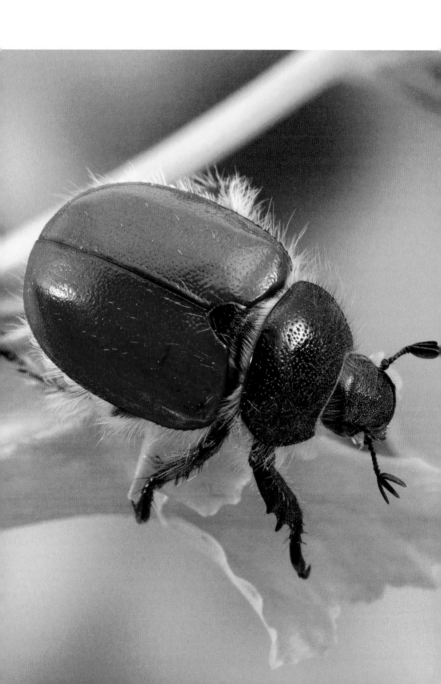

CONTENTS

PREFACE

Many naturalists are surprised at the diversity of insect life, only a few people have a broad appreciation of it, and many are skeptical when they hear the estimated numbers of insect species for a given natural community or geographical region. About one million described species of insects are known, more than five times the number of all other animals combined. Estimates of the number remaining to be discovered and named vary between three million to 30 million or more. Discrepancies in such estimates are due primarily to the poor state of knowledge concerning tropical communities and many difficult-to-sample habitats, such as the deep soil, worldwide. Even in California, the discovery of morphologically distinct, new species is commonplace; with each family inventoried by specialists during the past 40 years, 10 percent to 40 percent of the species have been discovered to be new. Only with quite well-known large insects that are popular with collectors, such as dragonflies, butterflies, and large moths, are we relatively sure that the inventory is nearing completion.

For example, very few new species of butterflies have been described from California since the first edition of this field guide and for those that were, recognition relied on DNA data to establish species from morphologically similar or polymorphic populations. There is no list of all insect species recorded in the state, but by comparing the numbers in families of various taxa that we are familiar with and by informally polling various experts, a figure of 30,000 to 40,000 species emerges as a conservative estimate for all the insect species in California. Therefore, it is obvious that a small book cannot treat all California insects. Whereas pocket guides can be developed with species treatments for a group that includes only several dozen or a few hundred species (such as California's birds, amphibians and reptiles, cacti, etc.), comparable treatment of all insects would fill many volumes—a prospect that is neither practical in terms of cost nor possible in terms of available knowledge and expertise.

The primary problem in planning this work, encountered at the outset, was: How does one summarize knowledge on 40,000 species of insects? Choosing which insects to exclude was an agonizing process. This guide is meant to cover some but not nearly all of the spectacular

diversity Californians may encounter. We decided to select about 600 of the most common and interesting kinds, and to discuss the biology, natural history, and diagnostic features of each, letting this small sample represent the whole diversity. Given this sample, there is no doubt that readers will find some conspicuous insects, common in a given region or at a particular time of year, omitted from our treatment. Smaller, more obscure groups are characterized at the family level, while more conspicuous insects and those of importance to humans are treated in more detail with representative species or genera. Each of these entities is illustrated with one or more photographs. The selection mixes many insects that will be encountered easily with some that are rarely seen, but the latter are worth the effort it takes to find them and witness firsthand their wonderful and peculiar forms and behaviors. These rarer species are included as something of a challenge to readers to go out on their own expeditions and try to find some of California's amazing but little-seen insects.

This introductory guide to identification and natural history of California insects does not attempt to compile all information on any of the species discussed nor to present technical information on other fields of entomology. As a gateway to insect diversity and a general reference for groups, the guide is not intended to show their complete diversity. It is written for the general public and beginning students of entomology. We hope that the format encourages you to read the book and build a general familiarity with and passion for the insects that share California with us. There are several excellent, detailed, often species-level field guides for specific groups, such as bees, beetles, dragonflies and damselflies, and butterflies, and we encourage anyone with a strong interest in a specific group to seek these out. Likewise, there are excellent textbooks on entomology that cover details and vocabulary of morphology and collection-building methods in a way not possible in the field guide format. These sources are now augmented by a significant and growing wealth of information online.

Our identifications of specimens and statements on the natural history, biology, and geographical distributions of the included species are based on and informed by our work and literature accounts as well as on collections of the California Academy of Sciences, San Francisco; the Los Angeles County Museum of Natural History; the University of California at Berkeley; the University of California at Davis; and the University of California at Riverside. We have also received substantial advice from our colleagues and the entomology community at large, especially through a number of online forums such as BugGuide.

Note that in the color plates insects are not shown to the same scale even on the same page. Readers should refer to the species accounts where the size of the insects is given. Images may appear immediately

before or after a given species account and so each image number has an adjacent arrow (◄ or ►), oriented to indicate which direction to look for the referenced images. The abbreviation BL is used throughout for body length. Most size ranges refer to the apparent length of the insect from the front of the head to the tip of the abdomen. For insects with wings that reach the tip of the abdomen, the wings are included in the body length. In some cases we specifically refer to wing width or the length including wings.

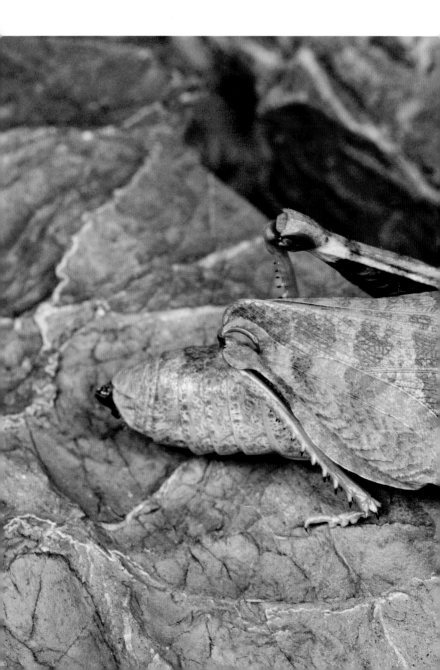

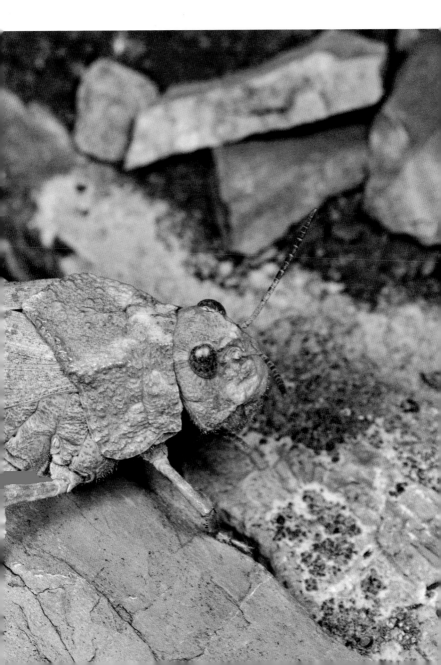

What Is an Insect?

Insects occur everywhere except in the high polar regions and below the surface of the oceans. A few species have even adapted to life on the Antarctic shelf margins; on cold, subarctic islands; in intertidal zones; and on the surface of the open ocean. Insects live in great abundance at every ecological horizon on land and in freshwater—in soil, where many feed on decaying organic matter and fungi or on plant roots; on ancient, low-growing plants such as mosses and ferns; on or in the trunks of shrubs and trees; and on or in foliage, flowers, or seeds of flowering plants. At each of these horizons, there is a complex of insects, each living in its own way, as a scavenger, primary consumer of plant material, predator, or parasite of other insects or other animals, and so on. Among both plant feeders and parasites, there are some generalist feeders and some that show great specialization for particular hosts.

Growth and Reproduction

In most insects, males and females are produced in about equal numbers, mating occurs, and females deposit eggs on or near the food used by the young. There are many modifications of this basic pattern—males may be produced only at certain seasons, as in social insects; generations of females may be produced without mating (parthenogenesis) while environmental conditions are favorable, as in aphids; or sexual forms are lost altogether, a phenomenon known in certain weevils, moths, and other insects. In typical forms, the sexes locate one another extremely effectively, and most females are mated almost as soon as they emerge. Commonly, the attraction of mates is accomplished using a volatile chemical or scent (pheromone) broadcast in the air, usually by the female. In some insects, such as butterflies and fireflies, visual perception of the mate is necessary; in others, like crickets and cicadas, calls or other sounds are perceived by one or both mates.

Adult insects do not grow. Growth occurs through a series of stages (instars) in juveniles; at the end of each, the shell or skin is shed (molted), and the new, temporarily pliable stage of the insect enlarges. After the final juvenile instar, molting produces the adult stage. In the simplest life cycle (hemimetabolous), such as that of roaches and grasshoppers, the eggs hatch into tiny nymphs resembling the adults except that they are smaller and lack wings and reproductive organs. Most insects have a more complex life cycle, normally with four stages (holometabolous—a complete change or metamorphosis): adults lay eggs that hatch into caterpillars, maggots, or various other forms of larvae that feed and grow through a series of molts. A largely nonmotile pupa is produced at the

last larval molt. A cocoon of silk may or may not be formed by the larva when it is ready to form the pupa, varying with the kind of insect. Finally, transformation to the adult occurs within the pupa, the shell of which is broken by the emergence of the adult.

An intermediate kind of change or metamorphosis occurs in certain aquatic insects, such as mayflies. The young stages, called nymphs or naiads, are quite different from the adults that do not live in water, and the transformation includes an active but nonfeeding subadult stage (subimago). In an evolutionary sense, the adaptation to complete metamorphosis was perhaps the single greatest achievement by insects. It enabled them to exploit a vast range of habitats by allowing adults and larvae to occupy and specialize in different niches. Complete metamorphosis allowed more versatile development of a resting stage, in which all growth and development can be stopped (diapause). This resting stage enables insects to synchronize activities to favorable seasons and to enhance survival during unfavorable times, such as the long dry season in California, by remaining dormant. Diapause may occur in the egg, larva, pupa, or adult, varying with the species. Many insects can even wait two or more years to complete the life cycle if seasonal conditions are highly unfavorable or uncertain, as in desert habitats.

Breathing and Circulation

Insects and related animals, such as sowbugs, spiders, and lobsters (Arthropods), have an exterior shell or skeleton within which the blood (hemolymph) freely circulates (open circulation). In insects the blood is moved primarily by the action of a tubular heart located in the upper part of the body cavity, opening just behind the brain. Blood is pumped forward to the head area, from which it circulates to the organs and into the appendages before reentering the posterior end of the heart.

In the majority of insects, air is taken in through holes in the body wall (spiracles). These are located along the sides of the body, usually one pair to each segment or fewer where segments have merged. Tubes (tracheae) lead from the spiracles throughout the body cavity. These branch through the organs and appendages, branching into finer and finer tubes (tracheoles). Oxygen passes from the tracheoles directly into the body, and carbon dioxide diffuses in the reverse direction. Most respiration is via passive diffusion, but limited, active pumping of air is known for some insects.

Some aquatic insects breathe in the usual manner, by periodically coming to the surface to collect a bubble of air. In many aquatic forms, however, breathing occurs through the general body surface, special organs, or gills. Therefore, some of these forms can spend their whole lives beneath the surface of the water. Insect gills are thin-walled out-

growths located along the sides of the thorax, abdominal segments, at the tail end, or on some combination of these body regions. Oxygen diffuses directly from the water through the gill walls, which are well supplied with tracheae and tracheoles. Tracheal gills are present in immature stages of mayflies, dragonflies, damselflies, stoneflies, caddisflies, alderflies, and many aquatic two-winged flies.

Feeding

Insects use many methods to feed. The kind of mouthparts and the mode of feeding are generally correlated with major groups or orders of insects. Thus grasshoppers and related insects have jaws or mandibles adapted for biting and chewing, as do beetles, wasps, bees, and most other insects. By powerful musculature, the horizontally opposing mandibles are capable of biting through solid food substances, which may be as tough as hardwood. In other insects, such as aphids, leafhoppers, true bugs, and some flies, the mouthparts are formed into a tubular beak that is stabbed into the food and juices are sucked up using pumping action. Butterflies and moths have the mouthparts modified into a long, coiled tube that is inserted into food sources such as nectar in flowers, and this is taken up by a pumping action. In some insects, enzymes are ejected from salivary glands to liquefy food, such as dried honeydew, before it is sucked up. In other cases, as in mosquitoes and fleas, salivary fluid is injected that prevents coagulation of vertebrate blood that is then ingested. Many kinds of flies are adapted to feed on blood, and they have piercing and sucking mouthparts, while other flies take up their food via a proboscis with a sponge-like tip.

Most insects are harmless to humans from a medical or health standpoint. However, lice, fleas, bedbugs, and a few other true bugs as well as mosquitoes and certain other flies are familiar for their bites. Some bugs and flies, normally predaceous on other insects, can inflict a painful bite if prompted, but none of these injects venom comparable to that of a black widow spider. But certain diseases are transmitted by insects, especially in tropical regions, commonly by biting and blood-feeding insects. In California these diseases include plague, transmitted by fleas from rodents; encephalitis and West Nile virus infecting birds, transmitted by mosquitoes; and malaria, carried by mosquitoes. None of these is epidemic today in California, although some cases of West Nile virus, encephalitis, and plague are recorded each year. Other mosquito-borne diseases not known in California presently, such as Chikungunya or Zika virus, have entered the United States and in time may be found in the state.

Stinging

Few insects are capable of stinging, but often the term "sting" is misused to describe insect bites. The true stinging apparatus is a modified ovipositor in female ants, wasps, and bees. No other insects sting, but many non-stinging insects mimic those that do and thereby gain protection from potential predators that are fooled. In contrast to insect bites, the sting is accompanied by the injection of toxins, a mixture of complex proteins and enzymes that act on the tissues of the victim, and in humans and other mammals this often causes the release of histamines. In humans, depending on individual sensitivity, the effects may be severe. Many kinds of wasps and bees are capable of stinging if provoked, but the behavior has its most damaging effect in social species: ants, yellowjackets, bumble bees, and the Honey Bee. When provoked, the workers rush out in great numbers to attack intruders, activated by alarm chemicals given off by their sisters. Some ants both sting and bite. In the Honey Bee worker the sting stylet is equipped with barbs so that it fixes in place and the entire sting apparatus pulls out of the bee, which kills her. Worker bees are expendable for the protection of the colony as a whole.

Distribution and Diversity of the California Insect Fauna

California's size, long span of latitude, and diverse topographic features set the stage for tremendous biological diversity. The second largest of the 48 contiguous states, comprising an area about equal to the New England states, Pennsylvania, and New York combined, California by size alone would be expected to have large numbers of plant and animal species. In addition, several geographic and climatic zones are created by topography, dominated by two mountain systems. These ranges parallel the coast and serve to modify the ocean's influence. Elevations extend from above 4,400 m in the Cascade Range and the Sierra Nevada to below sea level in the Imperial and Death Valleys. Average annual rainfall varies from more than 270 cm in Del Norte County to less than 5 cm in parts of the deserts. In most of the state, nearly all the precipitation falls between October and May. Coastal areas often have 365 frost-free days per year, while there are fewer than 100 at high elevations. Fog is also an important climatic influence, particularly along the coast, where it is regular during the summer months, and ground fog may be an important winter influence in the interior valleys.

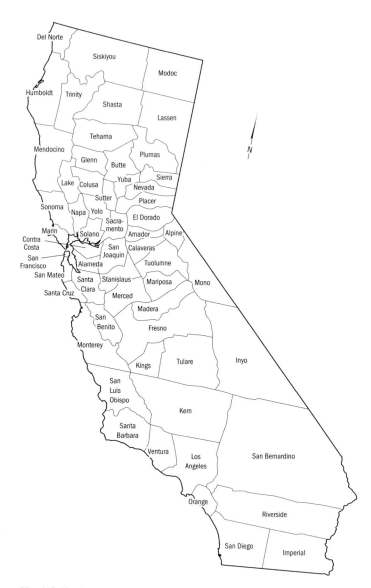

Map 1. California counties.

Topography

Two major mountain chains compose the state's most prominent topographical features: the Coast Ranges (including North Coast, Diablo, and Santa Lucia) and the inland Sierra Nevada, which are joined in the north by the southern end of the Cascade Range and in the south by the Transverse Ranges. The Sierra Nevada is the dominant feature; it consists of an immense granitic uplift more than 600 km long, extending from Plumas County to Kern County. In general, its east side rises abruptly from 1,500 to over 4,000 m defining the Great Basin to the east and descends gradually on the western slopes via a tipped plateau, divided by a series of deep canyons carved by the west-flowing rivers draining extensive snowpack. The Coast Ranges—subdivided into outer, marine-influenced, and inner, hotter, drier ranges—are lower but reach elevations above 2,500 m in the north. The Transverse and Peninsular Ranges also reach elevations of 2,500 m and 3,000 m and, like the others ranges, serve to block the ocean's influence, creating a rain shadow effect resulting in arid interior regions.

Geographical Distribution

Many methods have been developed for describing and analyzing the distribution of animal species. These include defining geographical divisions, using vegetation types, ecoregions, and faunal provinces. None perfectly reflects the patterns of all species nor can any single system satisfy all biologists.

Botanists have classified the flora of California into natural plant communities or alliances. Most of these have a climatic basis and have been shaped by relatively recent events. Many plant alliances are highly influenced by soil type, hydrology, and fire regimes. An alliance is defined by the associated composition of plant species and is considered an emergent natural community. These communities vary in their distinctiveness and the complexity of their distributions. Based on *A Manual of California Vegetation* (Sawyer et al. 2009), there are now nearly 500 alliances so defined. These are organized into Woodland and Forest Alliances and Stands, Shrubland Alliances and Stands, and Herbaceous Alliances. This organization is a wonderful tool for botanists and land managers with a focus on plants but is difficult to apply to insects. For our purposes, we retain Munz and Keck's (1959) 11 vegetation types, which generally are more useful in a qualitative discussion of insect occurrences and as a predictor of insect distributions in California. A great many insect species, especially plant-feeding forms, are restricted to one of the vegetation types: (1) Coastal Strand, (2) Salt Marsh, (3) Freshwater Marsh, (4) Scrub, (5) Coniferous Forest, (6) Mixed Evergreen Forest, (7) Woodland Savan-

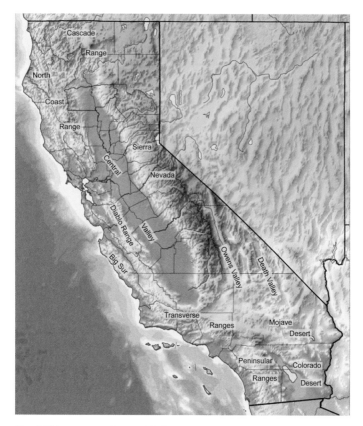

Map 2. Major ranges and geographic features of California.

nah, (8) Chaparral, (9) Grassland, (10) Alpine Fell-fields, and (11) Desert Woodland. The California Native Plant Society provides an online tool for easy conversion between Munz Communities and California Vegetation Alliances.

Because most insect species are more widely distributed than any given geographic feature or plant community, larger ecoregions provide convenient categories for distribution description and analysis. Perhaps the best approach to insect distributions in California is one in which faunal provinces are proposed, based on a combination of topographical features, ecoregions, and ecological or vegetation types. Many attempts have been made by biologists to define useful biotic provinces, but none has unanimous acceptance, primarily because various plants and ani-

mals differ in adherence to one or another of the criteria used to create the provinces. The ecoregions we present approximate what we see as optimal for insects (map 3). They are close to the regional terminology commonly used in scientific literature and are recognized by a wide array of biologists working in California. We have modified this based on our own collecting experience, data from the Essig Museum of Entomology, University of California at Berkeley, data from the *Bulletin of the California Insect Survey*, information about insect distributions from many colleagues, and reports from online resources such as BugGuide and iNaturalist.

Six provinces are defined for the entomofauna (entomological fauna), each including several plant community types and often multiple major geographic features (map 2). Perhaps half the state's insect species are limited to one or a portion of one of these provinces, including the majority of plant-feeding types. Many species, including general feeders such as scavengers and predators, are more widespread, though many flightless species can be very narrowly distributed. The diversity of insects makes exceptions to any rule a regular occurrence. Although parasitoid insects often are specific to a host species or a particular habitat, others are less restricted and can be widely distributed. There are also many plant-feeding species that either feed on a wide variety of plants (polyphagous) or are restricted to one plant family or genus but use representatives that grow in diverse ecological situations.

The provinces presented here are intended as a tool for the insect enthusiast, observer, and collector to help them plan travels so they may more fully experience California's insect diversity. Given that insects may violate any one system of areas, we take a mixed approach in describing their distributions and may refer to these provinces, the ecoregions, or even counties (maps 1–3) in describing the ranges for the insects. It should not overly surprise readers if in their explorations, they discover a species outside the range we have estimated for it. The entomofaunal provinces and their ecoregions that we use are as follows:

Sierran Province

The Sierran Province is the largest entomofaunal province, and it includes most of the state's mountainous area. It includes many vegetation types and covers numerous topological features. There are many insect species or groups of closely related species that span the entire province. Some insects may be restricted to one or more of the ecoregions included in the province as described below.

SLOPES AND FOOTHILLS OF THE EASTERN CASCADES AND THE MODOC PLATEAU. Receiving much less rain than the adjacent high North Coast Ranges, this region has a more central-north continental flora and fauna. There are

many buttes, cones, and plateaus of volcanic origin in the region, dotted with open conifer forests, scrub, and grasslands.

KLAMATH MOUNTAINS AND HIGH NORTH COAST RANGES. This region is irregularly bound on its western flank by the coastal "fog belt" (see "Coastal" below), extends from further north south into California, and is the southern extent of many insect groups that reach their greatest diversity in the Pacific Northwest. The area is thought to have been largely unglaciated during the Pleistocene and so has served as a refugium for northern species. It has a relatively mild and humid climate, though not as wet as the Coastal and North Coast Ranges.

NORTH SIERRA AND CASCADE RANGES. This is a disjunct portion of the larger Cascade ecoregion that extends from northern California through Oregon to Washington. The insect fauna blends northern elements and central Sierran elements. Some peaks reach over 4,000 m with rocky alpine and subalpine habitat on the slopes. Much of the lower elevations are moist, rich conifer forest, an area that has been heavily used for timber production. Many of the insects are shared with the Central Range.

CENTRAL RANGE. Traditionally this area is referred to as the Sierra Nevada. Containing most of the coniferous forests of the state and including a range from 1,000 m to over 4,000 m elevation, this region is probably the most diverse in habitat types and the richest province in insect species. Owing to its diversity, the Sierra Nevada has a high proportion of species that range into adjacent ecoregions or provinces, such as the Sierra Nevada foothills and the Coast Ranges. Nevertheless, there are vast numbers of insect species found only in this province.

WESTERN FOOTHILLS. This narrow, north-south region is characterized by Blue Oak and Foothill Pine woodlands and chaparral. It is on the western face of the Sierra Nevada from roughly 150 m to 1,000 m elevation. It shares a considerable number of species with the Sierra Nevada region above and the Central California Valley below but has endemics and often unique assemblages of species.

TRANSVERSE AND PENINSULAR RANGES. The region, diverse in vegetation and its associated insects, includes large areas of fire-prone chaparral and oak woodlands. At higher elevations summers are cooler and precipitation is greater than in adjacent ecoregions, resulting in many insect species that are shared with the Sierra Nevada, extending north but reaching their southernmost extent here. This is especially true in areas of extensive and diverse coniferous woodlands. These southern mountains are an ecoregion boundary with elements of the Mojave Basin, the Sierra Nevada, and southern California regions mixing or closely adjacent.

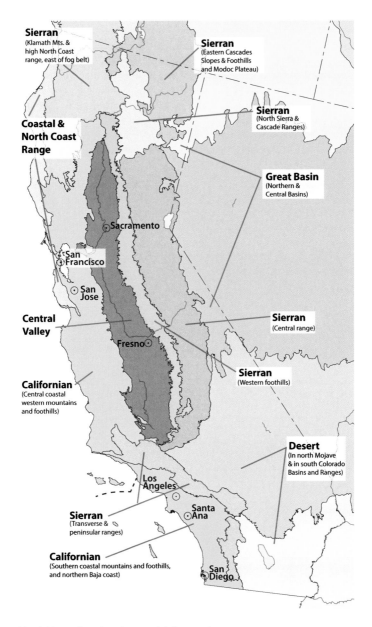

Sierran
(Klamath Mts. &
high North Coast
range, east of fog belt)

Sierran
(Eastern Cascades
Slopes & Foothills
and Modoc Plateau)

**Coastal &
North Coast
Range**

Sierran
(North Sierra &
Cascade Ranges)

Great Basin
(Northern &
Central Basins)

⊙Sacramento

San
⊙Francisco

⊙San
Jose

**Central
Valley**

Sierran
(Central range)

Fresno⊙

Sierran
(Western foothills)

Californian
(Central coastal
western mountains
and foothills)

Desert
(In north Mojave
& in south Colorado
Basins and Ranges)

Los
Angeles
⊙

Sierran
(Transverse &
peninsular ranges)

⊙Santa
Ana

Californian
(Southern coastal mountains and foothills,
and northern Baja coast)

San
⊙Diego

Map 3. Entomofaunal provinces and their ecoregions.

Coastal and North Coast Ranges Province

This province is dominated by the marine influence that results in summers characterized by fog and cool breezes at the coast. The marine effect diminishes quickly going inland, resulting in hotter summers and colder winters. A fog belt zone that extends from the coast to approximately 50 km inland is an area remarkably distinct from the drier inland areas for both plants and insects. The fog is vital to the ecoregion. For example, the Coastal Redwoods can get more than half of the water they need from fog, critical during the summer drought period. Winter rainfall is the highest in the state and can be nearly 300 cm, including significant snow accumulation at higher elevations.

COASTAL. The coastal ecoregion includes coastal strand and coastal plains dominated by grasslands and coastal terrace prairies, dunes, saltmarshes, and scrublands. In the north, lowland areas near the coast are dominated by Coastal Redwood and Douglas Fir–Tan Oak forests. The southern coasts and lower western-facing foothills are clothed in oak, pine, and chaparral.

NORTH COAST RANGES. This ecoregion is dominated by a series of ranges that parallel the coast and become successively higher elevation going inland. Characterized by plants and animals with northern affinities and including parts of the coastal strand, coastal scrub, and northern coastal coniferous forest, this ecoregion has a high proportion of insects that range along the coast from Vancouver Island, Canada, or further north. There are only a few species known strictly from California (endemic) in this area.

Central Valley Province

Much of this province has been converted to agriculture and oil and gas extraction, but there are still some remnant grasslands, marshes, vernal pools, riparian woodlands, alkali sink vegetation habitats, and stands of Valley Oak. Toward the southern end, this area shares an appreciable number of its insects with the Mojave Desert, especially those of the western San Joaquin Valley, which has sandy areas harboring desert plants. Many other insects occur widely here and in the western foothills and the central coastal western mountains and foothills.

Californian Province

This, the second-largest province, extends over much of the length of the state. It has a distinctly Mediterranean-type climate and a larger proportion of species endemic to California than any other province. This area is also diverse in habitats, soils, and microclimates.

CENTRAL COASTAL WESTERN MOUNTAINS AND FOOTHILLS. This region contains the central coastal strand and coastal scrub as well as the chaparral, foothill woodland, and coniferous forests of the central and southern ranges. All of these are relatively arid compared to their northern counterparts. Although most insects range northward into the Coastal Ranges or east in the Sierra Nevada, a large number occur only in this region or are shared with the adjacent Southern California/northern Baja coast. A central geographic feature is the Diablo Range, extended from the northeast at the San Joaquin River to the southwest at the Salinas River, bordered on the east by the San Joaquin Valley. This range is drier, hotter, and shares more with the Central Valley than its parallel counterpart to the west, the Santa Lucia Range that defines the Big Sur coast.

The Channel Islands have been treated by some as a distinct province, but the islands' insects generally are those of the mainland. The insects are not well inventoried, but it appears that most of those of the northern island group, especially Santa Cruz Island, are species also found in the central coastal western mountains and foothills region, with few endemic species. By contrast, the southern islands, especially the more distant ones, have higher numbers of endemics and a greater affinity with the southern part of the southern California/northern Baja coast and the desert provinces.

SOUTHERN COASTAL MOUNTAINS AND FOOTHILLS, AND NORTHERN BAJA COAST. This is a region with coastal and alluvial plains and low hills, extending south into Baja California. Though the vast majority of the native habitat has been converted for human use, the remaining grasslands, coastal sage scrub, scrub oak, and mountain-mahogany habitats include endemic plants and insects. The southern Channel Islands appear to share much of their insect fauna with this region.

Great Basin Province

California only includes the far western fringe of the Great Basin. The bulk of the ecosystem extends over 1,200 km east from California ending at the Rocky Mountains. Generally the relatively dry, cold climate of the province supports mainly steppe shrub and grasses at low and medium elevations and conifer and aspen trees at higher elevations.

NORTHERN BASIN AND RANGE. This area represents the western edge of a vast sea of sagebrush scrub covering areas to the east and north of California. It is rather uniform in character, rich in species, and relatively distinct from other parts of the state's fauna. It contains almost no insects endemic to California, as the majority of the area is in eastern Oregon and southern Idaho. It is cooler and wetter than the Central Basin and range and so has a much more northern faunal influence.

CENTRAL BASIN AND RANGE. This region is the western edge of the Great Basin region. Aside from the overlapping fauna with the Northern Basin and range, it is highly distinct from the rest of California. It is significantly warmer, especially during summer, and somewhat drier than the Northern Basin and range. Many species that are widespread from California to Utah are at the western edge of their distribution here.

Desert Province

This province is very distinct within California but harbors few endemics. It is characterized by low and rather unpredictable rainfall. The higher elevations receive regular snowfall and relatively longer winters, while the lower elevations may remain warm year-round and very rarely experience freezing temperatures.

MOJAVE BASIN AND RANGE. This region has broad basins, alkali flats, and scattered, rocky mountains. The vast majority of species that are restricted to this province in California also range into Arizona, Nevada, and beyond. Within California the overall similarity in insect species with the Colorado Basin and range is very high, although there is a merging of Mojave, Sierran, and Central Valley faunas near the Tehachapi Mountains and Transverse Ranges.

COLORADO BASIN AND RANGE. Though similar in its insect fauna to the Mojave, this low desert region is notably hotter, with large areas of Giant Saguaro Cactus and a mix of palo verde and smaller cactus species, compared to the typical vegetation in the Mojave, which is largely Creosote Bush. This area also includes the largest areas in the state of wind-blown (aeolian) sand deserts with active dunes and the longest stretch of Colorado River shoreline. The sparse precipitation that might fall in this region is almost equally divided between winter rain systems and the occasional late summer monsoon that may stray west from Arizona. Both of these sources of precipitation can fail to materialize, sometimes for years.

Diversity

Summer visitors from the eastern United States, especially if their travels are restricted to lowland areas, around the cities, and major north-south highways, often remark on the dryness of the California countryside. Insect collectors from places like Minnesota or Illinois, arriving here in June, when the collecting season is just getting into full swing there, are dismayed to find that it is about finished in lowland California. Unless they obtain local advice or plan to work in the mountains, these visitors are likely to find summer collecting in California a bleak prospect; and they may justifiably find it hard to believe that we have a larger number of insect species than nearly any other state.

The mild climate with a long dry season is a key to the hidden diversity. Prolonged drought imposes a strong seasonal partitioning on plants and animals. In California this is superimposed on the topographical diversity, creating a complex mosaic of geographical, ecological, and seasonal niches to which insects have adapted. Northern, higher-elevation, and interior regions of North America have a short growing season, with the vast majority of the insects active during summer months. In most of California, by contrast, the growing season for annual plants takes place mainly during winter and spring. The insects feeding on annuals and using their pollen, as well as associated parasitic insects, must complete their activity early, often ahead of the growing and flowering seasons of perennial plants.

For example, small moths are active in January and February in southern California and along the immediate coast northward. They are day-fliers and are dark-colored to take advantage of the sun's warming during a season when temperatures at night are too cold for activity. This early start enables their larvae to complete feeding before the annual plants, on which they specialize, dry out in late March or April. Comparable adaptations occur in large numbers of other insects. Even species associated with broad-leafed shrubs and trees often complete their activity early. Leafing out generally occurs at the end of the rainy season, in April and May, and the leaves harden, becoming more resistant, by summertime. Many other insects are active in fall, such as those associated with fall-blooming composite shrubs. Many fall-fliers feed as larvae in spring, having overwintered in the egg stage.

Therefore, to study the insects of California, all seasons have to be considered. At lower elevations there are many spring-active species from January to April, but there are summer species in marshes, river habitats, and in association with perennial plants. Elsewhere in the state insect activity peaks in the foothills by May, at intermediate elevations in June, and in the high Sierra in July or August. By the time regular frosts occur at timberline, fall-active species are in full swing at low elevations. Even during the most dormant period (mid-November to mid-January), there are insects to be found. This is the time adults of many species, including some particularly unusual kinds, reach peak abundance, especially in the deserts and at coastal localities.

Whereas 50 species of a given family may be collected by sampling one or a few localities in Wisconsin or Ohio (possibly the same 50 in both states), a comparable number, probably more, may be known in California, but the beleaguered collector must work in a dozen habitats from February to August to find them. It is no wonder that most habitats have not been adequately sampled and that discovery of new species in California is commonplace. Occasionally we rediscover a species known

Common Microhabitats with Characteristic Insect Examples

Microhabitat	Common Insects
On ground under stones or woody debris	Webspinners, ground beetles, darkling beetles
In sand of beach or desert dunes	Burrowing bugs, ground beetles, scarab and darkling beetles, weevils, larvae of moths
In moist leaf litter	Springtails, diplurans, and many kinds of small beetles especially fungus feeders
In freshwater ponds	Diving beetles, backswimmers, water boatmen, naiads of damselflies and dragonflies
On or under stones in swift-moving streams or cascades	Immatures of stoneflies, caddisflies, water pennies, riffle beetles, black flies
On surface of pools and ponds	Water striders, riffle bugs, whirligig beetles
On sand or mud margins of streams or ponds	Toad bugs, shore bugs, tiger beetles
In galls of woody plants	Larvae of gall wasps, gall midges, small moths, and the parasitic wasps of all three
On or in leaves of living plants	Aphids, whiteflies, lace bugs, most caterpillars including leaf-miner moths and fly larvae
Visiting flowers	Various beetles, hoverflies, moths and butterflies, bees
Inside fruit or seeds of flowering plants	Larvae of moths, weevils, and fruit flies
On or in fungi	Fungus gnats, moth larvae, many kinds of small beetles
On recently felled tree branches or trunks	Bark beetles, metallic wood borer beetles, long-horned beetles, parasitoid wasps
Under bark of old stumps or logs	Ironclad beetles, carpenter ants, various fly larvae, many small beetles
In punky wood of old rotting logs	Termites, adults and larvae of click beetles and stag beetles
On recently killed vertebrate animal carcasses	Blowflies, hister beetles, carrion beetles
On old, drying vertebrate carcasses	Hide beetles, rove beetles, tineid moth larvae
On or in animal droppings, especially cow pats	Dung flies, blow flies, scarab beetles
On living mammals or in their fur	Horse flies, fleas, lice
On human skin	Head lice, crab lice

only from specimens taken by an early explorer and not collected for the past 100 years or more.

Microhabitats

Within any one of the ecoregions there are a large number of different habitats varying with the season. Habitats may be large or small in extent, but each has only a narrow range of environmental conditions. The list above gives some examples of microhabitat types, and each may be further subdivided according to shade, moisture conditions, and other factors because insects often specialize by moisture tolerance, temperature preference, and so on.

Making an Insect Collection

The study of insects is called entomology. Insect collecting is not only an excellent learning experience for the serious entomology student; it may be an exciting and satisfying hobby for anyone. Because of the enormous variety, new additions to the collection are possible almost endlessly. One should carefully consider when and where it is appropriate to collect, however, as this involves killing or "taking," to use the sanctioned terminology of hunting, fishing, and foraging. With the ubiquity of excellent digital cameras in nearly everyone's pockets, or the availability of high-end digital SLR cameras for the serious enthusiast, many insects can be photographed with excellent resolution. But the number of insects that can be photographed and released alive, such that the result will be an identifiable image, is vastly smaller than the number that can be collected by various passive and active methods. Plus, image-only collection precludes all additional types of study, such as dissections (sometimes necessary for identification) or DNA extraction.

We recommend a combined approach, for groups that a budding entomologist is not very interested in or when in a place that taking specimens is not appropriate. For example, in a National Park without a formal permit, taking photographs is the best and only legal course of action. Otherwise, for focus groups and where appropriate, a properly prepared collection is far superior as a learning and research tool and may even make a lasting contribution to science.

Some people may be concerned that collecting insects could have a significant impact on insect populations. This has never been shown to be the case. Unlike birds and mammals, which grow fairly slowly and produce relatively few offspring, most invertebrates, including insects, have annual life cycles and produce hundreds, often thousands of off-

spring. Populations can include hundreds of thousands or even millions of individuals across a species' range. The number of individual insects a person kills when driving a car or running security lights is far more than any one collector could collect by hand in a lifetime. There is no evidence that collecting adult insects, even in relatively small populations, affects the overall numbers in succeeding generations. It is obvious that human activities (e.g., urban sprawl, agriculture, transport of weeds, and mining of sand dunes) are responsible for the wholesale destruction of habitats. This often leads to the destruction of the insect populations inhabiting these habitats, especially on a local scale. But insects are amazingly hardy as long as their habitat is reasonably preserved. Even attempts to eradicate insect pests are successful only on a local basis, and normal collecting techniques have no lasting effect on the population size. Habitat destruction, host elimination, misuse of pesticides, and human-induced climate change all have serious and lasting impacts on insects, potentially including extinction.

No one should wantonly take insects without the intent to properly study and preserve them. To ensure permanency and to make collections of value beyond their aesthetic appearance, collections must be properly prepared, labeled, and cared for. Ultimately, even people who do not make entomology their full-time vocation can make significant contributions to the field with well-prepared and curated collections that are the result of serious, lifelong avocation. Indeed, amateur contributions are a cornerstone of the science of entomology. Making a collection takes a little planning and a modest investment. The general references listed at the end of the book will provide basic and more advanced instructions for construction of equipment for collecting and preparing specimens. To be of scientific value, every insect specimen must have data labels permanently associated with it. Labels should be small, on good-quality paper, and contain the following information:

Locality. The place of collection should be given as exactly as practical and should be so designated that it can be found on a road map and include latitude and longitude.

Date. The day, month, and year.

Collector. The collector's name should be indicated, as a possible source of further information.

Ecological source. If known, the host, food plant, or other activity should be indicated (e.g., "under loose bark on pine stump," "mating on fungus 10:30 a.m.," and so on).

In addition to the minimal information on the specimen label, we strongly recommend keeping a notebook of other details surrounding the collecting event and photographing the habitat. With all of this information, a collection can be a great learning and discovery tool for the

collector and researchers in the future. Much of the most important work occurring today is based on historical specimens and notes from a large and diverse community of contributors.

Classification

Animals are classified into a hierarchy of categories called *taxa* (singular = taxon) with each higher taxon containing one to many taxa of the next subordinate rank. Following are the levels commonly used for insects, in descending order:

Phylum
 Class
 Order
 Suborder
 Superfamily
 Family
 Subfamily
 Genus
 Species

The arrangement is based on many characteristics in insects, including anatomical features of adults and immatures, and genetic evidence through the analysis of DNA sequence data. The classification is predicated on a reflection of natural or evolutionary relationships. Thus predictions about species beyond the information already available can be made based on what is known about closely related species. For example, a thread-waisted wasp of the genus *Ammophila* **(680)** may be known only from adult specimens, yet it is possible to predict with confidence that the species preys on moth caterpillars, digs burrows of a certain type, supplies caterpillar provisions to one offspring per burrow, and so on, because all other *Ammophila,* for which habits are known, do so. It would be possible to classify animals in some artificial way, such as by numbers or alphabetically by name, which would be useful in locating and retrieving information in a library or museum, but the predictive quality and its connection to the process of evolution would be lost.

Insects and other animals with an exoskeleton and jointed legs, including spiders, lobsters, sowbugs, and others, make up the Phylum Arthropoda. Insects are distinguished from other arthropods by having three body regions—head, thorax, and abdomen—and by having only three pairs of legs. Within the Class Insecta there are about 30 orders, their number varying with authorities' interpretation; the major orders

are characterized below. For example, beetles make up the Coleoptera, the largest order in numbers of species.

Because there are so many kinds of insects, it is impossible to know and talk about all the species even for a local area. Therefore, the family is most often the level at which communication about insects occurs. Most families contain species of generally similar appearance and habits. For example, beetles of the family Cerambycidae **(359–365)** are generally recognizable by their long antennae, and their larvae are all similar-appearing grubs that bore in roots or wood of living or dead trees and shrubs. When students learn to recognize 300 or 400 of the common or distinctive families in a region such as California, they can communicate about the vast majority of insects around them. Moreover, much of this information is applicable in many other parts of the world because the major families are typically worldwide in distribution. Studies have shown that communication systems used by humans outside of formal scientific classification systems for entities such as plants or animals generally contain about 250 to 800 items, for which recognition and the ability to communicate names are useful to the people. This shows why we cannot directly communicate information easily about 30,000 to 40,000 species of insects in California, but a few hundred dominant families fall within a range most people can comprehend, retain, and apply practically.

Names

The scientific names of animals are based on the two lowest-rank categories, the genus (plural = genera) and the species (plural and singular = species). Therefore, each insect has two parts to its name: the generic name, with the first letter capitalized, followed by the specific name, which is entirely lowercase. For example, the scientific name for the Mourning Cloak Butterfly is *Nymphalis antiopa* **(619)**, while the California Tortoiseshell Butterfly, a member of the same genus, is *Nymphalis californica* **(618)**. The names are Latinized and are usually printed in italics. It is common practice to abbreviate the genus after it has been introduced in its verbose form. For example, we can unambiguously refer to *N. californica* and the reader will know we mean *Nymphalis*. In cases where two genera are being discussed and both begin with the same letter; care must be taken to avoid ambiguity.

In technical literature and a properly labeled collection, the name of the author who first named and described the species is also given. The simplicity of this system is so attractive that zoologists have used it universally ever since it was proposed by Linnaeus in the mid-1700s. In what are perhaps the only international agreements accepted by all nations,

zoologists and botanists throughout the world use sets of rules governing the names of animals and plants. Every animal has a unique name. The generic name of an insect cannot be used for any other kind of animal, but a specific name can be used more than once, so long as the species are in different genera. For example, many species in different genera are named *californica*. In many cases, industrious taxonomists have added a third name, the subspecies, to describe geographically limited populations that differ in color or other respects. In general, we do not mention these in this guide, even though they have been applied to many of the species we discuss.

There are no rules regarding common names, and they change from place to place for the same animal. For instance, *Nymphalis antiopa* is called the Mourning Cloak here, while in England it is the Camberwell Beauty. Although there is a list of common names approved by the Entomological Society of America (ESA) for the more important species in agriculture, laboratory research, and so on, most insects have never had common names proposed. We have adopted the scientific and common names given in the ESA list, with a few exceptions. In cases where we were unable to locate formally or generally accepted common names, new ones are applied in this book.

Synopsis of Hexapods and the Orders of Insects

Arthropods (Phylum Arthropoda)
Hexapods (Subphylum Hexapoda)
Coneheads (Class Protura)

Minute, slender, delicate. Head pear-shaped; compound eyes, ocelli, and antennae absent; mouthparts formed for sucking, retracted within head. Legs short, tarsi with only one segment, each bearing a single claw; wings absent. Abdomen composed of 11 segments, the last three very short, the basal three with ventral, paired styli (vestigial legs); cerci absent. Metamorphosis gradual; immatures similar to adults except for size; molting continues throughout life with segments added terminally to abdomen.

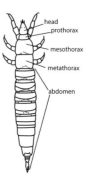

Two-pronged Bristletails (Class Diplura)

Small to medium-sized, slender, unpigmented. Head large, oval; antennae long, with numerous beadlike segments; compound eyes and ocelli absent; mouthparts mandibulate, retracted within head. Thoracic segments similar; legs similar, tarsi with only one segment, each bearing two claws; wings absent. Abdomen with 10 segments, some with ventral, paired styli (vestigial legs); cerci well developed, either (a) long, filamentous, and many segmented, (b) short and few segmented, or (c) unjointed and forcepslike. Metamorphosis gradual; immatures similar to adults except for size.

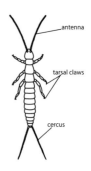

Springtails (Class Collembola)

Minute to small, soft-bodied, cuticle (outer layer of body wall) often with scales, rods, and tubercles. Compound eyes absent or represented by groups of separate facets; antennae short with few segments; mouthparts chewing or sucking, retracted within head. Abdomen with only six segments, some bearing unique ventral appendages, a median projection (collophore) on segment 1, elongate springing apparatus (furcula) on segment 4 or 5, and catch (tenaculum) for holding the furcula on segment 3; cerci absent. Metamorphosis gradual; immatures similar to adults except for size.

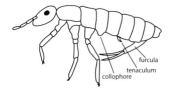

Insects (Class Insecta)

Bristletails (Order Archaeognatha)

Small to moderate-sized, clothed with scales. Wingless; body cylindrical, brown or yellow with darker gray or black mottling; thorax arched dorsally; antennae long, hairlike (filiform), with many segments; compound eyes present, large and dorsal; ocelli usually present; mouthparts mandibulate, external. Legs similar, tarsi with two or three segments, bearing two claws. Abdomen with 10 full segments, some with large, ventral, paired styli; 11th abdominal segment a long filament, two lateral filamentous cerci. Metamorphosis gradual; immatures similar to adults except for size. Able to jump by snapping the abdomen against the ground.

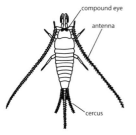

Silverfish (Order Zygentoma)

Small to moderate-sized, often clothed with scales. Wingless; body flat, tapering to tip, brown often with darker gray or black mottling; antennae long, hairlike (filiform), with many segments; compound eyes small or absent; mouthparts mandibulate, external. Legs similar, tarsi with two or three segments, bearing two claws. Abdomen with 10 full segments, some with large, ventral, paired styli; 11th abdominal segment a long filament, two lateral filamentous cerci. Metamorphosis gradual; immatures similar to adults except for size.

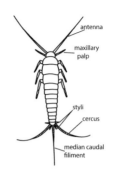

Mayflies (Order Ephemeroptera)

Small to moderate-sized, delicate. Compound eyes large (sometimes secondarily divided); ocelli present; antennae with two large basal segments, the remainder threadlike (flagellum); mouthparts vestigial. Prothorax small, free; mesothorax large; wings present, two pairs, membranous, fore pair much larger than hind, both pairs with complex netlike venation. Abdomen slender, tipped with two or three long, many-segmented filaments. Metamorphosis hemimetabolous; naiads aquatic, with abdominal gills; winged immature form (subimago) precedes final molt to adult.

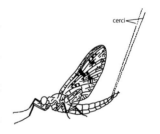

Dragonflies and Damselflies (Order Odonata)

Medium-sized to large, slender. Eyes very large with facets (ommatidia), extraordinarily numerous; ocelli present; antennae minute; mouthparts biting, mandibles strongly developed. Thoracic segments fused and tilted obliquely backward; legs similar, placed far forward, armed with heavy spines; wings present, two pairs, similar, membranous, complexly veined. Abdomen long and narrow; cerci one-

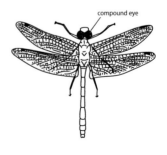

segmented; secondary male copulatory apparatus attached ventrally to second and third segments. Metamorphosis hemimetabolous; naiads aquatic with gills, change directly to adults.

Stoneflies (Order Plecoptera)

Small to large, soft-bodied. Head broad and flattened; compound eyes and ocelli present; antennae long, many segmented; mouthparts mandibulate, sometimes reduced. Prothorax large, free; four wings, membranous hind pair larger than fore, with large posterior (anal) area, both pairs with complex venation. Metamorphosis hemimetabolous; nymphs aquatic, with filamentous gills, change directly to adults.

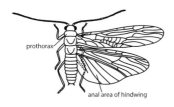

Ice Crawlers (Order Grylloblattodea)

Wingless, elongate, with eyes reduced or absent. Antennae moderately long, threadlike; mouthparts mandibulate. Legs similar to one another, tarsi five-segmented. Female with large ovipositor. Abdominal cerci long, eight-segmented. Metamorphosis hemimetabolous; nymphs similar to adults. Some sources use the name Notoptera for this order.

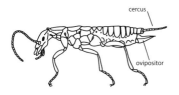

Cockroaches, Termites, and Mantises (Superorder Dictyoptera) (Order Blattodea)

Cockroaches are medium-sized, flattened, with the head nearly or completely covered from above by large, shieldlike pronotum. Antennae threadlike (filiform) with numerous segments; mouthparts mandibulate. Legs similar to one another; tarsi five-segmented. Fore wings thickened, somewhat leathery, held flat over back; hind wings broader, membranous, fan-shaped, folding under fore wings when

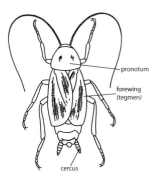

at rest. Abdomen with two short, many-segmented cerci. Nymphs similar, lacking wings. Metamorphosis hemimetabolous; nymphs resemble adults except lacking wings. Termites (isopterans) are small to medium-sized, elongate, polymorphic (various castes) with highly developed social habits. Body usually soft, eyes usually present in reproductive castes, absent in others; mouthparts chewing, for feeding on wood (worker caste only, very large mandibles used for defense in some soldier castes); prothorax free; wings usually absent, when present, only temporary (in dispersing adults), similar, with strong anterior veins only, shed after new colonies founded. Metamorphosis hemimetabolous; immatures similar to adult workers in structure and habits.

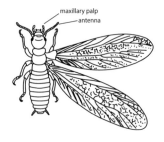

Mantises (Order Mantodea)

Medium-sized to large, winged. Antennae threadlike with numerous segments; mouthparts mandibulate. Forelegs fitted for grasping prey (raptorial); mid- and hind legs unmodified; tarsi five-segmented. Fore wings thickened, leathery, often short; hind wings fan-shaped, often colorful, folded under fore wings when at rest. Abdominal cerci many-segmented. No hearing or sound-producing organs. Metamorphosis hemimetabolous; nymphs similar to adults except wingless.

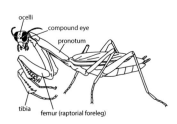

Grasshoppers, Crickets, and Katydids (Order Orthoptera)

Mostly medium-sized to large, winged or wingless. Mouthparts mandibulate; antennae many segmented, short, thick or long, threadlike. Hind legs usually enlarged for jumping. Fore wings narrow, usually thickened, leathery, folded flat or rooflike over back; hind wings membranous, fan-shaped, often brightly colored, folded under fore wings when at rest. Abdominal cerci short and unsegmented. Specialized hearing and sound-producing organs frequently developed. Metamorphosis hemimetabolous; nymphs similar to adults except lacking wings.

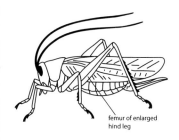

femur of enlarged hind leg

Walkingsticks (Order Phasmida)

Mostly large, winged or wingless across the order, but sticklike and wingless in all our species. Mouthparts mandibulate; antennae many segmented, short or long, and threadlike. Prothorax short, meso- and metathorax elongate; legs widely spaced, similar to one another; tarsi usually five-segmented. Cerci short, unsegmented. No hearing or sound-producing organs. Metamorphosis hemimetabolous; nymphs similar to adults.

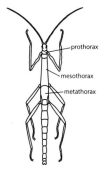

prothorax

mesothorax

metathorax

Webspinners (Order Embiidina)

Small to medium-sized, soft-bodied, elongate. Eyes present; ocelli absent; antennae long, many-segmented; mouthparts biting. Prothorax large, free; first tarsal segments of forelegs containing silk glands for spinning webs in which the insects live; wings absent in females, sometimes present in males, two pairs, similar, elongate, venation simple. Abdomen with short cerci, tip of abdomen in male usually different on the two sides (asymmetrical). Metamorphosis hemimetabolous; nymphs resemble adults in structure and habits.

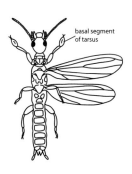

basal segment of tarsus

Earwigs (Order Dermaptera)

Small to moderate-sized, elongate, well-sclerotized. Compound eyes and ocelli well developed or absent; antennae threadlike (filiform), many segmented; mouthparts biting. Thoracic segments distinct; legs short, heavy, tarsi three-segmented; two pairs of wings usually present, fore pair leathery, short, leaving abdomen exposed, hind pair large, broadly oval, membranous, with many radiating veins, folding under fore wings when at rest. Abdomen usually with thick, one-segmented, pincerlike cerci. Metamorphosis hemimetabolous; nymphs similar to adults in structure and habits.

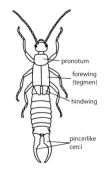

Barklice, Booklice, and Parasitic Lice (Order Psocodea)

Includes several distinct but related groups. Barklice and booklice are minute to small, soft-bodied. Head and eyes prominent, mouthparts chewing; prothorax usually small, meso- and metathorax usually separated; wings absent or present, membranous, with simple venation, few cross-veins, fore pair larger than hind, sometimes scaly or hairy; legs slender, tarsi with two or three segments; cerci absent. Metamorphosis hemimetabolous; immatures similar to wingless adults in structure and habits. The parasitic lice include chewing lice or bird lice that are minute to small, wingless, and exoparasites, primarily of birds (some on mammals). Body strongly flattened; antennae simple, short, exposed, or lying in ventrolateral grooves; mouthparts biting, ventral, for feeding on feathers, fur, or skin; prothorax free, rarely fused to mesothorax; legs tipped with normal claws, no special grasping mechanism for clinging to feathers or hairs; no cerci.

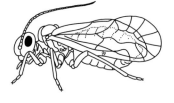

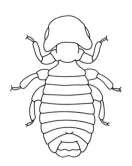

Metamorphosis hemimetabolous; nymphs similar to adults in structure and habits. The sucking lice are minute to small, wingless ectoparasites of mammals. Body flattened; eyes reduced or absent; antennae simple, short; mouthparts suctorial, long slender piercing stylets opening on short, anterior, unjointed rostrum, adapted for feeding on vertebrate blood; thoracic segments fused; legs stout, tibial process opposing tarsal claw to form a grasping mechanism for clinging to hairs; no cerci. Metamorphosis hemimetabolous; nymphs similar to adults in structure and habits.

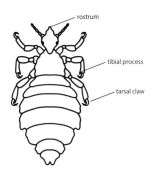

True Bugs, Hoppers, Aphids, Scales, and Other Bugs (Order Hemiptera)

Minute to large. Mouthparts fitted for piercing and sucking, mandibles and maxillae present as long, slender stylets enclosed in a beaklike labium, projecting downward or backward. Two pairs of wings usually present, fore wing (hemelytron) thick at base and membranous apically, hind wing membranous entirely or both wings membranous. Many species lack wings as adults and some have very reduced and simplified anatomy. Metamorphosis hemimetabolous; nymphs similar to adults in structure and habits.

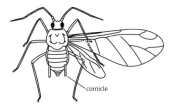

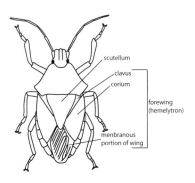

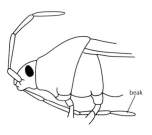

Thrips (Order Thysanoptera)

Minute to small, slender. Mouthparts fitted for sucking, consisting of a posteriorly directed, cone-shaped sheath that encloses the mandibular and maxillary stylets. Two pairs of wings usually present, similar, narrow, with few or no veins, fringed with long hairs. Tarsi with eversible bulb at tip. Metamorphosis hemimetabolous; nymphs similar to adults in structure, except wingless; terminal nymphal instars often quiescent and pupalike.

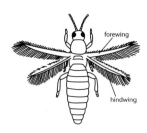

Fishflies and Alderflies (Order Megaloptera)

Medium-sized to large, soft-bodied. Mouthparts mandibulate, in some males extremely elongate; antennae usually long, threadlike, with many segments; wings always present, two pairs, hind wings broad at base, usually distinctly larger than the front wings, membranous, moderately hairy, venation generalized, complex, without or with few veins forked at wing margin, leading edge cell with numerous cross-veins. Metamorphosis complete; larvae caterpillar-shaped, with biting mouthparts, aquatic; pupae free, active.

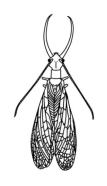

Snakeflies (Order Raphidioptera)

Small to medium-sized, soft-bodied. Characterized by the prolonged head and very long first thoracic segment. Mouthparts mandibulate; antennae usually long, threadlike, with many segments; wings always present, two pairs, similar, membranous, without scales, venation generalized, with many accessory veins, forked at wing margin, leading edge cell with numerous cross-veins. Metamorphosis complete; larvae silverfish-shaped (campodeiform), with biting mouthparts, terrestrial; pupae free, active.

Nerve-winged Insects (Order Neuroptera)

Small to medium-sized, soft-bodied. Mouthparts mandibulate; antennae usually long, threadlike, with many segments; wings always present, two pairs, hind wings narrow at base, small, not distinctly larger than front wings, membranous, naked or moderately hairy, venation generalized to complex, with many accessory veins, often forked at wing margin, wing leading edge cell with numerous cross-veins. Metamorphosis complete; larvae variably shaped, many silverfish-shaped (campodeiform), suctorial mouthparts, mostly terrestrial, some aquatic; pupae free or in cocoons, active.

Stylops (Order Strepsiptera)

Small; larvae and adult females endoparasitic in other insects. Adult males free-living; eyes well developed; antennae with one or several segments prolonged laterally (flabellate); mouthparts reduced; prothorax and mesothorax small, metathorax large; fore wings small, club-shaped; hind wings large. Female larviform, remaining in puparium; with antennae and mouthparts absent; head and thorax fused; abdomen a large sac with three to five sexual openings giving birth to larvae (viviparous). Metamorphosis complete, complex; first stage larvae active, long-legged; later stages grublike; pupae in host.

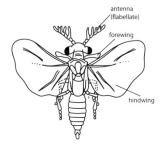

Beetles (Order Coleoptera)

Minute to large; hard-bodied; aquatic or terrestrial. Head usually prominent; with well-developed mandibulate mouthparts; antennae variously modified, often with apical segments enlarged; ocelli rarely present. Prothorax distinct from rest of thorax; two pairs of wings, the front pair

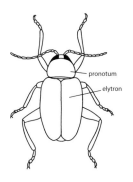

(elytra) thickly sclerotized, almost always meeting in a straight line down the middle of the back, hind wings membranous, usually folded beneath the elytra when at rest. Metamorphosis complete; larvae mandibulate, variously shaped; pupae usually in cells in ground or plant material.

Fleas (Order Siphonaptera)

Small, wingless, strongly compressed side to side, jumping, with dark-colored, hardened (sclerotized), bristly body and legs. Ectoparasitic as adults on mammals or rarely on birds. Mouthparts fitted for piercing and sucking; eyes present or absent; antennae short and stout, reposing in grooves; thoracic segments free; coxae large. Metamorphosis complete; larvae elongate, cylindrical, legless with well-developed head and biting mouthparts; free-living; pupae enclosed in cocoons.

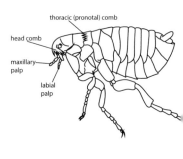

Gnats, Midges, and Flies (Order Diptera)

Minute to moderate-sized, rarely large, usually with exceptionally good powers of flight. Mouthparts suctorial, usually constructed for lapping or piercing. Both prothorax and metathorax small and fused with the prominent mesothorax. Only the mesothoracic wings developed (rarely wingless), the veins and cross-veins not numerous; hind wings replaced by small, knobbed structures (halteres). Metamorphosis complete; larvae always legless, maggot or grublike, frequently with indistinct head and retracted mouthparts; pupae either free or encased in a capsule (puparium) formed from hardened larval exuviae.

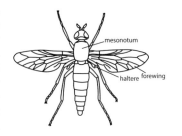

Scorpionflies (Order Mecoptera)

Small to medium-sized, slender. Head nearly always prolonged, beaklike, with well-developed mandibulate mouthparts at the tip; antennae long, threadlike; prothorax small, free; meso- and metathorax similar; wings absent or present, when present two pairs, membranous, usually long, narrow, and naked, with few cross-veins; legs long and slender; genitalia of male often enlarged and forming a reflexed bulb. Metamorphosis complete; larvae caterpillar-like; pupae free, active.

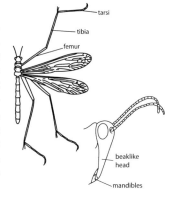

Caddisflies (Order Trichoptera)

Small to medium-sized, slender, mothlike. Antennae long, threadlike; mouthparts atrophied except for palpi; prothorax small, free; meso- and metathorax similar, wings similar, membranous, with few cross-veins, densely clothed with hairs; legs long with tibial spurs. Metamorphosis complete; larvae aquatic, usually with tufted gills, either free-living or in cases constructed of silk mixed with sand or plant particles or in silken webs or nets; pupae with legs free and with functioning mandibles.

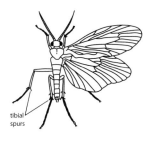

Moths and Butterflies (Order Lepidoptera)

Small to large. Wings and body clothed with modified, flat hairs (scales) that usually form a color pattern. Antennae long, variously modified, threadlike, comblike (pectinate), or clubbed; mouthparts reduced or suctorial, composed of a long tube coiled under the head when not in use (proboscis); four wings, the two pairs similar in texture but not in shape, venation moderately complex with few cross-veins. Metamorphosis complete, pronounced;

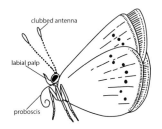

larvae (caterpillars) mandibulate with paired false legs on some abdominal segments in addition to normal thoracic legs; pupae usually enclosed in a cocoon or earthen cell.

Ants, Wasps, and Bees
(Order Hymenoptera)

Moderate-sized, small or minute, rarely large, with varied plant-feeding (phytophagous), predatory, or parasitic habits. Four membranous wings, the fore pair larger and more complexly veined than hind; mouthparts mandibulate but usually modified for lapping; abdomen usually with six or seven visible segments, the first true segment (propodeum) fused with the thorax, not forming part of apparent abdomen; ovipositor often elongate, sawlike or drill-like, or modified into a stinger. Metamorphosis complete; larvae caterpillar-like or grublike; pupae free, sometimes enclosed in a cocoon.

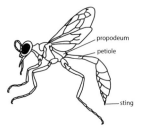

Wingless Hexapods

Bristletails (Archaeognatha)

Silverfish (Zygentoma)

Mayflies (Ephemeroptera)

Dragonflies and Damselflies (Odonata)

Stoneflies (Plecoptera)

Ice Crawlers (Grylloblattodea)

Cockroaches and Termites (Blattodea)

Mantises (Mantodea)

Grasshoppers, Crickets, and Katydids (Orthoptera)

Walking Sticks (Phasmida)

Webspinners (Embiidina)

Earwigs (Dermaptera)

Barklice, Booklice, and Parasitic Lice (Psocodea)

True Bugs, Hoppers, Aphids, Scales, and Other Bugs (Hemiptera)

Thrips (Thysanoptera)

Fishflies and Alderflies (Megaloptera)

Snakeflies (Raphidioptera)

Nerve-winged Insects (Neuroptera)

Stylops (Strepsiptera)

Beetles (Coleoptera)

Fleas (Siphonaptera)

Flies, Gnats, and Midges (Diptera)

Scorpionflies (Mecoptera)

Caddisflies (Trichoptera)

Moths and Butterflies (Lepidoptera)

Ants, Wasps, and Bees (Hymenoptera)

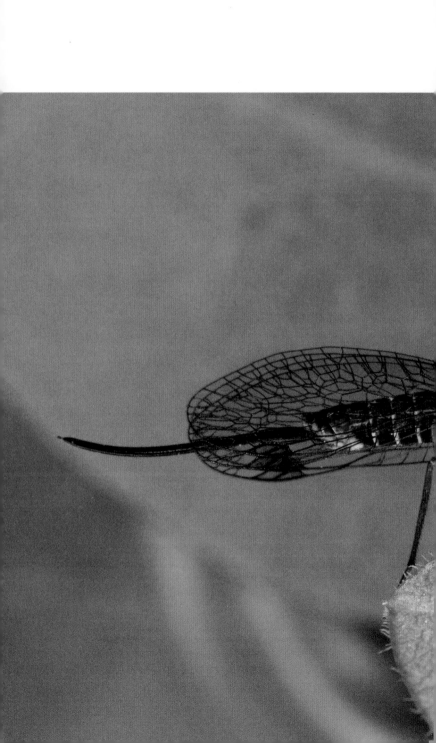

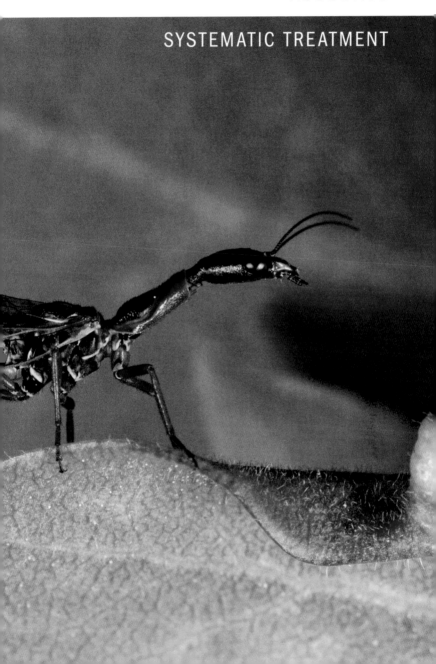

Coneheads (Class Protura)

Proturans **(1)**, usually called coneheads because of their distinctive form, are primitive wingless hexapods. Given their extremely small (BL 0.5–2 mm) size and secretive habits, they are virtually unknown to most people and were only recognized as a group by scientists in the 20th century. They lack eyes and antennae, the function of the latter being assumed by the front pair of legs that are held forward in a probing position. The basal three abdominal segments bear ventral, segmented appendages called styli. Although seldom seen, even by entomologists, enormous populations may inhabit areas of moist soil, leaf mold, rotting wood, and similar situations. Only about 10 species from two of the three orders (Acerentomoidea and **Eosentomidae [1]**) have been found in California, the commonest probably being the California Telson-tail (*Nipponento-mon californicum*), found throughout the state in the upper soil layers.

Two-pronged Bristletails (Class Diplura)

Diplurans are wingless insects restricted to moist habitats. Recognition characters are small size (BL 6 mm or less), pale-colored body, compound eyes absent, tarsi one-segmented, and pair of conspicuous appendages (threadlike or pincerlike) at the tip of the abdomen. Diplurans live primarily in soil and leaf mold but may also occur under bark or objects lying on the ground. The class is very diverse in California, with nearly 60 species from a dozen genera. Several genera are common, such as **Campodea (2)** with 15 species and *Holjapyx* (**Japygidae**) **(3)** with 10. One rare family (Anajapygidae; posterior appendages are segmented but very short) has its sole North American representative (*Anajapyx hermosus*) only found in Placer County.

Springtails (Class Collembola)

Springtails, like proturans and diplurans, are primarily members of the soil community, but they are of even more importance because of their much greater diversity and numbers. Most springtails are readily recognized by a forked, tail-like appendage (furcula) that arises toward the rear of the abdomen, which the insect snaps open to push off and spring itself into the air. A small, tubular lobe (collophore) projects between the legs from the underside of the first abdominal segment. Other characteristics

1. Conehead
(Eosentomidae sp.).

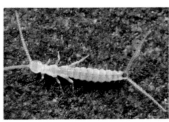

2. Two-pronged Bristletail
(*Campodea essigi*).

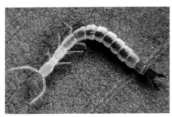

3. Forcep-tail
(Japygidae sp.).

4. Triangle-marked Springtail
(*Isotoma viridis*).

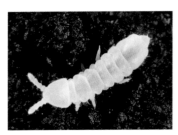

5. Rootfeeding Springtail
(*Onychiurus* sp.).

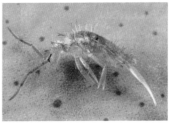

6. Cotton Springtail
(*Entomobrya unostrigata*).

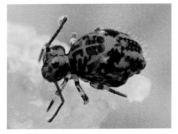

7. Globular Springtail
(*Ptenothrix beta*).

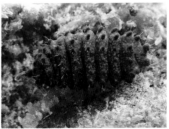

8. Bear-bodied Springtail
(*Neanura magna*).

are the short abdomen and antennae (six or fewer segments), small size (BL normally less than 6 mm), and absence of cerci at the tip of the abdomen.

Habitats are soil, leaf litter, decaying wood, in fungi, near and on water, and similar damp places. A few species, called "snow fleas" (*Onychiurus cocklei* and *Achorutes nivicola* in California), swarm in enormous numbers on snow. The following are only a few of about 150 species in the state.

Family Isotomidae

◀ **4. TRIANGLE-MARKED SPRINGTAIL** *Isotoma viridis*
ADULT: Maximum BL 3–5 mm; distinctively patterned with often triangular dark-brown to reddish-black marks along the midline of the dorsum and a dark band laterally along the length of the body; body form elongate; antennae long and furcula present; body hairy.
HABIT: Common in damp places.
RANGE: Widespread throughout the state.

Family Onychiuridae

◀ **5. ROOTFEEDING SPRINGTAILS** *Onychiurus* **spp.**
ADULT: BL 1.8–2.1 mm; body cylindrical; eyeless; antennae short; cuticle with numerous minute spots (pseudocelli) through which a protective fluid is released.
HABIT: Some species such as the introduced *O. folsomi* can be abundant in earthworm, fruit fly, and other cultures as well as moist places in nature, such as under cattle dung.
RANGE: General occurrence in the state.

Family Entomobryidae

◀ **6. COTTON SPRINGTAIL** *Entomobrya unostrigata*
ADULT: BL 3–5 mm; pale straw to silver-gray colored with a thin black medial stripe on the dorsal surface; furcula is well developed; numerous long hairs and a more or less dense pile of short hairs on head and elongate body.
HABIT: This is a common species in Californian lawns and gardens that was introduced from its native habitat in Europe.
RANGE: Of general occurrence.

LAGUNA MARINE SPRINGTAIL *Entomobrya laguna*

ADULT: BL 6–7 mm; usually with bluish mottling on gray ground color; furcula well developed; numerous spatulate hairs on head and elongate body.

HABIT: Lives in rock hollows and crevices in the marine intertidal zone, where it survives complete submergence.

RANGE: Rocky portions of entire coast.

Family Dicyrtomidae

◄ 7. GLOBULAR SPRINGTAIL *Ptenothrix beta*

ADULT: BL 1.0–1.5 mm; compact, globular body with posterior lobes above furcula; segmentation indistinct; generally yellow with distinct black or brown markings.

HABIT: This species and similar-looking relatives are common on the soil surface and plants in parks and lawns.

RANGE: Widespread.

Family Neanuridae

◄ 8. BEAR-BODIED SPRINGTAIL *Neanura magna*

ADULT: BL up to 5 mm, stocky body form; bluish white to gray, with conspicuous bristle-bearing tubercles over entire body; furculum absent; very short, four-segmented antennae.

HABIT: Common in spring under stones, logs, and other objects lying on leaf mold and in moist soil.

RANGE: Coastal and northern counties; found primarily in wooded, hilly areas.

Insects (Class Insecta)

Bristletails (Order Archaeognatha)

Jumping bristletails, or rockhoppers, are usually found outdoors: under stones, beneath bark, in leaf litter, and the like. They feed on lichens, terrestrial algae, molds, decaying fruits, and dead insects. Though similar to Zygentoma, they are distinguished by the large eyes that meet dorsally, ventrally projecting mouthparts, rounded body (in cross-section), and middle and hind coxae without style-like projections.

Family Machilidae

▶ **9. ROCKHOPPERS** *Mesomachilis* **spp.,** *Pedetontus* **spp.**

ADULT: BL 10–12 mm; elongated form and distinctive humped thorax; usually gray or brown, sometimes finely patterned. The several species in these and related genera that are separable only by close examination of small anatomical features.

HABIT: Occasional individuals enter homes, but rockhoppers normally are found only outdoors.

RANGE: Generally throughout the state; most common in dry places, such as rocky or sandy habitats, and leaf litter.

Family Meinertellidae

ROCK BRISTLETAIL *Machilinus aurantiacus*

ADULT: BL 6–8 mm; silvery scales over most of the body and the body under the scales and legs yellowish brown.

HABIT: Found in moderately moist habitats; exceptional in being diurnally active.

RANGE: Generally throughout the state.

Silverfish (Order Zygentoma)

Silverfish are well known from their habit of infesting homes and buildings where they feed on a wide variety of dry organic materials such as paper, bookbinding paste, starch in clothing, fabrics, dried meat, cereals, and the like. Household species probably originated in warmer countries and survive in California primarily in heated buildings. There are also many native species in habitats such as sand dunes and chaparral woodlands. Most also are secretive, shun the light, and some live in association with ants. Anatomical characteristics of this order include the small, widely separated eyes, anteriorly projecting mouthparts, somewhat flattened body, and middle and hind coxae with style-like projections. Like the Archaeognatha, silverfish possess eversible, bladderlike vesicles on the underside of the abdomen that are used to sponge up moisture from the substratum. A body covering of scales is another general feature of the order, except in the Venerable Silverfish **(10)**.

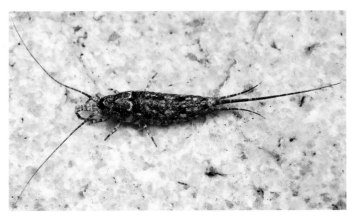

9. Rockhopper (*Mesomachilis* sp.).

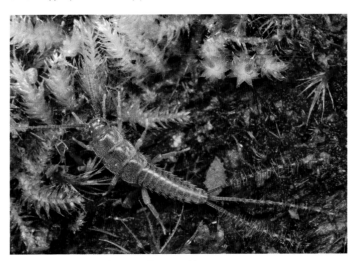

10. Venerable Silverfish (*Tricholepidion gertschi*).

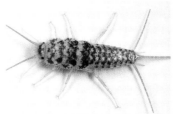

11. Sand Dune Silverfish
(*Leucolepisma arenaria*).

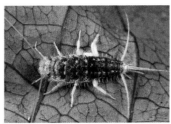

12. Firebrat
(*Thermobia domestica*).

Family Lepidotrichidae

◀ **10. VENERABLE SILVERFISH** *Tricholepidion gertschi*
ADULT: BL 12 mm; reddish or yellowish brown; lacks scales.
HABIT: Lives in cool crevices and under decaying bark and in rotten logs of redwood and Douglas Fir. This is a "living fossil" in the sense that anatomically it exhibits what are considered primitive characteristics compared to other silverfish, and it is thought to closely resemble the hypothetical ancestor of today's more derived insects. The family was first described on the basis of a similar, extinct species found fossilized in Baltic amber, 30 million years old.
RANGE: Restricted to the redwood-mixed conifer forest of the Coast Ranges of Mendocino and Humboldt Counties; known only from localities along the Eel River.

Family Lepismatidae

◀ **11. SAND DUNE SILVERFISH** *Leucolepisma arenaria*
ADULT: BL to 13 mm; pale tan, without strong markings on the back; maxillary palp with six segments; upper body hairs in tufts of combs.
RANGE: It is a native species, common in the deserts of California.

◀ **12. FIREBRAT** *Thermobia domestica*
ADULT: Body color is two-toned, scales darker brown and paler, giving them a mottled pattern.
HABIT: This species is notable for its preference for hot environments and is typically found around ovens, in bakeries, heating pipes, furnaces, boilers, and the like, where temperatures often range from 32 to 40 degrees C.
RANGE: Throughout warmer parts of California.

▶ **13. FOUR-LINED SILVERFISH** *Ctenolepisma lineata*
ADULT: BL 15–18 mm; a fairly stout, dull silverfish that typically has four dark-brown lines set off by pale areas apparent on the dorsal surface, but the color pattern is highly variable.
RANGE: This species is introduced on both coasts of North America from southern Europe and is often very abundant in houses and gardens throughout the state.

▶ **14. LONG-TAILED SILVERFISH** *Ctenolepisma longicaudata*
ADULT: BL 15–18 mm; uniform slate gray with outer bristles of abdomen arranged in three rows of combs on each side; tail about as long as body.

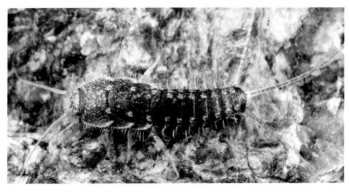

13. Four-lined Silverfish (*Ctenolepisma lineata*).

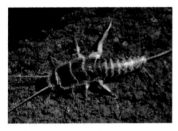

14. Long-tailed Silverfish
(*Ctenolepisma longicaudata*).

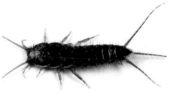

15. Spined Silverfish
(*Allacrotelsa spinulata*).

16. Common Squaregill Mayfly
(*Caenis latipennis*).

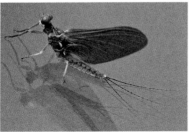

17. Blue-winged Dun
(*Ephemerella* sp.) male.

HABIT: Primarily a house-infesting insect; can damage paper and other stored organic products.

RANGE: Cosmopolitan and widespread in California, in domestic and commercial buildings. Prefers moister and cooler places than the Firebrat (21–27 degrees C optimal).

◀ **15. SPINED SILVERFISH** *Allacrotelsa spinulata*

ADULT: BL 8–12 mm; dark to pale brown species having long, spine-like body hairs and moderately long tails, all three of about equal length.

HABIT: Common in leaf litter, rotting logs, and in sandy areas.

RANGE: Found along the coast, in the foothills of the Coast Ranges and Sierra Nevada, and in the Central Valley.

Mayflies (Order Ephemeroptera)

Adult mayflies are small to medium-sized insects with glassy-appearing wings, frail bodies and two or three long, threadlike tail filaments. They are commonly seen in swarms, engaged in peculiar, dipping flights above ponds and streams where they are easy prey for dragonflies and fish. The ordinal name derives from the ephemeral life of adults that lack functional mouthparts and cannot feed. An adult lives but a few hours or a day or two, an ignoble end for the immature that has taken many months to mature.

Mayflies first leave the water as preadult winged forms (subimagos), recognized by their milky wings and poor flight abilities. After about a day, the subimagos molt to become the clear-winged, graceful, flying adult. These are the only insects that undergo molting in a winged state.

The aquatic immatures, called naiads, are remarkably diverse in form. They breathe using articulated, flaplike gills located at the sides of the abdominal segments. Because most are herbivorous and abundant in various freshwater habitats, they occupy a vital role near the base of the food chain. They constitute a staple in the diet of many predators, especially fish. For centuries anglers have recognized the importance of mayflies as fish food and have used the emergence periods ("hatches") of the subimagos ("duns") and adults ("spinners") to time fishing efforts as well as to employ the insects or feathered replicas of them as bait ("flies"). The examples mentioned here are common representatives of the approximately 155 species in 15 families that occur in the state.

Family Caenidae

Small squaregilled mayflies are known for only a single genus and five species in California, but they have a distinctive form, are notably small and lack the hind wing, which helps distinguish them from other mayfly families. Emergence from subimago to the full adult can be very rapid in these mayflies and sometimes the cast-off skin will still be stuck to a flying adult that was "undressing" in flight.

◄ 16. COMMON SQUAREGILL MAYFLY *Caenis latipennis*
ADULT: Small (BL 6–8 mm); contrasting brown thorax with medial smoky-black markings and lateral black dots or dashes on the abdomen.
HABIT: In almost any pond, stream, or river, but typically those with no or slow currents and back waters are preferred. This species is very tolerant of pollution.
RANGE: Throughout the state.

Family Ephemerellidae

These are California's most common mayflies, with about 60 species from nearly 20 genera recorded in the state.

◄ 17, 22. ► BLUE-WINGED DUNS *Ephemerella* spp.
There are six species in this genus in California.
ADULT: (17) Variable in size (BL 5–15 mm), color, and markings; most species with brown-to-gray body and clear wings; males with divided eyes, lower portion small and dark, upper portion large and cone-shaped.
NAIAD: (22) BL 5–20 mm; most with enlarged, spined femora; legs and gills with hair fringes or thoracic and abdominal plates armed with tubercles and spurs.
HABIT: Most species are found under rocks in moderate currents; others on silt bottoms or among trash and debris.
RANGE: Rivers and streams throughout most of the state.

Family Baetidae

Members of the family Baetidae, the small minnow mayflies, are among the most prolific of the pond herbivores and their numbers may reach prodigious proportions. They serve as the major sustenance for associated predators, both vertebrate and invertebrate. Species of the genus *Baetis*

are the most commonly encountered mayflies; the following species are characteristic representatives of the more than a dozen genera and about 35 species in the family from California. Male and female adults are distinctly different; most notably the males have very large turban-shaped and subdivided eyes. Female eyes are relatively smaller and round.

▶ **18–19. SPECKLED SPINNER** *Callibaetis ferrugineus*
ADULT: BL 9–10 mm. Male **(18)** dark brown, somewhat shiny abdomen; fore wings entirely clear. Female **(19)** duller brown abdomen; fore wings with a wide, brown anterior margin patterned with white into the anterior half.
NAIAD: BL 6–10 mm; rather elongated and relatively narrow, frail-looking form.
HABIT: Excellent swimmers, frequently in still water.
RANGE: Central and northern California.

▶ **20. BLUE-WINGED OLIVE** *Baetis tricaudatus*
ADULT: BL 7–10 mm; body reddish brown with legs uniformly paler; wings clear, hind wing very small.
NAIAD: Pale yellow with darker brown forebody and distinct smoky markings on abdomen and legs.
HABIT: Found in a wide variety of water types.
RANGE: Throughout the state.

Family Ameletidae

Combmouthed minnow mayflies, with 20 species in California, can all be distinguished by the naiad's comblike mouthparts (maxillae).

▶ **21. COMBMOUTHED MINNOW MAYFLY** *Ameletus validus*
ADULT: BL 12–15 mm. Body form is elongate and relatively thin; thorax darker than abdomen with the forelegs dark and middle and hind legs the color of the abdomen; wings are clear.
NAIAD: Typically beautifully bi- or tricolored.
HABIT: Found in streams and rivers with fast-running waters but usually in the quieter parts, where they feed on detritus.
RANGE: Throughout the state.

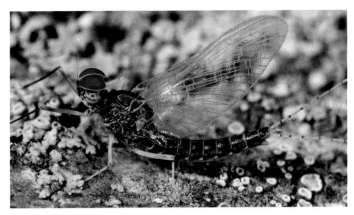

18. Speckled Spinner (*Callibaetis ferrugineus*) male.

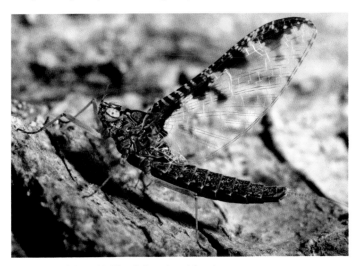

19. Speckled Spinner (*Callibaetis ferrugineus*) female.

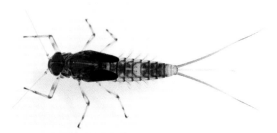

20. Blue-winged Olive (*Baetis tricaudatus*) naiad.

Ephemeroptera

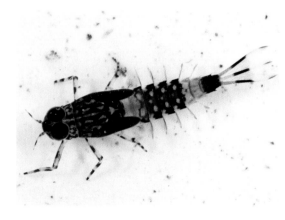

21. Combmouthed Minnow Mayfly (*Ameletus validus*) naiad.

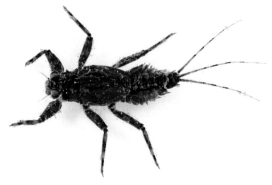

22. Blue-winged Dun (*Ephemerella* sp.) naiad.

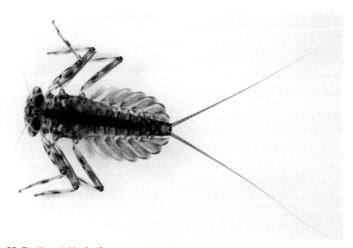

23. Flat Nymph Mayfly (*Epeorus* sp.) naiad.

Family Heptageniidae

A family of about 35 species in California distributed among nine genera.

◄ 23. FLAT NYMPH MAYFLIES *Epeorus* spp.

ADULT: BL 6–11 mm, wing length 10–16 mm; wings entirely clear; body light brown with paler legs.

NAIAD: Many species in the family are like *Epeorus* and have a flattened body and a rounded, depressed head with the eyes on top; gills broad and flaplike, the first and last pairs often meeting beneath the body and overlap the lateral ones to form the rim of a "suction cup" (abdomen acting as the piston) that assists the insect in its hold upon smooth rocks in swift water. Long fringes of hairs on the legs enhance this effect.

HABIT: Adults emerge from high-elevation streams where naiads cling to rocks in the fast currents.

RANGE: Many California species live in the Sierra Nevada.

Dragonflies and Damselflies (Order Odonata)

Dragonflies and damselflies are familiar insects and possibly the oldest extant flying insect group, with modern-looking forms known from the Jurassic era (200 million years ago) and having developed no significant morphological modifications since then. Fossils of giant dragonflies (Protodonata) are known from the Permian, many millions of years before birds and bats evolved flight. They are typically found around streams or ponds, where the immature stages, called naiads or nymphs, live and develop under water. The naiads are usually dull colored or hairy so that they catch mud and debris, allowing them to match their surrounding habitat. From their hiding places, they snatch up prey by quick extension of a long, jointed lower lip (labium). Breathing is accomplished in nymphal damselflies primarily by three leaflike gills extending from the tip of the abdomen. Typical dragonfly larvae have internal, rectal gills over which they continually pump water.

Odonates have an unusual mating ritual in which, before mating, the male transfers sperm from his genital opening at the end of his abdomen to his penis, located at the front of his abdomen, just behind his wings. He then swoops down and grasps a female by the neck with cerci at the tip of his abdomen. The pair may fly and land in tandem for quite some time. To receive the sperm, the female must curl the tip of her abdomen in front of her body to reach his penis, forming an odd circle, or wheel. These gymnastics often confuse the uninitiated as to which sex is which,

especially when the insects are in flight. Males often continue to grasp females (damselflies) or stand guard (dragonflies), after sperm has been retrieved, to ward off rival males.

Dragonflies are mostly larger, 80–110 mm body length and 60–90 mm wing span, and have a bulky thorax, large eyes, and a slender abdomen. The body and wings often display brightly colored patches of red, orange, blue, green, or white. Damselflies are smaller, slender-bodied, mostly 50–80 mm and wing span 38–75 mm. Their eyes protrude laterally and are widely separated, in contrast to the large compound eyes of dragonflies that meet on top of the head. When perched, damselflies usually hold the wings upright, whereas dragonfly wings are held laterally in flight and at rest. The damselfly body and abdomen usually are blue or green, but the wings lack color patterns in nearly all species.

The naiads are predaceous on a wide variety of aquatic insects and other animals, even tadpoles and small fish, while the adults feed on flying insects or, in the case of damselflies, even perched insects. They catch their prey in flight with extraordinary maneuverability followed by quick extensions of a long, jointed lower lip of the labium and basketlike prolegs, scooping prey and shoving it into their gaping mouths. At least 108 species of odonates are recorded in California. Each is restricted to a particular kind of habitat, such as rapid or slow-running streams, or ponds, at low or high elevations. Some species are of conservation concern due to their ecological specializations.

Damselflies (Suborder Zygoptera)

Damselflies are weak fliers most often seen perching on vegetation near water. Eggs are inserted into tissues of rushes or other plants at, or just below, the water surface. The naiads live under water, breathing through leaf-shaped external gills at the tip of the abdomen. About 40 species occur in California. Because of their slower flight, they can easily be observed courting mates or hunting slow-flying or perched insects, which are deftly plucked from vegetation.

Broad-winged Damselflies (Family Calopterygidae)

▶ **24. AMERICAN RUBYSPOT** *Hetaerina americana*
This is one of the largest and most beautiful damselflies in California.
ADULT: BL 37–50 mm; male body has metallic reddish-purple iridescence; females are dark purplish brown with pale stripes on the sides of the

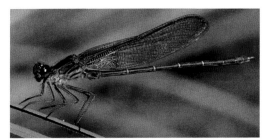

24. American Rubyspot (*Hetaerina americana*).

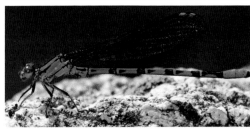

25. Vivid Dancer (*Argia vivida*).

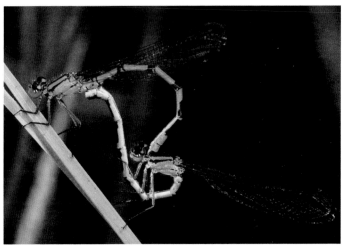

26. Bluet (*Enallagma* sp.) male top, female bottom.

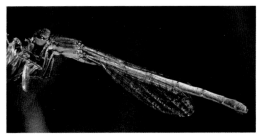

27. Forktail (*Ischnura perparva*).

thorax. In males the basal part of wings have bright-red patches on the upper surface; in females patches are diffuse and dull red, amber, or brown.

NAIAD: Protectively colored, mottled brown; clinging to debris, plants, or rocks at the edge of slow currents.

HABIT: Most often seen along slow streams or around springs. Females completely submerge to oviposit in aquatic vegetation.

RANGE: Widespread at low elevations, including desert oases, to about 5,000 ft.

Narrow-winged Damselflies (Family Coenagrionidae)

◀ 25, 30. ▶ VIVID DANCER *Argia vivida*

Perhaps the state's most ubiquitous damselfly.

ADULT: (25) Moderately large (BL 30–38 mm); narrow-winged, blue, violet, or tan with black markings resembling those of the bluets *(Enallagma)* but dancers have larger bodies, much longer leg spines, and hold their wings elevated above the abdomen, whereas bluets hold their wings drooped down on either side of the abdomen. The Vivid Dancer is recognizable by patches of blue or violet on the mature male. Recently emerged individuals are lavender gray and gradually change to gray and then blue.

NAIAD: (30) Short, thick-skinned, often dark brown. Slow-moving among submerged vegetation or rocky recesses near the edges of ponds and streams. Posterior caudal gills short, arched-shaped, often with a pale, transverse band.

HABIT: Found along small streams, rivulets, and the like. Has even adapted to artificial drainages and irrigation ditches. Dancers are fast, jumpy damselflies, which often rest on bare ground or rocks in contrast to bluets that prefer to perch on vegetation.

RANGE: Throughout the state, where water permits, from below sea level at the Salton Sea to 2,100 m elevation. There are at least eight species of *Argia* in California. Of those, the Vivid Dancer is the most widespread and has been recorded in all 58 California counties and at all times of the year, although rarely seen during winter.

◀ 26. BLUETS *Enallagma* **spp.**

These are the common bright blue and black damselflies that are seen around most kinds of aquatic habitats where there is shallow, still or slow-flowing, freshwater with abundant vegetation.

ADULTS: Medium-sized (BL 28–40 mm); males predominantly bright blue; females vary, blue or gray or brown—with black markings and with colorless wings.

NAIAD: Long, pale green or brown, with gills tapering to a point. They actively clamber among submerged plants.

HABIT: They fly immediately above the surface of the water, often perching on emergent vegetation, rarely wandering far from the shore. At least some species fly virtually throughout the year at low elevations, spring and summer higher up.

RANGE: Five species are common and widespread throughout California, all quite similar in appearance and all more or less widespread, although usually not all occurring together.

◄ 27. FORKTAILS *Ischnura* spp.

The forktails are so-called because the males have a bifurcate process on the last dorsal plate of the abdomen.

ADULTS: Small (BL 22–32 mm) with bright green or blue spots on head and stripes on thorax. In contrast to *Enallagma* and other damselflies, the abdomen is mostly black with a conspicuous blue- or green-colored band preceding the tip. Females in some species have two color forms, one resembling the male and the other less brightly colored gray or brownish gray.

NAIAD: Long, pale green, resembling *Enallagma* from which they differ by having six instead of five antennal segments.

HABIT: These damselflies also occur near still freshwater, often at margins of ponds rather than along running streams with the bluets. Flight is spring through early fall.

RANGE: Six species of *Ischnura* occur very widely in California, except perhaps southeastern deserts; three are common, all similar in appearance.

Spread-winged Damselflies (Family Lestidae)

▶ 28. CALIFORNIA SPREADWING *Archilestes californica*

Lestids differ from other damselflies in that they usually spread their wings, as dragonflies do, when perched.

ADULT: Large (BL 48–55 mm); body gray dorsally, tan ventrally with two white incomplete, diagonal stripes on thorax, wings clear, each with a distinct apical brown spot or pterostigmata (sometimes appearing gray/white in bright sun). The male has bright blue eyes dorsally (the female's eyes are uniformly gray).

NAIAD: Slender, with elongate, banded anal gills; climbing on vegetation in still water, such as pools at the margins of streams.

HABIT: The eggs are inserted in regular groups of six into stems of aquatic or woody plants, such as willow, just under the bark and sometimes several meters above the water surface. On the wing until late fall.

RANGE: Throughout the state at low to mid-elevations, including the Central Valley, and urban areas. May be scarce or absent from the southeastern deserts, absent east of the Sierra Nevada.

A related species, and the only other *Archilestes* in the state is the Great Spreadwing (*A. grandis*), the largest damselfly in California; BL reaching 60 mm. It has a single, broad, diagonal yellow stripe on the thorax.

▶ 29, 31. EMERALD SPREADWING *Lestes dryas*

ADULT: (29) Small (BL 35–42 mm); thorax and abdomen typically metallic emerald, bronze, or blue green in both sexes. Male with blue eyes. Apical black spot (pterostigmata) on wings. Wings held apart at rest.

NAIAD: (31) Long, slender, brown to dark brown; active climbers.

HABIT: Has a relatively short breeding season, mostly June to August. Breeds in a variety of still water, from ditches to lakes.

RANGE: Widely distributed in North America and Eurasia. Appears to favor cooler, wetter regions of the state, found on the coast only in far northern California; restricted to increasingly higher, cooler mountain ranges (425–2,700 m) southward to the Transverse Ranges; more common in the north. Four other species of *Lestes* occur in the state; all inhabit still water.

Dragonflies (Suborder Anisoptera)

Dragonflies are among the most conspicuous and familiar of all insects, owing to their large size, bright colors, and strong, swift flight; they rival butterflies for the public's recognition and admiration. They have long, slender bodies and enormous compound eyes that enable extraordinary perception of prey, which is captured on the wing. Males of many species establish territories and cruise around their habitats, engaging in combat with other insects in their size range, especially males of their own species. Their aerial maneuvering is extraordinarily impressive to every naturalist, particularly their uncanny ability to alter their position in an instant and with effortless grace, so as to remain just out of reach of the collector's net—always a humbling experience.

The naiads are varied in form and their aquatic habitats. Although they appear awkward when climbing over debris or burrowing in bottom mud, they can suddenly jet forward by forcibly squirting water from the

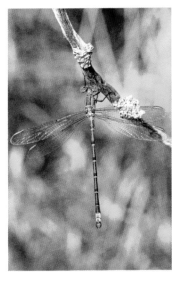

28. California Spreadwing (*Archilestes californica*).

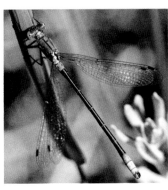

29. Emerald Spreadwing (*Lestes dryas*).

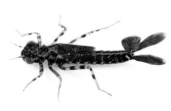

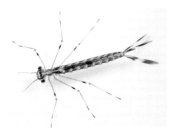

30. Dancer (*Argia* sp.) naiad.

31. Spreadwing (*Lestes* sp.) naiad.

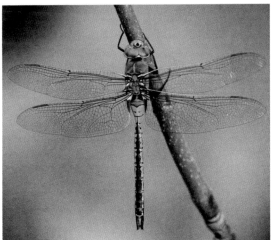

32. Common Green Darner (*Anax junius*).

rectum, allowing them to escape enemies or seize their victims. Oxygen is absorbed from the water through internal rectal gills. Development requires a few months to four years. Egg placement by females varies, from unselective scattering on the water to insertion into mud below shallow water or plant tissues. All nine North American families of dragonflies occur in California, represented by about 60 species.

Darners (Family Aeshnidae)

◀ 32. COMMON GREEN DARNER *Anax junius*

This is a widespread species, ranging from the Neotropics to Canada, gradually moving northward as the season shifts and more northern and higher-elevation habitats become available.

ADULT: Large (BL 68–80 mm); head yellow-green with prominent dorsal black spot in front of the eyes; thorax is bright green, abdomen bright blue in males, typically green in females, both with black dorsal stripe. Wings are ochreous-tinged.

NAIAD: Elongate, smooth, decorated with patterns of green and brown; lives among submerged pond vegetation.

HABIT: Strong-flying dragonflies that can be found throughout the year, but most common from midsummer through fall.

RANGE: One of the most widespread North American dragonflies; common throughout the state.

GIANT DARNER *Anax walsinghami*

This is North America's largest dragonfly (male BL attaining 100–115 mm); wings do not become yellow with age in this species. Abdomen is arched in flight unlike *A. junius*.

RANGE: Patrols in foothill canyons; common in southwestern California, becoming progressively more scarce northward as far as Colusa County; April to September.

▶ 33, 45, 46. BLUE-EYED DARNER *Rhionaeschna multicolor*

Regarded by many as our most distinctive darner, males appear bright blue on the wing (though actually being mottled blue on a black background) and smaller than the Common Green Darner.

ADULT: (33) Moderately large (BL 64–72 mm); male with bright blue head, black and brown thorax and abdomen with prominent bright blue stripes on the thorax and blue spots along the abdomen, forked tail tip appendages distinguish this species from others in the state; female occasionally colored as in male, usually head and body brown, with same stripe and spot pattern as male but in yellow or light green, pale tan dusting on the wings distally, quite variable; prominent cerci in both sexes.

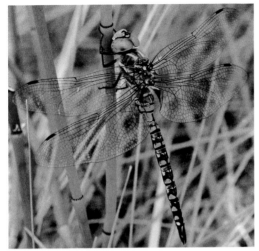

33. Blue-eyed Darner (*Rhionaeschna multicolor*).

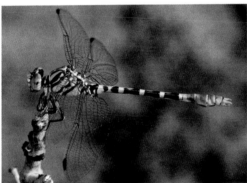

34. White-belted Ringtail (*Erpetogomphus compositus*).

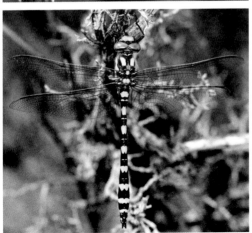

35. Pacific Spiketail (*Cordulegaster dorsalis*).

NAIAD: Lateral view **(45)**; dorsal view **(46)**: streamlined, neatly patterned in longitudinal streaks of green and brown.

HABIT: Females deposit eggs into stems of aquatic plants and naiad lives in submerged vegetation of ponds, marshes, sluggish streams, and similar habitats. Adults may stray far from water to hunt.

RANGE: Perhaps the commonest dragonfly in lowland areas throughout California. May be migratory in fall, when numbers seem to peak.

PADDLE-TAILED DARNER *Aeshna palmata*

In this related species the male is distinguished by having green-yellow stripes on the thorax.

RANGE: Throughout the state in coastal and montane areas, most common in the northern half of the state.

Clubtails (Family Gomphidae)

◄ 34. WHITE-BELTED RINGTAIL *Erpetogomphus compositus*

One of the most dazzlingly colored dragonflies in our fauna.

ADULT: Medium-sized (BL 45–55 mm); male with white face, eyes pale blue; thorax with complex pattern of black, white but mostly yellow and brown, with distinct medial white belt; abdomen alternately banded with black and off-white, until terminal segments, which are dramatically enlarged and bright goldish orange. Female, as in male, but terminal segments not enlarged.

NAIAD: In streams and rivers.

HABIT: Males perch in sunny spots on rocks, gravel bars, or low vegetation, typically near riffles. They forage away from water in grassland and arid shrubland.

RANGE: Typically flies at lower elevations from Shasta County south to the Mexican border, including all desert areas, and east of the Sierra Nevada into the Great Basin to 5,000 ft. Absent from the northwest part of the state and coastal areas north of Los Angeles. Occurs sparingly, more common in Southern California, including deserts, where water is present.

Spiketails (Family Cordulegastridae)

◄ 35, 47. ► PACIFIC SPIKETAIL *Cordulegaster dorsalis*

This is the only member of the family in the California. They get their name from the female's prominent ovipositor that is used to drill eggs into streamside mud.

ADULT: (35) Among the largest of California's dragonflies (BL 70–85 mm); eyes pale blue and separated, just meeting at top of head; face yellow; thorax and abdomen banded black and yellow; wings colorless.

NAIAD: (47) Body stout, rough, hairy, and often covered with green algae.

HABIT: Peak flight is May to September, though it flies later into the fall. Naiad lives in mud at the bottom of flowing streams, where it burrows by kicking silt with the hind legs and descends by squirming vigorously. Then the naiads lie concealed in muck and ambush their prey. Adults are often found coursing along woodland canyons.

RANGE: Throughout the state except for the Central Valley and the southeastern deserts, in Southern California it may be more common at higher elevations. A desert subspecies (*C. d. deserticola*) lives around springs and in permanently boggy areas in Inyo County.

Skimmers, Whitetails, and Meadowhawks (Family Libellulidae)

This is the most diverse dragonfly family in the world, and the 17 genera in California vary widely in appearance. Skimmers and whitetails are among the most striking of California's dragonflies and, in several of the species, the males have bands of black and white across the wings and the abdomen is powdery white. The females of those species have a similar dark pattern but lack the white patches. The naiads are hairy, sluggish, sprawling in bottom silt and debris.

▶ 36. EIGHT-SPOTTED SKIMMER *Libellula forensis*

ADULT: Medium-sized to large (BL up to 50 mm); male with eyes and head black, thorax with lateral black markings, powdery light blue dorsally; abdomen also powdery whitish blue, black cerci. Wing extremities clear especially at tips and edges, with two alternating patches each of whitish-blue and black bands, rendering a total of eight black spots. Female face with two dorsal yellow spots just in front of brown eyes. Thorax brown with lateral yellow spots. Abdomen dark brown with numerous lateral yellow spots, one per segment. Wings in female as in male, though powdery blue spots are much smaller and less distinct, or frequently absent entirely.

HABIT: Ponds, lakes, and other sluggish water bodies. Spring to fall flight; much more common from late May to August.

RANGE: Common from the coast to Great Basin across northern California, including the Bay Area; sparse or absent south of Fresno.

▶ 37. TWELVE-SPOTTED SKIMMER *Libellula pulchella*

The Twelve-spotted is similar to the preceding species but has four additional spots, one at each wing tip, and is a bit larger.

ADULT: BL 52–58 mm; male with eyes and head black, thorax brown with two oblique yellow streaks; abdomen powdery whitish blue, sometimes so faintly colored they look brown. Easily distinguished from the Eight-spotted Skimmer by having wing tips with black bands that extend to the front margin, fore wing with three irregular patches of black alternating with only two spots of whitish blue, hind wing has three of each color, with third blue spot next to the body and behind the most elongated black band; rendering a total of twelve black spots. Female face with two dorsal yellow spots just in front of brown eyes. Thorax brown with lateral yellow spots. Abdomen dark brown with numerous lateral yellow spots, one per segment. Wings with same black spots as male but lacking whitish-blue spots entirely.

HABIT: Flies from April to October with a distinct peak between May and October.

RANGE: Rarer than the Eight-spotted Skimmer; frequents ponds, lakes, and rivers, more common throughout much of the northern two-thirds of the state; present, sparsely, throughout southern California, including deserts.

▶ 38–39. WIDOW SKIMMER *Libellula luctuosa*

Very broad black patches on wings distinguish this species.

ADULT: Medium-sized to large (BL 42–50 mm); male **(38)** head and face dark brown; thorax black laterally, blue on top, abdomen powdery light blue that rubs off with age, exposing black abdomen; wing tips clear with apical, black stigmata, broad powdery whitish-blue band in middle, very broad black near base of wing. Female **(39)** with head and face light brown, thorax light brown with oblique lateral yellow stripes and a single dorsal yellow stripe on thorax which bifurcates at the abdomen becoming two lateral yellow stripes, with black in the middle. Wings with same broad, apical black patches as male, but lacking blue bands and with black wing tips.

HABIT: In a wide range of slow-moving water, including in developed habitats. Flies April to October, with a strong peak in midsummer.

RANGE: This is a common pond species through much of California at low to moderate elevations, including urban areas and southeastern deserts but is missing east of the Sierra Nevada. It may be expanding its range in the state.

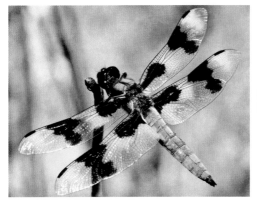

36. Eight-spotted Skimmer
(*Libellula forensis*).

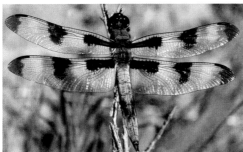

37. Twelve-spotted Skimmer
(*Libellula pulchella*).

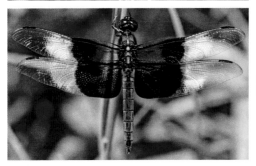

38. Widow Skimmer
(*Libellula luctuosa*) male.

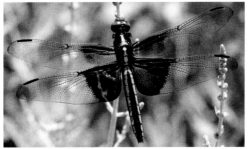

39. Widow Skimmer
(*Libellula luctuosa*) female.

▶ 42. FLAME SKIMMER
Libellula saturata

One of the state's most common dragonflies. The theme is red.

ADULT: Large (BL 52–61 mm); face, head, thorax, body, and basal half of wings are rusty red. Female paler red than male, usually with yellow apical wing spots. Wings held perpendicular to body at rest.

NAIAD: Hairy; squats amid ooze at the bottom of stagnant ponds.

HABIT: Adults course slowly up and down sluggish streams and around pond and lake margins.

RANGE: Throughout low-to-moderate elevations in California, including desert regions, wherever water accumulates, including urban areas.

▶ 40–41. COMMON WHITETAIL
Plathemis lydia

Whitetails, *Plathemis*, have been split from the genus *Libellula*, but they are closely related. Males are highly territorial and use their prominent white abdomens in threat displays, defending their territories against rival males.

ADULT: Medium-sized (BL 49–51 mm); male **(40)** with head and face dark brown; thorax brown near head, shifting quickly to bluish white; abdomen broad and entirely bluish white. Wings clear, including tips, with broad irregular black patches in apical third, small black dots basally against body, bluish-white spots only on hind wings below black dots. Female **(41)**, brown head and face, thorax brown with lateral white oblique streaks. Abdomen brown with prominent white lateral triangles on each segment, becoming yellow toward terminus. Wings with three irregular black patches located at tips, middle, and at base against the body.

NAIAD: Squat and sluggish, covered in algae.

HABIT: Flies from April to September with strong midsummer peak.

RANGE: Widespread throughout California, including urban areas, much less common in southern California and sparse in southeast deserts.

MEADOWHAWKS
Sympetrum spp.

Ten similar species of meadowhawks occur in California; males of most have bright metallic red- or orange-colored abdomens, and females are brown, including the wings along the leading edge (costal margin) and basally.

▶ 43. CARDINAL MEADOWHAWK
Sympetrum illotum

At rest, wings held at a downward droop, most easily distinguishing this species from Flame Skimmers that hold their wings horizontally when perched.

ADULT: Small (BL 38–40 mm); male with red head, face, and thorax (with two white lateral spots); brilliant red abdomen. Wing veins basally bright

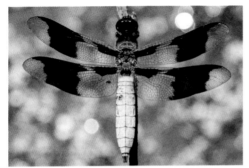

40. Common Whitetail (*Plathemis lydia*) male.

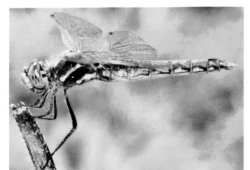

41. Common Whitetail (*Plathemis lydia*) female.

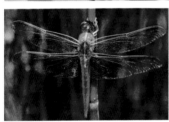

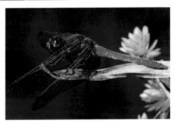

42. Flame Skimmer (*Libellula saturata*).

43. Cardinal Meadowhawk (*Sympetrum illotum*).

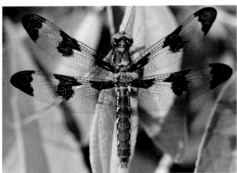

44. Variegated Meadowhawk (*Sympetrum corruptum*).

red becoming dull brownish red apically. Female with same pattern as male but dull tan color, including on wing veins.

NAIAD: Stocky and hairy and, like other libellulids, lives in bottom detritus and vegetation in still water.

HABIT: Flies from March through December with a peak in early summer. Usually are seen coursing around standing water, pond margins, along roadside ditches, lakes, and the like.

RANGE: Recorded throughout much of the state, though most common in the Sierra Nevada foothills at low elevations and coastal regions of the state, including urban areas. May be scarce at high elevations and east of the Sierra Nevada.

◀ 44. VARIEGATED MEADOWHAWK *Sympetrum corruptum*

ADULT: Medium-sized to small (35–44 mm); male remarkably variable mix of red, pink, brown, and white that may change with age. Head and face light orange or brown, thorax brown with two lower lateral yellow spots followed by oblique white streaks; abdomen with longitudinal stripe of red (that may outline each segment), and base color ranging from light brownish orange to dark brown or gray, each segment with distinct lateral spots of white (sometimes suffused with red) surrounded fully or partially by black. Legs noticeably yellow. Wings clear with veins of upper margins outlined in orange or red. Color pattern may be vibrant and distinct or very muted. Female pattern very similar to male but red on abdomen is lacking, sometimes replaced by pale orange; color scheme throughout tends to be paler, with more white or gray.

NAIAD: Compact, relatively slender; lives amid vegetation and bottom detritus in still and very slow-moving waters of ponds and minor streams.

HABIT: It may be present year-round in warmer areas near slow-moving water, but in contrast to its relatives, this widespread species is commonly observed long distances from water, sometimes migrating in large numbers during the fall months.

RANGE: Occurs throughout the state, at all elevations in arid and moist regions, including urban areas.

Stoneflies (Order Plecoptera)

Stoneflies are aquatic insects whose nymphs require moving water for development. Accordingly, the weak-flying adults are usually found near mountain streams. They are dull-colored, usually with membranous wings that fold over the back when at rest; most species are gray or brown, while others are shades of yellow or green. They are commonly found

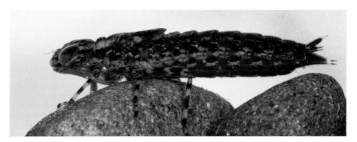

45. Darner (*Rhionaeschna* sp.) naiad, lateral view.

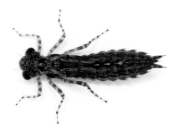

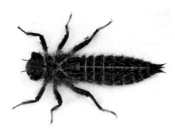

46. Darner
(*Rhionaeschna* sp.) naiad, dorsal view.

47. Spiketail
(*Cordulegaster* sp.) naiad.

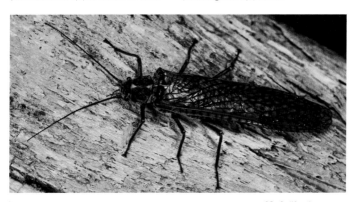

48. California
Giant Salmonfly
(*Pteronarcys
californica*) adult.

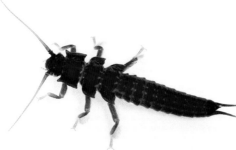

49. California
Giant Salmonfly
(*Pteronarcys
californica*) nymph.

on vegetation or resting on rocks or tree trunks. Although somewhat resembling winged termites, alderflies, and fishflies, stoneflies are distinguished by having fan-shaped hind wings with a network of many veins.

The nymphs have two long cerci (or tails) at the tip of the abdomen and often have fringes of long, silky hairs on the wing pads, legs, or tails. They obtain oxygen from the water with hairlike or branched gills on the underside of the thorax or abdomen. There are about 100 species in California, with all nine North American families represented. They vary in size from 4 mm to 50 mm in body length, up to 60 mm to the tips of the wings of the largest individuals.

Family Pteronarcyidae

◀ 48–49. CALIFORNIA GIANT SALMONFLY *Pteronarcys californica*

This is one of the largest stoneflies in North America.

ADULT: (48) Male (BL to wing tips 35–45 mm); female larger (BL to wing tips up to 60 mm); gray or brown with a reddish-brown median line on the thorax and pale or light red spots at the sides.

NYMPH: (49) Abdominal segments 1–2 with branched gills on the underside; thorax with long lateral processes and pointed wing pads.

HABIT: Adults can be found around shaded streams between April and July.

RANGE: Sierra Nevada and the Coast Ranges from Kern and Santa Clara Counties northward. A similar species, the Ebony Salmonfly *(P. princeps)*, is slightly smaller and occurs in the same area as well as the mountains of southern California.

Family Perlidae

▶ 50. YELLOW-BANDED STONEFLY *Calineuria californica*

ADULT: BL 23–31 mm; wings and body brown, body with yellow markings, including the conspicuous median line on top of the thorax.

NYMPH: Thorax with profusely branched gills at lower angles, anal gills lacking; eyes located near hind margin of head; a yellow triangle in front of eyes. The nymph of a similar species, the Golden Stonefly *(Hesperoperla pacifica)*, has anal gills.

HABIT: The Yellow-banded Stonefly flies from April to July.

RANGE: *Calineuria californica* and *H. pacifica* are both widespread from Los Angeles County northward.

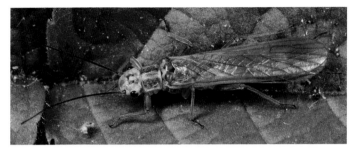

50. Yellow-banded Stonefly (*Calineuria californica*).

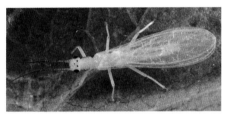

51. Cascade Sallfly (*Alloperla fraterna*).

52. Early Brown Stonefly nymphs (*Capnia lacustra*).

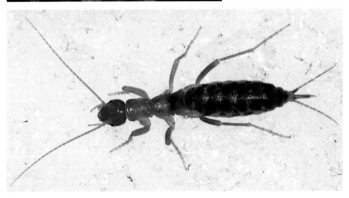

53. Sierran Ice Crawler (*Grylloblatta bifratrilecta*).

Family Chloroperlidae

◀ **51. CASCADE SALLFLY** *Alloperla fraterna*

At least a dozen similar-looking species are known from California.

ADULT: BL 6–10 mm; green to yellow with slight darkening at the edges of the pronotum and a dusky, longitudinal line down the middle of the dorsal surface of the abdomen.

NYMPH: Inner margin of hind wing pad with a median notch; the nymphs of most species have not been associated with the adults or described.

RANGE: Coast Ranges, Cascades, and the Sierra Nevada.

Family Capniidae

Adults of many capniids are active very early in the year and are often referred to as "winter stoneflies." They are commonly observed around snowbound streams, alighting on rocks, tree trunks, and even in large numbers on the snow itself.

◀ **52. EARLY BROWN STONEFLIES** *Capnia* **spp.**

Members of this genus are among the commonest stoneflies in California; 17 species are represented, all similar in appearance.

ADULT: Small (BL 6–10 mm); blackish brown, with clear, smoky, or brown wings and long cerci (tails).

NYMPH: Inner margin of hind wing pad with a median notch; the nymphs of most species have not been associated with the adults or described.

HABIT: Fly in early spring, mostly between February and April in California, with a few species as late as June.

RANGE: Several species are widespread in the Sierra Nevada and the Coast Ranges. A unique species of conservation concern in this genus is the **Tahoe Wingless Stonefly** *(C. lacustra)* **(52)**. The adults are without wings and live their entire lives at depths below 60 m on the bottom of Lake Tahoe. Females hold the eggs internally and give live birth to offspring.

Ice Crawlers (Order Grylloblattodea)

This is an enigmatic, rarely encountered order of insects, with only around 30 described extant species that are highly specialized to cold habitats such as the edges of glaciers or snow fields, ice caves, and high elevations. The order is restricted to East Asia and western North America. California has six described species and an equal number yet to be

described, all from ice caves and high elevations in the Sierra Nevada and Cascade Range. They are nocturnally active when temperatures are around freezing. All species are superficially very similar in appearance. They are scavengers or predators.

◀ **53. SIERRAN ICE CRAWLER** *Grylloblatta bifratrilecta*
ADULT: BL 17–22 mm; buff orangish brown, darker dorsally than ventrally; terminal cerci of male rather long and slender.
RANGE: High-elevation passes in Tuolumne and Alpine Counties.

Cockroaches, Termites, and Mantises (Superorder Dictyoptera)

Recent phylogenetic work, based on genetic information, confirms that the superorder (or order in some classifications) Dictyoptera now contains the mantises, cockroaches, and termites, as a single evolutionary group that all share a relatively recent common ancestor (i.e., they are monophyletic). Genetic data has confirmed that termites, formerly in their own order, Isoptera, are actually contained within the cockroaches and should be considered a group of highly social, and evolutionarily successful, roaches.

Cockroaches and Termites (Order Blattodea)

The domestic cockroaches are all-too-familiar insects. Fortunately the pests are only a few species of a large and interesting but mainly tropical group. Cockroaches are easily recognized by a compressed body; large, oval, shieldlike prothorax almost hiding the head; very long, slender antennae; aversion to light; a glossy, waxy surface; and generalist food habits. All form a purse-shaped egg capsule that is often seen protruding from the female's abdomen, where it may be carried up to a month before deposition or nymphs hatching.

Although cockroaches are widely considered as dirty, they are probably of little importance in disease transmission except when very abundant under filthy conditions. They are known to transmit diseases such as *Salmonella* through direct physical contact by walking on infested surfaces and then inoculating new surfaces. Allergies to dust containing their feces and crushed body parts may also occur. A few species of wasp, including species of *Evania* and *Aprostocetus*, parasitize the egg cases of

Blatta orientalis and *Periplaneta* species, providing some measure of biological control, though these parasitoids do not seem to be as prominent in California as they are elsewhere in the country. Most of the following species are cosmopolitan household pests long associated with humans; all those are considered to be tropical in origin, probably having spread to North America through trade either directly *(Periplaneta* and *Supella)* or via Europe *(Blattella* and *Blatta).* The others characterized below are representative of our meager native fauna of five or six species.

Family Blattidae

▶ **54–55. ORIENTAL COCKROACH** *Blatta orientalis*

ADULT: BL 18–32 mm; male **(54)** with dark brown wings that do not quite reach the end of the abdomen; female **(55)** wingless; body shining black.

EGG CASE: Largest egg cases of the domestic species (length 10 mm); black, hard, and smooth; purselike (rounded ends); usually with about 16 egg chambers.

HABIT: Attracted to warm, moist areas (bathroom toilet bowls, bathtubs, water pipes, kitchen sinks, etc.) and so this species has acquired the name "water bug"; gregarious but forms only small colonies.

RANGE: Thought to originate in Africa or southeastern Europe, it is now cosmopolitan. Statewide in domestic habitats; survives well outdoors in warm weather.

▶ **56–58. TURKESTAN COCKROACH** *Shelfordella lateralis*

ADULT: BL 18–30 mm; body elongate and relatively slender; males **(56)** dark brick red to brownish orange, with long pale-yellow wings when mature. Females **(57)** darker brown to black, slightly broader-bodied than males; vestigial wings render females flightless.

NYMPH: (58) Similar form to females, distinctly red color.

HABIT: Unlike most introduced cockroaches, which hail from the tropics, this temperate species can reside primarily outdoors, although flying males may be attracted to house lights. These cockroaches cannot climb glass or burrow, and so are popular as live food in the exotic pet trade, probably hastening their spread across North America.

EGG CASE: Deep brown cases that may contain 10–20 eggs; cases are laid under substrate, and a female can produce a new clutch every four to seven days.

RANGE: This species was well-positioned to spread across the American West since its native range includes the deserts of the Middle East, North Africa, and Central Asia from where it was introduced in the late 1970s. *Shelfordella lateralis* has spread throughout the Southwest, apparently

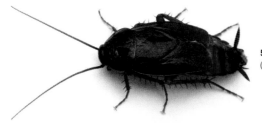

54. Oriental Cockroach (*Blatta orientalis*) male.

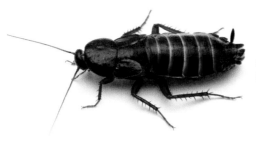

55. Oriental Cockroach (*Blatta orientalis*) female.

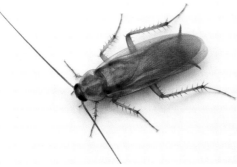

56. Turkestan Cockroach (*Shelfordella lateralis*) male.

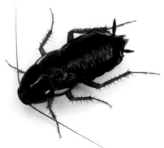

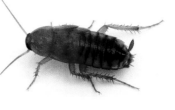

57. Turkestan Cockroach (*Shelfordella lateralis*) female.

58. Turkestan Cockroach (*Shelfordella lateralis*) nymph.

outcompeting *B. orientalis* due to shorter generation times and preference for drier climates. Recorded throughout the Central Valley, warmer parts of the San Francisco Bay Area, and lower elevations across southern California, including desert areas.

▶ **59. AMERICAN COCKROACH** *Periplaneta americana*

ADULT: Large (BL 33–54 mm) but not as immense as barroom tales and online urban legends suggest; both sexes fully winged; head reddish brown to dark brown, thorax with pale yellowish-brown margin at the sides and front, and dark brown splotches in the center and along the back margin. They have a pungent and distinctive odor, which volatilizes readily when they are crushed; it is also indicative of their presence in closed spaces such as closets and pantries.

HABIT: Prefers warm, humid spaces.

EGG CASE (OOTHECA): (59 inset) Length 8 mm; black, hard, and smooth; purselike (rounded ends); a series of teeth along upper ridge of case; 14–16 egg chambers. Usually prominently carried by the female in her ovipositor when fresh and then deposited.

HABIT: Their unpleasant size and tendency to leap into cumbersome flight have earned them the nickname "B-52" in Hawaii.

RANGE: Probably originally African in origin but now widespread in the company of humans, though more sensitive to cool temperatures than even the German Cockroach. Cosmopolitan and statewide. The most prevalent house roach in California. Usually occurs in small numbers but is jarring to homeowners nonetheless. The Australian Cockroach *(P. australasiae)* occurs sporadically in California in urban situations; it is recognized by the bright yellow border on the head shield and elongate, yellow shoulder triangles.

Family Ectobiidae

▶ **60–61. BROWN-BANDED COCKROACH** *Supella longipalpa*

ADULT: Smallest domestic cockroach (BL up to 14 mm); generally brown with two pale transverse bands crossing the wings; wings developed in both sexes. Male **(60)** slightly longer and more slender than female; wings cover the entire length of the abdomen. Females **(61)** have a relatively wider and more robust abdomen that extends beyond the wings, and they are not able to fly. Similar to the German Cockroach, but this species lacks the two black pronotal stripes that define its more common relative.

EGG CASE: Smallest case of the indoor species (length 4 mm); yellowish to reddishbrown; rectangular (lower ridge convex); 14 egg chambers, well-marked externally; usually stuck to vertical surfaces in clusters.

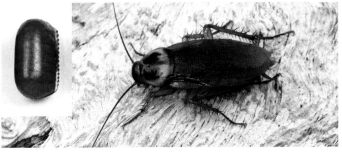

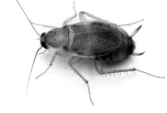

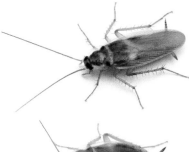

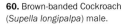

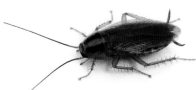

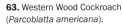

59. American Cockroach (*Periplaneta americana*) ootheca (inset).

60. Brown-banded Cockroach (*Supella longipalpa*) male.

61. Brown-banded Cockroach (*Supella longipalpa*) female.

62. German Cockroach (*Blattella germanica*).

63. Western Wood Cockroach (*Parcoblatta americana*).

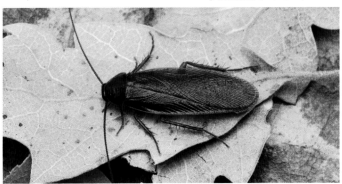

HABIT: Capable of rapid, darting flight to escape capture. Solitary and the least common of the domestic roaches. This species is more wide ranging in houses than other species (e.g., found in bedrooms, behind picture frames, in closets). The egg cases are often attached very firmly in closed spaces, including creases in food boxes in the back of pantries or among the folds of hanging or folded clothing, where the adhesive is so strong that they can create holes when removed.

RANGE: Originally from Africa, occurs only in milder parts of the state.

◄ 62. GERMAN COCKROACH
OR CROTON BUG *Blattella germanica*

ADULT: Medium-sized (BL 16 mm), with full set of wings extending beyond the tip of the abdomen in both sexes; light brown with parallel, dark, longitudinal stripes on the head shield.

EGG CASE: Length 8 mm; light brown, soft; elongate, rectangular; 30–40 egg chambers, conspicuously marked externally. Usually carried by the female until nymphs hatch, can be seen protruding conspicuously from her terminal end. If you time it right, you can see the nymphs hatching while the case is still attached to their mother.

HABIT: Gregarious and often develops enormous populations; prefers the dark recesses in bathrooms, kitchens, and commercial establishments.

RANGE: Originally probably Southeast Asian in origin (not from Germany), spread with humans throughout the world. In California, widespread throughout coastal areas, the Central Valley, and the Sierra Nevada foothills; may occur in any domestic environment, though they are sensitive to temperatures below 16 degrees C. The related Field Cockroach *(B. vaga)* is normally an outdoor species in the Central Valley and deserts but can become a pest indoors.

◄ 63. WESTERN WOOD COCKROACH *Parcoblatta americana*

ADULT: 10–15 mm; shining, dark brown, the wingless female much darker than the male; wings well developed and extending beyond the abdomen in the males.

HABIT: Found in old logs and under rocks in chaparral areas; males are often attracted to lights. This is the only other common native roach, aside from the Sand Roaches **(65–66)**.

RANGE: Foothills to middle elevations throughout the state.

▶ 64. THREE-STRIPED OR
MEDITERRANEAN COCKROACH *Luridiblatta trivittata*

ADULT: Small (BL up to 6 mm), wingless, shiny gray with three distinct black stripes down the body, which distinguishes it from the German Cockroach nymph (that has only two lines).

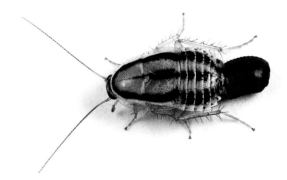

64. Three-striped Cockroach (*Luridiblatta trivittata*) female with ootheca.

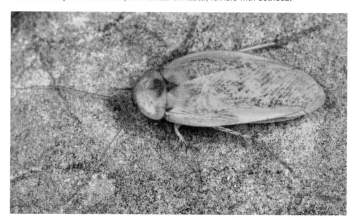

65. Sand Roach (*Arenivaga* sp.) male.

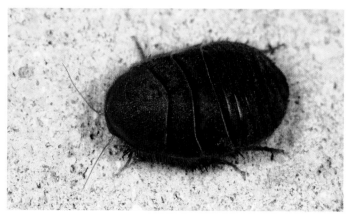

66. Sand Roach (*Arenivaga* sp.) female.

EGG CASE: Small, brown, purse-shaped. Overwinter outside with nymphs hatching in spring.

HABIT: Their numbers appear to build through summer into fall. Populations can build up to fairly high numbers in leaf litter and among debris in yards, but this species does not appear to thrive indoors, though if populations are high outside, they can become an indoor nuisance. Feeds on a variety of organic material, including pet food. It may surprise those afflicted by this species to know that it is apparently of interest to those who keep roaches as pets, where it has a reputation of being relatively difficult to maintain.

RANGE: Native to the Mediterranean Basin, this species probably arrived in the state sometime just after the turn of the 21st century, becoming locally very common since the 2010s and garnering much notice and concern, especially in suburban areas around the greater San Francisco Bay Area, where outdoor cockroaches were previously uncommon. Perhaps because this species is not tropical, it tolerates much drier conditions than do most other introduced roaches and appears to have spread rapidly, now occurring throughout lower elevations of the coastal counties from the Oregon border to central California, including the greater San Francisco Bay Area. This species might be expected to spread throughout much of the rest of the state at lower elevations, except in the coldest and driest areas.

Family Corydiidae

◄ 65–66. SAND ROACHES *Arenivaga* spp.

ADULT: BL 20–30 mm; males **(65)** fully winged, the wings mottled and pale brown, slightly translucent; females **(66)** wingless, oval, and strongly convex (form suggestive of prehistoric trilobites); nearly hairless.

HABIT: Males commonly attracted to lights at night in the desert or other sandy areas; burrowers in sandy soil and dunes, their presence indicated by serpentine surface ridges.

RANGE: Several species in the state, limited to deserts, the Central Valley, and southern coastal dunes. The Hairy Desert Cockroach *(Eremoblatta subdiaphana)* is distinguished by the translucent and unmarked wings of the male and the pale or yellow hairs on the body of the female.

Termites (Superfamily Isoptera)

Recent phylogenetic systematic work has confirmed that termites are nested within the cockroach evolutionary tree and represent an

interesting example of how rapidly evolution has operated on the ecology and morphology of this group of insects. Termites are, essentially, tiny social cockroaches. Well-known because of their destructive feeding on structural wood, termites are social insects, meaning they have a well-defined caste system, and many species develop immense colonies. Although termites are most abundant, diverse, and destructive in tropical regions, they sometimes cause serious damage to structural timbers in temperate areas, stimulating the growth of a considerable industry associated with control and preventive measures.

Termites are small and soft-bodied, normally pale or white (sometimes called "white ants"), with biting mouthparts and incomplete metamorphosis. Some forms are blind, and many species develop seasonal, winged sexual forms. The four similar wings are long and narrow; they fold flat over the back when at rest and often are lost following the mating flight. These mating flights are timed to occur simultaneously and can result in the sudden appearance of thousands of winged insects, often to the surprise of residents unaware of a subterranean colony. The colonies live either in wood aboveground, where wood is accessed through mud tunnels, or belowground, feeding on buried wood, decaying roots, and so forth. There are about 15 species known in the state, of which about 10 are desert species of little or no economic significance to humans.

Family Termopsidae

▶ **67–69. PACIFIC DAMPWOOD TERMITE** *Zootermopsis angusticollis*

This is the largest yet one of the least destructive of California's termites. **ADULT:** Colonies consist of large (BL 16–24 mm), yellowish-white soldiers **(67)** with red-brown heads and contrasting black mandibles; smaller reproductives, which may be fully winged **(68)**, short-winged, or wingless; winged form light brown with a short body (BL 9–10 mm) and long (20–24 mm), dark brown, heavily veined wings. The wings are shed following the mating swarms and establishment of new colonies in August and September.

HABIT: There are no true workers, this function being carried out by immature forms of the reproductives **(69)**. Reproductive pairs enter new wood, primarily inhabiting pine or fir logs and stumps. Old colonies may consist of 3,000 individuals or more. Occasionally structural wood is used, especially if damp.

RANGE: Coastal and mountain areas. A similar species, the Sierran Dampwood Termite *(Z. nevadensis)*, is more common in the northern half of the state, especially at higher and drier localities.

Family Rhinotermitidae

▶ 70–72. WESTERN SUBTERRANEAN TERMITE
Reticulitermes hesperus

This is the commonest and most destructive termite in California.

ADULT: BL 5–6 mm; colonies consist of elongate-headed soldiers **(72)**; up to three forms of reproductives; and blind, wingless, small (BL to 5 mm) white workers **(72)**; winged forms **(71)**, BL 8–10 mm to tips of wings, translucent black. The wings are shed **(70)** following the mating swarms and establishment of new colonies.

HABIT: Flights occur in the daytime, in spring or fall following the first rains. Mature colonies require three to four years to develop and are often massive, consisting of many thousands of individuals.

RANGE: Throughout low to moderate elevations in California, wherever sufficient soil moisture and suitable wood are available. Damage to structural wood is common, primarily the understructure of houses but also fruit trees, grapevines, even potatoes are sometimes invaded.

Family Kalotermitidae

▶ 73–76. WESTERN DRYWOOD TERMITE
Incisitermes minor

This is the most common termite in coastal southern California.

ADULT: Colonies consist primarily of white nymphs **(75)** (BL to 8 mm); and less common red-brown to blackish-brown soldiers **(74)** (BL 8–12 mm). In summer and fall, numerous winged reproductives **(73)** appear with lustrous reddish- or bluish-black wings (11–12 mm to tips of wings).

HABIT: All kinds of sound wood are invaded, including structural timbers (any portion of houses), dead tree branches, driftwood, and in drier areas of the state buried portions of stumps and posts. Accumulations of their frass (feces) **(76)** are often noticeable and recognizable as being composed of nearly uniform cubelike pellets.

RANGE: Coastal areas and inland canyons from Mendocino southward.

DESERT DAMPWOOD TERMITE
Paraneotermes simplicicornis

While members of Kalotermitidae characteristically use dry wood, this species is confined to wood with some moisture in or on the soil in desert areas. They penetrate the earth at times but do not build mud-covered runways to reach wood aboveground.

ADULT: Soldiers are brown or yellowish brown with flat heads and short mandibles (BL 10–14 mm); nymphs are small (BL to 8 mm), whitish gray with the pronotum narrower than the head; and the winged reproductives are dark brown, including the wings (13–15 mm to tips of wings).

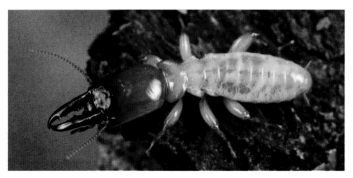

67. Pacific Dampwood Termite (*Zootermopsis angusticollis*) soldier.

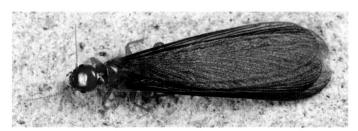

68. Pacific Dampwood Termite
(*Zootermopsis angusticollis*) winged adult reproductive.

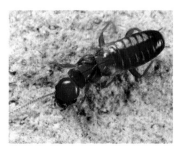

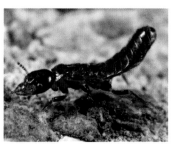

69. Pacific Dampwood Termite
(*Zootermopsis angusticollis*) immature
reproductive.

70. Western Subterranean Termite
(*Reticulitermes hesperus*) adult after
wing loss.

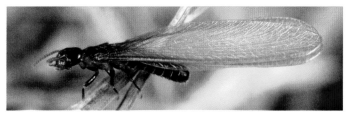

71. Western Subterranean Termite (*Reticulitermes hesperus*) winged adult.

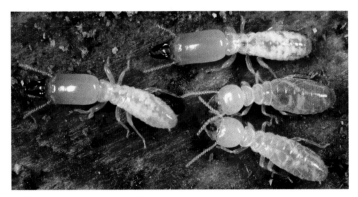

72. Western Subterranean Termite
(*Reticulitermes hesperus*) group of workers and soldiers.

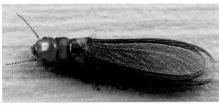

73. Western Drywood Termite
(*Incisitermes minor*) winged adult.

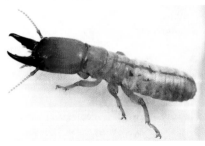

74. Western Drywood Termite
(*Incisitermes minor*) soldier.

75. Western Drywood Termite
(*Incisitermes minor*) worker.

76. Western Drywood Termite
(*Incisitermes minor*) frass.

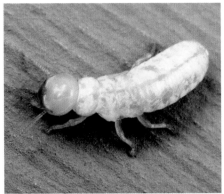

Vicinity of Barstow eastward, usually in washes and sand dunes in association with dead roots or buried branches of mesquite and other desert shrubs or sometimes structural wood in irrigated areas.

Mantises (Order Mantodea)

Mantises are unique insects because of their predaceous habits. They are easily distinguished by the elongate prothorax and forelegs modified for grasping. They perch waiting for prey, with front legs upraised in a "praying" attitude. The eggs are laid in hardened froth cases attached to vegetation, rocks, and sometimes buildings. Adults are primarily nocturnal and are readily attracted to light. Recent DNA-based studies have revealed that mantises share a most recent common ancestor with the cockroaches and termites.

Only the first two of the illustrated species are California natives. The remainder have been introduced, though some have spread widely and may have negative impacts on the native fauna, as is often the case with non-native species. These insects are sometimes used as biological control agents, such as in gardens, by introduction of the egg cases. Because all mantises are cannibalistic, they do not build up high densities needed to suppress most pests, and egg cases with many young do not provide a higher density of mantises in a small area—at least not for very long. Furthermore, because they are indiscriminate predators, they eat beneficial insects, including pollinators and other predators. Observations of most species tend to peak in late summer and early fall, when individuals are at full size and seeking mates. Only the egg cases survive winter.

Family Mantidae

▶ **77–78. CALIFORNIA MANTIS** *Stagmomantis californica*
ADULT: Moderately large (BL 50–65 mm); green, yellow, and brown color phases; wings of male **(77)** extending well beyond tip of abdomen, short (only to middle of abdomen) in female **(78)**; hind wing generally dark, marked anteriorly with ashy blotches; abdomen with four conspicuous dark, transverse bands.
HABIT: Males commonly come to light.
RANGE: Essentially a desert and arid land species, found in all of southern California and north through the Central Valley and foothills.

CAROLINA MANTIS *Stagmomantis carolina*

The Carolina Mantis is introduced from the eastern United States and is much rarer and localized in California.

ADULT: Similar to the California Mantis but generally smaller (BL 45–50 mm); more often green; abdomen lacks dark basal crossbands; female abdomen strongly widened at middle.

RANGE: Appears to be sparsely distributed in southern California and the Central Valley.

▶ **79–80. GROUND MANTISES** *Litaneutria* **spp.**

ADULT: Small (BL 20–30 mm); slender; pale grayish brown; male **(79)** with fully developed wings; female **(80)** with short or full-sized wings; hind wing has a dark purple blotch near the base in both sexes.

HABIT: Very active and normally found on the ground in chaparral or coastal sage scrub.

RANGE: This genus represents a complex of native species occurring in sparsely vegetated, dry portions of the state; deserts from San Diego north through the Central Valley and foothills.

▶ **81. EUROPEAN MANTIS** *Mantis religiosa*

ADULT: Large (BL 50–75 mm); both green and brown phases, well-developed wings in both sexes; hind wing clear with prominent venation. Can be distinguished from other mantises by the distinctive black spots at the base of each of the raptorial front legs, sometimes with a white center. Mature females often become so heavy that they are unable to fly.

RANGE: Introduced from Europe at the end of the 19th century, this species is now distributed widely across the continent, probably thanks to its popularity with the nursery trade, under the assumption that the purchase of its egg cases provides significant pest control. Occurs throughout the state except perhaps in the hottest and driest desert areas. More common at lower elevations and in warmer regions.

CHINESE MANTIS *Tenodera sinensis*

ADULT: Large (BL 75–100 mm); green; wings complete in both sexes and somewhat jointed apically; hind wing mottled throughout; abdomen without dark crossbands. It has established local populations in various parts of the state, usually in suburban areas.

HABIT: Widely sold as egg masses for garden pest control. Escapees readily naturalize where climate permits.

RANGE: Native to Asia. Known from the San Francisco Bay Area, the Los Angeles Basin, San Diego County, and a few other locations.

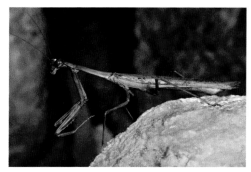

77. California Mantis (*Stagmomantis californica*) male.

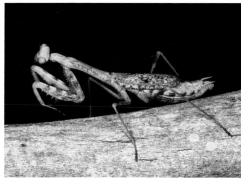

78. California Mantis (*Stagmomantis californica*) female.

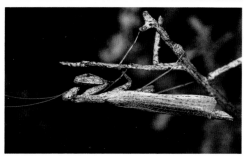

79. Ground Mantis (*Litaneutria ocularis*) male.

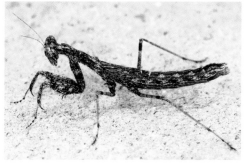

80. Ground Mantis (*Litaneutria ocularis*) female.

Family Tarachodidae

▶ **82. MEDITERRANEAN MANTIS** *Iris oratoria*

ADULT: Medium-sized (BL 25–57 mm); green and brown phases; both male and female with well-developed wings, the female's shorter, exposing about half the abdomen; hind wing **(82 inset)** with a shining bluish-black eye-spot near the base and an area of brick red toward the front.

HABIT: In the form of egg masses, *T. sinensis* and *I. oratoria* are the two mantises most widely sold to gardeners for pest control.

RANGE: Introduced from the Mediterranean region; established in the Central Valley and throughout lower elevations of southern California and apparently expanding its range in the state.

Grasshoppers, Crickets, and Katydids (Order Orthoptera)

The order Orthoptera is a diverse group that includes both winged and wingless heavy-bodied insects, most of which are adapted for jumping. Those that are winged possess long, straight, many-veined, stiff, or leathery fore wings and large fan-shaped hind wings. All have chewing mouthparts and most feed on plants, although they sometimes prey on other insects or are scavengers of dead organic matter. There are more than 300 species in California, including many of our most conspicuous and familiar insects. They are often voracious feeders and can be a significant pest on cultivated plants.

Well-developed muscles in the enlarged femora of the hind legs give most members of this group exceptional jumping ability. Many species are capable of producing sounds by rubbing together specialized frictional areas, either at the bases of the fore wings (katydids and crickets) or between the hind leg and the fore wing (grasshoppers). These "songs" or stridulations usually are part of their courtship behavior and in most species are produced by only the males. Both sexes possess hearing (tympanic) organs, located at the base of the foreleg tibia (katydids and crickets) or the base of the abdomen (grasshoppers).

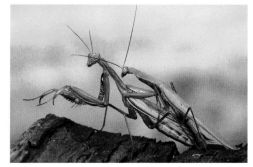

81. European Mantis (*Mantis religiosa*) male green, female brown.

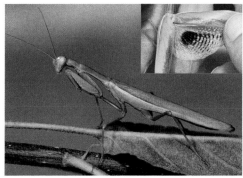

82. Mediterranean Mantis (*Iris oratoria*) hind wing (inset).

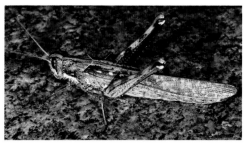

83. Gray Bird Grasshopper (*Schistocerca nitens*).

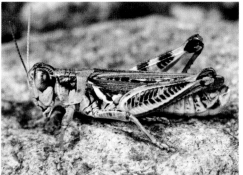

84. Devastating Grasshopper (*Melanoplus devastator*).

Grasshoppers (Suborder Caelifera)

Short-horned Grasshoppers (Family Acrididae)

These grasshoppers differ from the majority of other jumping Orthoptera by their short, robust antennae, which seldom extend beyond the thoracic region. The hearing organs are large and located on the sides of the first abdominal segment. Although most adult grasshoppers are winged and many are strong fliers, some species are flightless. "Lubbers" (or "land lubbers") are short-winged, bulky forms that are often brightly colored, advertising they have chemicals in their bodies that make them distasteful to vertebrate predators.

The family Acrididae is large and diverse, with about 200 species known in California. Nearly all habitats, from seacoast and deserts to Alpine Fell-fields above timberline, are occupied by different species.

Bird Grasshoppers
(Subfamily Cyrtacanthacridinae)

◄ 83. GRAY BIRD GRASSHOPPER *Schistocerca nitens*

ADULT: Both sexes fully winged; male (BL 40–50 mm to tips of wings) considerably smaller than female (BL 60–70 mm); gray or dark brown to tan; hind wing uniform translucent olive; a pale mid-dorsal stripe on head and prothoracic shield.

NYMPH: Bright green.

HABIT: Adults, which are active in spring, and immatures feed on a wide variety of garden and crop plants.

RANGE: Widely distributed, from Monterey and Fresno Counties southward.

◄ 84. DEVASTATING GRASSHOPPER *Melanoplus devastator*

A member of a large genus (about 50 species in California). This is the most widespread, abundant, and destructive grasshopper in the state.

ADULT: Pale to dark gray or brown (BL 20–24 mm); hind femur with three dark bars, tibia blue (rarely red); fully winged, hind wing clear, lightly tinged with greenish gray.

HABIT: Because of its migratory and gregarious habits, *M. devastator* is a true locust and has been responsible for spectacular plagues during California's agricultural history. Feeds on rangeland herbs and grasses and, during outbreak years, moves from the foothills into agricultural lands.

RANGE: Typically found in semiarid grassy foothills from near sea level to 1,500 m elevation.

Band-winged Grasshoppers (Subfamily Oedipodinae)

Oedipodinae has a larger number of species in California than any other subfamily, with many endemic species. Members of this subfamily commonly have brightly colored hind wings, often with a black or contrastingly colored band across the outer portion. The face is vertical or rounded rather than slanted, and the pronotum usually has a median ridge. The fore wings are cryptically colored like rocks, gravel, or sand, camouflaging the resting insect.

Band-winged grasshoppers are widespread and most abundant in arid parts of the state, such as deserts, dry canyons, and sparsely vegetated, grassy mountainous areas. Few species are of appreciable economic concern. Their presence is most often noticed by their flight, which shows off the conspicuous hind wing color, and sometimes produces a crackling noise that is audible for considerable distances. The sound is created by the males snapping their wings together. The hind wing colors can be revealed in a captive individual by carefully holding them and rolling open the wings **(91)**. With practice, this maneuver doesn't harm the grasshopper, so they may be released after identification.

▶ **85. PALLID-WINGED GRASSHOPPER** *Trimerotropis pallidipennis*
ADULT: BL 31–42 mm to wing tips; fore wing dull tan or brown with darker markings; hind wing pale yellow or greenish yellow with a black median band.
RANGE: One of our most widely distributed and common species, in a wide variety of habitats, up to 2,600 m elevation.

▶ **86. RED-WINGED GRASSHOPPER** *Dissosteira pictipennis*
ADULT: BL 22–38 mm to wing tips; hind wing rosy-red on basal third, followed by a broad black band and with the apical third colorless.
RANGE: Found in the Bay Area, central western Sierra foothills and south to the southern coastal mountains and foothills of the southern Sierra.

▶ **87. CAROLINA OR MOURNING CLOAK GRASSHOPPER** *Dissosteira carolina*
A spectacular and much larger (BL 42–55 mm to wing tips) *Dissosteira* species with pale tan to brown, unspotted fore wing, and hind wing colored dark brown like the Mourning Cloak Butterfly **(619)**, bordered by a cream or greenish-yellow band; males produce a loud intermittent snapping while in flight.
RANGE: Found in the Bay Area and then north through the Coast Ranges and northern Sierra.

▶ 88. SIERRAN BLUE-WINGED
GRASSHOPPER *Circotettix undulatus*

ADULT: BL 32–40 mm to wing tips; recognizable by the translucent, pale blue, or greenish-blue hind wing without a dark crossband, and the dull, brownish-gray mottled fore wing, resembling the granitic surfaces it frequents.

HABIT: Males fly high and hover over slopes where females are likely resting, issuing a high-pitched crackling that sometimes is mistaken for rattlesnake buzz at a distance.

RANGE: A familiar insect on high Sierran trails, occurring in the Sierra Nevada and Cascade Range at moderate to high elevations, and on the east side.

▶ 89. CLEAR-WINGED GRASSHOPPER *Camnula pellucida*

ADULT: BL 19–38 mm to wing tips; hind wing clear, colorless; fore wing brown, mottled, each fore wing with a conspicuous yellowish-tan line that meet to form a narrow "V" when the insect is at rest.

RANGE: One of our most abundant species, occurring in grasslands of mountain meadows (to elevations above 2,200 m), foothills, and valleys throughout the state. When abundant, adults and nymphs often migrate into agricultural areas.

▶ 90–91. CALIFORNIA SULPHUR-WINGED
GRASSHOPPER *Arphia behrensi*

ADULT: This is a relatively small (BL 22–40 mm to wing tips) springtime grasshopper with brightly colored hind wings **(91)** that are greenish yellow or ochreous having a dark brown outer band at the apex.

RANGE: From the southern Sierra Nevada and San Francisco Bay Area northward.

The similar **California Orange-winged Grasshopper** *(A. ramona)* **(92–93)** is common throughout southern California west of the deserts, north in the Coast Range to Mount Diablo, with hind wing bright orange **(93)**. The **Bloody-winged Grasshopper** *(A. pseudonietana)* **(94–95)** occurs together in the Mount Diablo area but its range extends further north, flying late in the season, and is similar but has the hind wing bright blood-red **(95)**.

▶ 96–97. ROBUST BLUE-WINGED
GRASSHOPPER *Leprus intermedius*

ADULT: Body robust, BL 32–46 mm to wing tips; hind wing **(97)** bright blue with a broad black band across the outer half; fore wing conspicuously

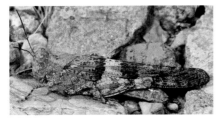

85. Pallid-winged Grasshopper (*Trimerotropis pallidipennis*).

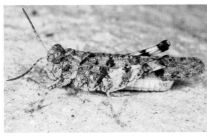

86. Red-winged Grasshopper (*Dissosteira pictipennis*).

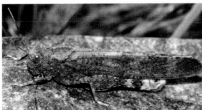

87. Carolina Grasshopper (*Dissosteira carolina*).

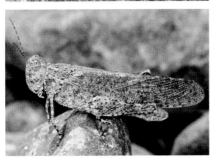

88. Sierran Blue-winged Grasshopper (*Circotettix undulatus*).

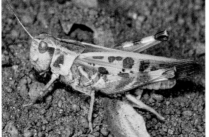

89. Clear-winged Grasshopper (*Camnula pellucida*).

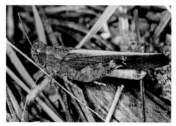

90. California Sulphur-winged
Grasshopper
(*Arphia behrensi*).

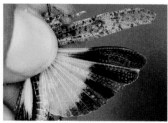

91. California Sulphur-winged
Grasshopper
(*Arphia behrensi*) hind wing.

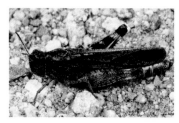

92. California Orange-winged Grasshopper
(*Arphia ramona*).

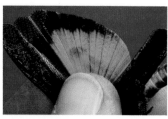

93. California Orange-winged Grasshopper
(*Arphia ramona*) hind wing.

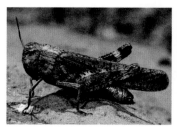

94. Bloody-winged Grasshopper
(*Arphia pseudonietana*).

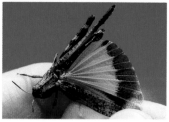

95. Bloody-winged Grasshopper
(*Arphia pseudonietana*) hind wing.

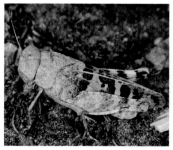

96. Robust Blue-winged Grasshopper
(*Leprus intermedius*).

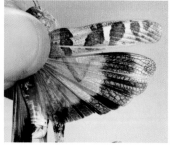

97. Robust Blue-winged Grasshopper
(*Leprus intermedius*) hind wing.

marked with crossbands that are white and dark, varying from brown to black.

RANGE: A conspicuous species in southern California mountains and coastal areas during summer.

▶ **98–99. LUBBERLY BAND-WINGED GRASSHOPPER** *Agymnastus ingens*

ADULT: Female **(98)** BL 36–48 mm to tip of abdomen; male **(99)** BL 28–32 mm to tips of wings; hind wing of both sexes yellow or greenish yellow with a broad black marginal band; inner side of the broad hind femur blue toward the base; hind tibia bright reddish orange. Female characterized by a very broad and rough prothoracic shield; sluggish, grotesquely robust, and short-winged. Male long-winged and slender; normally active; often observed riding on back of female.

RANGE: Rocky hillsides and mountain ridges in northern half of California.

Slant-faced Grasshoppers (Subfamily Acridinae)

▶ **100. CREOSOTE BUSH GRASSHOPPER** *Bootettix argentatus*

ADULT: Medium-sized (BL 20–26 mm), slender grasshopper; head oblong, with an acute apex and slanted face; green with pearly white, oblique lateral areas on sides of thorax.

HABIT: A heat-loving species found clinging to twigs of Creosote Bush *(Larrea tridentata)* throughout summer. The markings and colors of this insect, which serve effectively to hide it on the plant, are also exhibited by the slender Creosote Bush Katydid *(Insara covilleae)* **(110)**, which also lives on Creosote Bush.

RANGE: High and low deserts of southern California. A less spectacularly colored, slant-faced acridid, the Desert Clicker Grasshopper *(Ligurotettix coquilletti)*, is often found on the same plant. It is a dull, olive-gray species that stridulates from Creosote Bush all day and on warm nights during late summer and fall. Its range is the same as that of the Creosote Bush Grasshopper.

Lubbers (Family Romaleidae)

▶ **101. DRAGON LUBBER** *Dracotettix monstrosus*
ADULT: Female (BL 38–48 mm) much larger than male (BL 20–24 mm); mottled gray and brown; very short wings in both sexes; a jagged median crest along back of prothoracic shield.
HABIT: Usually seen on gravelly soil amid grasses or shrubs on which it customarily feeds. Males active but females sluggish, relying on camouflage for protection.
RANGE: West, central, and southern California; in the foothills and the mountains.

Desert Long-horned Grasshoppers (Family Tanaoceridae)

▶ **102. KOEBEL'S DESERT LONG-HORNED GRASSHOPPER** *Tanaocerus koebelei*
ADULT: BL 18–25 mm; rather variable in color, from light brown mixed with white to orange or brick red, and sculpturing, from heavily sculptured to quite smooth. They tend to closely match the color and texture of the substrate where found.
HABIT: A shrubland, chaparral, and desert species, associated with Blackbrush *(Coleogyne ramosissima)*.
RANGE: In the southern part of the state as far north as Inyo County on the east face of the Sierra Nevada and across dry and desert habitats in the southeast.

Pygmy Grasshoppers (Family Tetrigidae)

▶ **103. AWL-SHAPED PYGMY GRASSHOPPER** *Tetrix subulata*
ADULT: BL 13–15 mm to tip of elongate pronotum; variably colored from light gray to dark brown, sometimes with a red tinge; form of the resting grasshopper when viewed from above is a distinct narrowly elongate diamond, the long extension of the pronotum gives the shape and the common name; fore wing vestigial.
HABIT: Typically found in moist or wet grassy areas.
RANGE: Widespread in the state in mesic habitats.

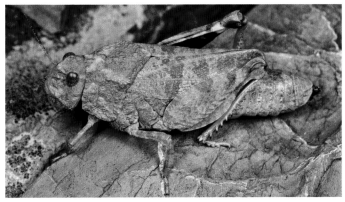

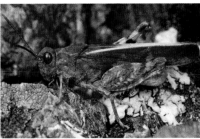

98. Lubberly Band-winged Grasshopper (*Agymnastus ingens*) female.

99. Lubberly Band-winged Grasshopper (*Agymnastus ingens*) male.

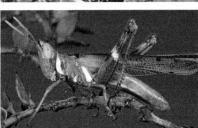

100. Creosote Bush Grasshopper (*Bootettix argentatus*).

101. Dragon Lubber (*Dracotettix monstrosus*) male top, female bottom.

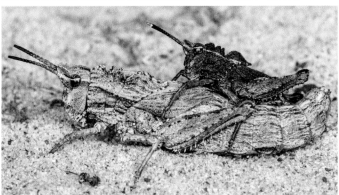

Pygmy Mole-crickets (Family Tridactylidae)

▶ **104. PYGMY MOLE-CRICKETS** *Ellipes* **spp.**

ADULT: Very small (BL 4–5 mm); bold contrasting pattern of white or cream-colored markings on a black or brown base color; front legs fitted for digging and hind tarsi elongate; tip of the abdomen has four stylelike appendages.

HABIT: Found along the shores of lakes and streams where they burrow in the sandy soil. They jump readily when approached and, in a behavior rare in orthopterans, may dive beneath the water. They feed on detritus and algae and do not "sing." While referred to as crickets, they are actually grasshoppers.

RANGE: Found across the state but more commonly encountered in southern counties.

Long-horned Orthopterans (Suborder Ensifera)

Katydids (Family Tettigoniidae)

Katydids are large, typically leaf-mimicking insects with slender legs and very long, threadlike antennae often exceeding the length of the body. By abrasion of special roughened files at the bases of the fore wings, they produce a variety of notes. The sounds play an important part in courtship. The note produced by one eastern species sounds like "Kate-she-did" and gave rise to a legend of an unhappy love story. The phrase stuck as the common name of the family. Small apertures in a swelling near the base of the tibia of the front leg mark the openings of the hearing organs.

▶ **105. ANGULAR-WINGED KATYDID** *Microcentrum rhombifolium*

ADULT: Large (BL to wing tip 50–65 mm); fore wing much broader at middle than at either end (rhomboid shape), giving the back of the insect an angular hump. Wings green, a perfect model of a leaf, complete with veins.

SONG: Male (lacks bladelike ovipositor) emits short, lisping and ticking sounds that are responded to by low-intensity ticking from female (curved bladelike ovipositor). Calls from trees in late summer and fall at dusk and through the night when warm.

EGGS: Flat, oval, and gray, placed by female on twigs in a single or double overlapping row.

RANGE: Common throughout the state.

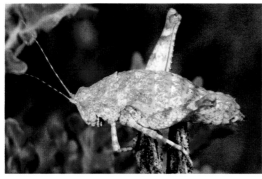

102. Koebel's Desert Long-horned Grasshopper (*Tanaocerus koebelei*).

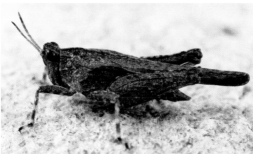

103. Awl-shaped Pygmy Grasshopper (*Tetrix subulata*).

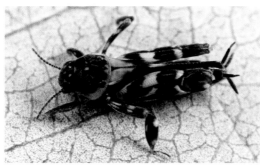

104. Pygmy Mole-cricket (*Ellipes* sp.).

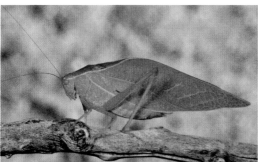

105. Angular-winged Katydid (*Microcentrum rhombifolium*).

▶ **106. BUSH KATYDIDS** *Scudderia* **spp.**

ADULT: Smaller than preceding species (BL to wing tips 30–38 mm); wings slender and straight.

SONG: Male usually lisps ("zeek" or "zip") in series of three or four; female may respond with a ticking noise. Habits otherwise similar to those of previous species.

EGGS: Flat and inserted lengthwise into the edges of leaves.

NYMPH: Distinguishable from that of the Angular Winged Katydid by a horn on the head between the antennae.

RANGE: Widespread in the state; **Mexican Bush Katydid (S. mexicana) (106)** is common in southern California; Fork-tailed Bush Katydid (*S. furcata)* is more common in the northern part.

▶ **107. MEDITERRANEAN KATYDID** *Phaneroptera nana*

ADULT: Similar to *Scudderia*, BL 13–18 mm; overall light green with small black spots, eyes often yellow or orange.

HABIT: Does well in urban gardens and parks.

SONG: In their duet the male produces two to 11 pulses of "chirps" that a receptive female responds to with a short "click."

RANGE: An introduced, invasive species common in the San Francisco Bay Area and Los Angeles Basin.

▶ **108. OVATE SHIELD-BACK KATYDID** *Aglaothorax ovata*

ADULT: Large (BL 25–40 mm); body yellow or green, with brown and green or yellowish-green mottling; wings completely hidden beneath the thoracic shield.

HABIT: This is California's most characteristic representative of a group of katydids that are dull colored (mimicking sticks or wood), with abbreviated wings and enlarged thoracic shields. Active in late summer and fall.

SONG: Males repeat a sharp "zip-zip-zip" series between long pauses.

RANGE: Typical form in desert portion of southern California. Other forms are found in the state, including a larger one along the eastern slopes of the Sierra Nevada.

▶ **109. BROWN-WINGED SHIELD-BACK** *Capnobotes fuliginosus*

This is a spectacular desert insect because of its large size (BL to wing tips up to 75 mm) and ear-splitting call.

ADULT: Fully winged; brownish gray mottled hind wing darker than fore wing. Found all summer on Mesquite and other shrubs in desert; most active on hot nights. Partly carnivorous.

SONG: Very loud, continuous, shrill buzz.

RANGE: Desert portions of southern California.

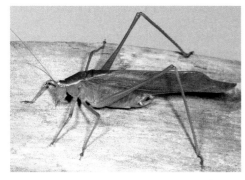

106. Mexican Bush Katydid (*Scudderia mexicana*).

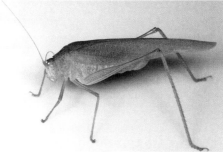

107. Mediterranean Katydid (*Phaneroptera nana*).

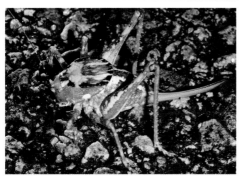

108. Ovate Shield-back Katydid (*Aglaothorax ovata*).

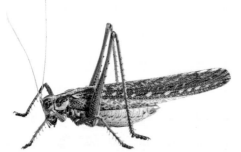

109. Brown-winged Shield-back (*Capnobotes fuliginosus*).

▶ 110. CREOSOTE BUSH KATYDID *Insara covilleae*

ADULT: Slender (BL to wing tips 28–30 mm); color basically green, fore wings marked with a series of oblique light-green bars; pearly blotches on sides of the prothoracic shield. This is a graceful insect that lives on Creosote Bush *(Larrea tridentata)* in the desert. Its broken pattern and green color provide camouflage amid the dissected leaves of the plant, similar in color to the Creosote Bush Grasshopper **(100)**.

RANGE: Restricted to desert areas of the southeastern part of the state.

▶ 111. MORMON CRICKET *Anabrus simplex*

ADULT: Very large, robust (BL 18–50 mm), flightless; usually brown but color varies from green, gray, brown to black, in some individuals with red or purple hues.

EGGS: White, elongate 7–8 mm long.

HABIT: Feed on a variety of grasses and shrubs and is occasionally predaceous. Though flightless, walking swarms may form. When swarming, they can cause a significant amount of crop damage.

SONG: While not a true cricket, the male does produce a cricketlike chirp.

RANGE: In the eastern Sierra Nevada from about Inyo County north and in the northwest to the eastern Cascade Range.

Camel Crickets (Family Rhaphidophoridae)

Most rhaphidophorids live on the ground or in burrows. All are pale or dull, usually brown-colored and resemble katydids in having long antennae, legs, and body form. They differ by lacking wings and are silent. The auditory organs on the forelegs are absent. Although most species are ground-dwellers, a few occur in trees. All are nocturnally active, and many are rarely seen during the day.

▶ 112. CALIFORNIA CAMEL CRICKET *Ceuthophilus californianus*

ADULT: Body arched or "hump-backed" (BL 15–25 mm); yellowish to reddish brown; hind tibia of both sexes stout and straight.

HABIT: Common in moist grasslands, where it lives in underground burrows, gopher holes, under stones, boards, and the like.

RANGE: Generally distributed at lower and middle elevations.

▶ 113. SAND TREADERS *Macrobaenetes* spp.

ADULT: BL 20–25 mm; conspicuous large bristles on the hind tibiae that form a basket for pushing sand, adapting them for a burrowing life on desert and coastal dunes.

RANGE: Coastal and desert sand dunes throughout the state.

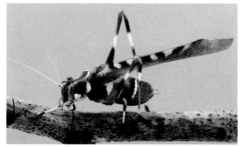

110. Creosote Bush Katydid (*Insara covilleae*).

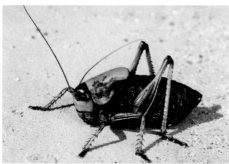

111. Mormon Cricket (*Anabrus simplex*).

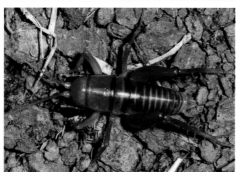

112. California Camel Cricket (*Ceuthophilus californianus*).

113. Sand Treader (*Macrobaenetes algodonensis*).

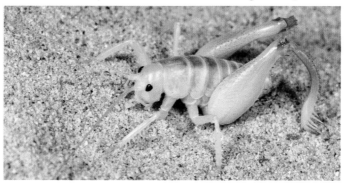

▶ **114. MUSHROOM CAMEL CRICKETS** *Pristoceuthophilus* spp.

ADULT: BL 15–20 mm; males have noticeably bowed hind tibiae and roughened or tuberculate areas on the back of the abdomen.

HABIT: They are sometimes destructive in commercial mushroom plantings.

RANGE: Common throughout the state.

▶ **115. CHAPARRAL CAMEL CRICKETS** *Gammarotettix* spp.

ADULT: BL 10–18 mm, brownish gray, and often maculate.

HABIT: In California commonly found on shrubs, oaks, and other trees.

RANGE: Common throughout the state.

Jerusalem Crickets (Family Stenopelmatidae)

▶ **116. JERUSALEM CRICKETS
OR POTATO BUGS** *Stenopelmatus* spp.

No other California insect inspires such awe. Its large size (BL up to 50 mm), spiny legs, giant jaws, and more than anything its oversized, foreboding, humanoid bald head give rise to fear that it is dangerous and even a demon. Also known as Woh-tzi-Neh ("Old Bald-Headed Man") and "Niña de la Tierra" ("Child of the Earth"). It is not poisonous and except for possibly biting when mishandled, these are harmless native insects, most commonly encountered by gardeners when turning the soil in spring.

ADULT: Generally tan; abdomen bulbous with black segmental rings; wingless; eyes small.

HABIT: Burrows in soil, feeding on roots, tubers, and the occasional insect. May wander aboveground at night, especially on wet nights in winter and so are a favorite snack for many owls.

RANGE: Widespread in state. There are many similar species in California. This genus is restricted to western North America.

True Crickets (Family Gryllidae)

Crickets are the virtuosos among insect singers. Their melodious trilling and chirping, part of courtship, are produced like the notes of katydids, by stridulation of roughened veins at the bases of the fore wings. In crickets only the males sing.

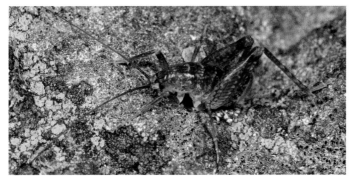

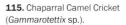

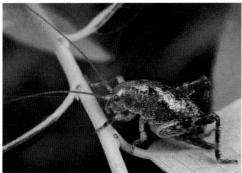

114. Mushroom Camel Cricket (*Pristoceuthophilus* sp.).

115. Chaparral Camel Cricket (*Gammarotettix* sp.).

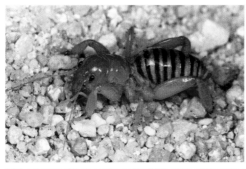

116. Jerusalem Cricket (*Stenopelmatus* sp.).

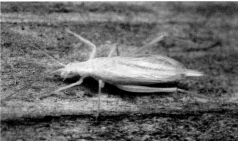

117. Tree Cricket (*Oecanthus* sp.).

◄ 117. TREE CRICKETS *Oecanthus* spp.

Tree crickets are quite different from field crickets. Instead of having the cylindrical, robust, heavy, darkly pigmented form found in field crickets, their bodies are frail, pale green, yellowish brown, or white, translucent; the males, with their greatly expanded wings, appear rather flattened. There are several species, distinguishable only by details of markings and song.

ADULT: Medium-sized (BL 10–15 mm); male broad, with flattened, transparent wings; female cylindrical, wings folded down sides of body.

SONGS: Varying series of rolling chirps ("treet-treet-treet") or continuous, soft trill. Usually call from shrubs or trees on warm nights. Because the pitch and frequency of chirps are a function of temperature, *Oecanthus* are also called "thermometer crickets."

RANGE: Throughout the state but very uncommon in desert habitats.

► 118. FIELD CRICKETS *Gryllus* spp.

Common native crickets of fields and grasslands.

ADULT: Medium-sized (BL 15–30 mm); dark brown to black; usually solid-colored but sometimes with light markings on wings.

SONG: Intermittent, shrill trill.

HABIT: During certain years population explosions of this species may occur, and plague levels may cause heavy crop losses. During such times, following summer thunderstorms, thousands of crickets may congregate around lights at gas stations, restaurants, and the like, and constitute a considerable nuisance. Normally individuals live under objects on the ground and feed on native herbaceous plants.

RANGE: Ubiquitous.

► 119. HOUSE CRICKET *Acheta domesticus*

ADULT: BL 16–21 mm; light brown color, distinct banded head.

HABIT: In the north they are probably only in close association with humans, typically indoors. They are widely used as a food source for animals in the pet trade.

RANGE: An introduced insect that is much more rarely encountered in California than field crickets. It is established outdoors only in southern California, and there are scattered records as far north as San Francisco in human association.

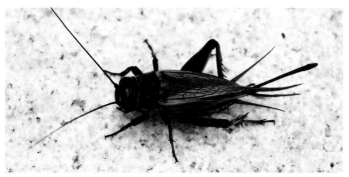

118. Field Cricket
(*Gryllus* sp.).

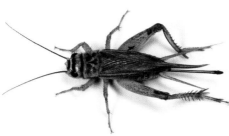

119. House Cricket
(*Acheta domesticus*).

120. Ant Cricket
(*Myrmecophila oregonensis*).

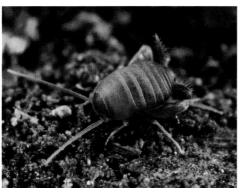

121. Southern Mole Cricket
(*Neoscapteriscus borellii*).

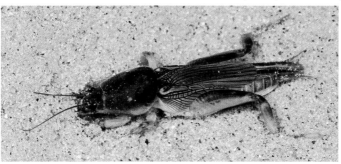

Ant Crickets (Family Myrmecophilidae)

◀ 120. ANT CRICKET *Myrmecophila oregonensis*

This is one of a variety of insects whose lives are spent as "guests" in social insect colonies.

ADULT: Wingless, very small (BL 2–3 mm); brown or gray.

HABIT: Found in and near the entrance of the nests of various species of ants, under bark of stumps and logs, or under boards and rocks on the ground. Apparently this insect feeds on the host's food and secretions.

RANGE: Widespread, especially in arid habitats.

Mole Crickets (Family Gryllotalpidae)

◀ 121. SOUTHERN MOLE CRICKET *Neoscapteriscus borellii*

ADULT: BL 25–32 mm; pale or dark brown or pinkish brown; heavily built, cylindrical; front legs modified for digging.

SONG: Males produce a sustained ringing trill amplified from a horn-shaped burrow.

HABIT: Burrowing in wet or moist, sandy or mucky soils in open areas such as fields and lawns. Mostly carnivorous but extensive burrowing can cause significant damage to lawns and ornamental plants.

RANGE: Introduced from the Neotropics into the eastern United States and has progressively moved westward. Currently established in Los Angeles County.

Walking Sticks (Order Phasmida)

Walking Sticks are large insects that in California are wingless, elongate, and cylindrical. They possess well-developed mandibles for chewing, like those of jumping Orthoptera, and feed on plants. The legs are all similar and are widely spaced. The ovipositor is small and mostly concealed by an enlargement of the abdominal underside. Slow, jerky movement and the body form mimicking twigs make these insects difficult to find in nature. There are only a few species in California, whereas in the tropics the group can be quite diverse and prominent, with many species reaching over 300 mm in length, including some that can fly, rendering a rather impressive sight. There are multiple parthenogenetic (female only) species in the group.

▶ 122. WESTERN SHORT-HORNED
WALKING STICK *Parabacillus hesperus*

ADULT: BL 60–90 mm; antenna much shorter than front femur; light brown; smooth-bodied.

HABIT: Feeds on grasses and soft shrubs such as burroweed *(Haplopappus)* and desert mallow *(Sphaeralcea).* Typically found sparsely throughout spring, summer, and fall. Can be attracted to lights at night.

RANGE: Known from widely scattered California localities; more abundant toward the south, particularly in the southern foothills and mountain ranges, including deserts.

GRAY WALKING STICK *Pseudosermyle straminea*

This similar looking species is easily distinguished from the preceding species by antennae that are longer than front femur; usually light gray, occasionally with a pink or yellow cast; thorax spiny, roughened, or ridged lengthwise, especially in female.

ADULT: BL 40–75 mm.

HABIT: On grasses and various desert shrubs.

RANGE: Arid portions of southern California, at low elevations.

▶ 123. INDIAN WALKING STICK *Carausius morosus*

ADULT: BL 80–100 mm; antenna much shorter than front femur. Easily distinguished from other species by prominent red patches at base of forelegs **(123 inset)**, after which those legs flare more broadly; body color ranges from light green to dark brown; body smooth, relatively thick.

HABIT: This parthenogenetic species hails from southern India but is easily reared and has been spread as lab stock and as classroom pets. It has naturalized recently in many parts of the state, occasionally reaching pest status on ornamentals. It is somewhat surprising that this tropical species is tolerant of the cold and drought typical of coastal California (it has also invaded Great Britain and South Africa), suggesting that even tropical species thought to be harmless can become invasive in California. On various plants including ivy and blackberry.

RANGE: Widespread along the coast from the Mexican border to the San Francisco Bay Area, especially in cities. Probably still spreading.

▶ 124. TIMEMAS *Timema* spp.

ADULT: Small (BL less than 35 mm); atypical walking sticks, having stout bodies and short legs; green, brown, or pinkish-tan forms are known, even in the same species. Many species are difficult to differentiate.

HABIT: Run actively when disturbed and secrete an unpleasant odor. Live on shrubs and trees, where they may be abundant in spring and early summer. This peculiar group has been the subject of long-standing evo-

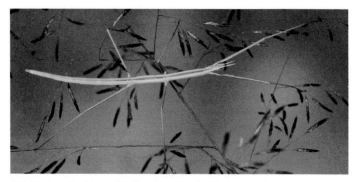

122. Western Short-horned Walking Stick (*Parabacillus hesperus*).

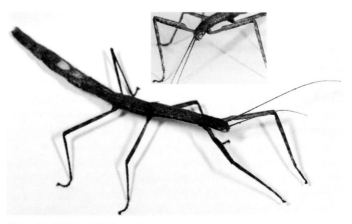

123. Indian Walking Stick (*Carausius morosus*) red femora (inset).

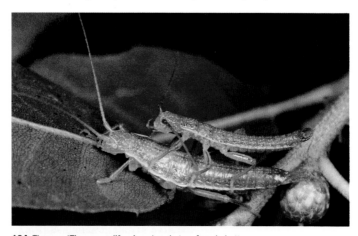

124. Timema (*Timema californicum*) male top, female bottom.

lutionary research into the nature and process of speciation, and includes parthenogenetic species. Different populations are thought to specialize on particular host plants in the same area, which is presumed to have led to cases of in situ speciation.

RANGE: There are around 15 species in the state, including some endemic to particular mountain ranges. They are characteristic members of the chaparral and oak woodland communities and occur in many areas with suitable habitats, including the coastal fog belt and foothill areas. Absent from the Central Valley and low desert.

Webspinners (Order Embiidina)

Webspinners are small, elongate, flattened insects that live in silken galleries among grass roots under rocks, in leaf litter, and similar habitats. Silk is produced from glands in the greatly swollen front legs. Females are wingless, while males in many species are fully winged. Embiids are easily recognized by their distinctive body form with widely spaced, short legs and by their ability to run backward. The wings, when present, are flexible, enabling reverse movement in the galleries, and their flight is weak and reminiscent of termites in flight.

A great diversity of webspinners occurs in tropical regions. Only four species are known in California, three of them introduced from the Mediterranean region. All are scavengers, eating decayed plant matter.

Family Oligotomidae

▶ **125. PINK WEBSPINNER** *Haploembia tarsalis*
ADULT: BL 8–11 mm; wingless, soft-bodied, typically pale with a faint, mottled pattern of reddish brown on the back that renders a pink appearance, but color varies considerably from blackish to reddish brown to pale amber.
HABIT: This introduced species has been known in California from colonies of asexual females since before the turn of the 20th century. Colonies are easily recognized by the extensive silk trackways running through grass roots at the edges of stones, under boards, and in dry cow chips.
RANGE: The most widespread and commonly encountered embiid in California, inhabiting grassy areas from the northern end of the Central Valley southward, throughout foothill areas of the Sierra Nevada and the Coast Ranges.

BICOLORED WEBSPINNER *Haploembia solieri*

Remarkably, a sexually reproducing colony was discovered at Redwood City in the 1980s that is now recognized as a second species.

ADULT: Form and size as in the Pink Webspinner, though usually on the large end of the range, but typically with a dark, nearly black middle and hind thorax and abdomen, dark head, and contrastingly paler orange prothorax and forelegs.

RANGE: This sexually reproducing species was introduced from Europe and is found from Redwood City south to Coyote Valley in the San Francisco Bay Area.

▶ **126. BLACK WEBSPINNER** *Oligotoma nigra*

ADULT: BL 6–10 mm; female blackish brown; male uniformly pale brown to dark brown including wings; cerci at the tip of his abdomen, two-segmented, similar in form.

NYMPH: Tan to brown.

HABIT: The species is common around trunks of palms and in other habitats and is believed to have been introduced with date palm cuttings from Egypt in the 1890s.

RANGE: Widely established in deserts and coastal portions of southern California, where the males often are attracted to lights.

Family Anisembiidae

RED WEBSPINNER *Chelicerca rubra*

This is the only native embiid in California. Colonies usually occur under stones on well-drained, grassy slopes with cactus and other xeric plants. The males are believed to disperse in the daytime.

ADULT: Small (BL 5–7 mm), red; male winged, with terminalia and head black; cerci at the tip of his abdomen dissimilar, the left is one-segmented, curved.

NYMPH: Pale red-brown.

RANGE: Near the coast in San Diego County, through desert margins north to Tehachapi.

Earwigs (Order Dermaptera)

Earwigs are nocturnal, terrestrial insects that seek out relatively moist secluded places, such as cracks in the soil and under boards or other

refuse around human habitations. They are somewhat flattened, elongate, with incomplete metamorphosis, a tough, shiny integument, and well-developed, movable forceps at the tip of the abdomen, which are used for defense, mating, and grasping prey. Despite folklore, they are not used for entering people's ears; only a disoriented earwig would attempt such a maneuver. The adults may be winged or wingless. When present, the fore wings are short and leathery and cover all but the tips of the large, membranous hind wings, which are folded radially when at rest. The large, spherical eggs are laid in clusters and are guarded by the mother. Of the 10 species known in California, all but one are introduced from other parts of the world. These earwigs have been spread around the planet as an unintended result of global trade.

Family Forficulidae

▶ 127. EUROPEAN EARWIG *Forficula auricularia*

Although this introduced species is now the most abundant earwig in California, it was not known in the state until 1923.

ADULT: Medium-sized (BL 12–22 mm); mostly brown with pale fore wings and antennae; forceps much larger and more widely spaced in male.

HABIT: The immatures and adults feed on a wide variety of substances—from flowers and green foliage near the ground to living and dead insects, including aphids. They are generally considered pests due to the damage they cause to plants, including fruits and flowers. Populations in lawns can reach extremely high numbers.

RANGE: Distributed across the United States. Widely distributed from San Diego to the Oregon border throughout low to moderate elevations, especially in association with humans. Less common in very dry areas.

Family Labiidae

▶ 128. TOOTHED EARWIG *Vostox apicedentatus*

This species is the only native earwig in California.

ADULT: Small (BL 8–12 mm); fully winged, reddish brown; forceps in male possess a conspicuous subapical tooth. Most commonly found in dead cactus, yucca, and rotting wood of other desert plants, where some moisture remains.

RANGE: Southern California coastal areas, margins of the Mojave Desert, and in the low deserts.

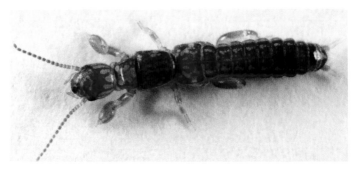

125. Pink Webspinner (*Haploembia tarsalis*).

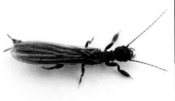

126. Black Webspinner
(*Oligotoma nigra*).

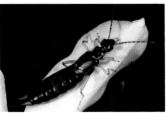

127. European Earwig
(*Forficula auricularia*).

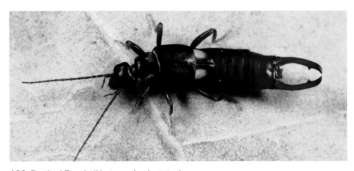

128. Toothed Earwig (*Vostox apicedentatus*).

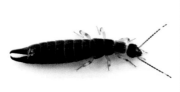

129. Ring-legged Earwig
(*Euborellia annulipes*).

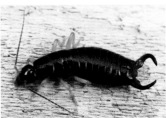

130. Maritime Earwig
(*Anisolabis maritima*).

Family Anisolabididae

◀ 129. RING-LEGGED EARWIG *Euborellia annulipes*

ADULT: Medium-sized (BL 15–17 mm), wingless species that has pale legs ringed with dark brown. General feeder on plant and insect matter.

RANGE: Established around Los Angeles at least since the early 1880s (which may be the earliest records for North America) and spread through the central part of the state since the turn of the 20th century, becoming abundant in the San Francisco Bay Area, in addition to urban southern California; this earwig is apparently less common, but long present, throughout the Central Valley and Inland Empire. This species has been spread around the world by human activity.

AFRICAN EARWIG *Euborellia cincticollis*

A closely related species that since its discovery at Blythe in 1946 has spread rapidly through the arid parts of California, including the Central Valley. They are general feeders and, along with the Ring-legged Earwig, are the commonest earwigs in southern California.

ADULT: Small to medium-sized (BL 9–15 mm); dark brown with pale legs and dark antennae having the third and fourth preapical segments pale.

RANGE: Desert regions, including the Central Valley. Apparently replaced by the Ring-legged Earwig in coastal areas.

◀ 130. MARITIME EARWIG *Anisolabis maritima*

ADULT: Large (BL 25–30 mm) wingless with a shiny brown to black body, discerned from the preceding species by long uniformly dark antennae and pale yellow legs lacking any other markings. Asymmetrical forceps in the male, straight in female and young.

HABIT: Female not only guards her eggs but also provisions nymphs with food after hatching, significantly increasing their survival. This species tends to be more predaceous than other earwigs, enjoying crickets, sand fleas, and other invertebrates that cohabit the coast.

RANGE: First recorded in Orange County in the 1920s, it spread sporadically along the coast; as the name implies, this species inhabits the high tide zone along the entire Pacific coastline of the state, including urban areas. Though there are few records north of the San Francisco Bay Area, it should be expected throughout, hiding under beach debris. It is thought to be Asian in origin and quickly spread globally with human transport.

Barklice, Booklice, and Parasitic Lice (Order Psocodea)

The order Psocodea, sometimes treated as a superorder, includes both free-living and parasitic species. All are small to tiny, many are flightless. While the many species of barklice that are common and abundant in natural habitats go unnoticed, the booklice and parasitic lice, despite their small size, tend to draw attention because of their close and usually unwanted association with people.

The free-living insects in the group are called "lice" because of their louselike appearance. Although small and soft-bodied, they frequently have wings; they live on tree trunks or foliage, under bark or stones, where they feed on molds, pollen, and a variety of organic matter. When in large numbers, some free-living species can be pests in houses, in stored foods, or around pet areas.

Barklice (Suborder Psocomorpha)

A structural feature readily identifying the group is the swollen or bulbous area on the front of the head between the widely spaced antennae. The California species are incompletely classified but at least 50 species are recorded.

Stout Barklice (Family Peripsocidae)

▶ **131. BRIGGS' PSOCID** *Ectopsocus briggsi*
This common species is a typical outdoor psocid.
ADULT: BL about 2 mm; wings transparent, with few veins and small brown spots.
HABIT: Common on the leaves of many kinds of trees. Gregarious, groups of adults and young living under a frail web spun by the adult from glands opening on the lower lip.
RANGE: Generally in counties along the California coast.

Chewing Bird and Mammal Lice

Members of the suborders Amblycera and Ischnocera are called chewing lice or bird lice because they are external parasites of vertebrates, princi-

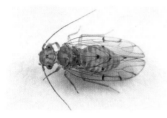

131. Briggs' Psocid
(*Ectopsocus briggsi*).

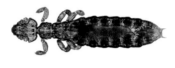

132. Guinea Pig Louse
(*Gliricola porcelli*).

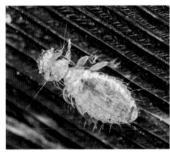

133. Chicken Body Louse
(*Menacanthus stramineus*).

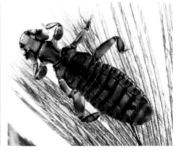

134. Large Duck Louse
(*Trinoton querquedulae*).

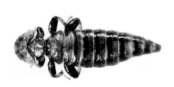

135. Pelican Pouch Louse
(*Piagetiella bursaepelecani*).

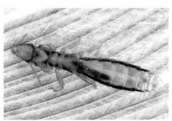

136. Slender Pigeon Louse
(*Columbicola columbae*).

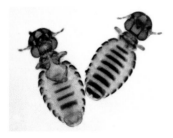

137. Livestock Biting Lice (*Bovicola* sp.)
ventral view left, dorsal view right.

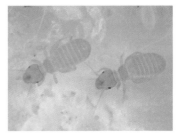

138. Cereal Psocids
(*Liposcelis bostrychophila*).

pally birds. While some make mammals their hosts, none are parasites of humans. These wingless lice are distinguished from sucking lice (Anoplura) by possessing chewing, mandibulate mouthparts. Food of chewing lice consists of feathers or fur and the outer layer of skin. Because most of the included species tend to be fairly host-specific, and as we have an extensive avifauna, California has a large number of species (at least 170).

Suborder Amblycera

Family Gyropidae

◀ 132. GUINEA PIG LOUSE *Gliricola porcelli*
ADULT: Small (BL 1–1.2 mm); body slender; head triangular, antennae fitting into notches on sides; claws of legs greatly reduced; hind two pairs of legs with tibiae and femora curved and grooved, with opposing movement for clasping hairs.
HABIT: Remain close to skin, clinging to a single hair.
HOST: Guinea Pig only, not found on native mammals.
RANGE: Wherever Guinea Pigs are kept in captivity.

Family Menoponidae

◀ 133. CHICKEN BODY LOUSE *Menacanthus stramineus*
ADULT: BL 2–2.5 mm; slender with broad abdomen; head triangular; antennae small and hidden; abdominal segments with two transverse rows of hairs; straw yellow (dark spots from food in intestine).
HABIT: Often develops very large populations (35,000 on a single bird). Favors portions of skin not densely feathered, especially below vent. Although these lice do not suck blood, they result in a nervous condition of infested birds that prevents sleep, causes loss of appetite, emaciation, and reduction in number of eggs laid. Young birds brooded by lousy hens are often killed by lice swarming to them.
HOST: Common and most injurious louse on chickens and other poultry species.
RANGE: Widespread, wherever chickens or turkeys are housed.

◀ **134. LARGE DUCK LOUSE** *Trinoton querquedulae*
ADULT: 3–4 mm; elongate, robust, dark brown.
HOST: Found on a wide variety of duck species.
HABIT: As a bit of a twist, these parasites are known to carry Myialginae mites, hyperparasites of the lice.
RANGE: Found wherever their hosts fly.

◀ **135. PELICAN POUCH LOUSE** *Piagetiella bursaepelecani*
ADULT: Large (BL 4–5 mm); body elongate; dark brown, nearly black laterally; head broad, hiding small antennae.
HOST: This louse inhabits the inside of the pouch of the Brown Pelican and is apparently host specific (a distinct species occurs on the White Pelican).
RANGE: Coincides with range of host, entire coast.

Suborder Ischnocera

Family Philopteridae

◀ **136. SLENDER PIGEON LOUSE** *Columbicola columbae*
ADULT: BL 2.1–2.6 mm; very slender; antennae large and exposed.
HOST: Restricted to pigeons and related birds.
RANGE: Widespread, where pigeons fly.

Family Trichodectidae

◀ **137. LIVESTOCK BITING LICE** *Bovicola* spp.
ADULT: Small (BL 1–2 mm); head circular in outline; antennae large and exposed; abdomen with distinct transverse bands.
HABIT: Several species in this genus parasitize mammals, including domestic livestock. When excessively abundant they may cause a kind of mange and severe irritation to the host's skin.
HOST: Cattle, horses, goats, dogs, deer, and the like.
RANGE: Widespread, wherever livestock are raised.

Booklice (Suborder Troctomorpha)

Family Liposcelididae

◄ 138. CEREAL PSOCID *Liposcelis bostrychophila*

ADULT: Tiny (BL less than 1 mm); wingless; white or brown; hind femur enlarged.

HABIT: This is one of several domestic psocopterans. Individuals are common inhabitants of homes and buildings where they appear as minute, pale brown specks moving over paper, windowsills, wallpaper, or other surfaces. Feeds on and may damage organic matter of all kinds (cereal products, wallpaper and bookbinding pastes, dead insects), especially if slightly damp; it is not clear whether their primary food is molds on these materials or the substances themselves.

RANGE: Urban areas.

Sucking Lice (Suborder Anoplura)

The suborder Anoplura is distinguished from the chewing or bird lice by mouthparts formed of long, needlelike stylets adapted for sucking blood. Sucking lice are wingless, external parasites of mammals including humans, who harbor two species all our own. Anoplura has fewer species (around 40 in the state) than the chewing lice because of the smaller number of hosts.

Family Pediculidae

▶ 139. HUMAN LOUSE *Pediculus humanus*

ADULT: Small (BL 1.5–3 mm); grayish white; elongate oval with greatly swollen abdomen in blooded specimens. There are two forms recognized: the **Human Head Louse (P. humanus capitis) (139)** infests the head and tends to be smaller and with proportionately heavier legs than the Human Body Louse (*P. humanus humanus*), which primarily locates itself under the clothing on the body. It can act as a vector of epidemic typhus and has led to disease and death for millions of people in historical times.

EGGS ("NITS"): White, attached firmly to the hairs.

HOST: Humans.

RANGE: Usually the Human Body Louse is limited locally to people practicing poor hygiene, but Human Head Lice frequently have outbreaks

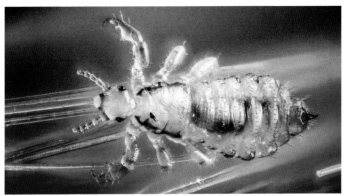

139. Human Head Louse
(*Pediculus humanus capitis*).

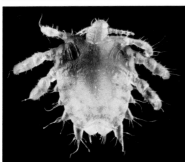

140. Crab Louse (*Pthirus pubis*).

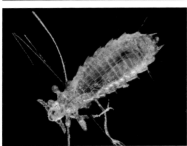

141. Spiny Rat Louse (*Polyplax spinulosa*).

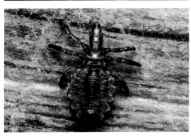

142. Livestock Sucking Louse
(*Haematopinus suis*).

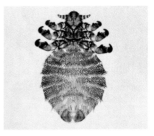

143. Seal Louse
(*Echinophthirius horridus*).

among schoolchildren where head contact and sharing personal items is common.

Family Pthiridae

◀ **140. CRAB LOUSE** *Pthirus pubis*
ADULT: BL 1.5–2 mm; body triangular, abdomen tapering posteriorly with short side lobes, short and broad, having large legs with very heavy claws (crablike)—features that readily distinguish it from the Human Louse.
HABIT: This nuisance (not known to transmit diseases) inhabits the hairs of the pubic region almost exclusively.
HOST: Humans. Transmitted by close contact, most commonly during sexual activities, rarely by sharing bedding, clothing, or towels.
RANGE: Wherever poor hygiene accompanies sexual activity among humans.

Family Polyplacidae

◀ **141. SPINY RAT LOUSE** *Polyplax spinulosa*
ADULT: Small, slender (BL 1 mm); pale white, with conspicuous transverse back plates bearing large bristles; antennae arising near anterior end of the head.
HOST: On native as well as domestic rats and mice.
RANGE: Widespread; wherever rats breed.

Families Haematopinidae and Linognathidae

◀ **142. LIVESTOCK SUCKING LICE** *Haematopinus* **spp.,**
 Linognathus **spp.**
ADULT: Large for lice (BL 2–6 mm); head elongate with protuberance behind the antenna (*Haematopinus* **spp. [142]**) or short and without head lobe (*Linognathus* spp.); abdomen of latter also covered with dense rows of long bristles as opposed to only scattered bristles on former.
HABIT: These genera, in parallel to livestock biting lice (*Bovicola* spp. **[137]**), form a complex of species on domestic mammals.
HOST: Cattle, horses, hogs, dogs, and the like. Located mostly in the ears and folds of the skin, sometimes causing severe irritation.
RANGE: Wherever hosts occur.

Family Echinophthiriidae

◄ **143. SEAL LOUSE** *Echinophthirius horridus*
ADULT: BL about 3.5 mm; heavily pigmented, brown; densely covered with scalelike bristles.
HABIT: Several kinds of sucking lice infest marine mammals off the California coast. Valves that close breathing pores prevent the lice from drowning when the host is in the water.
HOST: Seals, especially the Harbor Seal.
RANGE: Congruent with hosts' range.

True Bugs, Hoppers, Aphids, Scales, and Other Bugs (Order Hemiptera)

Hemiptera is the fifth largest order of insects, and it includes a great diversity of forms. All possess tubular, beaklike mouthparts, adapted for piercing and sucking fluids. Most have two pairs of wings in the adult, while some are seasonally or always wingless. There are three suborders (treated by some as orders): Heteroptera (true bugs) in which the apical part of the fore wing is membranous and the remainder usually thicker and leathery; Auchenorrhyncha (cicadas, hoppers), and Sternorrhyncha (aphids, scale insects, mealybugs) where in both the fore wing, when present, is uniform in consistency, and often quite similar to the hind wing. The metamorphosis is gradual; nymphs resemble the adults except for lacking wings, though they often have small wing buds in later nymphal stages, and they usually pass through four or five stages (instars). The last instar in male scale insects and whiteflies is immobile and appears quiescent. It is often called the pupa, owing to its resemblance to the pupa of holometabolous insects. The California fauna probably contains more than 2,000 described species, but there is no accurate estimate.

True Bugs (Suborder Heteroptera)

The true bugs are most reliably recognized by the form of the wings, although adults of a few species are short-winged or wingless. The fore wings are thickened, often brightly colored, leathery in consistency, with membranous tips; the hind wings are membranous, fanlike, and fold under the fore wings when at rest. When the wings are folded, the membranous portions of the fore wings overlap, and with the dissimi-

lar basal parts, form a characteristic "X" on the back, by which nearly all Heteroptera can be recognized. Many true bugs are aquatic or semi-aquatic, living in the water, on its surface, or at wet margins of ponds and streams; practically all of these are predaceous on other small animals. The great majority of species are terrestrial, living on plants, where most are herbivorous and a few are predaceous. A very few are bloodsucking parasites of mammals or birds. The suborder Heteroptera includes species exhibiting a great diversity of size, color, structural modifications, and habitat preferences. More than 600 species are known in California.

Stink Bugs (Family Pentatomidae)

Pentatomids are among the most easily recognized true bugs because of their fairly consistent five-sided outline. The triangular scutellum is large, extending about half the length of the wings, and is narrowed apically. Most species are moderately large. They may not be easily seen on plants, but their presence is often noticed by a characteristic, powerful odor from a fluid ejected from ventral thoracic glands when the bugs are disturbed. These bugs are fairly strong fliers but primarily rely on cryptic coloration and sedentary behavior to escape detection. The majority are plant feeders, but species of one subfamily are predaceous on other insects. About 50 species occur in California, representing a diversity of colors, forms, and habitats.

▶ **144–145. GREEN STINK BUGS** *Chlorochroa* spp.

Two species of this genus are among the largest and most often seen of California's pentatomids.

▶ **144. SAY'S STINK BUG** *Chlorochroa sayi*

ADULT: BL 10–15 mm; bright to dark green, with variable amounts of white speckling on the back, the tip of the scutellum, and three spots at its base, pale yellow or white.

NYMPH: Variable, pale to dark green with orange markings.

HABIT: The bugs are found on a wide variety of plants, including wheat, alfalfa, and other field crops, where their feeding sometimes causes damage.

RANGE: East of the Sierra Nevada, desert areas, coastal southern California, and the Central Valley.

▶ **145. CONCHUELA** *Chlorochroa ligata*

This is similar in appearance and range but is larger and dark olive green with a narrow marginal border and the tip of scutellum red or orange.

ADULT: BL 12–16 mm.

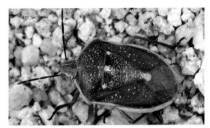

144. Say's Stink Bug
(*Chlorochroa sayi*).

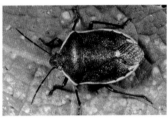

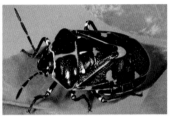

145. Conchuela
(*Chlorochroa ligata*).

146. Harlequin Cabbage Bug
(*Murgantia histrionica*).

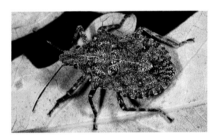

147. Rough Stink Bug
(*Brochymena sulcata*).

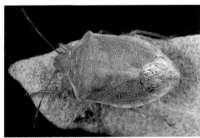

148. Western Red-shouldered Plant
Bug (*Thyanta pallidovirens*).

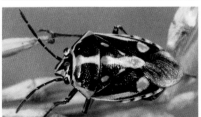

149. Bagrada Bug (*Bagrada hilaris*).

NYMPH: Gray with red markings.

HABIT: Nymphs are often gregarious, living in compact colonies. The species is sometimes injurious to a variety of crops.

◄ 146. HARLEQUIN CABBAGE BUG *Murgantia histrionica*

ADULT: BL 7–11 mm; brightly colored, black with variable orange or red markings.

EGGS: White with conspicuous black rings; deposited in clusters, resembling miniature white barrels with black hoops.

NYMPH: Shining black with conspicuous white, yellow, and orange markings. All stages live on plants of the mustard family and may be found throughout the year in warmer parts of the state.

RANGE: Lower-elevation areas throughout California.

◄ 147. ROUGH STINK BUGS *Brochymena* spp.

ADULT: Large (BL 12–18 mm); brownish gray with a roughened surface and strongly angulate outline.

RANGE: Throughout most of the state, at low to moderate elevations.

HABIT: Members of the genus are most often found on trees and shrubs, where they are predaceous on soft-bodied insects. Rough stink bugs often occur in orchards of central and southern California, where they are regarded as a beneficial insect because both nymphs and adults prey on caterpillars and other pests.

RANGE: The Rough Stink Bug *(B. sulcata)* is the most common species in the Sierra Nevada, the Central Valley, and the Coast Ranges.

◄ 148. WESTERN RED-SHOULDERED
PLANT BUG *Thyanta pallidovirens*

ADULT: BL 8–11 mm; variable color, reddish brown to bright green, often with a distinct red band across the thorax.

HABIT: Common on a wide variety of grains, flowers, field crops, and shrubs.

RANGE: Throughout most of the state, up to 1,800 m elevation in the Sierra Nevada.

◄ 149. BAGRADA BUG *Bagrada hilaris*

ADULT: BL 5–8 mm; black bugs that are boldly patterned with orange or yellow spots on white areas or lines, often mostly white on the underside.

HABIT: Bagrada bugs can be a significant pest on cabbage, broccoli, and similar crops. Many individuals can be found on a single plant, and the group typically includes all life stages. Adults in these groups are easy to locate as they are commonly observed copulating.

RANGE: An invasive species native to southeastern Africa that has been established in California at least since 2008. Still more common in southern California but known as far north as Yolo Country.

Black Bugs (Family Thyreocoridae)

▶ **150. COMMON BLACK BUGS** *Corimelaena* **spp.**

ADULT: Small (BL 3–5 mm); shining black, sometimes with white, yellow, or orange lateral marks at the base of the wings. The back is almost covered by the greatly enlarged, strongly convex scutellum.

HABIT: These bugs usually feed on plants of the nightshade family, including tomato, where they are occasionally encountered in large clusters.

RANGE: Throughout lower and middle elevations of the state except the deserts.

Shield Bugs (Family Scutelleridae)

Shield bugs differ from stink bugs in having the scutellum of the thorax greatly enlarged to form a broad, rounded shield that almost entirely covers the back and wings. About a dozen species are known in California. They are widespread and common in weedy fields but are often overlooked owing to their cryptic coloration and behavior.

▶ **151. COMMON SHIELD BUGS** *Eurygaster* **spp.**

ADULT: BL 7–12 mm; variable in color and markings; pale to dark brown, usually with distinct, longitudinal or triangular pale markings on the shield.

HABIT: Most commonly encountered in late spring when the bugs climb up onto drying grasses where they are easily collected in sweep nets.

RANGE: Coast Ranges and Sierra Nevada foothills, to about 2,000 m elevation.

Burrowing Bugs (Family Cydnidae)

As the common name implies, burrowing bugs are soil-dwelling bugs that use their modified legs for digging. They often feed on plant roots but also climb to feed and can be common at lights at night.

► **152. PEANUT BURROWING BUG** *Pangaeus bilineatus*
ADULT: BL 5–8 mm; shining black with heavily-built, spiny legs, noticeable pits scattered across the body, and a distinct impressed groove in the anterior-middle of the pronotum.

HABIT: Peanut Burrowing Bugs feed on various plants but can be significant pests on crops—for example, on peanuts in the eastern United States.

RANGE: Found in areas of loose, sandy soils where food plants grow across the state. Adults are sometimes found in caves feeding on plant roots. However, they are only visitors and not residents of the caves.

LEATHERY BURROWING BUG *Dallasiellus californicus*
Similar to the Peanut Burrowing Bug but larger and lacking the impressed groove on pronotum.

ADULT: BL 8–10 mm.

RANGE: Found in the southern part of the state, sometimes together with the Peanut Burrowing Bug. Typically inhabiting dry, sandy areas.

Leaf-footed Bugs (Family Coreidae)

Coreids are often brightly colored, with enlarged, flat, leaflike hind legs. They feed by piercing plant parts with their elongate beaks and sucking out the juices. Frequently they select fruits and are sometimes destructive to cultivated plants. More than 40 species are known in California, mostly from warmer parts of the state.

► **153. SQUASH BUG** *Anasa tristis*
ADULT: BL 12–17 mm; pale or dark brown with the margins of the abdomen that protrude beyond the wings alternately striped with orange or tan and brown.

NYMPH: The first nymphal stage is pale green with a pink tinge to its appendages and often covered with a whitish powder. Later instars have dark appendages and are generally darker gray or brown.

HABIT: This is a widespread, common, and often destructive insect. All stages feed on cucurbits, especially melons and squashes, but also wild gourds and manroots.

RANGE: Coastal areas, desert margins, the Central Valley, and the Sierra Nevada foothills.

► **154. WESTERN LEAF-FOOTED BUG** *Leptoglossus clypealis*
ADULT: Large (BL 16–19 mm); uniform brown with an irregular, narrow, white band across the middle of the wings, yellow marginal spots on the abdomen, and leaflike enlargements of the hind legs.

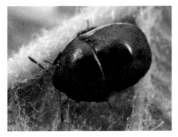

150. Common Black Bug
(*Corimelaena* sp.).

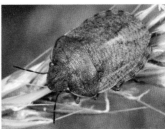

151. Common Shield Bug
(*Eurygaster* sp.).

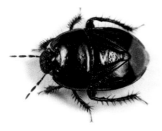

152. Peanut Burrowing Bug
(*Pangaeus bilineatus*).

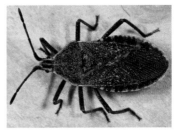

153. Squash Bug
(*Anasa tristis*).

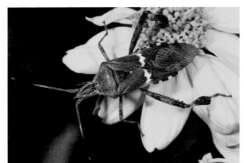

154. Western Leaf-footed Bug
(*Leptoglossus clypealis*).

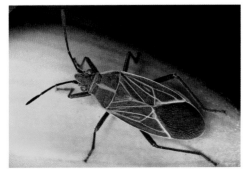

155. Western Box Elder Bug
(*Boisea rubrolineata*).

HABIT: Common on juniper and sometimes injures young green fruit in orchards and cotton fields. Occasionally enters homes during cold weather.

RANGE: Wide variety of habitats in lower-elevation deserts and the Central Valley.

Family Rhopalidae

◄ **155. WESTERN BOX ELDER BUG** *Boisea rubrolineata*

ADULT: Elongate (BL 9–13 mm); rather flat; gray to black with conspicuous red lines on the thorax and wings; abdomen bright red and conspicuous when the bugs are in flight.

NYMPH: Gray and bright red, becoming marked with black in later stages.

HABIT: This species is especially noticed in fall and winter when the adults often migrate into buildings for hibernation, and in early spring when large numbers emerge on the first warm days and swarm onto all kinds of plants. All stages normally feed on Boxelder *(Acer negundo)* and other maples, but sometimes they visit fruit trees and puncture developing fruit.

RANGE: Widely distributed in California north of the deserts, at low to moderate elevations.

▶ **156. RED-SHOULDERED BUG** *Jadera haematoloma*

ADULT: BL 9–14 mm; dark gray with brightly contrasting red eyes and lateral margins of the pronotum. Adults may be fully winged or short-winged.

HABIT: Often found in large aggregations on a variety of food plants such as soapberries and maples. While primarily plant feeding, they are known to also feed on a variety of foods, such as dead insects or even human food scraps. Sometimes they become a serious nuisance when they enter homes to form winter aggregations.

RANGE: From the Sierra Nevada foothills west to the coast for the length of the state.

Family Lygaeidae

Most lygaeids are dark-colored bugs, often with short wings, that live on and under plants and in other secluded spots where they feed on fallen seeds. Some species feed on green plant parts, and a few are brightly colored, warning predators of distastefulness acquired from milkweeds

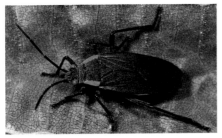

156. Red-shouldered Bug (*Jadera haematoloma*).

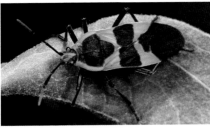

157. Large Milkweed Bug (*Oncopeltus fasciatus*).

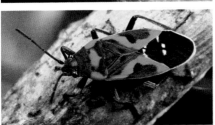

158. Common Milkweed Bug (*Lygaeus kalmii*).

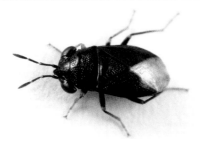

159. Big-eyed Bug (*Geocoris* sp.).

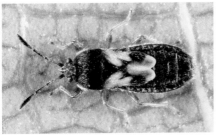

160. Hairy Chinch Bug (*Blissus leucopterus*).

upon which they feed. More than 70 species have been recorded in California.

◀ **157. LARGE MILKWEED BUG** *Oncopeltus fasciatus*

ADULT: Large (BL 10–15 mm) and slender; pale orange to bright red, with three large, black areas on the thorax and wings; underside has black spots; appendages black.

NYMPH: Bright red; often occurring in dense clusters.

HABIT: This bug is often used in laboratory experiments because it is easily reared in large colonies. In nature the adults and nymphs usually are restricted to milkweed, sometimes becoming abundant, especially late in the season when the seed pods are opening.

RANGE: Warmer parts of the state; deserts, the Central Valley, and coastal areas from San Francisco Bay southward.

◀ **158. COMMON MILKWEED BUG** *Lygaeus kalmii*

This is a smaller bug than the preceding species.

ADULT: BL 8–12 mm; head, thorax, and spots on abdomen velvety gray-black with abdomen and markings on the thorax and fore wings red; wing membranes black, each with a conspicuous median white spot and white lateral margins.

NYMPH: Red with black markings.

HABIT: Found on a wider variety of plants than the Large Milkweed Bug; sometimes large numbers aggregate in seed clusters of plants such as woody shrubs of the sunflower family.

RANGE: Throughout much of the state at a wide range of elevations; adults occur outside the range of milkweed.

Big-eyed Bugs (Family Geocoridae)

◀ **159. BIG-EYED BUGS** *Geocoris* **spp.**

ADULT: Small (BL 3–4 mm); large, protruding eyes; head, thorax, and abdomen are of about the same width; maybe pale tan or nearly white with black eyes or wholly black.

HABIT: Several species of this genus are common on the ground under a wide variety of low-growing weedy plants as well as in alfalfa fields and other truck crops. Probably most feeding occurs on fallen seed, but big-eyed bugs sometimes eat soft-bodied insects such as leafhopper nymphs and mealybugs.

RANGE: Throughout most of California.

Family Blissidae

◀ 160. CHINCH BUGS *Blissus* spp.

Several species occur or have been reported to have been introduced in California, including the **Hairy Chinch Bug** *(B. leucopterus)* **(160)**, which is found in the southern counties.

ADULT: Small (BL 3–5 mm); slender, black, with the base of the antennae and legs reddish or yellowish brown; wings either well developed, white with two median lateral spots, or short, covering only the base of the abdomen, brown with white tips.

NYMPH: Brown with a reddish-brown abdomen bearing dark spots but variable in color between instars. All stages feed on grasses, causing withering and drying of the plants by sucking the juices.

RANGE: Scattered occurrence where suitable host plants are cultivated, sometimes causing damage to lawns; and in warmer parts of the state, such as the Central Valley, southern California, and the San Francisco Bay Area. A native species, the Dune Chinch Bug *(B. mixtus)*, occurs on coastal grasses.

Stilt Bugs (Family Berytidae)

▶ 161. SPINED STILT BUGS *Jalysus* spp.

ADULT: BL 7–9 mm; light brown, often with a slight green or yellow tint; slender body with very thin, relatively long legs and antenna, the end of the antenna is an enlarged, darker segment; small spinelike projection from around the thoracic scent gland opening.

HABIT: Spined stilt bugs are typically insect egg predators, but they also can take some plant juices. They are commonly seen moving rather slowly on various plants.

RANGE: Throughout the state.

Bordered Plant Bug (Family Largidae)

▶ 162. BORDERED PLANT BUGS *Largus* spp.

These are conspicuous and common bugs in a wide range of habitats.

ADULT: Large (BL 13–17 mm); mostly black with lateral margins of the thorax and fore wings bright orange and with a variable amount of orange speckling over the wings.

NYMPH: Broadly oval, convex; bright metallic blue with a conspicuous, bright red spot at the base of the abdomen. Two effectively indistinguishable species are found in California, *L. californicus* and *L. cinctus*.

RANGE: West of the Sierra Nevada at low elevations and in southern California. Especially common in beach and coastal strand habitats in association with lupine.

Flat Bugs (Family Aradidae)

Aradids are broad, flattened insects that are adapted to living under bark of dead trees. Apparently, most species feed on wood-rot fungi, and both nymphs and adults are often found clustered together around bracket fungi on dead or living stumps and trees. About 30 species are known in California, and diligent collecting probably will reveal others.

▶ **163. COMMON FLAT BUGS** *Aradus* spp.

Most California aradids belong to this cosmopolitan genus.

ADULT: Small to moderately large (BL 4–11 mm); brown to blackish brown, mottled with tan or reddish brown; abdomen flared, more broadly so in female; thorax and abdomen sculptured with raised ridges; antennae short, thickened in some species; wings narrow, folded over middle of back.

NYMPH: Similar in outline, flatter with less sculpturing.

RANGE: Forested areas; often found on the bark of fallen conifers, frequently in association with wood-rot fungi, especially the nymphs.

Members of another genus, *Mezira,* are more abundant in the foothills, often forming aggregations of nymphs and adults under loose bark of oak.

ADULT: Medium-sized (BL 6–9 mm); black or dark brown; somewhat rectangular in outline; the abdomen not flared, not as ornately sculptured as *Aradus.*

RANGE: Throughout forested parts of the state.

HABIT: Found under bark of conifers and hardwoods, and sometimes adults fly to freshly stained wood.

Lace Bugs (Family Tingidae)

Members of the family Tingidae are small, flat bugs with the head and body hidden beneath a lacelike, rectangular shield, which consists of enlarged fore wings and expanded thorax. The nymphs look quite different, usually much darker and covered with spines. All stages live together

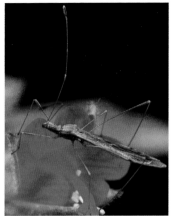

161. Spined Stilt Bug (*Jalysus* sp.).

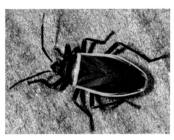

162. Bordered Plant Bug (*Largus* sp.).

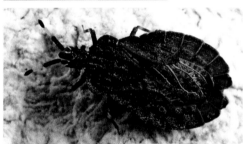

163. Common Flat Bug (*Aradus* sp.).

164. Common Lace Bug (*Corythucha* sp.).

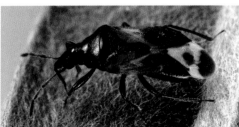

165. Minute Pirate Bug (*Anthocoris* sp.).

in colonies, often on undersides of leaves. Their feeding causes drying of the leaves, and a colony's presence is evidenced by characteristic pepper-like frass pellets stuck to the paler, affected areas.

◀ 164. COMMON LACE BUGS *Corythucha* spp.

ADULT: Small (BL 3–4 mm); white, yellowish, or pale greenish, sometimes mottled with brown.

HABIT: About a dozen species of this genus occur in California, each associated with a certain kind of native plant including Yerba Santa, various species of ceanothus, sycamore, sunflowers, walnut, alder, willow, and the like.

RANGE: Nearly throughout the state.

Pirate Bugs (Family Anthocoridae)

◀ 165. MINUTE PIRATE BUGS *Anthocoris* spp. (165), *Orius* spp.

Several species of these genera are common in California.

ADULT: Small (BL 2–4 mm); with an elongate, triangular head; black with a characteristic, white chevron pattern on the fore wings.

NYMPHS: Pink or salmon-colored; often render annoying, pin-prick bites when a person picks them up from a dense population in vegetation, such as alfalfa fields.

HABIT: They live on foliage and flowers where they are predaceous on aphids and other small insects.

RANGE: Throughout much of the state at low to moderate elevations.

Assassin Bugs, Kissing Bugs, and Ambush Bugs (Family Reduviidae)

Members of the family Reduviidae are typically oval or elongate bugs, often with long legs and antennae. The forelegs are used for catching prey, and sometimes are modified to be mantislike (raptorial). Reduviids have large, beadlike, protruding eyes. Many species are spiny or hairy. These hairs may bear sticky substances that collect bits of plant material and other debris that aid in prey capture and cryptic concealment of the bugs. Most species inhabit plants, are diurnal, and are slow fliers. They stalk their prey by slowly moving over vegetation or waiting at flowers. The victims, which include all kinds of insects, are snatched by quick movements of the forelegs and immediately subdued by a powerful venom injected through the beak. About 40 species are known in California, a few of which are nocturnal and normally suck the blood of mammals.

▶ **166. PACIFIC AMBUSH BUG** *Phymata pacifica*

ADULT: Variable in size (BL 7–12 mm) and color, bright yellow to nearly white with reddish-brown or blackish-brown markings; deep-bodied, boat hull–shaped, with heavy, mantislike forelegs for grabbing the victims.

HABIT: Common in flowers such as buckwheat *(Eriogonum* spp.*)* and various members of the sunflower family but often overlooked because of their cryptic coloration that allows them to blend with the flowers in which they wait for their prey. Their quarry is often an insect much larger than themselves, such as a Honey Bee or butterfly, which are ambushed and quickly subdued by a powerful puncture with the Pacific Ambush Bug's piercing mouthparts.

RANGE: Warmer areas, including mountains, the Central Valley, and southern California coastal and desert areas.

▶ **167. WESTERN BLOODSUCKING CONENOSE** *Triatoma protracta*

ADULT: BL 16–19 mm; black or brownish black; with an elongate head.

HABIT: This large nocturnal bug normally inhabits wood-rat nests but sometimes invades campsites and cabins. The adult readily flies and is attracted to lights, increasing the possibility they will enter homes. Its bite causes a swelling and a systemic reaction, leading to severe illness in sensitive persons. Related species in Mexico and South America transmit the debilitating Chagas' disease, but virulent strains of this disease are not endemic in California.

RANGE: Warmer parts of the state including the Central Valley as well as oak-woodland and chaparral foothills of the Coast Ranges and southern California.

▶ **168. SPOTTED ASSASSIN** *Rhynocoris ventralis*

ADULT: BL 9–14 mm; variable in color, usually red or tan with black thorax and wing membranes, and evenly spaced spots along the flared, protruding margins of the abdomen; legs with conspicuous black rings.

HABIT: This is the most commonly seen assassin bug in northern California during spring and early summer.

RANGE: Siskiyou and Modoc Counties south through the Sierra Nevada and the Coast Ranges to the desert margins of the mountains in southern California.

▶ **169. WESTERN CORSAIR** *Rasahus thoracicus*

ADULT: BL 18–23 mm and moderately slender; smooth, shining body and legs, the front pair enlarged; tan or amber-colored with black markings and wing membranes, each of which has a large, round tan spot.

HABIT: The painful bite of this bug is scarcely exceeded in severity by that of any other insect. The bug normally preys on other insects and bites humans only in self-defense. The Western Corsair is nocturnal and often attracted to lights on warm evenings. Because most reduviids rarely bite when handled, many collectors make the unforgettable mistake of picking up a Western Corsair while collecting at lights.

RANGE: Warmer parts of California, including the Sierra Nevada foothills, coastal valleys, the Central Valley, and desert areas.

▶ 170. ROBUST ASSASSIN BUGS *Apiomerus* spp.

Several species of this genus occur in California.

ADULT: Moderately large (BL 10–17 mm); thick-bodied with stout, hairy, tarantulalike legs. These bugs resemble spiders at first glance. The common species of the Coast Ranges is mainly black with red markings; red and yellow species occur in southern California and the deserts.

HABIT: They are most often seen at flowers, where they wait for insect visitors.

RANGE: Warmer parts of the state, from the San Francisco Bay Area southward.

▶ 171. FOUR-SPURRED ASSASSIN BUG *Zelus tetracanthus*

ADULT: BL 10–16 mm; slender, elongate with very thin legs and antennae; brown, gray, or black, paler individuals tending to have banded legs and abdomen; four pointed spurs occur in row across the back of the thorax.

HABIT: Adults and nymphs of this genus accumulate a sticky secretion that gathers debris and aids in capturing prey.

RANGE: Throughout warmer parts of the state, including both sides of the Sierra Nevada at moderate elevations, the Central Valley, and deserts.

▶ 172. LEAFHOPPER ASSASSIN BUG *Zelus renardii*

ADULT: Usually smaller than the Four-spurred Assassin Bug (BL 10–13 mm); green or gray when alive, with red areas on the wings and abdomen; thorax lacking spurs on hind dorsal margin.

HABIT: Wide spread in the state and common in alfalfa fields and weedy areas, where they prey on leafhoppers and other small insects.

Bed Bugs (Family Cimicidae)

Bed bugs used to be well-known domestic insects in all parts of the world inhabited by humans. However, with improved living conditions since the turn of the 20th century, these bugs largely disappeared from all but

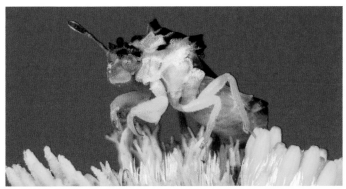

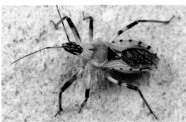

166. Pacific Ambush Bug (*Phymata pacifica*).

167. Western Bloodsucking Conenose (*Triatoma protracta*).

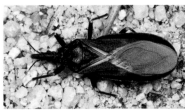

168. Spotted Assassin (*Rhynocoris ventralis*).

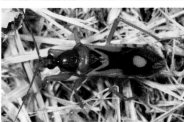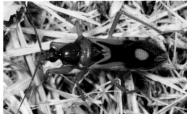

169. Western Corsair (*Rasahus thoracicus*).

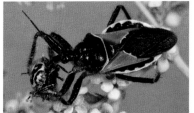

170. Robust Assassin Bug (*Apiomerus* sp.) feeding on a ladybird beetle.

the most economically depressed residential areas. However, bed bugs have made an aggressive resurgence since the turn of the 21st century. Multiple factors appear to have contributed to the resurgent infestations, including increased international travel, pesticide resistance among bed bugs, and reduced indoor use of insecticides. Still, most Californians have never seen a bed bug and will never be bitten by one. Even if you are one of the unlucky victims of a bed bug bite, there is little to worry about as they are not known to be vectors of human diseases. These bugs are small, oval, flat, dark brown, wingless or with wing stubs. Both nymphs and adults feed nocturnally on the blood of birds or mammals using a stout beak that pierces the skin and injects a secretion containing both an anticoagulant and an anesthetic.

▶ **173. BED BUG** *Cimex lectularius*

ADULT: BL 4–5 mm; brown, rust red, or purplish; covered with short bristles.

HABIT: They hide under mattress covers or in bedding by day, and their presence may be determined by dark stains of excrement on the sheets and a characteristic odor. Bites often occur in a slightly curving row of three evenly spaced punctures.

RANGE: Unclean hotels, hostels, and residences; less common in California than in eastern parts of the United States.

▶ **174. SWALLOW BUG** *Oeciacus vicarius*

ADULT: BL 3.5–4.5 mm; similar to the Bed Bug **(173)** but clothed with longer, pale hairs.

HABIT: More than 1,000 individuals may occur in severely draining the nestling birds.

RANGE: Cliff Swallow and rarely Barn Swallow nests throughout the state.

Plant Bugs (Family Miridae)

Members of the family Miridae are one of the commonest Hemiptera in most areas of California. Many species attain high population densities, and most are specific to certain plants. Sweeping a given kind of plant, such as grasses or oaks, often will reveal large numbers of mirids. They are small, soft-bodied, elongate or oval bugs with prominent eyes and long, thin antennae and legs. Plant bugs actively run or fly, although some species have short-winged adult forms that resemble ants. Most mirids suck juices of soft plant parts via a long beak, but some are predators on other soft-bodied insects. More than 150 species are recorded in California, and no doubt others await discovery.

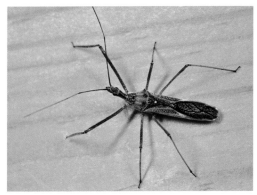

171. Four-spurred Assassin Bug (*Zelus tetracanthus*).

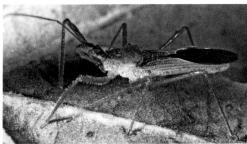

172. Leafhopper Assassin Bug (*Zelus renardii*).

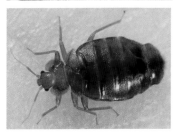

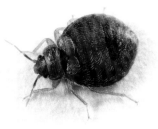

173. Bed Bug (*Cimex lectularius*). **174.** Swallow Bug (*Oeciacus vicarius*).

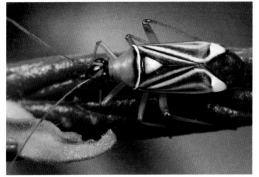

175. Pleasant Plant Bug (*Closterocoris amoenus*).

◄ **175. PLEASANT PLANT BUG** *Closterocoris amoenus*

ADULT: One of the largest (BL 7–9 mm) and most colorful mirids in California. Black with orange thorax and bright yellow lines on the wings.

HABIT: This species is common on various native flowers.

RANGE: Coast Ranges and coastal areas from southern Mendocino County southward; more prevalent in southern California.

▶ **176. BLACK GRASS BUGS** *Irbisia* spp.

ADULT: BL 5–8 mm; shining black or grayish black with either black or red legs.

HABIT: Several species of this and related genera are common in grassy areas, particularly during spring. As the grasses dry, the bugs often migrate into nearby cultivated fields and gardens.

RANGE: Coastal areas, inland valleys, and mountains throughout the state.

▶ **177. LYGUS BUGS** *Lygus* spp.

ADULT: BL 4–6 mm; winged; pale green or yellow-green to dark brown or reddish brown, with a large pale scutellum.

NYMPHS: Pale yellow or green.

HABIT: Members of this genus are among the commonest bugs in California, occurring in great numbers on a wide variety of flowers, fruit trees, crops such as cotton and alfalfa, and on weeds.

RANGE: Throughout all but the deserts at a wide range of elevations. *Lygus elisus* and *L. oblineatus* are widespread species occurring abundantly in agricultural areas, particularly in the Central Valley. Over half of the cultivated plants grown in the United States are known to be hosts for the Tarnished Plant Bug *(L. lineolaris)*, which is one of the most commonly encountered species in California.

Damsel Bugs (Family Nabidae)

▶ **178. COMMON DAMSEL BUG** *Nabis americoferus*

ADULT: BL 7–9 mm; slender; pale brownish gray; reminiscent of a tiny mantis but lacking the enlarged forelegs.

HABIT: A common inhabitant of weedy and cultivated fields in California. Common Damsel Bugs are predaceous, feeding on smaller bugs such as aphids and leafhoppers.

RANGE: Throughout low to moderate elevations in the state.

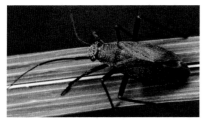

176. Black Grass Bug (*Irbisia* sp.).

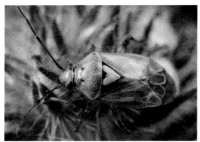

177. Lygus Bug (*Lygus* sp.).

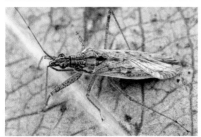

178. Common Damsel Bug (*Nabis americoferus*).

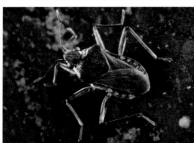

179. Minute Riffle Bug (*Microvelia* sp.).

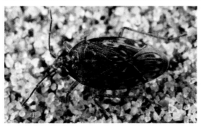

180. Black Shore Bug (*Saldula* sp.).

Riffle Bugs (Family Veliidae)

Riffle bugs are tiny, oval insects having shorter legs than water striders. Veliids are found on and near the banks and vegetation at the edges of streams and ponds, venturing out onto the water surface only when dislodged. Most species are restricted to freshwater habitats, but a few live around brackish or saltwater. Riffle bugs eat small insects and other organisms, including those that live nearby the water and those that fall onto the water's surface.

◀ 179. MINUTE RIFFLE BUGS *Microvelia* **spp.**

ADULT: Small (BL 1.0–2.5 mm); flat, dull black bugs; winged forms less common than wingless adults, which resemble immature stages. Eight species occur in California, at least two of which are very common, but they are often overlooked because of their small size and secretive habits.

HABIT: All stages are found together skittering in small herds across the water surface when their stream-side retreats are disturbed.

RANGE: Mostly in the Coast Ranges and foothills of the Sierra Nevada up to about 1,500 m elevation.

Shore Bugs (Family Saldidae)

Saldids are small, oval, somewhat flattened bugs with moderately long legs used for running and jumping. Most are black or brown, although some have conspicuous white or yellow markings. These bugs inhabit lake shores, beaches, stream banks, and moss-covered rocks and tree trunks in wet places. About 30 species are known in California, and some are quite abundant, yet they are overlooked by all but the most careful observers. Many saldids are quick, running or flying at the slightest disturbance, while others are secretive, hiding in overhanging vegetation or other shady spots. Shore bugs are predators or scavengers, eating a variety of living or dead organisms found on the damp soil.

◀ 180. BLACK SHORE BUGS *Saldula* **spp.**

ADULT: Small (BL 3.5–5.0 mm to wing tips); body and basal half of wings a deep bronze brown or almost black, distal part of wings white opaque, translucent, or with various brown patterns.

HABIT: The 22 species of this genus in California occupy all kinds of shoreline situations, including briny and alkaline places.

RANGE: Throughout the state including springs in desert areas. *Saldula pallipes,* which occurs over all of North America and Europe, is the com-

monest species in California. It ranges from low-elevation salt marshes to over 3,000 m, varying in size and color from one habitat to another.

Water Striders (Family Gerridae)

Gerrids are elongate bugs that have long legs with the claws set well back from the tips, enabling the bugs to skate on water on little depressions in the surface film. Naturalists often observe the curious, symmetrical shadows cast by these depressions on the bottoms of ponds. Water striders move by synchronous, oarlike movements of the middle legs, which are longer than the others. Gerrids are predaceous, mainly on insects and other organisms that fall on the water, but they also catch aquatic insects that come to the surface. Adults of some species are wingless, but the degree of wing development varies greatly. Apparently, this is related to dispersal and habitat stability; day length and temperature have been shown to influence the development of winged forms. Generally, winglessness occurs only in species that live on permanent rivers, where flight dispersal is unnecessary. About 10 species are known in California, of which one occurs only on the Pacific Ocean, and two are restricted to the Colorado River.

▶ **181. COMMON WATER STRIDER** *Aquarius remigis*

ADULT: Large (BL 14–18 mm, length across leg span 30 mm); body brownish black, covered with velvety, waterproof pile that sometimes appears gray or silvery; winged or wingless.

HABIT: The Common Water Strider is a familiar sight on all kinds of freshwater surfaces, from eddies in fast-running streams to isolated stock tanks. This bug is aggressively predatory, feeding on mosquito larvae living under the surface and other insects, alive or dead, that fall into the water.

RANGE: The most widespread semiaquatic insect in the United States and California; occurs throughout the state, except in the deserts, up to about 2,500 m elevation.

Backswimmers (Family Notonectidae)

Notonectids differ from all other aquatic insects in California by swimming upside down. The body is boat hull–shaped, elongate, with a flat underside and convex back. The eyes are large, occupying most of the head; the beak is short, sharp, and capable of inflicting a powerful bite.

A collector needs just one painful lesson in carelessly picking up a back-swimmer. These bugs have both the front and middle legs adapted for grasping their prey, while the hind legs are long and oarlike, flattened and fringed for swimming. Backswimmers are most commonly seen in pools of streams, springs, and ponds, but they are good fliers and often appear in places such as swimming pools remote from other water. Prey consists of other insects and occasionally small fish, and some species are helpful in mosquito control.

▶ **182–184. BACKSWIMMERS** *Notonecta* **spp.,** *Buenoa* **spp.**

Eleven similar species of these familiar genera occur in California. Large species are typically in the genus *Notonecta*.

ADULT: BL 10–16 mm; robust; variable in color, white, gray, or black-and-white to red-brown.

RANGE: Throughout most of California, up to 2,750 m elevation. Adults may be seen throughout the year. One species, the **Single-banded Back-swimmer *(N. unifasciata)* (182)** is widespread and occurs in a broad range of habitats, including saline pools and hot springs with temperatures as high as 36 degrees C. **Kirby's Backswimmer *(N. kirbyi)* (183)** is the largest and most widespread species in California. The small backswimmers, members of the genus *Buenoa* **(184)**, are smaller (BL 5–7 mm) and more slender than *Notonecta* spp.

ADULT: Some species are either short-winged or fully winged and may have two color forms at the same locality. Four species are known in California, of which the Scimitar Backswimmer *(B. scimitar)* is the most common. It is a pale to smoky gray species with a large, sword-shaped stridulatory area on the foreleg.

RANGE: Coast Ranges, the Central Valley, and the Sierra Nevada foothills, from Sonoma County to San Diego, and in the Imperial Valley.

Water Boatmen (Family Corixidae)

The family Corixidae has more species than any of the other aquatic hemipteran families. Populations often occur in huge numbers so that corixids are an important link in the food chain of water communities, converting plants and tiny animals into food for fish. Water boatmen possess a triangular, flat head and characteristically have alternating dark and light, transverse banding on the thorax. These insects resemble backswimmers to the casual glance, but corixids are flattened and swim right side up. Each pair of legs is adapted to a special function: the forelegs are used for food gathering, the midlegs for clinging to substrates while

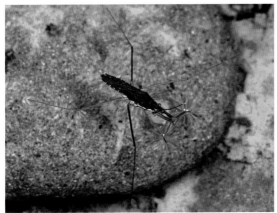

181. Common Water Strider (*Aquarius remigis*).

182. Single-banded Backswimmer (*Notonecta unifasciata*).

183. Kirby's Backswimmer (*Notonecta kirbyi*).

184. Small Backswimmer (*Buenoa* sp.).

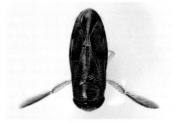

185. Smooth Water Boatman (*Trichocorixa* sp.).

feeding or resting, and the hind legs are long, flattened, oarlike, and are used to propel the bugs through the water.

Water boatmen live in a wide range of habitats, from saline waters of Death Valley below sea level to frigid waters beneath ice in subarctic and high montane sites. Some species live exclusively in saltwater, in the Salton Sea or along the coast in ocean bays; however, most corixids prefer freshwater. Usually these bugs forage in bottom ooze, eating algae, protozoa, and other microscopic organisms, but sometimes water boatmen are predators on larger animals, such as mosquito larvae. Corixids are preferred food of many fish, and the bugs and their eggs are harvested for human food in Mexico, referred to as "Ahuatle," or more tongue in cheek as "Aztec Caviar." Tons of nymphs and adults are used in bird, fish, and turtle pet food every year. There are seven genera and 25 species of Corixidae known in California, some of which are widespread and abundant.

◀ 185. SMOOTH WATER BOATMAN *Trichocorixa* spp.

ADULT: Smaller individuals than other genera (BL 3–6 mm); with smooth, shiny wing covers and pronotum. Our four species are restricted to coastal marshes and either salty or fresh waters of the desert areas. Some *Trichocorixa* prefer saline or alkaline water, including Salt Marsh Water Boatman *(T. reticulata),* which is the smallest California corixid (BL 2.8–5.4 mm); females distinguished from all others by lacking the frosted white area along the lateral margin of the fore wing.

RANGE: Salt marshes and tidal pools along the coast, the Colorado River Valley, at the Salton Sea, and in alkaline waters of Death Valley, where they inhabit the pool at Badwater.

LARGE WATER BOATMAN *Hesperocorixa laevigata*

ADULT: Large (BL 9–13 mm); dark, with strong, netlike lines on the fore wings, especially prominent at the middle of the wings.

RANGE: One of the commonest corixids in California, *H. laevigata* occurs everywhere except in the deserts.

COMMON WATER BOATMAN *Corisella* spp.

ADULT: Small (BL 4–8 mm); pronotum roughened, wing covers nearly smooth with the dark reticulations forming irregular, longitudinal rows.

RANGE: Throughout much of the state at a wide range of elevations; one species, *C. decolor,* is common in freshwater and saline ponds and is especially abundant in the rice fields of the Sacramento Valley, where countless numbers of adults are attracted to lights.

Toad Bugs (Family Gelastocoridae)

Gelastocorids are short, flattened, broad bugs with protruding eyes and a warty appearance, and they jump frog-hop fashion when approached. Two genera with four species occur in California.

▶ **186. TOAD BUG** *Gelastocoris oculatus*

ADULT: BL 7–9 mm; mottled in gray, tan, greenish gray, or red-brown, these bugs take on colors that blend in with the sand along edges of streams and ponds. The variation in color pattern at one locality is often striking.

HABIT: Their short, grasping front legs are used to catch prey, which includes insects and other small animals. They can give a nasty bite if mishandled.

RANGE: In nearly every county at a wide range of elevations.

Creeping Water Bugs (Family Naucoridae)

Naucorids are oval, flattened bugs with mantis-type forelegs used for grasping their prey. They somewhat resemble the giant water bugs (Belostomatidae) but are smaller and lack the straplike tail appendages characteristic of that family. Most naucorids inhabit slow streams with pebbly bottoms. They crawl or swim among the rocks in search of small prey, such as water boatmen, mosquito larvae, and mollusks. These bugs can inflict an extremely painful bite. Six species in two genera occur in California.

▶ **187. MORMON CREEPING WATER BUG** *Ambrysus mormon*

ADULT: BL 9–12 mm; deep brown to reddish brown with distinctly paler, nearly yellow forebody and lateral markings. The edge of the abdomen is strongly spinose at the posterolateral corners of the segments.

HABIT: Can be extremely abundant in still or slow-moving water.

RANGE: Occurs throughout the northern two-thirds of the state at a wide range of elevations, in a variety of stream and lake habitats. A similar species, the California Creeping Water Bug *(A. californicus)* is smaller (BL 7–8 mm); yellowish brown to greenish brown with darker markings.

RANGE: Streams of the Coast Ranges from Mendocino County south to the Transverse Ranges and San Bernardino Mountains. The Western Creeping Water Bug *(A. occidentalis)*, which is larger (BL 10–12.5 mm) and paler, is the common species in still pools in southern California.

Giant Water Bugs (Family Belostomatidae)

Members of the family Belostomatidae are brown, elongate-oval, flattened bugs with a pair of retractable, straplike breathing appendages at the end of the abdomen. Three genera occur in California, *Belostoma* and *Lethocerus* in standing water habitats and *Abedus* in streams. Belostomatids are strong swimmers but normally perch on submerged objects to wait for prey. The grasping front legs are held in readiness and quickly seize the victims, including other insects, tadpoles, and even small fish and snakes. A paralyzing toxin is injected by the bug's strong beak. Some species occasionally are pests in fish hatcheries. They can bite a human, producing a burning sensation that lasts several hours and causes considerable reddening and swelling. One of the most distinctive features of *Abedus* and *Belostoma* is their oviposition behavior; females deposit their eggs on the backs of males, who carry and care for them until they hatch **(190)**.

▶ **188. ELECTRIC LIGHT BUG** *Lethocerus americanus*
ADULT: Huge (BL 45–60 mm to tips of wings); brown.
HABIT: Sometimes attracted to lights in large numbers where they are often eaten by the vertebrate predators that await them.
RANGE: Northern half of the state; there are older records from Riverside and Orange Counties but drying of freshwater ponds probably has eliminated this bug in southern California.

A related species, *L. angustipes,* occurs in Death Valley but is primarily Mexican in distribution. Another large member of the genus *Lethocerus* is considered a great delicacy in some Asian cuisines, and one can purchase giant water bugs from food stores in Chinatown in San Francisco or Los Angeles.

▶ **189–190. TOE BITER** *Abedus indentatus*
ADULT: Proportionately broader (BL 27–37 mm, width 14–20 mm) than other giant water bugs in California. Males may have eggs glued to their backs **(190)** by females. The male protects and grooms the eggs until they hatch.
HABIT: These large bugs are very common in riffle areas of streams, clinging to submerged vegetation or under debris.
RANGE: Streams of the southern two-thirds of the state, including the deserts.

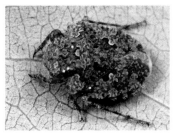

186. Toad Bug
(*Gelastocoris oculatus*).

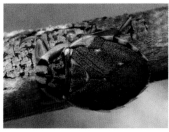

187. Mormon Creeping Water Bug
(*Ambrysus mormon*).

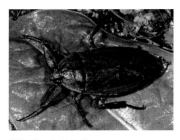

188. Electric Light Bug
(*Lethocerus americanus*).

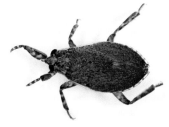

189. Toe Biter
(*Abedus indentatus*).

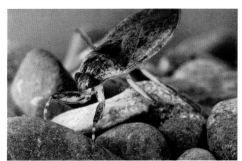

190. Toe Biter
(*Abedus indentatus*) male
with eggs.

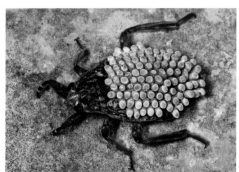

191. Little Toe Biter
(*Belostoma bakeri*).

◀ **191. LITTLE TOE BITER** *Belostoma bakeri*

Bugs of this genus are smaller than *Abedus* and have a well-developed fore wing membrane.

ADULT: BL 18–23 mm, width 9–12 mm.

HABIT: Found in ponds, springs, and slow creeks. May be collected year-round.

RANGE: Wide-ranging in the state. Another very similar and common species is *B. flumineum*, occurring principally in the Central, Coachella, and Imperial Valleys.

Water Scorpions (Family Nepidae)

Water scorpions are green or brown, slender, cylindrical, or somewhat flattened, with long, thin legs, which are not modified for swimming. The common name derives from a long, tail-like air siphon on the end of the abdomen. These bugs are found in still-water habitats in tangled plant growth or debris where they are camouflaged by their sticklike appearance. They feed on a wide variety of aquatic animals, such as mosquito larvae and tadpoles, which they catch by waiting motionless until a victim swims within reach of the lightning-quick, grasping front legs. Only three species are known in California.

▶ **192. COMMON WATER SCORPION** *Ranatra brevicollis*

ADULT: BL 30–40 mm, plus an additional 20-25 mm of tail siphon; elongate, cylindrical; brown; closing face of the foreleg femur with a broad, shallow excavation and a long process on the metathoracic underside nearly reaching the base of the abdomen.

HABIT: This common Californian species and other members of the genus can stridulate—that is, make a squeaking sound by rubbing the basal segment of the front leg against the thorax.

RANGE: Low-elevation streams from southern Humboldt County to San Diego, inland in the Sierra Nevada foothills and mountains of southern California.

A related species, the Desert Water Scorpion (*R. quadridentata)*, occurs in the Coachella and Imperial Valleys. Its foreleg femur has a narrow, subapical notch defined basally by a strong tooth.

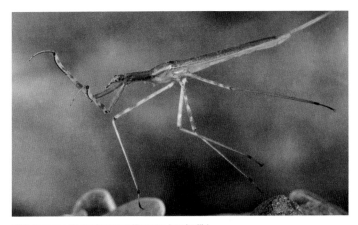

192. Common Water Scorpion (*Ranatra brevicollis*).

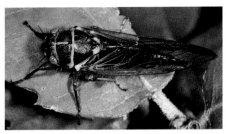

193. Woodland Cicada (*Platypedia* sp.).

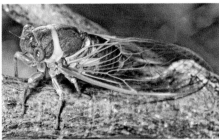

194. Apache Cicada (*Diceroprocta apache*).

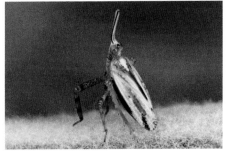

195. Dictyopharid Planthopper (*Scolops* sp.).

Cicadas and Hoppers (Suborder Auchenorrhyncha)

The suborder Auchenorrhyncha contains a diverse group of insects with many structural and life history modifications. Many are common and conspicuous, displaying bright colors or singing loud mating songs in summer. Leafhoppers and froghoppers are relatively unmodified, while planthoppers and treehoppers often possess grotesquely enlarged and complex head or pronotal structures.

Cicadas (Family Cicadidae)

The most characteristic feature of cicadas is sound production. The males possess organs (tymbals) in the base of the abdomen that emit a high-pitched shrill cry. The sound waves are generated by strong muscles vibrating a taut membrane at a high frequency, something like a drumhead. Specific "song" patterns play a role in courtship. The small males of the genus *Platypedia* lack tymbals and can emit only short clicking noises by rattling their wings together. Cicadas are notoriously long-lived, the nymphs requiring two to five years to develop (up to 17 years in several species in the eastern United States). The immature cicadas burrow underground and feed on roots. Some 65 species of cicadas live in California, mostly in drier habitats, deserts, brush-covered hills, and forest clearings, although some species extend into agricultural areas as well. Population explosions often occur in some species (e.g., *Okanagana cruentifera* on Great Basin Sage Brush in Inyo and Mono Counties). This tendency and their loud songs make cicadas one of our more conspicuous insects.

◄ 193. WOODLAND CICADAS *Platypedia* **spp.**

Members of this genus are relatively slender cicadas characteristic of foothill and mountain areas.

ADULT: BL 20–30 mm; generally black or bronze-colored with yellow, orange, or red legs and body markings; often with a distinctly colored line across the hind margin of the prothorax.

HABIT: Females oviposit into twigs of native trees (oaks, Madrone, willows, etc.), shrubs such as *Baccharis,* and sometimes in deciduous orchard trees.

RANGE: Northern mountains, Coast and Peninsular Ranges. Most of the 18 species recorded in California occur in the northern half of the state.

◀ 194. APACHE CICADA *Diceroprocta apache*

ADULT: BL 25 mm, wing length 35 mm; generally brown or blackish brown with contrasting yellow transverse collar; veins conspicuously lighter over basal half of wing.

HABIT: The deafening chorus of males of this species, emanating from roadside saltcedars and palo verdes, is a familiar sound to motorists passing through the lower deserts in summer. Hosts are mainly native desert shrubs, but oviposition punctures by the females cause minor damage to elms, date palms, and citrus in the Coachella Valley.

NYMPH: Body heavy, abdomen down-curved; forelegs thickened and clawed for digging; dark brown. Lives underground, sucking sap from roots of plant host; life cycle requires two years.

RANGE: Limited to Colorado Desert, Imperial and Riverside Counties.

RED-WINGED GRASS CICADA *Tibicinoides cupreosparsus*

ADULT: BL 20 mm; wing length 15 mm; body black, with bright red areas at the bases of the black-veined, clouded wings.

HABIT: Male is a feeble singer; use various species of grasses in grass-covered hillsides of upland forests and woodland habitats in the adult and nymphal stages.

RANGE: Southern California, primarily in Los Angeles, San Diego, and western Riverside Counties.

Planthoppers (Superfamily Fulgoroidea)

Many planthoppers are difficult to distinguish from leafhoppers and spittle bugs. They are normally flatter and broader, have antennae arising on the sides of the head beneath the eyes (rather than in front of or between), and often have complex (usually snoutlike) projections, keels, or ridges on the front of the head. California has only about 100 species as this is primarily a tropical group.

Family Dictyopharidae

◀ 195. DICTYOPHARID PLANTHOPPERS *Scolops* **spp.**

Of the 45 species of dictyopharid planthoppers in California, eight or more are in the genus *Scolops*.

ADULT: BL 3–6 mm; head produced into a long, upturned process; adults may have full-length or short wings; color is quite variable from somber brown to straw yellow to green; wings may be opaque or transparent; legs, especially the front pair, are usually relatively long.

HABIT: Found on various herbaceous plants such as milkweed, ragweed, and sweet clover.

RANGE: Found widely across the state.

One of the most curious dictyopharid planthoppers is Dammers' Planthopper *(Ticida dammersi)* because of its amusing antics and shape. Holding its snout erect, it runs in all directions and tries to hide on the far side of its perch when teased. It is small (BL 4 mm), lacks a head horn, and is pale green with transverse brown bands. Its host is *Agave* and its range is the Colorado Desert.

Spittle Bugs (Superfamily Cercopoidea)

Nymphs of the spittle bugs are more often encountered than the adults but are seldom seen because of the thick, white, frothy mass surrounding them **(198)**. These foam masses are most common on herbaceous plants that provide food for the nymphs and adults.

Family Aphrophoridae

▶ **196. SPITTLE BUGS** *Aphrophora* **spp.**

ADULT: Medium-sized (BL 8–11 mm) and brown with irregular, darker brown markings, resemble leafhoppers but sit froglike with the head elevated; they differ in being broader across the middle rather than parallel-sided and by having only one or two stout spines on the hind tibia. California has only about six species, all generally similar in form.

HABIT: They may be found on almost any plant but especially herbs and grasses.

RANGE: Throughout the state except at the highest elevations.

Family Aphrophoridae

▶ **197–199. MEADOW SPITTLE BUG** *Philaenus spumarius*

ADULT: (197) BL 5–7 mm; color is quite variable but typically patterns of brown, yellow, and cream white.

NYMPH: (199) Pale green, living in characteristic foam masses **(198)**.

HABIT: Tolerant of many types of habitats and is frequently found in pastures, parks, and open forests on a variety of plants.

RANGE: Widely distributed in the state in any habitat that is not very wet or extremely dry.

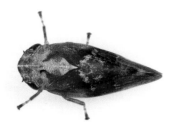

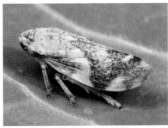

196. Spittle Bug
(*Aphrophora* sp.).

197. Meadow Spittle Bug
(*Philaenus spumarius*) adult.

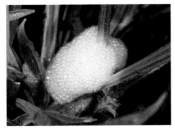

198. Meadow Spittle Bug
(*Philaenus spumarius*) spittle mass.

199. Meadow Spittle Bug
(*Philaenus spumarius*) nymph.

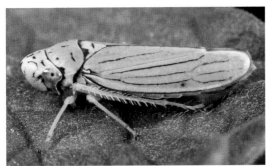

200. Blue-green
Sharpshooter
(*Graphocephala
atropunctata*).

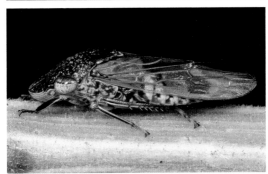

201. Glassy-winged
Sharpshooter
(*Homalodisca
vitripennis*).

Leafhoppers (Family Cicadellidae)

Many plant pests are members of the family Cicadellidae, which has more than 200 species in California. Their feeding can remove enough sap to wilt and kill growing tips and sometimes transmits disease-producing viruses. Leafhoppers are agile, hopping insects, often running sideways, and many are brightly colored (although many are cryptically colored as well). Unlike their close relatives, the spittle bugs, leafhoppers are slender (thorax scarcely wider than wing margins), the nymphs never cover themselves with froth, and the hind tibiae have one or more rows of small spines. The ranges of the included species are coincident with the ranges of their host plants.

◄ 200. BLUE-GREEN
SHARPSHOOTER *Graphocephala atropunctata*
ADULT: A medium-sized (BL 6–7 mm) bright blue or blue-green species.
HABIT: Often seen on garden plants, frequently on woody vines and known to be a vector of Pierce's disease of grape.
RANGE: California, wherever suitable woody vine host plants occur.

◄ 201. GLASSY-WINGED
SHARPSHOOTER *Homalodisca vitripennis*
ADULT: BL 10–12 mm; dark brown to black with black-and-yellow underside, and the upper parts of the head and back are speckled with ivory or yellow spots. The wings are transparent with red veins.
HABIT: This is a notorious vector of bacterial plant diseases, including Pierce's disease of grape.
RANGE: This species is native to the southeastern United States and is an invasive in California wherever suitable host plants occur in the state.

► 202. VARIEGATED LEAFHOPPER *Euscelis variegatus*
ADULT: BL 3–5 mm; yellowish-brown variegated pattern, speckled with black, an introduced species originally from the Palearctic that vectors plant diseases including some that infect citrus.
RANGE: Coastal California, wherever suitable host plants occur.

► 203. TWO-SPOTTED LEAFHOPPER *Sophonia orientalis*
ADULT: BL 4–6 mm; yellow to white with a dark medial line and two prominent "eye spots" on the wings near the posterior end.
HABIT: Native to southeast Asia, introduced to southern California from Hawaii on cut flowers in 1996. Extremely polyphagous with nymphs known to develop on more than 300 species of plants.
RANGE: Central to southern California, particularly in coastal counties.

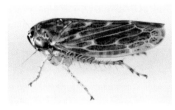

202. Variegated Leafhopper
(*Euscelis variegatus*).

203. Two-spotted Leafhopper
(*Sophonia orientalis*).

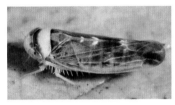

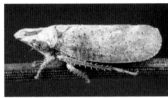

204. Yellow-banded Leafhopper
(*Colladonus reductus*).

205. Mottled Pine Leafhopper
(*Koebelia* sp.).

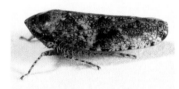

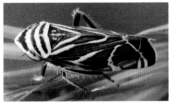

206. Bespeckled Leafhopper
(*Paraphlepsius* sp.).

207. Black Grass Leafhopper
(*Cochlorhinus* sp.).

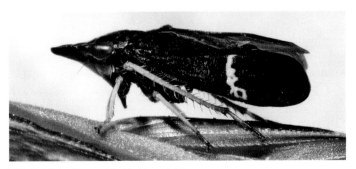

208. Pluto's Leafhopper (*Cochlorhinus pluto*).

◀ 204. YELLOW-BANDED LEAFHOPPER *Colladonus reductus*

ADULT: BL 4–5 mm; brown, usually bronzy and iridescent with a bold, transverse yellow or white band on the pronotum.
HABIT: Typically found on alder and poplar.
RANGE: Throughout the state but more common in central and southern counties.

◀ 205. MOTTLED PINE LEAFHOPPERS *Koebelia* **spp.**

ADULT: 3–5 mm; typically gray, brown, or reddish brown patterned with scatterings of black spots; head distinctly broader than pronotum.
HABIT: Found on a variety of pines.
RANGE: Throughout the state.

◀ 206. BESPECKLED LEAFHOPPERS *Paraphlepsius* **spp.**

LT: BL 5–7 mm; light gray with an intricate network of light brown to black patterns and spots.
HABIT: Typically found on various oak species including California's live oaks. Some species can occasionally be pests of crops such as alfalfa.
RANGE: Throughout the state.

◀ 207–208. BLACK GRASS LEAFHOPPERS *Cochlorhinus* **spp.**

ADULT: BL 3.5–6 mm; typically with bold white patterns on black **(207)**; distinctly pointed vertex of the head.

◀ 208. PLUTO'S LEAFHOPPER *Cochlorhinus pluto*

ADULT: BL 5–6 mm; shiny black with a bold, transverse white bar on each wing rather than a network of white lines.
HABIT: Species in the genus are commonly found on grasses.
RANGE: Black grass leafhoppers are found throughout the state.

Treehoppers (Family Membracidae)

Adult treehoppers have the front portion of the thorax greatly expanded to cover the abdomen, even extending upward and laterally to form various thornlike projections. With such shapes and their brown or green colors, they easily escape detection on vegetation. The nymphs are characterized by numerous erect spines on the back of the abdomen. Both immatures and adults jump readily. California has about 40 species, several of which injure plants by puncturing plant tissues to lay eggs.

▶ 209. THREE-CORNERED
ALFALFA HOPPER *Spissistilus festinus*

ADULT: Small (BL 5 mm); bright green, with a rounded, triangular thorax bearing short, anterolateral spines.

HABIT: One of the most common and widespread species, found on a wide variety of agricultural and ornamental plants.

RANGE: Widespread, especially along watercourses, in the southern half of California, including the deserts.

▶ 210–211. OAK TREEHOPPER *Platycotis vittata*

ADULT: (210) BL 9–12 mm to tips of wings; pale bluish gray with the surface of the pronotum finely punctured, with a long, median horn and with longitudinal reddish-orange stripes, or dull bronzy with a short horn and reddish-orange dots.

NYMPH: (211) Black with yellow-and-red markings and two soft black spines on the back.

HABIT: Compact aggregations of nymphs or adults of this species are found on lower branches of deciduous and live oaks in spring and occasionally on other broadleaf trees. The eggs are inserted into small branches; females remain with their eggs until they hatch and maintain contact with the aggregations of nymphs **(211)**.

RANGE: Foothills of the Coast Ranges and the Sierra Nevada.

▶ 212. BROOM HOPPERS *Philya* spp.

LT: BL 4–5 mm; gray to reddish brown, heavily and densely sculptured, with a long, broad, and rounded horn.

HABIT: Typically found on brooms (*Baccharis* spp.).

RANGE: Across the state in association with the host plants.

Aphids, Scale Insects, Psyllids, and Whiteflies (Suborder Sternorrhyncha)

Species in the suborder Sternorrhyncha are entirely plant-feeding. This group includes aphids, scale insects, psyllids, and whiteflies. They have many significant structural and life history modifications related to their close evolution with plant hosts. Females of scale insects and mealybugs are greatly modified, completely wingless, and often fixed in place. Life history specializations include the seasonal alternation of bisexual and parthenogenetic, all-female, generations of aphids. In some forms the

Hemiptera

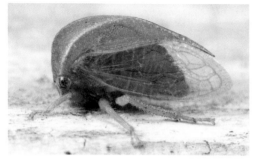

209. Three-cornered Alfalfa Hopper (*Spissistilus festinus*).

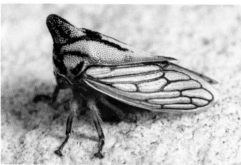

210. Oak Treehopper (*Platycotis vittata*) adult.

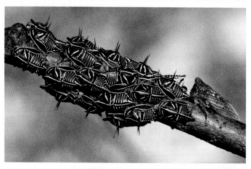

211. Oak Treehoppers (*Platycotis vittata*) nymphs and adult.

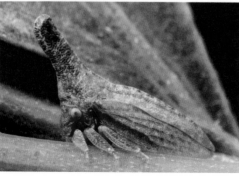

212. Broom Hopper (*Philya* sp.).

mouthparts are poorly developed and nonfunctional in the adults; others secrete waxy substances that may cover the body or form projecting filaments or frothy masses. Many species secrete liquids rich in sugar ("honeydew").

Aphids (Family Aphididae)

Aphids are small, soft-bodied insects, well-known to gardeners and farmers because of their destructive feeding habits; there are many economically important species. Consistent characteristics that distinguish aphids are a pear-shaped body with a pair of tubular, hornlike projections (cornicles) near the posterior end. The winged forms have two pairs of membranous wings, the fore pair much larger than the hind, both with few veins. When at rest, the wings are held vertically over the body.

Aphid life cycles are complex, with winged and wingless forms as well as sexual and parthenogenetic reproductives (213) appearing at different times or alternating regularly according to season. Individuals have the habit of discharging a sugary solution ("honeydew") from the anus. Large quantities of honeydew on and under plants with many aphids creates a sticky mess and growth of black sooty mold. Ants are also attracted to honeydew and foster the spread of aphids by protecting them from predators and parasites. California has over 450 species of aphids.

▶ **213. ROSE APHID** *Macrosiphum rosae*
ADULT: Fairly large (BL 3 mm) with pinkish-brown or green body and contrasting black cornicles.
HABIT: This is the nemesis of the rose gardener; dense colonies form on buds and terminal shoots, usually in springtime.
RANGE: Nearly everywhere in the state where the hosts are grown.

▶ **214. DEODAR APHID** *Cinara curvipes*
Similar in appearance to the Giant Willow Aphid *(Tuberolachnus salignus)* **(216)**.
ADULT: Very large (BL to 5 mm), dark gray with black mottling.
HABIT: It forms dense colonies on the undersides of Deodar Cedar *(Cedrus deodara)* branches and its native host, firs *(Abies)*.
RANGE: Coincident with the distribution of *Abies* in montane areas and in urban situations where the hosts are grown.

▶ **215. OLEANDER APHID** *Aphis nerii*
ADULT: BL 1.5–2.6 mm; yellow with black legs and cornicles; winged forms have black wing veins and thorax.

HABIT: A common pest of various ornamental plants that also feeds on milkweeds (*Asclepias*). As an obligate parthenogenetic species, adult females may be winged or wingless.
RANGE: Throughout the state.

▶ **216. GIANT WILLOW APHID** *Tuberolachnus salignus*
ADULT: Large (BL to 4.2 mm); brown with black spots, including a larger spot in the center of the abdomen; cornicles short, surrounded by larger black spots; body covered with a fine, waxy powder.
HABIT: This species feeds in colonies on the trunks and branches of willow. Adults and nymphs kick their hind legs vigorously when disturbed.
RANGE: Throughout the state where willows are found.

Phylloxerans (Family Phylloxeridae)

Phylloxerans are similar to aphids but are without cornicles on the abdomen, and they hold their wings horizontally at rest. They are equally destructive plant pests, especially the following notorious species.

▶ **217. GRAPE PHYLLOXERA** *Daktulosphaira vitifoliae*
ADULT: Minute (BL 1 mm); oval; yellowish green or brown; four forms (a nonfeeding sexual form, parthenogenetic leaf form, feeding root form, and the winged form), with or without wings, and with different habits.
HABIT: A native of the eastern United States, this species inhabits the roots of indigenous grapes without doing serious harm. After being carried to the West (reaching California in 1852), the insect proved so destructive to imported European grapes that it nearly destroyed the state's wine industry. Use of resistant rootstock finally limited its damage. Causes galls on grape roots **(217)** and leads to the slow death of the vine.
RANGE: Widespread but a more severe pest in the vineyards of the moister northern half of the state than in the south.

Scale Insects and Mealybugs (Superfamily Coccoidea)

Scale insects and mealybugs, like aphids, cause extensive damage to California agriculture. Many of the state's 200-plus species become so numerous on cultivated plants, especially orchard trees, shrubs, and ornamentals, that they may kill the host. The group exhibits strong sexual dimorphism: males are very small, delicate, white insects having one pair of wings and long, hairlike processes on the tip of the abdomen; females

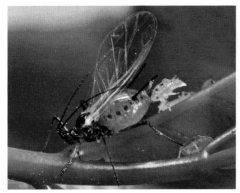

213. Rose Aphid (*Macrosiphum rosae*) female giving birth to daughter.

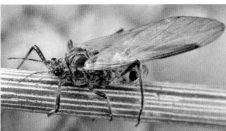

214. Deodar Aphid (*Cinara curvipes*).

215. Oleander Aphids (*Aphis nerii*).

216. Giant Willow Aphids (*Tuberolachnus salignus*) adults and nymphs.

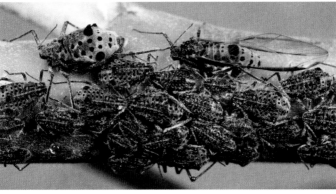

are obese, rounded forms, lacking wings, a separate head, or body segments and with minute, nonfunctional appendages at maturity. Adult females of the "armored scales" live under a scalelike covering secreted by their numerous wax glands. The unarmored or "soft scales" do not form a scale and are often rather large (BL 5–8 mm). The adult females of both types remain fixed in place by their nonretractable, filamentous mouthparts and often also gluelike secretions. Dispersion is accomplished by the young, actively crawling nymphs. The mealybugs remain active throughout life and are an exception in the group.

Family Diaspididae

▶ 218. CALIFORNIA RED SCALE *Aonidiella aurantii*

ADULT: Female: small (BL 1.8–2 mm); very flat, round to kidney-shaped, with abdominal portion on indented side; legless; red body color shows through clear, circular scale. Attaches to all parts of plant, often conspicuous on fruit. Male: tiny (BL 1 mm), covered with powdery, white wax.

HABIT: This armored scale is the most important citrus pest in the world. Hosts include a wide variety of native and cultivated plants, but the damage is most serious to citrus.

RANGE: Southern half of the state, primarily in the coastal citrus belts. Thought to be introduced from Australia before 1880.

SAN JOSE SCALE *Quadraspidiotus perniciosus*

ADULT: The female is small (BL 2 mm); oval, disc-shaped, with two pairs of lobes; body bright yellow; scale grayish, circular, irregular, with central nipple. The most serious scale pest of deciduous fruit trees in the state; lives on a large number of hosts, making control difficult.

RANGE: Supposedly introduced to San Jose from China around 1870, now troublesome throughout the state.

Family Dactylopiidae

▶ 219–220. COCHINEAL SCALES *Dactylopius* spp.

ADULT: Unarmored; medium-sized (BL 2–3 mm); body oval, convex, flattened beneath; abdominal segmentation distinct; red or crimson, covered by masses of white, cottony wax secretions. The latter is conspicuous on flat cactus *(Opuntia)* pads in springtime **(219)**.

HABIT: One member of the genus, *D. coccus*, was long used by the Aztec and Maya peoples and other indigenous groups in Mexico and Central America for preparing a crimson dye. During the Spanish colonial

217. Grape Phylloxeras (*Daktulosphaira vitifoliae*) on a grape root gall.

218. California Red Scale (*Aonidiella aurantii*).

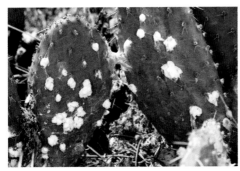

219. Cochineal Scales (*Dactylopius* sp.) on cactus pads.

220. Cochineal Scale (*Dactylopius* sp.) close up.

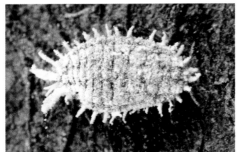

221. Mealybug (*Pseudococcus* sp.).

period, it was cultured in other parts of the world and its host, Prickly Pear Cactus, became widely dispersed. In Australia the spread of the plant became disastrous to ranchlands. A cactus-feeding pyralid moth from South America, *Cactoblastis cactorum*, was successfully introduced to control it. Synthetic dyes finally replaced the product and killed the industry.

RANGE: Several species are common in the deserts and other dry zones of southern California.

Family Pseudococcidae

◄ **221. MEALYBUGS** *Pseudococcus* **spp. and related genera**

ADULT: Mealybugs are like unarmored scale insects but are usually larger (BL 2–4 mm), have well-developed legs, and are quite mobile. They are covered with a frosty secretion of white wax and with fingerlike lateral and terminal filaments.

HABIT: They frequently congregate on the roots, stems, and leaves of citrus, garden, and greenhouse plants, causing harm by extracting sap and depositing honeydew.

RANGE: About 170 species are known throughout the state, occurring on many kinds of plants. Perhaps the most common is the Long-tailed Mealybug *(P. longispinus).*

Family Coccidae

▶ **222–223. KUNO SCALE** *Eulecanium kunoense*

ADULT: Male **(222)** BL 1–1.5 mm; shiny, black to reddish black; wings translucent with light reddish-brown edges. Female **(223)** about 3–4 mm in diameter and beadlike, shiny, dark red with black markings.

HABIT: On plum and other *Prunus*. Can become abundant and produce large amounts of honeydew, attracting ants and resulting in black sooty mold growth on plant leaves. Large populations can cause hosts to be water-stressed.

RANGE: The San Francisco Bay Area and the Sacramento Valley regions.

▶ **224. OAK LECANIUM SCALE** *Parthenolecanium quercifex*

ADULT: Female about 4–6 mm long; somewhat irregular convex form; dark brown or reddish brown, broad lengthwise, yellow-brown or orange median stripe.

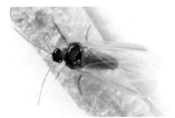

222. Kuno Scale
(*Eulecanium kunoense*) male.

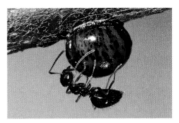

223. Kuno Scale (*Eulecanium kunoense*)
female being tended by a False Honey Ant
(*Prenolepis imparis*) worker.

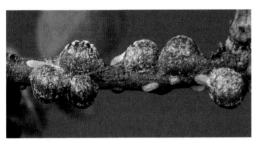

224. Oak Lecanium Scales
(*Parthenolecanium
quercifex*).

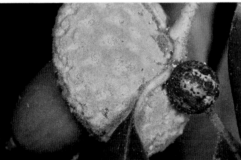

225. Gall-like Scale
(Kermesidae sp.) on oak.

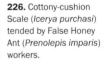

226. Cottony-cushion
Scale (*Icerya purchasi*)
tended by False Honey
Ant (*Prenolepis imparis*)
workers.

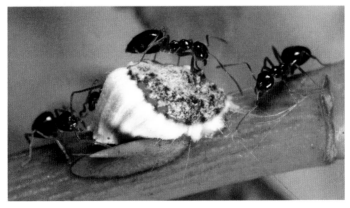

HABIT: Found primarily on oak, rarely on other woody plants. Large infestations produce copious amounts of honeydew.

RANGE: Throughout California at low elevations.

Family Kermesidae

◀ **225. GALL-LIKE SCALES** *Allokermes* **spp.,** *Kermes* **spp.**

ADULT: Female about 5 mm long; very convex shell, gall-like; pale brownish yellow, marbled with a slightly darker red tint, and small black spots throughout. Male pale pink to orange, wings translucent.

HABIT: On oaks or more rarely other related trees.

RANGE: Generally distributed across the state.

Family Monophlebidae

◀ **226. COTTONY-CUSHION SCALE** *Icerya purchasi*

ADULT: Male shiny black; opaque wings. Female an unarmored scale easily recognized by the elongate, fluted or grooved, white, waxy egg sac; large (BL 5–7 mm; with egg sac, 10–15 mm); egg sac contains hundreds of bright red oblong eggs; body color reddish brown, legs black; tufts of short black hairs in parallel rows along edge of body.

HABIT: Feeds on a wide variety of plants. Before the turn of the 20th century, this species nearly destroyed the citrus industry in southern California, earning it a place among agriculture's worst pests. A native of Australia, this species was introduced at Menlo Park in 1868 or 1869. The growers were able to stop it only with help from the Vedalia Beetle **(357)**, a natural predator brought from Australia in the 1880s. This was an early example of the technique of biological control.

RANGE: Still widely distributed in California and a potential danger to citrus.

Psyllids (Family Aphalaridae)

▶ **227–228. RED GUM LERP** *Glycaspis brimblecombei*

ADULT: BL 4–5 mm; yellow to light green with conspicuously darker eyes.

NYMPH: Up to approximately 1.5–2.0 mm in length; yellowish orange, with dark-brown coloration on the wing pads, legs, antennae, last abdominal segments, and in blotches on the dorsal areas of the head and thorax. The wing pads and other parts of the body have bright white spots. Nymphs

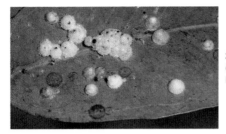

227. Red Gum Lerps (*Glycaspis brimblecombei*) closed lerps on bottom of leaf.

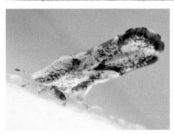

228. Red Gum Lerp (*Glycaspis brimblecombei*) open lerp revealing the resident insect.

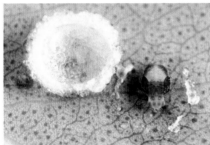

229. Asian Citrus Psyllid (*Diaphorina citri*).

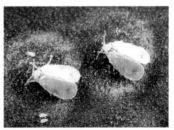

230. Iris Whiteflies (*Aleyrodes spiroeoides*).

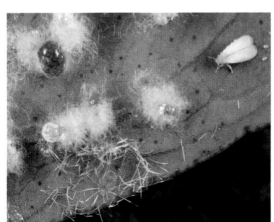

231. Wooly Whitefly (*Aleurothrixus floccosus*) adult and nymphs.

form a lerp, a hard covering mainly comprised of hardened honeydew, under which they shelter **(227)**. Lerps are 1–4 mm in diameter and are usually off-white to gray or black. Lerps occupied by nymphs often have curled tendrils of wax protruding from the upper surface.

HABIT: Native to Australia but has been introduced in many parts of the world where eucalyptus trees are now grown.

RANGE: Distributed in California with its host plant.

Family Psyllidae

◄ **229. ASIAN CITRUS PSYLLID** *Diaphorina citri*

ADULT: BL 3–4 mm; mottled brown, head uniformly light brown; fore wing is broadest in the apical half, mottled with a brown band extending around the edge of the apical half of the wing; generally they are covered with a whitish, waxy secretion, making them appear dusty.

HABIT: An important citrus pest introduced from Asia. This psyllid is a vector of a serious citrus disease called "greening disease" (or Huan-glongbing). The disease is responsible for the destruction of several citrus industries in Asia and Africa.

RANGE: It is known to occur throughout southern California.

Whiteflies (Family Aleyrodidae)

Both wings and body of these minute (BL 2–3 mm) sternorrhynchans are covered with a fine, white, powdery wax. The wings at rest are held rooflike over the body, and the insect resembles a tiny moth. Male and female are winged and similar. The nymphs of many species resemble scale insects and secrete flat wax plumes or ribbons from the back. Radiating from the body, these excrescences make the insect look like a tiny flower. Whiteflies occur in dense colonies, usually on the undersides of leaves of citrus, greenhouse, and other valuable plants. Sap feeding by adults and nymphs causes leaf curl and general decline. Damage occurs also from heavy honeydew deposition that encourages the growth of sooty fungus. This is primarily a tropical group and relatively few species live in California.

Family Aleyrodidae

◄ 230. IRIS WHITEFLY *Aleyrodes spiroeoides*

ADULT: BL about 1 mm; coated with a white, powdery wax, with a dusky black, ill-defined spot on the wings.

HABIT: Common on field crops such as strawberries but rarely a significant pest, unlike the similar Greenhouse Whitefly (*Trialeurodes vaporariorum*), which lacks the dark marks on the wings and has become a major pest along the Central Coast and in southern California.

RANGE: Associated with a wide variety of crop plants across the state.

◄ 231. WOOLY WHITEFLY *Aleurothrixus floccosus*

ADULT: BL 1–1.5 mm; white wings, abdomen yellowish white, coated with a white, powdery wax.

NYMPHS: Flat, oval with "wooly" white wax filaments.

HABIT: Found on a variety of plants, significantly on citrus as a pest. An introduced species detected in 1966 in California, where an attempt to eradicate it was unsuccessful.

RANGE: Primarily in southern California citrus-growing regions.

Thrips (Order Thysanoptera)

Thrips (plural and singular are the same) are peculiar, tiny insects, commonly less than 1 mm long, although a few range up to 5 mm. They are mostly yellow, brown, or black, and are found on vegetation, particularly in flowers. Adults sometimes are wingless but usually have four very narrow wings with reduced venation and long marginal fringes. Many thrips exhibit the behavior of curving the apex of the abdomen upward, and in winged individuals this is preparatory to flight. Thrips have unique mouthparts in which the right mandible is greatly reduced, and only the left mandible is used for puncturing food. In some respects the metamorphosis is of an intermediate type, and although they are considered hemimetabolous and the sister group to the Hemiptera, thrips have a pupal stage, which has evolved quite independently of the holometabolous orders. The early stages, or nymphs, resemble the adults in general form but are often pale-colored, followed by one or two active or inactive "pupal" instars, during which some species spin a cocoon in which the adult develops. This combination of traits makes them unlike any other insects.

The vast majority of species feed by sucking juices from living plants, causing typical silvering or stippling of the leaves, and many are quite specific as to the kind of plant inhabited. Some species are predaceous and can be important for biological control of plant pests, including other thrips species, while others live in moist, decaying plant matter such as under bark of dead trees. Thrips often occur in tremendous numbers and can cause severe injury to crop plants by drying up blossoms or developing fruit. In some cases their feeding can also deform the leaves of their host, forming galls that shelter social colonies. A few transmit plant virus diseases.

There are two suborders: the Terebrantia, in which females possess a sawlike ovipositor, and the Tubulifera, in which both sexes have the terminal abdominal segments tubelike. The latter group contains only about one-third of the close to 300 species of thrips recorded in California, but Tubulifera are more secretive in their habits, fewer are of economic concern, and likely many more species await discovery.

Family Thripidae

▶ **232. BEAN THRIPS** *Caliothrips phaseoli*
ADULT: BL 1–1.5 mm; black with white bands on the wings.
NYMPH: Yellow with pink or red markings.
HABIT: Bean and alfalfa are among the preferred host plants. Feeding results in whitened areas on tops of leaves where chlorophyll has been removed; copious small dark deposits of fecal material is usually seen on leaves.
RANGE: Found throughout the state on suitable plants.

▶ **233. WESTERN FLOWER THRIPS** *Frankliniella occidentalis*
ADULT: Small (BL about 1.0 mm); orange-yellow with dusky markings on the sides of the abdomen, large eyes, and covered with stout bristles.
HABIT: Major crop pest and vector of tomato spotted wilt virus, it has evolved resistance to many pesticides. Found on innumerable kinds of flowers, leaves, and fruit.
RANGE: Native to the West, it is the most widespread thrips in California (and now probably the world); occurs almost throughout the state in a wide variety of habitats, from Mount Whitney to the Imperial Valley.

▶ **234. GREENHOUSE THRIPS** *Heliothrips haemorrhoidalis*
ADULT: BL about 1.25 mm; dark brown to almost black; with a reticulated surface and transparent wings.

232. Bean Thrips
(*Caliothrips phaseoli*).

233. Western Flower Thrips
(*Frankliniella occidentalis*).

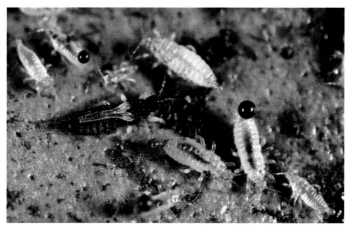

234. Greenhouse Thrips (*Heliothrips haemorrhoidalis*) adult and nymphs.

235. Black Hunter Thrips
(*Leptothrips mali*).

236. Myoporum Thrips
(*Klambothrips myopori*).

237. Leaf deformed by Myoporum Thrips
(*Klambothrips myopori*).

238. Wasp-like Thrips
(*Franklinothrips vespiformis*).

HABIT: It feeds on and most often damages a wide range of woody ever-greens, including rhododendron, azalea, and avocado.

RANGE: In greenhouses throughout the world and outdoors in areas with mild climates, such as coastal parts of California.

Suborder Tubulifera

Family Phlaeothripidae

◄ **235. BLACK HUNTER THRIPS** *Leptothrips mali*

ADULT: Relatively large (BL 1.8–2.6 mm); dark brown to black elongate abdomen with clear, white wings that appear as a white line down the back when folded.

HABIT: This beneficial species occurs on a wide range of plants where it is predaceous on a variety of mites, scale insects, aphids, moth eggs, and pest thrips. Actively searches plants, unlike the plant-feeding species.

RANGE: Throughout most of California, on both sides of the Sierra Nevada at low to moderate elevations, to the margins of the deserts.

◄ **236–237. MYOPORUM THRIPS** *Klambothrips myopori*

ADULT: Large (BL to 2.5 mm); dark brown to black with transparent wings. Antennae with yellow-and-black banding. Superficially similar to Green-house Thrips *(Heliothrips haemorrhoidalis)* **(234)**, use host plant association to distinguish the two.

HABIT: This species is a recent invader, native to New Zealand, but first described in 2006 from specimens collected across southern California, as a species new to science, indicating just how poorly known thrips are. It is having a devastating impact on introduced ornamental *Myoporum* (dwarf myrtle), widely planted in the drier, coastal lowlands of California, especially along roads. However, because *Myoporum* has invaded natural areas and competes with native plants, many consider it to be a beneficial introduction, controlling a weed that should never have been brought to California. In Hawaii there are native, rare *Myoporum* species, and the recent introduction of this thrips there is having a wholly negative impact on the native ecosystem as the insect spreads, uncontrolled, across the islands. Feeding causes severe deformation of the terminal host leaves **(237)**, making the insect's presence quite conspicuous.

RANGE: Along the coast from at least the San Francisco Bay Area south to San Diego, possibly limited inland due to cold or hostplant availability.

◀ **238. WASP-LIKE THRIPS** *Franklinothrips vespiformis*
ADULT: BL 2.5–3.0 mm. Females have long legs and a constricted waist; brown to black, with banded black-and-white wings and a white band at the base of the abdomen. Males are very rare and have less constricted waists, smaller than females, with longer, darker antennae.

HABIT: The fast-moving antlike adults are beneficial as predators of small arthropods, often feeding on pest species. Last-stage nymphs construct a silken cocoon within which they pupate.

RANGE: At least coastal and southern parts of the state. Possibly more widespread.

Fishflies and Alderflies (Order Megaloptera)

Members of the order Megaloptera are medium-sized to large insects, which are found around streams the larvae inhabit. The adults have long wings that are folded rooflike over the back when at rest, and they are most often seen clinging to streamside vegetation. Males of some species have greatly enlarged, scythelike mandibles that are used to compete for females, but they are harmless. The females, with smaller, stouter mandibles, can give a powerful bite, much like the larvae. The larvae ("hellgrammites") are aquatic and are distinguished by the tail-like last segment and slender, tapering lateral processes on the abdominal segments. Tufts of filaments on or at the bases of these processes serve as gills, and most hellgrammites spend their entire larval lives under water. They have large, powerful mandibles and are fiercely predaceous on all kinds of small animals. They seek prey in the bottom mud or under debris, and are most active at night, when they can be spotted with a flashlight. When mature, the larvae leave the water and burrow into banks above the waterline where they pupate in earthen cells. The adults do not enter the water but deposit the eggs in masses on objects overhanging aquatic habitats.

Fishflies (Family Corydalidae)

▶ **239–240. CALIFORNIA FISHFLIES** *Neohermes* **spp.**
ADULT: Large (BL 40–55 mm to wing tips; wing expanse 85–105 mm); wings gray with a transverse, variegated pattern of interrupted black lines. Antennae of males are as long as the body and have beadlike segments, each with a band of erect hairs around it.

LARVA: (240) Commonly called a hellgrammite. Elongate (BL to 40 mm); cylindrical; body white or brown, head usually and thorax often darker brown; abdomen with lateral, fingerlike processes on segments 1–8; last segment with a pair of lateral hooks. Hides in leaf and twig litter in small streams.

HABIT: Adults nocturnal and often attracted to lights near streams during summer. Larvae are found in seasonal streams and only rarely in perennial reaches.

RANGE: Three similar species occur widely in mountainous areas of the state: *N. filicornis* **(239)** in southern California and the Coast Ranges north to Mendocino County; *N. inexpectatus* from a few locations in Napa, Sonoma, and Mendocino Counties; *N. californica* in the Cascade Range and Sierra Nevada foothills to about 2,000 m elevation. Several species of another genus, *Protochauliodes* **(241)**, co-occur and are easily confused with *Neohermes*. They are similar in general appearance but differ by having threadlike antennae in both sexes.

Alderflies (Family Sialidae)

▶ 242. CALIFORNIA ALDERFLIES *Sialis* **spp.**

ADULT: Medium-sized (BL 10–15 mm); wings and body smoky black. Fly sluggishly during the day amid streamside vegetation.

LARVA: Similar to preceding but much smaller (BL 10–15 mm); can be distinguished by abdomen with lateral filaments on segments 1–7 only and terminating with a distinctive long, median filament or tail and no lateral hooks at the terminus of the abdomen.

HABIT: Aquatic, in stream riffles, debris, and pools.

RANGE: Coastal, foothill, and montane areas of northern California, restricted to mountains in southern California. Five quite similar species occur in the state.

Snakeflies (Order Raphidioptera)

The snakefly lineages have largely maintained their form for over 100 million years; their current global distribution is likely relictual. Adult snakeflies are characterized by the prolonged head and very long first thoracic segment, which are movable and give them a serpentlike appearance. The wings are transparent with a conspicuous dark spot on the anterior margin near the tip. Females have recognizable, long ovipositors. Some species have pupae that can move very actively, escaping

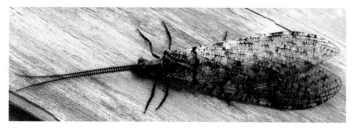

239. California Fishfly (*Neohermes filicornis*) adult.

240. California Fishfly (*Neohermes* sp.) hellgrammite.

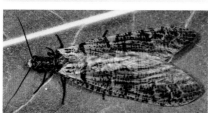

241. California Fishfly (*Protochauliodes* sp.).

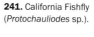

242. California Alderfly (*Sialis* sp.).

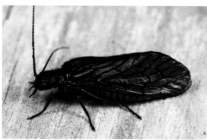

243. Common Snakefly (*Agulla* sp.).

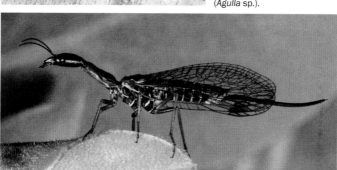

would-be predators, which is uncommon among insects. They devour a variety of smaller insects including aphids and other plants pests. In North America they are restricted to the West and are most common in California. The order is divided into two families, Raphidiidae and Inocelliidae, the latter is less common and most easily distinguished from the former by having much longer and thicker antennae and the absence of dorsal simple eyes (ocelli).

◄ **243. COMMON SNAKEFLIES** *Agulla* **spp.**

ADULT: Medium-sized (BL 12–25 mm to wing tips); ocelli present; wing spot containing a crossvein. Antennae shorter than head. Common on shrubs from early spring through summer.

LARVA: Elongate (BL 15–20 mm); head and first thoracic segment shiny black; abdomen pinkish brown; slightly swollen at middle.

HABIT: Larvae found under loose tree bark and in other protected habitats where they prey on other small insects. Pupa can writhe rapidly to escape capture.

RANGE: Generally distributed throughout much of the state, including urban areas; more common in cooler climes and mountains, absent from southeastern deserts. About a dozen similar species are known in California.

Nerve-winged Insects (Order Neuroptera)

The Neuropterans are characterized by four membranous wings with many branched, longitudinal veins connected by a great many crossveins. Adults have chewing mouthparts and larvae have long, sickle-shaped, hollow mandibles to pierce prey. Both adults and larvae are typically predacious but a few feed on nectar or pollen, and some adults do not feed. Neuroptera have a pupal stage, and the larvae have ecologies and appearances that are very different from the adults. There are more than 150 species represented in California.

Green Lacewings (Family Chrysopidae)

▶ **244–246. GREEN LACEWINGS** *Chrysoperla* **spp.,**
 Chrysopa **spp.**

Two of the most common genera, these are hard to distinguish.

ADULT: A large group of species of small (BL 10–15 mm), delicate, green, yellow-green, or brown neuropterans with transparent, shining wings

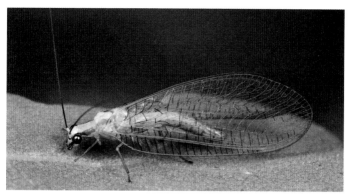

244. Colorado Green Lacewing (*Chrysopa coloradensis*).

245. Green Lacewing (Chrysopidae sp.) eggs.

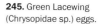

246. Green Lacewing (Chrysopidae sp.) larva.

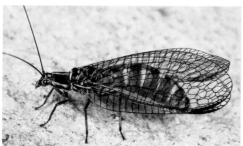

247. San Francisco Lacewing (*Nothochrysa californica*).

(anterior marginal crossveins of fore wing unbranched) and copper- or golden-colored shining eyes. They are common on foliage and often fly to lights at night.

LARVA ("APHID LION"): (246) Small (BL up to 10 mm); tapered toward both ends; mottled whitish tan to red-brown; thorax dark, with two pairs of light bumps on each side; head with a pair of conspicuous, sickle-shaped jaws used to capture and drain body juices of prey, which includes aphids; legs with a trumpet-shaped extension between the paired, apical claws.

EGGS: (245) Oval, white or pale green, elevated above the surface on long (5–10 mm) stalks.

HABIT: Larvae of some species have the curious habit of entangling carcasses of victims and other debris among their hooked body hairs, thus acquiring a kind of camouflage. One of the gardener's best friends because of the larva's voracious appetite for plant pests, especially aphids and scale insects. Adults feed on honeydew, pollen, or are predaceous. They produce a foul-smelling substance when disturbed.

RANGE: Widespread, common even in urban areas.

A representative species is the **Colorado Green Lacewing** *(Chrysopa coloradensis)* **(244)**. Frequently found in milder climates, especially common in midsummer.

◄ 247. SAN FRANCISCO LACEWING *Nothochrysa californica*
ADULT: BL 11–13 mm; head with distinct orange and black pattern; pronotum with pale middle stripe; abdomen black or brown with each segment having a pale transverse line.
HABIT: Found on oaks and conifers in moist, coastal and Sierran forests.
RANGE: Found in coastal counties throughout the state and in the Sierra Nevada.

Brown Lacewings (Family Hemerobiidae)

There are more than two dozen genera in this family worldwide. While most species are brown or dark yellow, they can, despite their name, also be green. Recent DNA-based research suggests that they may be most closely related to Mantispidae despite superficially resembling the green lacewings.

► 248. PACIFIC BROWN LACEWING *Hemerobius pacificus*
ADULT: Resembles green lacewings in general form and habits except for usually smaller size (BL 5–10 mm), somber brown or yellowish-brown colors, and anatomical details (anterior marginal [costal] crossveins in fore wing forked).

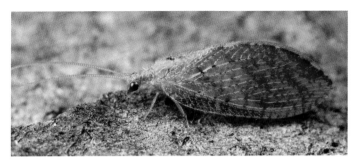

248. Pacific Brown Lacewing (*Hemerobius pacificus*).

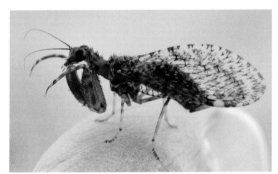

249. Brown Mantispid (*Plega signata*).

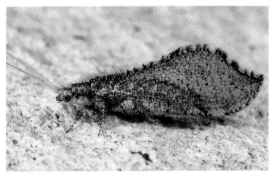

250. Termite Terror (*Lomamyia* sp.).

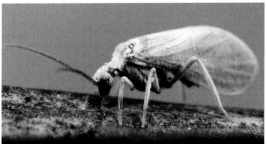

251. Common Dustywing (*Semidalis* sp.).

LARVA: Similar to chrysopids but more slender-bodied and with smaller heads and mandibles; distinguished by lack of trumpet-shaped extension between the paired tarsal claws, and lack of hooked body hairs. Feed on small, soft-bodied insects and mites, including many agricultural pests such as spider mites, aphids, and other sternorrhynchans.

EGGS: Placed singly directly on the substrate, not elevated on stalks.

HABIT: Various species of brown lacewings are used widely in biological control. The Pacific Brown Lacewing is known to feed on pests such as acacia psyllids. They are low-temperature tolerant and active throughout the year in coastal areas.

RANGE: Widespread in the state.

Mantispids (Family Mantispidae)

Mantispids are named for their enlarged grasping forelegs, resembling those of mantises, that make them easily recognizable. Among the several species in the state, one is of wide distribution (*Leptomantispa pulchella*); many of the others are confined to the desert areas; all are restricted to lower elevations and foothills. The family is far more abundant and diverse in more humid and tropical climates, and they are often Batesian mimics of wasps or bees. They are frequently attracted to lights at night. The family has remarkable life histories with the larvae of different species attacking a range of insects and spiders. In some cases they feed as a parasite on the blood (hemolymph) of adult spiders; in other cases they prey on eggs within the spider's egg case. Adults are predatory.

◀ 249. BROWN MANTISPID *Plega signata*

ADULT: Medium-sized (BL 22 mm to wing tips); wings speckled with black.

HABIT: Nocturnal, often attracted to light.

RANGE: Restricted to lower elevations of southern California.

Beaded Lacewings (Family Berothidae)

An early report on the natural history of the beaded lacewings challenges credibility. The larvae are obligate cohabitants of termite nests. There, they feed on termite workers that are immobilized after encountering the waving tip of the lacewing larva's abdomen. It has been speculated that a blast of gas produced from their anus subdues their hapless victims. This amazing story remains to be fully confirmed and understood. There is only one genus, *Lomamyia,* with about 10 species in the United States. While the group is thought to be rare, this may be an artifact of their small size and resemblance to lacewings.

◄ 250. TERMITE TERRORS *Lomamyia* **spp.**

ADULT: Small (BL 9–13 mm); head with prominent, bulbous eyes, long antennae. Thorax and wings are hairy, including hairy wing fringe. Abdomen yellow. Wings with indistinct light and dark brown patches and black spots, diagnostic curve, and swooping apical indent on wings easily identifies this genus.

LARVA: Larvae with small head, straight mandibles, elongate soft, tapered body.

HABIT: Eggs laid on trees or logs near termite colonies. First instar larvae enter and inhabit termite nests, where they apparently subdue termites with anal gas.

RANGE: Occurs in the foothills of all mountain ranges from the Mexican border north to at least Sonoma County. May occur more broadly; apparently absent from deserts. Sparse records suggest a flight period between May and September. Attracted to lights.

Dustywings (Family Coniopterygidae)

◄ 251. COMMON DUSTYWINGS *Coniopteryx* **spp.,**
 Semidalis **spp.**

ADULT: Dustywings might be confused with whiteflies **(230–231)** because of their small size (BL 2–3 mm) and powdery-white wax covering, but coniopterygids have long, threadlike antennae and chewing mouthparts. The simple wing venation with few crossveins distinguishes them from other Neuroptera.

LARVA: Smooth; large thorax and small, strongly tapering abdomen.

HABIT: Mainly arboreal and often occur on conifers, oaks, and other trees as well as on many other kinds of plants. Prey actively on tiny plant-feeding insects and mites, and are beneficial to horticulture.

RANGE: Seldom noticed because they are small, but there are more than 20 species known from various parts of California, several recently discovered.

Spongilla-flies (Family Sisyridae)

▶ 252. SPONGILLA-FLY *Sisyra vicaria*

ADULT: Similar to Pacific Brown Lacewings (*Hemerobius pacificus*) **(248)** but smaller (BL 5–6 mm) and with the two major, anterior, longitudinal wing veins fused some distance from the wing tip. Wings uniformly deep, smoky brown, legs and body lighter brown.

LARVA: Aquatic; form basically similar to that of lacewings but mouthparts joined in front of the head, mandibles very long and needlelike; several pairs of segmented gills on the abdomen. From lakes and slow-moving water with host sponges.

HABIT: Adults found near water on vegetation or at lights and feed on nectar, pollen, and small insects. Larvae live on freshwater sponges, piercing the cells for food.

RANGE: Known from records in Lake and Mendocino Counties.

The California Spongilla-fly *(Climacia californica)* is smaller yet (BL 4 mm or less) and has a distinct pattern of white and dark brown markings on its wings. Known in California first from Clear Lake but occurs in other northern lakes and parts of the Sacramento River Delta, where the host sponges occur. A record from Imperial County suggests a much wider range. The Clear Lake population may have been exterminated by the indiscriminate insecticide treatment for the Clear Lake Gnat.

Moth and Giant Lacewings (Family Ithonidae)

▶ **253. MOTH LACEWING** *Oliarces clara*

ADULT: Medium-sized (BL 22–34 mm to wing tips, wing expanse 25–40 mm); body dark brown to black; wing membrane milky, translucent, shiny; tufts of black hair protruding from sides of thorax.

HABIT: This is a rarely seen insect whose life history was almost a complete mystery until recently. Moth and Giant lacewings are an ancient branch of Neuroptera and have a relictual distribution; *Oliarces* is a monotypic genus and has no close relatives in North America. During synchronized emergence, hundreds may be seen during late morning and early afternoon over a short period of days in April or May. May not be as uncommon as thought due to the very limited flight period.

LARVA: Subterranean, feeding on plant roots and resembles those of scarab beetles; they are the only plant-feeding group in all of Neuroptera and related orders.

RANGE: Known only from desert canyons of Imperial, San Bernardino, and Riverside Counties; possible in adjacent parts of Arizona and Mexico.

Giant Lacewings

▶ **255. SPOTTED GIANT LACEWING** *Polystoechotes punctata*

ADULT: Large (BL 22–38 mm to wing tips); hairy, with broad wings marked with numerous small or medium-sized irregular, dark brown spots;

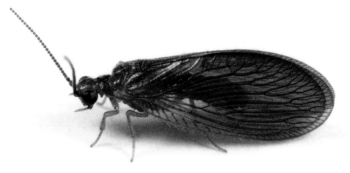

252. Spongilla-fly
(*Sisyra vicaria*).

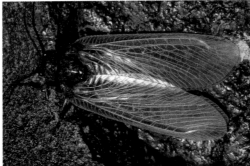

253. Moth Lacewing
(*Oliarces clara*).

254. Lined Giant
Lacewing
(*Platystoechotes lineatus*).

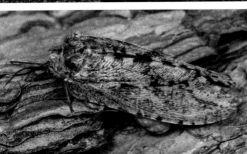

255. Spotted Giant
Lacewing
(*Polystoechotes punctata*).

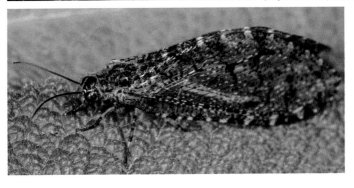

longitudinal veins of central area of wing mostly parallel, only one staggered line of crossveins.

HABIT: Often attracted in numbers to campfires or porch lights at night in wooded areas. The larvae are terrestrial predators but poorly known. Fly in very late summer in the Sierra Nevada or early fall in the Coast Ranges.

RANGE: At middle to high elevations in the Sierra Nevada, White Mountains, and Cascades; down to near sea level in the far North Coast Ranges. Can be seen around Lake Tahoe. The Lined Giant Lacewing *(Platystoechotes lineatus)* **(254)** is related and roughly similar-looking to the Spotted Giant Lacewing but is more heavily built and more densely hairy and gray. It is endemic to the Sierra Nevada.

Antlions (Family Myrmeleontidae)

Antlions are well represented in all parts of the state, with more than 50 species. They are best known from the larval habits of certain genera (only *Myrmeleon* in California), which wait at the bottom of funnel-shaped pit traps they construct in sandy soil **(258)** to catch ants and other small insect prey. To increase its success, the larva pelts passing insects with sand grains until a victim tumbles into the larva's jaws. Most other genera conceal themselves in loose soil, lying in wait for unwary passersby. The irregular pathways they make as they move backward through loose soil resemble whimsical doodles, giving the larvae their nickname. The jaws are hollow and inject venom that immobilizes and digests tissues in the prey, which is then sucked dry. The victim's husks are unceremoniously tossed away.

Some species can take years to mature, and remarkably large adults can issue from much smaller larvae. While they occur throughout the state, species diversity is highest in the more arid, southern portions of California, where the dominant genus is *Brachynemurus*. The nocturnal adults are often attracted to lights and the larger species are sometimes mistaken for dragonflies, which they approach in size, but their clumsy flight and clubbed antennae are instantly diagnostic. The overall morphology of the group is rather homogenous, making generic determination challenging for the nonexpert.

▶ **256. COMMON ANTLIONS** *Brachynemurus* **spp.**

ADULT: Medium-sized (BL 25–50 mm); abdomen soft, very long and slender, extending considerably beyond wing tips; wings elongate with complex net venation but generally not spotted; antennae clubbed.

LARVA ("DOODLEBUG"): Small (BL 5–15 mm); robust, toadlike insects with conspicuous head jutting from an enlarged thoracic region, often a

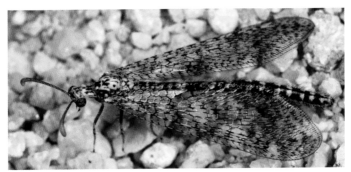

256. Sacken's Antlion
(*Brachynemurus sackeni*).

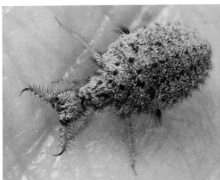

257. Pit Antlion (*Myrmeleon* sp.)
larva.

258. Pit Antlion (*Myrmeleon* sp.)
larval pit.

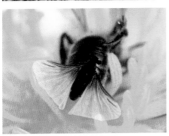

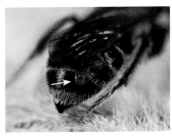

259. Stylops
(*Stylops* sp.) male.

260. Stylops (*Stylops* sp.) female
indicated by arrow.

bloated abdomen, head with outsized sickle-shaped jaws, and the integument bristly.

HABIT: The larvae lie beneath the surface of sandy soil with jaws exposed to catch passing insects. Burrow backward rapidly when disturbed. Adults are feeble nocturnal fliers; feed on small insects, nectar, or pollen.

RANGE: Arid and semiarid parts of the Central Valley, the Sierra Nevada, the central Coast Ranges, southern California, and deserts.

◀ 257–258. PIT ANTLIONS *Myrmeleon* spp.

These are the most famous members of the family, and their dramatic and conspicuous feeding strategy has inspired the imaginations of science fiction writers. There are several species in the state, which are difficult to distinguish.

ADULT: Medium-sized to large (BL 25–50 mm), much like the preceding genus, but wings can extend beyond abdomen. Wings often spotted.

LARVA: (257) Medium-sized to large (BL 5–15 mm); morphologically very similar to the preceding genus.

HABIT: Gentle sifting at the base of their pits **(258)** will reveal these miniature "monsters." Larvae form the familiar pits in loose soil, often near where ants forage. More common in arid regions but present in forests and along rivers and alluvial plains as well.

RANGE: Throughout the state in areas with loose soil.

Stylops (Order Strepsiptera)

This is perhaps one of the most bizarre orders of insect, which is truly saying something. The nine families and 600 or so species worldwide are so unusual in ecology and appearance that until recently there was hot debate as to which other order was their closest relative (Coleoptera has finally claimed that prize, supported by genomic data). The entire order has a bizarre life history in which the crawling early instar larvae, called triungulins, are scattered in the environment. Successful larvae find the particular host for their species and enter it, losing all their appendages. The larvae of different species are variously specialized to feed inside wasps, bees, Diptera, Hemiptera, Blattodea, Mantodea, Orthoptera, or Zygentoma. Usually the adult female spends all her life in a case inside the host insect, which is said to be "stylopized."

When mature, she protrudes her head and her brood canal opening located just behind her head, out from between the sclerites of the host abdomen. She then releases a pheromone that the males follow, mating with her, while she remains inside the host insect! The eggs hatch inside

the female, and the larvae crawl around inside her, feeding on her body briefly before dispersing into the environment from that same canal behind her head—all while the mother is still attached to her unwitting host. The males are small creatures with thick, featherlike antennae; bulging eyes; tiny, twisted fore wings; and large, fanlike hind wings. Fewer than 30 species are known in California. There has been some interest in using them as a biological control for some pest insects, though this has not been fully developed.

Family Stylopidae

◄ 259–260. STYLOPS *Stylops* **spp.**

Most commonly, species in this genus parasitize andrenine bees, and although the males are short-lived and rarely seen, stylopized bees can be fairly common, especially early in spring.

ADULT: (259) Males are small (BL 2–3 mm); black with white hind wings. Females **(260)** grublike, evidenced only by the tip of the head and thorax protruding from between adjacent abdominal segments of the host bee.

LARVA: When newly hatched, rapidly running, minute, silverfish-shaped (triungulin).

HABIT: Larvae emerge from the living bee as it visits flowers, where they wait to attach to legs of other bees that come along, to be carried back to the nests. There they seek out the bee larvae, burrow in, and change to a legless maggotlike form. They are fed by the host's blood and go through several molts but do not kill the bee larva. After the host pupates and undergoes metamorphosis to the adult bee, the stylops protrudes its head between two abdominal segments. Adult male stylops emerge through the projecting pupal shell, while the larviform female remains in place. Adult males may be attracted in numbers to a caged, stylopized bee if the female stylops is unmated. Either sex of the bee may be stylopized, and up to 30 stylops of both sexes may occur in a single bee.

RANGE: Relatively common in parts of the Coast Ranges, though various, less-common species are found wherever appropriate hosts occur.

Beetles (Order Coleoptera)

In terms of the number of named species, beetles make up the largest order in the animal kingdom, with about twice the number of described species of any of the three other major insect orders, Lepidoptera, Hyme-

noptera, and Diptera. Coleoptera are unsurpassed in morphological modifications and behavioral adaptations.

Beetles occur in nearly every conceivable habitat. In temperate regions they especially inhabit the ground and spend their life in the soil or on it, using decaying animal or vegetable substances. Dung, carrion, leaf litter, humus, rotting wood, and fungi all support large assemblages of beetles. A particularly rich habitat is beneath the bark of dead, standing, or fallen trees, where some species of about half the families can be found. Moreover, many species eat living plants, and their larvae are found on or in flowers, fruits, leaves, stems, or roots. A few are parasitic on other insects, and many are predators. More than a dozen families are true aquatic insects, and several other families have aquatic or semi-aquatic representatives in freshwater or more rarely in brackish water. Of the more than 23,000 species of beetles in North America, it is safe to say that there are at least 8,000 species in California, and many await discovery and description.

Included in the order are some of the largest and some of the smallest of all insects in California. They range from 60 mm in female California *Prionus* longhorns **(359)** to less than 2 mm in some featherwing beetles (Ptiliidae). Usually they have two pairs of wings, with the fore wings modified into hard or leathery covers (elytra), which almost always meet to form a straight line down the back. This is the most easily seen characteristic of beetles. Many species have the hind wings reduced or missing and are flightless. When present, the hind wings are membranous and folded beneath the elytra when not being used for flying. The mouthparts are adapted for biting and chewing with well-developed mandibles. Metamorphosis is complete, and larvae show a great diversity of form and habits from grublike borers, to rapidly running or swimming, silverfish-shaped predators, caterpillar-like plant feeders, and so on. Normally pupation takes place in chambers in the soil or wood, without a cocoon.

Reticulated Beetles (Family Cupedidae)

Reticulated beetles are well-represented in the fossil record starting in the Jurassic, so the few species found today are thought to be remnants of a much greater diversity. California has only two or three species, all of which are typical for the family in being narrow, elongate beetles with distinctive rows of square punctures and a covering of scales on their elytra. Adults and larvae are borers in rotten wood.

▶ **261. TOOTHED RETICULATED BEETLE** *Priacma serrata*
ADULT: BL 10–20 mm; gray with reticulate black markings, elytra more-or-less distinctly punctate.

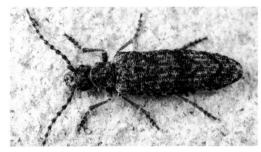

261. Toothed Reticulated Beetle (*Priacma serrata*).

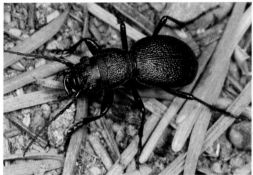

262. California Night-stalking Tiger Beetle (*Omus californicus*) adult.

263. California Night-stalking Tiger Beetle (*Omus californicus*) larva.

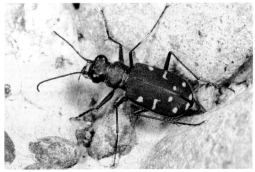

264. Oregon Tiger Beetle (*Cicindela oregona*).

HABIT: Adult males are known to sometimes be attracted in large numbers to bleach or freshly bleached fabric. Presumably the bleach contains a chemical also produced by females as a pheromone.

RANGE: Found in the Sierra Nevada and the Transverse and Peninsular Ranges.

Tiger Beetles and Ground Beetles (Family Carabidae)

With well over 700 species in California, carabid beetles are one of the most diverse families of insects in the state. Most are brown or black, medium-sized beetles, but some are metallic colors, mostly bronze, green, or shades of purple. They are widespread across habitats and are found in both highly disturbed and pristine natural areas. Most are natives, but there are several introduced species that are common in disturbed habitats and gardens. Areas that are moist or at least seasonally have available water have the greatest diversity and abundance of these beetles. They are mostly considered beneficial, predatory species, but many will scavenge widely, a rare few occasionally damaging fruit crops. All are chemically defended, secreting smelly, irritating substances from abdominal glands when threatened.

Tiger Beetles

Tiger beetles are highly active predators that typically feed on other arthropods. They have prominent eyes and large, curved, toothed mandibles that can be used to great effect on their prey. Larvae in this group live in burrows where they lie in wait with their head and first thoracic segment forming a trap door **(263)**. When a small insect or other arthropod passes by, the larva springs out from the burrow to grab its meal. Because of their distinctive appearance, they have frequently been classified as a separate family. However, recent systematic studies place this group within Carabidae. There are around 70 species of tiger beetles in California.

◀ 262–263. CALIFORNIA NIGHT-STALKING TIGER BEETLE *Omus californicus*

ADULT: (262) BL 13–19 mm; black to dark brown, pronotum variably roughened, elytra more-or-less distinctly punctate. There is a significant amount of variation between individuals of *O. californicus* in sculptur-

ing of the pronotum and elytra and in general proportions of the body regions. Because of this, several subspecies have been described and these may represent a complex of species in the region.

HABIT: They can be abundant in both oak woodland and conifer forest. These large, flightless predators are nocturnally active walkers and can often be found under woody debris in open forests and forest margins during the day. The larvae **(263)** can be found by looking for pencil-sized diameter holes in the ground along paths and banks in the forests and woodlands where adults are known to occur.

RANGE: Found in the Coast Ranges, coastal and inland foothills to southern California, and throughout the Sierran entomofaunal province.

◄ 264. OREGON TIGER BEETLE *Cicindela oregona*

ADULT: BL 10–14 mm; dorsally deep brown to olive color, elytra with variable yellowish-white markings, labrum yellowish white; ventrally metallic green. This and other *Cicindela* species are often beautiful, metallic colors and are extremely wary, fast moving, and quick to fly when pursued.

HABIT: This species and many species of the genus are active during the day in areas with exposed, often sandy soils adjacent to water. Especially common on sandy shores of coastal beaches, creeks, and rivers well inland. While typically active during the day, they are sometimes found at lights at night.

RANGE: Widely distributed throughout California.

The beautiful white-marked, metallic-green **Ohlone Tiger Beetle** *(C. ohlone)* **(265)** is found only in Santa Cruz County and is federally listed as an endangered species. Its narrow habitat requirements that restrict it to selected grasslands have put these beetles in conflict with human activities in the area.

Ground Beetles

The bulk of the species in Carabidae are terrestrial predators and scavengers collectively known as ground beetles. While it is true most species in California are found in the leaf litter and soil, some are arboreal—a habitat where they are commonly found in the tropical parts of the world. Ground beetles can be found in every habitat in the state—from caves, seashores, lawns, and farmlands to pristine mountaintops. Often one or more species of ground beetle is the most common beetle found in a given area, so every beginning collector or insect enthusiast will encounter a variety of species. California has more than 700 species.

▶ 266. CATERPILLAR HUNTERS

Calosoma **spp.**

Members of this genus are large beetles having the thorax nearly as wide as the abdomen, much wider than the head. They are black, green, or bronze-colored, often with a metallic iridescence. Some species are expert tree climbers and voracious predators of caterpillars and other insect defoliators. Adults are often seen at lights, feeding on the remains of insects that have been crushed underfoot or that these large beetles have killed themselves. When disturbed, they give off a distinctive fetid odor from abdominal glands.

BLACK CALOSOMA

Calosoma semilaeve

One of the most common *Calosoma* species in California.

ADULT: (266) Large (BL 20–27 mm); black and almost smooth.

LARVA: Shining black above with white markings on the sides and ventrally. Feeds on cutworms and other ground-inhabiting arthropods.

RANGE: Found in southern California, most commonly at low elevations in coastal regions and in the Central Valley.

California's most spectacular but less common caterpillar hunter is the Green Caterpillar Hunter *(C. scrutator)*, a large (BL 28–34 mm), variably colored and often steel blue with burnished head and thorax and metallic-green elytra that is margined in gold. These beetles live on the ground but commonly climb willows to catch caterpillars in the Central Valley.

▶ 267. SNAIL-EATER BEETLES

Scaphinotus **spp.**

Characterized by their narrow, elongate head and mandibles, relatively narrow pronotum, and broad convex elytra. Usually black, some species have a subtle metallic blue or purple color at the margins.

ADULT: BL 13–20 mm.

HABIT: Common in conifer forests and oak woodlands but also frequently found in moist habitats with low brush and brambles. Known for eating snails and slugs as their name implies, they will feed on a variety of invertebrates and even eat fallen berries and other fruit. Their flight wings are completely absent and elytra fused. They are nocturnally active even during the winter months in coastal areas.

RANGE: Snail-eater beetles are found throughout the state except for the desert regions. ***Scaphinotus interruptus*** **(267)** is a typical and very common species in the Coast Ranges, foothills, and mountainous areas throughout central and northern California.

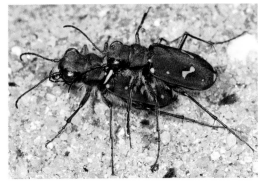

265. Ohlone Tiger Beetle (*Cicindela ohlone*) male top, female bottom.

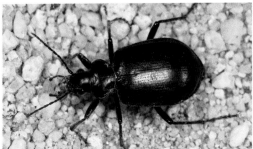

266. Caterpillar Hunter (*Calosoma semilaeve*).

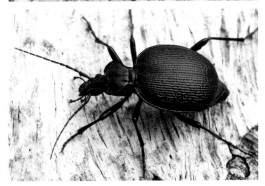

267. Snail-eater Beetle (*Scaphinotus interruptus*).

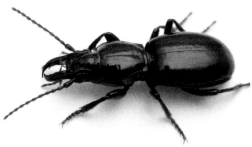

268. Smooth Millipede Hunter (*Promecognathus laevissimus*).

◄ 268. SMOOTH MILLIPEDE
HUNTER *Promecognathus laevissimus*

ADULT: Small to medium-sized (BL 5–18 mm); deep black, shiny. Body form is notably narrowed in the middle and the jaws are massive, as long the rest of the head.

HABIT: Nocturnally active with adults abundant in winter and early spring. Although they will feed on a variety of invertebrates, they typically kill and feed on millipedes, using their elongate jaws to subdue and dismember the prey.

RANGE: Found in foothills and lower elevations in the coastal and North Coast Ranges and the Californian entomofaunal province.

▶ 269. CALIFORNIA TIDE-WALKER *Thalassotrechus barbarae*

ADULT: BL 5–7 mm; elytra bluish black; pronotum, head, and legs orange or reddish brown.

HABIT: One of the few carabids that is part of the intertidal crevice fauna. They emerge to forage and mate at night only during periods of low tide.

RANGE: In rocky but somewhat protected shorelines throughout the California coast.

▶ 270. TOOTHED ROUND SAND BEETLE *Omophron dentatum*

ADULT: BL 5–7 mm; form almost circular in outline, yellowish or reddish brown with broad, transverse black and metallic-green markings.

HABIT: Restricted to bare sandy areas immediately adjacent to freshwater, even on the coast where freshwater flows into sandy beaches.

RANGE: From Sonoma and Calaveras Counties at middle to low elevations, south to San Diego.

▶ 271. BOMBARDIER BEETLES *Brachinus* spp.

ADULT: BL 6–10 mm; head, pronotum, and legs reddish orange, contrasting with the blackish-blue elytra. The elytra are truncate, often exposing several terminal abdominal segments. There are many, nearly identical species in the genus in California.

HABIT: As far as is known, bombardier beetle larvae are ectoparasites of water beetles, so adults are found near lakes, rivers, and streams. Frequently huge numbers of adults of several species aggregate together under large rocks and woody debris along streams. *Brachinus* species and species of closely related genera produce a mix of hydrogen peroxide and hydroquinones in their defensive glands. When threatened, the beetles spray these compounds, mixing them with catalysts that cause a boiling-hot chemical reaction. When molested, a visible steam and audible pop are produced. The heat of the reaction can be felt, though it is not harmful

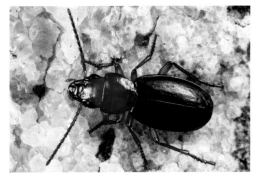

269. California Tide-walker (*Thalassotrechus barbarae*).

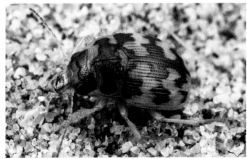

270. Toothed Round Sand Beetle (*Omophron dentatum*).

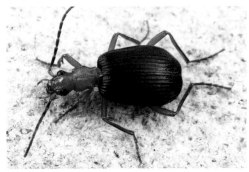

271. Bombardier Beetle (*Brachinus elongatulus*).

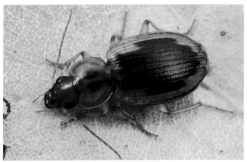

272. Tule Beetle (*Tanystoma maculicolle*).

to humans; however, it will discolor skin, leaving a small brown spot that fades in time. Regularly found at lights at night.

RANGE: Found commonly at low elevations throughout the state along medium-sized to large streams and rivers.

Metrius contractus, BL 10–14 mm, a solid black beetle that greatly resembles a darkling beetle, is another ground beetle bombardier that, unlike *Brachinus,* is common in the oak and bay woodlands of California in early spring. Though distantly related to *Brachinus*, it uses the same type of chemical reaction to deter predators.

◀ 272. TULE BEETLE *Tanystoma maculicolle*

ADULT: BL 8–12 mm; head, middle of the pronotum, and central portion of the elytra reddish brown or darker, almost black (extent and color rather variable); margins of the elytra and appendages paler, often yellowish brown.

HABIT: A very common beetle that can be found at the edges of watered lawns, in irrigated agricultural areas, moist pastures, marshy and riparian habitats. Occasionally there are reports of mass emergences coincident with early fall rains. In some cases beetles enter buildings, probably attracted to lights, and are considered a nuisance due to their strong defensive chemical odors. The chemical mix they produce is mostly formic acid with some rather smelly hydrocarbons.

RANGE: Found throughout California, including the Channel Islands, south to Baja California, Mexico. Common at low elevations and often very common in the Central Valley in disturbed habitats.

▶ 273. CALIFORNIA SUN BEETLE *Amara insignis*

ADULT: Medium-sized (BL 8–13 mm); stout, convex body, brown with a bronzy, green or blue luster.

HABIT: Open grassland and vernal pool edge areas. Sometimes day active but most active at night when they can be seasonally extremely abundant.

RANGE: Found along the coast, east to the western edge of the Central Valley in central California, south to Mexico. Other species of *Amara* are often seen scurrying along sidewalks and in grassy lawns. These have a similar form, although somewhat flatter and more oval than *A. insignis*, and may be black or brown but typically have a bronze sheen.

▶ 274. GIANT WOODLAND GROUND BEETLE *Pterostichus lama*

ADULT: Large (BL 15–29 mm), black beetles with powerful mandibles. Pronotum with distinctly sinuate margins.

HABIT: Found in conifer and mixed forests in association with logs and woody debris. A generalist feeder but primarily preying on large ants

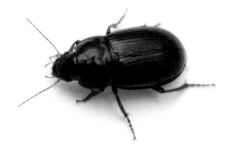

273. California Sun Beetle (*Amara insignis*).

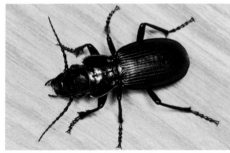

274. Giant Woodland Ground Beetle (*Pterostichus lama*).

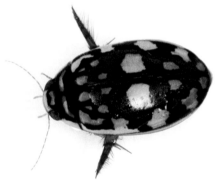

275. Yellow-spotted Water Beetle (*Thermonectus marmoratus*).

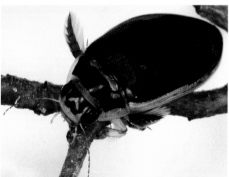

276. Giant Green Water Beetle (*Dytiscus marginicollis*).

and termites. The flightless *P. lama* is among the largest ground beetles in North America.

RANGE: Found throughout California at low elevations in coastal conifer woodlands and at higher elevations in all nondesert mountainous areas. The genus *Pterostichus* is species-rich and represented by at least 75 species in California. They vary in size, but all are of a similar recognizable form. *Pterostichus* species are often very abundant and occur in almost all habitats and across elevations from sea level to above tree line. The beginning collector is certain to encounter them.

Predaceous Water Beetles (Family Dytiscidae)

Members of the family Dytiscidae live in ponds and streams and are carnivorous as larvae and adults. The beetles are streamlined, oval in outline, and convex both above and below. They are distinguished from the scavenger water beetles, which they most generally resemble, by having threadlike antennae, longer than the head. Dytiscids swim by simultaneous strokes of the hind legs, which are flattened and fringed with long hairs. They breathe by periodically coming to the surface to collect a bubble of air that is taken at the end of the abdomen and held beneath the wing covers. The adults of most species can fly from pond to pond, and they are regularly attracted to lights.

In many species, eggs are deposited in stems of aquatic plants. The larvae that emerge are slender, spindle-shaped, often strongly tapered toward the head and tail. They swim using their legs, which are fringed with hairs. Breathing occurs through a pair of pores at the end of the abdomen; the last abdominal segments are fringed with hairs, enabling individuals to hang downward from the water's surface film. Some species have long, lateral filaments on the abdominal segments, which do not function as gills. When mature, the larva forms a cell in damp soil near the water, adults return to the water after emerging from the pupal stage.

This family is well represented in temperate regions, with about 160 species known in California. Dytiscids are widespread, numerous in species, often abundant, and active during the day. With the possible exception of the whirligig beetles, they are more often noticed than other aquatic Coleoptera, and most people who refer to "water beetles" have dytiscids in mind.

◀ 275. YELLOW-SPOTTED WATER BEETLES　　　*Thermonectus* **spp.**
Two pond-dwelling species include the most colorful of California's water beetles.

MARBLED WATER BEETLE *Thermonectus marmoratus*
ADULT: Medium-sized (BL 10–15 mm); rather broad, oval in outline **(275)**, black with 10 or 11 orange or yellow spots on each wing cover.
RANGE: Riverside and San Diego Counties.

CATTLE POND DIVING BEETLE *Thermonectus basillaris*
ADULT: Slightly smaller (BL 8–11 mm), black with irregular speckling forming longitudinal yellow marks on the sides and yellowish red legs.
RANGE: Lower elevation ponds from Shasta to San Diego Counties.

◀ 276. GIANT GREEN WATER BEETLE *Dytiscus marginicollis*
Most dytiscids are small or medium-sized (BL 3–10 mm), however, this is the largest dytiscid in California and is typically BL 26–34 mm.
ADULT: Elongate oval usually with a distinct dark green cast over dark brown, broad pale margins on the thorax and wing covers and legs pale.
HABIT: The adults typically live in grassland ponds that are frequently saline or temporary cattle ponds. They are regularly attracted to lights, where the beetles clumsily thrash about and attract attention.
RANGE: Common throughout the state where suitable habitat is found.

There are many other diving beetles including the oval diving beetles like *Cybister ellipticus* and *C. explanatus* that are similar to *D. marginicollis* but have the wing covers broadest beyond the middle, and lack the yellow margin at the anterior and posterior margins of the thorax and the patterns of spots typical of *Thermonectus* species **(275)**. *Cybister explanatus* occurs in the Central Valley, Owens Valley, and southern California, while *C. ellipticus* is limited to San Diego and Imperial Counties.

HOLY-DIVER BEETLES *Agabus* spp.
There are over 30 species of river beetles (*Agabus*) in California.
ADULT: Small to medium-sized (BL 7–12 mm); mostly black or with pale to dark brown wing covers, usually without longitudinal lines; margin of each eye with an indentation above the antenna.
HABIT: Members of *Agabus* are often the most prevalent water beetles in fast-flowing streams and rivers.
RANGE: Throughout the state wherever permanent running streams occur.

Whirligig Beetles (Family Gyrinidae)

Whirligig beetles are perhaps the most unmistakably recognizable family of all Coleoptera: shiny streamlined beetles that swim on the surface of ponds and still parts of streams. They are often seen in small aggregations

whirling in amazing feats of tireless acrobatic skating, constantly darting in graceful curves around one another. All the species appear elongate-oval in outline, flattened, and usually chrome black. They are otherwise easily distinguished from other water beetles by their eyes, which are divided into upper and lower portions (literally four eyes), enabling them to see simultaneously above and below the water surface. The hind legs, and middle legs to a lesser degree, are flattened, adapted for swimming. The larva is elongate with deeply constricted segments. Each of the first eight abdominal segments bears a pair of lateral, plumose gills, and two pairs are borne on the ninth segment. Both larvae and adults are predaceous on other small aquatic insects, worms, or small vertebrates. About 10 species are known in California.

▶ 277. COMMON WHIRLIGIG BEETLES *Gyrinus* spp.
Most of the state's gyrinids are similar-appearing members of the genus.
ADULT: Small (BL 5–6 mm); distinctive flattened body form and fully divided compound eyes; shiny black.
HABIT: Seen on the water surface, turning in rapid circles when alarmed.
RANGE: Throughout the state at a wide range of elevations, from desert canyons to above 2,000 m in the Sierra Nevada.

Trout-stream Beetles (Family Amphizoidae)

One genus and six species worldwide; a single species in California. Although aquatic beetles, they lack the swimming legs and the sleek hydrodynamic form of most other water beetles. Instead of swimming, they cling tightly to submerged woody debris and rocks in foam-covered eddies. Adults must periodically come to the surface and collect a bubble of air with the tip of their abdomen and wing covers to breathe. Likewise, larvae must extend the end of their abdomen to obtain air to breathe. Eggs are laid among the debris and both adults and larvae are found in the same habitat, preying or scavenging on other insects.

▶ 278. PROUD TROUT-STREAM BEETLE *Amphizoa insolens*
ADULT: Medium-sized to large (BL 10–15 mm); robust, black or deep brown beetles with relatively short antennae and thin legs.
HABIT: Typically found at higher elevations (around 2,000 m) in cold, flowing streams. More rarely in cold ponds with some inflow. When handled, adults emit a foul-smelling yellow-orange fluid that contains sulfur skatole (3-methylindole) from glands near the tip of the abdomen (pygidial glands) that gives it a fetid odor and acts as a defense against predators.
RANGE: Throughout the Sierra Nevada and Transverse Ranges.

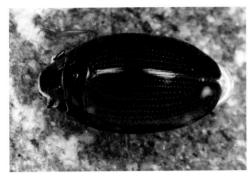

277. Common Whirligig Beetle (*Gyrinus* sp.).

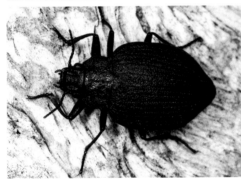

278. Proud Trout-stream Beetle (*Amphizoa insolens*).

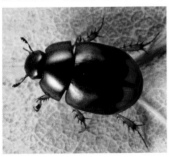

279. Spotted Dung Beetle (*Sphaeridium scarabaeoides*).

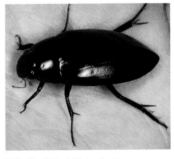

280. Giant Black Water Beetle (*Hydrophilus triangularis*).

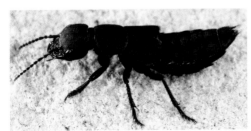

281. Devil's Coach Horse (*Ocypus olens*).

Scavenger Water Beetles
(Family Hydrophilidae)

The family Hydrophilidae includes beetles of diverse sizes and shapes, mostly adapted for life in stagnant ponds, water-filled ditches, shallows of lakes, or quiet places in streams containing an abundance of vegetation. Some species live in moist, decaying leaves, soil rich in humus, or fresh mammal dung. Hydrophilids are distinguished from other water beetles, especially the dytiscids, which they most resemble, by having short, clubbed antennae held in small grooves next to the eyes. The maxillary palps are usually very elongate and resemble antennae at a casual glance. The aquatic species are generally not as well adapted for swimming as are the predaceous water beetles, being less streamlined, with the back more convex and the underside concave, often bearing a conspicuous, posteriorly directed, median spine or keel. They swim by alternately stroking the hind legs, and they breathe by breaking the surface film of the water with the hairy antennal club. Air is taken in along pubescent tracts on either side of the thorax and is held under the wing covers and in hairy tracts along the underside.

The larvae also are of diverse form and structure: some of the aquatics have long gill-like structures on the first seven abdominal segments, but in most the breathing pores are functional only on the last segment, occurring there on protrusions or in pits; in terrestrial species the larvae are grublike with vestigial legs. The adults are mostly scavengers on decaying organic material, while a few are predaceous. The larvae of most are predaceous on other invertebrates. Most hydrophilids have dispersal flights in spring or fall. At these times the beetles may be attracted to lights in great numbers. The family is cosmopolitan, and about 70 species are recorded in California.

◀ 279. SPOTTED DUNG BEETLE　　　*Sphaeridium scarabaeoides*

ADULT: Small (BL 5–7 mm); circular in outline with convex back; black or dark brown with yellowish-orange tips and a reddish-brown spot on each wing cover.

LARVA: Slightly curved upward on both head and posterior ends, grublike with short legs, not tapered posteriorly; last segment enlarged, with a pair of lateral processes on each side.

HABIT: The beetles occur in fresh dung, especially cow manure, often when it is of almost liquid consistency. Feed on fly larvae in mammal dung.

RANGE: This species was introduced and established in North America from Europe in 19th century and is now found throughout the state, especially wherever cattle grazing occurs.

◀ **280. GIANT BLACK WATER BEETLE** *Hydrophilus triangularis*
The largest and best known member of the family, this beetle often comes to lights, attracting attention as it thrashes about noisily but harmlessly.
ADULT: BL 33–38 mm; shining black with a prominent keel on the underside.
LARVA: Elongate, somewhat spindle-shaped, strongly tapering toward the tail end; without lateral, gill-like processes; head strongly pigmented; body without armor plates.
HABIT: Both adults and larvae are predaceous, devouring all procurable dead and living animals and are said to be troublesome in fish hatcheries at times.
RANGE: Widespread, including east of the Sierra Nevada, central coastal areas, and particularly common in the Central Valley.

Rove Beetles (Family Staphylinidae)

Rove beetles are usually easily recognized by their short wing covers. In most species the abdomen is almost completely exposed, and often it is held curled upward in a characteristic fashion when the beetles are running about. Some notable exceptions to the exposure of most of the abdomen among members of the family are found in a few subfamilies of very small beetles (e.g., Scydmaeninae, antlike stone beetles, and Scaphidiinae, shining fungus beetles). Usually the hind wings are large. Although the flight wings, when present, are completely folded beneath the short elytra, they can be unfolded quickly for instant flight. Staphylinid larvae are silverfish-shaped, resembling those of ground beetles (Carabidae), often are armored with sclerotized plates on the back, and have a tubular tail-end segment bearing two segmented tails (urogomphi). Many are predaceous, and some are parasitic inside the pupae of other insects, but the habits of most species await investigation.

Rove beetles occur in diverse habitats, abounding wherever there is decaying organic material, including dung and animal carcasses. Some live in fungi, others along streams, or even in intertidal zones on the ocean shore. A large number are ant associates, this is especially so in tropical regions but also in some cases in California. There is a tremendous diversity of species, with nearly 1,000 described species known from California and probably many others awaiting discovery. Most rove beetles are small and inconspicuous, but they can be very abundant.

◀ **281. DEVIL'S COACH HORSE** *Ocypus olens*
The largest staphylinid in our fauna.
ADULT: BL 17–32 mm; black, without conspicuous hairiness.

HABIT: Introduced from Europe and first recorded in California in 1931. A foul-smelling liquid is emitted from two cream-colored glands at the tip of the abdomen when the insect is alarmed. They are a mixed blessing to gardeners. Adults and larvae are voracious and feed on pest slugs and snails (as well as native species of mollusks), but they may also feed on ripening fruits.

RANGE: Widely established in urban areas of southern California and the San Francisco Bay Area.

▶ 282. PICTURED ROVE BEETLE *Thinopinus pictus*

ADULT: Large (BL 12–22 mm); robust, broad, pale ochreous brown with black markings on the back. Unlike most staphylinids, it is wingless.

LARVA: Similar to the adult, narrower without wing covers, and with the second and third thoracic segments shining, dark red–brown.

HABIT: This remarkable beetle lives on beaches, where it may be found in great numbers under seaweed and on open sand at night. Both adults and larvae are predaceous on small organisms, especially sand fleas (amphipods).

RANGE: Beaches along the length of California.

▶ 283. ANT-LOVING BEETLES *Batrisodes* spp.

ADULT: Minute (BL 1.5–2 mm); chestnut brown, head constricted behind the eyes, pronotum narrower than abdomen, legs with thickened femur.

HABIT: Frequently found in rotten woody debris, leaf litter, or mosses. Some are associates of ants, and others are found in caves.

RANGE: The genus has a cosmopolitan distribution worldwide with 18 species known from across California. They and related Pselaphinae genera can be found anywhere that moist litter and humus naturally accumulates.

▶ 284. CRAB-LIKE ROVE BEETLE *Sepedophilus bisignatus*

ADULT: Small (BL 6–8 mm); distinct elongate, tapering form, with oval fore body.

HABIT: Flightless, probably predaceous. Found in fungus-rich leaf litter and under bark of rotten logs.

RANGE: Found in mountain ranges throughout California.

▶ 285. RUGOSE ROVE BEETLE *Trigonurus rugosus*

ADULT: BL 4–6 mm; a rectangular body form with deep, dense punctures throughout.

HABIT: Adults are found under bark of conifer trees.

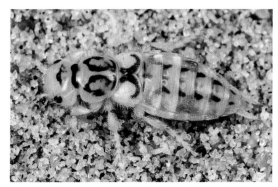

282. Pictured Rove Beetle (*Thinopinus pictus*).

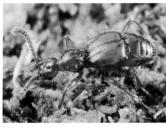

283. Ant-loving Beetle (*Batrisodes* sp.).

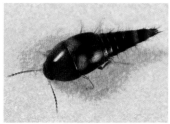

284. Crab-like Rove Beetle (*Sepedophilus bisignatus*).

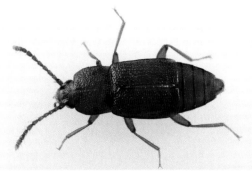

285. Rugose Rove Beetle (*Trigonurus rugosus*).

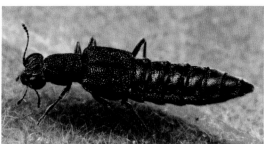

286. Skimming Rove Beetle (*Stenus* sp.).

RANGE: This species is restricted to the central Sierra Nevada, while the genus as a whole extends from Alaska to southern California in mountain ranges and lower elevations near the coast.

◄ 286. SKIMMING ROVE BEETLES — *Stenus* spp.

ADULT: BL 4–8 mm; very large, prominent eyes, slender body; black or bluish black, shiny, sometimes with pale markings on the elytra or paler legs.

HABIT: Their extra-long, telescoping mouthparts can be extended at high speed to snag prey such as springtails. They can also walk on the surface of the water and, when needed, move with explosive speed by dropping a chemical from a gland onto the water's surface that creates a rapidly moving wave that they ride.

RANGE: Throughout the state near pools of water in wet pastures and river or stream backwater areas.

Carrion Beetles (Family Silphidae)

Silphids have a flattened-to-robust form with the wing covers slightly shorter than the abdomen. They have conspicuous antennae that are enlarged gradually or terminate abruptly in a flattened club. Nearly all feed on carrion and the associated maggots, although some are vegetarians. The larvae of most silphids are somewhat flattened with a shieldlike back that covers the head and legs, but in burying beetles they are more grublike. The family is small, primarily of Temperate Zone distribution, with about 10 species in California.

▶ 287. NORTHERN CARRION BEETLE — *Thanatophilus lapponicus*

ADULT: BL 8–15 mm; flattened form, with an olive-colored, velvety sheen of scales on the head and thorax.

HABIT: It occurs at a wide range of elevations and is most common in less disturbed habitats throughout California feeding on carrion and maggots. They are known to prefer reptile and amphibian carcasses.

RANGE: Widely distributed in the state at lower elevations.

Somewhat similar is the Garden Silphid *(Heterosilpha ramose)*, which is slightly larger (BL 12–18 mm), flattened, and black with three irregular, longitudinal ridges on each wing cover. Adults are also found across the state and primarily feed on decomposing vegetable matter and are known to occasionally feed on garden and field crops at night.

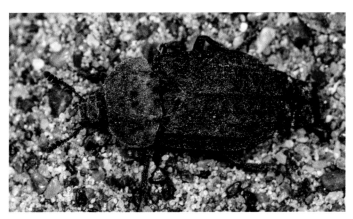

287. Northern Carrion Beetle (*Thanatophilus lapponicus*).

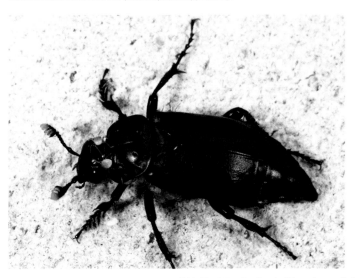

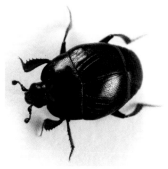

288. Black Burying Beetle (*Nicrophorus nigrita*) with mites on back of head and ventrally.

289. Predatory Clown Beetle (*Saprinus* sp.).

ADULT: Moderately large (BL 12–28 mm); shining black with yellow or orange markings and in some, conspicuous orange antennae. These beetles commonly carry colonies of large dispersing mites (phoretic) under the wing covers or on other areas of the body.

LARVA: Grublike, somewhat flattened, broadly spindle-shaped, broadest at the anterior abdominal segments, with a row of blunt spines across the back of each segment.

HABIT: The adults, typically working as a male and female pair, remove all hair and macerate carcasses of small animals, such as rodents and snakes, making them into balls of prepared food. They bury these portions in chambers. So stored, this can prevent fly larvae from eating the carrion and slows the drying and rotting of the flesh until the silphid larvae mature. Their eggs are laid in a depression on top of these carcass balls, and the adult beetles remain with the larval brood until it matures.

RANGE: Coastal and mountainous parts of California at a wide range of elevations.

The Red and Black Burying Beetle *(N. marginatus)* is one of our common species. It has orange or red antennal clubs, pale regions on the underside of the thorax, and two wide reddish-orange bands across the wing covers. The **Black Burying Beetle *(N. nigrita)* (288)** is similar in form but the body is entirely black.

Clown Beetles (Family Histeridae)

Clown beetles include small or medium-sized, compact, and robust beetles that typically are black and often more or less shiny. They are found on dung, carrion, decomposing fungi and leaves, and under bark of deadwood. Some live with ants or in mammal or reptile burrows. Adults and larvae are predators on other insects, typically maggots and other invertebrates they encounter in their habitat.

◀ 289. PREDATORY CLOWN BEETLES *Saprinus* spp.

ADULT: BL 3–4 mm; shiny, black, nearly oval form, antennae are elbowed (geniculate) and have a prominent club at the tip.

LARVA: Active larvae are elongate with well-developed mandibles and are silverfish–shaped, resembling those of ground beetles (Carabidae), and have a tubular tail-end segment bearing two-segmented tails (urogomphi).

HABIT: Somewhat more common in drier habitats on carrion and dung.

RANGE: At middle to low elevations in central and southern California.

Stag Beetles (Family Lucanidae)

Stag beetles derive their common name from the great development of their antlerlike mandibles that seem like antlers in males. Actual horn-like projections from the head are uncommon. Males are usually larger than the females and vary greatly in size. These variations are coupled with differences in development of the head; larger beetles have dispro-portionately large mandibles or horns. The antennae terminate in broad, flattened segments that cannot be closed together to form a compact club as they do in the Scarabaeidae. Lucanid larvae are C-shaped grubs that make rasping noises by rubbing hard ridges on the third pair of legs against a rugose area at the base of the second pair. They inhabit soft, rotting wood of fallen trees and stumps, and four to six years may be required to reach maturity. Often the adults are found with the larvae, and the beetles are rarely seen away from wood. This is a small family in temperate regions with fewer than 10 species known in California.

▶ **290. RUGOSE STAG BEETLE** *Sinodendron rugosum*
ADULT: More robust than the Oregon Stag Beetle **(291)** (BL 10–18 mm), cylindrical; head much narrower than thorax; black; rugose; the head in the male with a short horn that curves backward.
LARVA: Head brown, body dirty white with the dark gut contents showing through; the last three segments enlarged.
HABIT: In rotten wood of oak, California Bay Laurel *(Umbellularia cali-fornica)*, and other trees.
RANGE: Coast Ranges and the Sierra Nevada to middle elevations.

▶ **291. OREGON STAG BEETLE** *Platycerus oregonensis*
ADULT: Moderately small (BL 9–15 mm); dull metallic blue; wing covers with rows of fine indentations. Males resemble females but have greatly elongated mandibles.
LARVA: White, C-shaped grubs with a darker head.
HABIT: Commonly found in rotten wood of California Bay Laurel *(Umbel-lularia californica)*.
RANGE: Santa Cruz County northward along the coastal and North Coast Ranges and the Sierra Nevada.

Scarab Beetles (Family Scarabaeidae)

Scarabaeids are small to large, robust, dull or brightly colored beetles with antennae that end in three to seven broad, leaflike segments that can be closed together to form a tight club. The family includes a tremen-

dous diversity of forms and behavioral adaptations: larvae of many live among roots or in rotting plant material, especially rotting wood, others in dung, ant or termite nests, burrows of vertebrates, carrion, or fungus. Adults often feed on living plants and damage crops independently from the larvae. They include some of the most notorious of insects, such as the invasive Japanese Beetle *(Popillia japonica)*. The larvae are C-shaped grubs commonly with about three fleshy lobes to each segment, except for the last three, which are usually smooth, shiny, and semitransparent. The legs lack the ridges used in making rasping noises found in the Lucanidae. This is a large, worldwide family, well represented in Temperate and Tropical Zones, with upward of 300 species in California.

▶ 292. EUROPEAN DUNG BEETLE *Aphodius fimetarius*

ADULT: Small (BL 5–7 mm); oblong, convex; black with bright, reddish-brown wing covers.

LARVA: Head brown, body white.

HABIT: Found in or under cow pats and other dung.

RANGE: Widely distributed in California wherever animals are grazed, except in the most arid areas; introduced from the Old World.

▶ 293. TEN-LINED JUNE BEETLE *Polyphylla decemlineata*

ADULT: Large (BL 22–35 mm); robust; brown, with white scales that form longitudinal stripes on the head, thorax, and wing covers and with scattered yellowish-white scales between the stripes; antennae reddish brown in male, with very large, leaflike segments forming the club.

LARVA: Large (BL 25–50 mm); cream or whitish-gray C-shaped grub.

HABIT: On roots of shrubs and trees, including ornamental shrubs and nursery trees; two or three years may be required to complete growth. The adult beetles appear in spring and early summer, when their loud, buzzing flight can be heard as the fly at dusk low over fields.

RANGE: Throughout most of the state at low to moderate elevations.

▶ 294. LITTLE BEAR *Paracotalpa ursina*

ADULT: Medium-sized to large (BL 10–23 mm); robust, round in outline; steel bluish-green or bronze head and thorax with bright reddish-brown or black wing covers; body clothed with long, yellow hairs. In mountains of southern California the beetles are black or metallic green with black wing covers.

HABIT: The beetles appear in large numbers in early spring, males frequently fly low over grassy fields during the day, alighting on flowers to feed.

RANGE: Lower foothills of southern California, margins of the Central Valley, and the Carrizo Plain.

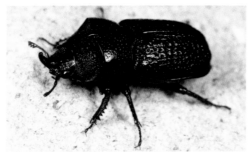

290. Rugose Stag Beetle (*Sinodendron rugosum*).

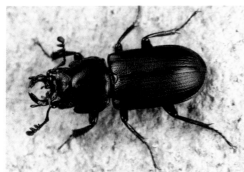

291. Oregon Stag Beetle (*Platycerus oregonensis*).

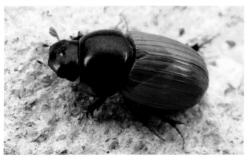

292. European Dung Beetle (*Aphodius fimetarius*).

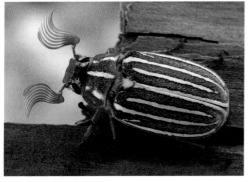

293. Ten-lined June Beetle (*Polyphylla decemlineata*).

▶ **295. GREEN FRUIT BEETLE** *Cotinis mutabilis*

ADULT: Large (BL 20–34 mm); robust, somewhat pentagonal in outline, widest at the base of the wings; body bright metallic green; back and wings velvety olive green with marginal bands of brownish yellow.

LARVA: Burrows in and under decaying or dry horse dung on which it feeds.

HABIT: The adult beetles feed on a wide variety of fruits and succulent plant parts including cacti, figs, peaches, and grapes. These unmistakable, day-flying beetles are iridescent in the sunlight and produce a loud buzz as they fly around fruit trees.

RANGE: Southern California, having apparently expanded its range from Arizona in historical times; common near stables.

▶ **296. ANT SCARABS** *Cremastocheilus* **spp.**

ADULT: Medium-sized (BL 10–16 mm); rather flat with pentagonal outline; usually black with faint white markings.

LARVA: Covered with long, silky hairs; in nests of mound-building harvester ants, where they live as scavengers.

HABIT: They are most often seen solitary, flying or on the ground, but occasionally under bark or rocks in association with ant colonies. They prey on ant larvae.

RANGE: Widely distributed from foothills to middle elevations of the Coast Ranges and the Sierra Nevada.

▶ **297. GREEN CHAFERS** *Dichelonyx* **spp.**

ADULT: BL 7–12 mm; rather slender with the thorax narrower than the abdomen; reddish brown or black with metallic-green wing covers.

HABIT: Adults feed on a variety of tree and herbaceous plant leaves and are frequently attracted to lights in large numbers.

RANGE: Throughout chaparral and forested parts of California. The Green Pine Chafer *(D. backi)* is a common species that is variable, reddish brown to reddish black with bright green to brown or greenish-black wing covers. It is typically found in pine and Douglas Fir forests throughout the Sierra Nevada and the Cascade Range.

Rain Beetles (Family Pleocomidae)

Large, robust, scarablike beetles, distinctly hairy on the underside, and typically quite shiny above. There is only one genus, distributed from Washington to Baja California, which includes around two dozen species. Most species have very limited distributions, even to specific parts of mountain ranges in some cases, and the majority of species are found

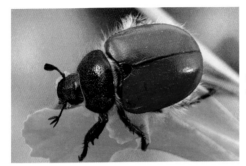

294. Little Bear
(*Paracotalpa ursina*).

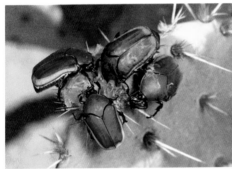

295. Green Fruit Beetles
(*Cotinis mutabilis*).

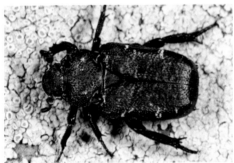

296. Ant Scarab
(*Cremastocheilus angularis*).

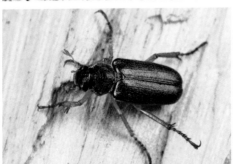

297. Green Chafer
(*Dichelonyx* sp.).

in California. Females are flightless, and adults lack functioning mouthparts and do not feed. Males fly in search of females and must use stored fat for their brief nuptial flights. Once they have successfully consummated the mating, they die. Adult male emergence is triggered by a required minimum amount of rainfall or snowmelt. When conditions are right, usually at the onset of winter rains in the coastal Mediterranean climate region, males fly in the rain or mist. Some fly at night and are attracted to lights.

▶ 298. RAIN BEETLES *Pleocoma* spp.

ADULT: Moderately large (BL 20–40 mm); the females larger and more robust than males; wing covers shiny, black, reddish brown, or nearly translucent; underside clothed with dense hair. The front of the head is broadened, bilobed, and flattened—an adaptation for scooping soil.

LARVA: Head amber-colored; body shining white with tiny, raised black spots peppering the back.

HABIT: With the first soaking rains in fall, males of this genus suddenly appear in abundance, flying at dusk or during the day when cloudy and drizzly, in search of the flightless females in burrows. Evidently females give off a scent that attracts males to their burrows, where mating occurs. After mating, the females plug the tunnels with soil and deposit eggs. The larvae feed on plant roots, typically hardwood trees and shrubs, and the life cycle is reported to last as long as 10 or 12 years.

RANGE: Throughout the foothills and mountainous parts of the state. The ranges of most of the species are restricted and isolated, like islands. In the Sierra foothills is the **Tulare Rain Beetle *(P. tularensis)* (298)**. In southern California common species include the Black Rain Beetle *(P. puncticollis)* in the Santa Monica Mountains, which is shining black with black hair, and the Southern Rain Beetle *(P. australis)* in the San Gabriel Mountains, a black species with reddish-brown hair. In the north Behren's Rain Beetle *(P. behrensi)* in the Berkeley Hills is dark mahogany brown in the male, reddish brown in the female, with pale hairs. Behren's Rain Beetle is attracted to lights and so is one of the most commonly collected species.

Water Pennies (Family Psephenidae)

Water pennies receive their common name from the remarkable larvae, which are round or ovoid in outline, extremely flattened, almost scalelike. The margins of the body are greatly expanded and cover the head and legs, enabling the larvae to cling to rocks in rapids of streams. They breathe using abdominal gills or a retractile tuft of anal filaments. The

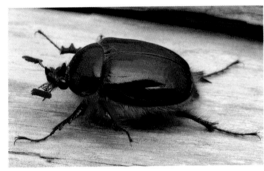

298. Tulare Rain Beetle (*Pleocoma tularensis*).

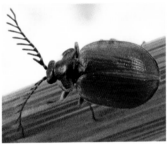

299. Edwards' Water Penny (*Eubrianax edwardsii*) adult.

300. Edwards' Water Penny (*Eubrianax edwardsii*) larva.

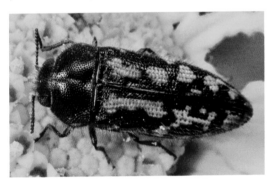

301. Spotted Flower Buprestid (*Acmaeodera* sp.).

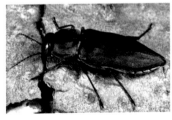

302. Black Fire Beetle (*Melanophila acuminata*).

303. Goldspotted Oak Borer (*Agrilus auroguttatus*).

adults are terrestrial, although females may enter the water to lay eggs. Psephenid adults are small, ovoid, flattened beetles with long, feathery antennae in males; they are found on streamside rocks or vegetation but are not commonly encountered because adults are present only a few weeks each year. Larval water pennies are quite common and characteristic inhabitants of moderate to rapid streams throughout California. Only six species are recorded in the state.

◄ 299–300. EDWARDS' WATER PENNY *Eubrianax edwardsii*

ADULT: (299) Small (BL 3–6 mm); dark brown or black (female) or with wing covers pale tan (male); head hidden beneath expanded thorax.
LARVA: (300) Broad, flat, round-oval; with the segments fitted tightly together to the outer margin; abdomen with lateral gills on segments 1–4; on rocks in well-aerated water that is protected from erosion and silting.
RANGE: Streams throughout California below 2,000 m. Members of the related genus *Psephenus* are similar, but in the adult the head is not hidden beneath the pronotum. The larva has gills on segments 1–6 or 2–6.

Metallic Wood-boring Beetles (Family Buprestidae)

Buprestids are small to moderately large beetles, including many with beautiful metallic colors. They are nearly always streamlined in appearance, elongate or oval and flattened, often etched with longitudinal grooves. The larvae bore in roots, branches or trunks of woody plants, or under bark of fallen logs, and a few species are leaf or stem miners. The larvae are elongate, flat, strongly segmented grubs with a small head that is almost entirely withdrawn into the greatly enlarged first thoracic segment. This characteristic body form and habit give rise to the somewhat erroneous yet descriptive common name "flat-headed borers."

The adults of some genera are most often encountered at flowers, where they congregate to feed on pollen; others are found on recently cut trees or felled branches. Many are exceedingly fast fliers and take off at the slightest disturbance. More than 260 species occur in California.

◄ 301. SPOTTED FLOWER BUPRESTIDS *Acmaeodera* spp.

Members of this large genus are common on a variety of flowers in the foothills and deserts.
ADULT: Small (BL 4–14 mm); somewhat flattened, bullet-shaped, broadest at the base of the wings; tan, brown, or black with yellow, orange, or red markings on the wing covers, and covered with hair.
LARVA: White with a brown head.

HABIT: Adults of this large genus are common on a variety of flowers on sunny days in the foothills and deserts. Larvae live in dead or dying branches and trunks of various shrubs and broad-leafed trees.

RANGE: Throughout low- to middle-elevation parts of the state, most common in oak woodland and desert areas.

◄ 302. BLACK FIRE BEETLE *Melanophila acuminata*

ADULT: BL 7–11 mm; black, shiny, sometimes with a slight metallic tint.

HABIT: Well-known for swarming to recently burned conifer forests. The beetles can detect the infrared signature of the recent burn using paired receptors on the thorax near the middle coxal cavities. It is frequently reported that they land on firefighters and bite exposed skin.

RANGE: Throughout California.

◄ 303. GOLDSPOTTED OAK BORER *Agrilus auroguttatus*

This species, aka the GSOB, is a beautiful but notorious recent addition to the Californian beetle fauna.

ADULT: BL 8–10 mm; black with a bronze sheen, four pairs of golden or yellow spots (three on the elytra and one on the pronotum).

LARVA: Mature larvae are about 18 mm long, legless, slender, and white.

HABIT: Originally a native species in southeastern Arizona, the GSOB was first detected in San Diego County in 2004 and is now known to be a significant cause of oak mortality. It is possible that this species was introduced by careless importation of firewood from Arizona and once out of reach of its natural parasites, it has become a serious pest. Several oak species are hosts, including Coast Live Oak (*Quercus agrifolia*), California Black Oak (*Q. kelloggii*), and Canyon Live Oak (*Q. chrysolepis*).

RANGE: Currently known from Los Angeles County and south, but the range of its hosts cover the state and so it is likely to expand north.

Pill Beetles (Family Byrrhidae)

Named pill beetles after their ability to fold up their legs when disturbed and form a "pill" as a means of defense. This gives them a distinctive look. They are very convex and compact, and the head is flexed down and slightly back. Most pill beetles feed on mosses, but a few are found of tender leaves of herbaceous plants and deciduous shrubs in forests and meadows. As the name implies, they are oval-shaped and minute or small (BL 1–10 mm), and they may be smooth and shiny or dull and scale-covered. They usually hide in the soil during the day and emerge to feed in the evening. In California, 13 described species have been reported.

▶ **304. DENTATE PILL BEETLE** *Amphicyrta dentipes*

ADULT: BL 5–9 mm; light brown to almost black, very convex form, antennae threadlike.

HABIT: Adults are active from around sundown through the night and can easily be spotted climbing and feeding on tender leaves of small herbaceous plants in oak woodlands and mixed conifer forests along trails and in clearings near streams.

RANGE: Throughout California. The second species in the genus, *A. chrysomelina*, also found in California, has the same life history and is very difficult to distinguish.

Riffle Beetles (Family Elmidae)

Riffle Beetles are very small (BL 1–8 mm), elongate, long-legged beetles with the head pointing down and back. There are more than 20 species found in California, and all are fully aquatic or semiaquatic. Found in cold, running, highly oxygenated waters, they feed on algae and detritus. Because of their habitat requirements, they have been shown to be excellent, sensitive indicators for water quality. Although aquatic, Riffle Beetles are not built for swimming like predaceous or scavenger water beetles. Instead they cling to rocks and submerged debris and crawl slowly in the rushing water. They breathe oxygen that diffuses from the water into a thin layer of air held to their body by a thick mat of short hairs (plastron). Although small, adults can be found by careful examination of rocks and other submerged debris in gravel-bottom streams.

▶ **305. MURKY RIFFLE BEETLE** *Ordobrevia nubifera*

ADULT: Minute (BL 2.2–2.6 mm); elongate parallel-sided form, black or dark brown forebody and light brown or dark and light brown patterned wing covers.

HABIT: Found in streams of all sizes but most common in areas of fast flow and coarse substrate.

RANGE: This species is found throughout California's mountains at least as far south as Los Angeles County.

Net-winged Beetles (Family Lycidae)

Net-winged beetles are elongate, soft-bodied beetles that typically have distinctive ridges that form a netlike pattern on their wing covers. They usually have long, saw-toothed antennae and are boldly colored, red, orange, blue, and sometimes black. Larvae are thought to feed on fungi,

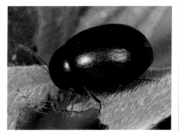

304. Dentate Pill Beetle
(*Amphicyrta dentipes*).

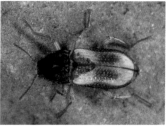

305. Murky Riffle Beetle
(*Ordobrevia nubifera*).

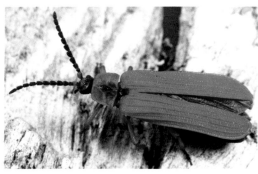

306. Red-legged
Net-winged Beetle
(*Dictyoptera simplicipes*).

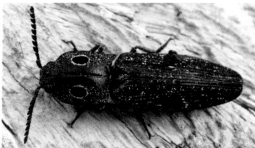

307. Eyed Elater
(*Alaus melanops*).

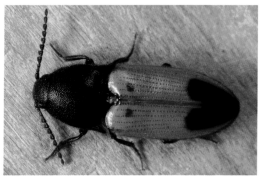

308. Valentine Elater
(*Ampedus cordifer*).

and adults are found on plants, often feeding on nectar or honeydew (aphid waste secretions). Adults and larvae are frequently defended by distasteful chemicals and have typical warning coloration (aposematic). It is common to find aggregations of adults on plants, apparently benefiting from amplification of their aposematic signal.

◄ 306. RED-LEGGED NET-WINGED
BEETLE *Dictyoptera simplicipes*
ADULT: Medium-sized (BL 6.5–12.5 mm); bright red or orange with black antennae and a black diamond-shaped mark in the center of the pronotum.
HABIT: Frequently found in mating aggregations in spring.
RANGE: Found throughout California in conifer and mixed forests.

Click Beetles (Family Elateridae)

Click beetles are rather slender, somewhat flattened, and characteristically shaped, with the thorax rectangular in outline and drawn out into pointed posterior corners, and with narrow, oval wing covers. Elaterids are easily recognized by a posteriorly directed process on the underside of the first thoracic segment, and a corresponding groove on the second segment. By articulation of these two segments, the process is snapped into the cavity, resulting in an audible click. When the beetle is lying on its back, this enables it to spring several centimeters into the air. Most species are brown or black, others have various color patterns, and some are nocturnal and come to lights.

The larvae ("wireworms") are elongate, thin, and cylindrical with heavily armored skin. They live in the soil or rotten wood, and are either vegetarians, eat both plant and animal material, or are predaceous. Some species are of economic importance, destructive to the roots of field crops. This is a large family, with more than 300 species known in California.

◄ 307. EYED ELATER *Alaus melanops*
This is the largest elaterid in California. Most often found under loose bark of old conifer stumps.
ADULT: Large (BL 22–40 mm); black with variable white scaling and two conspicuous, oval, eyelike spots on the prothorax that are velvety black and often surrounded by rings of white scales.
LARVA: BL 50–60 mm; smooth, cylindrical, yellowish brown with the head and thorax dark brown.
HABIT: In rotten wood or logs and stumps; predaceous on larvae of wood-boring beetles.
RANGE: All coniferous forest regions of California.

◀ **308. VALENTINE ELATER** *Ampedus cordifer*
ADULT: Medium-sized (BL 8–11 mm); bright orange with black patches. One black patch near the tip of the wing covers forms a heart-shaped mark.
HABIT: Adults and larvae can be found under the bark of rotting oaks and cottonwoods.
RANGE: Distributed throughout California.

▶ **309. WEBB'S ELATER** *Chalcolepidius webbi*
ADULT: Large (BL 25–38 mm); the white margins of the pronotum and wing covers in this species are distinctive.
HABIT: Larvae are found under bark of Ponderosa Pine and other large trees, where they feed on the immatures of other beetles. Adults can be found among willows, along riparian corridors feeding on various plant fluids.
RANGE: In California, found in the far southern counties, especially near the Colorado River.

▶ **310. TIGER CLICK BEETLE** *Pseudanostirus tigrinus*
ADULT: BL 9–11 mm; wing covers with three distinctive zigzag markings and head and pronotum black. Entirely pubescent.
HABIT: Adults and larvae are associated with conifer trees and can be commonly found on the terminal new growth feeding on aphids and adelgids.
RANGE: Much of the forested parts of the state, especially in the Sierra Nevada.

Glowworms (Family Phengodidae)

Glowworms are remarkable because the females are larviform, much larger than the males, and have rows of luminescent spots (sometimes of two colors, although not in California species). The females produce volatile chemicals (pheromone) that have immense powers of attraction for males. The males resemble leather-winged beetles but have feathery antennae and shorter elytra than most cantharids. They fly in the evening and sometimes come to lights. The larvae, which also have luminescent bands or spots, feed on millipedes and other invertebrates. The family is small and restricted to the Americas, with nine species in California.

▶ **311–312. CALIFORNIA PHENGODID** *Zarhipis integripennis*
ADULT: Male **(311)** BL 10–20 mm; orange with a black or orange head and blue-black wing covers that are slightly shorter than the abdomen; female

Coleoptera

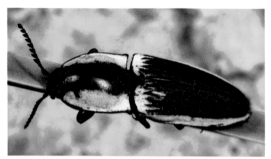

309. Webb's Elater (*Chalcolepidius webbi*).

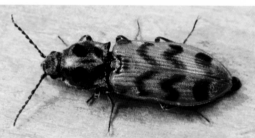

310. Tiger Click Beetle (*Pseudanostirus tigrinus*).

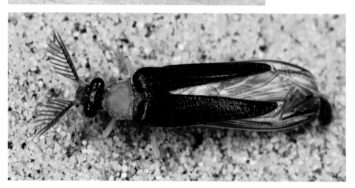

311. California Phengodid (*Zarhipis integripennis*) male.

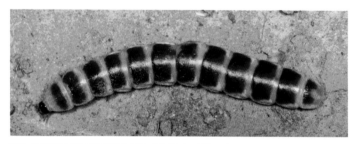

312. California Phengodid (*Zarhipis integripennis*) female.

(312) larviform and much larger (BL 30–80 mm); amber or buff-colored with black markings on the back and spots along the sides that luminesce bright green; active at night.

LARVA: Resembles the female but smaller.

HABIT: Females and larvae subdue millipedes by curling around them snake-fashion and paralyzing them by biting them ventrally just behind the head. The glowworm then enters just behind the millipede's head and eats its way tailward, leaving only the segmental rings of the shell.

RANGE: Coast and Transverse Ranges and the Sierra Nevada foothills to middle elevations.

Fireflies (Family Lampyridae)

The family Lampyridae includes some of the most familiar of all insects in humid regions, including the eastern United States, but California has only a few species and these are not luminescent as winged adults or have only a very small and weak light. The light organs are borne on the hind segments of the abdomen in most lampyrids; in California's species these are mostly lacking or are inconspicuous in males and present only in the females of certain species, which are wingless (glowworms). The larvae are predaceous on snails and slugs and sometimes other invertebrates. There are nearly 20 species in California.

▶ **313–314. PINK GLOWWORM** *Microphotus angustus*

ADULT: Male **(313)** BL 8–10 mm; with grayish-brown prothorax and elytra and a pink body, small luminescent organ produces feeble light; female **(314)** BL 10–15 mm; wingless, larviform, flattened; pinkish; luminesces with a bright green light.

HABIT: They occur in dry, grassy areas in summer and late spring.

RANGE: Foothills of the Coast Ranges and the Sierra Nevada.

▶ **315. FEATHER-HORNED FIREFLY** *Pterotus obscuripennis*

ADULT: Male BL 12–18 mm; wing covers black; apical portion of the legs, and antenna brownish black; base of legs and prothorax orange; antennae featherlike.

RANGE: Found throughout California in chaparral and oak woodland foothills.

▶ **316. CALIFORNIA GLOWWORM** *Ellychnia californica*

ADULT: Medium-sized (BL 8–16 mm to tips of wings); black with broad, rounded wing covers and thoracic shield that has two bright rosy red marks near the lateral margins.

Coleoptera

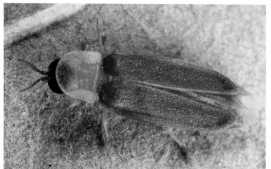

313. Pink Glowworm (*Microphotus angustus*) male.

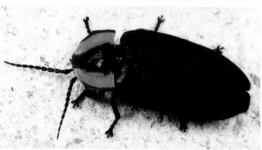

314. Pink Glowworm (*Microphotus angustus*) female.

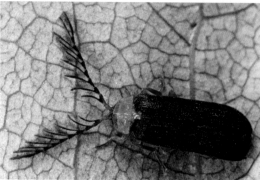

315. Feather-horned Firefly (*Pterotus obscuripennis*).

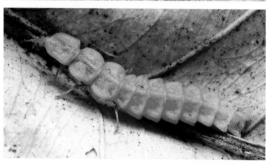

316. California Glowworm (*Ellychnia californica*).

HABIT: They are often found on low, grassy vegetation during the daytime. Larva and adults are active at night during winter, feeding on native land snails. Their lights can be seen at a distance, even through the snail shell when feeding.

RANGE: Wet areas of the Coast Ranges.

Leather-winged Beetles (Family Cantharidae)

Cantharids are most easily distinguished by their narrow-rectangular shape, soft wing covers, and large thoracic shield that is expanded but does not cover the head. They have long, threadlike antennae and well-developed wings in both sexes. Adults may be general feeders or feed mostly on plants and larvae are predaceous. The beetles are most often seen on vegetation in the daytime, although some species come to lights. There are more than 100 species in California; the great majority of them are similar in appearance, red or orange with gray, black, or brown wing covers.

▶ **317. DOWNY LEATHER-WINGED BEETLE** *Podabrus pruinosus*

ADULT: Small (BL 9–15 mm); head and body pale orange, wing covers blackish to pale brown, with a covering of short, pale hair giving a grayish-blue appearance.

LARVA: BL 15–20 mm; pink, covered with fine hair, and with two longitudinal dark lines on the back of the thorax; live in the soil.

HABIT: Common in spring and summer eating aphids on flowering shrubs. They feign death by curling the head downward and dropping to the ground when disturbed.

RANGE: Natural or developed habitat in coastal valleys to middle elevations of the Coast Ranges and the Sierra Nevada, especially in chaparral areas.

▶ **318. BROWN LEATHERWING** *Pacificanthia consors*

ADULT: Moderately large (BL 14–19 mm); body orange, wing covers brown, and legs reddish brown marked with black.

HABIT: Common in a variety of habitats, often found on vegetation and at lights; the larva is unknown.

RANGE: Californian province; Coast Ranges and coastal valleys of central and southern California.

Branch and Twig Borers (Family Bostrichidae)

Members of the family Bostrichidae make cylindrical burrows in dried wood, especially hardwoods, including dead limbs and fire-killed trees, and sometimes cause damage by mining limbs of living, cultivated trees. The beetles characteristically are cylindrical with the head turned downward. Often the thorax and elytra are heavily sculptured, and the body is truncated at the tail end. The larvae are somewhat scarablike, curved, and resemble those of anobiine ptinids but have a smaller head and more enlarged thoracic region. More than 30 species occur in the state, and several are frequently intercepted in quarantine inspections at ports.

▶ **319. STOUT'S BRANCH BORER** *Polycaon stouti*

ADULT: One of the largest bostrichids in California but greatly variable in size (BL 10–23 mm); cylindrical, black or reddish black; hairy but not strongly sculptured; head only slightly turned down.
LARVA: Burrows in the heartwood of dead hardwood trees.
HABIT: Frequently found at lights, even in urban areas.
RANGE: Coastal valleys and mountains to middle elevations.

CALIFORNIA BRANCH BORER *Apatides fortis*

ADULT: Medium-size (BL 7–14 mm); generally dark reddish brown.
HABIT: Same habits as Stout's Branch Borer, but the adults sometimes burrow into living orchard trees and cause damage.
RANGE: Widespread in foothill and agricultural areas.

Another California bostrichid is called the Lead Cable Borer (*Scobicia declivis*) because it sometimes bored holes in lead-wrapped telephone cables used up to the mid-20th century. This would cause short circuits in the telephone system. The beetles are small (BL 3.5–7 mm), black, with the head more strongly turned down than in *Polycaon*.

Hide Beetles (Family Dermestidae)

Dermestids are small, compact, oval beetles that are covered with fine hairs or appressed scales. The sides of the body are grooved for reception of the antennae and legs, which are drawn in tightly when the beetle is alarmed. The larvae are elongate, cylindrical, and somewhat caterpillar-like, with bands of stiff, jointed hairs. They are scavengers on dried animal and plant material of high protein content, including furs, hides, wool, feathers, debris in spider webs and wasp nests, and stored grain. Adults of some dermestids are common flower visitors where they feed on pollen. About 80 species are known in California.

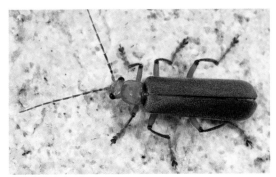

317. Downy Leather-winged Beetle (*Podabrus pruinosus*).

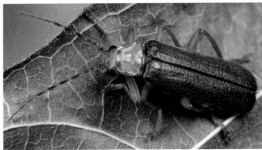

318. Brown Leatherwing (*Pacificanthia consors*).

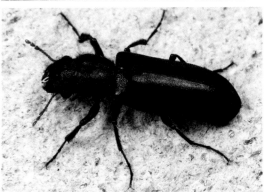

319. Stout's Branch Borer (*Polycaon stouti*).

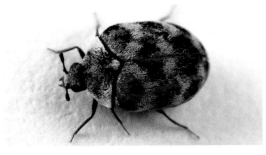

320. Carpet Beetle (*Anthrenus verbasci*).

◀ 320. CARPET BEETLES *Anthrenus* spp.

ADULT: Small (BL 3–4 mm); oval, convex; black, covered with white, brown, orange, and yellow scales that form a checkered pattern. They are often found on windowsills in infested buildings and in nature on flowers.

LARVA: Pale brown with narrow bands of long, stiff brown hairs and longer tufts at the tail end.

HABIT: Larvae feed in wool, museum specimens, and other animal products and so are a menace to every insect collector. The larvae of this genus seem to appear out of nowhere whenever a collection is left unattended, and they go unerringly to the most prized specimens to feed. If not deterred by preventative chemicals such as naphthalene flakes, they can reduce an entire collection to dust in a few months. They wreak similar havoc in stored woolen fabrics, feathers, preserved animal skins, and the like.

RANGE: Throughout most of the state, except the deserts.

▶ 321. FRISCH'S CARRION BEETLE *Dermestes frischi*

ADULT: BL 6–10 mm; generally brownish black; edge on the hind margin of each wing cover is smooth.

RANGE: The species is widespread at lower elevations on carrion and as a pest in animal products.

A very similar-looking species, the Hide Beetle *(D. maculatus)*, is similar in size and form; generally brownish black, with pale white-and-yellow spotting on the upper side; distinguished by a spine and sawtooth-like edge on the hind margin of each wing cover.

HABIT: Used successfully for many years to clean skeletons of vertebrate specimens for museums.

RANGE: The species is found worldwide and in California is also widespread at lower elevations on carrion and as a pest in animal products.

COMMON CARRION DERMESTID *Dermestes marmoratus*

The largest dermestid in California (BL 9–14 mm). This species is common around animal carcasses in later stages of decomposition.

ADULT: Elongate-oval, slightly flattened; black with gray scales forming spots and a broad band across the base of the wing covers; underside mostly whitish.

LARVA: Elongate, reddish brown with a pale stripe down the back, and covered with long, reddish-brown hairs; on hides, bones, and the like.

RANGE: Throughout the state at low to middle elevations. Probably frequently distributed by hide traders in the early days of commerce.

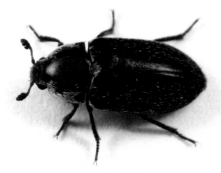

321. Frisch's Carrion Beetle (*Dermestes frischi*).

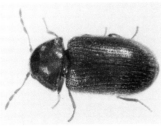

322. Drugstore Beetle (*Stegobium paniceum*).

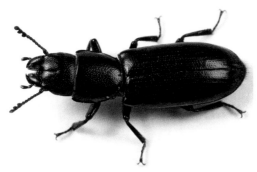

323. Spider Beetle (*Ptinus verticalis*).

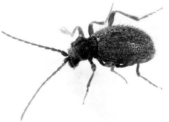

324. Green Bark-gnawing Beetle (*Temnoscheila chlorodia*).

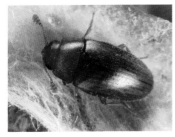

325. Pubescent Fungus Biting Beetle (*Dacne pubescens*).

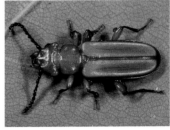

326. Red Flat Bark Beetle (*Cucujus clavipes*).

Death-watch and Spider Beetles
(Family Ptinidae)

These are small beetles that come in two general body forms. Those with a more elongate form are characterized by having the head somewhat withdrawn under the hoodlike prothorax (anobiines) that are largely brown- or gray-colored beetles. When these beetles are startled, the legs and antennae can be drawn up into sockets while they feign death. Sometimes anobiines are called "death-watch beetles." This name originates from British folklore and suggests ghost stories set in old castles. The beetles create a noise by bumping their heads on the top of the tunnels as a telegraphic message at mating time. An eerie tapping is audible in silent rooms, such as during a bedside death-watch.

The ptinines, on the other hand, have a distinctly different look that is more ovoid, with some long-legged, spiderlike, and very convex. Most members of the family feed in wood (dead branches, woody galls, etc.) in nature, and sometimes they are destructive to furniture and flooring, riddling them with small, round emergence holes. A few species, including the two that are illustrated, are stored-products pests. The larvae are crescent-shaped with enlarged thoracic area and tail end, resembling those of scarab beetles but with the legs much reduced or absent. About 150 species are known in California.

◀ 322. DRUGSTORE BEETLE *Stegobium paniceum*

ADULT: Small (BL 2.4–4.0 mm); slender; elytra reddish brown with narrow, parallel grooves; body clothed with dense, short hairs.

LARVA: Small, white, C-shaped; clothed with long hairs.

HABIT: The species occurs around the world. Larva feeds in all kinds of cereals, dried fruits, nuts, and the like, as well as dried animal products including wool, hair, leather, and plant and insect museum specimens. It is often encountered in packaged spices such as paprika.

RANGE: Urban and inhabited rural areas.

◀ 323. SPIDER BEETLE *Ptinus verticalis*

ADULT: BL 3–4 mm; brown, oval body form; clothed with erect hairs.

HABIT: Typically found on oaks and woody shrubs in woodlands. The distinctive elytra have been identified among insect remains in packrat middens dated from the late Holocene (about 2,000 ybp) in northern Baja California.

RANGE: Southern Sierra Nevada and southward in woodland habitats.

Bark-gnawing Beetles (Family Trogossitidae)

Bark-gnawing beetles come in both cylindrical and broadly flattened forms and are typically found under bark of dead trees or associated with bracket fungi. They are mostly predatory but may also scavenge or feed on fungi. There over 30 species known in California.

◄ 324. GREEN BARK-GNAWING BEETLE *Temnoscheila chlorodia*
ADULT: Moderately large (BL 9–20 mm); slender, nearly cylindrical; metallic green or blue.
LARVA: Slender, somewhat flattened; white or pink with shining black or dark brown head and thoracic shield; anal plate bearing two short, posteriorly directed spurs.
HABIT: Both adults and larvae are predaceous, foraging under bark of fallen trees, in galleries of wood-boring insects, or wood-rot fungi.
RANGE: In California these beetles are found throughout forested regions, including the desert mountains.

Pleasing Fungus Beetles (Family Erotylidae)

As the name implies, these beetles are often brightly colored and pleasing to the eye, and adults and larvae typically feed on fungi. Most can be found, often in aggregations, under bark of rotten logs feeding or at night crawling on wood and fungi. Some are day-active, including species of the genus *Languria* (lizard beetles) that are very narrow, elongate, and can be found feeding on flowers. Their larvae bore into plant stems. Most species, however, are broad and dorsally moderately or notably convex. Only a little more than a dozen species are known from California.

◄ 325. PUBESCENT FUNGUS BITING BEETLE *Dacne pubescens*
ADULT: Small (BL 4–6 mm), elongate oval beetles that are brown and noticeably hairy. Antennae have a loose three-segmented club.
HABIT: Typically found on fungi, especially polypore fungus.
RANGE: This species is widespread in the mountains and foothills of the state.

Flat Bark Beetles (Family Cucujidae)

Typical members of the family Cucujidae are rather elongate, very flattened, adapted for life under bark. Other cucujids live in decaying plant

material, dried fruit, and cereals, and a few are pests of stored products. About six species occur in California, many of which are very small.

◄ 326. RED FLAT BARK BEETLE *Cucujus clavipes*

This is the largest and most conspicuous cucujid in California.

ADULT: BL 12–17 mm; bright red with black eyes, antennae, and apical leg segments; somewhat rectangular in outline, very flattened, with rows of fine indentations on the wing covers.

LARVA: Also very flattened, amber-colored, elongate with head wider than body segments, the last two body segments equal in length, and there is a two-pronged process on the tail end; lives under bark of logs and stumps.

HABIT: Adults and larvae feed under the bark on other small arthropods such as wood boring beetles and mites.

RANGE: Widely distributed in coniferous forests of California. The larvae may be confused with those of another beetle, family Pyrochroidae, which live under bark and are similar in appearance but have the last body segment before the pronged tail plate about twice as large as the preceding segment.

Silvanid Flat Bark Beetles (Family Silvanidae)

The dozen species in California of silvanid flat bark beetles are very similar to flat bark beetles but can be distinguished by their antennae, which are either distinctly clubbed or at least with the last few segments noticeably expanded. Most species are thought to feed on plant debris or fungi, but some are well-known pests of stored food products.

▶ 327. SAW-TOOTHED GRAIN BEETLE *Oryzaephilus surinamensis*

ADULT: Small (BL 3–4 mm); reddish brown or dark brown; slender with ridged wing covers and six saw teeth on each side of the thorax.

LARVA: Slender; the body tapering to a posterior tip; white with brown head and yellow plates on each segment; in cereal, dried fruits, sugar, tobacco, and the like.

HABIT: This species lives in all kinds of stored foods and has been carried by commerce to all parts of the world.

RANGE: Urban and agricultural areas throughout the state and out-of-doors in decayed, dry vegetable products.

The Merchant Grain Beetle *(O. mercator)* is similar in appearance to the Saw-toothed Grain Beetle but has a preference for feeding on nuts or products that contain nuts.

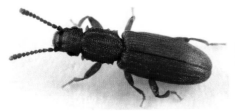

327. Saw-toothed Grain Beetle (*Oryzaephilus surinamensis*).

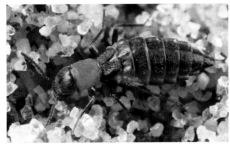

328. Flightless Western Beach Beetle (*Endeodes collaris*).

329. Common Soft-winged Flower Beetle (*Listrus* sp.).

330. Ornate Checkered Beetle (*Trichodes ornatus*).

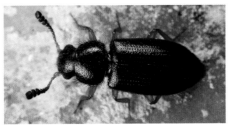

331. Red-legged Ham Beetle (*Necrobia rufipes*).

Soft-winged Flower Beetles (Family Melyridae)

This is one of the more common families of beetles in California with more than 400 species, and yet they are often overlooked. Small to medium-sized beetles, some with bright red-orange and blue contrasting color patterns, most are dull gray and brown. Many may be found on flowers almost year-round, but large numbers are present during spring and early summer bloom periods. The bright red-orange and blue contrasting colored species are advertising their chemical defenses, and when disturbed, can evert pouches of defensive chemicals from along the sides of their bodies.

◄ 328. FLIGHTLESS WESTERN BEACH BEETLE *Endeodes collaris*

ADULT: Small (BL 4–5 mm); head, appendages, and abdomen dorsally dark bluish black. Elytra very short so that they superficially look like a rove beetle.

HABIT: The adults can be seen running over driftwood and debris just above the high tide point or occasionally in the intertidal areas. While *E. collaris* is totally flightless, another red and blue-black (rarely green) species, *Malachius mixtus*, is an extremely good flier that can be found on many flowers in oak woodland and grassland habitats of California. Both species have eversible pouches on their bodies.

RANGE: The Flightless Western Beach Beetle is found on ocean beaches throughout California.

◄ 329. COMMON SOFT-WINGED FLOWER BEETLES *Listrus* spp.

ADULT: BL around 3 mm. Relatively hard-bodied, somewhat cylindrical-shaped, pubescent gray or brown, often with patterns of darker and lighter patches on the wing covers.

HABIT: *Listrus* and related genera can be one of the most abundant insects in flowers and are probably very important pollinators. However, the group is poorly studied and identification of species is difficult or impossible presently.

RANGE: Found throughout California.

Checkered Beetles (Family Cleridae)

Clerids are slender, hairy, often brightly colored and patterned beetles. Most are found in flowers or elsewhere on plants, although a few occur in animal carcasses or on recently felled trees. The larvae are nearly all predaceous on wood-boring beetles and other insects found in cones and seeds, galls, foliage, and dead twigs. There are nearly 100 species in

California, inhabiting a wide range of habitats from conifer forests to the deserts. Some are frequently found at lights at night.

◀ 330. ORNATE CHECKERED BEETLE *Trichodes ornatus*

ADULT: BL 5–13 mm; metallic blue with variable amounts of irregular, bright yellow or orange banding on the wing covers.

LARVA: BL 5–15 mm; slender, yellowish brown or light brown with head, thoracic shield, and anal plate dark brown.

HABIT: Larva feeds on pollen and animal material found in burrows of solitary bees and wasps. Adults are found on flowers in many different ecological situations.

RANGE: Throughout most of California, foothills to timberline.

◀ 331. RED-LEGGED HAM BEETLE *Necrobia rufipes*

ADULT: Small (BL 4–5 mm); green or blue with the bases of the antennae and legs red.

LARVA: Yellowish brown or light brown with the head and thorax darker brown; somewhat hairy.

HABIT: Adults and larvae are predaceous on fly maggots and other insects in decaying meat. The larvae may also feed on stored foods of animal and vegetable origin.

RANGE: Widespread in low-elevation areas and occasional at high elevations in arid parts of the state.

Sap Beetles and Dried Fruit Beetles (Family Nitidulidae)

Nitidulids are variable in form but most often are rather broad (with the thorax as wide as the elytra), somewhat flattened beetles with clubbed antennae and short wing covers that expose at least the tip of the abdomen or more. Many species are found in flowers, others live in wood-rot fungi, decaying fruit, or animal matter. The larvae of most burrow into plant substances. More than 65 species are known in California.

▶ 332. DRIED-FRUIT BEETLE *Carpophilus hemipterus*

ADULT: Minute (BL 1.5–2.2 mm); blackish brown with bold yellow marks on the wing covers.

RANGE: This cosmopolitan species that is native to tropical Asia is now widespread in North America including California.

CACTUS FLOWER BEETLE *Nitops pallipennis*

The beetles may be common in flowers, especially those of cacti.

ADULT: Small (BL 3–4 mm); brown or reddish brown with the wing covers pale amber or yellow.

LARVA: Yellowish white, blunt, cigar-shaped; with short legs, sparse hairs, and two short, dark spurs at the tail end; in old cactus fruit and other decaying vegetable matter, rarely in stored foods.

RANGE: Desert areas and other arid parts of southern California.

▶ **333. FRUIT BUD BEETLE** *Conotelus mexicanus*

ADULT: Elongate, parallel-sided beetles that are small (BL 3–4 mm) and deep black except for their pale tarsi.

HABIT: Adults feed on pollen and nectar and are primarily active during the late fall and winter months.

RANGE: Southern California.

Blister Beetles (Family Meloidae)

The Meloidae includes species with some of the most interesting life histories of all Coleoptera. These beetles are variable in form but typically have the head turned down and are soft-bodied, with particularly soft, leathery wing covers. Some species have elytra that are much shorter than the abdomen. Females deposit immense numbers of eggs, usually on the ground. The larvae go through successive stages that differ in form: at first they are active, leathery-skinned, and look like minute silverfish (triungulins). At this stage they wander in search of hosts (specific kinds of Hymenoptera or egg cases of Orthoptera), and most perish in the attempt. Those that locate a host, molt into maggotlike, short-legged forms. Finally, in many species, stages of pupalike larvae and further feeding stages complete the larval growth by feasting on the host. The adults eat plant material, especially flowers. Most are chemically defended; some secrete defensive fluids (cantharidin) that cause severe blistering of human skin. Few if any of the 130-plus species in California possess this capability, despite the common name.

▶ **334. PUNCTATE BLISTER BEETLE** *Epicauta puncticollis*

This is perhaps California's most common meloid outside of the desert areas.

ADULT: Medium-sized (BL 7–15 mm); black with a blue sheen; entire surface with dense, minute dents.

LARVA: On grasshopper egg masses.

HABIT: Most commonly seen in late spring and summer on tarweed *(Hemizonia)* and related plants, but the beetles sometimes eat flowers of various field crops, especially in late summer.

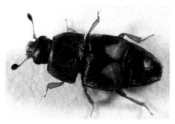

332. Dried-fruit Beetle
(*Carpophilus hemipterus*).

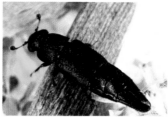

333. Fruit Bud Beetle
(*Conotelus mexicanus*).

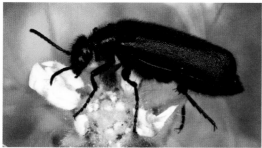

334. Punctate
Blister Beetle
(*Epicauta puncticollis*).

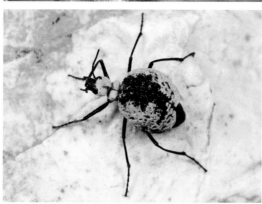

335. Desert
Spider Beetle
(*Cysteodemus
armatus*).

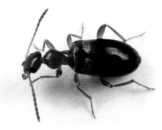

336. White-shouldered Ant-like Flower
Beetle (*Ischyropalpus nitidulus*).

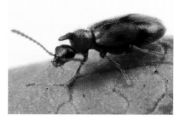

337. Pacific Coast Monocerus Beetle
(*Notoxus lustrellus*).

RANGE: Coastal areas, foothills, and mountains to middle elevations all over the state.

◄ **335. DESERT SPIDER BEETLE** *Cysteodemus armatus*
ADULT: BL 7–17 mm. This flightless beetle is spiderlike, with inflated abdomen, relatively small head and thorax, and long legs; black, blotched with variable white or yellow, waxy secretion. The wing covers are not as soft as in most meloids and are fused, forming a heavily sculptured shell over the abdomen.
RANGE: Desert areas of the state.

Antlike Flower Beetles (Family Anthicidae)

The antlike flower beetles have an abruptly constricted head behind the eyes that gives them an apparent neck and contributes to their antlike appearance. The pronotum is narrower than the elytra and widest in the anterior half. Some have a large pronotal horn that extends forward covering the head. Adults are mostly predators or scavengers but may also feed on plant fluids, pollen, or fungi. They can typically be found on the ground under stones or woody debris and in leaf litter. Some species are quite abundant along the shores of saline lakes, on mud flats, or sand dunes. Of the more than 100 species in California, only a few are commonly found on flowers.

◄ **336. WHITE-SHOULDERED ANT-LIKE
FLOWER BEETLE** *Ischyropalpus nitidulus*
ADULT: BL 3–5 mm; distinctly antlike in form, shiny black or deep brown with a hint of red, especially on the legs, and a dense covering of pubescence across the base of the wing covers that can be silvery or contrasting white.
HABIT: Commonly encountered on plants and their flowers; attracted to lights at night. Unlike the Monocerus Beetle **(337)**, the White-shouldered Ant-like Flower Beetle does not have a pronotal horn.
RANGE: This species is found throughout the state at low and middle elevations.

◄ **337. PACIFIC COAST MONOCERUS BEETLE** *Notoxus lustrellus*
ADULT: Small (BL 3–4 mm); pale brown with lightly patterned wing covers and distinctly toothed pronotal horn extended over the head.
RANGE: Coastal regions of California.

Minute Tree-fungus Beetles (Family Ciidae)

Tiny, nearly cylindrical brown beetles with males frequently bearing head and pronotal horns. They are tiny, but close inspection of fungi (typically wood-rotting polypores) can turn up ciids throughout California. It is thought that most species have an intimate relationship to the fungus host and to the host's range. Males use their tiny horns to fight for mates in their galleries inside the host fungus. Almost 30 species known for California, and numerous unidentified or undescribed species are likely.

▶ **338. HORNED POLYPORE BEETLE** *Cis vitulus*

ADULT: Small (BL 2.5–3.5 mm); stout and very cylindrical form with a covering of pubescence. Males have both pronotal horns and an elevated head ridge.

LARVA: Minute, white caterpillar-like larvae with small, upturned, hook-like processes on the end of the abdomen.

HABIT: Like the adults, larvae are found in fungi, typically *Polyporus* species on hardwoods.

RANGE: Found throughout California but more common near the coast and below 1,500 m.

Darkling Beetles (Family Tenebrionidae)

Tenebrionids are abundant and diverse, with nearly 500 species in California. The larvae are found in almost all terrestrial habitats: in rotten wood, wood-rot fungi, sand dunes and other loose soils, in termite and ant nests, stored-food products, and the like. The adults occur with the larvae, under bark and debris on the ground, or are seen running about in desert habitats or other arid places, especially at dusk.

Although nearly all Temperate Zone tenebrionid beetles are black or dark brown, they exhibit a wide range of dissimilarity in form, being tiny to large, slender or robust, flattened or convex. Some are quite active and resemble ground beetles, while many are sluggish, and often they are flightless, with vestigial hind wings and fused wing covers. The larvae ("false wireworms") are mostly uniform in character, elongate, rather slender, thick-skinned, amber-colored or reddish brown, usually without conspicuous spurs or other armature.

▶ **339. YELLOW MEALWORM** *Tenebrio molitor*

ADULT: Medium-sized (BL 13–15 mm); elongate-oval in outline, somewhat flattened; brown or blackish brown with longitudinal lines on the wing covers.

LARVA: BL to 25 mm; slender, convex above, flat beneath; tan or brown with darker bands at the segmental joints; in grains, seeds, and the like.

HABIT: Many people are familiar with this cosmopolitan species that lives in stored cereals and is often reared in colonies for experimental purposes or as food for lab animals or pets, such as lizards, or used as fish bait.

RANGE: Throughout urban and agricultural areas of the state and occasionally out-of-doors at lower elevations.

▶ 340. LIVE OAK CLUSTER BEETLE *Cibdelis blaschkei*

ADULT: BL 13–15 mm; stout, oval, slightly flattened; black with the thorax smooth, dull, the wing covers faintly roughened.

HABIT: Often found in aggregations under loose bark of oaks in winter and early spring.

RANGE: Coast Ranges and the Sierra Nevada.

▶ 341–342. STINK BEETLES *Eleodes* spp.

Members of this genus are legion, with about 100 species represented in California. They are medium-sized to large, robust, usually smooth, black beetles. All *Eleodes* beetles produce quinone or quinone-like secretions that are believed to make them unpalatable to would be would-be vertebrate predators such as rodents. There are six species of another genus, *Coelocnemis*, that are similar to *Eleodes* in form and chemical defense, but can be distinguished by having lines of golden hairs on the inner margins of the legs (tibiae) and bottoms of the "feet" (tarsi) that are not found in *Eleodes*. While *Coelocnemis* is not considered to be closely related to *Eleodes* on evolutionary bases, pairs of species in the two genera that live together mimic one another in appearance, thus presumably mutually aiding each other in defense against predators that need to only learn one form that should be avoided.

ADULT: BL 8–40 mm; the wing covers tapered or attenuated to the posterior tip; legs long.

LARVA: Slender, nearly cylindrical; amber to brown, with the last abdominal segment pointed and curved upward; in sand or soil, feeding on roots.

HABIT: Many have the interesting habit of standing on their heads and spraying or oozing an offensive-smelling fluid as protection against predators. Often seen wandering over sandy terrain. Some can be remarkably long-lived, over five years in captivity.

RANGE: Throughout the state.

▶ 341. ARMORED STINK BEETLE *Eleodes armata*

ADULT: Large (BL 17–33 mm); with prominent spurs on all the legs.

RANGE: Widespread in arid areas, coastal southern California, deserts, and the Central Valley.

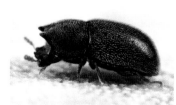

338. Horned Polypore Beetle
(*Cis vitulus*).

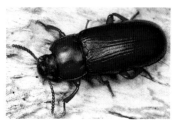

339. Yellow Mealworm
(*Tenebrio molitor*).

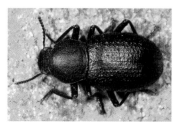

340. Live Oak Cluster Beetle
(*Cibdelis blaschkei*).

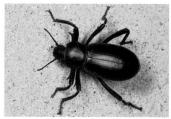

341. Armored Stink Beetle
(*Eleodes armata*).

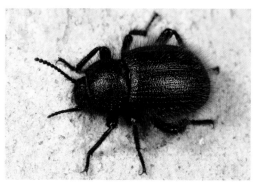

342. Woolly Ground Beetle
(*Eleodes osculans*).

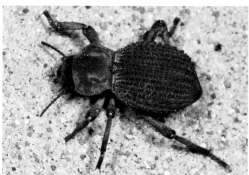

343. Warty Desert Ironclad
Beetle
(*Asbolus verrucosus*).

DENTATE STINK BEETLE *Eleodes dentipes*

ADULT: Small (BL 16–28 mm); variable in shape, with the tooth on the front legs of both sexes (that also occurs in several other species).
RANGE: From San Luis Obispo County northward, common in stumps, logs, dry leaves, and the like.

◄ 342. WOOLLY GROUND BEETLE *Eleodes osculans*

ADULT: BL 12–16 mm; rectangular; black; sparsely covered with long, reddish-brown hair.
HABIT: Often seen along roads or paths in wooded or chaparral areas.
RANGE: Coastal, southern to central California.

◄ 343. WARTY DESERT IRONCLAD BEETLE *Asbolus verrucosus*

ADULT: Large (BL 18–22 mm); robust and heavily built, with distinctly bumpy wing covers. The body is covered in a powdery, white-blue hue that is due to a wax secreted by the beetle onto its exoskeleton.
HABIT: Most common in gravelly sand soil areas in the Colorado and Mojave Deserts.
RANGE: Found in southern California.

▶ 344. DUSTY DARKLING BEETLES *Coniontis* spp.

The genus includes about 50 described species, and there are likely many yet to be described.
ADULT: Small to medium-sized (BL 5–15 mm); dull, black oval or elongate oval-shaped beetles.
HABIT: Some species are commonly found in lawns and pastures. While they are found year-round, they are most abundant during the hottest months when they spend the heat of the day underground, often in mammal burrows, and emerge at night to feed.
RANGE: The adults are common throughout California, especially in foothills, grasslands, and remnants of natural habitat in the Central Valley.

▶ 345. ARMORED NIGHT-WALKER *Nyctoporis carinata*

ADULT: Medium-sized (BL 12–16 mm); black, often with a blue tint and distinctly and densely punctate on the head and pronotum, wing covers with deep rows of punctures and sharply raised ridges and bumps. Tarsi ("feet") with distinct, golden, thick pelage of hairs. Flightless; wing covers are fused.
HABIT: Often associated with deadwood and under bark of rotten stumps.
RANGE: Coastal Californian and the Coast Ranges.

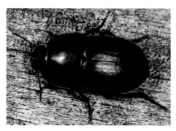

344. Dusty Darkling Beetle
(*Coniontis* sp.).

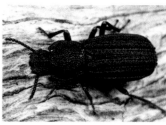

345. Armored Night-walker
(*Nyctoporis carinata*).

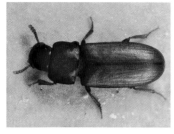

346. Flour Beetle
(*Tribolium castaneum*).

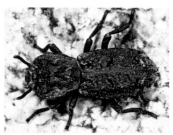

347. Ironclad Beetle
(*Phloeodes diabolicus*).

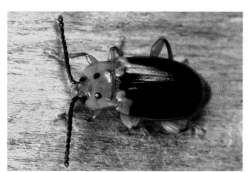

348. Red-shouldered
Handsome Fungus Beetle
(*Aphorista laeta*).

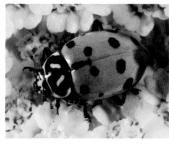

349. Convergent Ladybird Beetle
(*Hippodamia convergens*).

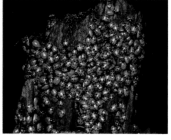

350. Convergent Ladybird Beetle
(*Hippodamia convergens*) aggregation.

◄ 346. FLOUR BEETLES *Tribolium* **spp.**

ADULT: Small (BL 3–4 mm); slender, flattened, with smooth margins on the thorax; pale to dark reddish brown, with the head and thorax darker.

LARVA: Nearly cylindrical, strongly segmented; white to yellowish brown with dark mandibles and a pair of short tail spurs.

HABIT: Adults and larvae commonly found together in all kinds of cereal products, nuts, and other dried foods.

RANGE: Urban and agricultural areas throughout the state.

Ironclad Beetles and Cylindrical Bark Beetles (Family Zopheridae)

California's 40 species of zopherid beetles fall into two main groups: ironclads, which are large, heavily built beetles that closely resemble many conspicuous darkling beetles (most Zopherinae), and smaller, more lightly built and rather variably shaped beetles that were previously classified in other families (e.g., possum beetles [Monommatini] and cylindrical bark beetles [Colydiinae]). They are associated with and probably feed in dead wood or other decaying plant material, likely feeding on fungi growing on these materials.

◄ 347. IRONCLAD BEETLE *Phloeodes diabolicus*

This beetle is named for its extremely hard shell (exoskeleton).

ADULT: BL 15–23 mm; oval in outline with the thorax as broad as the abdomen, flattened and rough-surfaced; dark brown, mottled with black and gray. Common under loose bark of dead oak and cottonwood.

LARVA: Superficially like a flat-headed borer (Buprestidae), with enlarged thorax and short legs; in rotten wood.

HABIT: Specimens have the peculiar ability to postpone breathing and survive long periods in killing jars with cyanide or even immersed in alcohol. When finally dead, they are quite difficult to pierce with a pin.

RANGE: Woodlands throughout much of California.

Handsome Fungus Beetles (Family Endomychidae)

California has about a dozen species of handsome fungus beetles that are usually broadly oval with antennae that are loosely clubbed in the last three segments. Many species are brightly colored and all are less than 10 mm long. They can be distinguished from similar beetles by the pair of

well-impressed lines running longitudinally on the pronotum. Some are defended by reflex bleeding, where a noxious fluid that deters predators is produced from their leg joints when they are disturbed.

◀ 348. RED-SHOULDERED HANDSOME
FUNGUS BEETLE *Aphorista laeta*
ADULT: BL 7–9 mm; somewhat shiny beetles with a red-orange head, pronotum and legs that contrast with the blue-black elytra and darkened antennae. Only the "shoulders" and tip of the wing covers have contrasting red-orange patches.
HABIT: Adults occasionally come to lights and can be found under bark of rotten logs.
RANGE: Known from throughout California, more common in the central and north coastal counties.

Ladybird Beetles (Family Coccinellidae)

Coccinellids are uniformly oval or round beetles that are strongly convex above, flat beneath, shining, and often brightly colored. Ladybird beetles, or ladybugs as they are often called, are among the most familiar of all insects, and their beneficial effects have long been known to gardeners. Both adults and larvae of most species eat aphids, mealy bugs, and similar soft-bodied insects as well as mites. The larvae are caterpillar-like, alligator-shaped, and broadest in the thoracic area or anterior part of the abdomen, tapering toward the end of the abdomen. They are mostly gray, spotted with orange, yellow, or white, and often are found on aphid-infested plants. Many larvae are covered with spines, skin processes, or waxy secretions.

Ladybird beetles are interesting in several ways: when disturbed, many species secrete a bitter, amber-colored fluid that is believed to have toxic effects on vertebrates; some species form huge masses of individuals for hibernation and may migrate long distances to and from hibernation sites and summer feeding grounds; and few coccinellids have remarkable color variation in which adults occur in two or more completely different-looking forms (polymorphism). Although rather consistent in body shape and habits, there are a great many species, with around 190 known in California.

◀ 349–350. CONVERGENT LADYBIRD
BEETLE *Hippodamia convergens*
ADULT: (349) BL 6–8 mm; oval, with the wing covers somewhat pointed at the end; bright orange with variable spotting; thorax black with a narrow

rim and a pair of narrow, diagonal, converging, white or yellowish-white spots.

LARVA: Elongate, somewhat flattened with the segments strongly protruding; gray with indistinct orange markings on the thorax and larger abdominal spots.

HABIT: One of the most common insects in California, this species assembles in great numbers in canyons and hills of the Coast Ranges and the Sierra Nevada for hibernation **(350)**. The beetles are often seen when the overwintering masses begin to disperse on warm days in February or March. They migrate to the valleys, where they feed on aphids. Adults of the following generation return to the mountain aggregations in May or June, when the lowland vegetation is drying.

RANGE: Throughout all but the driest parts of California, at a wide range of elevations.

This species is often confused with the Five-spotted Ladybird Beetle *(H. quinquesignata)*. It is also variable, from an unspotted form west of the Sierra Nevada to one having three nearly complete bands across the elytra in the Great Basin. It usually does not have the convergent spots on the thorax.

▶ 351–352. WESTERN SPOTLESS LADYBIRD BEETLE *Cycloneda polita*

ADULT: (351) BL 4–6 mm; oval, with the wing covers bright red-orange without spotting; thorax black with a narrow white rim and a pair of white, nearly closed crescents.

LARVA: (352) Elongate, somewhat flattened, the segments with strongly protruding bumps; dark gray with distinct orange markings on the middle of the thorax and larger abdominal spots medially and laterally.

HABIT: Adults and larvae are voracious aphid predators frequently found in urban gardens and uncut lots.

RANGE: Native to western North America and found throughout the state, except perhaps the desert regions.

▶ 353. TWICE-STABBED LADYBIRD BEETLE *Chilocorus orbus* complex

There are several nearly indistinguishable species under this name.

ADULT: BL 4–5 mm; similar in color to the Ashy Gray Ladybird Beetle **(356)** but shiny and more convex, with the head end blunt; commonly black with two large, red spots on the elytra, less often pale gray with small black spots.

LARVA: BL to 7 mm; covered with many long branched spines; black with a median yellow belt.

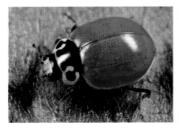

351. Western Spotless Ladybird Beetle (*Cycloneda polita*) adult.

352. Western Spotless Ladybird Beetle (*Cycloneda* sp.) larva feeding on aphids.

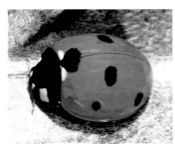

353. Twice-stabbed Ladybird Beetle (*Chilocorus* sp.).

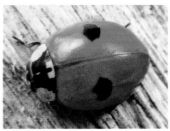

354. Two-spotted Ladybird Beetle (*Adalia bipunctata*).

355. Seven-spotted Ladybird Beetle (*Coccinella septempunctata*).

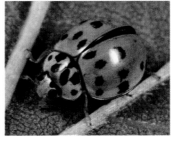

356. Ashy Gray Ladybird Beetle (*Olla v-nigrum*).

357. Vedalia Beetle (*Rodolia cardinalis*).

358. Mealybug Destroyer (*Cryptolaemus montrouzieri*).

HABIT: Feeds on scale insects of many kinds, especially in orchards and gardens.

RANGE: Widespread in the state.

◀ 354. TWO-SPOTTED LADYBIRD BEETLE *Adalia bipunctata*

This small species has distinctly different color forms.

ADULT: BL 4–5 mm; usually red with the thorax black, irregularly margined white, and with a large black spot on each wing cover; other forms are mostly black with two variable orange spots on the front margin and middle of the elytra.

LARVA: Slender, widest at abdominal segments 2, 3, and 4; dark brown to bluish gray, mottled with cream-colored spots; each segment with three pairs of raised spots bearing spines; last segment with eversible, fleshy protuberances.

RANGE: Widespread, in all but the desert in the state.

◀ 355. SEVEN-SPOTTED LADYBIRD BEETLE *Coccinella septempunctata*

One of the most commonly encountered ladybird beetles.

ADULT: BL 7–8 mm; reddish orange with seven black spots that are arranged with three on each wing cover and one across the bases of both wing covers; pronotum is mostly black, with two lateral white marks.

HABIT: The Seven-spotted Ladybird Beetle is a strong flyer and disperses widely. When in large numbers, they are known to outcompete and have a negative impact on native ladybird beetles.

RANGE: Intentionally introduced from Europe into North America in the 1960s and 1970s for the biological control of aphid pests, the species is now widespread in the state and throughout North America.

CALIFORNIA LADYBIRD BEETLE *Coccinella californica*

ADULT: BL 5–7 mm; more convex and less elongate than *Hippodamia* but colored similarly, with predominantly black thorax and reddish-orange elytra, usually without spots; color fades to a dull orange or orange-brown in pinned specimens.

LARVA: Stout, widest at the second segment, light to dark bluish with orange spots from the fourth abdominal segment forward; body wall with blunt, fleshy protuberances on the dorsum and upper sides; feeds extensively on aphids.

RANGE: Coastal counties south to the Transverse Ranges.

◄ 356. ASHY GRAY LADYBIRD BEETLE *Olla v-nigrum*

This species has two distinct forms.

ADULT: BL 4–6 mm; nearly hemispherical; either pale tan to gray with numerous small black spots on the thorax and wing covers or a form resembling the Twice-stabbed Ladybird Beetle **(353)**, mostly black with two large red spots in the middle of the elytra; distinguished by white on the leading edge of the pronotum.

LARVA: BL to 20 mm; black with very light yellow to orange markings.

HABIT: Feeds on acacia psyllids, aphids of walnut, and other plants.

RANGE: Widely distributed; primarily at lower elevation and foothill localities.

◄ 357. VEDALIA BEETLE *Rodolia cardinalis*

ADULT: Small (BL 2.5–3.5 mm); nearly hemispherical; dark red with irregular black markings that are more extensive in the male; color pattern obscured by fine gray hairiness.

LARVA: Pink with black markings and a blue cast.

HABIT: This is one of the most famous of all insects to entomologists because it was the first successful introduction of a predaceous insect into any country to control a pest insect. This was a breakthrough for applied biological control, which has become increasingly important in the effort to reduce insecticide use. The species was introduced into southern California from Australia in 1888 and developed huge populations, which within a year effectively controlled the Cottony-cushion Scale *(Icerya purchasi)* **(226)**, a major pest of citrus.

RANGE: Established at citrus-growing locations in southern California and the Central Valley.

◄ 358. MEALYBUG DESTROYER *Cryptolaemus montrouzieri*

ADULT: Small (BL 3–4 mm); oval in outline, tapering to the tail end; shining black with the head, thorax, tips of elytra, and abdomen reddish orange.

LARVA: Yellow, entirely covered with long white, waxy filaments, resembling large mealybugs.

HABIT: Following the success of the Vedalia Beetle introduction, about 50 more kinds of coccinellids were introduced in the 1890s, but only four species, including this one, became established. The Mealybug Destroyer survives winter only in coastal San Diego County but is mass-produced in insectaries and released by the millions.

RANGE: Annually released in warmer parts of the state.

Longhorn Beetles (Family Cerambycidae)

Cerambycidae includes beetles of a wide array of sizes, colors, shapes, and ornamentation. There are approximately 400 species of longhorn beetles in California, including some of our largest beetles. They have long been a favorite among collectors, probably exceeded in popularity only by butterflies and larger moths. Most cerambycids are somewhat elongate and cylindrical with long antennae; more than two-thirds of the body length, which are usually attached in a notch of the eye. The beetles have chewing mouthparts, long rather thin legs, and well-developed wings. Many are rather slow-moving, but some are quick and can be seen running rapidly on recently cut wood or taking flight suddenly at the least disturbance. Adults feed on pollen, flower parts, foliage, or bark of twigs, varying according to species; many, especially the brightly colored forms, are found at flowers during the day. Others, especially larger longhorn beetles, are only commonly seen at lights on hot summer nights.

The larvae bore into the wood of dying or dead trees or, in some genera, in roots of living shrubs. Different species select moist, dry, or rotting stages of dead wood, while others use bark or wood of living trees. Usually a special pupation chamber is constructed in a gallery leading away from the larval tunnel, and it is plugged by frass and fibrous chips. The larval form is correlated with habits; most are cylindrical, those living in bark are flattened. The head is small and usually somewhat inserted into the prothorax, which is broader than the remaining body segments. The legs of the larva are either absent or if present very short. The life cycle usually requires one year, but in some species it involves several years. Larvae of a few species may lie dormant in dry wood for years. There are records of cerambycids emerging after 20 years or more from wood made into furniture or beams in homes.

▶ **359. CALIFORNIA PRIONUS** *Prionus californicus*

Some individuals are perhaps among the largest beetles in California.

ADULT: BL 40–60 mm; similar to the Spined Woodborer (*Trichocnemis spiculatus*) (**360**) but broader in form, darker in color, and with sawblade-like, toothed antennae in the male; three large spines project from each side of the thorax.

LARVA: Large, tan or yellowish-white grub somewhat less strongly segmented than the Spined Woodborer and lacking the teeth on the front of the head.

HABIT: Lives in dead or dying roots and stumps of oaks and other hardwoods and conifers.

RANGE: Coastal and inland valleys, foothills, and mountains to middle elevations in areas with large, dead oaks.

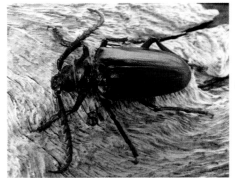

359. California Prionus (*Prionus californicus*).

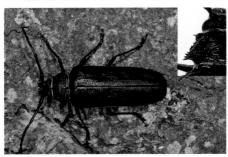

360. Spined Woodborer (*Trichocnemis spiculatus*) spined pronotal margin (inset).

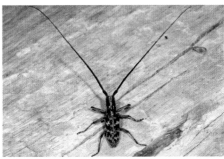

361. Spotted Pine Sawyer (*Monochamus clamator*).

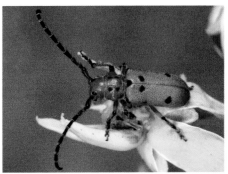

362. Red Milkweed Beetle (*Tetraopes femoratus*).

◀ 360. SPINED WOODBORER *Trichocnemis spiculatus*

ADULT: Large (BL 40–45 mm); brown with the head and thorax granulate above and darker than the wing covers; lateral margins of the thorax with many small teeth **(360 inset)**.

LARVA: Large (BL to 60 mm); white grub with strongly differentiated segments and a dark head bearing four blunt "teeth."

HABIT: Lives in older dead logs and stumps of pine and other conifers; maturation requires two to three years. This and the California Prionus are the largest beetles in California, and they frequently startle residents and campers when they noisily fly to lights on warm summer evenings.

RANGE: Coniferous forest regions.

◀ 361. SPOTTED PINE SAWYER *Monochamus clamator*

ADULT: Medium-sized to large (BL 14–30 mm) reddish brown with pubescence that varies in color from reddish brown, white, to gray and forms a variegated pattern on the wing covers. Antennae are impressively long and can either extend past the wing covers a full five segments in males or three segments in females.

LARVA: Larvae bore extensively in sapwood and heartwood of dying and recently killed pines, spruces, or firs.

RANGE: Found in all nondesert mountain ranges in California.

OREGON FIR SAWYER *Monochamus scutellatus*

This slow-moving species is not conspicuous but is one of the most spectacular beetles in California. It may be found in numbers by looking for aggregations on the lower side of recently felled trunks of White Fir and other coniferous trees.

ADULT: Large (BL 16–31 mm); enormously elongated antennae, particularly in males; females black with white or gray pubescent spots and white annulations on the antennae; males tend to be mostly black often with a slight metallic sheen.

LARVA: In recently dead or dying fir and other conifers.

RANGE: North Coast Ranges and the Sierra Nevada at middle to higher elevations.

◀ 362. RED MILKWEED BEETLES *Tetraopes* spp.

ADULT: BL 10–15 mm; blunt, cylindrical with the wing covers broadest at the base, giving a broad-shouldered appearance; red with variable black spotting.

LARVA: In roots of living milkweed (*Asclepias* spp).

HABIT: The slow-moving, bright red members of this genus are common on milkweed, where they perch conspicuously, evidently protected by distastefulness from vertebrate predators.

RANGE: California has only three species from this genus, all very similar in appearance. *Tetraopes basalis* is the most common species throughout the state west of the Sierra Nevada, **T. femoratus (362)**, is widespread in California, and *T. sublaevis* is known from Kern County and south.

▶ **363. DIMORPHIC FLOWER LONGHORN** *Anastrangalia laetifica*

ADULT: BL 7–13 mm; females are black, with bright red wing covers bearing small black spots; males are either entirely black or have dull yellowish-brown or tan markings on the elytra.

LARVA: Unornamented, white grub with a brown head; in older, dead pine wood.

HABIT: The beetles are very active and visit a wide range of wildflowers in the foothills and mountains during spring and early summer.

RANGE: Mountains and foothills throughout the state except the desert ranges. Many similarly shaped and brightly colored species of the same subfamily occur in California and are common flower visitors. Among these, the Yellow Velvet Beetle *(Cosmosalia chrysocoma)* BL 9–15 mm is one of the most conspicuous. It is a beautiful golden yellow, covered with fine hairy pile. Common in mountain meadows at middle elevations throughout the state.

▶ **364. SHORT-WINGED LONGHORN BEETLE** *Necydalis diversicollis*

ADULT: BL 13–20 mm; elytra very short, scarcely extended over the base of the abdomen, flight wings not folded. Body slender, very wasplike in appearance. Color variable from reddish brown in all or part to entirely black.

LARVA: The larvae feed in heartwood of various deciduous trees—for example, alder and willows.

HABIT: Larvae are most frequently found in the basal portion of stumps or dead standing trees. Adults are active feeding on flowers in midsummer.

RANGE: Found throughout California in habitats with suitable host trees.

▶ **365. OPAQUE SAWYER** *Asemum striatum*

ADULT: BL 10–23 mm; elongate, brown or black and moderately shiny, covered with fine short hairs. Wing covers appear faintly striated. Antennae are only moderately long and reach back only about half the length of the wing covers.

LARVA: Larvae feed in recently dead conifer trees and their stumps.

RANGE: Common in conifer forests statewide.

Leaf Beetles (Family Chrysomelidae)

In species numbers the family Chrysomelidae is one of the largest families of Coleoptera, probably second only to the Curculionidae, and more than 400 species are recorded in California. There are various body forms, but for the most part chrysomelids are small, oval, blunt, and cylindrical or flattened, and they are often brightly colored and shiny metallic. The antennae are threadlike without a club and are generally shorter than those of the longhorn beetles, which many leaf beetles somewhat resemble. Some chrysomelids have enlarged hind legs and can jump long distances when startled (flea beetles), but most tend to draw up their legs, feigning death, and drop to the ground when disturbed.

Both the adults and larvae feed on living plants, most often on the leaves. Some are leaf miners in the larval stage and a few bore into stems. Most are fairly specific in host-plant preference. The more commonly seen larvae feed externally on leaves and are caterpillar-like. They are rather fat, tapered toward the tail end, and often metallic. During feeding, the leaf surface is skeletonized or holes are produced, accompanied by characteristic droppings plastered to the leaf surface. A few species feed on aquatic plants, and still others construct snail shell-like cases of earth and excrement and live in ants' nests or leaf litter.

▶ **366. WESTERN SPOTTED
CUCUMBER BEETLE** *Diabrotica undecimpunctata*

This is one of the commonest insects in California, occurring on a wide array of weedy and cultivated plants.

ADULT: BL 4–6 mm; oval in outline with the thorax narrower than wing covers and the head strongly protruding; bright green with six variable black spots on each wing cover and variable amounts of black on legs and underside.

LARVA: Slender, wireworm-like in form, with short legs; yellowish white with brown head; last segment brown, with a nearly circular outline.

HABIT: Adults eat leaves and flowers of all kinds except conifers; particularly abundant on plants of the squash family. Larvae are in roots of grasses, corn, and other plants.

RANGE: Throughout most of California, except at the highest elevations.

▶ **367. AQUATIC LEAF BEETLES** *Plateumaris* spp.

ADULT: BL 8–12 mm; slender, convex, with thorax narrower than wing covers; sutural margin of the wing covers turned outward and widened apically; iridescent blue, green, purplish, or bronze.

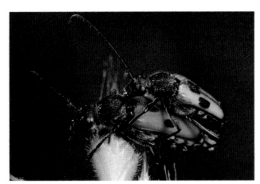

363. Dimorphic Flower Longhorn (*Anastrangalia laetifica*) male top, female bottom.

364. Short-winged Longhorn Beetle (*Necydalis diversicollis*).

365. Opaque Sawyer (*Asemum striatum*).

366. Western Spotted Cucumber Beetle (*Diabrotica undecimpunctata*).

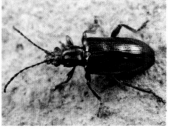

367. Aquatic Leaf Beetle (*Plateumaris* sp.).

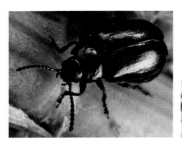

368. Green Dock Beetle (*Gastrophysa cyanea*).

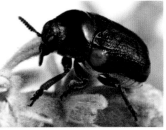

369. Red-shouldered Leaf Beetle (*Saxinis saucia*).

LARVA: Elongate, subcylindrical; whitish, with short, hooked legs. The abdomen is terminated by a pair of spines, enabling larvae to perforate the plant and insert the tail into air spaces for breathing.

HABIT: Beetles of this genus are found on emergent or submerged parts of aquatic plants. Typical hosts are sedges (Cyperaceae). Adults breathe by cutting the stem of the plant with their mandibles, allowing oxygen to escape. The oxygen is caught by hairs on the antennae and face and spread back over the body surface. Found in ponds and lakes at a wide range of elevations.

RANGE: Throughout the state in suitable habitat.

◀ 368. GREEN DOCK BEETLE *Gastrophysa cyanea*

ADULT: Small (BL 4–5 mm); oval, convex, bright metallic green; sometimes turning blue in pinned specimens. Common in spring on Curly Dock (*Rumex crispus*) and related plants. The females' abdomens are grossly distended, greatly exceeding the wing covers, before laying large masses of eggs.

LARVA: Black, hump-backed grub eats all but the larger veins of dock leaves.

RANGE: Throughout lower elevation parts of the state, and on the west side of the Sierra Nevada.

◀ 369. RED-SHOULDERED LEAF BEETLE *Saxinis saucia*

ADULT: BL 4–6 mm; robust, cylindrical; metallic blue above with a conspicuous red spot at the base of each wing cover, hairy and pale, almost gray beneath.

HABIT: Common on buckwheat (*Eriogonum* spp.), ceanothus, and other flowers, where it eats the buds.

LARVA: Slender, white; in ants' nests covered by cases made of mud and frass. The eggs are brown with longitudinal ribs, resembling seeds, and are probably collected by ants.

RANGE: Throughout foothill and lower elevation parts of the state, excluding the deserts; occasionally seen at higher elevations.

▶ 370. BLUE MILKWEED BEETLE *Chrysochus cobaltinus*

This is the largest and arguably the most spectacular chrysomelid in California.

ADULT: BL 8–12 mm; robust, oval, with the thorax slightly narrower than the wing covers; beautiful, shining, metallic dark blue to greenish blue.

HABIT: Common on milkweed (*Asclepias* spp.).

LARVA: White grubs in the soil, feeding on roots of the milkweed (presumed from habits of related eastern species).

RANGE: Throughout the state at a wide range of elevations, wherever milkweed is found.

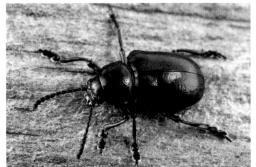

370. Blue Milkweed Beetle (*Chrysochus cobaltinus*).

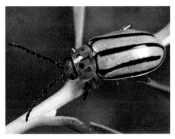

371. Golden Tortoise Beetle (*Charidotella sexpunctata*).

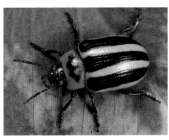

372. Striped Bidens Leaf Beetle (*Calligrapha californica*).

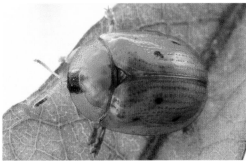

373. Striped Willow Leaf Beetle (*Disonycha alternata*).

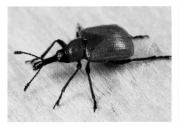

374. Western Rose Curculio (*Merhynchites wickhami*).

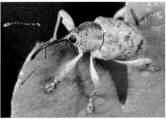

375. Nut and Acorn Weevil (*Curculio* sp.).

◀ 371. GOLDEN TORTOISE BEETLE *Charidotella sexpunctata*

These and related beetles look like burnished brass buttons and are sometimes called "gold bugs."

ADULT: BL 5–6 mm; flattened, nearly round in outline with the thorax and wing covers expanded completely concealing the head and legs. In life the wing cover that make up what looks like a shell are golden and nearly translucent in the expanded portions, but pinned specimens become dull ochreous or reddish. The color can be restored temporarily by placing the specimens in a humidity chamber.

LARVA: Mealybug-like; oval; brown with branched spines on the margins; carry fecal material on the back, which is supported and attached by a forked-tail process.

HABIT: Larvae and adults eat the leaves of morning glory and related plants, but the adults are found on various plants.

RANGE: Foothills and valleys on the west side of the Sierra Nevada.

◀ 372. STRIPED BIDENS LEAF BEETLE *Calligrapha californica*

ADULT: Medium-sized (BL 6–10 mm); convex, ovate beetles with bold stripes on the wing covers, head is black, pronotum red to yellow with various black markings.

LARVA: The larvae feed on host plant leaves and are dark-colored, with a black head and blackish-brown body that is fat caterpillar-like in form.

HABIT: Host plants are composites such as *Bidens* and *Coreopsis*, where adults can typically be found from April to June.

RANGE: Throughout California where host plants are found.

◀ 373. STRIPED WILLOW LEAF BEETLE *Disonycha alternata*

ADULT: BL 6–8 mm; elongate oval and boldly patterned with contrasting black and white or yellow wing covers and orange head, pronotum and abdomen.

HABIT: Larvae and adults are common on willow.

RANGE: Across all of California where host plants are found.

Another willow-feeding leaf beetle, *Chrysomela aeneicollis,* with a bold variegate pattern on its wing covers and a bright metallic head and pronotum. Found throughout northwestern North America with high-elevation, montane populations in California that are at the southernmost edge of its range. California populations of this beetle have been extensively studied and shown to have fluctuated dramatically over the past two decades, correlating with climatic conditions and suggestive of impacts that severe climate change may have on insect populations.

Tooth-nosed Snout Beetles (Family Attelabidae)

Attelabids resemble typical weevils in Curculionidae but their antennae are not elbowed (geniculate) as in weevils; instead they have a more threadlike form with three segments near the tip expanded into a club.

◄ 374. WESTERN ROSE CURCULIO *Merhynchites wickhami*

ADULT: Small (BL 4–6 mm); rather slender with the thorax elongated, much narrower than the wing covers; body black with the elytra and back of the thorax bright red. Head usually black.

LARVA: Small white grubs in the base of flowers and seed pods; in roses, blackberry, and related plants.

HABIT: The beetles bore holes for feeding and egg-laying in the buds of plants of the rose family.

RANGE: Throughout foothill to middle-elevation areas of the state.

Also found throughout foothill to middle-elevation areas of the state is the Rose Curculio *(M. bicolor)*, which is very similar to the Western Rose Curculio except that its head is usually red. These beetles bore holes for egg-laying in rose hips.

Weevils and Bark Beetles (Family Curculionidae)

No other family in the entire animal kingdom has as many species as the family Curculionidae. The numbers and diversity of form and habits of weevils are legion; there are probably more than 1,000 species in California. Typical weevils are easy to recognize as the major distinguishing features are their long snout, which may be slender or broad, and the elbowed, clubbed antennae, which arise from the sides of the snout. The body shape and ornamentations are exceedingly varied—oval, elongate, flattened, with long or short legs, and varying in size from tiny to large (BL 1–35 mm). In general, weevils use the snout in boring out a pit for the eggs. Unlike most Coleoptera, many weevils are frequently clothed with scales. Most North American forms are dull-colored, but in tropical regions many are resplendent in bright, metallic colors. The larvae are legless grubs and generally similar in form. The majority feed inside seeds, stems, or roots, while some subterranean species eat the surface of roots, and a few live on aquatic plants. Usually pupation occurs in the soil or larval galleries, although some genera have species that produce a parchmentlike cocoon. Many curculionids cause serious economic damage to crops or stored foods.

◀ 375. NUT AND ACORN WEEVILS *Curculio* spp.

These vary in size from BL 4–14 mm. They are distinguished by their long, slender snouts. There are several species in California that are difficult to separate.

CALIFORNIA ACORN WEEVIL *Curculio uniformis*

ADULT: BL 5–7 mm; robust, with a narrow thorax, long legs, and greatly elongated snout, in the female much longer than the body, shorter in the male; body brown-spotted, covered with bright yellow and ochreous scales.

LARVA: Develop in acorns of several species of oaks.

HABIT: Common on live oaks and deciduous oaks, especially during the bloom and early acorn periods.

RANGE: Throughout oak woodlands across the foothills of the state.

▶ 376. YUCCA WEEVIL *Scyphophorus yuccae*

One of the largest native weevils in California, this species is abundant at the bases of the Chaparral Yucca *(Hesperoyucca whipplei)* and on the Joshua Tree *(Yucca brevifolia).*

ADULT: BL 12–20 mm; black; nearly rectangular in outline, somewhat flattened; with thickened legs and beak; thorax smooth, as broad as the wing covers, which are deeply etched with longitudinal grooves.

LARVA: In green, flowering stalks of yucca, leaving before the stalks dry to pupate in the ground.

RANGE: Throughout the range of yucca in California.

▶ 377. TULE BILLBUG *Sphenophorus australis*

ADULT: BL 14–18 mm; oval in outline, with a shiny surface. It is generally black above with variable cream-colored streaks and regions and rows of deep pits.

HABIT: It normally breeds in tules or cattails along rivers.

RANGE: Along permanent wetlands, rivers, and creeks of the Central Valley and coastal areas.

Similar in size and form, the related Clay-colored Billbug *(S. aequalis)* has cream-colored legs and patches of pale color ventrally. It is found in the same habitats as the Tule Billbug and occasionally can be a pest in grain fields nearby their wetland habitats.

▶ 378. FULLER'S ROSE WEEVIL *Naupactus cervinus*

ADULT: BL 7–9 mm; cylindrical, broad-nosed; dull brown, faintly covered with a whitish waxy powder and marked with a white oblique stripe on each side of the sealed elytra; flightless.

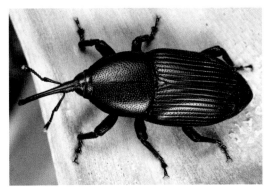

376. Yucca Weevil
(*Scyphophorus yuccae*).

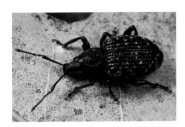

377. Tule Billbug
(*Sphenophorus australis*).

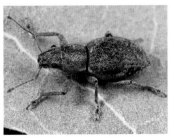

378. Fuller's Rose Weevil
(*Naupactus cervinus*).

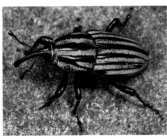

379. Black Vine Weevil
(*Otiorhynchus sulcatus*).

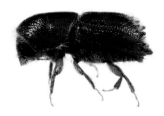

380. California Five-spined Ips
(*Ips paraconfusus*).

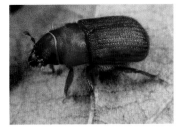

381. Red Turpentine Beetle
(*Dendroctonus valens*).

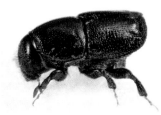

382. Hemlock Engraver
(*Scolytus tsugae*).

LARVA: BL 5–6 mm; white, legless grubs; in the roots and lower stems of various plants, often a pest of ornamental garden plants.

HABIT: The adults hibernate and often appear in large numbers in spring, eating the leaves of a wide variety of plants; frequently seen on sidewalks and driveways in cities in fall and spring.

RANGE: At lower elevations throughout the state, except the deserts.

◄ 379. BLACK VINE WEEVIL *Otiorhynchus sulcatus*

ADULT: BL 7–9 mm; black, very convex and oval shape, snout relatively short and blunt. Wing covers with irregularly placed patches of pale hairs.

HABIT: Adults feed on seedlings and leaves of a variety of plants. Larvae are root feeders.

RANGE: Native to Europe and introduced widely in North America. Common in gardens in California.

Bark Beetles (Subamily Scolytinae)

Bark beetles (Scolytinae) are small, dull-colored, cylindrical, short-legged curculionids that do not have prominent snouts. They live in the bark or between the bark and wood of trees and shrubs. Their secretive habits and inconspicuous appearance belie their importance, for bark beetles kill more trees than all other forces combined, including forest fires. The adults bore an entrance tunnel into bark or, in a few species, into seeds or cones. At the inner end of the tunnel, two or more egg tunnels are cut between the bark and the wood, and eggs are scattered or laid in niches along the walls. Later the white legless larvae excavate slender burrows at right angles to the egg tunnels. These galleries become filled with frass and increase in diameter as the larvae grow. When population densities are high, the galleries eventually encircle the limb or trunk and cut off flow of water and food in the critical cambium layer, killing the parts of the trees beyond that point. The form or arrangement of the galleries is characteristic for given species or genus, and practiced forest entomologists can identify specific bark beetles by them.

There is remarkable variation in relations of the sexes, with some species polygamous and others monogamous. In some, a nuptial chamber is excavated by the male, and he produces a powerful scent in the frass, which attracts females of the same species. Some scolytines, called ambrosia beetles, feed deeper in the wood. Females prepare a bed or layer of chips and frass upon which the fungal spores she brings with her in specialized pouches develop to be used as food by the beetles and their larvae. Ambrosia—food of the gods—is the name applied to this fungus

food. California, owing to its rich diversity of plant communities, has a large fauna of bark beetles, with more than 170 species.

◄ 380. CALIFORNIA FIVE-SPINED IPS or YELLOW PINE ENGRAVER — *Ips paraconfusus*

Species of *Ips* have a concave area at the tail end of the elytra, bearing spines on its margins. The genus includes some of the most important insects in the forest industry in California, and one of the most destructive of them is arguably this species.

ADULT: Small (BL 4–5 mm); brown, with five spines on each lateral margin.
LARVA: Feed in apparently healthy smaller trees, damaged trees, and tops of larger trees of all species of pine within its range.
HABIT: The male is joined by three to five females, each of which bores an egg gallery along the grain of the wood. The resultant pattern resembles a tuning fork.
RANGE: West side of the Sierra Nevada, Coast, and Southern Ranges. This species was differentiated only recently from Pinyon Pine Engraver *(I. confusus)*, and nearly all older literature on *I. confusus* refers to *I. paraconfusus.*

◄ 381. RED TURPENTINE BEETLE — *Dendroctonus valens*

ADULT: Moderately large (BL 6–9 mm), robust; bright reddish brown. Galleries occur near the base of all kinds of pines.
HABIT: It sometimes kills ornamental trees such as Monterey Pine, where it is grown in hotter, drier zones than its native range along the coast.
RANGE: The Sierra Nevada and Coast Ranges; into low-elevation urban areas.

WESTERN PINE BEETLE — *Dendroctonus brevicomis*

Known as "DB" to forest entomologists, this is one of the most destructive pine pest insects in the western United States.

ADULT: Small (BL 3–5 mm); broadly cylindrical, pale brown to black.
HABIT: The female cuts long, meandering egg galleries with egg niches 8–10 mm apart in Ponderosa and Coulter Pines.
RANGE: Throughout the Sierra Nevada and scattered in the Coast Ranges.

◄ 382. HEMLOCK ENGRAVER — *Scolytus tsugae*

ADULT: Small (BL 2.5–4 mm); dark brown or blackish, shiny; wing covers project over a deep concavity of the abdomen.
HABIT: Attacks fresh slash, the main bole, and large branches of hemlocks.
RANGE: Found in the central Sierra Nevada.

SHOTHOLE BORER *Scolytus rugulosus*

Introduced from Europe and now occurs in many parts of North America, including California. This scolytine feeds in pome and stone-fruit trees and frequently causes limbs to die in orchards.

ADULT: Small (BL 2–3 mm), exceptionally stout; nearly black with the antennae and legs cinnamon red.

RANGE: Coastal areas and valleys and the Central Valley.

The genus *Scolytus* has nearly 30 similar-looking species, many that occur in California and are frequently extremely important pests of conifer trees. Damage to trees is most severe when there are environmental stresses like prolonged drought and infestation by other insects.

Fleas (Order Siphonaptera)

Fleas, like lice, have lost all traces of the wings their ancestors had, likely as an adaptation to their parasitic lifestyle since wings would cause drag as the insects dart between the follicles of hairs or feathers on their hosts. This loss of wings is also seen in some flies (Hippoboscidae) where the wings are shed when the flies find a host. While fleas share a similar lifestyle with lice, they are only very distantly related and have evolved their similarities through convergent evolution (similar selective forces on independent lineages). Fleas differ from lice structurally in many ways, like their side-to-side compressed bodies rather than the flattened body of a louse and the famous jumping hind legs of fleas (allowing them to travel up to 200 times their body length in a jump). But the biggest difference that shows the distance between lice and fleas is the holometabolous development of fleas (passing through larval and pupal stages)—strong evidence for the remarkable evolutionary pathway of fleas and consistent with the hypothesis that their sister group is Mecoptera (Scorpionflies) and those two together are most closely related to Diptera (Flies). Some fleas lack eyes, but the examples described below all have well-developed eyes.

Some fleas are potential vectors of plague, typhus, and tapeworms, among other diseases and parasites. The **Oriental Rat Flea (*Xenopsylla cheopis*) (387)** was the primary vector transmitting the Black Death (plague) across Eurasia. There are at least 166 species recorded from the state on a variety of birds and mammals, including livestock, pets, and humans. California's list includes the world's largest (at 13 mm), the Giant Mountain Beaver Flea *(Hystrichopsylla schefferi)*, which occurs only on the Mountain Beaver, perhaps one of the most ancient and cryptic lineages of extant rodent, restricted to North America's northwestern mesic forests. The larvae are all very similar, white, wormlike forms with long

body hairs. They develop in the host's nests or, in the case of humans and our cohabitants, carpets and pet beds, where they feed on organic debris including dried blood passed by the adults.

▶ **383. GROUND SQUIRREL FLEA** *Diamanus montanus*
ADULT: BL 1.5–2 mm; lacks head comb but with thoracic comb; head rounded; labial palps very long.
HOST: Restricted almost entirely to the California Ground Squirrel *(Spermophilus beecheyi)* on which it may be extremely abundant.
HABIT: This flea is an important vector of wild rodent plague and helps maintain the disease in nature. It can be dangerous to handle a ground squirrel because, particularly if sick or dying, it may harbor the plague bacilli that can be transmitted by the bite of infected fleas of this or other species, especially the Oriental Rat Flea (*Xenopsylla cheopis*) **(387)**.
RANGE: Generally throughout state except deserts, following range of the host.

▶ **384. HUMAN FLEA** *Pulex irritans*
ADULT: BL 2–3.5 mm; lacks head comb and thoracic comb; head outline rounded; large head bristles (below eye). Extremely good jumper.
HOSTS: All domestic and many wild animals and humans; most important flea in farming areas.
RANGE: Probably originally from South America, it has been spread around the globe. In all parts of California. *Pulex simulans*, which is found on deer, is distinguishable only by details in the male and is frequently confused with *P. irritans*.

▶ **385. CAT FLEA** *Ctenocephalides felis*
ADULT: BL 2–3 mm; combs of heavy, sharp-pointed dark bristles on lower margin of head and prothorax.
HOSTS: Cats, dogs, opossums, rats, humans. Essentially a domestic species.
RANGE: Widespread; more abundant along humid coastal areas than in the drier inland. Particularly abundant in spring and summer when the weather warms. The Dog Flea *(C. canis)* is a less common, and slightly larger, relative of the Cat Flea, known to occur in the San Diego area.

▶ **386. STICK-TIGHT FLEA** *Echidnophaga gallinacea*
ADULT: Small (BL 1–1.5 mm); without head comb or thoracic comb; head angulate, blunt anteriorly; thorax greatly contracted.
HOSTS: Wild rodents; domestic situations on rats and fowl. This flea partly buries its head in the host's flesh when feeding and remains firmly attached for long periods.
RANGE: Widespread.

Siphonaptera

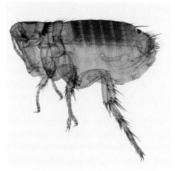

383. Ground Squirrel Flea
(*Diamanus montanus*).

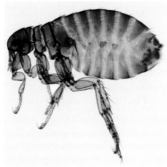

384. Human Flea
(*Pulex irritans*).

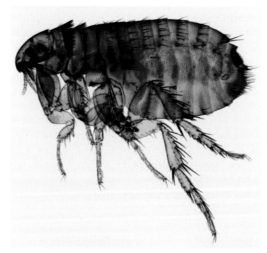

385. Cat Flea
(*Ctenocephalides felis*).

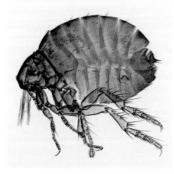

386. Stick-tight Flea
(*Echidnophaga gallinacea*).

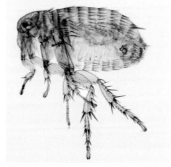

387. Oriental Rat Flea
(*Xenopsylla cheopis*).

ADULT: Distinguished from many other fleas by the lack of head combs and thoracic combs; head rounded; large head bristles in front of eye.

HOSTS: Lives mainly on rodents associated with human dwellings, principally the Norway Rat (that is actually native to eastern Asia), but commonly bites humans. This is probably the most important vector of Bubonic Plague in both urban and field situations.

RANGE: Limited mostly to seaport towns and proximate inland valleys (Sacramento Valley). Introduced from Old World on rats. Can be expected wherever Norway Rats occur.

Flies, Gnats, and Midges (Order Diptera)

In terms of its impact on humans, Diptera is easily the most important order. As disease vectors, flies are responsible for more human death and morbidity than any other animal. They are also hugely beneficial, including pollinators and the famous vinegar fly *Drosophila melanogaster* (family Drosophilidae) that has been a model for genetics and development. However, this order is still not thoroughly studied in California. There are presently over 6,000 species recognized in the state, which probably represents a considerably smaller number than the actual total fauna.

These are minute to medium-sized insects with only one pair of flight wings. The hind pair has been modified into knobbed structures, called halteres, which have a sensory function that flies use to detect their body orientation to allow them to stabilize their flight. Many species are wingless or the females are wingless (in some of these halteres persist), but when present, the wings are always membranous and usually transparent, with or without darker markings and with relatively few veins in most species. The mouthparts are adapted for taking liquid food by lapping, sponging, or piercing and sucking. Metamorphosis is complete and the larvae are legless and may be grublike or wormlike with a well-developed head, or a typical maggot, lacking a defined head.

It is useful in the field to recognize two major types of Diptera. The early branching lineages, once treated as a formal suborder, but that are now known to not all be each other's closest relatives, are typically referred to as midges or gnats. We present them here as a group of convenience using the traditional name "nematocerans." They are characterized in the adult stage by long antennae with many similar segments and long, slender legs; the larva has a well-developed head capsule and is frequently aquatic. The adults of the second type, the so-called higher flies (suborder Brachycera), typically possess short antennae in which one

or more segments are greatly modified and differentiated from the others, and the legs in the majority of species are short and stout; the larvae are extremely varied in form and habitat, but many are typical maggots without a recognizable head. Flies in the suborder Brachycera may be referred to as "muscoid" if they bear some resemblance to the common House Fly **(479)**; the especially small, bothersome forms are often also called "gnats" even though they are not members of the nematoceran groups. Because so many Diptera are bloodsuckers or live and develop in filthy materials, this is the most significant order in the transmission of diseases of mammals, including humans.

"Nematocerans"

Crane Flies (Family Tipulidae)

Crane flies are small to large, very slender, long-legged flies whose appearance suggests giant mosquitoes (hence the occasionally used name "mosquito hawk"). Their small, soft mouthparts are not adapted for biting or predation. Because their legs detach easily, the adults are not popular with collectors. The larvae **(390)** are rather tough-skinned, cylindrical, and gray, brown, or black maggots, often referred to as "leather jackets." Fleshy, fingerlike protuberances from the posterior and a protrusile head also identify them. Tipulids are abundant in all kinds of damp habitats; females can be observed at night, sometimes in large numbers, depositing eggs into the soil or rotten wood; the larvae live in grass roots or decaying vegetation, under bark of rotting logs, or are aquatic. Most feed on decaying organic matter, but some are predaceous or feed on living plants such as mosses. This is probably the largest family of Diptera, with about 600 described species in North America; more than 400 are known in California.

▶ **388. GIANT CRANE FLY**　　　　　　　　　*Holorusia hespera*
ADULT: Enormous (BL up to 35 mm or more), one of the world's largest flies; generally reddish brown, with broad, white bands on side of thorax; wings brown.
HABIT: Most commonly seen in spring and summer near streams; frequently attracted to lights at night.
LARVA: Very large (BL up to 60 mm), cylindrical, with dark, leathery skin and posterior, fingerlike processes.
HABIT: Semiaquatic or aquatic; in shore vegetation or debris and on bottom of small stream pools.

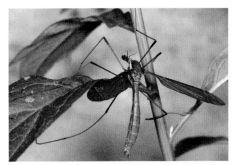

388. Giant Crane Fly
(*Holorusia hespera*).

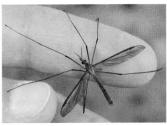

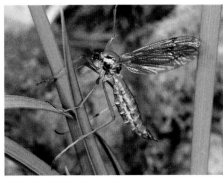

389. Common Crane Fly
(*Tipula oleracea*) adult.

390. Common Crane Fly
(*Tipula* sp.) larvae.

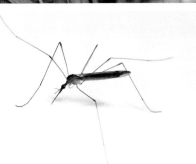

391. Banded Crane Fly
(*Phoroctenia vittata*).

392. Limoniid Crane Fly
(*Limonia* sp.).

RANGE: Coast Ranges, lower elevations of the Sierra Nevada, and southern California mountains.

◄ 389–390. COMMON CRANE FLIES　　　　　　*Tipula* spp.

A genus with many species of familiar insects, 170 known from California.

ADULT: (389) Large (BL 15–20 mm); generally brown, with clear or brown-tinted wings.

HABIT: Active most of the year; commonest in meadows, grassy hillsides, and moist, wooded areas; feed on nectar and other natural sugar sources.

LARVA: (390) From creamy-white to dark brown or black, thick-skinned, wormlike maggots; fleshy, fingerlike protuberances from posterior.

HABIT: Larvae found in soil rich with humus, rotting logs, and the like; feed on roots and decaying vegetation, occasionally injurious to plants, bulbs, and tubers. One species, the Range Crane Fly *(T. simplex)*, is destructive to grasses, especially in the Central Valley. In seasons when conditions are favorable for the larvae, they denude vast areas of grassland and grain crops.

RANGE: Generally distributed throughout state.

◄ 391. BANDED CRANE FLY　　　　　　*Phoroctenia vittata*

Perhaps the most striking crane fly in California.

ADULT: BL 19–24 mm; distinct orange-brown and black patterning with black knees, black head, and irregular black stripe on the abdomen. Male with branched antennae.

HABIT: Larvae are found in decaying wood.

RANGE: Forests of the Coastal, North Coast Ranges, and northern Sierran regions.

Roof-winged Crane Flies (Family Limoniidae)

◄ 392. LIMONIID CRANE FLIES　　　　　　*Limonia* spp.

ADULT: BL 6–10 mm; typically brownish gray but frequently paler, nearly yellow; wings in many species with patterns of black spots; some species are often mistaken for a large mosquito due to their elongate mouthparts used for feeding on flower nectar.

HABIT: Adults are typically found along streams, rivers, and other mesic areas where the larvae reside. Larvae are very diverse in habits, known from the marine intertidal area, living in steep or vertical cliffs, and fungus.

RANGE: Throughout the state in coastal areas, foothills, and higher elevations. Nearly 40 species are known from California, but this is a small portion of the genus, which has around 2,000 species worldwide.

Fungus Gnats (Family Mycetophilidae)

Mycetophilids are diverse and probably more than 200 species are generally distributed in wet areas throughout the state. The majority belong to the genus *Mycetophila*.

▶ **393. FUNGUS GNATS** *Mycetophila* **spp.**

ADULT: Small to medium-sized (BL 5–10 mm), with the body compressed side to side. They are generally red-brown, brown, or yellowish brown, with long legs, extra-long coxae, and large spurs at the tips of the tibiae.

HABIT: They are most common in dark, damp places such as undercut stream banks.

LARVA: Slender, wormlike, white or yellowish white, often with a dark head, transparent skin.

HABIT: Larvae live in fungi, decaying wood or vegetation, and moist soil and are frequently gregarious. A common species is the Mushroom Gnat *(M. fungorum)*, which is found widely in commercial mushroom cultures.

RANGE: Generally distributed throughout state.

Dark-winged Fungus Gnats (Family Sciaridae)

▶ **394. DARK-WINGED FUNGUS GNATS** *Sciara* **spp.,** *Bradysia* **spp.**

There are a dozen or so species in California. Most are members of the genus *Sciara* or *Bradysia* **(394).**

ADULT: Small (BL 2–3 mm), fragile; black, dusky-brown, or gray gnats, similar to fungus gnats but with shorter legs (coxae much shorter) and kidney-shaped eyes (with a bridge above the antennae). The three simple eyes (ocelli) are conspicuous.

HABIT: Sciarids do not bite but are annoying when they appear indoors (the usual gnat in fresh paint!).

LARVA: Slender and wormlike.

HABIT: Frequently found in moist, shady places where they scavenge on decomposing plant matter. Commonly they infest soil and humus mixes used for potted plants.

RANGE: Generally distributed throughout California and common around human-developed areas.

Gall Midges (Family Cecidomyiidae)

This is one of the two or three largest families of Diptera, with about 100 species known in California, in addition to many others that await discovery. Probably upward of 400 species will be found to occur in the state.

▶ **395–396. GALL MIDGES** **Cecidomyiidae**

ADULT: Small (BL 2–3 mm) gnats; especially delicate with very long legs, broad wings (usually with only three to four veins reaching the wing margin), and fine, threadlike antennae. In one species, the **Coyote Brush Bud Gall Midge** *(Rhopalomyia californica)* **(395)**, both male and female adults are short-lived (e.g., a day or two) and have vestigial mouthparts.

HABIT: Adults are found on or near host plants or places their food is abundant. Females of gall inducers lay eggs in the actively growing parts of the host plant.

LARVA: Legless maggots that are typically concealed in the tissue of their host plant and cause deformations or galls **(396)** that are characteristic in form and color for each species.

HABIT: Varies, some feed on decaying organic matter (usually of plant origin) or fungus; others are predaceous on mites and minute insects; the majority of species feed on internal plant tissue; a single gall may have up to 100 larvae.

RANGE: Generally distributed throughout state, wherever their host plants thrive.

Sand Flies (Family Ceratopogonidae)

Ceratopogonids are tiny gnats ("no-see-ums") with BL less than 3 mm. They are noticed mostly for the fierce biting habits of the females. The larvae are eel-shaped and live in moist or aquatic habitats.

▶ **397. PUNKIES** *Culicoides* **spp.**

ADULT: Tiny gnats (BL 1.0–2.5 mm); usually with mottled thorax and spotted wings (an especially noticeable dark mark midway on anterior margin).

RANGE: Numerous species occur throughout state.

HABIT: Females of most bite, some fiercely, and in some cases may vector diseases of livestock.

RANGE: Across the state and especially well known to inhabitants and visitors of the lower Colorado River *(C. variipennis)*, northern coasts near salt marshes *(C. tristriatulus)*, the Central Valley *(C. reevesi)*, and northern mountains *(C. obsoletus)*.

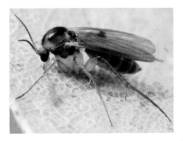

393. Fungus Gnat
(*Mycetophila* sp.).

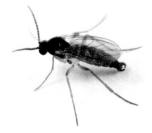

394. Dark-winged Fungus Gnat
(*Bradysia* sp.).

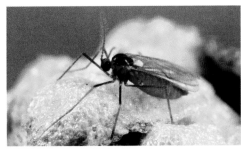

395. Coyote Brush
Bud Gall Midge
(*Rhopalomyia californica*)
adult.

396. Coyote Brush
Bud Gall Midge
(*Rhopalomyia californica*)
gall with a wasp (Torymidae:
Torymus sp.).

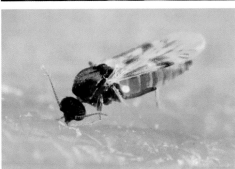

397. Punky (*Culicoides* sp.).

VALLEY BLACK GNAT *Leptoconops carteri*

A related species is the Valley Black Gnat.

ADULT: Tiny gnat (BL 2 mm); shining black with white wings.

HABIT: Very annoying, primarily in April, May, and June. This is a well-known species with a bad bite that produces a long-lasting, inflammatory swelling in many people. The larvae live in pore spaces in wet clay or adobe soils rich with organic matter.

RANGE: Most abundant in the western Sacramento Valley. Several similar species in this genus occur in the state, including biters around coastal estuaries and desert saline lake margins.

Black Flies (Family Simuliidae)

▶ **398–399. BLACK FLIES** *Simulium* spp.

ADULT: (398) Biting gnats, like sand flies **(397)**, but larger (BL up to 4 mm) and distinctively "humpbacked" in appearance; body often shiny gray; legs mottled with yellow; wings broad and transparent.

HABIT: Females bite humans and other mammals and constitute a major nuisance when abundant near streams; they are known to attack helpless livestock in such large numbers as to cause death through blood loss or shock.

LARVA: (399) Elongate, swollen rearward, with terminal sucker; head well developed, with large mouth fans. Found in streams, on rocks in swift water, often in massive groups.

PUPAE: In cocoons with open wide end facing downstream.

RANGE: More than 20 species found throughout state. Species with bad reputations for biting are *S. vittatum* along the Colorado River and generally throughout the state, *S. tescorum* near desert springs and other wet places, *S. trivittatum* along rivers in the Central Valley, and *S. venator* east of the Sierra Nevada.

Net-winged Midges (Family Blephariceridae)

▶ **400–401. COMSTOCK'S NET-WINGED MIDGE** *Agathon comstocki*

ADULT: (400) Large midge (wing length 12 mm); gray-brown body with clear wings; eyes large and divided into upper and lower sections; wing membrane with creases or wrinkles.

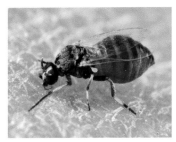

398. Black Fly (*Simulium* sp.) adult.

399. Black Fly (*Simulium* sp.) larvae.

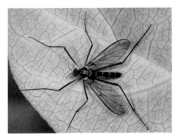

400. Comstock's Net-winged Midge (*Agathon comstocki*) adult.

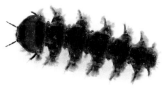

401. Comstock's Net-winged Midge (*Agathon comstocki*) larva.

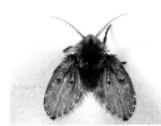

402. Bathroom Fly (*Clogmia albipunctata*).

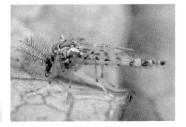

403. Clear Lake Gnat (*Chaoborus astictopus*) adult.

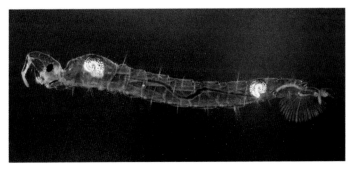

404. Clear Lake Gnat (*Chaoborus astictopus*) larva.

HABIT: Flies in spray below waterfalls or over swift water in streams; also rests under overhanging banks, boulders, and logs near streams; active in spring and summer; female sucks blood of other small flies.

LARVA: (401) Medium-sized (BL 10–12 mm); black; body elongate and divided into seven sections by strong constrictions; each section with two lateral extensions; median series of six suckers on underside. Aquatic in shallow, fast-water streams; on smooth boulders and stones. Spring and summer; feed on diatomaceous and algal films on substratum.

PUPA: Medium-sized (BL 10 mm); black; oval, hemispherical (with flat underside); a pair of conspicuous, earlike, anterior respiratory horns.

HABIT: Larvae and pupae firmly attached (often in groups) to smooth, emergent boulders near waterline or on submerged stones.

RANGE: In all granitic ranges throughout the state.

Moth Flies (Family Psychodidae)

Psychodids are tiny, furry-appearing gnats with wings and body covered with a dense vestiture of scales. Often they perch with the wings held rooflike over the body or obliquely erect. They resemble minute moths as they scuttle about with a quick jerky gait. There are about 35 species in California.

◄ 402. BATHROOM FLY *Clogmia albipunctata*

ADULT: Small gnat (wing length 2.6–4.1 mm); brown and white-scaled; antennae white; white spots at tips of wing veins; wings are broadly oval and pointed at the tips. Common near damp places; mostly noticed on walls indoors having emerged from drains in houses and public toilets.

LARVA: BL 8–10 mm; very slender, wormlike; with pigmented dorsal plates on each segment; short posterior breathing tube.

HABIT: Develops in sludgy organic material that accumulates in shallow pools, tree holes, sink traps, drains, and the like.

RANGE: Generally throughout the state.

LANCE-WINGED MOTH FLY *Maruina lanceolata*

Similar to this species is the Lance-winged Moth Fly.

ADULT: Very small gnat (wing length 1.9–2.5 mm); blackish gray; wingtips white; wings narrow and sharply pointed.

HABIT: Usually seen crawling (with wings held obliquely erect) on stream boulders or resting under overhanging stones, logs, or vegetation near streams. Adults active in late spring and summer. Larvae are aquatic and feed on diatomaceous and other algal films.

RANGE: Throughout state, in mountain or foothill streams.

Phantom Midges (Family Chaoboridae)

◄ 403–404. CLEAR LAKE GNAT *Chaoborus astictopus*

ADULT: (403) Small (BL 3–5 mm); pale yellow; mosquitolike but nonbiting, with short mouthparts; scales confined to wing fringe.

HABIT: May synchronously emerge in enormous numbers, be attracted to lights, and thus be very annoying for lakeshore residents. The adults were a longtime nuisance at Clear Lake, but the numbers of gnats have declined over the years likely due to a combination of the introduction of predatory fish, impact from agricultural runoff, and pesticide use.

LARVA: (404) Transparent, sometimes called "glassworms," elongate wrigglers similar to mosquito larvae; prehensile antennae directed downward (used to capture prey); float organs on thorax and seventh abdominal segment.

HABIT: Aquatic; member of lake plankton community, migrating upward from bottom during night to feed and adults take to the air from the surface.

RANGE: Lakes and reservoirs of north coastal counties.

Mosquitoes (Family Culicidae)

Mosquitoes are small, slender, gnatlike, and familiar to almost everyone from the biting and blood-sucking habits of the females. They have long, slender legs, body and wings clothed with scales, and an elongate proboscis fitted with piercing stylets. The antennae are densely featherlike in males, covered with short hairs in females. The aquatic larvae ("wrigglers") and pupae ("tumblers") are both quite active, living in stagnant or slow-moving water, often just beneath the surface film. The wrigglers are elongate, hairy, and have a distinct, movable head, bearing incessantly moving mouth brushes, usually with an elongate, posterior breathing tube **(407)**; the larvae swim by rapid, lateral jerking movements. The pupae **(408)** are ovoid, with a suspended, movable abdomen tipped with flat paddles and a pair of breathing trumpets or siphons projecting anteriorly from the thorax. Mosquitoes are the best studied family of Diptera because of their role as carriers of human diseases such as West Nile virus, malaria, and yellow fever. Life cycles are known for most of the world's species and nearly all of the North American forms. There are 53 species known in California, some of these introduced from other parts of the world and established only since the early 2000s.

▶ 405–409. COOL-WEATHER MOSQUITO　　　　*Culiseta incidens*

ADULT: (405–406) Large (BL 6–8 mm); wing speckled; abdominal segments basally white; tarsi with narrow, white basal rings.

PUPA: (408) Curled form with two respiratory trumpets emerging from a combined head and thorax that poke through the water's surface to breath air.

LARVA: (407) A pair of conspicuous hair tufts near the base of the posterior breathing tube.

EGG: (409) Laid as part of a raft on the water's surface consisting of many dozens of eggs.

HABIT: Larvae live in the water and pass through four growth stages. They come to the surface to breathe through a siphon tube that they also use to hang from the water's surface. The larvae feed on microorganisms and organic matter in the water. The Cool-weather Mosquito is a common domestic species, most abundant during cooler seasons, when they bite people readily. It breeds in a wide variety of natural groundwaters (ditches, clear pools, swamps) and artificial containers (rain barrels, tin cans, old tires).

RANGE: Common throughout state, from sea level to 3,400 m in the high Sierra.

▶ 410. WESTERN MALARIA MOSQUITO　　　　*Anopheles freeborni*

ADULT: Medium-sized (BL 5–8 mm); abdomen without scales; wing scales forming four spots.

LARVA: Breathing tube absent; rests parallel to surface when taking in air.

HABIT: Semidomestic, often entering houses seeking a meal. The body position is nearly vertical when female bites. Breeds in clear ground pools (seepage water, rice fields), preferring protection of marshy vegetation.

RANGE: Greatest abundance reached in the Central Valley; limited in foothills and the Sierra Nevada to 2,000 m. Endemic malaria outbreaks are now very rare in California, and most cases are imported by travelers. When local transmission does occur, this mosquito is likely the principal vector.

▶ 411. WESTERN ENCEPHALITIS MOSQUITO　　　　*Culex tarsalis*

ADULT: Medium-sized (BL 5–6 mm); generally dark; tarsi banded; proboscis with median white band; abdominal segments with black "V" ventrally.

LARVA: Hair tufts on breathing tube all in a row below the median lines.

HABIT: A ubiquitous, semidomestic species. Bites birds primarily but also people and is the primary vector of Western Equine Encephalitis in California. Found in a wide variety of standing, clear (sunny ground pools) or foul water habitats (ditches, excess irrigation water, sewage lagoons).

RANGE: Generally throughout the state below 2,700 m.

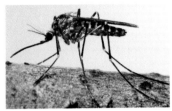

405. Cool-weather Mosquito
(*Culiseta incidens*) female.

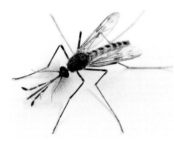

406. Cool-weather Mosquito
(*Culiseta incidens*) male.

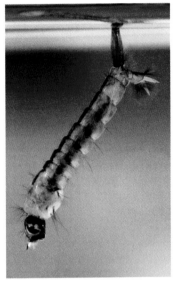

407. Cool-weather Mosquito
(*Culiseta incidens*) larva.

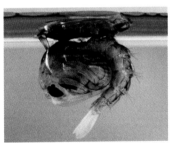

408. Cool-weather Mosquito
(*Culiseta incidens*) pupa.

409. Cool-weather Mosquito
(*Culiseta incidens*) eggs.

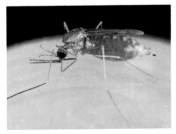

410. Western Malaria Mosquito
(*Anopheles freeborni*) female.

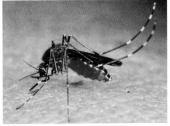

411. Western Encephalitis Mosquito
(*Culex tarsalis*) female.

▶ 412. HOUSE MOSQUITO

Culex pipiens

ADULT: Medium-sized (BL 5–6 mm); reddish brown; tarsi not banded; proboscis all dark.

LARVA: Breathing tube with several pairs of hairs.

HABIT: Highly domestic, commonly entering buildings and biting people. Breeds in small accumulations of foul water in almost any situation (septic tanks, drains, gutters, ditches, etc.).

RANGE: *Culex pipiens* is found in the northern part of the state, mates in swarms, hibernates, and rarely bites humans. A very closely related species, the Southern House Mosquito (*C. quinquefasciatus)* is more common in the southern part of the state; it usually does not mate in swarms, does not truly hibernate, and bites people readily. Intermediates of these two are found along the coast and in the northern Central Valley. *Culex quinquefasciatus* is an effective vector of many diseases and is largely responsible for transmitting avian pox and malaria that wiped out dozens of species of endemic birds across the Hawaiian islands.

▶ 413. WESTERN TREEHOLE MOSQUITO

Ochlerotatus sierrensis

ADULT: BL 3–5 mm, similar to the Tiger Mosquito with white-banded legs and body but lacking the distinctive dorsal white stripe in that species.

LARVA: A cluster of comb scales at the base of the breathing tube and two pairs of setae laterally above the anal papillae.

HABIT: Readily bites humans and other mammals, including dogs and is a significant vector of dog heartworm. Breed in tree holes and small water containers and can lay eggs without a blood meal.

RANGE: Widespread throughout California.

▶ 414. YELLOW FEVER MOSQUITO

Aedes aegypti

ADULT: BL 4–7 mm; has distinct white markings on its legs and four white lines that together form the shape of a lyre on the upper surface of its thorax.

HABIT: Does well near human habitation and breeds in water-holding containers. Transmits dengue and yellow fever, among other serious disease pathogens.

RANGE: Established in California at least since 2013 and now known from Merced County south, through the Central Valley and to the southern border of the state.

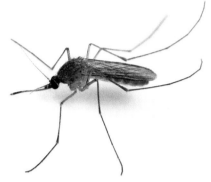

412. House Mosquito (*Culex pipiens*) female.

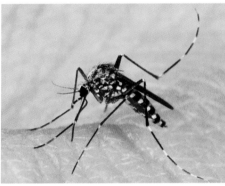

413. Western Treehole Mosquito (*Ochlerotatus sierrensis*) female.

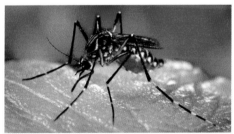

414. Yellow Fever Mosquito (*Aedes aegypti*) female.

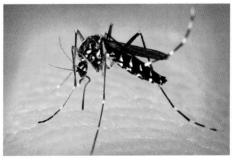

415. Tiger Mosquito (*Aedes albopictus*) female.

◀ 415. TIGER MOSQUITO *Aedes albopictus*

ADULT: Relatively small (BL 3–6 mm), distinctive black with bold white striping on the body and legs, and a white line that begins at the eyes and continues along the dorsal side of the thorax.

HABIT: Readily uses a variety of both natural and artificial water container habitats to breed and travels well with humans. The female bite can transmit Zika, chikungunya, and a variety of other serious diseases.

RANGE: Established since 2011, now found from Kern County south to San Diego.

BLACK SNOW MOSQUITO *Aedes ventrovittis*

Other significant mosquitoes in the state include the Black Snow Mosquito.

ADULT: BL 4–5 mm; black, with long hairs on back of thorax; back of abdomen with metallic, plum-colored sheen; tarsi all dark.

LARVA: Large hairs on center of head unbranched; hair tuft on breathing tube located beyond comblike spines.

HABIT: Attacks and bites viciously in daytime in large numbers (sometimes clouds) in open meadows; June–July. Breeds in shallow pools after the snow melts; matures rapidly.

RANGE: Sierra Nevada at 2,100–3,350 m; from Tulare to Lassen and Shasta Counties.

SOUTHERN SALT MARSH MOSQUITO *Aedes taeniorhynchus*

ADULT: BL 3–5 mm; wing scales all dark; abdominal segments black with white basal bands; proboscis dark with central white ring.

LARVA: Breathing tube with a single pair of small hair tufts near end; portion of anal segment complete around base of ventral hair brush.

HABIT: Persistent biters, though preferring cattle over humans, during day into early dusk. Develops in brackish water in salt marshes.

RANGE: Along south coast from San Luis Obispo to San Diego County and inland in alkaline waters in deserts of eastern Imperial and Riverside Counties along the Colorado River.

Water Midges (Family Chironomidae)

There are numerous species of water midges, with about 200 known in California and with many more sure to be found. The adults are generally gnatlike but extremely varied in form and size (BL 0.5–6.0 mm). The wings are long and narrow; legs and antennae long (in males often featherlike); proboscis short, nonbiting. Adults often perch with the front legs held in the air and frequently swarm in huge numbers near ponds

and lakes, both natural and artificial, causing considerable nuisance. The larvae are long, slender, and wormlike, with a complete head and prolegs on the anterior and posterior body segments. Most are white but some are red because they possess hemoglobin in their blood that helps them respire in low oxygen conditions (a rare case in insects). These are called bloodworms. The larvae of most species are aquatic, in streams, lake mud, ponds (and even some in marine tide pools), where they dwell in silk cases or nets (lacking in some).

▶ **416. MARINE MIDGE** *Telmatogeton macswaini*
ADULT: BL 3–5 mm; mosquitolike, with long legs; head small and turned down under thorax. Generally gray-brown with silky, brown wings.
LARVA: Slender (BL up to 15 mm), cylindrical; posterior segment with hooked, stubby, leglike appendages; pale, whitish.
HABIT: Adults crawl on patches of sea lettuce *(Ulva)* on intertidal seashore rocks and are often covered by surf. Larvae are submerged in sandy sediments underlying thick mats of sea lettuce; form silken tubes incorporating sand grains.
RANGE: Rocky portions of the entire coast and the Channel Islands.

▶ **417. COMMON MIDGES** *Chironomus* spp.
ADULT: Large gnats (BL up to 13 mm); males with broad, featherlike antennae.
LARVA: BL 20–25 mm; body usually curled at both ends, red with hemoglobin; head brown; next-to-last segment with four fingerlike gills.
HABIT: Larvae develop in lakes and ponds, both natural and artificial; often extremely abundant in soft bottom mud where they build a silk-lined tube; respiration is aided by body undulations (irrigating the tube); feed on phytoplankton caught in a silken net spun over the tube mouth. Large numbers of adults can sometimes be a nuisance near artificial lakes and reservoirs in summer.
RANGE: Generally throughout the state.

March Flies (Family Bibionidae)

March flies are small to medium-sized, moderately robust, and often hairy, with shorter legs and wings than most other nematocerans. The eyes are much larger in males than females, usually meeting at the top of the head, and the two sexes sometimes differ markedly in color and body form. Many species frequent meadows or other areas with abundant decaying vegetation, appearing in spring and fall in great numbers. In some species the males form swarms in which their slow flight makes

them easy prey for dance flies **(456)** and other predators. The larvae feed on decaying organic matter at roots of grasses and in leaf mold. They are grublike with a well-defined head and often with short fleshy processes on the body segments. There are 21 species recorded in California.

▶ **418. PALE-LEGGED MARCH FLY** *Bibio xanthopus*

ADULT: Medium-sized (BL 8–11 mm); shiny black, hairy, with bold pale orange bands or regions of the legs; flight weak.

LARVA: Small (BL 10 mm); cylindrical maggot; head distinct; skin leathery and warty in appearance; with enlarged posterior pair of spiracles.

HABIT: Larva is in soil feeding on plant roots (tubers, grass, etc.).

RANGE: Throughout the Coast Ranges and the Sierra Nevada. The Black Urban Bibionid *(Dilophus orbatus)* is a smaller (BL 5–7 mm to wing tips) black species, commonly seen flying over lawns during summer and fall; the females are especially conspicuous, having all black wings; this species apparently was introduced from the Gulf Coast region of the United States, first collected in Los Angeles in 1950 and the San Francisco Bay Area during the 1960s.

Suborder Brachycera

Brachycera is a suborder of flies that represents a major evolutionary group with approximately 120 families worldwide and a great diversity of species and life histories, including scavengers, predators, and parasitoids. The name Brachycera (or "shortened horn") refers to their shortened antennae as compared to "nematocerans."

Soldier Flies (Family Stratiomyidae)

Soldier flies are mostly medium-sized to large, bristleless, flattened flies somewhat resembling bees or wasps, often with white, yellow, or green markings. They are distinctive in their habit of holding the basal parts of the antennae together while the outer parts diverge, like the letter "Y." These flies often occur in numbers at flowers, on vegetation in wet areas, or around outhouses in campgrounds. The larvae are either carnivores or scavengers, aquatic or terrestrial, and vary greatly in form. The body may be broad and flattened or elongated and tapering to the tail with the last segment drawn out and tubular; the thick, leathery skin is impregnated with calcareous matter. Those larvae living in water or mud hang from the surface film using a crown of feathery hairs that closes to trap an air bubble. There are about 65 species of stratiomyids recorded for California.

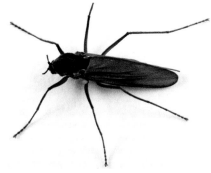

416. Marine Midge (*Telmatogeton macswaini*).

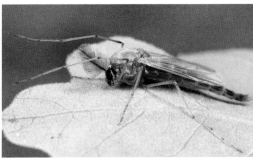

417. Common Midge (*Chironomus* sp.).

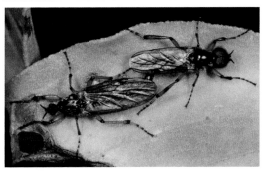

418. Pale-legged March Fly (*Bibio xanthopus*) female left, male right.

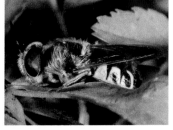

419. Spotted Soldier Fly (*Stratiomys maculosa*).

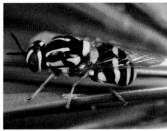

420. Yellow-bellied Soldier Fly (*Caloparyphus flaviventris*).

◀ 419. SPOTTED SOLDIER FLY *Stratiomys maculosa*

ADULT: A typical member of the family with black-and-yellow markings. Moderately large (BL 13–14 mm); eyes hairy; a pair of conspicuous spines on the scutellum.

HABIT: Usually seen in the late spring visiting flowers of shrubs where resemblance to wasps evidently protects it from predators. Early stages unknown; larva probably aquatic, living in sluggish or stagnant water rich in vegetation and organic debris.

RANGE: Found throughout the state but localized in inland valleys and deserts.

◀ 420. YELLOW-BELLIED SOLDIER FLY *Caloparyphus flaviventris*

ADULT: BL 9–11 mm; distinctive yellow-and-black pattern including a mostly yellow ventral surface of the abdomen, black femur on the leg, which is otherwise pale.

HABIT: Adults are frequently found visiting flowers. Larvae for several other species in the genus are known to live in still water rich in decaying plant material, which is probably the case for this species as well.

RANGE: Central and northern region of the Sierra Nevada.

▶ 421–422. BLACK SOLDIER FLY *Hermetia illucens*

ADULT: (421) Moderately large (BL 15–20 mm); resembles a wasp in form and behavior: shiny black, with dusky wings, a pair of transparent areas ("windows") at the base of the abdomen; the median dark line separating these areas simulates wasp waist. Eyes with an irregular branching or reticulate pattern.

LARVA: (422) Elongate (BL 25 mm), tapered toward head, blunt posteriorly; somewhat flattened, with dark brown, leathery skin bearing numerous short bristles.

HABIT: Adults are common during summer around habitations (often entering houses), larvae are often found in moist compost piles, around stock and poultry ranches, and campground outhouses. Larvae are terrestrial, developing in various organic substances (decaying vegetation, garbage, chicken manure) or soil of high organic content where it preys on other fly larvae; rarely occur in Honey Bee hives. Recently they have been used for large-scale conversion of organic waste, and the larvae dried and used as food for livestock.

RANGE: Low coastal mountains and valleys, mostly southern California to the San Francisco Bay Area, and the Central Valley.

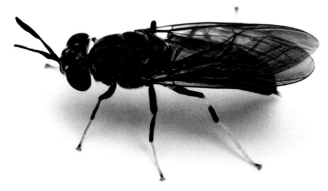

421. Black Soldier Fly (*Hermetia illucens*) adult.

422. Black Soldier Fly (*Hermetia illucens*) larva.

423. Western Horse Fly (*Tabanus punctifer*).

424. Deer Fly (*Chrysops discalis*).

425. Biting Snipe Fly (*Symphoromyia* sp.).

426. Ornate Snipe Fly (*Chrysopilus* sp.).

Horse and Deer Flies (Family Tabanidae)

Tabanids are medium-sized to large, robust flies with short legs. They are powerful fliers with strong wings that are often tinted or spotted. In life the eyes frequently are striped with bright metallic colors. Only the females bite to acquire blood proteins for their developing eggs but, like the males, they subsist on nectar and other fluid food sources. Their habit of attacking large animals makes them potential vectors of disease, including tularemia and anthrax. The larvae are elongate, cylindrical, tapering at both ends and usually have bumps or swellings circling the anterior portions of the middle segments. Most are aquatic or semi-aquatic, living in ponds, marshes, or other moist situations such as rotten logs and damp soil, although some live in dry forest or sand dune habitats. They prey on other invertebrates. About 75 species of Tabanidae occur in California.

◄ 423. WESTERN HORSE FLY　　　　　　　　*Tabanus punctifer*
ADULT: Large (BL 18–22 mm); mostly black; male (eyes large, meet on mid-dorsal line) thorax white on rear and side margins; female (eyes smaller, separate on top of head) thorax all pale and hairy; wings opaque; tinted black and with an isolated dark spot on the outer portion.
LARVA: Large (BL 45 mm).
HABIT: Females feed on blood of large mammals, especially horses; rarely bite people. Larvae live in mud and decaying vegetation of marshy ponds or lake and stream margins.
RANGE: Throughout the state at lower elevations.

◄ 424. DEER FLIES　　　　　　　　　　*Chrysops* **spp.**
ADULT: General form like horse flies but smaller (BL 8–12 mm) and wings usually spotted.
HABIT: Fierce biters and very bothersome.
RANGE: Many species throughout the state, mountains to desert. Most common in low, swampy areas where many species breed. This genus has numerous species, with about 25 in California. ***Chrysops discalis* (424)**, with pale, diffuse brown wing markings, is a vector of tularemia. It is found in the Owens Valley and northern Sierra Nevada.

Snipe Flies (Family Rhagionidae)

Rhagionids, sometimes hairy but lacking large bristles, are slender flies with conical, elongate abdomens that resemble robber flies. Textbooks often say they are predaceous on other insects, but the mouthparts in

most are small compared with those of robber flies, and predation has not been observed. Members of the genus *Symphoromyia* are the most common rhagionids in California and are biters that suck mammalian blood. The larvae are cylindrical grubs with small heads, the body may or may not have false legs. They are carnivorous, preying on other insects in soil, leaf mold, or water. About 40 species of the family occur in California; they include a diversity of forms from the large, hairless, orange *Rhagio* in shaded woods to tiny, golden-haired *Chrysopilus* perching on sunny, streamside vegetation.

◀ 425. BITING SNIPE FLIES *Symphoromyia* spp.

ADULT: Small (BL 5–8 mm); wings clear; males generally all brown to gray or gray with orange or light brown abdomen, rather hairy; females hairless, often pale gray with wide palpi and flattened, kidney-shaped, second antennal segment.

HABIT: Common during spring (lower elevations) and summer in mountainous areas, where they bother hikers and campers with their bites; also suck the blood of deer, horses, and other mammals.

LARVA: Early stages little known; larvae develop in damp stream banks and similar places.

RANGE: Generally throughout the state, especially mountains and foothills.

◀ 426. ORNATE SNIPE FLIES *Chrysopilus* spp.

As the name suggests, some ornate snipe flies are covered with brilliant, golden hairs or other striking patterns; others are more somber but usually have at least some tufts of bright setae.

ADULT: BL 4–6 mm; body with dense or scattered yellow or gold hairs; male with large eyes that touch or nearly touch medially; tibia of front legs lacking terminal spurs.

RANGE: Found throughout the state.

Wormlions (Family Vermileonidae)

▶ 427–428. WORMLIONS *Vermileo* spp.

ADULT: (427) Small (BL 6 mm); slender, with long legs, brownish gray, abdomen curved under at apex, with segments humped dorsally.

LARVA: (428) BL 3-10 mm; maggot-shaped, gray, posterior segment flattened terminally.

HABIT: Adults rest on vegetation but are rarely seen. Larval pits are frequently mistaken for those made by pit antlions **(258)** because they are similar funnel-shaped pitfalls in fine sand. Larval funnels can be found

in fine soils, often sheltered under overhanging rocks, logs, or picnic tables at less frequented campsites. The larva can typically be seen laying on its back, across the bottom of the pit. The larva feeds on the trapped ants and other small crawling insects, as do antlions.

RANGE: Two species in California are found in the Sierra Nevada, Transverse Ranges, southwestern Diablo Range, and southern coastal mountains and foothills.

Mydas Flies (Family Mydidae)

Medium-sized to very large flies with long, somewhat tapering abdomens. They only have bristles on their legs, the hind pair of legs are noticeably longer than the front two pairs. Adults visit flowers and are fast noisy fliers.

▶ **429. MOJAVE GIANT FLOWER-LOVING FLY** *Rhaphiomidas acton*

ADULT: (429) Very large (BL 25–33 mm); robust, hairy gray thorax contrasts with the orangish-brown abdomen and legs, males sport large clasping genitalia (epandrial lobes), females lack these and tend to be more somber-colored and larger; wings clear, veins in wing apex curve sharply forward to meet margin in front of tip.

LARVA: Larvae develop in the soil at depths of one to two meters and are not well known but are thought to be predators on other insects.

RANGE: Southern California deserts; occasional in coastal dunes, north to Contra Costa County. The **Valley Mydas Fly *(R. trochilus)* (430)**, one of several threatened species in the genus, is restricted to riverine dunes in a small area near Bakersfield. It was first found at Merced, recorded primarily at Antioch, and is now believed to have been extirpated across most of its former range owing to destruction of habitat. Without protection, these flies are likely to go extinct.

HABIT: Adults are seen in spring in desert areas where their large size and extremely fast, buzzing, beelike flight attracts attention.

▶ **431. ORANGE-WINGED MYDAS FLY** *Mydas xanthopterus*

This fly is a good mimic of orange-winged species of Tarantula Hawks (*Pepsis*) **(670)**.

ADULT: Very large (BL 21–35 mm); body deep blue-black with coppery-orange wings.

HABIT: Adults are summer active and seen visiting flowers during the hottest time of the day. Males are territorial and defend an area against rival males and other insects.

RANGE: In arid habitat and desert areas of southern California.

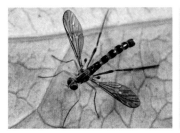

427. Wormlion
(*Vermileo comstocki*) adult.

428. Wormlion (*Vermileo comstocki*)
larva.

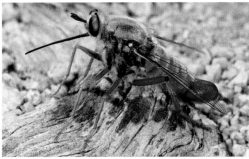

429. Mojave Giant Flower-
loving Fly
(*Rhaphiomidas acton*)
male.

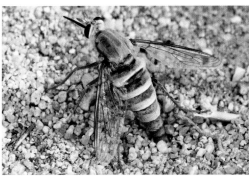

430. Valley Mydas Fly
(*Rhaphiomidas trochilus*)
female.

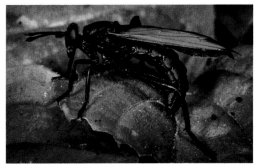

431. Orange-winged
Mydas Fly
(*Mydas xanthopterus*).

Flower-loving Flies (Family Apioceridae)

▶ **432. FLOWER-LOVING FLIES** *Apiocera* **spp.**

A couple dozen species are found in California. Many of them endemic to the state.

ADULT: Large (BL 16–26 mm); typically light gray, with bold, black or reddish-brown markings; males can be recognized by the enlarged, dark, bulbous, end of their abdomen, which is a structure enclosing their genitalia. Females have a tapering, cylindrical end to their abdomens. They resemble robber flies with black-and-white patterns but retain the strongly forward-arched veins in the apex of the wing.

HABIT: Most *Apiocera* are found between 300 and 2,000 m. These flies are typically found in dry, sandy habitats such as washes and desert areas, where they are frequently seen running on the ground or making short flights. Where they are isolated on relictual sand formations, some species have become endangered or extinct.

RANGE: Throughout the state, but most species are in the southern counties and on the eastern face of the Sierra Nevada.

Robber Flies (Family Asilidae)

Asilids are small to large (BL up to 40 mm), elongate, bristly, and sometimes hairy flies with a distinctive head: when viewed from the front, the eyes are strongly raised above the median forehead area. The proboscis is well-developed, sharp and rigid, adapted for piercing insect prey. Robber flies are opportunistic predators of other adult insects, taking whatever is available in their habitat. Neither the stings of wasps and bees, distastefulness of milkweed insects, armored elytra of beetles, nor insects larger than themselves deter these voracious killers. The victim is seized, often in midflight, and usually is rendered immobile immediately by a stab in the thoracic nerve cord area.

Probably more than 400 species live in California, the majority of which are small to medium-sized, black, gray, or brown, with clear wings and a thin, tapering abdomen. The larvae also are predaceous, living in sand, soil, or rotting wood, or in the burrows of other wood-boring insects. They are cylindrical with heads reduced to a small, anterior-pointed structure consisting primarily of mouthparts. In some species, segments of the body have raised bumps or "false legs" in rows or encircling the segment.

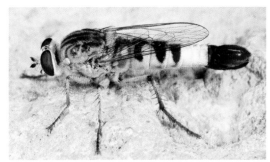

432. Flower-loving Fly (*Apiocera* sp.).

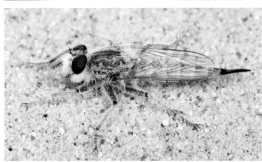

433. Common Robber Fly (*Stenopogon inquinatus*) with Honey Bee prey.

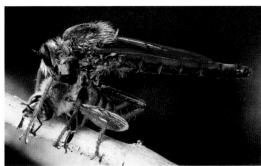

434. Common Robber Fly (*Efferia* sp.).

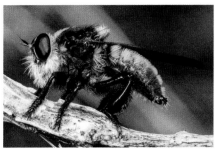

435. Bumble Bee Robber Fly (*Mallophora fautrix*).

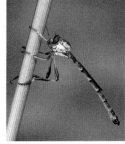

436. Slender Robber Fly (*Leptogaster* sp.).

◀ 433–434. COMMON ROBBER FLIES
Stenopogon spp., *Efferia* spp.

These genera are representatives of this extensive and diverse family; the majority of conspicuous asilids observed in the state belong to one of them.

ADULT: Medium-sized to large (BL 18–30 mm); bodies bristly; abdomen tapered in females, ending in capsule-like genitalia in males; wings usually transparent; body colors mostly drab brown or gray in *Efferia* **(434)** but brown or reddish brown, often with orange legs, in *Stenopogon* **(433)** (that may have pale, nearly white areas at the base of the wings).

LARVA: Those few known are elongate and cylindrical, with a distinct "head."

HABIT: Larvae live in the soil and feed on other subterranean insects. Adults are active predators on other insects, which are usually taken while in flight. They do not attack humans but can inflict a painful bite if handled carelessly.

RANGE: General, most common in arid and sandy areas.

◀ 435. BUMBLE BEE ROBBER FLY
Mallophora fautrix

ADULT: Medium-sized (BL 17 mm); robust, densely clothed in yellow and black hairs in a pattern resembling a bumble bee (abdomen yellow, thorax largely black).

HABIT: Adults rest on vegetation, ready to dart rapidly to catch prey, which consists of a wide variety of other flies, wasps, and bees, including Honey Bees (*Mallophora* are sometimes called "bee killers"). Their larvae live in old stumps and logs.

RANGE: Fairly common in southern California at lower elevations. Some members of the robber fly genus *Laphria*, which occur primarily in coniferous forests, also resemble bumble bees but are distinguished from *Mallophora* in being slightly less robust and in lacking a terminal filament on the antennae.

◀ 436. SLENDER ROBBER FLIES
Leptogaster spp.

Around six species are known from California.

ADULT: BL 6–11 mm; the long, slender body is distinctive; body color varies from gray to reddish brown or yellow, legs typically paler, long with relatively large tarsi.

HABIT: Adults on the wing will briefly hover and then suddenly dart after prey. They are generally found in areas with tall grass.

RANGE: Middle and higher elevations across the state, particularly in the Sierra Nevada.

Small-headed Flies (Family Acroceridae)

▶ **437. METALLIC SMALL-HEADED FLIES** *Eulonchus* spp.

ADULT: Easily recognized by their robust shape (BL 5–10 mm); large, humped thorax hiding a tiny head with very long mouthparts; and body metallic green or blue with bronzy reflections.

LARVA: Cylindrical maggots tapering at both ends.

HABIT: Adults are usually seen visiting flowers on warm days, and larvae are internal parasites of spiders.

RANGE: Most of the state but most common in forested areas where burrowing spider hosts are abundant. Generally considered rare, the small-headed fly enthusiast typically collects spiders with the hope of rearing out one of these flies.

Bee Flies (Family Bombyliidae)

Members of the family Bombyliidae are called bee flies because most are densely hairy and somewhat beelike in body form. They are highly skilled fliers able to stop and change direction instantly. They are small to moderately large with long, slender legs (which dangle noticeably when they hover) and often a long, projecting proboscis used for probing into deep flowers for nectar. The wings frequently are marked with dark blotches or lacy patterns and are held open, rather than folded over the back, when the insect is perched. The larvae are parasitic on a wide variety of insect larvae, usually those that occupy burrows; hosts include the young of solitary bees nesting in the ground or wood, tiger beetles, and wood-boring beetles. Female bombyliids in some genera are capable of covering their eggs with sand, using a special chamber in the abdomen, and then flipping their tiny eggs packets into open burrows, while hovering in midair. A large number of species is known, with over 200 in California.

▶ **438. NET-VEINED BEE FLY** *Conophorus fenestratus*

A similar-sized species that is also common early in the season is the Net-veined Bee Fly. It has a short proboscis, and the wings are marked heavily in a black, irregular network pattern.

RANGE: Foothills of the Coast Ranges, the Sierra Nevada, and slightly higher elevations as far south as San Diego County.

▶ **439. GREATER BEE FLY** *Bombylius major*

ADULT: Medium-sized (BL 7–12 mm); densely hairy, beelike; dorsally with a tawny pelage of long hairs, usually with a band of black hairs from the eye to base of the wing and areas of black hairs on the side or underside

of the abdomen; anterior half of the wings with a broad, solid dark-brown region.

LARVA: Grublike, with long body hairs; head poorly developed.

HABIT: Larvae develop in nests of solitary bees and feed on the bee larvae. Adults are common and are important pollinators in all-natural areas, particularly sunny spots where wildflowers are abundant.

RANGE: Widespread and common, often flying in early spring.

▶ **440. WESTERN FLOOF FLIES** *Lordotus* **spp.**

ADULT: BL 6–10 mm; distinctly fuzzy flies; usually with a long proboscis; often yellow or white fluffy hairs, with gray body and paler legs; enlarged thorax tends to give them a humped appearance at rest.

HABIT: Adults can be found feeding on flower nectar or drinking water at muddy spots in meadows.

RANGE: Found throughout the state but more common in southern counties.

▶ **441. MOTTLED BEE FLIES** *Thyridanthrax* **spp.**

Large (BL 10–15 mm); base of the wing heavily marked with blackish-brown mottling; body thickly clothed with pale yellow, orange, or black hairs.

HABIT: Adults visit flowers of desert and mountain shrubs; often rest on ground, with wings outstretched.

RANGE: Known throughout most of the state, except northwest Coast Ranges and the Central Valley.

Micro Bee Flies (Family Mythicomyiidae)

▶ **442. YELLOW-SHOULDERED MICRO BEE FLY** *Mythenteles propleuralis*

ADULT: Very small (BL 1.2–3 mm); black to dark brown with yellow markings, shiny, and distinctly humpbacked.

HABIT: Parasites of solitary bees. Found in conifer forest and chaparral.

RANGE: This species is known only from a few specimens from the San Bernardino Mountains and San Benito County. Species of this genus are uncommon and probably represent a very old lineage with its nearest relatives in Europe and Asia.

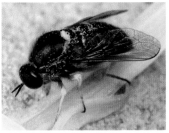

437. Metallic Small-headed Fly
(*Eulonchus* sp.).

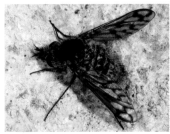

438. Net-veined Bee Fly
(*Conophorus fenestratus*).

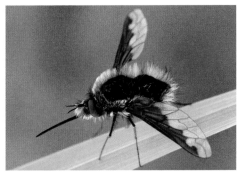

439. Greater Bee Fly
(*Bombylius major*).

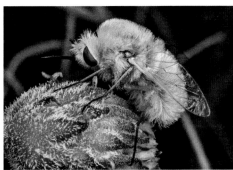

440. Western Floof Fly
(*Lordotus* sp.).

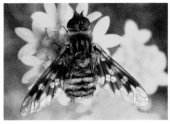

441. Mottled Bee Fly
(*Thyridanthrax nugator*).

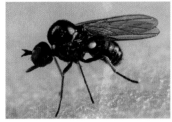

442. Yellow-shouldered Micro Bee Fly
(*Mythenteles propleuralis*).

Stiletto Flies (Family Therevidae)

Medium-sized to large, slender flies. Larvae are predators of other arthropods and live in the soil. Adults are nectar feeders and active during the day in arid country, where they tend to aggregate near any standing water or muddy areas.

▶ **443. POWELL'S STILETTO FLY** *Nebritus powelli*

ADULT: BL 6–7 mm; slender, with forward-directed, hairy antennae and distinctly patterned wings.

HABIT: Found in sand dune areas often on or near willow in spring and early summer.

RANGE: Coastal dunes of central California.

▶ **444. HAIRY-HEADED STILETTO FLY** *Thereva hirticeps*

ADULT: BL 10–15 mm; a beautiful black and golden-yellow pattern, densely hairy fly with smoky wings with subtle black markings.

RANGE: Found in the Coast Ranges, Peninsular Ranges, and Sierra Nevada.

Thick-headed Flies (Family Conopidae)

These are frequently bee or wasplike flies that have a distinctive large head and blunt face. Most are internal parasites of Hymenoptera (especially wasps and bees) as larvae. Eggs are deposited by the female pouncing on the host during flight and inserting the ovipositor briefly between the abdominal segments to inject the egg.

▶ **445. THREAD-WAISTED CONOPID** *Physocephala texana*

ADULT: Medium-sized (BL 9–12 mm); yellow and brown, wasplike, with a large head and narrow waist; anterior portions of the wings shaded in dark brown.

HABIT: Adults fly low over sandy areas in search of hosts; also this species visits flowers on warm days. Larvae are parasites of sand wasps (*Bembix*) and bumble bees.

RANGE: Widely distributed in coastal, foothill, and mountainous regions of the state; local or absent from humid north coast, deserts, and the Central Valley.

▶ **446. BRICK-RED THICK-HEADED FLY** *Myopa rubida*

ADULT: Medium-sized (BL 7–10 mm); body color is red to reddish brown, head with a white face and dorsally orange; wings are clear or somewhat dusky.

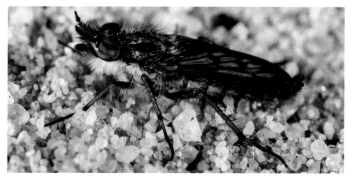

443. Powell's Stiletto Fly
(*Nebritus powelli*).

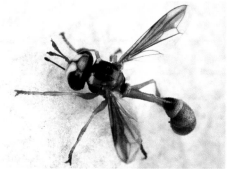

444. Hairy-headed Stiletto Fly
(*Thereva hirticeps*).

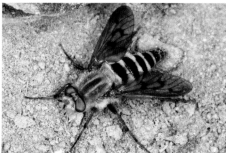

445. Thread-waisted Conopid
(*Physocephala texana*).

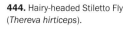

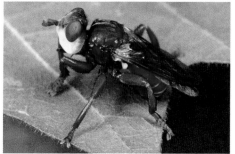

446. Brick-red Thick-headed Fly
(*Myopa rubida*).

HABIT: Adults are found in areas that their hosts burrow and visit flowers such as buttercups and various *Prunus* species. Larvae primarily use species of *Andrena* bees as hosts.

RANGE: Throughout the coastal, Sierra Nevada, and southern ranges from the upper foothills to higher elevations and seasonally in high desert areas. More than a dozen species in the genus are found in California.

Marsh Flies (Family Sciomyzidae)

Among the species where the life history is known, most marsh flies are parasitoids or predators of freshwater and terrestrial mollusks.

▶ **447. SNAIL-KILLING FLIES** *Dictya* **spp.**

ADULT: BL 7–9 mm; white face with a distinct black, central dot; gray-and-brown pattern on the body and wings, the body also with dense black spots.

HABIT: Found in marshes and wetlands.

RANGE: Throughout the state.

Hover Flies (Family Syrphidae)

Hover flies are so named from their habit of hovering motionless in the air. Flies of the family Syrphidae are small to moderately large, often brightly colored. They bear a resemblance to bees or wasps and almost always are without bristles, although some are hairy and colored like bumble bees. Syrphids also are called "flower flies," because they commonly visit flowers for nectar. Although diverse in size, shape, and color, all are recognizable by a pigmented line (or "false vein") lengthwise along the middle of the wing.

Larval habits are varied: some are plant feeders (including bulb maggots); many are predaceous, living externally on plants, especially in aphid colonies where the larvae are cryptically colored in greens and resemble the larva of lycaenid butterflies; others live in decaying organic matter, such as dung, mud, stagnant water, or rotting wood, or as predators of ant brood in the ant nest, or as scavengers in nests of social insects. The larvae are thick maggots with a reduced head. Those living exposed have the hind part of the body blunt, while those living in water have short or long tail extensions ("rat-tailed maggots") used for breathing at the surface. This family of Diptera has numerous species, with probably more than 300 in California.

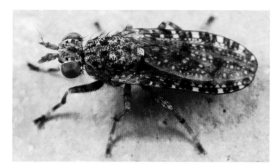

447. Snail-killing Fly (*Dictya* sp.).

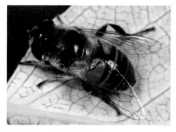

448. Drone Fly (*Eristalis tenax*) adult.

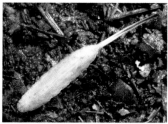

449. Drone Fly (*Eristalis* sp.) maggot.

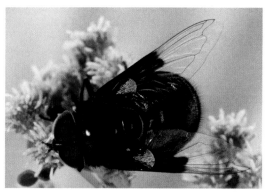

450. Mexican Cactus Fly (*Copestylum mexicanum*).

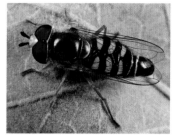

451. Common Hover Fly (*Eupeodes volucris*).

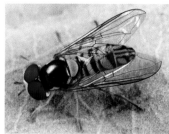

452. Common Hover Fly (*Allograpta obliqua*).

◀ 448–449. DRONE FLY *Eristalis tenax*

ADULT: (448) A moderately large fly (BL 15 mm); brownish black, light yellow triangles at base of abdomen dorsally; similar to drone Honey Bee in general appearance.

LARVA ("RAT-TAILED MAGGOT"): (449) A sausage-shaped maggot, with an extremely long, extendable, posterior breathing tube.

HABIT: Likely to occur almost anywhere. Adults are most often noticed visiting flowers. Aquatic larvae; usually in sluggish streams or small stagnant ponds that are foul with decaying organic matter; also in fresh cattle dung or other fluid animal manure or soil contaminated with same. Extends telescoping breathing tube to surface for oxygen.

RANGE: Throughout California. The adult mimics the Honey Bee, which undoubtedly gives it considerable protection. Like its model, it is an introduced species from the Old World. The ancient myth of bees being generated from dead oxen surely derives from development of larvae of *Eristalis* under carcasses.

◀ 450. MEXICAN CACTUS FLY *Copestylum mexicanum*

ADULT: Large (BL up to 20 mm); robust, shiny, purplish black; wing clear, with pigmented areas near base.

LARVA: Large (BL to 30 mm), cylindrical, pale maggot; short, pigmented breathing tube from posterior.

HABIT: Adults in spring and summer are in arid places; frequent visitors of shrub flowers, especially rabbit brush. Larvae feed in dead and decaying tissues of large cacti, especially prickly pear and cholla *(Opuntia)*.

RANGE: Desert and semiarid portions of the state; the Central Valley and southern Coast Ranges north to the San Francisco Bay Area.

◀ 451–452. COMMON HOVER FLIES *Eupeodes volucris* (451), *Allograpta obliqua* (452), *Syrphus* spp., *Scaeva* spp., and *Metasyrphus* spp.

These genera include similar-looking syrphid flies with yellow-and-black–banded abdomens.

ADULT: BL 8–15 mm; thorax shiny, often greenish; abdomen largely black with yellow or nearly white bands; wings clear.

LARVA: BL 10–15 mm; sluglike, with numerous bumps and protuberances; head end elongate and pointed; usually greenish with median dorsal yellow line.

HABIT: Many species are considered beneficial to agriculture because their larvae are predators of aphids and other plant pests. Adults are quick in flight, often hovering in midair and darting from place to place; common flower visitors and important pollinators. Larvae are also active, moving

about on leaves and stems, puncturing and grasping aphids or other prey with mouth hooks and sucking out body fluids.

RANGE: All portions of the state.

▶ **453–454. ANT NEST HOVER FLIES** *Microdon* **spp.**

Five or six species of these extraordinary flies are found in California.

ADULT: (453) BL 9–15 mm; stout-bodied, generally dark-colored with pale hairs that give them a somewhat beelike appearance.

LARVA: (454) Their peculiar larvae are nearly round and convex, with a single tubercle at the posterior end. So unlike typical insect larvae that they were first described as a mollusk.

HABIT: The larvae live in ant nests where they prey on the ant brood. Adults can be found near the ant nest sometimes hovering over the area. *Formica* and *Camponotus* are the host ants for some *Microdon* species, but host associations of most are not known.

RANGE: Rare but found throughout the state where their hosts occur except in the drier ecoregions and very high elevations.

Long-legged Flies (Family Dolichopodidae)

Dolichopodids are small, often metallic green, bristly flies with a curved abdomen and long, slender legs. With only a few exceptions they occur in damp situations, especially along muddy margins of creeks and ponds; several live in the tidal zone of rocky beaches. The flies are predaceous on small, soft-bodied insects. The larvae are also usually carnivorous, living in humus, rotten wood, and the like, and a few are aquatic. Larvae are elongate and cylindrical, with a small, retractile "head," and most of the body segments bear false legs equipped with spines used for locomotion. A large number of species live in California, probably more than 300.

▶ **455. GARDEN LONG-LEGGED FLY** *Condylostylus occidentalis*

ADULT: Small (wing length 5 mm); metallic green or coppery green, with two incomplete, transverse, dark brown bands across outer half of wing; legs black, long, and slender.

HABIT: Often seen in gardens, walking jerkily and rapidly on leaves.

RANGE: Widespread but primarily a coastal and mountain species; most common at lower elevations.

Dance Flies (Family Empididae)

Many species of dance flies attract the attention of hikers and trout fishermen because of their habit of gathering in swarms beneath forest

trees and over streams. Wheeling and gyrating, these flies perform aerial maneuvers during courtship and mating. Most empidids are predaceous, catching small insects such as weak-flying Diptera, Psocoptera, and stoneflies. In some species both sexes catch prey, but in most the males do the capturing, form swarms, and present the prey to the female as a "nuptial gift" upon mating. The strangest habits are exhibited by a few species in which males secrete material from the digestive tract, which is formed into a frothy white ball (or "balloon"). This balloon either entraps a small prey or is substituted for prey in the courtship gift-giving sequence. The flies are usually black or gray, small to moderately large, generally slender with a small head, often with one or more pairs of legs and the male genitalia grotesquely modified. The larvae of few species are known. They are cylindrical and spindle-shaped with a small retractile head and live in damp places such as humus, decaying wood, or algae at water's edge. Most probably are predaceous. There is a large number of species—about 100 are recorded for California, but many others have not been named.

▶ **456. COMMON DANCE FLIES** *Rhamphomyia* **spp.**
Members of this genus are the dominant empidids in California.
ADULT: Vary greatly in size (BL to 10 mm) and habits; black, gray, or orange.
HABIT: Some visit flowers and do not appear to swarm, while most form small-to-massive swarms in spring.
RANGE: Foothills and mountains to middle elevations throughout the state.

Fruit Flies (Family Tephritidae)

The common name of fruit flies refers to the fact that larvae of some of the most notorious members of this family feed in fruit. However, most feed in flowers, especially the flower heads of the sunflower family, or they are leaf miners; a few form galls. Tephritids are sometimes called "peacock flies" because males strut about, flicking their outstretched, spotted wings as a part of courtship behavior. The wings of nearly all species are mottled with distinctive patterns of black, brown, or orange. They are most often encountered by carefully observing plants such as woody daisies, rabbit brush *(Ericameria), Baccharis,* and thistles when in bud or early bloom. About 100 species of these flies are known in California. Periodically, a few foreign species, which are serious pests of fruit and other crops, are detected in the state, such as **Oriental Fruit Fly *(Bactrocera dorsalis)* (457)**, **Mediterranean Fruit Fly *(Ceratitis capitata)* (458)**, and Mexican Fruit Fly *(Anastrepha ludens)*. Larvae are small maggots

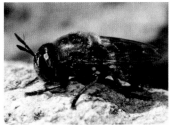

453. Ant Nest Hover Fly (*Microdon* sp.) adult.

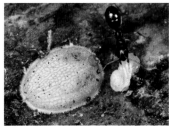

454. Ant Nest Hover Fly (*Microdon* sp.) larva on left, *Formica* ant with ant pupa on right.

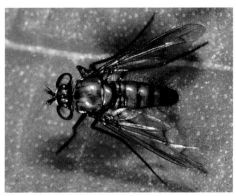

455. Garden Long-legged Fly (*Condylostylus occidentalis*).

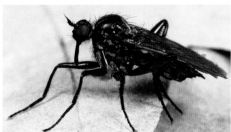

456. Common Dance Fly (*Rhamphomyia* sp.).

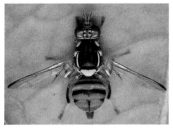

457. Oriental Fruit Fly (*Bactrocera dorsalis*).

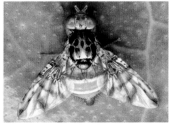

458. Mediterranean Fruit Fly (*Ceratitis capitata*).

that are elongate, with the anterior end narrowed and with anterior mouth hooks. They are found in association with their host plants.

◄ 457. ORIENTAL FRUIT FLY *Bactrocera dorsalis*

ADULT: Small to medium-sized (BL 6.0–8.0 mm). Typically with prominent yellow and dark brown to black markings on the thorax; abdomen with horizontal black stripes and a longitudinal median stripe. Markings may form a T-shaped pattern, but they vary considerably. The female has an ovipositor that is very slender and sharply pointed.

HABIT: Females locate host fruits to lay eggs by using both visual and olfactory cues. This fly is easily moved by people and can be an extremely destructive pest of a large number of different fruit crops.

RANGE: Native to southeast Asia, the Oriental Fruit Fly is not established in California, but chronic detection of their reintroduction requires ongoing eradication programs.

◄ 458. MEDITERRANEAN FRUIT FLY *Ceratitis capitata*

ADULT: Small (BL 6.0–7.0 mm); black thorax marked with silver patterning; a tan abdomen with darker stripes; and clear wings with two light brown bands across the wing, another along the front edge near the tip, and gray flecks scattered near the base.

HABIT: This fruit fly (aka the "Medfly") has a wider range of hosts than any other pest fruit fly and is considered the most important agricultural pest in the world.

RANGE: Medfly regularly invade California as eggs or larvae in fruit being brought into the state and so requires ongoing eradication programs.

► 459. WALNUT HUSK FLY *Rhagoletis completa*

ADULT: Small (BL 5–6 mm); thorax brownish yellow; three transverse, dark brown wing bands, the most basal faint, the outer with a broad extension over the anterior wing apex.

HABIT: Active and ovipositing on hosts during summer. Infests husks of walnuts and affects nut quality by staining husks and kernels. Pupates in soil.

RANGE: Indigenous to the mid- and south-central United States; introduced into central and western portions of southern California. Now known to occur the whole length of the state.

► 460. APPLE MAGGOT FLY *Rhagoletis pomonella*

ADULT: Small (BL 5–6 mm); black, thorax with a distinct white region (the scutellum) and lighter crossbands dorsally on abdomen; wings with a very distinctive black banding pattern.

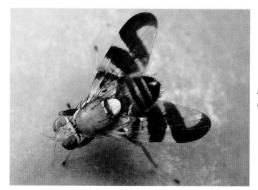

459. Walnut Husk Fly
(*Rhagoletis completa*).

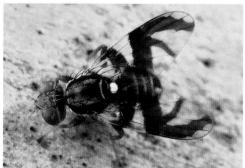

460. Apple Maggot Fly
(*Rhagoletis pomonella*).

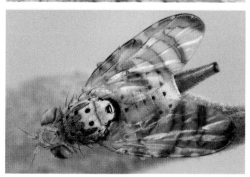

461. False Peacock Fly
(*Chaetorellia succinea*).

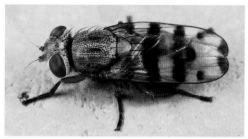

462. Narrow-banded Picture-winged Fly
(*Ceroxys latiusculus*).

HABIT: Females deposit eggs under the skin of apples, and larvae burrow and feed on the fruit's flesh.

RANGE: This fly is a native pest in the eastern United States that has been introduced in California. It is easily confused with *R. zephyria* (Snowberry Fruit Fly) that is found across the state, but this native species is not a pest on apples.

◄ 461. FALSE PEACOCK FLY *Chaetorellia succinea*

ADULT: BL 3.5–4.5 mm; eyes are metallic green; body pale yellow with three rows of prominent black spots on the thorax that extend to the sides of the thorax, and light brown wing bands.

HABIT: This species was accidentally introduced into California in 1991 and has since become a major biological control for the extremely noxious weed, Yellow Starthistle (*Centaurea solstitialis*). However, it is not an approved biocontrol agent, as the potential risk that the flies may move to seed heads of native plants has not been adequately studied. The similar-looking Yellow Starthistle Peacock Fly (*Chaetorellia australis*) was intentionally introduced for starthistle control but is outcompeted by the False Peacock Fly where they overlap.

RANGE: Areas where the host plant grows. Statewide, except for desert and Great Basin regions.

Picture-winged Flies (Family Ulidiidae)

Most picture-winged flies feed on a variety decaying organic matter (saprophagous), and others are somewhat particular about what sort of rotting plant material they will live in as larvae. Still others feed on living plants, in some cases using damaged tissue of otherwise live plants. Adults of many species are known to have complex courtship behaviors that include elaborate wing displays by males inviting females to mate.

◄ 462. NARROW-BANDED
PICTURE-WINGED FLY *Ceroxys latiusculus*

ADULT: BL 9–12 mm; thorax rather long and gray; abdomen black with gray bands; legs reddish brown to darker brown; wings distinctly banded.

HABIT: Larvae feed in the seed heads of ragworts (*Senecio*). Occasionally common enough around and in human dwelling to be considered a nuisance pest.

RANGE: Throughout the state.

Leaf-miner Flies (Family Agromyzidae)

These very small to medium-sized flies are typically black and yellow, in some cases mostly yellow. All species feed on living plant tissues and, as their name suggests, most "mine" leaves as internal leaf-feeding maggots. Many species are considered significant pests of crop and ornamental plants.

▶ **463–464. VEGETABLE LEAF-MINER** *Liriomyza sativae*

ADULT: (463) BL 1–2 mm; contrastingly yellow and black; prominent yellow scutellum of the thorax; yellow head; and legs at least partly yellow.

LARVA: By feeding within the leaf **(464)**, the larva makes an irregular mine that increases in width as the larva grows, from about 0.25 mm to about 1.5 mm wide.

HABIT: Will feed on many different plants but tends to prefer cucurbits, like squash and cucumber, and solanums, like nightshades.

RANGE: Established in warmer parts of the state, though frequently moved with plants to all areas.

Black Scavenger Flies (Family Sepsidae)

Small, slender, shiny black flies. All feed on decaying organic material, but most are fond of mammal feces. One of the common places to see them is on a fresh cowpat. For humans this may not seem like a romantic setting, but for black scavenger flies the cowpat is the stage for an elaborate courtship that involves the males grasping the female's wings using his specially modified front legs.

▶ **465. SHINY DUNG FLIES** *Sepsis* spp.

ADULT: BL 3–5 mm; black, shiny, with a narrowing of the body that gives them a somewhat antlike appearance.

HABIT: Found on dung or on the vegetation nearby, where they are usually flexing and waving their wings in a twitching or rowing motion.

RANGE: Found everywhere suitable decaying matter accumulates.

Kelp Flies (Family Coelopidae)

▶ **466. FLAT-BACKED KELP FLY** *Coelopa vanduzeei*

ADULT: Small (BL 4–6 mm); dark gray, wings clear; body flattened, especially the thorax, which is wide and depressed.

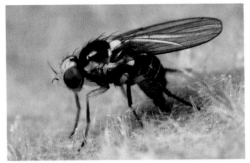

463. Vegetable Leaf-miner (*Liriomyza sativae*) female laying egg in leaf.

464. Vegetable Leaf-miner (*Liriomyza sativae*) mines in leaf.

465. Shiny Dung Fly (*Sepsis* sp.).

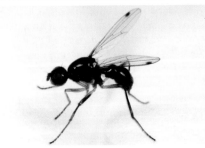

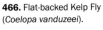

466. Flat-backed Kelp Fly (*Coelopa vanduzeei*).

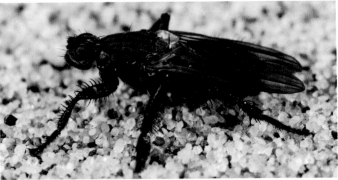

LARVA: A small (BL up to 12 mm), cylindrical, white maggot; fingerlike processes on anterior spiracle (segment 2).

HABIT: Develops in moist, decomposing kelp. Adults are common (sometimes in swarms) on and under kelp wrack on beaches.

RANGE: Along the entire coast.

Shore Flies (Family Ephydridae)

▶ 467–468. KOOCHAHBIE FLY *Ephydra hians*

ADULT: (467) Small (BL 3–6 mm); black or dark gray, with green reflections.

LARVA: (468) Small (BL 12 mm); maggot-shaped; whitish, with wide, dorsal pigmented band; ventral leglike appendages with spines; posterior tube short, without basal fork.

PUPA: Similar in shape to larva but hard and dark brown; attached (often in large numbers) to submerged vegetation or debris.

HABIT: Larvae live near bottom of briny and alkaline lakes.

RANGE: Limited to inland mineral lakes (Clear Lake, Mono Lake, Owens Lake) and ponds. The southernmost band of Northern Paiute people, in early days, prepared a food (called "Koochahbie") from pupae heaped on lake shores by storms.

BRINE FLY *Ephydra millbrae*

ADULT: Small (BL 4.5 mm), gnatlike; body brown, face white or golden brown dorsally; antennal hair (arista) with long, numerous branches on basal half dorsally; lower portion of face protruding, oral margin wide.

LARVA: Medium-sized (BL 10–12 mm); maggotlike; long, apically branched breathing tube posteriorly; many pairs of spined, ventral leglike swellings, the last larger and hooked forward for clasping vegetation.

HABIT: Larvae are aquatic, developing in brackish to supersaturated saltwater in desert playas or coastal bays. Adults swarm in great numbers on the shores of desert salt lakes and briny marshes (e.g., San Francisco Bay).

PUPA: Like that of preceding species.

RANGE: Entire coast and southern deserts where suitable aquatic habitats are found.

▶ 469. PETROLEUM FLY *Helaeomyia petrolei*

ADULT: Very small (BL about 2 mm), gnatlike; shiny black with white balancers (halteres); eyes densely hairy; large bristle of antenna (arista) feathered on upper side; face and oral margin not expanded.

LARVA: Elongate-oval, small (BL 8–10 mm); somewhat transparent; body with 12 segments, pointed anteriorly; four projections from posterior end. Live in small pools of oil.

HABIT: The larva may feed on other insects caught in the oil. Adults found around natural crude oil seeps and commercial fields.

RANGE: Known from the state's petroleum fields and natural oil seeps (e.g., common at Rancho La Brea).

Minute Sap-feeding Flies (Family Lauxaniidae)

These small, compactly built flies with rather large eyes come in a variety of colors. They feed on a wide array of decaying plant material and in some cases, fungi.

▶ **470. YELLOW SAP-FEEDING FLY** *Minettia flaveola*

ADULT: BL 5–7 mm; very stout flies; typically pale yellow to cream color, sometimes gray, bicolored, or banded; noticeable rows of stiff black bristles; wings are not marked.

HABIT: Maggots feed in decaying cones from pine and fir trees.

RANGE: Throughout the state.

Stilt-legged Flies (Family Micropezidae)

Stilt-legged flies, with their slender, elongate body and very long legs, strike a distinctly recognizable pose when perched on leaves or stems of plants. If lucky, you may witness their elaborate courtship that includes signaling with leg waving and the exchange of oral fluids. The family is found in the foothill and mountain ranges throughout the state.

▶ **471. COMMON WESTERN STILT-LEGGED FLY** *Compsobata mima*

ADULT: BL 5–8 mm; black, shiny body, slender form; legs pale or in populations from the northern part of the state and higher elevations, the femur is darkened.

HABIT: Larvae are probably saprophagous, feeding on moist, decomposing vegetation.

RANGE: Sierra Nevada foothills and range from about 700 m elevation upward, from Tulare County north.

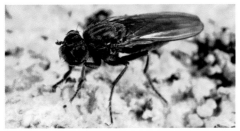

467. Koochahbie Fly
(*Ephydra hians*) adult.

468. Koochahbie Fly
(*Ephydra hians*) larva.

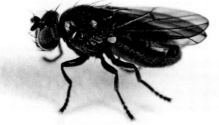

469. Petroleum Fly
(*Helaeomyia petrolei*).

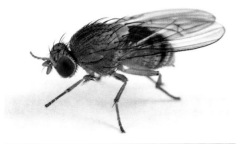

470. Yellow Sap-feeding Fly
(*Minettia flaveola*).

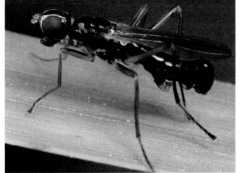

471. Common Western Stilt-
legged Fly
(*Compsobata mima*) male.

Pomace or Vinegar Flies (Family Drosophilidae)

Drosophilids are often called "fruit flies," a name universally applied to the flies in the family Tephritidae, and so this is a misnomer based on the annoying occurrence of a few drosophilid species common around fruit and vegetables in kitchens and at picnics. The larvae feed in decaying fruit and other organic matter. Pomace flies are small with a somewhat swollen appearance and commonly have red eyes.

▶ **472. VINEGAR FLIES** *Drosophila* **spp.**

ADULT: Small (BL 2–4 mm); stubby, gnatlike flies; body yellow to brown, abdominal segments typically banded; eyes typically bright red. Commonly seen around fruit-processing plants (tomato canneries, wineries, cider mills) or anywhere odor from damaged fruit attracts them.

LARVA: Small (BL to 7 mm); white maggots; posterior spiracles on short stalk.

HABIT: Develop in fermenting or rotting fruit, vegetable, and more rarely, animal matter and fungi, feeding on yeasts therein. Although occasionally a nuisance around homes and in food, *Drosophila* have more than made up for their negative attributes by their usefulness in the study of genetics. No other organism has contributed so much to the understanding of heredity and development.

▶ **473. TRAIL-GNAT** *Phortica picta*

ADULT: Small (BL 2–3 mm); generally gray with vague, darker spots on the thorax and abdominal segments; dark cloudy spots on wing crossveins, and legs dark-banded.

HABIT: Attracted to humans, especially to the eyes, and may be an extremely irritating pest to hikers, especially on trails near streams.

RANGE: Mountains of southern and central California; Coast Ranges, at least north to San Francisco Bay Area, where it may occur in the valleys as well as upper elevations.

Frit Flies (Family Chloropidae)

▶ **474. GRASS FLIES** *Thaumatomyia* **spp.**

ADULT: BL 3–4 mm; stout body form, typically shiny yellow or greenish yellow with broad longitudinal black stripes in the thorax and head, a few species are reddish orange.

HABIT: Larvae are aphid predators, and adults feed on sugary plant fluids.

RANGE: Coastal Ranges and Sierra Nevada and foothills. Other frit flies in California include the eye-gnats *(Hippelates* and *Liohippelates).*

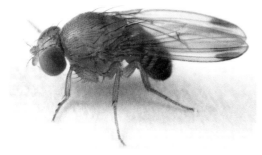

472. Spot-winged Fruit Fly (*Drosophila suzukii*).

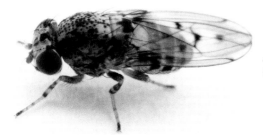

473. Trail-gnat (*Phortica picta*).

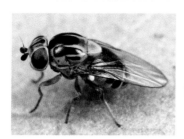

474. Grass Fly (*Thaumatomyia* sp.).

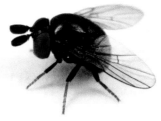

475. Cottony-cushion Scale Killer (*Cryptochetum iceryae*).

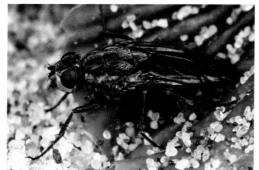

476. Seaweed Fly (*Fucellia costalis*).

Three important pestiferous species (*L. currani, H. dorsalis,* and *H. impressus*) in California act as vectors of "pink eye," a bacterial form of conjunctivitis in humans.

ADULT: Small (BL 1.5–2.5 mm); stocky, generally dull or shiny bronze-black.

LARVA: Minute (BL 2.5–3.5 mm); opaque white maggots.

HABIT: Breed mainly in friable loose soils impregnated with decaying organic matter, including irrigated and tilled agricultural land (citrus groves, orchards—especially date palm—vegetable fields, etc.). Females attracted to mucous secretions of animals.

RANGE: South of Madera County, below 1,850 m in mountains—including desert ranges; abundant in some localities in San Joaquin, Coachella, and Imperial Valleys.

Scale Parasite Flies (Family Cryptochetidae)

◄ 475. COTTONY-CUSHION SCALE KILLER *Cryptochetum iceryae*

ADULT: Tiny (BL 1.5 mm); compact; deep metallic blue thorax, abdomen blue-green; wings transparent; eyes extra-large; antennae lacking major bristle.

LARVA: Stubby, semitransparent, pear-shaped maggot with two long, slender, tail-like processes.

HABIT: Adults crawl slowly over colonies of Cottony-cushion Scale, into which they insert eggs. The larva kills the scale by consuming its internal tissues.

RANGE: Intentionally introduced in 1888 into California from Australia to control this harmful citrus and ornamental pest. Locally established in several areas of the state where the host persists.

Root-maggot Flies (Family Anthomyiidae)

◄ 476. SEAWEED FLY *Fucellia costalis*

ADULT: Medium-sized (BL 7–8 mm); dull brown to gray; abdomen with four readily visible segments; thorax rounded and bristly.

HABIT: Larva feeds on decomposing tissue of stranded beach kelp. Adults are very common along beaches, often swarming around piles of rotting kelp where they catch and feed upon other small invertebrates, especially "sand fleas" (amphipods).

RANGE: Entire coast, more common in the warmer south.

Dung Flies (Family Scathophagidae)

▶ **477. GOLDEN-HAIRED DUNG FLY** *Scathophaga stercoraria*
ADULT: Medium-sized (BL 8–9 mm); slender, densely covered with bright yellow or tawny hair that is longer in the male.
LARVA: A medium-sized (BL 15 mm) white maggot.
HABIT: Breeds in all types of fresh excrement (ubiquitous in human feces, cattle and horse droppings) and most decaying vegetation. Adults are common in meadows and pastures, often around fresh animal dung, where they catch other insects (muscids, blow flies), which they feed upon with a hardened, toothed proboscis.
RANGE: In all parts of the state, except the highest elevations; more common where moist.

Lesser House Flies (Family Fanniidae)

▶ **478. LITTLE HOUSE FLY** *Fannia canicularis*
ADULT: BL 3–5 mm; more slender than the House Fly; abdomen yellow basally; the third vein near the tip of the wing curves evenly to margin; abdomen gray, without pattern; large bristle (arista) of antenna bare.
LARVA: BL 6–7 mm; broad and flattened, with prominent lateral and dorsal rows of fingerlike projections.
HABIT: On hot, summer days swarms of males are often seen hovering, flying in horizontal patterns in the shade of trees, in garages, under house awnings, and other such places. Develops in decaying accumulations of manure, especially from fowl; the species abounds around poultry ranches.
RANGE: Of general occurrence in the state.

Muscid Flies (Family Muscidae)

The family Muscidae is one of the largest families of Diptera, with about 450 species known in California. In many habitats they are our commonest flies. Most are small to medium-sized and dull-colored, bearing a general resemblance to the House Fly, but a few are larger and rather brightly colored. A few species suck blood of mammals, including humans, using piercing mouthparts (and both sexes bite). The vast majority are incapable of biting and take up nourishment with "sponge"-type mouthparts, visiting all kinds of rotting vegetable matter, foodstuffs, exudates from plants and homopterous insects, plus flowers for nectar.

Some species, particularly the House Fly, are implicated in the trans-

mission of diseases such as dysentery and typhoid fever via mechanical pickup from filth; and others cause considerable annoyance by flying around the face, seeking to alight and feed on perspiration and the secretions of the eyes. There is a great diversity of larval habits, some are plant feeders, as leaf miners or root maggots, and several are important agricultural pests; most species inhabit decaying organic matter and are scavengers, while a few are predators of other soft-bodied larvae in such habitats. All are headless, legless maggots, and many are capable of very rapid development in warm weather.

◀ 479–482. HOUSE FLY *Musca domestica*

ADULT: (479) Small (BL 5–7 mm); dull gray with four darker longitudinal lines on thorax; basal abdominal segments semitranslucent yellow laterally; wings transparent; third vein near tip curving toward second vein; large bristle (arista) of antenna plumose on both sides; soft, spongy proboscis.

PUPA: (482) Around 8 mm long, elongate ovoid shape. Deep brown color or black when the adult fly is ready to emerge.

LARVA: (481) White maggot (BL up to 12 mm); posterior breathing pores enclosed in a definite border with sinuous slits; area around spiracles smooth.

EGG: (480) Elongate (1–2 mm), shiny white. Often in clusters.

HABIT: Constant companion of humans, a major pestiferous species in all situations. Feeds on all sorts of substances; directly imbibes fluids and liquefies solids with saliva by regurgitation onto the food source. Breeds in a wide variety of waste substances: animal feed and manures (including dog feces), garbage, and freshly rotting vegetation.

RANGE: Literally every place inhabited by people.

▶ 483. STABLE FLY *Stomoxys calcitrans*

ADULT: BL 5–6 mm; very similar to the House Fly but with a slender, rigid, nonretractable proboscis, having cutting teeth at apex; other differences are the more pronounced and interrupted thoracic stripes and checkered abdomen.

LARVA: Moderate-sized (BL up to 12 mm) maggot; posterior breathing pores sinuous but without encircling border.

HABIT: Breeds in decaying vegetation; often in straw and grass near stables as well as piled grass clippings and weeds in residential areas. Also develops in seaweed piles on beaches, producing adults that annoy swimmers ("beach flies"). Adults suck blood and can seriously torment humans and domestic animals.

RANGE: Throughout the state, especially in suburban and rural environments.

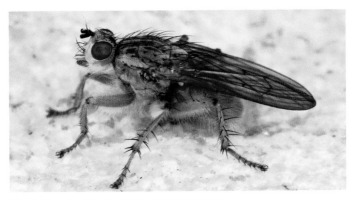

477. Golden-haired Dung Fly (*Scathophaga stercoraria*).

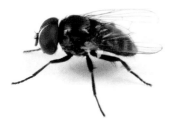

478. Little House Fly
(*Fannia canicularis*).

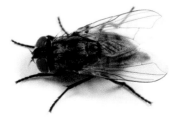

479. House Fly
(*Musca domestica*) adult.

480. House Fly
(*Musca domestica*) eggs.

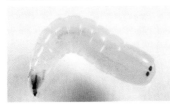

481. House Fly
(*Musca domestica*) maggot.

482. House Fly
(*Musca domestica*) pupa.

► **484. TIGER FLIES** *Coenosia* **spp.**

ADULT: BL 2–5 mm; gray, sometimes with a yellow cast; legs often reddish or yellowish brown; body with many long, heavy bristles.

HABIT: These flies are well-known for their predatory nature. Both larvae and adults are predators of other insects. Adults often attack and capture their prey in flight. Because of their rapacious life history, they are thought to be beneficial by helping to control pest insects.

RANGE: Widespread in the state. Some species are common in urban gardens.

Blow Flies (Family Calliphoridae)

Calliphorids are similar in general form to tachinids, muscids, and sarcophagids but are more often metallic green or blue and with less developed bristles, especially on the abdomen. They are most commonly seen at flowers, fresh dung, or swarming around dead animals. The larvae are legless, headless maggots, mostly breeding in carrion, excrement, or other rotting organic matter, usually of animal origin. Blow flies are important from a medical and veterinary standpoint. Some species, including the notorious Screwworms *(Cochliomyia macellaria* and *C. hominivorax),* which are both found in California, feed as parasites or in wound tissue of domestic animals and humans or attacks nesting birds. Those that frequent contaminated materials often enter houses and can mechanically transmit disease organisms. About 35 species are recorded in the state.

► **485. GREEN BOTTLE FLY** *Lucilia sericata*

ADULT: A beautiful, moderate-sized fly (BL 5–10 mm) with a bright emerald, bluish-green, or coppery metallic body; without markings but with numerous black spines; eyes brick red.

LARVA: BL up to 16 mm; slender white maggot, tinged with pink or purple; posterior breathing pores pear-shaped with three straight, converging slits, in pit surrounded by 10 tubercles.

HABIT: The commonest species in household garbage and urban carrion. Extremely common near and inside homes, especially during summer. Some species in the genus are known for cutaneous myiasis ("flystrike") in sheep.

RANGE: Known nearly everywhere in the state.

A related species, *L. cuprina,* may replace *L. sericata* in coastal and northern parts of the state. Species of Black Garbage Flies *(Hydrotaea)* are also associated with garbage. They are common around refuse dumps

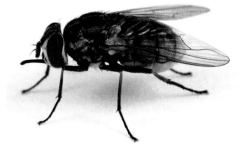

483. Stable Fly
(*Stomoxys calcitrans*).

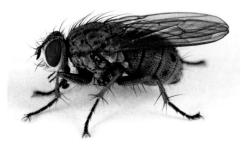

484. Tiger Fly
(*Coenosia* sp.).

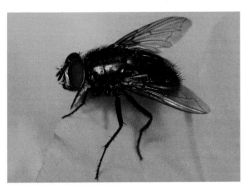

485. Green Bottle Fly
(*Lucilia sericata*).

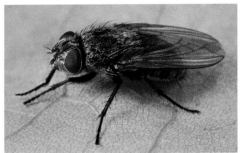

486. Cluster Fly
(*Pollenia pediculata*).

and in the manure of garbage-fed hogs but are not usually found near homes. They are distinguished from *Lucilia* by smaller size (BL 5 mm), shiny black color, and white area in the center of the face. The larvae are thick-skinned and have spiny protuberances ventrally. They prey on other insect larvae.

◄ 486. CLUSTER FLY *Pollenia pediculata*

ADULT: Robust (BL 7–9 mm); checkered black and silvery abdomen; uniquely distinct from relatives by body covering of sparse, crinkly, golden hairs.

LARVA: Medium-sized (BL up to 12 mm), smooth maggot; the last segment with eight terminal protuberances; terminal spiracles with three straight slits, encircled by a weak border.

HABIT: Larvae are predaceous on earthworms. Adults feed on nectar and may enter houses in winter in cold climates.

RANGE: An early European introduction, now generally distributed throughout the state; rare and local in desert areas.

► 487. EUROPEAN BLUE BOTTLE FLY *Calliphora vicina*

ADULT: Medium-sized (BL 5–12 mm), heavy-bodied; thorax dull black, abdomen metallic dark blue with silvery, checkered markings; fine, head with sparse upper bristles; orange in the mouthpart cavity and "cheeks."

LARVA: BL up to 19 mm; spiny bands around abdominal segments; posterior segment tipped with a circle of small tubercles above; two large lobes below.

HABIT: Attracted to any foul-smelling, decaying material, especially carrion. A very common maggot on dead animals. Occasionally infests living animal tissue in infected wounds or if inadvertently swallowed.

RANGE: Generally distributed in California.

COMMON BLOW FLY *Cynomya cadaverina*

The Common Blow Fly is extremely similar to the European Blue Bottle Fly.

ADULT: Identified by slightly smaller size (BL variable but usually 5–9 mm) and heavier upper bristles in row on face lateral to antennae.

HABIT: Readily enters houses and often attracted in large numbers to human surroundings. Develops in freshly killed carcasses of small animals, usually rodents and birds.

RANGE: The most abundant and widespread blow fly in California.

BLACK BLOW FLY *Phormia regina*

Found in fresh carrion and sometimes living tissue of animals where wounded is the Black Blow Fly.

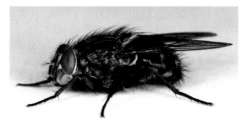

487. European Blue Bottle Fly (*Calliphora vicina*).

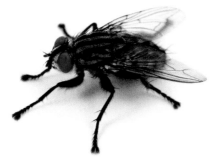

488. Common Flesh Fly (*Sarcophaga* sp.).

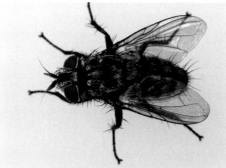

489. Caterpillar Destroyer (*Compsilura concinnata*).

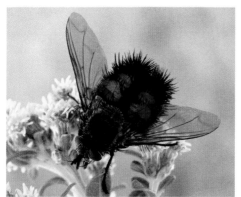

490. Spiny Tachina Fly (*Paradejeania rutilioides*).

ADULT: Medium-sized (BL 6–11 mm); body shiny, nearly black or dark olive green; head black; conspicuous orange hair around main thoracic spiracle.

LARVA: A large maggot (BL up to 17 mm); creamy translucent white to yellow; posterior breathing pores in pits incompletely encircled by border.

RANGE: Of general occurrence in the state.

Flesh Flies (Family Sarcophagidae)

Sarcophagids are mostly gray flies with a longitudinally striped thorax and often with a checkered abdomen. They resemble muscids and tachinids, but most species have large bristles only on the hind part of the abdomen, and often the abdominal tip is red. Flesh flies are most commonly seen at flowers or buzzing about on the ground in dry, rocky areas; in arid places they sometimes constitute an annoyance by persistently alighting on the skin in search of moisture. The larvae of most species occur in dead animal matter or are parasites of other insects, such as grasshoppers, cicadas, and adult beetles; scorpions and snails also serve as hosts. Many of the smaller sarcophagids live on the paralyzed insects provisioned by ground-nesting wasps. Many of the larger species "larviposit" (the eggs are incubated in a pouch inside the female), and the young larvae are placed or dropped from the air onto fresh meat or living insect or mammalian hosts (and sometimes also animal droppings). The larvae are headless and legless, tapered toward the front, with a rounded tail end, and the segments have transverse bands of minute, toothlike spurs. More than 100 species have been recorded in the state.

◄ 488. COMMON FLESH FLIES *Sarcophaga* spp.

ADULT: BL up to 15 mm; a little like a giant House Fly but seldom enter houses and are distinguished by the three, instead of four, black bars on the thorax and by the red-tipped abdomen.

LARVA: Large (BL to 20 mm), pale maggots; lobes present around posterior spiracles, the slits of the latter directed away from the midline.

HABIT: Scavengers on animal feces and carrion or parasitic on other insects. Commonly feed on dead garden snails.

RANGE: Generally across the state.

Tachinid Flies (Family Tachinidae)

The family Tachinidae has more members than almost any other family of Diptera, with probably more than 400 species occurring in California. Many are large and common insects; as a result tachinids constitute

a conspicuous part of the fly fauna in most natural habitats. They have a well-developed lobe under the mesothoracic scutellum ("postscutellum") and are often recognizable by numerous heavy bristles covering the abdomen. Tachinids are frequently seen at flowers or buzzing circuitously about in vegetation near the ground. The adults feed on nectar or other plant exudates, while the larvae are parasitic in other insects or rarely other arthropods. Tachinids most often parasitize Lepidoptera caterpillars but sometimes adult Coleoptera, Hemiptera, and Orthoptera, or larvae of other insects. Females may cement their eggs onto the host integument, often on or near the heads of caterpillars, where they can be easily seen but are impossible for the host to remove, but some species deposit large numbers of minute eggs on plants, which are then ingested and hatch within the bodies of the hosts. In other cases, females incubate their eggs and either inject incubated eggs into the host or allow eggs to hatch and deposit the maggots, leaving them to find their host on their own. Inside the victims the larvae breathe free air either by perforating the body wall of the host or by a connection to its tracheal system. When full grown, most tachinid larvae leave the host and form puparia on the ground.

◄ 489. CATERPILLAR DESTROYER *Compsilura concinnata*

ADULT: Small (BL 5–7 mm); similar in size to House Fly but with heavy bristles at the tip of the abdomen; third antennal segment very long.
LARVA: A thick-skinned, ovoid maggot.
HABIT: Internal parasite of the caterpillars of many larger moths and butterflies (a perpetual enemy of the brush-footed butterflies).
RANGE: Widespread at low elevations, including the deserts.

◄ 490. SPINY TACHINA FLY *Paradejeania rutilioides*

ADULT: Large (BL 16–18 mm); robust; abdomen orange or with a black line down the middle and black fifth abdominal segment (the form occurring in California); whole body, especially abdomen, with dense vestiture of enormous, stiff, black bristles; wings smoky.
LARVA: Large, cylindrical maggot.
HABIT: Most abundant in early fall frequently on blooming *Baccharis* flowers and other species in the sunflower family. An internal parasite of caterpillars, possibly restricted to larvae of the large tiger moth, Edwards' Glassywing (*Pseudohemihyalea edwardsii*) **(567)**.
RANGE: Mountains of the southern half of state, the Coast Ranges in northern California, and possibly in the northern Sierra Nevada at low or moderate elevations.

Louse Flies (Family Hippoboscidae)

The family Hippoboscidae has only a few members in California (12 species). Louse flies are external parasites of mammals and birds. They are conspicuously flattened and cling tenaciously to their hosts, sucking their blood and sometimes transmitting diseases. While they frequently land on humans, they rarely linger or bite, having no taste for human blood. The larvae develop one at a time within the female's abdomen and receive nourishment from internal glandular secretions and pupate shortly after birth in at least some species, having been fully nourished by their mothers.

▶ 491. DEER LOUSE FLY *Lipoptena depressa*

ADULT: Small (BL 3–4 mm); V-shaped lines on upper surface of the abdomen; wings break off after the fly has settled on the host.
HOST: Deer.
RANGE: Foothills and mountainous regions of the state wherever the host is found.

PACIFIC DEER KED *Neolipoptena ferrisi*

A related species, the Pacific Deer Ked, lacks abdominal markings and also occurs on deer. Another common species is the Pigeon Louse Fly *(Pseudolynchia canariensis).*

ADULT: Large (BL to wing tips 8 mm); dull brown; wings retained throughout life, tips folded.
HOST: A specialist on pigeons and doves. Infests adult birds and squabs. Transmits pigeon malaria.
RANGE: Introduced from the Old World; fairly common throughout the state on feral pigeons and possibly doves.

Bot Flies (Family Oestridae)

▶ 492. RODENT BOT FLIES *Cuterebra* spp.

ADULT: Very large, robust flies (BL 20–30 mm), somewhat resembling carpenter bees in form; body generally black, with contrasting, dense white pubescence on lower sides of the thorax, and shiny bluish-black abdomen.
LARVA: Very large (BL 35 mm); ovoid and grublike (rounded at both ends); skin thick with heavy plates and fine spines.
HABIT: Internal parasites of rabbits, wood rats, and mice.
RANGE: There are seven California species, ranging widely with their hosts.

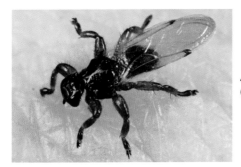

491. Deer Louse Fly (*Lipoptena depressa*).

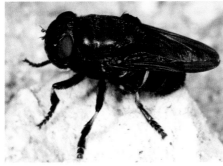

492. Rodent Bot Fly (*Cuterebra* sp.).

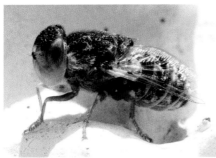

493. Sheep Bot Fly (*Oestrus ovis*) adult.

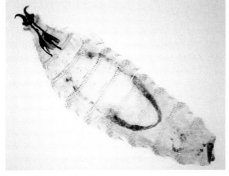

494. Sheep Bot Fly (*Oestrus ovis*) larva.

◄ 493–494. SHEEP BOT FLY *Oestrus ovis*

ADULT: (493) A small bot fly (BL 10–12 mm); generally dull yellow; head yellow with deep pockmarks; thorax with gray powder and numerous small tubercles, each bearing a yellow hair.

LARVA: (494) BL up to 20 mm; more or less cylindrical, grublike; skin leatherlike, with rows of fine spines ventrally; yellowish, changing to brown when mature.

HABIT: Larva lives in the nostrils and head sinuses of sheep and goats, causing extreme annoyance and often death. Adults are active in hot sunshine; do not feed; female thrusts living maggots up nostrils of host animals.

RANGE: Sheep-raising regions of the state; also in feral populations of sheep and goats.

HORSE BOT FLY *Gasterophilus intestinalis*

Related flies that also attack livestock include the Horse Bot Fly.

ADULT: Medium-sized (BL 11–15 mm); yellowish brown; slightly resembles the Honey Bee **(707)**; thorax completely haired; abdomen rather elongate and frequently curled beneath body.

LARVA: Large (BL up to 20 mm); thick-skinned grublike; anterior end tapering, posterior blunt; single major row of large, slender, blunt-tipped spines bordering anterior margins of segments.

HABIT: The eggs are laid on hairs of the horse, particularly on backsides of knees, and hatch when licked; the young larvae enter the horse's tongue, wander in the mucosa of the mouth, and eventually work their way down the esophagus to the stomach.

RANGE: Throughout area where horses are boarded; common around suburban horse stables.

CATTLE GRUBS *Hypoderma* spp.

ADULT: Large (BL 13 mm); robust; with dense, black and light yellow hairs, somewhat similar to a bumble bee; tuft of pale hairs on sides of the thorax, pale red hair at tip of the abdomen; longitudinal, black, bald areas on back of the thorax. Seldom seen except when ovipositing on animal hosts.

LARVA: Very large (BL up to 30 mm); thick-skinned; yellow-brown to dark brown; row of larger spines near anterior margin of some or all segments, patches of small spines near posterior border. Internal parasites of bovine animals; younger stages burrow through deep tissues and lodge beneath skin on the back when mature ("warbles"); hole made for breathing and emergence ruins hides.

EGG: Attached in series *(H. lineatum)* or singly *(H. bovis)* to hairs of the legs or belly, where the larvae hatch and burrow through the hide.
RANGE: Found in association with cattle throughout the state.

Scorpionflies (Order Mecoptera)

Scorpionflies derive their name from the bulbous male genitalia of some species, which resembles a scorpion's stinger. However, California scorpionflies do not exhibit this form. Their most characteristic identifying feature is their long face (head greatly elongated with the antennae situated near the chewing mouthparts). Only six mostly uncommon or relatively rare species occur in the state. Recent DNA-based research has revealed Mecoptera and Siphonaptera to be sister groups, demonstrating the remarkable adaptations of fleas to their peculiar lifestyle.

Hangingflies (Family Bittacidae)

▶ **495. WINGLESS SCORPIONFLY** *Apterobittacus apterus*
ADULT: BL up to 20 mm; entirely wingless; legs long and slender; yellow-brown to dull olive green.
LARVA: Caterpillar-like but with abdominal legs reduced to immovable spines, the back and sides with lobed protuberances.
HABIT: Larvae live in sod among grass roots. Adults feed on crane flies **(389)** and other small insects.
RANGE: Grassy hillsides, mainly in central Coast Ranges; common in the spring in the San Francisco Bay Area.

▶ **496. GREEN STIGMA** *Bittacus chlorostigma*
ADULT: Large (BL 25 mm, wing length 25 mm); resembles a large Common Crane Fly **(389)** but has four equally sized wings; tarsi hook around objects when they perch; a pale green spot near the tip of each wing.
HABIT: This is the only California mecopteran that could be considered common. Large numbers sometimes appear on grassy hillsides in spring. Predaceous on various small insects that they capture in flight with their raptorial hind tarsi.
RANGE: Southern Sierra Nevada, foothills.

GOLD RUSH HANGING SCORPIONFLY *Orobittacus obscurus*

Another special member of this family restricted to the state is the Gold Rush Hanging Scorpionfly.

ADULT: BL 14–16 mm; black to blackish brown, head with plum-colored eyes; legs vary from yellowish brown to brown, with tarsi dark brown near the tips; wings yellowish brown with diffuse gray region along veins.

HABIT: Adults roost during the day in deeply shaded sheltered areas with high humidity. This species is formally listed as critically imperiled in the state.

RANGE: Known only from a couple localities on the western slopes of the central Sierra Nevada.

Snow Scorpionflies (Family Boreidae)

▶ **497. CALIFORNIA SNOW SCORPIONFLY** *Boreus californicus*

ADULT: Small (BL 4.5 mm); black, male wings only about half as long as the abdomen; female wingless.

HABIT: Appears in winter and early spring (even seen running on the surface of snow) in the moist boreal zone, where it feeds on mosses.

RANGE: Mountain ranges of northern California, south to Nevada County.

DESERT SCORPIONFLY *Boreus notoperates*

ADULT: Very small (BL 3–4 mm); shiny black with a slight bronze or green glint; legs somewhat paler, otherwise similar in structure to the California Snow Scorpionfly.

RANGE: Inhabits a considerably arid life zone, restricted to chaparral and yellow pine regions of Mount San Jacinto.

Caddisflies (Order Trichoptera)

Trichoptera is the evolutionary sister group of the Lepidoptera, though the latter is far more diverse in species and ecology. The common name for the group, "caddisworm," has a curious origin. It is thought to have come from 15th- or 16th-century England, where "cadise" or "caddyss" referred to cotton or silk. Itinerant vendors of yarn, braid, and ribbon wore bits of their wares stuck to their coats as an advertisement and were called "cadise men." It seems likely that anglers applied the term "cadiseworm" to the larvae that form cases covered with bits of debris. Trichoptera enjoy an unusually high profile beyond the scientific community

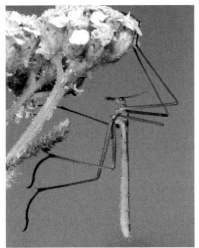

495. Wingless Scorpionfly
(*Apterobittacus apterus*).

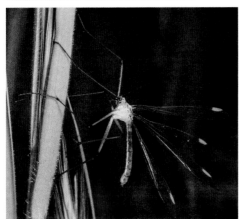

496. Green Stigma
(*Bittacus chlorostigma*).

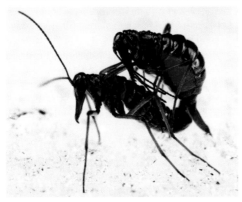

497. California Snow
Scorpionfly
(*Boreus californicus*)
female top, male bottom.

because the adults, and especially the larvae, are important food for fish, making them popular models for fly-fishing.

The adult caddisflies **(498–505)** are mothlike insects with long, thread-like antennae. Their wings are membranous, narrow or broad, with many veins, covered with hairs, and held rooflike over the body when at rest. The mouthparts of the adults usually are reduced and are used to absorb water and nectar, possibly prolonging their lives and increasing their fecundity. However, many species are short-lived as adults and probably do not feed, relying on energy stored as larvae to fuel reproduction. Most species are nocturnal, with muted gray to brown wings, and are inconspicuous, with a quick, shadowlike flight; they are often attracted to lights, sometimes in great numbers. Some of the larger species are more charismatic with reddish-brown to orange coloration. Most naturalists and anglers are more familiar with the aquatic larvae, many of which form tubular cases that they carry on their backs as portable housing, and in which they pupate.

The eggs are deposited in ponds or streams or on their vegetated margins, and the larvae ("caddisworms") live entirely under water. Breathing is accomplished by filament gills on the abdomen or simple cuticular transpiration. They have well-developed heads, spin silk, and have biting mandibles, allowing the group to evolve a wide variety of feeding strategies. The legs are caterpillar-like but the abdomen lacks the false abdominal legs typical of caterpillars, and the adults lack the scales of Lepidoptera. The larvae **(506–516)** of nearly all caddisflies form cases made of silk, to which plant fragments, pebbles, or other objects are attached in a systematic manner. About one-third of the species spin stationary silken or gravel-covered retreats that they use to ensnare food from the water column, while most of the other species are free-living and make complex, portable cases that they carry as they forage.

Usually the cases are tubular, open at both ends, with the anterior end larger, and the head and legs protrude as the larvae walk or feed. The form and materials used in case construction are often diagnostic of particular genera or families. Larvae living in stationary cases are opportunistic feeders consuming plant and animal material caught in their silken snares; those that drag their cases with them usually graze on decaying organic matter. At lower elevations, adults can be found during much of the year, and larvae are present year-round and can even be fished from snow-covered streams in midwinter as long as water is flowing beneath the ice. Development times usually depend on water temperature and can range from a few weeks to a few years, depending on the species and environmental conditions.

Trichoptera make up a diverse and important component of the aquatic insect fauna, having about 15,000 described species globally—more than any of the other primarily aquatic orders of insects, second

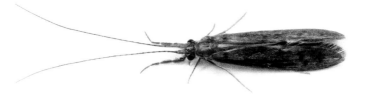

498. Variable Homemaker Caddisworm (*Oecetis* sp.).

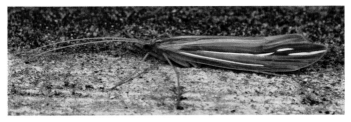

499. Silver-striped Caddisfly (*Psychoglypha bella*).

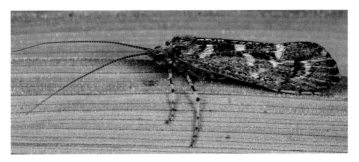

500. Speckled Northern Caddisfly (*Lenarchus rillus*).

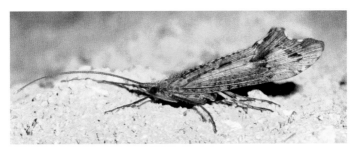

501. Autumn Sedge (*Neophylax* sp.).

only to Diptera in the aquatic realm. There are more than 1,500 species recorded in America north of Mexico and over 300 species in California, belonging to 14 families. One particularly interesting family that often escapes notice is Hydroptilidae, the microcaddisflies. Although it is the most diverse family in the order (with over 2,000 species), as the common name suggests, adults are very small (less than 5 mm). The tiny, hairy adults are occasionally abundant at lights; their larvae are free-living during all but their final larval stages; they occur widely in the state.

Long-horned Caddisflies (Family Leptoceridae)

Leptocerids are common in ponds and lakes, especially in warmer parts of the state, although they are not a dominant group in California. The adults range from black to white, are slender, and possess exceptionally long antennae. The larvae build cases that are usually tubular and slender and covered with fine sand, pebbles, or plant parts. Leptocerids live in permanent, warmer waters, including still ponds and slow-moving rivers. The larvae are distinguished by the relatively long antennae, protruding beyond the front of the head, and by hind legs that are much longer than the others. Abdominal gills are simple and often few in number. Leptocerids of most genera are indiscriminate feeders, but some rely on freshwater sponges. Of the more than 2,000 species described globally, only about a dozen are known in the state.

◄ **498. VARIABLE HOMEMAKER CADDISWORMS** *Oecetis* **spp.**
ADULT: BL 8–13 mm to tips of wings; narrow brown or orange wings and very long antennae, twice the wing length.
LARVA: Predaceous; distinguished by having long maxillary palpi and single-blade mandibles; unbranched gills on all but the last two abdominal segments.
CASE: Length to 15 mm; variable; some species use short lengths of transversely, and crudely, placed stems closely resembling a log cabin while others use tightly packed sand grains, sometimes combined with detritus.
RANGE: Widespread, including the Central Valley and urban areas.

▶ **506. CASA VERDE CADDISWORM** *Triaenodes tardus*
ADULT: BL 9–13 mm to tips of wings; orange-ochre with wavy darker brown pattern in fresh specimens; fades to pale orange quickly. Antennae much longer than body, palps prominent; noticeably scaly in appearance, resembling another pair of legs.
LARVA: Scavenging herbivore; hind legs prominent and long with pronounced "hairs" used for swimming between clumps of vegetation, even

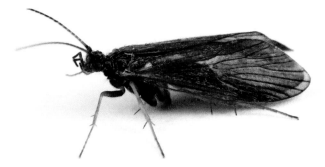

502. Green Sedge (*Rhyacophila oreta*).

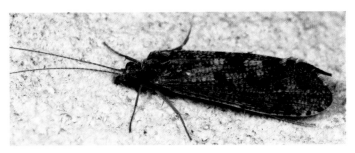

503. Common Web-spinning Caddisfly (*Hydropsyche occidentalis*).

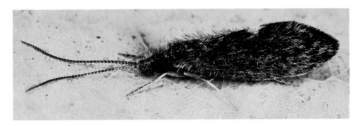

504. Bizarre Caddisfly (*Lepidostoma* sp.).

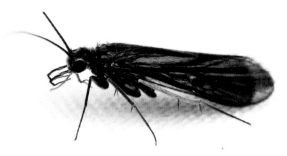

505. Charcoal Darter (*Chimarra* sp.).

while carrying a case more than twice the weight of the larva. Abdominal gills simple.

CASE: Remarkably green, made of spiraling rows of precisely cut, lightweight bits of green plant material.

RANGE: Widespread in still and slow-moving water, throughout much of the state.

Humpless Casemaker Caddisflies (Family Brachycentridae)

▶ **507. GRANNOM CADDISFLIES** *Brachycentrus* **spp.**

ADULT: BL 8–14 mm. Wings somewhat translucent with wing veins conspicuously outlined in black with variable light and dark brown patterns. Body can be green; head and abdomen usually dark, or light brown. Antennae about same length or shorter than body.

LARVA: Filter feeders, often green-tinged body with variably colored head.

CASE: Remarkably precise, chimney- or obelisk-shaped cases, covered with short, equal lengths of tightly packed and finely crafted stems placed transversely; much smoother and more symmetrical case than in species of *Oecetis*.

HABIT: This genus is well-known to anglers since the mass emergence of adults in spring elicits a feeding frenzy in resident trout, who particularly relish gobbling the pupae as they float to the surface. Larvae use specialized hairs on their legs to filter feed on drifting detritus and invertebrates that they snag from the water column.

RANGE: Flowing water in much of the state, absent from the lower, warmest regions of southern California.

Snailshell Caddisflies (Family Helicopsychidae)

▶ **508. NORTHERN SNAILSHELL CADDISFLY** *Helicopsyche borealis*

This species is the most common representative of its family in California; it is widespread and at times abundant in clear streams and at margins of lakes. It has an exceptionally broad temperature tolerance, occurring even in streams with thermal effluents (to 34 degrees C) where no other Trichoptera are found.

ADULT: Small (BL 5–8 mm to tips of wings), frail; females larger and darker than males; brownish gray without wing pattern; antennae about as long as fore wing.

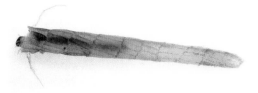

506. Casa Verde Caddisworm (*Triaenodes tardus*) larva in case.

507. Grannom Caddisfly (*Brachycentrus americanus*) larva in case.

508. Northern Snailshell Caddisfly (*Helicopsyche* sp.) larval case.

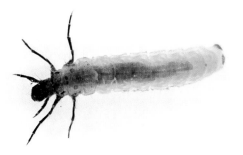

509. Silver-striped Caddisfly (*Psychoglypha* sp.) larva removed from case.

510. Silver-striped Caddisfly (*Psychoglypha* sp.) larval case.

LARVA: Spiral-shaped with long legs; sparse gills on abdominal segments 1–5; anal segment with comblike claws. Larvae are "grazers," scraping their food from the substrate.

CASE: Snailshell-shaped, made of closely fitted rock fragments and small pebbles.

HABIT: Larva is a general feeder, grazing on algae, diatoms, detritus, or animal matter. Case structure may resist crushing or be hydrodynamic. So remarkable is the resemblance of the cases to snail shells that in 1834 this species was originally described as a snail, apparently thought to have the (dubious) ability of strengthening its shell by gluing on particles of sand.

RANGE: Widespread in coastal areas, foothills, and mountains to moderate elevations; in a wide variety of water bodies both moving and still.

Colorful Caddisflies (Family Limnephilidae)

The family Limnephilidae is quite ecologically diverse and contains many of the most conspicuous and largest caddisflies in California, occupying a wide range of water bodies from temporal ponds to mountain streams. Adults are often large (BL 7–30 mm to tips of wings), and some are orange or reddish brown, sometimes with well-defined wing markings. The larvae live in a variety of habitats and can be diagnosed by having the base of the antennae located halfway between the eye and the base of the mandible. Generally, those living in cool mountain streams build cases covered with rock fragments, while those in still, especially warmer, waters use plant material. Plant tissues are the principal food, although in some genera fungi growing on dead plant matter is the primary attraction, and decaying fish or other animal matter is sometimes eaten. Other limnephilids scrape algae or other organic particles from rock surfaces. More than 40 species have been recorded in California.

◀ **499, 509–510. SILVER-STRIPED
CADDISFLIES** *Psychoglypha* **spp.**

ADULT: (499) BL up to 25 mm to wing tips; fore wing deep reddish orange or rust-colored, typically with two longitudinal silvery-white streaks bordered with a dark brown stripe, the central stripe splits toward the wing tip. In some species only the central stripe is present. Wings with very few hairs near the base and along the top when folded.

LARVA: (509) Large (BL to 30 mm); robust with (usually) brown head and thoracic plates well-sclerotized, lateral humps on first abdominal segment with several small sclerites, visible when larva is active. Single abdominal gills.

CASE: (510) Cases change from using redwood or Douglas Fir needles in early stages to incorporating pieces of bark, small pieces of gravel, and relatively large sticks, sometimes awkwardly placed, for larger larvae.

HABIT: Fly in winter and early spring at middle or low elevations. Some species also fly in the Sierra Nevada in the early fall.

RANGE: Widespread in the state.

SILVER-STRIPED SEDGES *Hesperophylax* spp.

Species of a this genus are very similar to those in *Psychoglypha*, sharing the coloration scheme but with only one longitudinal silver streak across the fore wings that tend to be lighter rust or golden red–colored and pubescent near the base and along the top when folded.

ADULT: Elongate (BL 17–27 mm to tips of wings); fore wing orange or rust-colored with a longitudinal silvery streak that splits toward the wing tip; abdomen often greenish.

LARVA: Large (BL to 33 mm); rather stout with dark plates on the first two thoracic segments and with gills having more than four branches on both dorsum and venter of most abdominal segments.

CASE: Cylindrical, usually entirely covered with irregularly sized rock fragments, sometimes incorporating small pieces of wood, in streams and at high elevations in still, cold water.

HABIT: Adults are often seen along mountain stream margins or lingering around lights. While not a very diverse genus (six species, five restricted to the western United States), their size and beauty often render them more conspicuous and admired than their relatives.

RANGE: Occurs at middle to high elevations in late spring and summer in the Transverse Ranges, the Sierra Nevada, and the Cascade Range.

RETICULATED CADDISFLIES *Limnephilus* spp.

Species in this genus make up a large element of the state's Trichoptera fauna, with more than a dozen species in a wide range of habitats.

ADULT: BL 10–15 mm; most are smaller than species of *Psychoglypha* and are dark rust-colored or orange-brown, often with delicate, lacelike, darker patterns.

LARVA: Primarily live in ponds, lakes, and marshes and build cases of sand grains, pebbles, bark, or wood chips and leaves, arranged lengthwise or transversely. They feed mainly on detritus.

RANGE: Widespread in foothills and mountains.

◀ 500. SPECKLED NORTHERN CADDISFLIES *Lenarchus* spp.

ADULT: Large (BL 18–24 mm): fore wing background color from gold to beige with irregular small white patches and extensive black mottling, often becoming mostly mottled toward the tip of wing.

LARVA: Somewhat elongate, dark plates on first two thoracic segments, gills with multiple fine branches.

CASE: Somewhat flimsy in appearance, made from bits of vegetative debris.

HABIT: Frequently attracted to lights in summer.

RANGE: Foothills to mid-elevations of the Coast Ranges and the Sierra Nevada.

Autumn Sedge Caddisflies
(Family Thremmatidae)

◄ 501, 511. ► AUTUMN SEDGES *Neophylax* spp.

These little caddisflies are typically on the wing quite late in fall at mid- and lower elevations *(N. rickeri* and *N. splendens)*, though there are some summer-flying species in higher mountain regions *(N. occidentalis)*. The larvae often attract notice for their peculiar cases.

ADULT: (501) Small (BL 5–8 mm), peppered gray, brown, and black with short, angular fore wings, having a distinctive inward scoop near the wing tip.

LARVA: Elongate light brown head with two broad longitudinal black stripes.

CASE: (511) Sand and, for their size, unusually large pebbles are used as ballast in the construction of the domiciles, giving the larvae an unusually comical "toddler" gait as they wander. Often attached to rocks.

HABIT: Adults often found sheltering in shady, cool moist areas along streams.

RANGE: In fast-flowing streams, throughout coastal and montane areas of northern and central California.

Free-living Caddisflies
(Family Rhyacophilidae)

Rhyacophilids are important occupants of cool, fast-moving streams and rivers. The larvae do not construct a portable case or fixed retreat, and they crawl actively over rocks in search of food. Most are predators, although a few eat living or dead plant tissue. At maturity a crude pupal shelter of small stones is constructed on or between rocks. The adults are inconspicuous, small to medium-sized, usually dark brown. About 50 species occur in California.

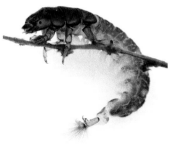

511. Autumn Sedge
(*Neophylax* sp.) larval cases.

512. Common Web-spinning Caddisfly
(*Hydropsyche* sp.) larva.

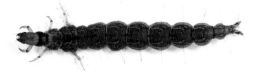

513. Green Sedge
(*Rhyacophila* sp.) larva.

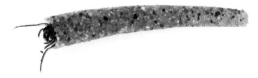

514. Desert Grayling
(*Gumaga* sp.) larva in
case.

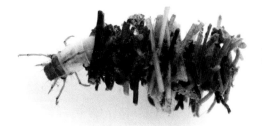

515. Bizarre Caddisfly
(*Lepidostoma* sp.) larva
in case.

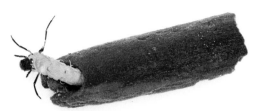

516. California Miner
(*Heteroplectron
californicum*) larva
in case.

FREE-LIVING CADDISFLIES *Rhyacophila* **spp.**

ADULT: (502) BL 9–17 mm; usually dark brown or reddish brown, broad winged without conspicuous markings, occasionally spotted with brown or gray.

LARVA: (513) Variable in form, body with rather strongly hardened integument, usually without filamentous gills on the abdomen but gills present in some species; legs strong and widely spaced, anal prolegs each with a strong, curved hook and sometimes an accessory, lateral, curved spike to assist in locomotion.

CASE: Only constructed as a cocoon for pupation.

RANGE: Valleys and foothills around the major rivers and in larger mountain streams throughout the state, including urban areas. One very rare species in the genus, the Spiny Rhyachophilan Caddisfly *(R. spinata)* is formally listed as imperiled by the state and is thought to be vulnerable to extinction. Males are tawny-colored with light markings on apical margin. Females are dark brown with the abdomen purplish brown dorsally. The larva of this species remains unknown, and the adults are known only from a few counties in the central Sierra Nevada.

Web-spinning Caddisflies (Family Hydropsychidae)

Members of the family Hydropsychidae are often abundant in California. The adults swarm to lights in great numbers at mountain localities near streams. Hydropsychid larvae are best known for the elaborate silken nets they spin around their shelters to strain their food from flowing water while they rest in safety; they lie in wait at the edge of the net and devour small aquatic insects, algae, or detritus gleaned from their nets in varying proportions at different seasons. The larvae live in tube-shaped retreats firmly attached inside crevices or camouflaged by plant fragments. Structurally, hydropsychid larvae are distinguished by having large, dark, dorsal plates on the thoracic segments and branched gills on the underside of all but the first body segment. About 25 species occur in California. Most are small (BL 10–15 mm).

◄ 503, 512. COMMON WEB-SPINNING
CADDISFLIES *Hydropsyche* **spp.**

Often locally extremely abundant. Only about eight species occur in California.

ADULT: (503) Medium-sized (BL 9–15 mm to tips of wings); brown with dull markings of darker brown and whitish; antennae shorter than the wings.

LARVA: (512) BL to 16 mm; thoracic plates dark, dorsum of abdominal segments also dark-patterned; prominent, frilly gills.

CASE: In fixed retreats built of plant fragments and other debris, with a spreading, taut, capture net at the entrance.

RANGE: Fast-flowing streams across low-elevation valleys and foothills to mid-elevations in mountainous parts of the state.

Bushtailed Caddisflies (Family Sericostomatidae)

◄ 514. DESERT GRAYLINGS *Gumaga* **spp.**

ADULT: Small (BL 10–15 mm); gray with dense coat of gray hairs; antennae approximately as long as body.

LARVA: Head striped; third legs elongated.

CASE: Made of fine grains of sand tightly woven into a remarkably smooth tube.

RANGE: Can be abundant in streams across the drier parts of southern California, including foothills and deserts.

Brown Sedges (Family Lepidostomatidae)

This family has developed the most dramatic sexual dimorphism of any family of Trichoptera. The males of various genera exhibit bizarre secondary structures, particularly on their antennae, maxillary palps, and wings, which have evolved to entice the females of their species.

◄ 504, 515. BIZARRE CADDISFLIES *Lepidostoma* **spp.**

ADULT: (504) Small (BL 6–10 mm); antennae usually about 1.5 times wing length, the first segment sometimes dramatically swollen, prominently hairy; wings variable, dark brown to ochre colors with prominent long hairs across head, thorax, and wings, along veins.

LARVA: (515) Light brown head and thorax without prominent markings, legs all similar in length.

CASE: Highly variable, ranging from fairly smooth, four-sided, elegant "chimney" cases made from an appealing patchwork of multicolored sand and debris to others with a complicated, messy jumble of debris, grit, and bits of irregularly sized stems assembled at odd angles such that the structure of the actual case is well hidden in the morass.

RANGE: Flowing water throughout coastal and montane regions to mid-elevations.

Family Calamoceratidae

This family is not very diverse (fewer than 200 species globally), with only a handful of genera and only a single genus and species in California, although that species is fairly widespread in the northern two-thirds of the state. The California species' larvae have one of the most peculiar case-making habits; rather than assemble a case from scratch, they chew a tube out of a stem or piece of wood and use that as a case. In rare instances, they appropriate the cases of other caddisflies, redecorating the outside a little to make it their own.

◀ **516. CALIFORNIA MINER** *Heteroplectron californicum*
ADULT: Small (BL 9–15 mm); antennae about 1.5 times body length yellow-brown with black stripes; wings rich dark brown with yellow flecks, not especially hairy; head and thorax with yellow-brown hairs; legs yellow.
LARVA: Head and thorax uniformly dark brown; legs roughly equal length.
CASE: Bits of stem or wood left intact save for that a shaft has been "mined" or hollowed out, case often decorated with additional bits of wood or grains of sand.
HABIT: Occasionally the larvae take over the case of another species of caddisfly; the fate of the original occupant is unclear but may not have been pleasant.
RANGE: Cool streams from at least Fresno County and Big Sur region northward, including the Coast Ranges and the Sierra Nevada foothills.

Fingernet Caddisflies (Family Philopotamidae)

The larvae in this diverse family (more than 1,000 species globally) of small caddisflies generally inhabit streams where they spin narrow nets of silk to capture prey. The larvae of a few species can withstand completely dry periods in summer and fall by aestivating. In California the adults are small and black. Although the genus *Chimarra* is globally distributed and the second most diverse in all of Trichoptera, with more than 800 species, California only hosts a handful. However, the species that do occur in the state can be abundant in the right habitats.

◀ **505. CHARCOAL DARTERS** *Chimarra* spp.
There are at least eight species in the state and probably others that remain to be discovered.
ADULT: Small (BL 6–8 mm); uniformly dark brown to charcoal black, except for hind legs that can be light gray. Maxillary palps notably long, thin, and flexible, often held curled back toward the body.

LARVA: Light brown head and thorax with well-developed mandibles and small eyes. Body often distinctively yellow or orange, making them popular models for fly-fishing ties.

CASE: Instead of a case, the larvae spin long, narrow, and very fine meshed nets of silk to capture edible morsels from the current.

HABIT: The small, dark-colored, and fast-flying adults are difficult to see during the day as they dart along stream banks, but they are readily attracted to lights at night; the larvae can be very numerous, especially in warmer streams.

RANGE: Throughout much of the state from the humid North Coast to the southern deserts, including desert streams where they can be remarkably numerous.

Moths and Butterflies (Order Lepidoptera)

Lepidoptera are among the most familiar and easily recognized of all insects because of the conspicuousness, large size, and bright colors of many species. Distinguishing characteristics are two pairs of wings, usually dissimilar in shape but structurally similar, the wings and body covered with broad, modified hairs (scales) laid down shingle fashion, and a long, coiled proboscis used for sucking fluids.

Moths are less familiar to the general public than butterflies but are far greater in species numbers and diversity of structural modifications and behavioral adaptations. In California about 240 species of butterflies are recorded, representing all six North American families of this group. By contrast, no one knows how many kinds of moths occur in the state (many of the smaller ones are not yet described), but there are more than 3,000 species, which represent four suborders and about 50 families. The metamorphosis is complete; all growth takes place in the larval stage (commonly called caterpillars), and the pupae may occur inside silken cocoons (most moths). Adult butterflies and moths may be short- or long-lived, but no change in size or form occurs once they become mature. The adults feed on nectar and other plant secretions, rotting substances, honeydew, or water, although a few species have atrophied mouthparts and do not require nourishment as adults. The larvae possess strong, chewing mouthparts and feed on a great diversity of substances. Caterpillars of butterflies and most moths eat living vascular plants. Certain moth groups feed in such diverse substances as wood-rot fungi; animal matter including wool, feathers, fur, and bee's wax; fallen leaves; or lichen.

Many species are general scavengers, and a few are predators in colonies of other insects. Among the plant feeders, certain species show a

pronounced specialization, while others eat a vast array of plants. Lepidoptera are of great economic importance to humans because of the larval feeding. Economically important species include the Corn Earworm and other cutworms, tent caterpillars, the Mediterranean Flour Moth and other pests of stored foods, lawn moths, the Codling Moth (which causes the "worms" in apples), Spruce Budworm and other defoliators in coniferous forests, clothes moths, and many others.

Lepidoptera have also become a conservation concern. The decline in Monarch butterfly populations has captured media attention, but there are many other Lepidoptera that are also in decline, and only a small fraction of these are federally protected under the Endangered Species Act. While most species are not specific pollinators, there are others, including the Yucca Moth, without which their plant hosts would surely disappear. These declines are almost always associated with loss of habitat and host plants due to human activities.

Butterflies are day-fliers (although occasionally individuals are attracted to lights at night) and are most easily distinguished from moths by having an enlarged club at the end of each antenna. Moths have thread-like, sawtoothed, or feathery antennae without apical clubs. Most are nocturnal, although some species fly in the daytime and are brightly colored. Butterflies have no attachment between the wings, which merely overlap, aided by the enlarged basal area of the hind wing. In most moths the wings are attached to each other by a bristle or group of bristles (frenulum) at the base of the hind wing. The frenulum hooks under a flap or tuft of scales (retinaculum) on the underside of the fore wing. Often the sexes are distinguished by the form of the frenulum, which consists of separated bristles in females. The bristles are fused into a single, bristle-like hook in males.

Superfamily Incurvarioidea

Members of the superfamily Incurvarioidea are usually day-flying, small moths, which are distinguished from nearly all other Lepidoptera by having the ovipositor modified for piercing. The females insert the eggs into plant tissue, usually leaves or newly developing seeds, where larval feeding occurs, at least in the early stages.

Family Adelidae

▶ **517–518. LONGHORN MOTHS** *Adela* **spp.**
Species of this genus are among California's commonest day-flying moths in spring. They are named for their long antennae, which are usually longer in the males than females.

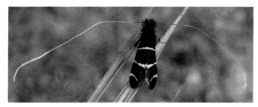

517. Three-striped Longhorn (*Adela trigrapha*) male.

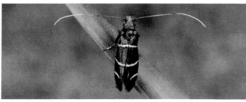

518. Three-striped Longhorn (*Adela trigrapha*) female.

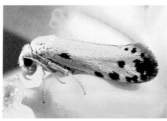

519. Yucca Moth (*Tegeticula maculata*).

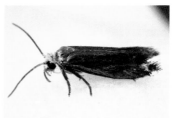

520. Bogus Yucca Moth (*Prodoxus* sp.).

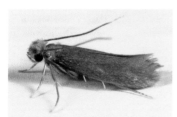

521. Webbing Clothes Moth (*Tineola bisselliella*) adult.

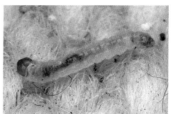

522. Webbing Clothes Moth (*Tineola bisselliella*) larva.

523. Skin Miner (*Marmara arbutiella*) leaf mines.

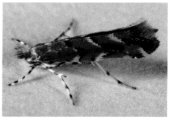

524. Live Oak Leaf Blotchminer (*Cameraria agrifoliella*).

◄ 517–518. THREE-STRIPED LONGHORN *Adela trigrapha*

ADULT: Male **(517)** black with three white stripes across the fore wing; large eyes nearly covering the top of the head; greatly elongate (15–20 mm), white antennae. Female **(518)** fore wing metallic bronzy-blue with yellowish-white stripes; hind wing purplish, head scaling bright orange; smaller eyes; shorter antennae (7–10 mm). BL 5–8 mm to tips of wings.

LARVA: At first in flowers of True and False Babystars (*Linanthus bicolor*, *L. androsaceus*); later in a flat, brown case on the ground, feeding on dead leaves.

HABIT: California's most common species. Male *Adela* are often seen dancing in small swarms above flowery meadows. Both sexes visit blossoms of the sunflower family and other plants for nectar, but females of each species select a particular kind of plant to oviposit in the buds.

RANGE: Coast Ranges up to 1,200 m elevation, the Central Valley, and the Sierra Nevada foothills up to 600 m. Less common in southern California.

A related species, the Flame Longhorn *(A. flammeusella)*, has a bronze-colored fore wing, tinged with deep burnished red in some populations; the hind wing is metallic purple. It is abundant in the same areas as *A. trigrapha* but selects Owl's Clover *(Castilleja)* for depositing the eggs.

Family Prodoxidae

◄ 519. YUCCA MOTHS *Tegeticula* spp.

Females of this genus are distinguished from all other Lepidoptera by having the mouthparts adapted for carrying a ball of yucca pollen. The **California Yucca Moth** *(T. maculata)* **(519)** is our most widespread species.

ADULT: Rather stout with the wings scarcely exceeding the tip of the abdomen in the female (BL 8–12 mm to tips of wings); white with black specks on the fore wing in the Transverse Ranges and northward, entirely black in the San Bernardino Mountains and southward.

LARVA: White becoming bright pink or green tinged with pink when mature; in green fruit of Chaparral Yucca *(Hesperoyucca whipplei)*, leaving in fall to form cocoons in the ground.

HABIT: After oviposition into seed-bearing parts of the yucca flower, the moths in this genus move to the flower's stigma and deposit the pollen. The larvae will eat only a portion of the seeds in each fruit establishing a complete mutual dependence (symbiosis): the moths are the only pollinators for yucca, and the plant provides the only food used by *Tegeticula* larvae.

RANGE: Monterey County southward and the Sierra Nevada from Tulare County southward, wherever the Chaparral Yucca occurs in natural populations.

Two related species are also exclusive pollinators: the Joshua Tree Yucca Moth *(T. paradoxa)*, a flat, dark gray, sawfly-resembling species on *Yucca brevifolia,* and the Mojave Yucca Moth *(T. mojavella)*, a larger, white species on Mohave Yucca *(Y. schidigera).*

◀ **520. BOGUS YUCCA MOTHS** *Prodoxus* **spp.**

ADULT: Tiny (BL 4–8 mm to tips of wings); bronze, gray, or white, sometimes with dark spots.

LARVA: White or pale green, legless grubs tunneling in seed capsules or main flowering stalks of yucca.

HABIT: Adults found rapidly scurrying about in yucca flowers. Larvae overwinter in yucca seed capsules, and the fully fed larvae can prolong their diapause in unfavorable years; recorded development and emergence has occurred after dormancy of 15, 20, 25, and 30 years. Several species of this genus occur in California, each adapted to larval feeding on a particular portion of a yucca's flowering parts but not in the seeds. The female moths have no modification for carrying pollen, and their relationship appears to be parasitic with the host.

RANGE: Coast Ranges and deserts, wherever yucca occurs.

Family Tineidae

Tineids are an early branch in the evolutionary tree of Ditrysia, the major derived branch of Lepidoptera, and do not feed on living plants. Most feed during the larval stage either on living wood-rot fungi, as scavengers in rotting wood, or on fur and feathers in animal nests such as rodent burrows. A few species have adapted to woolens and other processed animal products, and these are among the most notorious, and least popular, of all Lepidoptera.

◀ **521–522. WEBBING CLOTHES MOTH** *Tineola bisselliella*

ADULT: (521) Small (BL 5–7 mm to tips of wings); shining golden tan with a roughened tuft of red-brown scales on the head.

LARVA: (522) Elongate, white with a brown head; living in silken tunnels webbed together with bits of material from what they feed on. All kinds of fur and wool-containing products are eaten, including clothes, carpet pads, animal skins, and rabbit-foot charms, even the cover of a neglected tennis ball.

HABIT: Unlike most moths, this and related species are not usually attracted to lights. They retire to dark places so their presence is often unnoticed until larval damage is severe.

RANGE: Domestic situations. Originally from western Eurasia.

Family Gracillariidae

Larvae of the family Gracillariidae are leaf miners, at least during early stages. The caterpillars feed entirely within one leaf, excavating shallow blotches or linear galleries usually just beneath either the upper or lower leaf epidermis. The form of mine is characteristic for each gracillariid, and most species are restricted in choice to one or a few related plants. There are more than 80 species recorded in California, and undoubtedly many more remain to be discovered.

◄ 523. SKIN MINERS *Marmara* spp.

ADULT: Tiny (BL 2–3 mm); black with thin white stripes across the fore wing.

LARVA: Flat, pale red, in elongate, winding mines just under the skin of leaves, stems, or fruit. The mines appear white and persist long after the larvae have abandoned them to form cocoons covered with frothy, silken bubbles. The Madrone Skin Miner *(M. arbutiella)* **(523)** mines the leaves and stems of Madrone *(Arbutus menziesii)* in early spring. Other species make similar mines on prickly pear cactus *(Opuntia)*, bark of roses and berries, or in peels of oranges and apples.

RANGE: The genus is widespread, but particular species may be much more restricted.

◄ 524. LIVE OAK LEAF BLOTCHMINER *Cameraria agrifoliella*

The large, irregular, pale blotch mines on the upper side of Coast Live Oak leaves *(Quercus agrifolia)* are often noticeable, especially in urban situations where new growth is produced during late spring and summer.

ADULT: Small (BL 2.5–5 mm to tips of wings); golden orange; fore wing marked with white

LARVA: Flat, pale green, pupating in the mine; the pupa protrudes through the roof of the mine when the moth is ready to emerge.

HABIT: Adults perch in a characteristic head-downward posture, with the tail end protruding upward.

RANGE: Coastal valleys from southern Mendocino County to San Diego County. This name has been applied to *Cameraria* that are associated with several other species of oak, but these probably will be described as separate species.

Family Scythrididae

The family Scythrididae includes a large number of small moths that are teardrop-shaped when perched. Many species are day-flying, often black or bronze-colored, and visit flowers for nectar. Others are nocturnal, usually gray, white, or yellowish-white species that are attracted to lights. Many scythrids have the peculiar ability to postpone death in cyanide killing jars far longer than other insects. The larvae normally are slender, often somewhat colorful caterpillars that live externally in slight webs on various plants. Probably there are more than 100 species in California, but most remain to be discovered.

▶ **525. SAND-DUNE GRASSHOPPER MOTH** *Areniscythris brachypteris*

This is one of the most remarkable moths in our fauna.

ADULT: Small (BL 4–7 mm); sand-colored, with short wings, fore wing nearly reaching the end of the abdomen in the male, shorter in female.

LARVA: Extremely slender with very short legs, white with paired somewhat purple spots along the dorsum; living in sand-covered, silken tubes attached to stems or leaves of various plants just below the surface of active, moving sand dunes.

HABIT: Adults are flightless in both sexes and run on open sand dunes like miniature lizards. They are able to hop or leap 20–30 times their own length by means of enlarged hind legs. At night each individual buries itself in a pit dug by alternate swimming-motions of the hind and fore legs.

RANGE: Coastal dunes in the Pismo Beach–Vandenburg area.

Family Oecophoridae

Oecophorids are mostly broad-winged, small nocturnal moths that have a flat appearance when the wings are folded. The family contains species of diverse appearances and habits. The caterpillars of many species feed on living plants, especially of the parsley family, while others are scavengers, living in decaying plant material and sometimes in stored food products. More than 40 species are known in California, many of which are seldom seen because they are not readily attracted to lights.

▶ **526. SULPHUR TUBIC** *Esperia sulphurella*

ADULT: Small (BL 6–8 mm); slender, fore wing lustrous black with two prominent latitudinal yellow stripes and a yellow diamond two-thirds of the way down the fore wings when folded and abundant minute yellow streaking.

LARVA: Elongate, black, feeding in detritus under bark of fallen oaks.

HABIT: Adults are day-flying from late February through April. Often seen in rural areas near fallen limbs of oak or in stored firewood in urban areas.

RANGE: Introduced from Europe and now found in middle to low elevations throughout coastal central California, including the San Francisco Bay Area.

Family Depressariidae

Depressariids are somewhat slender moths, usually with thin, strongly upcurved palps. About 70 species are known in California, many of which are day-fliers that are active in winter or early spring when nightly temperatures are too low for small-moth activity. Flight in January, February, or March enables use of annual plants of the borage (Boraginaceae) family on which the larvae are specific feeders. Several other species fly in late fall or winter in desert areas.

▶ **527. POISON HEMLOCK MOTH** *Agonopterix alstroemeriana*

ADULT: Small (BL 7.5–9.5 mm); fore wing broad with prominent fringe, cream-colored, peppered with black dots, and a large rusty brown–gray marking halfway down each wing; thorax with smaller brown dot.

LARVA: Bright green, leafroller only on Poison Hemlock *(Conium maculatum)* in late spring.

HABIT: Adults are occasionally attracted to light, although larvae may be much more common. Introduced from Europe to New York, where it was discovered in 1973. It suddenly became widespread in the West in the early 1980s and is now used as a biological control agent on the invasive weed, Poison Hemlock. Overwinters as an adult.

RANGE: Across northern California and coastal counties of southern California, where host plant occurs, likely still spreading.

▶ **528. YERBA SANTA
BIRD-DROPPING MOTH** *Ethmia arctostaphylella*

The inspiration for the Latin name for the moth was a mistake because the original collection was a cocoon found on manzanita *(Arctostaphylos)*, evidently made by a wandering larva.

ADULT: Medium-sized (BL 10–13 mm to tips of wings); slender, with variably gray fore wings having wavy, pale white inner margins; abdomen bright yellow. There are three or four generations each season; summer moths are paler in color.

LARVA: Green or mostly black with orange dorsal spots; in hammocklike webs on leaves of Yerba Santa *(Eriodictyon)*.

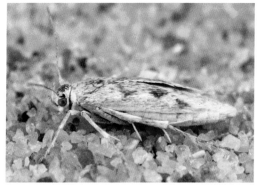

525. Sand-dune Grasshopper Moth (*Areniscythris brachypteris*).

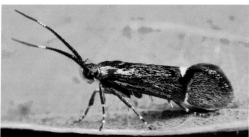

526. Sulphur Tubic (*Esperia sulphurella*).

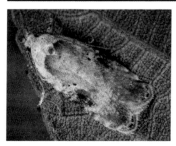

527. Poison Hemlock Moth (*Agonopterix alstroemeriana*).

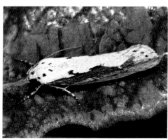

528. Yerba Santa Bird-dropping Moth (*Ethmia arctostaphylella*).

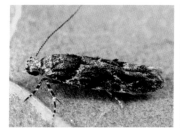

529. Oak Groundling (*Telphusa sedulitella*).

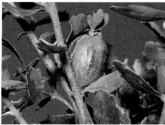

530. Gall Moth (*Gnorimoschema baccharisella*) gall.

HABIT: Adults characteristically perch along the midrib on upper sides of Yerba Santa leaves and resemble bird droppings.

RANGE: Foothill areas west of the Sierra Nevada, wherever Yerba Santa grows, particularly along roadsides.

Family Gelechiidae

The Gelechiidae is represented in California by at least 200 species in addition to many not yet described. These are mostly small moths characterized by narrow wings, strongly upcurved palpi, and the apex of the hind wing produced into an abruptly narrowed tip. Caterpillars of gelechiids feed on a great diversity of plants; various species specialize on leaves (including some leaf miners), seeds, twigs, or bark. A few are scavengers in dead leaves or abandoned insect galleries. Both adults and larvae of most species are extremely active, darting or rapidly wriggling away when disturbed. Nearly all gelechiids are nocturnal, and they are often attracted to lights.

◄ 529. OAK GROUNDLING *Telphusa sedulitella*

One of the longest-lived adult Lepidoptera in California.

ADULT: Small (BL 7–8 mm to tips of wings); fore wings black with upraised scale ridges, often with white markings forming a chevron on the back when the wings are folded.

LARVA: Bright green including the head, with large black hairs at the tail end; lives in rolls formed of newly developing leaves on various oaks.

HABIT: The moths are remarkable in that they emerge in the late spring and wait out summer, fall, and winter as adults, becoming active again in February. May be found in numbers on bark of oaks during summer, fall, winter, or in early spring before the trees have leafed out.

RANGE: Oak woodlands at low to moderate elevations throughout California.

◄ 530. GALL MOTHS *Gnorimoschema* spp.

A diverse genus with 20 species found in California that are a small part of the of 85 described species and many others that awaiting description.

ADULT: Small (BL 5.5–8 mm), slender moths, often gray or white with black markings.

LARVA: Small, pale, slender, with brown head. On Asteraceae. Many species are host-specific.

HABIT: Most *Gnorimoschema* cause plants to develop galls **(530)** in which the larvae feed. A wide variety of galls are made, each particular to a species, ranging from woody long-lasting features to temporary structures.

Species can often be identified by their galls alone, which are often far more noticeable than the adults.

RANGE: Widespread on a variety of Asteraceae from the coast to near 3,000 m, including deserts.

Family Plutellidae

▶ **531. DIAMONDBACK MOTH** *Plutella xylostella*

This species probably occurs in more habitats than any other Californian moth. Believed to have been introduced from Europe, the Diamondback Moth is found throughout the United States.

ADULT: Slender, small (BL 6–9 mm to tips of wings); fore wing brown or blackish, in male with white markings on the inner margin that join in the form of a diamond when the moth is at rest; pattern obscured in female.

LARVA: Slender, tapered toward both ends; pale green with yellow spots; skeletonizes or cuts holes through leaves.

HABIT: It feeds on a wide variety of weedy and cultivated plants of the mustard family, including cabbage, cauliflower, radishes, and the like.

RANGE: All of California at a wide range of elevations, from above 2,000 m on Mount Shasta and 3,000 m in the White Mountains to the deserts.

Plume Moths (Family Pterophoridae)

Pterophorids are called plume moths because the fore wings are deeply notched and the hind wings are divided into three linear parts, each with long scale fringes. When perched, the insects roll the fore wings around the folded hind wing plumes, resulting in a peculiar sticklike or cranefly-like appearance, unlike any other moth. Caterpillars of most plume moths are grublike, covered with short hairs, and colored to blend in remarkably with leaves on which they feed. A few species live as borers in bark or buds in the larval stage. More than 30 species are recorded in California; most are nocturnal and attracted to lights.

▶ **532. PLUME MOTHS** *Platyptilia* **spp.**

About 25 species of *Platyptilia* and one species of *Emmelina* live in California, each restricted in host choice to one or a few plants.

▶ 532. ARTICHOKE PLUME MOTH *Platyptilia carduidactylus*

ADULT: Wing expanse 16–26 mm, generally dark-colored; fore wing in most species with a dark triangular mark on the leading edge just inside the notch.

LARVA: Feed on various thistles.

RANGE: Throughout much of state where host plants grow.

WILLIAMS' PLUME MOTH *Platyptilia williamsi*

The similar-looking Williams' Plume Moth is dark brown with blackish-brown markings.

LARVA: Pale yellow or white with red bands.

HABIT: Found in flower heads of Seaside Daisy (*Erigeron glaucus*) and other plants of the sunflower family.

RANGE: Beaches and coastal bluffs from Humboldt to Monterey Counties.

MORNING GLORY PLUME MOTH *Emmelina monodactyla*

Belonging to another genus closely related to *Platyptilia* is a larger plume moth that is common around cities.

ADULT: Large for a plume moth (BL 10 mm; 23–27 mm wing expanse), very slender with long legs; fore wing ochreous tan to grayish-brown with a dark dot just inside the notch.

LARVA: Greenish, covered with short hairs.

HABIT: The caterpillars eat Bindweed (*Convolvulus arvensis*) and other plants of the morning glory family.

RANGE: Common around cities, but also found in rural areas of the coastal plain and inland valleys.

Clearwing Moths (Family Sesiidae)

Sesiids are called clearwing moths or wasp moths because most species have transparent wings, without a covering of scales, and have brightly colored bodies that mimic wasps and bees. They are day-flying and their mimicry has probably evolved through protection from vertebrate predators that learn to avoid stinging insects. Sesiid caterpillars bore into stems and roots or galls caused by other insects on plants. About 30 species are known in California, including many forms, colors, and sizes; our largest is the Manroot Borer *(Melittia gloriosa)*, which lives on manroot *(Marah)* and wild gourds in southern California and reaches 50–60 mm in wingspread, with the hind wing and immense leg brushes orange.

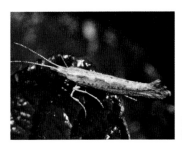

531. Diamondback Moth
(*Plutella xylostella*).

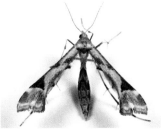

532. Artichoke Plume Moth
(*Platyptilia carduidactylus*).

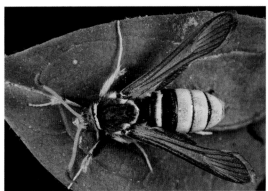

533. Locust Clearwing
(*Paranthrene robiniae*).

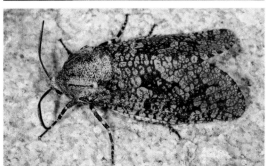

534. Carpenterworm
(*Prionoxystus robiniae*).

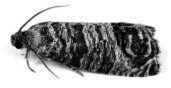

535. Codling Moth
(*Cydia pomonella*).

536. Apple Skinworm
(*Argyrotaenia franciscana*).

◀ 533. LOCUST CLEARWING *Paranthrene robiniae*

ADULT: BL 13–21 mm; bears a striking resemblance to the Golden Paper Wasp **(676)**, with opaque, ochreous, or brownish-red fore wing and clear hind wing; thorax black with a yellow hind border, abdomen yellow with broad, black bands on the basal three segments.

LARVA: Grublike, white with a red-brown head; in damaged and dying branches of willow, poplar, and locust trees.

RANGE: Warmer, low-elevation sites, including the Central Valley, east of the Sierra Nevada, and southern California.

Goat Moths (Family Cossidae)

Goat moths are moderately large, strong-flying, nocturnal moths. Their caterpillars bore in roots or trunks of woody plants. The adults are attracted to lights, and they often buzz around on their backs after landing, like clumsy beetles.

◀ 534. CARPENTERWORM *Prionoxystus robiniae*

ADULT: Large, bulky moth (BL to tips of wings 35–45 mm in females; 30–35 mm in males); fore wing gray, rather sparsely scaled, mottled with black; hind wing in male orange, margined with black. It flies in April, May, and June.

LARVA: Sluggish, grublike, large (BL up to 65 mm); pinkish with dark brown head.

HABIT: Larvae bore in trunks and crowns of Fremont Cottonwood (*Populus fremontii*) and other hardwood trees, including orchard trees; evidenced by large exudations of moist frass and sap, usually at the tree crown or at diseased spots. Larvae probably require two or three years to reach maturity.

RANGE: Warmer low-elevation regions of California, including coastal valleys, the Central Valley, and deserts.

Family Tortricidae

Tortricids are small to medium-sized moths, many of which have a rectangular or bell-shaped outline when the wings are folded. There are three subfamilies, the two with appreciable numbers of species are: the Olethreutinae, with about 250 species in California, and the Tortricinae, represented by about 75 species in the state. Larvae of nearly all olethreutines are borers in seeds, stems, or roots, and most are specialists in host-plant selection. Tortricine caterpillars live as leaf-rollers, and many are

indiscriminate feeders on a wide variety of plants. Most tortricids are nocturnal, but a few in each subfamily are day-fliers.

◄ 535. CODLING MOTH *Cydia pomonella*
One of the most notorious of all Lepidoptera, codling moth larvae are found in apples wherever they are not subject to control programs.
ADULT: Small (BL 9–11 mm to tips of wings); somewhat oval in outline when at rest; fore wing brown mottled with gray, with a darker blotch at the terminal end crossed by coppery-colored wavy lines.
LARVA: Pinkish, grublike with a brown head.
HABIT: The proverbial "worm" in the apple occurs in fruit and seed capsules of apple, quince, walnuts, and the like.
RANGE: Originally from Europe, it is distributed throughout urban and pome orchard districts of the state.

MEXICAN JUMPING BEAN MOTH *Cydia deshaisiana*
The Mexican Jumping Bean Moth is a related species whose larva inhabits the seeds of some native spurges in northern Mexico.
ADULT: Small (BL 9–11 mm to tips of wings), rather robust; fore wing rectangular dark brown, marked with bluish-gray lines.
LARVA: Grublike, stout with short legs; body whitish; head brown.
HABIT: After a period of activity in which the larva makes the seed "jump," which in nature evidently carries the seed to cracks or other secluded spots, the larva prepares a "trap door" for the moth's emergence and becomes quiescent before pupation. Roadside vendors in Mexican border towns often heat the seeds to make the larvae more active at the time of purchase, which usually kills them; but those packaged by American toy and novelty companies often successfully transform into moths.

◄ 536. APPLE SKINWORM
OR ORANGE TORTRIX *Argyrotaenia franciscana*
ADULT: Small (BL 7–11 mm to tips of wings); bell-shaped in outline when at rest; fore wing dark gray in winter to orange or tan in summer generations; male marked with variable, diagonal brown bands; female with a dark blotch on the inner margin; hind wing gray to white.
LARVA: Body bright green, head tan; in leaf shelters.
HABIT: Larvae of this native species are among the most indiscriminate feeders of all Lepidoptera, eating leaves of all kinds of herbs, shrubs, and trees, even conifers.
RANGE: Coastal plain from Mendocino to San Diego Counties, especially in urban situations. Rare in the Sacramento Valley.

▶ 537. VARIABLE OAK LEAF-ROLLER *Epinotia emarginana*

This is one of the commonest small moths in California.

ADULT: Small (BL 7–9 mm to tips of wings); fore wing rectangular, having a notch in the end; fore wing brown mottled with grayish, sometimes with a white patch on the inner margin or with the inner half ochreous tan or the whole wing tan, with a large black patch on the inner margin.

LARVA: Olive green to tan with pale dots and orange-brown head; in leaf shelters on various oaks, manzanita (*Arctostaphylos* spp.), or Madrone *(Arbutus menziesii)* in April, May, and June.

HABIT: The adults emerge in early summer but do not mate and lay eggs until early the following spring. They are often encountered overwintering in aggregations around houses.

RANGE: Forested parts of the state, up to 1,500 m in the Sierra Nevada.

▶ 538. SPRUCE BUDWORMS *Choristoneura* spp.

This genus includes several species related to the notorious Eastern Spruce Budworm (*C. fumiferana*) and makes up the most important group of conifer-feeding caterpillars across North America. Although producing just a single generation per year, periodic outbreaks defoliate millions of acres, particularly across boreal forest regions. These population explosions are less frequent in California. In California there are three discrete species: the Green Budworm *(C. retiniana),* associated with white fir (*Abies*), has green larvae; whereas the larvae of the **Spruce Budworm *(C. carnana)* (538)**, feeding primarily on Douglas Fir and Big Cone Douglas Fir (*Pseudotsuga*), are rust brown with conspicuous white spots. Populations blend genetically into the Western Spruce Budworm *(C. occidentalis)* near the Oregon border; *C. lambertiana* feeds on pines, particularly Ponderosa, Lodgepole, and Jeffrey.

Family Crambidae

A great diversity of species makes up the family Crambidae. Many have narrow fore wings, while in others the fore wing is a triangular shape. The hind wings are fanlike and held under the fore wings when folded. Most crambids have elongate, snout-shaped palpi, but these structures are shorter and turned up in front of the face in many species. The larval habits are even more diversified, including leaf-feeders, root-borers, moss-feeders, scavengers, predators on other insects, and at least one fungus-feeder. One subfamily even consists of aquatic species whose larvae feed on submerged plants! Probably 350–400 species have been described from California, including many of our commonest moths, especially in desert regions.

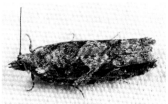

537. Variable Oak Leaf-roller
(*Epinotia emarginana*).

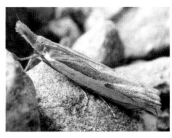

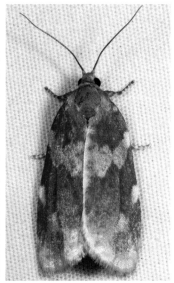

539. Sperry's Lawn Moth
(*Crambus sperryellus*).

538. Spruce Budworm
(*Choristoneura carnana*).

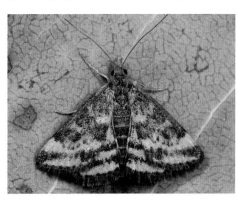

540. Weedfield Sable
(*Pyrausta subsequalis*).

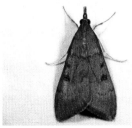

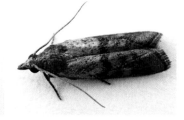

541. Genista Broom Moth
(*Uresiphita reversalis*).

542. Indian Meal Moth
(*Plodia interpunctella*).

◀ 539. SPERRY'S LAWN MOTH *Crambus sperryellus*

ADULT: Medium-sized (BL 12–16 mm to tips of wings); with long, snout-like palps; fore wing narrow, nearly rectangular, pale brown with a broad silver streak along the middle.

LARVA: Greenish gray or brownish gray with darker head and conspicuous, paired, black body spots edged with whitish; in silk-lined tunnels in the sod at the base of grasses on which they feed.

RANGE: Coastal plain, the Central Valley, and foothills of the Sierra Nevada, in cities where lawns are watered through summer. The Eastern Lawn Moth *(Parapediasia teterrella)*, which has tan fore wings and whitish-brown head and thorax, has replaced other lawn moths in many urban areas. It appeared in Los Angeles in 1954 and spread to the San Francisco Bay Area by 1988.

◀ 540. WEEDFIELD SABLE *Pyrausta subsequalis*

This is one of California's commonest moths in weedy places in urban and rural areas.

ADULT: BL 10–15 mm to tips of wings; triangular in outline when at rest; fore wing brown, hind wing orange, banded with black; more brightly colored in the smaller female.

LARVA: White with a brown head.

HABIT: Borer in thistle stems; may feed on plantain *(Plantago)*.

RANGE: Low to moderate elevations of coastal areas, inland valleys, and the Sierra Nevada, from Mount Shasta to southern California. The moths may be seen at any time of year in coastal areas.

◀ 541. GENISTA BROOM MOTH *Uresiphita reversalis*

This is a moderately large crambid with triangular brown fore wings and broad, yellow-orange hind wings.

ADULT: BL 15–17 mm; triangular outline when at rest; fore wing rusty red with indistinct black markings, hind wing and abdomen yellow-orange.

LARVA: Avocado green to orange with black-and-white spots and long white hairs, rests prominently on the host plant.

HABIT: Often seen day-flying, the adults and conspicuous larvae are aposematic, protected from bird predation by distasteful sequestered alkaloids (much like the Monarch). There are multiple generations throughout the season and colonies defoliate broom locally, but unfortunately do not eradicate their invasive, weedy hosts.

RANGE: Sea-level to moderate elevations wherever the host plant occurs. This species probably was native in Mexico, then expanded its range into adjacent states, dependent largely upon non-native brooms *(Genista,* Fabaceae). The moth was established in Los Angeles by 1930 and spread

northward in the Central Valley and along the coast, reaching the San Francisco Bay Area by 1980.

Family Pyralidae

◄ 542. INDIAN MEAL MOTH *Plodia interpunctella*

This is probably the commonest stored-food moth in California. Its habits and larval foods are similar to the other pantry moths.

ADULT: Small (BL 6–10 mm to tips of wings); fore wing narrow, grayish-white basally with the apical two-thirds brick red.

LARVA: Head brown, body pinkish to white without discernible body spotting.

RANGE: Wherever dried foods are stored; in natural situations in warmer parts of the state.

PANTRY MOTHS *Anagasta* spp., *Ephestia* spp.

Several species are common inhabitants of stored foods. The larvae eat all kinds of flour, meal, cereals, dried fruits, and nuts, even chocolate and pepper. When households are infested, the small, gray moths flutter persistently around kitchens, even after affected foods are removed, because the caterpillars wander to pupate and make cocoons in corners of cupboards and other recesses. The moths may continue to emerge and live for several weeks, so all new food containers should be stored in closed plastic bags until the moths die out.

ADULT: Small (BL 8–15 mm to tips of wings); fore wing narrow, rounded, tan or gray, marked with blackish in some species; bodies and hind wing white-gray.

LARVA: White or yellowish white with a pair of small black crescents on the second and next-to-last body segments; head brown; in silken webbing on stored foodstuffs.

RANGE: Urban and rural situations where dry foods are stored. The largest of these species is the Mediterranean Flour Moth (*E. kuehniella)*, which has gray fore wing marked with wavy, blackish crossbands.

Family Geometridae

Caterpillars of the family Geometridae retain only the last two or three pairs of false body legs. As a result, they walk in a looping fashion, advancing by measured steps equal to the distance between their thoracic legs and tail end. They are familiar to most naturalists as "loopers" or "inchworms." The moths are relatively slender-bodied with broad wings,

often with angulate margins. In most species the wings are held out at right angles to the body, appressed to the substrate when the moths are at rest, rather than folded over the back as in most moths. A few geometrids perch with the wings held together, butterfly-style. This is a large family, with more than 300 species in California. There is a wide range of sizes and colors, including a few that are brightly colored day-flying moths.

▶ **543. OAK WINTER HIGHFLIER** *Hydriomena nubilofasciata*
One of the best insect indicators of the approach of spring, this species appears in great numbers around oaks and at lights in late January and February.
ADULT: Medium-sized (24–30 mm wing expanse) with rounded wings; fore wing gray with variable pattern of olivaceous and dull red-brown, wavy crossbands.
LARVA: Stout, cutwormlike; yellowish with blue spots to mostly bluish.
HABIT: Larvae in leaf rolls on Coast Live Oak *(Quercus agrifolia)* and other oaks. Sometimes the commonest of the spring defoliators of oak.
RANGE: Coastal valleys and Coast Ranges from Mendocino County to San Diego.

Greens (Subfamily Geometrinae)

Moths of this subfamily are unusual because most of them are green. The larvae are remarkable in that there are three tribes: those that are twiglike in form; those that have large processes on the body, not specialized for attachment of plant matter; and those that have processes on the body bearing special hooks for the attachment of plant fragments. The last are particularly interesting because feeding often occurs in flowers, and petal fragments are attached, producing an extremely cryptic concealment (545). There are about 25 species of greens in California.

▶ **544–545. WAVY-LINED EMERALD**
OR HOARDER INCHWORM *Synchlora aerata*
One of the most widespread greens, with a peculiarly charming caterpillar that astonishes those who manage to notice it.
ADULT: (544) Wing expanse to 17 mm; bright green, wing veins usually outlined in white, all wings with two transverse wavy white bands. Lacks the red on the abdomen and wing fringes, only costal margin sometimes with a hint of red.
LARVA: (545) Extremely cryptic; body variable gray to light brown, covered in irregular bumps, setae with hooks for attaching plant debris. Usu-

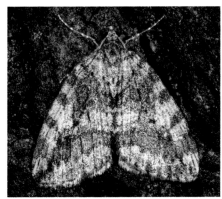

543. Oak Winter Highflier (*Hydriomena nubilofasciata*).

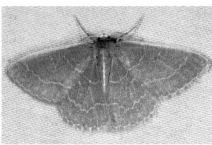

544. Wavy-lined Emerald (*Synchlora aerata*) adult.

545. Hoarder Inchworm (*Synchlora aerata*) larva of 544.

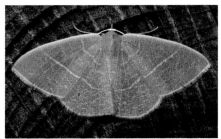

546. Pink-margined Green (*Nemoria leptalea*).

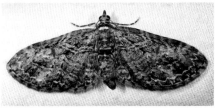

547. Pug Looper (*Eupithecia graefii*).

ally covered in a wide variety of plant debris almost completely obscuring the form of the caterpillar.

HABIT: Larva feeds on a wide variety of plants, especially residing on flowers, when available; petals are also collected and attached to the body for remarkable camouflage.

RANGE: Throughout the state, including urban areas.

◄ 546. PINK-MARGINED GREEN *Nemoria leptalea*

Probably the most commonly seen member of the genus.

ADULT: Wing expanse 22–30 mm; bright green, wings with two transverse white lines, many fine, incomplete whitish lines, and the margins pink.

LARVA: Dead-leaf brown with lateral lobes on abdominal segments 2, 3, and 4, slender and notched.

HABIT: Larva is probably a general feeder, reared on buckwheat *(Eriogonum)* and Christmas-berry *(Heteromeles)* in captivity.

RANGE: Coastal areas and Coast Ranges from Napa County southward to San Diego.

DARWIN'S GREEN *Nemoria darwiniata*

Another species, which is similar but has reddish dots in the middle of the wings, is Darwin's Green.

ADULT: Medium-sized (wing expanse 22–33 mm); wings dull green, each with a reddish dot in the middle with thin, whitish, transverse lines and edged in white, pink at the fore wing tip; abdomen with three white spots surrounded by red.

LARVA: Yellowish, mottled with brown and lavender; body with surface rugose and with prominent, keel-shaped processes on abdominal segments 2, 3, and 4.

HABIT: Larva is a general feeder, reared from willow and Madrone in British Columbia, oak and *Ceanothus* in southern California.

RANGE: Coastal areas, Coast Ranges, the Sierra Nevada, and southern mountains. Both *Nemoria* species are seen at lights in cities throughout the year.

◄ 547. PUG LOOPERS *Eupithecia* spp.

About 50 species of these small moths occur in California and are often seen at lights throughout the year. They are recognized by their narrow wings that are held out flat against the substrate when the moths are at rest.

ADULT: Small to medium-sized (wing expanse 12–35 mm); gray to white with darker thin lines across the wings.

LARVA: Variable in form and color, often twiglike or resembling flowers in which they live, such as yellow with brown, dorsal, arrowhead markings

when in oak catkins or lavender with darker purple spots in flower heads of *Ceanothus.*

RANGE: Throughout most of the state in a wide range of habitats, except the low deserts.

▶ **548. OMNIVOROUS LOOPER**　　　　　　*Sabulodes aegrotata*

This is one of the commonest garden inchworms in California.

ADULT: Wing expanse 40–48 mm, pale tan with two irregular, brown bands and faint striations across the wings, or rarely with variable amounts of broad, brown banding to entirely light chocolate brown.

LARVA: BL 35–45 mm; yellowish, green, or pinkish with parallel dark lines along the sides.

HABIT: Larva feeds on a remarkably wide variety of native and introduced plants, particularly English Ivy, shrubs, and trees. The pupae are commonly seen as well and are white with brown antennal cases, in a fluffy, translucent white silk cocoon wrapped in the leaves of its host.

RANGE: Coastal areas, Coast Ranges, and inland valleys, from Humboldt County to San Diego, especially in cities. A genetically determined form, *cottlei*, with all dark brown wings, and a blond thorax, occurs in about 15 percent of the population in the San Francisco Bay Area.

▶ **549. LEAFWINGS**　　　　　　　　　　　　*Pero* **spp.**

Members of the genus *Pero* are heavy-bodied compared to most geometrids and perch with wings curled, resembling dead leaves. They often appear at lights late in the evening when it is too cold for most other moths. There are at least 12, very similar, species.

ADULT: Wing expanse 36–44 mm; wing color variable, often from red-brown to gray-brown, with irregular black lines separating lighter apical wing tips.

LARVA: Wood brown; in exact simulation of a twig, the caterpillar assumes a rigid position at a right angle to the branch grasped by its tail-end feet.

HABIT: Larvae on buckwheat *(Eriogonum)* and various other plants, including ornamental garden shrubs.

RANGE: Widespread in most of the state. Fly throughout much of the year, especially in urban areas.

Family Lasiocampidae

▶ **550. TENT CATERPILLARS**　　　　　　*Malacosoma* **spp.**

Adults of the four species in California are dull-colored and not conspicuous, but the large, silken tents in which the colonies of caterpillars live are familiar sights on shrubs and trees.

ADULT: Tan to reddish brown, fore wing usually with contrasting dark or pale lines or bands. Males are medium-sized (wing expanse 22–34 mm) with narrow, feathery antennae. Females are larger (wing expanse 30–38 mm) with threadlike antennae, bulky bodies, and often more uniform-colored wings.

LARVA: Brown or black, usually with conspicuous stripes and chainlike markings of white or bright blue along the back and sides; covered with long, sparse, red-brown or whitish hair.

HABIT: Larvae live together in silk tents draped over host plants. They can be problematic defoliators.

RANGE: Throughout broad-leafed forest and chaparral areas of the state, including the Mojave Desert.

CALIFORNIA TENT CATERPILLAR *Malacosoma californicum*

The California Tent Caterpillar is the most widespread species in California.

ADULT: Males are red-brown with yellowish crossbands on the fore wing; hind wing darker; females are tan with pale, red-brown bands.

HABIT: The larvae feed on oak, willow, fruit trees, and various shrubs, including *Ceanothus* and antelope brush *(Purshia)*. Both this species and the Pacific Tent Caterpillar *(M. constrictum)* are common on oaks during spring in the Coast Ranges and the Sierra Nevada. Adults of *M. constrictum* are colored just the reverse: males tan, females reddish brown. Larvae of *M. constrictum* in these regions usually have conspicuous blue markings, and those of *M. californicum* do not.

▶ 551. YARN MOTHS *Tolype* spp.

ADULT: Medium-sized (BL 15–19 mm), with broad, rounded wings having white or gray scales with dark crossbands and fine white lines along the veins; body densely hairy, like a ball of fluff or yarn, white and gray with a black or steel blue scale ridge on the back of the thorax and base of the abdomen. When at rest, the wings are held along the sides of the body, and the abdomen extends beyond them. Males are smaller and have feathery antennae that are broad basally.

LARVA: Gray with faint longitudinal lines; third segment with a black, velvety band and two or three raised white spots; body flat underneath; with lateral flaps, each with many long hairs, forming a fringe.

HABIT: Larva is cryptic, using fringe to aid in shadow elimination and concealment as the caterpillar rests by day appressed to a similarly colored branch; on conifers or mountain mahogany *(Cercocarpus)* and other broad-leafed shrubs and trees.

RANGE: Foothills and mountains to mid-elevations throughout the state. Probably there are several species, including one in the Santa Cruz Moun-

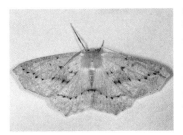

548. Omnivorous Looper
(*Sabulodes aegrotata*).

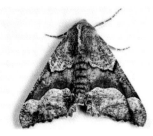

549. Leafwing
(*Pero* sp.).

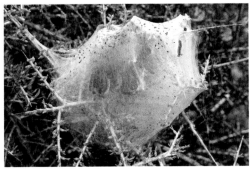

550. Tent Caterpillars
(*Malacosoma* sp.)
in silken tent.

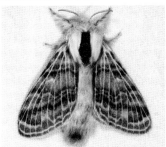

551. Yarn Moth (*Tolype* sp.).

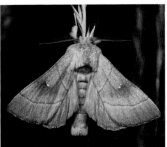

552. Tawny Prominent (*Nadata gibbosa*).

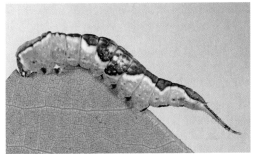

553. American Pussmoth
(*Furcula cinereoides*).

tains associated with pine and one in southern California that feeds on hardwoods. A common suburban resident.

Superfamily Noctuoidea

There are two major lineages within the superfamily Noctuoidea, the family Erebidae with about 700 species recorded in California, and the Noctuidae with more than 1,500 in the state. There is also the much less diverse Notodontidae, with only about 30 species in California. The adults are stout-bodied with moderately narrow fore wings and fan-shaped hind wings that in most species are hidden under the fore wings when folded. Nearly all of these moths have sound detecting "ears," tympanic eardrumlike structures recessed on each side at the posterior edge of the thorax. These enable the moths to detect the presence of bats and attempt evasive tactics. Most are cryptically colored, strong-flying, nocturnal moths, but several subfamilies are brightly colored day-fliers, often those that are active in early spring or at timberline and in the deserts. The thick-bodied caterpillars (many of which are called "cutworms") possess all four pairs of false abdominal legs. In some species the first two pairs are reduced, causing the larvae to walk like geometrid caterpillars, and these erebids are called "semiloopers" (Erebinae). Cutworms are mostly hairless and cryptically colored, living in leaf shelters or in debris on the ground, from which they emerge to feed at night.

Prominents (Family Notodontidae)

Notodontids are medium-sized, stout, usually nocturnal moths with thick coats of scales and hairs, and usually with reduced mouthparts. Their caterpillars are usually not hairy but often bear ornate humps or filaments, and they hold the tail end up when at rest. Compared to the eastern United States, the family is poorly represented in California with about 30 known species.

◀ 552. TAWNY PROMINENT *Nadata gibbosa*
ADULT: BL 24–30 mm to tips of wings; bulky, densely hairy moth; tan to brown, fore wing with two brown-edged, pale lines on either side of a pair of small white spots.
LARVA: Head and body green, paler on the back, with a narrow yellow stripe along each side.
HABIT: On oak and other broad-leafed trees.
RANGE: Coast Ranges and Sierra Nevada foothills to about 1,200 m.

SPOTTED DATANA *Datana perspicua*

A related species, the Spotted Datana, is about the same size but has a deep cinnamon red thorax and pale tan fore wing crossed by four thin, red-brown lines; hind wing dirty white.

LARVA: BL 50–60 mm; head black, body dark reddish brown or black, with bright yellow stripes along the back and sides, and clothed with sparse, white hair.

HABIT: On broad-leafed forest and orchard trees.

RANGE: North Coast Ranges, the Sierra Nevada, and mountains of southern California up to 900 m.

◀ 553. AMERICAN PUSSMOTHS *Furcula* spp.

Several forms occur in California.

ADULT: BL 18–23 mm to tips of wings; heavy-bodied; white to gray fore wing with variable development of broad, black crossbands and dots.

LARVA: Bizarre form with enlarged anterior portion and the anal legs modified into two elongate, thin tails; red-brown head slightly recessed into body, body yellow or green with a brown "saddle" area along the back, faintly dotted with brown.

HABIT: Larvae on willow or poplar; when disturbed, they may whip the tails at interlopers.

RANGE: Widespread in arid parts of the state, the Coast Ranges, and the Sierra Nevada foothills.

Subfamily Dioptinae

▶ 554–555. CALIFORNIA OAK MOTH *Phryganidia californica*

This peculiar diurnal moth is the only representative of its subfamily (which is overwhelmingly tropical) in the country.

ADULT: **(554)** BL 14–20 mm to tips of wings; pale, dull brown with slightly darker veins; a slow-moving day-flier.

LARVA: **(555)** BL 20–30 mm; olive green with black and yellow lines along the back and sides and a red head.

HABIT: Larvae on oaks. This species can become extremely abundant, even in urban areas, with the larvae completely defoliating oaks (notably *Quercus agrifolia*, but also other oaks), although the frequency of such outbreaks has decreased for reasons that are not clear. In between the outbreaks, the moths may be scarce. Also found on Cork Oak *(Q. suber)*, where it is grown as an ornamental tree in southern California. The distinctive pupae are often seen during outbreaks and are yellow with black or blue markings; lacking a cocoon, they hang like a butterfly chrysalis

from tree trunks and other objects. All life stages are conspicuous and probably distasteful to birds and thereby protected.

RANGE: Coastal areas from Napa County to San Diego. There are three generations each year, with successive buildup of numbers in summer broods, so that extreme defoliation usually occurs only in summer. In central California the populations spread inland and feed on deciduous oaks in summers of outbreaks, but the species is unable to survive freezing in winters and dies out except in coastal areas.

Millers and Cutworms (Family Erebidae)

The family-level organization of Noctuoidea has been a hotbed of current research with many discoveries and novel relationships revealed. As currently treated, the Erebidae includes the former Arctiidae, Ctenuchidae, Lymantriidae, and the subfamily Catocalinae as well as several ancestral lineages of former noctuids (Erebinae).

Subfamily Erebinae

▶ 556. BLACK WITCH *Ascalapha odorata*

Formerly *Erebus odora*. As big as a bat, this species has the largest wingspread (120–170 mm) of any insect in California, and its appearance at lights around a home or store never fails to attract notice. Individuals at times fly far north of the normal range, startling residents in places like San Francisco or Reno.

ADULT: Fore wing triangular; hind wing broad, rounded; dark brown or black with black lines and circular eyespots tinged with blue; female with a jagged white band across the wings.

LARVA: Up to 70 mm long; tapered posteriorly; dark gray tinged with brown, with a pale stripe down the back and dark stripes down the sides.

HABIT: Larva feeds on acacia, cassia, and other plants of the pea family.

RANGE: A native of Mexico, possibly resident in San Diego, breeding on ornamental plants; commonly migrating northward as far as Los Angeles and rarely to northern California, from July through fall months.

▶ 557. UNDERWINGS *Catocala* spp.

Large erebids that are among the showier moths of California, but they are rarely seen because of their cryptic fore wing colors and skittishness.

ADULT: Moderately large (BL 24–44 mm to tips of wings); fore wing gray and brown, triangulate, mottled, resembling tree bark, where the moths rest by day; hind wing red, orange, or white with black markings, covered when the wings are folded.

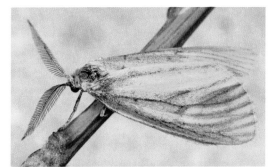

554. California Oak Moth (*Phryganidia californica*) adult.

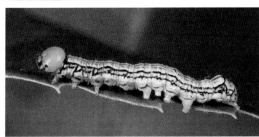

555. California Oak Moth (*Phryganidia californica*) larva.

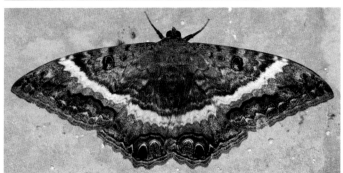

556. Black Witch (*Ascalapha odorata*).

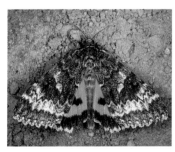

557. Underwing (*Catocala grotiana*).

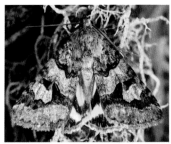

558. False Underwing (*Drasteria* sp.).

LARVA: Cryptic, gray, tapering posteriorly, with a fringe of lateral projections; often a prominence on the fifth abdominal segment and raised tubercles, especially on the eighth segment.

HABIT: Larvae on broad-leafed trees, including poplar, willow, oaks, and alders. They are cannibalistic if reared together. When the adults are disturbed, they flash the brightly colored hind wings suddenly, which is believed to have a startling effect on potential predators such as birds. A method of attracting adult *Catocala* to sweet, fermenting baits ("sugaring") is popular with collectors in the eastern United States where underwings are much more abundant and diverse. It is most successful on warm, humid evenings, thus results usually are poor in California. Attraction of underwings to lights seems to be erratic; they remain unusually active and can easily be scared off, never to return. Some species are more easily seen at their resting stations during the daytime. Hunting is sometimes productive if one quietly searches the trunks of trees or under loose bark, of cottonwood, alder, and the like in riparian zones. Other hiding places include the vertical surfaces of granite boulders and under eaves or bridges in wooded areas.

RANGE: Wooded parts throughout the state, including riparian strips with deciduous trees, even in foggy coastal areas. Typically on the wing between June and October, depending on elevation and species.

◄ 558. FALSE UNDERWINGS *Drasteria* spp.
Several species resemble true underwings in having the fore wing cryptically colored and hind wing orange, marked with black.

DESERT FALSE UNDERWING *Drasteria tejonica*
The Desert False Underwing has the fore wing strongly marked with white; hind wing mostly orange in the female, white-tinged with pink or orange in the male; 32–38 mm wingspread.

RANGE: Desert areas and the Central Valley north to Antioch; sometimes appearing in great numbers at lights on warm nights.

EDWARDS' FALSE UNDERWING *Drasteria edwardsii*
A species similar to the Desert False Underwing that has the hind wing orange, heavily marked with black, and a dark pattern narrowly outlined in yellow on fore wing.

RANGE: Adults are common in the Coast Ranges and the Sierra Nevada at mid-elevations, often seen flying in the daytime.

Subfamily Lymantriinae

▶ **559–561. TUSSOCK MOTHS** ***Orgyia* spp.**

Several members of this genus inhabit California, including one restricted to the immediate seacoast and another in coniferous forests. The moths are nondescript, particularly the wingless females.

ADULT: Males **(559)** are medium-sized (26–34 mm wingspread), with rounded brown wings and feathery antennae; fore wing with gray cross-bands and a white spot near the outer, lower corner. Females **(560)** lack wings, not easily recognizable as moths; pale tan, fluffy blobs found clinging to the hairy cocoons.

LARVA: (561): Brightly colored, with conspicuous hair tufts, body gray with yellow and red spots, long, black hair tufts on the front and tail ends, and four thick, white tufts on the back, resembling a garish toothbrush.

HABIT: Often seen in gardens feeding on a variety of plants. The common garden species in California was long known as *O. vetusta,* but careful taxonomic study may show that it should be called *O. gulosa,* with *O. vetusta* restricted to seacoast dune habitats.

RANGE: Coastal and mountain areas throughout the state. The Douglas-fir Tussock Moth *(O. pseudotsugata)* is a defoliator of conifers in the northern part of the state.

Tiger Moths (Subfamily Arctiinae)

Arctiines are stout-bodied, furry, and often brightly colored moths, usually with the antennae narrow and feathery in the male, slender and filamentlike in the female. Some species are day-flying, but most are nocturnal and often attracted to lights. The caterpillars characteristically are covered with long, erect hairs and are popularly called "woollybears." About 85 species are known in California, occurring throughout the state from the north coast fog belt to the Mojave.

▶ **562. SIERRAN PERICOPID** ***Gnophaela latipennis***

This diurnal moth is often observed fluttering weakly around mountain meadows in early summer.

ADULT: BL 25–32 mm to tips of wings; black with yellow-white, semitransparent spots on the wings; front of thorax orange on the underside; males have feathery antennae.

LARVA: Head orange; body reddish black with stripes of connected lemon-yellow diamonds down the back and on each side above the legs; each segment with raised blue-black tubercles bearing long hairs, like a sparsely clad woolly bear.

HABIT: Larvae feed on mountain blue bells *(Mertensia)*, Grand Hound's Tongue *(Cynoglossum grande)*, and California Stickseed *(Hackelia californica)*. The pupa is shiny black with yellow spots on the back; suspended hammocklike from hooks at both ends, in a flimsy cocoon.

RANGE: The Sierra Nevada, Cascades, North and Central Coast Ranges, at mid-elevations.

▶ **563–564. BANDED WOOLLYBEAR** *Pyrrharctia isabella*

A widespread species in the eastern United States, alleged to possess predictive powers for weather forecasts.

ADULT: (563) BL 21–28 mm; wing span 44–58 mm; pale orange or cream-colored, with the head and thorax darker; abdomen with a row of large, black spots.

LARVA: (564) The caterpillar is black at the ends, with a broad, reddish-brown band around the middle. The relative width of the colors is supposed to be an index to the severity of the coming winter. Although this may be as good a method for long-range predictions as any used by the weather bureau, if the colors are correlated with temperature or rainfall, probably they indicate past not future events.

HABIT: Like many tiger moths, the larva is the overwintering stage, leaving its shelter to bask in the sun and feed on a variety of low-growing vegetation on warmer days. Can be reared easily on organic salad mix.

RANGE: The species ranges west into California but is only common along the North Coast south through the Bay Area and in the Sierra Nevada south to Yosemite.

▶ **565–566. YELLOW-SPOTTED TIGER MOTH** *Lophocampa maculata*

ADULT: (565) BL 20–30 mm to tips of wings; fore wing yellow, variably marked with light brown; hind wing off-white. Common at lights in spring.

LARVA: (566) Densely hairy, frequently black with intermixed, longer white hairs and a wide, yellow or light brown band around the middle, with or without a series of black spots down the midline. Some larvae are mostly white or yellow with a series of black or orange spots down the midline.

HABIT: Larvae on willow and other broad-leafed trees and shrubs, most noticeable in late summer and fall.

RANGE: Coastal areas and mountains, including both sides of the Sierra Nevada to about 2,000 m. A related species, the Silver-spotted Tiger Moth *(L. argentata)*, has chocolate-brown fore wings marked with silver-white spots. Its larva feeds on coniferous trees in the Coast Ranges, the Sierra Nevada, and southern mountains.

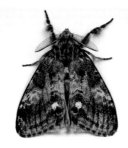

559. Tussock Moth (*Orgyia* sp.) male.

560. Tussock Moth (*Orgyia* sp.) female.

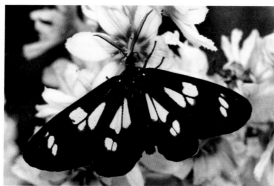

561. Tussock Moth (*Orgyia* sp.) larva.

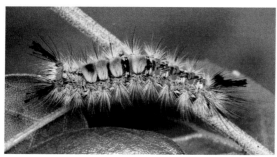

562. Sierran Pericopid (*Gnophaela latipennis*).

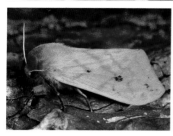

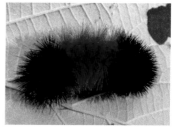

563. Banded Woollybear (*Pyrrharctia isabella*) adult.

564. Banded Woollybear (*Pyrrharctia isabella*) larva.

► **567. EDWARDS' GLASSYWING** *Pseudohemihyalea edwardsii*

ADULT: One of the state's largest tiger moths (BL 30–38 mm to tips of wings), this species is unusual in having the wings sparsely scaled and translucent. Wings tan, dusted with black, obscure transverse bands in fresh specimens; abdomen bright rose-pink with irregular blue spots.

LARVA: Head large, shiny dark brown; body velvety brownish black, densely clothed with tufts of brown hairs; underside and legs yellowish.

HABIT: Larvae on oaks and possibly other plants. The larvae often spend the day hiding in tree holes, emerging at night to feed.

RANGE: Coastal areas and mountains, also foothills of the Sierra Nevada to moderate elevations, flying in late summer and fall. Occasional in suburban areas.

► **568. VESTAL TIGER MOTH** *Spilosoma vestalis*

Flying only in spring, this moth is easily recognized by its bright red front legs and lustrous white coloration.

ADULT: BL 22–32 mm to tips of wings; white with small black dots on the wings and black bands on the abdomen.

LARVA: Black, densely clothed with relatively short, stiff hairs.

HABIT: Larva on various low-growing plants.

RANGE: Coastal areas and most mountain ranges to about 1,500 m, including suburban areas.

► **569. ACREA MOTH OR SALTMARSH CATERPILLAR** *Estigmene acrea*

Probably the most widespread and often seen tiger moth in California, this species is sometimes abundant enough in field crops to be of economic importance.

ADULT: BL 24–34 mm to tips of wings; female has white wings spotted with black and a yellow abdomen; male similar but has ochreous-yellow hind wing.

LARVA: Black with yellow, broken lines, covered with clumps of long hairs and red-brown hairs at the sides.

HABIT: Larvae are most abundant in fall; on various low-growing plants.

RANGE: Coastal areas, the Central Valley, and deserts.

► **570. PAINTED TIGER MOTH** *Arachnis picta*

A stunningly beautiful moth.

ADULT: BL 22–35 mm to tips of wings; fore wing gray, marked with wavy, white lines, giving the insect a lichenlike appearance when at rest; fore wing underneath yellow on the basal half: hind wing and abdomen bright pink with gray markings. Common in fall at lights.

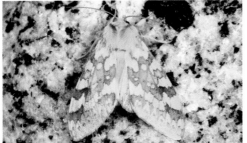

565. Yellow-spotted Tiger Moth (*Lophocampa maculata*) adult.

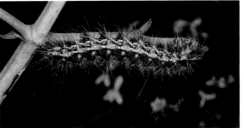

566. Yellow-spotted Tiger Moth (*Lophocampa maculata*) larva.

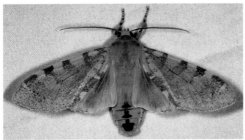

567. Edwards' Glassywing (*Pseudohemihyalea edwardsii*).

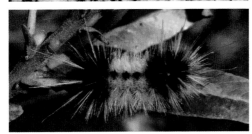

568. Vestal Tiger Moth (*Spilosoma vestalis*).

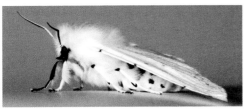

569. Acrea Moth (*Estigmene acrea*).

LARVA: Densely clothed with long, stiff, black and red-brown hairs.

HABIT: Larva on various herbs and shrubs in winter and spring. Populations can be abundant but highly localized, especially in the northern part of the range.

RANGE: Coastal and arid parts of the state, north to Sonoma. Populations in the mountains of the eastern Mojave and Inyo County consist of larger moths with restricted gray markings and bright rose-pink hind wings; they fly earlier than the coastal populations.

Subtribe Ctenuchina

The subtribe Ctenuchina is primarily tropical and consists mainly of brightly colored, day-flying moths that resemble wasps or beetles that are distasteful to vertebrate predators. They differ from other tiger moths only in minor structural features of the wing venation. Larvae and pupae of the two groups are similar. Fewer than 10 species occur in California.

▶ **571. BROWN-WINGED CTENUCHA** *Ctenucha brunnea*

ADULT: BL 20–26 mm to tips of wings; body metallic blue with pale red shoulder straps extended back over the thorax; fore wing brown with the leading edge white, veins black; hind wing black.

LARVA: Head orange, body black with longitudinal yellow stripes; long, erect white or tan hairs on the back with black tufts on the fourth and next-to-last body segments.

HABIT: Larva feeds on sedges and grasses in wet meadows and marshes. Pupation occurs in a soft cocoon of felted hairs shed by the larva.

RANGE: Coastal areas of southern California. North of Santa Maria the brown on the fore wing becomes black and the name *C. multifaria* is used. A related species, the Red-shouldered Ctenucha *(C. rubroscapus)*, occurs along the north coast and inland in the Coast and Cascade Ranges and the Sierra Nevada; fore wing is black without the white leading edge.

Family Noctuidae

The Noctuidae has more species than any other family of Lepidoptera. Noctuids make up about one-third of all described moths in North America, and probably over 1,500 species occur in California.

▶ **572. GREASY CUTWORM OR BLACK CUTWORM** *Agrotis ipsilon*

ADULT: Medium-sized (BL 22–28 mm to tips of wings); fore wing brown clouded with black, with a poorly defined, pale band preceding the terminal edge; hind wing shining, pearly white with dark veins and edges.

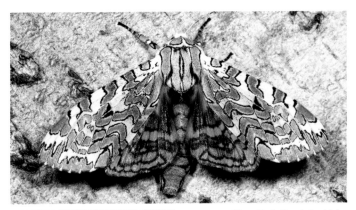

570. Painted Tiger Moth (*Arachnis picta*).

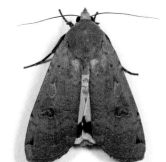

571. Brown-winged Ctenucha (*Ctenucha brunnea*).

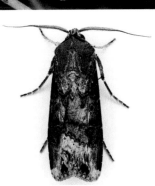

572. Greasy Cutworm (*Agrotis ipsilon*).

573. Large Yellow Underwing (*Noctua pronuba*).

LARVA: Greasy-looking, gray to brown with a paler stripe down the back; skin covered with large and small, convex, rounded granules.

HABIT: Larva feeds on a wide variety of low-growing plants, including many field crops. Hides in leaf litter or soil during the day, emerging at night to feed.

RANGE: Widely distributed at low to moderate elevations, from Mount Shasta to the Colorado River.

VARIEGATED CUTWORM *Peridroma saucia*

The Variegated Cutworm looks similar to the previous species.

ADULT: Usually somewhat larger than the preceding species (BL 24–30 mm to tips of wings); fore wing variably colored, dull red-brown, gray or blackish brown, sometimes with a broad, poorly defined tan area on the inner half or on the leading margin.

LARVA: Variable in color, gray or brown with darker mottling on the sides, a yellow dot on the midline of the back on most segments.

HABIT: Larvae are pests on a wide variety of garden plants, truck crops, and trees.

RANGE: Low to moderate elevations throughout the state.

◀ 573. LARGE YELLOW UNDERWING *Noctua pronuba*

This species is not closely related to native underwings *(Catocala)* but rather it is a more recent invader from the Palearctic, where it is regarded as a garden pest.

ADULT: BL 22–24 mm; fore wing various shades of brown, with variable black markings. Hind wing yellow with a broad black band along the outer margin.

LARVA: Typical cutworm, brown or dull green, heavy-bodied with black markings along back.

HABIT: Larva feeds on a diversity of low-growing vegetation.

RANGE: Widespread and migratory, often showing up in areas where it may not breed. This species completed a rapid invasion across North America, first found in Nova Scotia in 1973; in 25 years it spread to Michigan and by 2002 made its way to California, where it is now widespread and relatively common in both urban and natural settings.

▶ 574. EARLY SPRING MILLERS *Orthosia* spp., *Egira* spp.

Several species of these genera fly in winter and early spring. From December to March they are often seen at lights, even on nights with temperatures near freezing. *Egira crucialis* is one of the commonest.

ADULT: Medium-sized (BL 18–24 mm to tips of wings); fore wing pale gray marked by distinct, longitudinal black lines and a pink tinge in the pale areas and on the body. Hind wing white to pale gray.

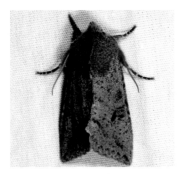

574. Early Spring Miller (*Orthosia* sp.).

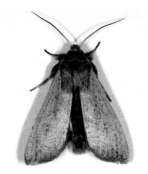

575. Armyworm (*Mythimna unipuncta*).

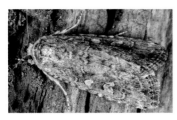

576. Beet Armyworm
(*Spodoptera exigua*).

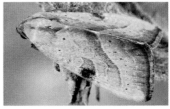

577. Garden Miller
(*Galgula partita*).

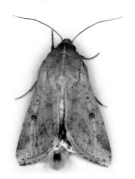

578. Corn Earworm (*Helicoverpa zea*).

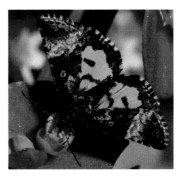

579. Orange Flash (*Annaphila decia*).

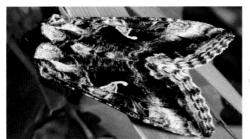

580. Alfalfa Semilooper
(*Autographa californica*).

LARVA: Head bright red; body light gray with smooth skin and faint, broken pale lines along back and sides.

HABIT: Larva on alder, oak, and other broad-leafed trees.

RANGE: Coast Ranges, Sierra Nevada foothills, and mountains of southern California. Adults fly from February to May, depending on elevation.

◀ 575. ARMYWORM *Mythimna unipuncta*

This is perhaps the most widespread and common noctuid in California; generations occur throughout the year in agricultural and weedy situations.

ADULT: Medium-sized (BL 20–26 mm to tips of wings); fore wing smooth, slightly pointed, nearly uniform pale or dark tan, or speckled with dark dots and mottled with pale tan, a small white mark near the middle and a black line leading to the apex; hind wing gray.

LARVA: Smooth, greenish brown to dark gray with three yellow lines down the back and a broader, darker yellow stripe on each side.

HABIT: Larva usually on grasses but sometimes on field crops, often in large numbers.

RANGE: Throughout California west of the Sierra to about 1,500 m and in the desert mountain ranges.

◀ 576. BEET ARMYWORM *Spodoptera exigua*

One of the commonest millers in California, occurring in weedy areas and agricultural fields throughout the year.

ADULT: Medium-sized (BL 12–19 mm to tips of wings); fore wing narrow, pale brown, mottled with gray, having on the outer, leading half, two fairly well-defined dull white spots sometimes containing orange; hind wing white.

LARVA: Pale or yellow-green, a dark line down the back and a broad dark stripe on each side.

HABIT: Larva on a wide variety of field crops and low, weedy vegetation.

RANGE: At low elevations throughout most of the state, including desert areas and foothills up to 1,000 m.

YELLOWSTRIPED ARMYWORM *Spodoptera ornithogalli*

ADULT: BL 16–26 mm to tips of wings; fore wing brown with pale lines, discrete tan markings, and a pearly white, blurred streak inward from the wing tip; hind wing white, narrowly edged in brown, without a spot underneath.

LARVA: Velvety black with two prominent and many fine, bright yellow stripes along the sides.

HABIT: Larva is a general feeder, at times seriously damaging young cotton and other field crops.

RANGE: San Joaquin Valley and Santa Barbara southward. The similar Western Yellowstriped Armyworm (*S. praefica*) is more widespread in California and is common throughout the Central Valley. It has a paler fore wing, lacking the white apical streak; hind wing gray or white with a small brown spot in the middle of the underside.

◄ 577. GARDEN MILLER *Galgula partita*

These moths, sometimes called Wedgling Moths, are often seen fluttering about gardens or in weedy areas late in the afternoon; also sometimes attracted to lights at night.

ADULT: Rather small (BL 10–14 mm to tips of wings); outline triangular. There is marked dimorphism: males have fore wing rust-tan with a dark spot in the middle of the leading margin and a transverse line before the terminal margin; in females fore wings are dark brown, maroon, or black with the markings obscured. The female is more often noticed due to its unusual appearance.

LARVA: Strangely formed with third to fifth body segments swollen into a large hump; green with white stripes along the sides, purple-brown stripes down the back, darker on either side of a white stripe across the hump.

HABIT: Larva on *Oxalis,* particularly introduced and weedy species, making the species arguably beneficial.

RANGE: Low elevations along the coast and in the Central Valley, especially in cities.

◄ 578. CORN EARWORM OR BOLLWORM *Helicoverpa zea*

This is the most destructive moth and perhaps the most destructive insect to California's agricultural economy, especially because of its damage to cotton and corn. It is estimated that American farmers grow an average of two million acres of corn each year lost to feed the corn earworm.

ADULT: BL 19–25 mm to tips of wings; variable in size and color, fore wing tan or olive tan, nearly unicolorous or marked with darker bands; hind wing white with a broad, dark band on the outer half; females are more strongly marked.

LARVA: Light green, pink, or brown with alternating dark and light stripes down the body.

HABIT: Larva in corn ears, cotton bolls, green tomatoes, and other field crops.

RANGE: Coastal areas, the Central Valley, and deserts, including urban areas.

◄ 579. ANNAPHILAS　　　　　　　　　　　　　　*Annaphila* spp.

Members of this western North American genus are diurnal, flying in spring; at least 23 species occur in California, making the state a center of their diversity. Their brightly colored hind wings and undersides—red, orange, or white—make annaphilas popular with collectors, but they are extremely wary and sensitive to sound, making them difficult to capture in a net or image. Adults occasionally nectar but often rest on dry twigs or the ground, depending on habits of particular species. Larvae of several species pupate in hollow stems, others in soft wood, and some in shallow soil cocoons. Many species have suspended development (diapause) in the pupal stage for several years, possibly waiting for a good rainy season to emerge.

◄ 579. ORANGE FLASH　　　　　　　　　　　　*Annaphila decia*

The Orange Flash is probably one of the most attractive in the genus.

ADULT: Small (wing expanse 18–21 mm); fore wing is gray with wavy black lines and a transverse band of white dusting across it; hind wing rich orange with a black border and two bisecting wavy black lines.

LARVA: Smooth, pale green, turning darker in later instars.

HABIT: Larva feed on reproductive parts of miner's lettuce (*Claytonia*).

RANGE: Coast Ranges and foothills of the Sierra Nevada and the Transverse Ranges from sea level to about 1,500 m, in wildlands but occasionally including suburban nature reserves where the host plant is present.

There are several other species with orange hind wings also flying in the Coast Ranges and foothills of the Sierra Nevada in spring, including the Rusty-barred Annaphila (*A. depicta*), which has a gray fore wing with a darker, dull red-brown transverse band in the outer one-third; the hind wing is orange with fewer black markings than *A. decia*, including a single, sometimes elongate black dot and black wing margin with only a single, highly variable, or absent, very thin and wavy black line near the thorax; wing expanse 21–24 mm; the smooth green larvae feed on Baby Blue Eyes *(Nemophila menziesii).*

WHITE ANNAPHILA　　　　　　　　　　　　*Annaphila diva*

The White Annaphila is the commonest species in the Coast Ranges.

ADULT: Small (BL 10–20 mm to tips of wings); fore wing triangulate, black mottled with white; hind wing white with a black border.

LARVA: Head amber-colored, body brown-gray with indistinct darker bands down the back and sides, joined by a series of black spots on the abdominal segments; each side has a distinct white stripe.

HABIT: Larval host is miner's lettuce *(Claytonia).*

RANGE: The Coast Ranges and foothills of the Sierra Nevada and the Transverse Ranges to about 1,500 m.

◀ 580. ALFALFA SEMILOOPER · *Autographa californica*

One of California's commonest moths, this species is seen throughout the year visiting flowers during the daytime or at lights at night.

ADULT: BL 20–25 mm to tips of wings; gray mottled with black and having a silvery, comma-shaped mark near the middle of the fore wing; hind wing light brown with a broad, darker margin. Newly emerged individuals have a curious profile when at rest because of upraised scale tufts on the back, which are lost with age.

LARVA: Olive green with a darker line down the back and a pale stripe along each side; first two pairs of false body legs greatly reduced, so the caterpillar walks like a looper.

HABIT: Larva feeds on a wide range of field crops and weedy plants.

RANGE: Throughout most of the state at a wide range of elevations. Common in urban areas. A related species, the Bilobed Semilooper *(Megalographa biloba)*, is brown with a broad silver spot; it is less widespread but common in cities.

▶ 581. MOON UMBER · *Zale lunata*

ADULT: Wing expanse 36–50 mm; bark-colored, brown mottled with variable black and ochreous patches.

LARVA: Gray to brown mottled with black, with roughened skin and large, conical tubercles on the eighth abdominal segment; with projecting flaps that lie against the substrate, resulting in strong cryptic resemblance to the tree branches on which they rest during the day.

HABIT: Larva feeds on blackberries *(Rubus)*, oaks, willows, and other plants. The adult moth is nocturnal and perches during the day on tree trunks or rocks with the wings spread out flat, similar to geometrid moths. There may be multiple similar species that are easily confused.

RANGE: Coastal Plain, foothills, and the Central Valley. Often seen at lights in cities.

Subfamily Agaristinae

Agaristines are day-flying moths resembling other noctuids, and tiger moths, with the antennae slightly enlarged toward the tip like those of sphinx moths. Only seven species occur in California although they are widespread, occurring along desert margins, the inner coast ranges, and mountains where their host plants are present.

▶ 582. FORESTER MOTHS *Alypia* **spp.**

These beautifully colored day-flying moths can be a challenging quarry for the novel collector or observer; adults have rapid and erratic flight, especially along ridgelines. Although they are widespread, they are rarely common.

▶ 582. MARIPOSA FORESTER *Alypia mariposa*

ADULT: Wing expanse 30–34 mm; black with white wing spots not divided by black veins; middle pair of legs with bright orange scaling.
LARVA: Off-white with brown spots and sparse long white hairs.
HABIT: Larvae feed on species of *Clarkia* and related plants in late spring, later in the season at higher elevations.
RANGE: The Coast Ranges and Sierra Nevada foothills in the northern two-thirds of the state.

RIDING'S FORESTER *Alypia ridingsi*

This species is very similar to the preceding in most respects, but black veins dissect the distal wing spots.
LARVA: Brightly colored with raised, black bands around the segments and orange or yellow spots with sparse long white hairs; humped toward the rear.
HABIT: Larva on a wide variety of *Clarkia*, *Oenothera*, and related plants.
RANGE: Throughout the state including desert ranges, occupying widely diverse habitats from near the coast to above 2,500 m.

EIGHT-SPOTTED FORESTER *Alypia octomaculata*

This is a widespread species in eastern North America that extends into California in the northern counties and along the coast as far south as Santa Maria. This Forester differs from the previous two species by having orange on both the fore legs and the middle legs and by having two spots on each wing—those of the fore wing yellow, those of the hind wing white.

Silk Moths (Family Saturniidae)

The family Saturniidae includes some of the largest and most beautiful Lepidoptera. They are broad-winged moths with stout, short bodies and feathery antennae in both sexes, broader in males. The caterpillars are not densely hairy but are usually armed with protuberances, sparse, spiny setae or many-branched spines, which in some species can cause a nettle-like, irritating skin rash. Pupation occurs underground, in leaf litter, or in a dense, silken cocoon, often attached to the host plant. In Asia some

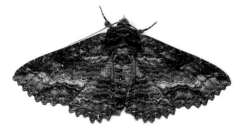

581. Moon Umber (*Zale lunata*).

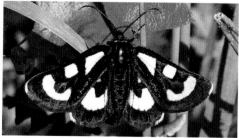

582. Mariposa Forester (*Alypia mariposa*).

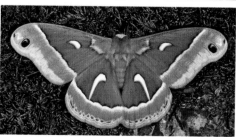

583. Ceanothus Silk Moth (*Hyalophora euryalus*) adult.

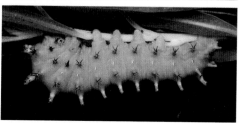

584. Ceanothus Silk Moth (*Hyalophora euryalus*) larva.

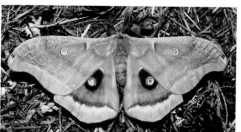

585. Polyphemus Moth (*Antheraea polyphemus*).

species yield commercial silk, but the principal Silk Moth *(Bombyx mori)* is an entirely domestic animal. It is a member of the Bombycidae, a family that has no native species in California. Saturniids are primarily tropical, and California, with only about 15 species, has a poor representation compared with Mexico or the eastern United States. There are two subfamilies in our fauna: the Saturniinae are mostly large, nocturnal moths with relatively sparsely spined or haired larvae; and the Hemileucinae are smaller, usually day-flying moths, whose caterpillars have abundant, branched spines. The eggs of all *Hemileuca* are deposited in a mass encircling a branch or twig and are easily seen on deciduous plants in winter. California is well-represented with at least nine species of *Hemileuca*, compared with two for the eastern half of the country.

◄ 583–584. CEANOTHUS SILK MOTH *Hyalophora euryalus*

This is probably California's most spectacular and commonly seen large moth.

ADULT: (583) Broad-winged (80–125 mm wings spread), with beautiful rose-red upper sides marked by white, crescent-shaped spots and crosslines of white; underside gray, white-flecked, and tinged with red.

LARVA: (584) Reaching a length of 100 mm; pale apple green with yellow protuberances on top of each segment, those of the first three segments larger and banded with black; smaller, pale blue tubercles on the sides.

HABIT: Larvae feed during late spring and summer; on *Ceanothus,* coffeeberry *(Frangula),* manzanita, willow, and other shrubs, including a population on Douglas Fir on the North Coast. Cocoon is gray, oval with the emergence end drawn out; firmly attached to branches of the host plant. Females release a chemical during early morning hours that attracts males. The moths are most active and often come to lights between midnight and dawn and are seen clinging to porches or storefronts in the morning, especially in spring.

RANGE: Coastal areas and mountains up to 2,700 m elevation. Flight is mostly in spring and early summer, though dramatically extended along the coast from February to July.

◄ 585. POLYPHEMUS MOTH *Antheraea polyphemus*

This species is slightly larger than the preceding (wing expanse 100–140 mm) but is not as commonly seen in most parts of California.

ADULT: The wings usually are tan (rarely tinged with olivaceous or reddish brown), each wing with a scaleless, windowlike, yellow-margined circular eyespot; those on hind wing surrounded by a large color spot of blue and black, resembling an eye.

LARVA: Pale green with oblique, pale yellow lines on each side and short tubercles arising from red spots.

HABIT: Larva feeds on a wide variety of broad-leaved trees and shrubs, especially birch in urban areas and oak elsewhere; historically a pest in stone fruit orchards, though many urban populations have declined precipitously in recent decades. The cocoon is white, oval without a drawn-out emergence neck. When the moth opens its wings upon disturbance, the wing markings give the illusion of large eyes suddenly opening, which is believed to frighten would-be predators.

RANGE: Throughout most of the state, except deserts, and only to moderate elevations; most common in the foothills, where oak is dominant. The only saturniid in California that has more than one generation per year, with as many as three in warmer areas.

▶ 586–587. COMMON SHEEP MOTH *Hemileuca eglanterina*

This day-flying moth appears from summer into fall, later at lower elevations; high-elevation populations can take two years to develop, overwintering as eggs, and then pupae. Females in this genus always lay egg rings.

ADULT: (586) Wing expanse 55–85 mm; relatively slender-bodied; variable but fore wing typically pink with a yellow streak in the middle outer area; hind wing yellow; variable black markings; an almost entirely black form occurs most commonly near Mount Shasta, and some individuals lack nearly all the black.

LARVA: (587) Black and colonial when young, with many-branched spines; head orange-brown and spines yellow or orange when full grown.

HABIT: Colonial when young, larvae wander as they mature, not as readily stinging to the human skin as are buck moths; larvae feed on wild rose, *Ceanothus,* coffeeberry *(Frangula), Purshia*, and many other shrubs. Females emerge in the morning, quickly calling in males to mate. Flight is erratic and very fast, the moths do not feed, and alight only to mate or lay eggs.

RANGE: Throughout much of the state, generally, but not exclusively, west of the Sierra Nevada crest; absent from the Central Valley except in the delta; highly localized along the immediate coast; restricted in southern California to the mountains.

Two similar species occur in sagebrush areas mostly east of the Sierra Nevada crest, though all three species may co-occur in some parts of the mountains: Nuttall's Sheep Moth *(H. nuttalli)*, the larvae of which feed on bitterbrush *(Purshia)* and snowberry *(Symphoricarpos)*; and the Hera Buckmoth *(H. hera)*, which feeds on sagebrush *(Artemisia)*. Both are pale-colored, lacking the pink tinge on the fore wing; *H. hera* has white wings with black stripes, *H. nuttalli* has a yellow hind wing and can be easily mistaken for some forms of *H. eglanterina*, *H. nuttalli* having a sudden, oblique angle to the apical dark line on the hind wings. Both of

these species can be seen perched on shrubs in their scrub habitat in the early morning.

NEVADA BUCK MOTH *Hemileuca nevadensis*

Similar in size to the Sheep Moths, but with a dark abdomen, having an orange or red tip; wings translucent white, black at base and apical margin, with a dark blotch surrounding a yellow eyespot on fore wing.

LARVA: Black with yellow stripes down back and sides; with yellow or brown branched spines.

HABIT: Larval spines render a stinging rash to sensitive areas of human skin; feeds on willow and poplar. The common name derives from a widespread eastern species that also flies in fall, during deer-hunting season.

RANGE: Riparian zones throughout the coastal plain in southern California, now declining in the Central Valley north to Merced; east of the Sierra Nevada it ranges north to at least Lassen County.

▶ 588. ELECTRA BUCK MOTH *Hemileuca electra*

Perhaps the most striking species in the genus, the Electra Buck Moth has at least four subspecies with differing coloration and habits.

ADULT: Wing expanse 54–80 mm, fore wings having variable amounts of white and black with prominent yellow discal spot, hind wings bright red-orange bordered with black;

LARVA: Black with tiny white spots and multiple lateral white lines and spots, prominent black and yellow spines that will sting the unwary.

HABIT: Colonial when young, larvae feed on California Buckwheat *(Eriogonum fasciculatum).* Pupates in flimsy silken cocoon in leaf litter at the soil surface. Like *H. nevadensis*, this species flies during the daytime in fall, from September to December, with a shorter flight season inland.

RANGE: Across lower elevations of southern California where host plant occurs, up to moderate elevations in the Mojave Desert. *Hemileuca electra* has been extirpated from much of its original range in coastal southern California due to development, as it requires relatively large patches of intact sage scrub to persist.

Hawk Moths and Sphinx Moths (Family Sphingidae)

Sphingids are moderate-sized to large moths with streamlined, stout bodies and elongate fore wings having a strongly oblique outer margin. The antennae are thickened toward the middle and tapered toward the tip, which is usually slightly hooked. Many species have a very long tongue, two or three times the length of the body, which is used to feed in

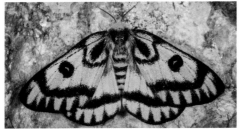

586. Common Sheep Moth (*Hemileuca eglanterina*) adult.

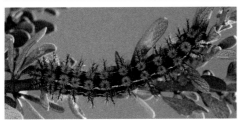

587. Common Sheep Moth (*Hemileuca eglanterina*) larva.

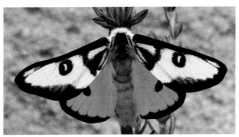

588. Electra Buck Moth (*Hemileuca electra*).

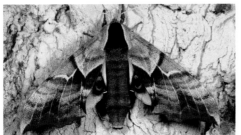

589. Eyed Sphinx (*Smerinthus cerisyi*).

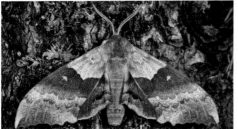

590. Western Poplar Sphinx (*Pachysphinx occidentalis*).

deep-throated flowers. Hawk moths, as the adults are called, are important pollinators for some plants. Most sphingids are nocturnal, but some species are day-flying moths that resemble hummingbirds or large bees when visiting flowers.

The caterpillars are smooth-skinned, without hairs or spines, and the eighth abdominal segment nearly always bears a thin spur or horn on the back, especially in the early instars. A wide variety of plants is eaten, although many species are quite specific in host selection, with larvae cryptically colored like the plant, even changing coloration through the instars to better match their host plant as they grow. The family name stems from the alarm posture of the larva. With its forequarter reared back and head tucked downward, it resembles the form of the Egyptian sphinx. Pupation occurs in a cell in or on the ground, without a cocoon. Most of the world's hawk moths occur in tropical regions. In California we have only about 25 species, a small number compared with the southeastern United States or Mexico.

◄ 589, 680. ► EYED SPHINX *Smerinthus cerisyi*

This species is one of California's most common sphingids and is often attracted to lights, especially late at night. There is some debate about whether western populations should be recognized as a different species, *S. ophthalmica*, based on limited DNA evidence.

ADULT: Moderate-sized (BL 20–32 mm; wing expanse to 90 mm); fore wing ragged-margined, gray or tan, with pale markings; hind wing rose pink, with dark blue circle enclosing a whitish spot, resembling an eye.

LARVA: (680) Green with a pair of subdorsal, pale yellow lines and six pairs of oblique, white bands above the spiracles; horn yellow, pink, or blue. Head triangular in later instars.

HABIT: Larva feeds on willow and poplar; when the moth is perched, it has a cryptic appearance, like dead leaves, but when disturbed the fore wings are brought forward, exposing the eyespots of the hind wing. The sudden appearance of the eyespots is believed to frighten potential predators.

RANGE: Throughout most of the state to at least 2,500 m, where host plants are present; infrequent in cities. Multiple generations per year at lower elevations. In southern California, *S. cerisyi* is replaced by *S. saliceti*, which is very similar in all respects, except the eyespot in the hind wing bisects the blue surrounding it and continues as a black streak to the hind wing margin.

◄ 590. WESTERN POPLAR SPHINX *Pachysphinx occidentalis*

This is the biggest sphingid in California.

ADULT: BL 38–50 mm; wing expanse to 150 mm. There are two color forms, one pale tan with faint brown crossbanding on the fore wing, and the

hind wing pale rose pink with an indistinct pale bluish eyespot; the other form is darker, gray-brown with a rose-purple hind wing.

LARVA: Green with fine white specks, pale, oblique lateral stripes, and a long brown anal horn.

HABIT: Larva on poplar and occasionally willow, different populations can be very particular about the host they will use.

RANGE: Low elevations throughout the warmer parts of the state, including deserts where host plants are present.

▶ **591. ELEGANT SPHINX** *Sphinx perelegans*

ADULT: BL 34–44 mm; wing expanse to 105 mm; fore wing nearly uniform gray, with a white band before the terminal margin; hind wing and abdomen banded black and white, thorax entirely black above.

LARVA: Bright green with broad, oblique white and purple bands on each side and a blue horn.

HABIT: Larva on manzanita *(Arctostaphylos)* and shrubs of the rose family.

RANGE: Coastal areas and mountains, including the Sierra Nevada up to about 2,000 m.

Several similar-appearing species occur in California, including the Chersis Sphinx *(S. chersis)*, which is more widespread but less common, with larvae feeding on ash *(Fraxinus)*. It is larger (wing expanse 90–115 mm), paler gray, and has the thorax pale gray with two black lines the length of the dorsum. The Sequoia Sphinx *(S. sequoiae)* is similarly colored but is much smaller (wing expanse 55–60 mm) and feeds on cedars and junipers in the foothills and mountains to moderate elevations.

▶ **592–593. BEAR SPHINX** *Proserpinus lucidus*

In December, January, and February, after adequate rains, this gorgeous small, fat, green sphingid appears at lights, often on rainy or unusually cold nights when little else is flying.

ADULT: (592) BL 18–24 mm; wingspread 40–50 mm; thickly clothed with woolly-appearing scaling; body and fore wing bright olive green with purple bands across the fore wing; hind wing dull rust with a green border.

LARVA: (593) Variable, usually green and black, venter gray-green, horn lost in later instars; dorsum with transverse white bands, each with a black patch in the middle; segments 4–9 with pairs of white dots and a row of oblique white lines below the red and blue spiracles.

HABIT: Larvae feed in early spring on a variety of low-growing Onagraceae, including evening primrose *(Oenothera)* in drier areas and various *Clarkia* and *Gaura* species when present.

RANGE: Inner foothills of the Coast Ranges, and those of the Sierra Nevada, and southern mountains, usually not above 500 m even in the south; rarely to 1,200 m in mountain valleys east of Sierra Nevada.

CLARK'S DAY SPHINX *Proserpinus clarkiae*

This is another small green sphinx moth in our region, although it is even smaller, and fore wings are paler green with white lines; hind wings are orange.

LARVA: Similar to *P. lucidus*, but the larva has white spiracle, not red and blue, and they develop a few weeks later in the season.

HABIT: The moth is diurnal, visiting flowers on warm spring afternoons; it uses the same larval host plants as our other *Proserpinus*.

RANGE: Inner slopes of the Coast Ranges and all mountains to 2,700 m, wherever host plants occur, although it is usually uncommon, and even scarce in southern California, populations will occasionally experience localized explosions before fading back into rarity.

▶ 594. WESTERN OR BUMBLEBEE
CLEARWING SPHINX *Hemaris thetis*

This moth flies during the daytime in late spring and summer and resembles a bumble bee as it hovers at deep-throated flowers for nectar.

ADULT: BL 16–23 mm; wings scaleless except reddish black at base, on the veins, and at the outer margin; body clothed with fluffy scaling, thorax olive to golden brown, abdomen black with a broad yellow band.

LARVA: BL to 45 mm; variable in color, pale green, thickly granulated with white, red-brown beneath; thoracic shield with a raised double row of yellow granules; body with a pale, lateral stripe; horn long, slender but sometimes lost.

HABIT: Larvae feed on Honeysuckle (*Lonicera*) and more commonly snowberry *(Symphoricarpos)* and other members of the honeysuckle family. Multiple broods at some, but not all, lower-elevation locations, usually most common in late spring, later at higher elevations, where the adults are smaller, with less black. Rarely at the coast. The pupa rests in a loose silk cocoon spun in leaf litter on the soil surface.

RANGE: Inner Coast Ranges and mountains throughout the state, often to 2,000 m, less commonly to 2,700 m.

▶ 595–596. WHITE-LINED SPHINX *Hyles lineata*

This is the most common and widespread sphingid in California, appearing occasionally even in urban coastal areas.

ADULT: (595) Moderate-sized (BL 25–45 mm; wing span to 95 mm); body and fore wing brown with pale tan markings and, of course, multiple thin

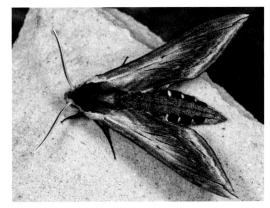

591. Elegant Sphinx (*Sphinx perelegans*).

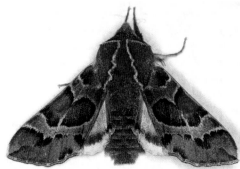

592. Bear Sphinx (*Proserpinus lucidus*) adult.

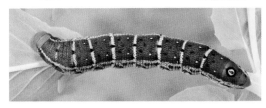

593. Bear Sphinx (*Proserpinus lucidus*) larva.

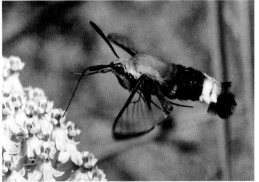

594. Western Clearwing Sphinx (*Hemaris thetis*).

white lines; abdomen spotted with black and white; hind wing pale rose pink with basal and marginal black bands.

LARVA: (596) Variable in color, ranging from green with thin, black lines to nearly entirely black with thin, pale lines; with the head and the short horn yellow or orange.

HABIT: Larvae feed on a wide variety of low-growing herbaceous plants. In late afternoon and at dusk the moths can be seen hovering like hummingbirds at petunias and other deep-throated garden flowers, and later at night they come to lights. Occasionally occurs in tremendous outbreaks, especially in desert areas after good rains. There, the larvae migrate in great hordes, devouring all annual vegetation, and have even been reported to slicken highways with their crushed bodies. Multiple generations.

RANGE: Throughout the state, including mountains to high elevations.

▶ 597. TOBACCO HORNWORM *Manduca sexta*

This species is one of California's largest and commonest sphingids, although it seems to be declining in urban areas.

ADULT: BL 40–55 mm; wing span 100–120 mm; fore wing dark gray with whitish and blackish wavy streaks and a distinct, white dot in the middle toward the leading edge; hind wing gray with indistinct white bands; abdomen with six yellow spots along each side.

LARVA: BL to 100 mm; green, blending well with tomato leaves, with oblique white streaks across the sides of body segments; tail horn brown or reddish.

HABIT: Larvae on tomato and other plants of the nightshade family; *Datura* is a common native host. The huge green caterpillar is familiar to home gardeners who grow tomatoes, the adults much less so. Pupa is dark brown with the tongue sheath separated, like a pitcher handle. There are usually two generations each year.

RANGE: The Central Valley and southward at low to moderate elevations. Occasional at the coast in gardens in the north, more common in southern urban areas.

The similar Five-spotted Hawkmoth (*M. quinquemaculata*) **(643)** is less common in California but nearly as widespread. It is often larger (wing span 110–130 mm) and has wavy black lines on the fore wing but no white dot, more distinct, wavy black lines on the hind wing and usually five yellow spots on each side of the abdomen. *Manduca sexta* was long known in popular literature as the Tomato Hornworm and *M. quinquemaculata* as the Tobacco Hornworm. However, the Entomological Society of America reversed the common names in its official list, which dictates usage by most professional entomologists, producing unnecessary confusion that will persist indefinitely.

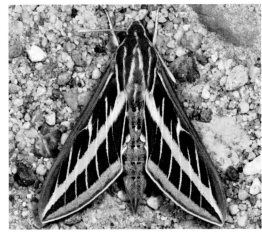

595. White-lined Sphinx (*Hyles lineata*) adult.

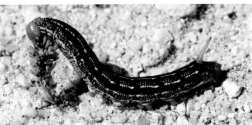

596. White-lined Sphinx (*Hyles lineata*) larva.

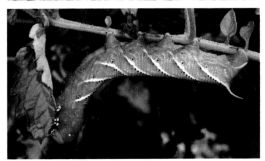

597. Tobacco Hornworm (*Manduca sexta*) larva.

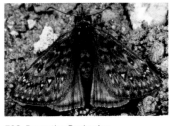

598. Propertius Duskywing (*Erynnis propertius*).

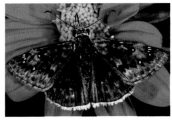

599. Mournful Duskywing (*Erynnis tristis*).

Skippers (Family Hesperiidae)

Compared to other butterflies, skippers are stout-bodied with relatively short wings. The head is large, and the antennae are widely separated at their bases, with the tip prolonged beyond the club to form a small, recurved point. The larvae are stout with a large head separated from the body by a constricted neck. They make silken shelters, and a weak cocoon is formed for pupation, in contrast to most butterflies.

There are three subfamilies represented in California, the Pyrginae, which are mostly black-and-white skippers whose larvae feed on a wide variety of broad-leafed plants, the Heteropterinae with one species, and the Hesperiinae, which are typically orange-and-brown species that feed on grasses. The family is a large and diverse one with more than 50 species in California. Representatives occur in nearly every habitat, from seacoast and low deserts to alpine places above timberline. The common name "skipper" derives from the powerful, erratic, jerky flight, which differs from the more uniform, fluttering or gliding maneuvers of other butterflies. When perched, Hesperiinae skippers usually hold the fore wings upright and the hind wings spread laterally, unlike most other butterfly groups.

◀ 598–599. DUSKYWINGS *Erynnis* spp.
Adults of this genus usually rest with wings held laterally like many other butterflies, they represent a series of brown, broad-winged skippers that occur across much of the state; the species of which can be very difficult to distinguish.

◀ 598. PROPERTIUS DUSKYWING *Erynnis propertius*
One of the state's most common skippers.
ADULT: Wing expanse 35–45 mm; broad brown fore wings heavily mottled and with extensive white spotting, hind wing lacking a white fringe.
LARVA: Dark brown head, body pale green.
HABIT: The larvae live in leaf rolls they make on newer growth of oaks.
RANGE: More common across central and northern California, occurring from sea level to at least 2,400 m elevation.

◀ 599. MOURNFUL DUSKYWING *Erynnis tristis*
This species also has a broad, mottled-brown fore wing and hind wing with white fringe.
LARVA: On new growth of oaks; it ranges throughout the state at lower and mid-elevations where oaks occur, including urban areas.

FUNEREAL DUSKYWING *Erynnis funeralis*
The very similar-looking Funereal Duskywing is the most widely distributed species of the genus in California among several that appear similar.

It can be distinguished from *E. tristis* by the pale brown patch on the outer, leading half of the fore wing and distinctly narrower shape of its fore wing. The wings are black and brown; fore wing relatively narrow with an indistinct pale area on the outer, leading half; hind wing broader with white marginal fringes.

LARVA: Black head with yellow spots; body pale green, yellow in the folds, marked with a yellow line on each side, and bearing a bright yellow spot on each segment; skin covered by short, pale yellow hairs.

HABIT: Larva feeds on various plants of the pea family including alfalfa and *Acmispon*; adults prefer more open, agricultural land than the preceding woodland species.

RANGE: *E. funeralis* is more common than the preceding species at low to moderate elevations from the Central Valley southward through southern California. There are several generations each season, and adults may be seen from February to October.

▶ **600. COMMON CHECKERED SKIPPER** *Pyrgus communis*

This is one of the most often seen skippers in northern California.

ADULT: Medium-sized (wing expanse 28–35 mm); dark gray or black, checkered with white; in males, body and basal areas of the wings covered by white hairs, giving a bluish appearance in flight.

LARVA: Yellow-white with delicate gray-green lines along the middle and sides of the back; head and collar black.

HABIT: Larva on various plants of the mallow family.

RANGE: Northern and central California. Occurring in a wide range of habitats, including vacant lots, throughout the year. In the southern half of the state, *P. communis* is almost completely replaced by its sister species the White Checkered Skipper (*P. albescens*), which is only distinguishable through genitalic dissection of the males—a feat not casually accomplished.

▶ **601. FIERY SKIPPER** *Hylephila phyleus*

This is the most abundant skipper around lawns in California's cities.

ADULT: Wing expanse 25–37 mm; males are bright yellow-orange, with blackish markings; females brown with yellow-orange markings; easily recognized by the yellow undersides speckled with small brownish dots.

LARVA: Yellowish brown to gray-brown with a black line along the back; head black with pale lines on the face.

HABIT: Larvae on various grasses, including lawn varieties. Much less commonly seen than the adults. Adults become more common through summer and fall until cold weather arrives.

RANGE: Urban and other lowland areas throughout the state; spreads to higher elevations as the season progresses but restricted to mild refugia

by winter; probably not cold-hardy. Abundant in southern California, where adults may be seen from March to December.

▶ **602. RURAL SKIPPER** *Ochlodes agricola*

This is the most frequently seen skipper throughout the wild habitats of the foothills and mid-elevation areas of the state in spring and early summer.

ADULT: Wing expanse 24–30 mm; deep ochreous orange in both sexes; fore wing with a strong, black diagonal mark in male; hind wing underside variable, from uniform ochreous orange to heavily mottled with purple-brown, defining a jagged, median band of ochreous orange.

LARVA: Head black; body yellow-tan with seven blackish, longitudinal lines.

HABIT: Larvae on various perennial grasses. Adult males are territorial, vigorously driving off interlopers.

RANGE: The Coast Ranges and the Sierra Nevada to mid-elevations in natural areas.

The Woodland Skipper (*O. sylvanoides*) replaces *O. agricola* after June in many places. It has a later flight period, on the wing from midsummer into fall. It lacks transparent white spots on the fore wing and tends to have more dark markings on the underwings. Curiously, on Santa Cruz Island, in the absence of *O. agricola*, it begins to fly much earlier, in spring, and continues throughout summer and into fall.

Gossamer-wing Butterflies (Family Lycaenidae)

Lycaenids are small, delicate butterflies, predominantly with metallic blue, coppery, orange, brown, or gray wings. The antennae are ringed with white, and frequently the undersides are white or some cryptic color that differs from the upper sides. The wings are held closed above the back when the insect is at rest. The larvae are grublike, tapering toward the ends, with broad, projecting lobes that conceal the head and legs. Most are clothed with short hairs, their form and color often blending remarkably with the plant on which they live. Most lycaenids are specific in food plant selection. Pupation occurs without a cocoon, and the pupa is stout, rounded in front and smooth with little or no freedom of motion of the abdominal segments.

There are three subfamilies in California; the Polyommatinae, or blues, of which there are about 25 species; the Lycaeninae, or coppers, represented by 12 species; and the Theclinae, or hairstreaks, with about 30 species.

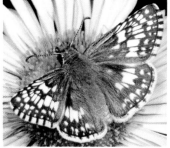

600. Common Checkered Skipper
(*Pyrgus communis*).

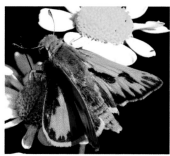

601. Fiery Skipper
(*Hylephila phyleus*).

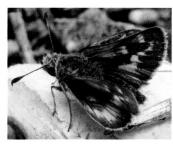

602. Rural Skipper (*Ochlodes agricola*).

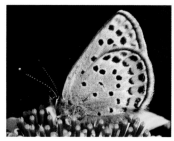

603. Acmon Blue (*Plebejus acmon*).

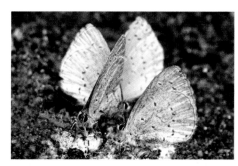

604. Echo Blues
(*Celastrina ladon*).

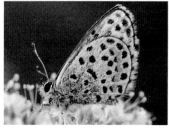

605. Bernardino Blue
(*Euphilotes bernardino*).

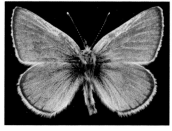

606. Xerces Blue
(*Glaucopsyche xerces*).

◀ 603. ACMON BLUE
Plebejus acmon

This species is the most generally distributed blue in California.

ADULT: Wing expanse 17–30 mm; wings metallic sky blue in the male, brown with variable basal blue in the female; hind wing with an orange band on the outer margin, pinkish and often reduced to a trace in the male; undersides whitish with black dots and a row of metallic blue or greenish dots at the edge of the orange band, color variable with the seasons.

LARVA: Yellowish with a narrow, green stripe down the back and variable markings on the sides, covered with short white hairs.

HABIT: Food plants are Deerweed (*Acmispon glaber*) and other plants of the pea family as well as buckwheats (*Eriogonum*).

RANGE: Throughout the state, from sea level up to 3,000 m in the southern mountains.

◀ 604. ECHO BLUE
Celastrina ladon

Sometimes listed as *C. echo*, this species is widespread but is usually seen only in small numbers, often flying in chaparral-covered areas.

ADULT: Wing expanse 22–35 mm; wings metallic powder blue with the leading and outer edges broadly margined with black in the female; darker at high elevations; undersides white with faint grayish speckling.

LARVA: Variable in color and markings, from green with reddish pattern to magenta with pale markings.

HABIT: On buds and flowers of various shrubs and trees.

RANGE: Throughout the state at a wide range of elevations, including urban areas, excepting lowest parts of the Central Valley and southeastern deserts. Double brooded at low elevations, where adults fly from January to July; the season is shorter for the single brood at high elevations.

◀ 605. BERNARDINO BLUE OR SQUARE-SPOTTED BLUE
Euphilotes spp.

These little blues have diverged into several geographical races/species with minor differences in size and color, possibly suggesting deeper divergence and diversity. There is active debate as to how many species to recognize and which species names should be applied to which populations, making precise identifications of many populations capricious at best.

ADULT: Wing expanse 17–27 mm; males are deep blue with a black margin on the wings; females are brown with a broad, orange bar just inside the hind wing margin; underside whitish with black spots and orange bars on the hind wing in both sexes. Typical populations occur at timberline in the high Sierra and have the underside spots large and nearly square; those of lower elevations have these spots smaller.

LARVA: Variable in color and pattern, pale green or yellow with brown subdorsal markings.

HABIT: The butterflies fly in close association with various buckwheats *(Eriogonum)* during the precise season when the plants are in bud, and the eggs are placed in the buds; larvae feed on flowers of buckwheats where they are very cryptic. Different species may share the same habitats but rely on different species of buckwheat, with different flowering times, effectively isolating the butterflies.

RANGE: Scattered at a wide range of elevations, from seacoast and deserts to high-mountain habitats. A local subspecies that is potentially a distinct species, the El Segundo Blue *(E. bernardino allyni)*, is restricted to a few remnant sand dunes in Los Angeles and was one of the first insects designated as an endangered species under the Federal Endangered Species Act.

◀ 606. XERCES BLUE *Glaucopsyche xerces*

One of the natural habitats most easily affected by the expansion of civilization is the unique and delicate community of sand dunes. Such areas have always been regarded as wastelands of no value to humans so they are destroyed by planting stabilizing vegetation introduced from other parts of the world, by urban growth, sand mining or, in recent years, by off-road vehicles that extend their influence far beyond the limits of normal urban sprawl. One of the casualties was the San Francisco sand dune system, from which plants and insects were collected and described before the western expansion of the city. The Xerces Blue occurred only on the San Francisco dunes, and the last individuals were seen alive in 1943. One of the few species of butterfly known to have become extinct during recorded U.S. history, it has given its name to the Xerces Society, a group of conservationists working to prevent the disappearance of other such endangered habitats that support unique invertebrates.

ADULT: Wing expanse 29–36 mm. There were several color forms, with males typically blue-violet with a whitish or silvery sheen, females brown with a tinge of blue basally on the upper side; underneath, individuals ranged from pale gray with black-pupiled, white eyespots to dark gray with white spots.

LARVA: Color variable, pale green with a darker line down the back, distinct, yellow oblique dashes on the sides, and a pale line along each side; on *Acmispon* and other plants of the pea family.

HABIT: An association with ants, which obtain a sugary solution from lycaenid larvae and provide feeding and protection, is known in certain other blues. This association may have been part of the delicate balance that was destroyed.

RANGE: Western San Francisco Peninsula; now extinct.

▶ 607. PURPLISH COPPER *Lycaena helloides*

ADULT: Wing expanse 18–32 mm; upper side in male brown with a metallic purplish sheen; with black markings and a row of reddish-orange crescents on the outer margin of the hind wing; female orange without the purplish sheen and with larger, darker markings; underside in both sexes ochreous to rust-orange with faint markings.

LARVA: Green with bright yellow stripes on the sides and a faint, oblique yellow dash on the side of each segment.

HABIT: Larva feeds on dock *(Rumex)* and knotweed *(Polygonum)*. May be in decline, especially in urban areas.

RANGE: Low to middle elevations throughout the state except in the deserts. Probably mostly mountains and coasts in the south. Colonies often occur in moist meadows or weedy lowland areas around cities. Adults fly from March to November, more common in the fall.

▶ 608. COMMON OR GRAY HAIRSTREAK *Strymon melinus*

Also known as the Bean Lycaenid and the Cotton Square Borer owing to its adaptability to a wide range of food plants, this species is California's most widely distributed lycaenid.

ADULT: Wing expanse 20–32 mm; wings mouse gray above with an orange spot on the outer, hind margin, preceding a thin tail-like extension of the hind wing; underside paler, ash gray with white-margined black lines and a more extensive orange and blue marginal spot.

LARVA: Green with oblique markings of varying colors on the sides and covered with short, yellowish-brown hairs.

HABIT: Larva on an extremely wide variety of plants.

RANGE: Throughout lowland and foothill areas of the state, often common around cities and agricultural areas; will stray to higher elevations. The butterflies may be seen from February to November in southern California. A similar species, the Avalon Hairstreak *(S. avalona)*, occurs only on Santa Catalina Island, while the Gray Hairstreak occupies most of the other Channel Islands but not Catalina.

▶ 609. BRAMBLE, JUNIPER, THICKET HAIRSTREAKS, AND ELFINS *Callophrys* spp.

There are many, highly varied species in the genus (the species of which used to be spread across three genera—and may yet again be in the future!). The taxonomy is still under active debate, making precise identification of many populations very difficult, even for experts.

ADULT: Wing expanse 24–33 mm. This is a diverse genus. Some species have bright green underwings, while in most others, they are brown with variable white markings; upper sides are usually a shade of brown.

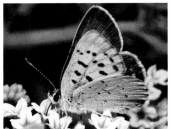

607. Purplish Copper
(*Lycaena helloides*).

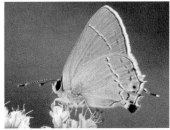

608. Common Hairstreak
(*Strymon melinus*).

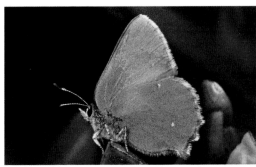

609. Bramble Hairstreak
(*Callophrys dumetorum*).

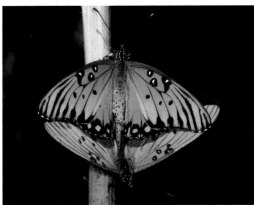

610. Gulf Fritillary
(*Agraulis vanillae*) female
above, male below.

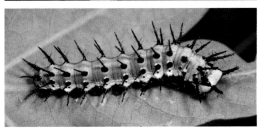

611. Gulf Fritillary
(*Agraulis vanillae*) larva.

LARVA: Small, variably green or yellow, often with white and brown flecks that make them extremely cryptic on their host plants.

HABIT: Most species are fairly host-specific, but the genus has a wide range of hosts including conifers, mistletoes, and some herbaceous plants (especially Buckwheats and Deerweed). Males often perch prominently on vegetation, darting out erratically and returning to the same spot. Usually found in the vicinity of the host plant.

RANGE: Throughout the state, where their host plants occur, including the coasts, mountains, and deserts, although many species are quite restricted.

Brush-footed Butterflies (Family Nymphalidae)

Nymphalids include a wide variety of medium-sized butterflies, all of which have the fore legs reduced and not used in walking in either of the sexes. The apical parts of these legs are short and clothed with long hairs, giving rise to the common name, brush-footed butterflies. These butterflies are broad-winged, usually strong fliers, and many are known to live for several months and to travel long distances. The larvae usually are cylindrical and armed with numerous protuberances bearing spines, but they do not irritate human skin. The pupae are characteristic in form for each group and often bear prominent tubercles or spines. They are suspended head downward, hanging by hooks attached to silk buttons prepared by the larvae. A great diversity of flowering plants serve as larval food, with specialization to one or a few by most nymphalid species.

Larvae of the subfamily Danainae, represented in California by the Queen *(Danaus gilippus)* and the **Monarch *(D. plexippus)* (612–613)**, are smooth with two or three pairs of fleshy filamentlike processes rather than spines. They feed on milkweed, which renders both larvae and adults distasteful to vertebrate predators. In other parts of the country, danaines are mimicked by adults of other nymphalids, which vary in their distastefulness, and share protection from birds that have learned by experience to avoid the danaines. There is some recent evidence that at least some of these mimics are as toxic as the Danainae, suggesting a more complex evolutionary process in which the different species converge in appearance to avoid predation. With more than 50 species in California, the family Nymphalidae has more members than any of the other families of butterflies, except maybe the skippers.

◀ 610–611. GULF FRITILLARY *Agraulis vanillae*
This species is not native in California but has long been a resident in urban areas, dependent on ornamental passion vines for larval feeding.

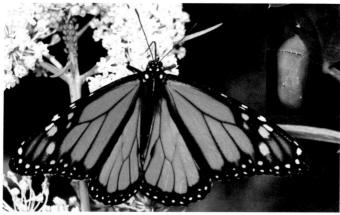

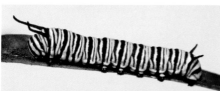

612. Monarch
(*Danaus plexippus*) adult, pupa
(chrysalis, inset).

613. Monarch
(*Danaus plexippus*) larva.

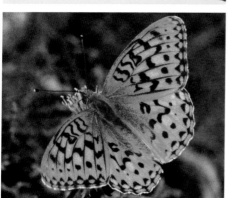

614. Fritillary (*Speyeria* sp.).

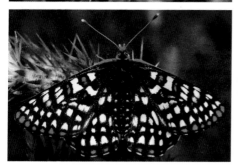

615. Chalcedon Checkerspot
(*Euphydryas chalcedona*).

ADULT: (610) Wing expanse 50–80 mm; wings bright rust-orange in the male, red-brown in the female, with black spotting; underside resplendent with elongate silver spots; fore wing relatively narrower than in other nymphalids.

LARVA: (611) Slate gray with deep orange stripes along the sides and black branched spines.

HABIT: Larva feeds on passion vines *(Passiflora)*, especially *P. caerulea* with five-lobed leaves.

RANGE: Urban and rural areas of southern California and coastal cities of the San Francisco Bay Area. In mild years the northern populations expand to inland areas where they are unable to survive winter freezing.

◀ 612–613. MONARCH *Danaus plexippus*

Probably the world's best known butterfly, the Monarch is often used to symbolize natural beauty and butterflies in general. Its form and colors appear on everything from advertisements for bathroom tissue to floats in the New Year's Rose Parade. This species occurs throughout most of North America. It is the insect best known to regularly migrate on a seasonal cycle, moving northward through spring and summer, while passing through two or three generations. The descendants migrate southward in fall to establish overwintering aggregations along the coasts and in Mexico. On the Pacific Coast these occur in groves of trees from Sonoma County to the Mexican border and have given rise to local protection measures, where the butterflies are a tourist attraction.

ADULT: (612) The largest nymphalid in California (wing expanse 80–100 mm); wings rust-orange, darker in females, with black veins and black margins, marked with white dots.

LARVA: (613) Green with bands of black and yellow, and two pairs of long filaments, on the second and next-to-last body segments.

HABIT: Larvae on milkweed *(Asclepias)*.

PUPA ("CHRYSALIS") (SEE INSET IN 612): Pale green with a thin black belt and raised golden spots.

RANGE: Individuals may be seen almost anywhere in the state, but breeding is restricted to lower- and middle-elevation areas and overwintering to the immediate coast.

◀ 614. FRITILLARIES or SILVERSPOTS *Speyeria* spp.

Members of this genus are among the most familiar butterflies in mountain meadows.

ADULT: Wing expanse 38–80 mm; orange with black markings on the upper sides; hind wing undersides usually spangled with silver spots.

LARVA: Black or brown with lighter, lengthwise stripes that are distinct or formed of speckles; six rows of branching, often pale-colored spines.

HABIT: Larvae are (often) nocturnal feeders, always on violets (*Viola*) in spring. About eight species occur in California; in each the wing markings and colors vary slightly from one locality to another, and industrious lepidopterists have applied myriads of names to the differing populations. Most are similar in appearance, and three or more species may occur together. Females can fly until late in fall.

RANGE: Foothills and mountains throughout the state except in the desert ranges.

◄ 615. CHALCEDON CHECKERSPOT *Euphydryas chalcedona*

This is one of our most abundant late-spring butterflies.

ADULT: Wing expanse 34–64 mm; wings mainly black, with yellow and red spots on the upper side, red-orange beneath with broader yellow spots. In desert areas the butterflies are more red on the upper sides.

LARVA: Black with branched spines, a row of red-orange spots along the back and variable white banding on the sides.

HABIT: Larva feeds on Bush Monkeyflower *(Diplacus aurantiacus)*, *Penstemon*, *Scrophularia*, and many other plants, especially in the plant families Plantaginaceae, Scrophulariaceae, and Phrymaceae. Larvae often disperse to other plants when nearly fully grown. Pupa is bluish white with fine, black speckling and raised orange spots on the abdomen.

RANGE: Coastal and foothill areas to moderate elevations throughout the state and in the desert ranges.

► 616. MYLITTA CRESCENT *Phyciodes mylitta*

This small butterfly occurs in meadows and disturbed areas, including vacant lots, often with only skippers as company.

ADULT: Wing expanse 26–37 mm; bright orange with black spots and a white fringe, underwings dull orange and white. Females darker.

LARVA: Black, spiny, with lateral white markings.

HABIT: Larvae on both native and alien thistles. The most common crescent in populated areas, it has a gliding flight, often along paths, perches on the ground or low-growing vegetation.

RANGE: Throughout the state, except for the low desert, wherever the host plants occur. Flying from early spring to late fall.

FIELD CRESCENT *Phyciodes campestris*

Often co-occurs with the Mylitta Crescent but has two distinct flight periods per year.

ADULT: The upper wing is mostly black with orange markings, underwing uniformly cream-colored, almost identical in size to the former species.

HABIT: Larvae feed gregariously on Asters.

RANGE: Widespread in the northern half of the state.

▶ 617. SATYR ANGLEWING
Polygonia satyrus

This species is one of several similar-looking *Polygonia* in California.

ADULT: Wing expanse 42–52 mm; wings appear ragged on the margins, orange on upper side with brown markings; underside brown with pale and darker, wavy markings, hind wing with a comma-shaped, silver mark in the middle.

LARVA: Black with a broad stripe along the back and extensive mottling of greenish white; each segment with seven many-branched, greenish-white spines.

HABIT: Larva feeds on Stinging Nettle *(Urtica dioica)* and creates a characteristic shelter by partially cutting the midrib from beneath, causing the leaf to droop downward, and the larva draws the margins together from beneath with silk. The resulting tents are distinguishable from those of the Red Admiral *(Vanessa atalanta)* **(621)**, which feeds on the same plant but creates its shelter by drawing the leaf margins upward, exposing the lower side of the leaf. Adult is commonly seen in wet areas, especially shaded canyons. Adults hibernate and can appear on warm winter days, although they are most often seen from early spring through fall. They often perch with wings folded up, sometimes on the underside of trunks, taking advantage of their excellent camouflage. Rarely nectar at flowers.

RANGE: Coastal areas and mountains to moderate elevations, possible wherever Stinging Nettle grows; occasionally seen in cities.

▶ 618. CALIFORNIA TORTOISESHELL
Nymphalis californica

This species is best known for its massive outbreaks that occur at irregular intervals.

ADULT: Medium-sized (wing expanse 45–60 mm); ragged-margined wings, orange, broadly margined and spotted with black; underside dark brown mottled with tan and dark blue.

LARVA: Black with numerous white dots each bearing a short hair and with seven long, branched spines on each segment, those of the midback yellow.

HABIT: Larvae feed on *Ceanothus*, especially new growth. Adults overwinter, their larval progeny feed in spring or early summer, and the new brood of butterflies emerges from June in the Coast Ranges through to early August at higher elevations, when the mass movements begin. In good years butterflies by the millions move up in spring and down in fall from the mountainslopes and have been reported in newspapers to hinder motorists' visibility and to slicken highways. Following these outbreaks, individuals appear (sometimes migrating in great numbers) in distant places, as far away as British Columbia and the Midwest states. In succeeding seasons, these migrants sometimes give rise to temporary colonies as far south as San Diego in 1952, 1960, and 1972–73. They can

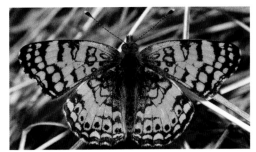

616. Mylitta Crescent (*Phyciodes mylitta*).

617. Satyr Anglewing (*Polygonia satyrus*) larva.

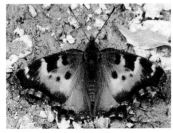

618. California Tortoiseshell (*Nymphalis californica*).

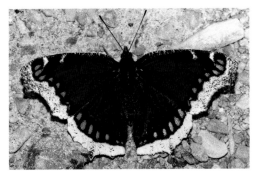

619. Mourning Cloak (*Nymphalis antiopa*).

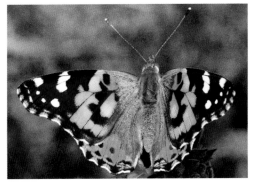

620. Painted Lady (*Vanessa cardui*).

also be very scarce or absent from a region for years only to become common again, showing the difficulty in estimating trends in insect populations over time.

RANGE: Probably a continuous resident only at mid-elevations (1,500–2,500 m) in the Coast Ranges, the Cascades, and the Sierra Nevada. Adults usually descend to overwinter in low elevations, migrating upslope in spring and summer.

◀ 619. MOURNING CLOAK *Nymphalis antiopa*

One of our most familiar butterflies.

ADULT: Wing expanse 60–90 mm; wings rich charcoal-brown or black, tinged with deep, lustrous purplish when fresh, with a yellow border preceded by a row of pale-blue spots; underside mottled black and brown with a dull yellow border.

LARVA: Feeding in a group when young, later dispersing and more or less solitary; black with seven rows of long, thin spines, white speckling, and a row of dull orange spots along the back.

HABIT: Larva feeds on willow, elm, alder, and poplar. Adults are long-lived, overwinter, and occasionally fly on warm winter days so the Mourning Cloak may be seen in any month in coastal areas.

RANGE: Throughout the state, including urban centers, except at the very highest elevations; in the deserts only in willow-lined mountain canyons.

◀ 620. PAINTED LADY *Vanessa cardui*

One of the best known, least variable, and most cosmopolitan butterflies in the world, the Painted Lady periodically migrates in large numbers northward throughout California, especially in spring after good rains in the southern deserts.

ADULT: Wing expanse 42–65 mm; similar in appearance to the West Coast Lady and American Painted Lady but often larger, fore wing with rounded margins and without the blue-pupiled eyespots of the hind wing.

LARVA: Lilac-colored with black spots and yellow, black, and white lines separating the segments, with the branched spines short and dark.

HABIT: Larvae on thistle *(Cirsium),* mallow *(Malva),* and other low-growing plants. In years when great population outbreaks occur in the deserts, a wide variety of plants is used by successive northward-moving generations. Northern colonies, however, usually die out during winter.

RANGE: Probably a permanent resident only in the deserts and coastal areas of southern California.

WEST COAST LADY *Vanessa annabella*

The West Coast Lady is very similar to the Painted Lady, except in color; occasional natural hybrids of the two are known.

ADULT: Wing expanse 38–55 mm; wings orange with black markings, hind wing with a row of four black-bordered, pale blue spots; fore wing underneath rose-pink with blue-gray and whitish markings; hind wing dull-colored, mottled in bluish and grays.

LARVA: Variable in color, usually black with orange blotches, covered with fine hairs and with seven pale, branched spines on each segment.

HABIT: Larvae on mallow *(Malva)* and related plants and nettle *(Urtica)*. The caterpillar forms a cup-shaped "nest" by pulling the margins of the leaf upward with silk. The West Coast Lady is more often seen in numbers than the Painted Lady (except during outbreaks), especially in weedy areas.

RANGE: Throughout most of the state, all year long in milder climates, scarce in the deserts. The least common (though not rare) of the three ladies, the American Painted Lady (*V. virginiensis*), can be distinguished by prominent eyespots on the underside of the hind wing.

▶ 621. RED ADMIRAL *Vanessa atalanta*

This species is widely distributed but not usually observed in large numbers.

ADULT: Wing expanse 44–60 mm; wings black above with a transverse, orange band followed by white spots in apical part of fore wing and a broad, orange border on hind wing; underneath the transverse band is pink on the fore wing, and the wings are mottled with brown and blue.

LARVA: Black-studded with whitish granulations and seven light-colored, branched spines on each segment.

HABIT: Larva feeds on nettle *(Urtica)* and related plants. Adults overwinter and are most often seen in cities during fall months as they seek shelter for winter.

RANGE: Throughout most of the state at a wide range of elevations, although scarce in the desert ranges. The butterflies may be seen through-out the year in coastal areas.

▶ 622. CALIFORNIA SISTER *Adelpha californica*

This is one of California's most easily recognized butterflies, with its broad wings and characteristic sailing flight as it glides among oak trees.

ADULT: Wing expanse 55–80 mm; wings black with a transverse band of white spots and a broad, orange spot before the tip of the fore wing; underneath these markings are less distinct and the wings have blue and reddish bands and spots.

LARVA: Dark green above, paler below, with six pairs of green fleshy tubercles.

HABIT: Larvae feed on a variety of oaks, adults are, to some degree, distasteful to birds.

RANGE: Foothills and middle elevations of mountains throughout the state. Occasionally in cities. May stray beyond its normal habitat. Lorquin's Admiral *(Limenitis lorquini)* is an unrelated species that resembles the California Sister but does not have its gliding flight. California lacks the famous Viceroy-monarch mimicry phenomenon, but this provides a unique analog.

ADULT: Similar to the preceding species but fore wing with a narrower orange patch extending to the tip; wing expanse 50–70 mm.

LARVA: A bizarre creature resembling a bird dropping, olive brown with yellowish markings on the thorax and a whitish, midabdominal patch on the back and two fleshy protuberances extending forward from the second segment.

HABIT: Larva feeds on willow, poplar, and occasionally plants of the rose family, including apple and wild cherry. Lorquin's Admiral often occurs along willow-lined creeks and trails, where plucky males establish perch stations and dash out to harass passing insects or objects thrown by the intrepid naturalist.

RANGE: Coastal areas, inland valleys, and mountains to moderately high elevations.

▶ 623. BUCKEYE *Junonia coenia*

The Buckeye is familiar to most naturalists for its distinctive appearance.

ADULT: Wing expanse 35–52 mm; wings brown, marked on the upper sides by a large and small eyespot on each wing and by basal orange bars and a broad white blotch on the fore wing; underside of fore wing similar to upper side, mottled in dull brown, red-brown, or olive on hind wing.

LARVA: Dark with longitudinal stripes of pale yellow and short, branching spines.

HABIT: Larva feeds on plantain *(Plantago)* and related plants and on members of several other families (e.g., Verbenaceae) from which it derives alkaloids that render it (but not the subsequent adult) distasteful. Adults perch with wings spread and fly throughout the year in warmer areas, being most abundant in fall.

RANGE: Throughout the state at a wide range of elevations, scarce in the deserts.

Subfamily Satyrinae

Satyrines are medium-sized, brown or off-white butterflies with round-margined wings that have some of the veins greatly swollen at the base. Most species have some form of eyelike wing spots, at least on the undersides. The butterflies usually perch with the wings closed, and the

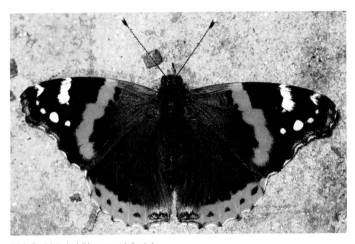

621. Red Admiral (*Vanessa atalanta*).

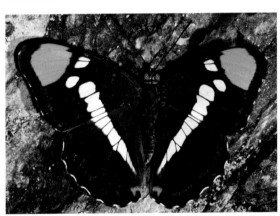

622. California Sister (*Adelpha californica*).

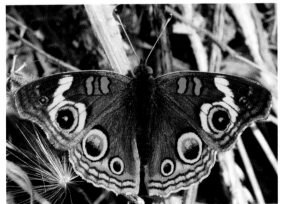

623. Buckeye (*Junonia coenia*).

eyespots are believed to provide protection from predators by deflecting the point of attack from vital body parts. The flight is weak and of a characteristic bouncing gait, unlike that of other butterflies. Satyrines usually seek sheltered spots on the ground where they perch motionless as a means of escape. The larvae are spindle-shaped, tapering at each end. The head is often horned, and the tail end has a pair of short, backwardly directed processes. The body otherwise lacks spines or protuberances. Most species feed on grasses.

This subfamily is primarily a temperate zone or boreal group, often restricted to mountainous regions, with seven species occurring in California.

▶ 624. COMMON RINGLET *Coenonympha tullia*

One of the state's most ubiquitous and abundant butterflies, this species is sometimes overlooked owing to its low flight and mothlike appearance. **ADULT:** Wing expanse 24–38 mm; wings whitish above, mottled with gray or tan beneath; hind wing with small, circular ring spots. The colors and number of spots vary seasonally and geographically, with darker forms in early spring and ochreous forms in summer and east of the Sierra Nevada. **LARVA:** Olive green or brownish, marked with light and dark longitudinal lines. **HABIT:** Larvae feed on perennial grasses, apparently including introduced species. Flies from spring through late fall. **RANGE:** Foothill and oak woodland areas throughout California, outside the deserts.

▶ 625. GREAT BASIN WOOD NYMPH *Cercyonis sthenele*

Contrary to its common name, this species occurs throughout California and is often one of the only butterflies active in California's extensive grasslands throughout the drier parts of summer, especially in the late afternoon and evening. **ADULT:** Wing expanse 35–43 mm light brown, with irregular darker brown lines and two distinct eyespots on the underside of the fore wing. **LARVA:** Green with dark dorsal stripe and white lateral stripes. **HABIT:** Larva feeds on grasses. Adult has a distinctive, jerking flight pattern. Usually perches with wings held closed. **RANGE:** Throughout the state except for the Central Valley and desert areas, including Santa Cruz Island. The Common Wood Nymph *(C. pegala)* (wing expanse 48–68 mm) has uniformly brown wings with bigger eyespots on the wings surrounded by pale scaling; the lower eyespot is at least as large as the upper one. It is more common in coastal areas, occurring in the northern half of the state.

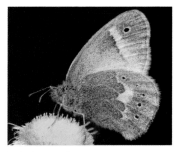

624. Common Ringlet
(*Coenonympha tullia*).

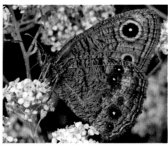

625. Great Basin Wood Nymph
(*Cercyonis sthenele*).

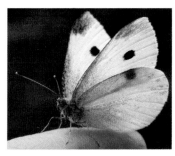

626. Cabbage Butterfly (*Pieris rapae*).

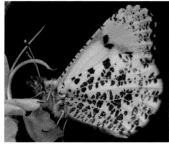

627. Sara Orange-tip (*Anthocharis sara*).

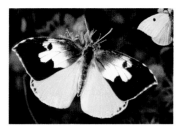

628. California Dogface
(*Zerene eurydice*) male, female wing
pattern (inset).

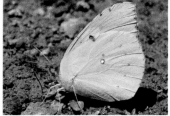

629. California Dogface
(*Zerene eurydice*) showing
underwing.

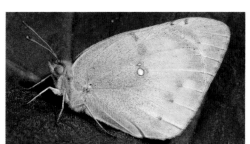

630. Alfalfa Sulfur
(*Colias eurytheme*).

Whites and Sulfurs (Family Pieridae)

Included in the family Pieridae are some of our most familiar butterflies, the whites and sulfurs. They are mostly medium-sized, yellow or white with black markings, and are strong fliers, occurring for the most part in open areas. The larvae are rather elongate with the segments divided by creases into ringlike sections; the body is covered with numerous short hairs but has no spines or protuberances. Most pierids feed on plants of either the mustard or pea families. Pierids have diversified in all regions of the world. About 25 species are resident in California, occurring in a wide range of habitats from the deserts and coasts to timberline.

◀ 626. CABBAGE BUTTERFLY OR IMPORTED CABBAGEWORM *Pieris rapae*

Probably this is the most economically injurious butterfly in the world.

ADULT: Wing expanse 38–52 mm; white, fore wing with black tips; male has a single black spot on each wing, female has two on the fore wing, one on the hind wing; underneath yellowish, fore wing with upper side spots repeated.

LARVA: Pale green, finely dotted with black, with a yellowish stripe down the back and a row of yellowish spots on each side.

HABIT: Larva feeds on all kinds of cultivated and weedy plants of the mustard family. Originally widely distributed in the Old World, the species was introduced into North America more than a century ago and now occurs throughout the United States in association with gardens, truck crops, and weed fields; ubiquitous in natural areas as well.

RANGE: Throughout low- to mid-elevation parts of California, although scarce in the deserts. The adults fly throughout the year in coastal areas.

◀ 627. SARA ORANGE-TIP *Anthocharis sara*

This is one of our commonest and most distinctive spring butterflies.

ADULT: Wing expanse 28–46 mm; male white with the apical one-third of the fore wing reddish orange, bordered by black; female either white or yellow, with a paler, less well-defined orange tip; beneath, wings heavily mottled with dark green in the early spring generation, less strongly so in the late spring brood that consists of larger but less numerous individuals.

LARVA: Green with a wide, yellowish stripe along each side above the legs, bordered below by a darker green area; back mottled with black dots with an indistinct darker line.

HABIT: Larva feeds on various plants of the mustard family, including ornamentals.

RANGE: Throughout much of the state, except the Central Valley and highest elevations; has adapted to urban areas. A small, dark race occurs in the mountains of the Mojave Desert.

◀ 628–629. CALIFORNIA DOGFACE *Zerene eurydice*

This is California's official state insect, so designated by the state legislature in 1972.

ADULT: Wing expanse 48–65 mm; male **(628)** has a yellow silhouette of a dog's head, defined by black over the outer half of the fore wing; fresh specimens have a beautiful violet iridescence; hind wing **(629)** yellow with or without a black border; female **(see inset 628)** usually is entirely yellow with a black spot at the position of the dog's eye, but occasional specimens have clouded blackish markings that poorly define the dog's head; undersides variable, from ochreous to pinkish.

LARVA: Dull green with a white lateral line, edged below with orange.

HABIT: Larva feeds on False Indigo *(Amorpha californica).*

RANGE: Foothills of the Sierra Nevada and Coast Ranges from the latitude of Sonoma County south to the Mexican border; more abundant in the south.

A similar species, the Southern Dogface *(Z. cesonia),* occurs in the deserts. It lacks the violet iridescence, and females normally are marked with the dog's head pattern.

◀ 630. ALFALFA SULFUR OR ALFALFA
CATERPILLAR *Colias eurytheme*

This butterfly swarms around alfalfa fields in agricultural areas and occurs widely in natural and weedy situations.

ADULT: Wing expanse 32–55 mm; male is yellow-orange with a distinct black border on the upper side of the wings; females have two forms, white and yellow-orange, and have clouded, blackish markings. The amount and intensity of orange are seasonally variable.

LARVA: Dark green with a white line on each side above the legs that borders a narrow reddish line.

HABIT: Larvae on alfalfa, clovers, and other plants of the pea family. Populations build toward fall, when they become even more abundant.

RANGE: Almost everywhere in the state, even at high elevations. The very similar Yellow or Clouded Sulfur *(C. philodice)* lacks an orange tinge to the yellow ground color. It is a more widespread species through the United States but occurs in California only in Great Basin areas of the Modoc Plateau and east of the Sierra Nevada and in the Imperial Valley, apparently spreading from the eastern United States in the past century.

Swallowtails (Family Papilionidae)

The Papilionidae includes the swallowtails and parnassians, some of the most magnificent of all insects. Most species are large with showy colors; although variable in form, the hind wings of most have conspicuous, tail-like extensions at the end of one or more veins. Larvae of swallowtails are smooth or provided with fleshy tubercles, while those of parnassians have clumps of hairs arising from raised spots. Papilionid larvae have characteristic organs called osmeteria, that consist of a forked sac that is protruded through a slit on the back of the first body segment. When disturbed, the larva everts the osmeterium and emits a strong odor, varying according to species, and often extremely disagreeable to mammals. The horn-shaped organ usually is bright orange or pink and contrasts sharply with the cryptic color of the larva. The pupa or chrysalis of swallowtails is also cryptic in form and color. It is formed head-upward and held by a girdle of silk at the middle and a button of silk at the tail. Parnassians pupate in a frail silken cocoon among leaves. Usually a few related plants are fed upon by larvae of any given species. In many cases the plants render the larvae and adults distasteful to vertebrate predators, so papilionids often serve as the models for mimicry by other insects, especially in the tropics.

The alpine or boreal parnassians are large, white butterflies having tailless, rounded wings with black and orange spotting. Three species occur in California and are sometimes common in Sierran meadows. The larvae feed on stonecrops *(Sedum)* or bleeding heart *(Dicentra)*. Most papilionids are tropical, with only a small representation reaching North America north of Mexico. Only about a dozen species occur in California.

▶ 631–632. ANISE SWALLOWTAIL *Papilio zelicaon*

This is our commonest swallowtail around cities.

ADULT: (631) Wing expanse 65–90 mm; yellow with black markings; black band on hind wing with yellow marginal crescents, preceded by bluish crescents, ending in an orange-margined eyespot at the inner corner; underside with considerable orange scaling in the yellow areas.

LARVA: (632) First three stages black with a white blotch on the back, resembling bird droppings; last two stages green, striped with black on each segment, with orange spots in the black bands, resembling plant colors, especially when feeding on flower heads.

HABIT: Larvae feed on Anise or Sweet Fennel (Foeniculum), other members of the parsley family (Apiaceae), and citrus. The spread of invasive fennel likely helped to dramatically increase its range.

RANGE: Throughout most of the state at a wide range of elevations but most abundant at low elevations near the coast. In southern California

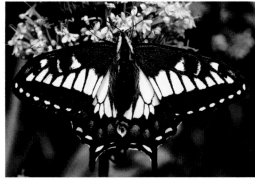

631. Anise Swallowtail (*Papilio zelicaon*) adult.

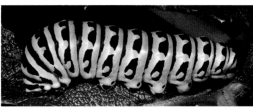

632. Anise Swallowtail (*Papilio zelicaon*) larva.

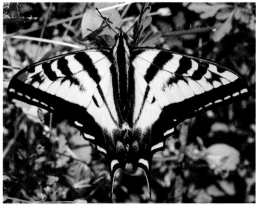

633. Western Tiger Swallowtail (*Papilio rutulus*).

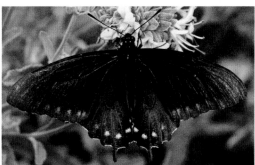

634. Pipevine Swallowtail (*Battus philenor*).

the butterflies may be seen throughout the year. Common in cities where the host plants occur.

◄ 633. WESTERN TIGER SWALLOWTAIL *Papilio rutulus*

This species is also a familiar sight around cities, especially where willows or sycamores are planted.

ADULT: Wing expanse 70–105 mm; yellow with black markings; the black hind wing margin contains yellow crescents, faint bluish crescents toward the tail end, and a crescent of orange at the hind corner.

LARVA: Deep green with a yellow line, edged with black on the back of the fourth body segment; has two yellow, black-bordered spots pupiled with blue; these resemble eyes when the larva is at rest with the head and first two segments tucked under.

HABIT: Larvae on willow, poplar, and sycamore.

RANGE: At low to middle elevations throughout the state except in the deserts. Has adapted even to city centers where sycamore is planted. A similar species, the Pale Swallowtail *(P. eurymedon),* has a white rather than bright yellow background color. It is less common but often occurs in the same areas as the Western Tiger Swallowtail.

◄ 634. PIPEVINE SWALLOWTAIL *Battus philenor*

ADULT: Wing expanse 60–95 mm; black with metallic greenish-blue sheen and a row of white spots on the hind wing; beneath, the wings are magnificently colored in metallic blue-green with a row of bright orange and white spots on the hind wing.

LARVA: Black with bright reddish-orange tubercles.

HABIT: Larva is only on Dutchman's Pipevine *(Aristolochia californica).* The larvae and adults are protected from vertebrate predators by distastefulness originating from the food plant.

RANGE: Common, though highly localized, in the Central Valley, foothills of the Coast Ranges (including San Francisco) and the Sierra Nevada in the northern half of the state, where the butterflies are smaller and densely hairy. The larger, typical form is taken occasionally in southern California, but no pipevine is known there, and these may be wandering individuals from populations in Arizona.

Ants, Wasps, and Bees (Order Hymenoptera)

Hymenoptera is an enormous order, with the second-largest number of described species, and many thousands of forms awaiting discovery. As with many others groups of insects, DNA data has revealed unexpected

evolutionary relationships across Hymenoptera, changing long-held associations and fomenting active debate, which continues today. Our understanding of how the different groups of Hymenoptera are related to each other is still in flux, again exemplifying how little we know about basic relationships even within such a highly recognizable group of insects.

Members of the order Hymenoptera are insects with two pairs of membranous wings, often with the venation greatly reduced, or they are wingless in one or both sexes, certain castes, or in certain seasons. The mouthparts are adapted for biting, and the abdomen is usually strongly constricted at the second segment with the basal segment (propodeum) fused to the thorax. Females are equipped with an ovipositor that is adapted for sawing or piercing, allowing them to insert eggs into plants or insects, or it may be modified for stinging. Most painful "bites" caused by insects are actually the stings of female Hymenoptera. Few members of this order bite strongly enough to affect humans, and the males cannot sting as they lack ovipositors. Using the stinger, female ants, wasps, and bees can inject a mixture of proteins and enzymes that act on the tissues of the victim as toxins or cause the release of histamines in mammals. In humans, depending on individual sensitivity, the effects may be severe.

Many Hymenoptera live during the larval stage as parasitic forms or parasitoids (i.e., parasitic forms that ultimately kill the host) within the bodies of other insects. There are many families of these parasitoids with great diversity, varying in structure and habits according to the family and kinds of insects parasitized. Many are tiny, little-known insects— likely more than half the species of this entire order will turn out to be parasitoids. In nonparasitic forms there is a great diversity of behavioral adaptation and structural modification: sawflies produce caterpillar-like larvae that feed on leaves; wasps paralyze insects or spiders and transport them to nests to feed their legless, grublike larvae; bees gather pollen for their young.

In many ways, however, specializations and lifestyles have reached their highest development in the socially organized groups: ants, certain wasps of the family Vespidae, and bees in the families Apidae and Halictidae. A large proportion of these societies constitute a separate type or caste known as the worker. These are modified females that do not lay eggs. Their functions include nest-building, food-gathering, tending of the nurseries, and so on. Defense of the colony may be another task of workers and, in ants, may be relegated to a special "soldier" caste. There is a great deal of variation in complexity and habits among semisocial and social forms, and this highly successful caste structure (eusocial and social) has evolved independently several times in the order.

Among solitary wasps and bees, females may provision the nest progressively, continuing to feed larvae from time to time; more often, mass

provisioning is practiced, with each cell completely stocked and closed off before the egg hatches. There is no accurate estimate of the number of Hymenoptera species in California, but the described species alone probably exceed 5,000, with most of the small, parasitic forms not yet named.

"Symphyta"

"Symphyta" was long considered as a suborder but is here used as a group of convenience for all the early diverging lineages of Hymenoptera, some of which are more closely related to Apocrita (true wasps) than they are to other symphyta. Symphytan groups morphologically and behaviorally resemble each other, despite some evolutionary relationships to the contrary. These insects are wasplike, distinguished from the true wasps most easily because the base of the abdomen is broadly attached to the thorax and the first section of the abdomen dorsally is distinct, not incorporated as part of the thorax, as is the case in true wasps. The symphyta includes ancient lineages of Hymenoptera and the sister group to all the rest of the wasps, ants, and bees that make up the vast majority of species in the order. Tenthredinoidea (in a group called Eusymphyta) makes up the majority of the diversity and consists of mostly small, stout-bodied sawflies with ovipositor blades that have saw-toothed serrations for splitting vegetation to deposit their eggs. They feed primarily on shrubs and trees.

Stem Sawflies (Family Cephidae)

Cephids are small, slender-bodied insects with a large thorax and the abdomen flattened side-to-side. They are mostly yellow and black, with transparent wings. The larvae bore in the stems and shoots of various plants and are legless except for tubercle-like rudiments. The abdomen ends in a small, retractable spine. Adults are common at flowers in spring; only five species are known in California.

▶ **635. WHEAT STEM SAWFLY** *Cephus cinctus*
ADULT: BL 8–11 mm; black with variable yellow markings and transparent wings.
LARVA: BL 12 mm; thorax somewhat enlarged; pale yellow with a brown head; in stems of various grasses, except oats, near the ground.
HABIT: This species is a major pest of wheat across much of North America, recently spreading on to new hosts in the southern part of its range. A theory that this species originated in northeast Asia and invaded North America has recently been debunked; it is probably native.

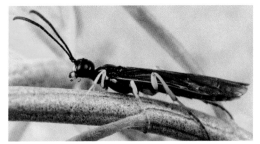

635. Wheat Stem Sawfly (*Cephus cinctus*).

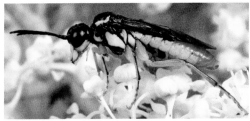

636. Common Sawfly (*Tenthredo* sp.).

637. Pearslug (*Caliroa cerasi*) larva.

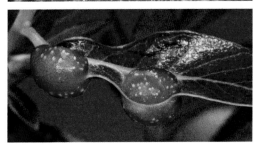

638. Willow Apple Gall Sawfly (*Pontania californica*) galls.

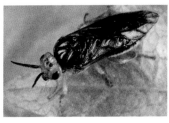

639. Crass Sawfly (*Neodiprion* sp.) adult. **640.** Crass Sawfly (*Neodiprion* sp.) larvae.

RANGE: Widely distributed in coastal and mountain areas, absent from the San Joaquin Valley and deserts. A similar species, the Western Grass Stem Sawfly (*Calameuta clavata*), occurs across the same range. The two are occasionally found together. *Cephus cinctus* emerges earlier in spring and has a longer flight period.

Sawflies (Family Tenthredinidae)

Sawflies are small to medium-sized, somewhat flattened insects with a rather wide abdomen, broadly attached to the thorax. The ovipositor is adapted for sawing, and females usually cut a slit in young shoots or leaves and insert the eggs. The larvae of most species feed externally on leaves and resemble caterpillars of Lepidoptera, from which they are distinguished by having false legs on all segments of the abdomen (these are always lacking from at least segments 1 and 2 in Lepidoptera) and by having a single large "eye" on each side instead of the group of small eyespots found in Lepidoptera. Some sawfly larvae cause plant galls in which they feed.

Female tenthredinids often reproduce parthenogenetically, in which case all resulting offspring are females. Males are unknown in many species. Although rather uniform in appearance, the family is large and its members feed on a wide diversity of flowering plants and ferns. There are more than 100 species known in California.

◀ 636. COMMON SAWFLIES *Tenthredo* spp.
There are many species of this genus in California.
ADULT: Rather large (BL 8–14 mm); entirely black or rust-red or black with yellowish-green transverse bands and a spot on the hind part of the thorax, the distal half of the abdomen may be rust-red; head large and quadrate, abdomen flattened and broadened toward the tip.
LARVA: Caterpillar-like; wide variety of colors and markings.
HABIT: Larvae feed on diverse plants according to the particular sawfly species. Often curl and drop, feigning death, when disturbed.
RANGE: Throughout all but the most arid parts of California. The Two-gemmed Sawfly *(T. bigemina)* is common in the Sierra Nevada at mid-elevations in spring. It is black with bright yellow or yellow-green bands.

GREEN SAWFLIES *Rhogogaster* spp.
Green sawflies of the genus *Rhogogaster* are similar to *Tenthredo* in size and form, and there are three common species in California.
ADULT: Medium-sized (BL 7–11 mm); bright green with a broad band of black markings down the back and transparent wings.

LARVA: Slender, caterpillar-like, of various colors.

HABIT: They live solitarily on chickweeds, poplars, alders, buttercup, and other broad-leafed plants.

RANGE: Lower- to mid-elevation areas of the state outside the deserts.

◀ 637. PEARSLUG *Caliroa cerasi*

ADULT: BL 6–8 mm; shining black with darkened wings.

LARVA: BL 10–13 mm; yellow when freshly molted, becoming dark olive green owing to a covering of slimy material that causes it to look like a slug.

HABIT: Feeding causes skeletonizing of the leaf surface; on cherries, pear, plum, and the like.

RANGE: Mountains and fruit-growing districts of the state.

CALIFORNIA PEAR SAWFLY *Pristiphora abbreviata*

This species, like the Pearslug, can also be a problem in Pear orchards.

ADULT: BL 5–6 mm; black with yellow markings on the thorax and transparent wings.

LARVA: BL 13 mm; bright green, matching the leaves on which they feed; on pear trees in spring.

HABIT: They characteristically rest on the margins of leaves in oval holes eaten into the edges.

RANGE: Northern half of California.

◀ 638. WILLOW APPLE GALL SAWFLY *Pontania californica*

The red, berrylike galls caused by this and related species are a familiar sight on willow leaves **(638)**.

ADULT: BL 3–5 mm; body shining black in male, dull reddish in the female; wings transparent.

LARVA: Whitish, grublike; feeding entirely within the galls, emerges from gall to form tough, silken cocoon on the ground.

RANGE: Widespread at low to mid-elevations.

Family Diprionidae

CONIFER SAWFLIES

ADULTS: Small (6–12 mm); superficially similar to some wasps but somewhat flattened, with glassine rather than colorful wings. All are restricted to conifers, where the eggs are deposited in a neat, regular line along a needle.

LARVA: Green with linear, darker mottling, resembling the pale and dark green foliage. They feed in clusters of 18 to 20 individuals. At maturity they form tough silken cocoons on the bark.

RANGE: The family is widespread across the Northern Hemisphere with more than 130 species in 13 genera, with 50 species occurring in North America. They are mostly restricted to specific conifers, including *Abies, Picea, Pseudotsuga,* and *Tsuga,* and there are several species associated with various pines. In most years conifer sawflies occur in low numbers, but occasionally some species become widely epidemic, causing spectacular defoliation. The outbreaks subside abruptly due to parasites and predators.

◀ 639–640. CRASS SAWFLIES *Neodiprion* spp.

There are about 20 species of *Neodiprion* in California.

ADULT: (639) BL 10–12 mm; broad, stout head and thorax broadly connected to the equally squat abdomen. Wings clear or smoky, body black in males, yellow-brown or reddish orange in females. Antennae feathery, forming large scooplike structures in the males.

LARVA: (640) Translucent green, often with attractive lateral pinstriping or spotting.

HABIT: Larvae are usually gregarious and prominently stationed feeding at the tips of branches, often older growth, leaving stubs of the needles in their wake. Larvae spin translucent, papery-brown cocoons attached to host foliage. On a range of pines, Douglas Fir and White Fir feeding communally, resembling lepidopteran caterpillars. They can cause economic damage to forests during population outbreaks. Perhaps one of the most disgusting sawfly larvae, they react to disturbance by thrashing their heads in unison and vomiting a foul-smelling resinous liquid derived from the trees on which they feed. This is often enough to dissuade many sightseers, although parasitoid wasps and other predators still reduce this sawfly's numbers significantly.

RANGE: Throughout most of the state, depending on species, where host plants occur.

Horntails (Family Siricidae)

Horntails are large, brightly colored insects. The body is cylindrical with the head, thorax, and abdomen of about the same width. The abdomen ends in a spine or horn that is short and triangular in males, lanceolate in females. The ovipositor is strong and, when at rest, projects backward with the plane of the body, resembling a huge stinger. However, horntails do not sting; rather, the ovipositor is used for drilling into wood, where

the eggs are deposited. The larvae have large heads, reduced legs, and a hornlike process on the last segment. They feed in the heartwood of scorched, weak, or recently killed trees. These insects are carried in shipments of timber or cut lumber, and the adults sometimes emerge after several years, causing holes in walls or flooring in homes. About a dozen species occur in California.

▶ **641. CALIFORNIA HORNTAIL** *Urocerus californicus*

This is the largest and most commonly collected western siricid.

ADULT: BL 18–40 mm including horn in female, 12–25 mm in male; wings, antennae, and leg bands yellow-orange; body in females entirely blue-black except for a pale spot behind each eye, in males entirely rust brown, the thorax darker; wings have an orange tinge, especially evident in flight.

LARVA: Yellowish white; slightly S-shaped with a short, sharply pointed spur on the tail end.

HABIT: Found in fir *(Abies)* wood and occasionally other conifers.

RANGE: Coniferous forest areas of the state.

Parasitic Woodwasps (Family Orussidae)

This branch of insects is considered to include the closest living relatives of the rest of the Hymenoptera (the Apocrita). They are also the only predators in symphyta, the rest of the early branches being composed of plant-feeding species, which was the ancestral feeding habit for Hymenoptera.

▶ **642. WESTERN ORUSSUS** *Orussus occidentalis*

ADULT: BL 8–14 mm; stout wasp with short wings; bluish-black with the last six segments shining reddish.

LARVA: White; legless, somewhat flattened grub with the tail end upturned but without a spine.

HABIT: This insect has unique habits. Adults patrol on bark-free wood of fallen logs of varying ages, where they resemble carpenter ants. Females detect galleries of wood-boring larvae, possibly by differences in reflected vibrations when they drum their antennae on the surface. Oviposition occurs by drilling through 5 mm to 20 mm of sound wood. After the eggs hatch, the larvae travel through the frass-packed gallery to find a host (larvae or pupae of horntails, flat-headed borers, or longhorn beetles) to feed on, beginning at its tail end, slowly working forward.

RANGE: Coniferous forest areas of the Coast Ranges and the Sierra Nevada.

Thread-waisted Wasps (Suborder Apocrita)

Despite all the significant changes in our understanding of relationships in Hymenoptera, the Apocrita has withstood the test of time, although within the suborder major reorganizations are commonplace.

Braconid Wasps (Family Braconidae)

Braconid wasps are small, stout or slender, with long antennae and transparent wings. In general structure and habits, they are similar to ichneumonids but lack the second, recurved vein present on the outer part of the fore wing in ichneumonids. Generally, braconids are smaller wasps with a larger dark spot or stigma on the leading margin of the fore wing. Many braconids are relatively stout-bodied, with antennae shorter than the fore wing.

All braconids live as parasitoids in the larval stage, and a great variety of insects serve as hosts. Lepidoptera larvae are the most commonly parasitized, and numerous individual braconids may emerge from a single caterpillar. The larvae are cigar-shaped, with a large head in the first instar. Forms that are internal parasites often have a tail appendage. When larvae are mature, they usually gnaw their way through the host's body wall and construct an external silken cocoon. Cocoons are usually white or yellowish white and somewhat fluffy in appearance, rather than smooth and paperlike as in Ichneumonidae.

This is an extremely diverse family, with considerable habitat specialization among its members. Some parasitize Diptera in particular habitats, others use larvae of wood-boring Coleoptera, weevil grubs, adult beetles, leaf miners, or aphids. Several hundred species are known in California, and probably even greater numbers are not yet described.

▶ **643–644. COMMON BRACONIDS** *Apanteles* spp. (643),
Cotesia spp.,
Dolichogenidea spp. (644)

These are three of the most species-rich genera of braconids, and the majority of them use Lepidoptera as their hosts. California has hundreds of species, with many yet to be described.

ADULT: Small (BL 2–3 mm); black, sometimes marked with red; with a short abdomen relative to the wings and legs.

LARVA: White with reduced head and swollen anal segment but no tail-like extension.

HABIT: Members of these genera are internal parasites in a wide variety of lepidopterous larvae, including leaf miners, small leaf-rollers, cutworms, and the like. In larger hosts, such as sphinx moth caterpillars, *Apanteles*

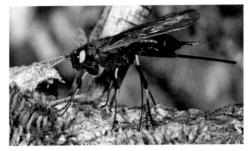

641. California Horntail (*Urocerus californicus*).

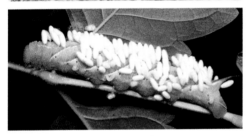

642. Western Orussus (*Orussus occidentalis*).

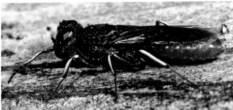

643. Common Braconids (*Apanteles* sp.) pupae on Tomato Hornworm.

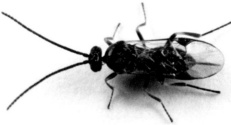

644. Common Braconid (*Dolichogenidea* sp.).

645. Aphid Parasite (*Aphidius* sp.) with infected hosts.

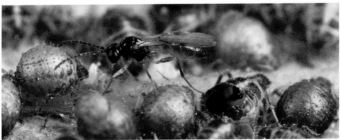

are sometimes gregarious and 50 or 100 white cocoons appear on the back and sides of the dying victim (643).

COCOON: External, silken, cylindrical, white or yellow, sometimes matted together in a heap.

RANGE: Nearly everywhere throughout the state.

◄ 645. APHID PARASITES *Aphidius* **spp.**

ADULT: Tiny (BL 1–2 mm); slender with reduced wing venation; black with brown or yellow markings on legs and abdomen, or entirely amber-colored. Females have a long, thin abdomen that is brought forward, between the legs, when injecting the eggs into an aphid in front of the wasp.

LARVA: Inside aphids, forming the cocoon there.

HABIT: All species of this and related genera parasitize aphids, one wasp per host. When about to pupate, the larva makes a cut in the bottom of the aphid and cements it to the leaf. Such carcasses are familiar objects, pale-colored, each with a large circular hole through which the wasp has emerged.

RANGE: Throughout most of the state.

Ichneumonids (Family Ichneumonidae)

In terms of described species, the Ichneumonidae is the largest family of Hymenoptera. If all the world's species were known, it might well be the largest family of animals. Probably more than 1,000 species occur in California. All are parasites of insects or occasionally other arthropods. Therefore their role in natural and human-affected communities is of enormous importance, and the majority are beneficial to agriculture. Most ichneumonids are day-fliers, and general collecting yields a variety of species. Nocturnal species are often attracted to light, showing up even in urban areas.

Adult ichneumonids are small to large, slender insects with a thread-like waist, exceptionally long antennae, and transparent wings. They inhabit every ecological situation and prey upon all kinds of insects, specializing according to genera and species. The majority are parasites of lepidopteran larvae, but many use either wood-boring or other Cole-optera, Diptera, wood wasps, aphids, or spiders, and some are parasites of other ichneumonids or other parasitic insects (hyperparasites). Usually the female searches a particular habitat, such as leaf-rolls or similar cat-erpillar shelters on trees, and oviposits into the body of any suitably sized victim she finds there. Thus many ichneumonids are not specialists on particular genera or families of host insects but parasitize a diversity of

insects that occupy similar habitats. A single larva develops within each host. When newly hatched, the larva has a prominent, tail-like extension. The full-grown larvae are tailless, variably shaped, legless grubs with a greatly reduced head. Pupation usually occurs outside the host's body in a smooth, oval cocoon, but in some species it takes place within the host's body, especially in species whose larvae delay maturing until the host has reached its pupal stage.

▶ 646. COMMON ICHNEUMONIDS *Ophion* spp.

ADULT: Moderately large (BL 10–28 mm); body amber to reddish brown in color, sometimes with yellow markings; very slender, with the abdomen flattened side-to-side; wings transparent; legs and antennae long (antennae often 1.25 times fore wing length). Although frightening in appearance, they do not sting.
LARVA: Live inside cutworms and other large caterpillars and scarab beetle grubs.
HABIT: The familiar orange wasps of this genus and several closely related genera are often attracted to lights, even during winter when little else is flying.
RANGE: Throughout most of the state at low to moderate elevations, especially in arid areas.

Members of a genus that is not closely related, *Netelia*, are similar in general appearance and habits, being nocturnal and parasites of cutworms. They are often attracted to lights and are sometimes confused with *Ophion*, but *Netelia* can deliver a formidable sting. They are usually brick red and have shorter legs and antennae (shorter than fore wing).

▶ 647. STUMPSTABBER *Megarhyssa nortoni*

This is the largest ichneumonid in California.
ADULT: Large (BL 25–38 mm, with ovipositor another 50–75 mm); marked with black, red-brown, and yellow, the legs mostly yellow.
LARVA: Feeding externally on nearly full-grown larvae of wood wasps.
HABIT: Known by a less delicate name to woodsmen, the female wasps are seen drilling their long ovipositors into stumps and recently felled logs, where they deposit eggs in galleries of horntail larvae.
RANGE: Middle to higher elevations of coniferous forest areas.

▶ 648. HOVER FLY ANNIHILATOR *Diplazon laetatorius*

ADULT: Small (BL 4–7 mm); head and body black, with broad red swath across middle of abdomen and femur of hind legs. Distinctive yellow spots on tibia of hind legs. Fore legs and middle legs are red, becoming bright yellow toward distal ends.

LARVA: Small, white, and legless.

HABIT: Larva feeds internally. These medium-sized parasitoid wasps attack hover fly (syrphid) maggots in which the wasp larvae feed, killing their hosts. Because some hover fly maggots are important biological control agents of aphids and other soft-bodied plant pests, this wasp is considered a pest, unusual for a parasitoid. It occurs worldwide, likely introduced accidentally as its host was moved to help control agricultural pests.

RANGE: Likely throughout the state wherever host hover flies occur. Common in urban gardens, especially where aphids and hover flies are common.

Gall Wasps (Family Cynipidae)

Most members of the family Cynipidae cause plant galls, which provide shelter and food for the larvae, or they live as uninvited guests (inquilines) in galls of other cynipids. The larvae consequently are internal feeders, maggotlike, without legs or a well-defined head. Pupation occurs in the larval cell without a cocoon. Adult cynipids are stout, with the abdomen oval, somewhat compressed and shining, its segments telescoped. The body surface frequently appears smooth and polished, and the wings have few veins.

Galls caused by these insects are exceedingly varied in form and location on plants, but the gall of any given cynipid is of characteristic shape. Gall formation is not well understood. In some cases the gall does not begin to grow until weeks or months after the wasp deposits the egg, so probably a secretion of the newly hatched larva influences abnormal growth of cells in the plant. In many cynipids there is a marked difference between seasonal generations of the wasp, both in body form and in the characteristic gall. One generation produces only females, which oviposit in a different part of the host and give rise to a bisexual generation.

The Cynipidae includes a large number of species, but the host plants are surprisingly restricted, with about 85 percent of described species on oaks and another 7 percent on roses. A small proportion of cynipids are parasitic on dipterous puparia or hymenopterous aphid parasites. Upward of 200 species are recorded in California, and many types of galls are known that have not yet been associated with their wasps.

▶ **649–650. CALIFORNIA OAK**
GALL WASP *Andricus quercuscalifornicus*
ADULT: **(649)** BL 3–5 mm; reddish brown with transparent wings and a stout form.

LARVA: Few to many in each gall, in individual cells near the center. They mature in fall, and the wasps deposit eggs that overwinter.

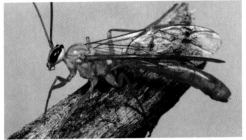

646. Common Ichneumonid (*Ophion* sp.).

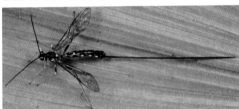

647. Stumpstabber (*Megarhyssa nortoni*).

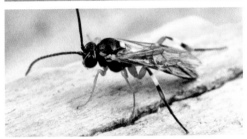

648. Hover Fly Annihilator (*Diplazon laetatorius*).

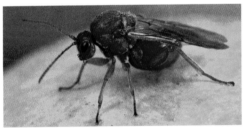

649. California Oak Gall Wasp (*Andricus quercuscalifornicus*) adult.

650. California Oak Gall Wasp (*Andricus quercuscalifornicus*) galls.

HABIT: This species causes the largest and best known gall in the western United States. It begins to form on twigs of California white oaks (Oregon, Valley, Blue, Scrub, and Leather Oaks) in spring and is at first kidney-shaped and green, becoming apple-shaped and up to 100 mm across its greatest width, pale green often with a reddish side ("oak apples") **(650)**. By late summer the gall dries and turns tan. Collecting galls to rear out insects can yield this wasp and also several kinds of lepidopterous and coleopterous inquilines as well their respective parasitic wasps.
RANGE: The Coast Ranges, foothill and valley areas.

Chalcidoids (Superfamily Chalcidoidea)

The chalcidoids are a diverse assemblage of small-to-minute wasps, made up of more than a dozen families, each with interesting, specialized structural and behavioral modifications. Chalcidoids are very numerous, with several hundred described species in California and probably still greater numbers unnamed. They often occur in great abundance, with many capable of producing a large number of offspring from a single egg (polyembryonic). Yet chalcidoids are mostly overlooked because of their small size.

Most species are parasitic in other insects, including other parasites (hyperparasitic). They are of even greater importance than ichneumonids and braconids in natural control of insect populations because of their extremely specific host preference and high fecundity. A few groups are plant-feeding, and the larvae live in seeds or in the plant galls that they induce. The parasitic forms most commonly affect Lepidoptera, Hemiptera, Diptera, or other parasitic Hymenoptera. Among the Chalcidoidea are some of the smallest of all known insects, including parasites of other insects' eggs, less than one-half of 1 mm in length in the adult stage. Adults of most species are stout-bodied, often metallic-colored, and have very few veins in the wings.

Family Agaonidae

▶ **651. FIG WASP** *Blastophaga psenes*
ADULT: BL 2–2.5 mm; females are shining black, winged; males are amber-colored, uniquely modified, wingless, larviform with an elongate abdomen that is normally curled under the body, extremely short antennae, greatly enlarged basal leg segments.
LARVA: Tiny, legless grubs; white with brown mandibles.
HABIT: This is one of the most remarkable of all insects in structure and biology. The sexes are entirely dissimilar and highly specialized for life

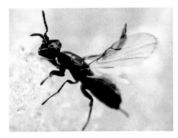

651. Fig Wasp
(*Blastophaga psenes*).

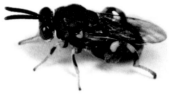

652. Butterfly Chrysalis Chalcid
(*Brachymeria ovata*).

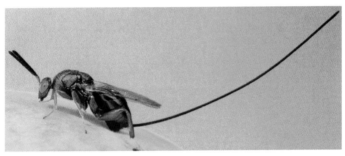

653. Oak Gall Chalcid
(*Torymus californicus*).

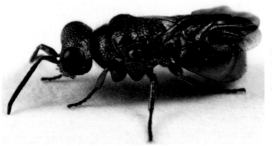

654. Cuckoo Wasp
(*Chrysis* sp.).

655. Red-blue Cuckoo
Wasp
(*Pseudomalus
auratus*).

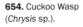

in fig flowers. The eggs are laid in the ovaries of the caprifig variety (that contains both male and female flowers), and galls are produced. The wingless male wasp emerges first, and upon locating a gall containing a female, gnaws a hole in the gall and fertilizes her. The female then leaves the flower and, laden with pollen, flies to a nearby flower, pollinating it, and ovipositing her eggs. The Smyrna variety of fig has no male flowers, and its pollination occurs by "caprification"—a process of hanging caprifigs in Smyrna trees. Should the female wasp enter a Smyrna fig, she finds the shape of the flowers prevents oviposition, but wandering about, she incidentally pollinates the flowers.

RANGE: On cultivated figs primarily in the southern San Joaquin Valley Counties and Riverside and Imperial Counties in southern California.

Family Chalcididae

◀ **652. BUTTERFLY CHRYSALIS CHALCID** *Brachymeria ovata*
This rather large and colorful species often emerges from pupae of butterflies or moths, to the chagrin of the expectant lepidopterist.
ADULT: BL 3–7 mm; robust, black and yellow, with a greatly enlarged hind leg segment that is black with a white or yellow spot at its tip.
HABIT: Parasitizes a wide variety of caterpillars.
RANGE: Widespread at low to middle elevations across the state.

Family Torymidae

◀ **653. OAK GALL CHALCID** *Torymus californicus*
This spectacular little wasp parasitizes larvae of cynipid wasps that cause galls on oaks.
ADULT: Small (BL 2–3 mm); stout, iridescent green, reflecting gold and coppery in varying lights, with black antennae and reddish legs; females have a long, thin ovipositor extending 4–6 mm beyond the body.
RANGE: Oak woodlands, associated with Blue, Valley, and Live Oaks.

Cuckoo Wasps (Family Chrysididae)

Chrysidids are metallic green, blue, or reddish wasps with a hard, often coarsely sculptured integument. They are easily recognizable by the abdomen that is a little longer than the head and thorax combined; the abdomen is convex above and slightly concave, smooth, and shin-

ing beneath. In most species, when the wasp is alarmed, it brings the abdomen forward, closely appressing it to the thorax, so that the insect rolls itself into a ball somewhat like a sowbug. This defensive posture protects female cuckoo wasps when they are attacked by a nest's defenders. Cuckoo wasps fly during sunny, warmer parts of the day. Their common name refers to the analogy with cuckoo birds: their larvae are raised in the nests of other wasps and bees. When a host burrow is left unguarded, the female chrysidid enters to deposit an egg. The resulting larva is either an external predator on the larval occupant of the nest, sometimes after the host cocoon is spun; or the newly hatched chrysidid kills the rightful occupant of the cell in an early stage and feeds on the provisions supplied by the unsuspecting nest-builder. The larvae are fat, legless grubs, superficially indistinguishable from those of their wasp and bee hosts.

Cuckoo wasps tend to be specialized in habitat preference, such as ground-nesting versus hollow stem–nesting hosts, but are indiscriminate as to the kind of host encountered there. Each chrysidid feeds in a single host cell and, as a consequence, there is considerable size variation within a species, depending on the size of the host. Those described here are among the largest of more than 160 species known in California, including several endemic to the state.

◀ 654. CUCKOO WASPS *Chrysura* spp., *Chrysis* spp.
These are among the most widespread and common chrysidids in California.
ADULT: Variable in size (BL 4–9 mm); metallic green to deep blue, integument densely punctured, with a row of deeper dents, like tooth marks, preceding the rim of the last visible abdominal segment.
LARVA: Attaches to larva of a host bee or wasp and feeds on it after the host cocoon is spun.
RANGE: Throughout much of the state, from foothills to timberline.

LARGE BLUE CUCKOO WASP *Chrysis coerulans*
Preys on the solitary vespid wasps that use holes in twigs or wood or abandoned mud-dauber nests. The egg is deposited during host provisioning; the *Chrysis* larva destroys the egg of the vespid, then feeds on the paralyzed caterpillar provisions.
ADULT: Small to moderately large (BL 6–11 mm); dark green to blue with densely punctate integument and a four-toothed, flared extension on the abdominal tip.
RANGE: Widespread in coastal regions, Central Valley, and mountainous parts of the state.

EDWARDS' CUCKOO WASP *Parnopes edwardsii*

Another large, common species is Edwards' Cuckoo Wasp.

ADULT: BL 6–12 mm; brilliant green to deep blue with densely punctate integument, pronounced depressions between the abdominal segments, and two deep creases on the last segment.

LARVA: In burrows of solitary ground-nesting wasps.

RANGE: Widespread in diverse habitats, from the Central Valley to the high Sierra.

◀ 655. RED-BLUE CUCKOO WASP *Pseudomalus auratus*

ADULT: BL 3–7 mm; head and thorax metallic blue, abdomen red.

LARVA: Kills the larvae and eats the provisions of a variety of small bees (Apidae, Colletidae, Megachilidae) and wasps (Crabronidae), typically those nesting in stems and dead wood.

HABIT: This small cuckoo wasp is native across Eurasia and was accidentally introduced to North America, probably in the early 19th century. It has recently spread across the continent. In addition to visiting flowers, it will visit aphid colonies for honeydew.

RANGE: Probably widespread, common in urban gardens.

Family Tiphiidae

Tiphiids are typically slender wasps, the females often wingless. They are not often seen by the general public, although some are very common in desert areas. All species are external parasites in the larval stage, usually on scarab or tiger beetle larvae in the soil. Winged adults commonly feed at flowers, on aphid honeydew, or other exudates on plants. Whether winged or not, the female wasps enter the soil to seek out prey on which to oviposit. About 50 species are recorded in California, but little or nothing is known about the biology of most of them.

▶ 656. NOCTURNAL TIPHIIDS *Brachycistis* spp.

This and related genera are represented by numerous species in California.

ADULT: BL 5–13 mm; males resemble flying ants, reddish brown to black, shiny, slender wasps with transparent wings and an upcurved spine at the end of the abdomen; females are slightly smaller, antlike, somewhat flattened, and modified with enlarged legs and spines for digging.

HABIT: At times males are attracted to lights in large numbers, yet their biology remains one of the mysteries of insect natural history. The females are wingless and so different in form that most were originally described in separate genera from the males.

RANGE: Sandy places in the deserts, the Central Valley, and coastal areas.

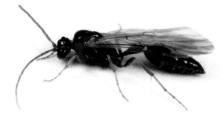

656. Nocturnal Tiphiid
(*Brachycistis* sp.).

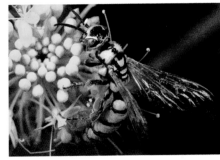

657. Flower Wasp
(*Myzinum frontale*).

658. Sacken's Velvet Ant
(*Dasymutilla sackenii*) female.

659. Radiant Velvet Ant
(*Dasymutilla aureola*) female.

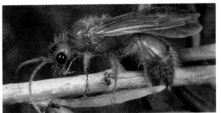

660. Blake's Velvet Ant
(*Sphaeropthalma blakeii*) male.

Family Thynnidae

Myzinum **spp.**

ADULT: BL 10–18 mm; males are slender with elongate antennae, wings, and abdomen; black-and-yellow–striped; females are much larger and much broader, with broadened legs adapted for digging.

LARVA: External parasitoid on subterranean beetle larvae.

HABIT: Probably prey on scarabaeid larvae in the soil, as is the case for related species in the eastern United States. Larvae are known to take only a few days to develop. The females go underground to hunt, locating beetle larvae that they paralyze with a sting, and then lay a single egg upon. The resulting larva feeds on the beetle grub, killing it. The mature larva then spins a cocoon and overwinters; adults emerge from the ground in the spring. These wasps can help control pest scarab beetles in agricultural and turfgrass environments and are considered beneficial.

RANGE: Desert areas and north in the foothills and the Central Valley at least to Antioch in Contra Costa County, where the two common species, *M. frontale* (**657**) and *M. maculatum,* occurred before 1955 but are now nearly extinct owing to destruction of the sand dunes in that area.

Velvet Ants (Family Mutillidae)

Although mutillids are actually related to spider wasps and not closely related to ants, mutillid females, which are wingless and densely covered with hair, somewhat resemble bulky ants as they erratically scurry about. Nocturnal species are pale or reddish brown with appressed hair forming velvety black or white bands; those active in the daytime are black wasps with brightly colored and dramatic coats of long white, red, or orange hair. Males resemble females but are winged. All species are parasitic on other insects, and females are most often seen in search of suitable hosts, mostly ground-nesting bees and wasps. They make a peculiar squeaking noise if held by the body, which is best done with forceps, for despite their pretty appearance, they can render a painful sting and are sometimes called "cow-killers" or "mule-killers," although their sting is not lethal. Probably the sting functions as defense against predators and adult bees defending their nests, because oviposition through the nest cell wall is not accompanied by a sting to paralyze the larval host.

About 100 species of Mutillidae occur in California, representing more than a dozen genera, most of them nocturnal and restricted to the deserts. Recent research has revealed that dozens of species and even genera of velvet ant have evolved a series of mutually beneficial (Mullerian) mimicry complexes, in which unrelated species resemble each other to

share protection from would-be predators, who then only have to learn once that velvet ant females are not to be trifled with.

◀ 658–659. VELVET ANTS *Dasymutilla* spp.

Members of this genus are brightly colored and active by day, especially near sunset.

ADULT: Medium-sized (BL 6–20 mm); rather robust, with a hard, dark integument.

The **Sacken's Velvet Ant** *(D. sackenii)* **(658)** adult is large (BL 10–18 mm); covered with long white or yellowish hair; occurs widely in the Coast Ranges and the Central Valley. A similar species, the Glorious Velvet Ant *(D. gloriosa)*, has paler integument and is a desert species covered with long white hair. Females resemble the bits of seed fluff from Creosote Bush *(Larrea)* that blow along the ground. The **Radiant Velvet Ant *(D. aureola)* (659)** has a nearly square head, wider than the thorax, and is covered with golden yellow, orange, or red hair. It is common in the foothills of central California but ranges widely from northern to southern California. The Variable-haired Velvet Ant *(D. coccineohirta)* is covered with yellow (in some nearly white), orange, or red hair; the size of the head distinguishes it from the previous species. It is one of our more common species, ranging widely in the Coast Ranges and the Sierra Nevada.

◀ 660. BLAKE'S VELVET ANT *Sphaeropthalma blakeii*

ADULT: BL 8–11 mm; male recognized by the small denticles on the internal margin of the hind coxa, the posterior margin of the head being quadrate-shaped, and the large stigma of the wing slightly longer than the marginal cell. The female has the dorsum of the body covered with sparse erect setae and the head evenly rounded in back.

HABIT: Males fly at night and are frequently seen at lights.

RANGE: Found in the Mojave and Colorado Desert regions.

Family Scoliidae

Scoliids resemble tiphiid wasps but are winged in both sexes and generally are much larger and relatively more robust. Like tiphiids, the scoliid wasps parasitize scarab beetle larvae in the soil. Four species occur in California, all of them most often seen at flowers in arid places.

▶ 661. KINGFISHER WASP *Crioscolia alcione*

ADULT: Males are rather slender, with a black-and-yellow–striped abdomen; females are large (BL 12–20 mm), with a broad, orange-banded abdomen and stout legs, adapted for digging.

HABIT: Female wasps pursue scarab larvae in the soil, parasitizing them for the wasp grub to feed upon.

RANGE: Deserts, southern California, and the Central Valley, north to Antioch. The Toltec Scoliid *(Campsomeris tolteca)* is similar in color and range but is much larger (females BL 15–28 mm).

Ants (Family Formicidae)

There are many species of ant, with more than 400 recognized in the United States and about 200 in California, a few of them introduced from other parts of the world by human activities. These introduced species have frequently become extremely destructive invaders. In all but a few parasitic forms, ants are social and form colonies with a worker caste. Ants may be distinguished from all other insects, including their many mimics, by the elbowed antennae, an accentuated constriction (pedicel) between the thorax and abdomen, and by one or two abdominal segments greatly narrowed and bearing one or two bumps, or "nodes." There is much variation in body form, but usually the head is rectangular, wider than the narrow thorax, and the abdomen is large and globose. Males occur only during a brief mating season, when both sexes are winged. Otherwise, the colony consists of the queen and various types of wingless workers, the latter being modified females that do not lay eggs. Males have disproportionately large eyes, and worker ants in some groups have the eyes greatly reduced or absent.

Ants care for all stages of their progeny, feeding, cleaning, and transporting them from place to place as needed. Larvae are legless, sightless grubs and are fed by the workers, in many species only by regurgitation. There is a bewildering array of behavioral specialization and extensive literature on ant biology. The nest architecture and size, caste variation, and foraging habits are all highly varied. Some species enslave other ant species to carry out worker chores, while others are parasitic in nests of other ants. Still others are carnivorous and do not form permanent nests but bivouac in temporary quarters, wandering from place to place in long columns.

Many ants are closely associated with certain plant-feeding insects that excrete a sweet liquid (honeydew), especially certain lycaenid butterfly caterpillars, aphids, and scale insects. The honeydew is harvested by the ants, which in turn protect the donors from parasites and predators.

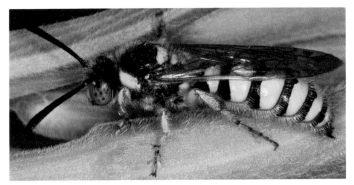

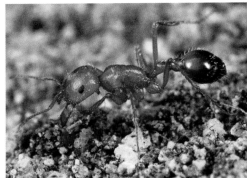

661. Kingfisher Wasp (*Crioscolia alcione*).

662. California Harvester Ant (*Pogonomyrmex californicus*).

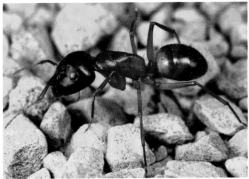

663. Carpenter Ant (*Camponotus* sp.) worker.

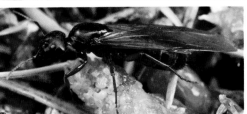

664. Western Carpenter Ant (*Camponotus modoc*) winged female reproductive (queen).

In extreme examples caterpillars are carried back to the nest and raised there. Tending of plant-sucking pests has made ants, indirectly, plant pests themselves. Many ants are vegetarians, and some feed exclusively on fungi that they culture in special chambers in the nest. In certain subfamilies a well-developed sting is present in females, including workers. Many ants can inflict a painful bite, whether or not they sting to defend the colony.

◀ 662. CALIFORNIA HARVESTER ANT *Pogonomyrmex californicus*

One of the common ants in California. Queens appear in spring and establish nests in sandy places. The colonies become quite large, with craters at the entrance but lack definite cleared, surrounding areas.

ADULT: Pale rust red in both queen (BL 8 mm) and workers (BL 5–6 mm).
HABIT: They forage for seeds during all but midday and frequently hold the abdomen erect. They bite and sting ferociously when disturbed.
RANGE: Lower elevations, especially in the more arid areas. In southern California, workers are black and reddish in some colonies.

◀ 663–664. CARPENTER ANTS *Camponotus* spp.

This genus includes the biggest of our ants. They live in large colonies in soil or wood, often extending their galleries underground. Most commonly workers are encountered **(663)**, but mating flights of winged reproductive castes can be seen in spring and summer.

HABIT: Although formidable in appearance, they do not sting or bite readily. Foods include honeydew, sap, fruits, and flesh of other insects.

◀ 664. WESTERN CARPENTER ANT *Camponotus modoc*

Commonly found making nests in dead wood, sometimes including wood frames of houses.

ADULT: BL 7–13 mm; black, somewhat dull, legs are slightly reddish brown, hairs are golden and more dense on the abdomen.
RANGE: Common in the central Sierra Nevada and Transverse Ranges.

GIANT CARPENTER ANT *Camponotus laevigatus*

Nests in fallen logs and stumps in forested areas.

ADULT: BL workers 6–10 mm, BL queen 13–15 mm; shining black, sometimes with reddish-brown legs.
RANGE: Middle to high elevations of the Coast Ranges and the Sierra Nevada.

▶ 665. ARGENTINE ANT *Linepithema humile*

ADULT: Workers are small (BL 1–2 mm); dark brown with slender bodies and unusually long antennae. Queens (BL 6 mm) are brown with a darker abdomen and silky hairs.

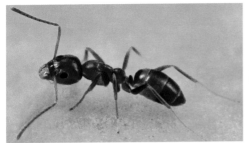

665. Argentine Ant
(*Linepithema humile*).

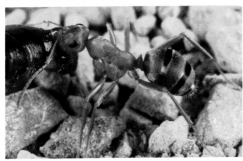

666. Red Mound Ant
(*Formica moki*).

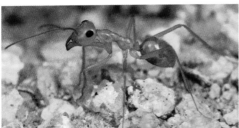

667. Honey Ant
(*Myrmecocystus mexicanus*).

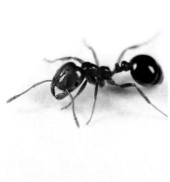

668. Red Imported Fire Ant
(*Solenopsis invicta*).

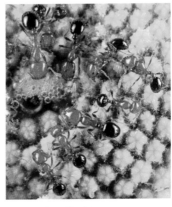

669. Southern Fire Ants
(*Solenopsis xyloni*).

HABIT: This native of South America was introduced into Louisiana about 1890 and spread westward, appearing in California in 1908. It forms large genetically similar colonies of numerous nests with multiple queens in soil, debris, or rotting wood and destroys native ants in its territory. It is one of our worst household pests, eating all kinds of sweets and dead animal matter. The workers protect honeydew-secreting aphids and other insects from natural enemies, making these ants pests of agriculture as well.

RANGE: Warmer parts of the state, especially urban areas in watered lawns and gardens.

◀ 666. RED MOUND ANTS _Formica_ spp.

ADULT: BL 3–8 mm; workers are rust red with the abdomen, and often parts of the legs, black.

HABIT: These ants make nests in rotting wood or in soil, covering the nest with conspicuous mounds of sticks and other vegetable detritus. They actively guard and tend aphids for honeydew; foods are similar to those of carpenter ants. When the colony is disturbed, the workers swarm out in huge numbers, creating a rustling noise as they scramble over the mound and biting any intruder foolish enough to loiter there.

RANGE: Chaparral and sparsely forested areas of the Coast Ranges and the Sierra Nevada.

◀ 667. HONEY ANTS _Myrmecocystus_ spp.

About 18 species occur in the state.

ADULT: Females are large (BL 6–13 mm); workers and males smaller (BL 2–6 mm); pale yellowish to dark brownish, sometimes with paler appendages; densely covered with fine hair; petiole with one node.

HABIT: Members of this genus inhabit arid and semiarid places. Colonies develop specialized workers, called "repletes," which serve solely to store liquid nutrients during superabundance of foods in certain seasons. These individuals hang from gallery ceilings like bloated bags, filled with nectar from flowers, fruit juices, honeydew from aphids, and the like. All species are general predator-scavengers.

RANGE: The most widely distributed species is _M. testaceus,_ which occurs in southern California, the Central Valley, and throughout the Great Basin. **_Myrmecocystus mexicanus_ (667)** is common in desert areas.

◀ 668. RED IMPORTED FIRE ANT _Solenopsis invicta_

ADULT: Variable, workers small to medium-sized (BL 2.4–6.0 mm), red to yellowish brown with black abdomen; petiole with a thick, blunt scale.

HABIT: Like the Argentine Ant, this species was introduced to the southeastern United States from South America (probably also Argentina) in

the early 20th century. It has since spread throughout the southern tier of the United States, only limited by available water, and the severity of winter. Unlike the Argentine Ant, fire ants have extremely painful stings and attack readily. In the United States alone, billions are spent on their control. They were first recorded in California in 1998, apparently brought in with potted plants as part of nursery shipments. Colonies can form distinctive raised mounds and achieve densities of hundreds of thousands of individuals. When disturbed, they will pour from the nest and sting aggressively, often in concerted attacks. Workers possess a formidable sting and are stimulated to attack by a pheromone released by their sisters, allowing them to swarm over the unwary interloper before attacking in unison. They have been known to kill or blind small animals, and old or weak livestock, and in rare circumstances they kill people through anaphylactic shock. They are attracted to electricity, chewing through insulation and damaging equipment. They also cause damage to agriculture through tending of sap-sucking insect pests and cause major harm in natural ecosystems by outcompeting native ants, decimating native invertebrates, and driving off larger animals, even attacking hatchling alligators in the southeastern United States. Colonies can have single or multiple queens, the latter resulting in very high worker densities.

RANGE: Southern California, mostly in urban areas associated with irrigation, also recorded from the San Joaquin Valley, associated with agriculture. *Solenopsis invicta* can be distinguished from the less damaging native **Southern or California Fire Ant (S. xyloni) (669)** by the number of clypeal teeth on its head or, more easily, by the former's aggressive behavior. The Southern Fire Ant occurs across the southern part of the state at lower elevations, including desert areas.

◄ 223, 226. FALSE HONEY ANT
OR WINTER ANT *Prenolepis imparis*

ADULT: Workers and males (BL 3–4 mm), queens (BL 7–8 mm); light to dark brown (males black), with the head and the last abdominal segments sometimes darker; smooth and shiny with no surface sculpturing; some hairs scattered across the back of the head and further along the body; legs and antennae are rather densely covered in hairs.

HABIT: Build deep underground nests in which the colony will seal themselves during the hotter months, surviving in the deepest, coolest chambers. They are omnivores, preferring a diet high in protein and fat, and are known to tend aphids or scale insects.

RANGE: Most commonly seen in the central and southern coastal regions of the state as well as the central Sierra Nevada.

Spider Wasps (Family Pompilidae)

Pompilids are slender wasps with long legs and antennae, recognizable in the field by their frenetic behavior. They run erratically, darting under low clumps of vegetation or rocks, constantly twitching their wings and waving their antennae. All species prey on spiders, which they quickly subdue by a powerful, paralyzing sting applied to the victim's underside. After capture, the prey is usually dragged to a suitable site, where a simple burrow is dug with a terminal cell just large enough for the spider. The busy pompilid then drags the immobile, but very much alive, arachnid into the chamber, deposits an egg on its abdomen, and closes the nest, obliterating all traces of it at the surface. Each species of wasp hunts in a characteristic habitat, gathering spiders of similar size; a single spider provides sufficient food for one offspring to develop completely from egg to adult.

The larvae are white, legless grubs that partially break down the spider's external skeleton by using enzymes and then feed by ingesting the host's internal fluids, waiting to consume the vital organs until last so as to delay the death of the host spider. There are about 130 species of spider wasps in California, most of them small and black or steel blue. Adults visit flowers of many kinds, feeding on nectar.

▶ **670. TARANTULA HAWKS** *Pepsis* **spp.**

These are our largest and best-known spider wasps.

ADULT: Large (BL 14–48 mm); with relatively bulky black or steel-blue bodies and broad orange or black wings.

HABIT: Attacks and subdues large tarantulas and often seen flying low over the landscape or visiting milkweed flowers in arid sites.

RANGE: Deserts and foothills north in the Central Valley and east of the Sierra Nevada to Lassen County.

Among our most widespread species, **P. thisbe (670)** is the largest (female BL 32–44 mm); body deep steel blue, wings bright orange. *Pepsis mildei* is nearly as large, distinguished by its darker wings and bright orange antennae in the male; and *P. pallidolimbata* is smaller (female BL 18–32 mm), with the body black and the wings pale orange.

▶ **671. FOREST SPIDER WASP** *Priocnemis oregona*

ADULT: BL 8–16 mm; entirely metallic blue-black except for the bright red abdomen.

HABIT: Unlike most pompilids, this species lives in shaded forest areas. It is commonly seen running about in leaf litter and on root-entangled banks in search of burrowing spiders, which are probably enticed from their burrows late in the afternoon.

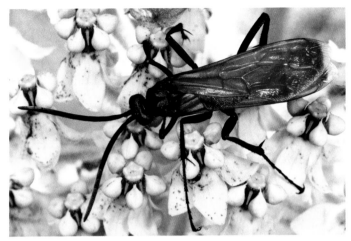

670. Tarantula Hawk (*Pepsis thisbe*).

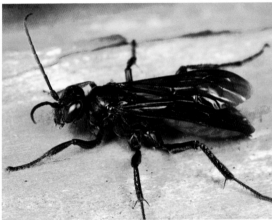

671. Forest Spider Wasp (*Priocnemis oregona*).

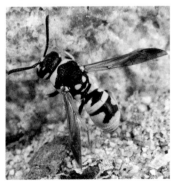

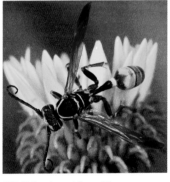

672. Common Potter Wasp (*Euodynerus annulatus*).

673. Yellow-legged Paper Wasp (*Mischocyttarus flavitarsis*).

RANGE: The Coast Ranges and the Sierra Nevada up to mid-elevations. Common in the redwood zone from Santa Cruz northward.

Paper Nest Wasps and Yellowjackets (Family Vespidae)

The family Vespidae contains a diversity of yellow and black wasps, including the social wasps, "yellowjackets" and "hornets." Vespids are distinguishable by their thorax that ends abruptly, hoodlike at the back of the head without a raised rim or "collar." Nearly all species can fold their wings longitudinally. Solitary species build mud nests or dig tunnels in the ground or use hollow stems in which they construct mud-partitioned cells. Most hunt caterpillars, which they sting into paralysis, storing several in a cell for each of their larva. Social species build nests of paperlike material that they fabricate from wood particles and saliva. The cells are honeycomblike in form and are suspended upside down from an overhanging object such as eaves, or in natural cavities in the ground, or in standing dead trees. Or they may be hung in trees and covered with layers of the wasp-paper. These nests are used for one season. Construction is initiated in spring by an overwintering female queen. She lays eggs that become nonreproductive, female workers, which in some genera are smaller than the queen. They gather miscellaneous animal matter to feed the larvae. Males are usually produced toward the end of summer.

More than 100 species occur in California, all but 15 of them solitary, although the social species are all larger and more conspicuous wasps.

◀ 672. COMMON POTTER WASP *Euodynerus annulatus*
This is one of the commonest of the solitary vespids in California.
ADULT: BL 7–14 mm; stout, with a globular abdomen nearly as broad as the thorax; yellow with variable amounts of black markings.
HABIT: Females make vertical burrows in the ground, topped by a mud chimney, and provision the burrows with caterpillars for their brood to devour.
RANGE: Widespread in arid areas, including deserts and foothills throughout the state.

◀ 673. YELLOW-LEGGED PAPER WASP *Mischocyttarus flavitarsis*
This species builds nests similar to those of *Polistes*, and the larvae are fed caterpillars and other soft insects. The adults feed at flowers or fruits and often enter buildings to overwinter, appearing at the windows in spring.
ADULT: BL 16–20 mm; similar to *Polistes* but with the abdomen smaller, globose, attached to the thorax by a long, slender, stalk-like segment;

thorax mostly black, abdomen and legs yellow with black markings; both queens and workers look alike.

RANGE: Widely distributed at lower to middle elevations but absent from the deserts.

▶ **674. YELLOWJACKETS** *Vespula* **spp.**

Members of this genus are the most abundant and troublesome wasps in California.

ADULT: BL 16–19 mm queens, BL 11–15 mm workers; stout, with the head, thorax, and abdomen of about equal width and appearing at a casual glance to be broadly attached to the thorax; yellow with black markings.

HABIT: They build nests of open-faced paper combs that are tended by increasing numbers of workers as the season progresses. The voracious workers attack everything in the vicinity, from resting insects (even honeybees) to pieces of hamburger on the picnic table. They are vicious defenders of their nest and deliver extremely painful stings when disturbed, attracting their sisters for a salvo attack with an aggregation chemical.

RANGE: Throughout coastal areas, foothills, and mountains in the state. *Vespula* in the strict sense, with about six species in California, build uncovered, flat-surfaced combs in existing cavities, such as in old rodent burrows, underground in jumbled woody debris, and hollow logs. The colonies may become very large by late summer or fall, when the roving wasps become increasingly aggressive in their search for scarce food. The **Western Yellowjacket** *(V. pensylvanica)* **(674)** is one of the most abundant and widespread species.

▶ **675. BALD-FACED HORNET** *Dolichovespula maculata*

Largest of the yellowjackets, also one of the most conspicuous in part because it is much larger than common yellowjackets and has white rather than bright yellow markings.

ADULT: BL 17–22 mm; robust white-on-black pattern is unmistakable.

HABIT: In addition to visiting flowers for nectar and hunting insects and spiders, it readily plunders unguarded human food, including raw meat. Usually this species is less numerous than the preceding because colonies tend not to last beyond midsummer. They build aerial nests, suspended from tree branches or in bushes. The combs are turned up at the margins and are surrounded by protective layers of paper sheeting. Each successive, larger comb is suspended below the preceding, and the nests become cone- or football-shaped, with the entrance near the bottom. Nests usually last between 150 and 170 days.

RANGE: Restricted to the northern and central parts of the state, usually in forested areas.

▶ **676. GOLDEN PAPER WASP** *Polistes aurifer*

ADULT: BL 11–19 mm; queens and workers of equal size; slender, with a narrowly constricted waist; thorax black with yellow markings, abdomen mostly yellow. About six similar looking species of *Polistes* occur in the state.

HABIT: This species builds small, open-faced combs of six-sided cells, suspended by a stalk under bridges, eaves of buildings, and the like. Although capable of stinging, the workers are not as easily agitated near their nests as are yellowjackets. Nests are provisioned with various food of animal origin, such as caterpillars, which are skinned by the adult wasps.

RANGE: Widespread at lower elevations; the markings are brick red instead of black in the deserts and other arid parts of southern California.

▶ **677. EUROPEAN PAPER WASP** *Polistes dominula*

ADULT: BL 11–20 mm; similar in form to the preceding species but bright yellow and black, more closely resembling yellowjackets in coloration. They can easily be distinguished in flight, by their dangling hind legs.

HABIT: As the name implies, this is yet another invasive insect from Eurasia. Introduced to the eastern seaboard in the 1970s, it has spread widely, displacing native species, especially other *Polistes*, that it competes with for resources. Unlike many native paper wasps, *P. dominula* does not specialize on caterpillars; rather they attack a broader range of invertebrates. They also visit flowers and damage ripening fruit (e.g., grapes and cherries) by biting the skin to feed on juices. Nests are similar to other *Polistes*, although they tend to be more robust and closer to areas of human activity, where they are readily defended.

RANGE: Widespread, especially in urban areas, and spreading. Human-mediated transport has moved this species across the continent fairly quickly, most likely as hibernating queens.

Bees and Digger Wasps (Superfamily Apoidea)

The taxonomy and relationships between the groups of wasps that are closely related to the bees, including Sphecidae, Crabonidae, and Larridae, is highly unstable, and likely to change in the future as more data is gathered. All bees evolved from within this supergroup of wasps, making the taxonomic resolution a complicated matter, as some of the wasps are more closely related to the bees than to other wasps. References to the following families are likely to change as our understanding of the evolution of this fascinating group of insects improves.

While females work alone to provision their nests with live prey, they

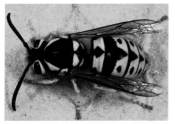

674. Western Yellowjacket
(*Vespula pensylvanica*).

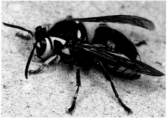

675. Bald-faced Hornet
(*Dolichovespula maculata*).

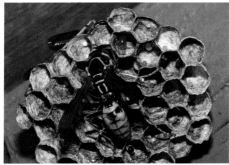

676. Golden Paper Wasp
(*Polistes aurifer*).

677. European Paper Wasp
(*Polistes dominula*).

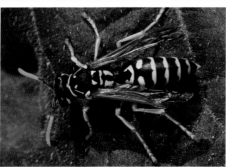

678. Yellow and Black
Mud Dauber
(*Sceliphron caementarium*).

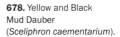

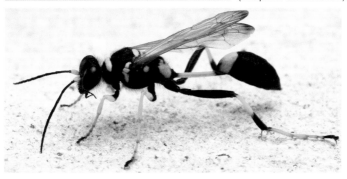

often seek similar substrates for digging their nests, frequently resulting in small "communities" of wasp burrows adjacent to each other.

Digger Wasps and Thread-waisted Wasps (Family Sphecidae)

Sphecid wasps make up one of the most interesting insect families because of their amazing diversity in nesting behavior. Each genus hunts specific kinds of insects or spiders, and there are remarkable specializations in prey transportation, burrow architecture, and the manner in which nests are maintained. Many books have been written on the subject, yet the field of study remains a fertile one, with habits of some genera and species unknown or not fully investigated.

These wasps vary greatly in form and size, from slender and thread-waisted to rather stout. They are distinguishable from vespid and pompilid wasps by having a visibly constricted neck and a raised "collar" around the rim of the thorax. Most are equipped with digging combs on the forelegs, and they nest in the ground, but other species use hollow stems or abandoned burrows of other insects, while a few construct free mud cells. Specialized hunters prey on orb-weaving or ground-inhabiting spiders, crickets of particular kinds, lepidopterous caterpillars, adult insects of nearly every order, even aphids or thrips, and some sphecids plunder the nests and provisions of other sphecids. In most genera the cells are provisioned, an egg laid in each, and they are closed off prior to larval feeding; but in a few cases the cells are provisioned progressively as the larva grows. In the extreme case, more than one nest is maintained simultaneously.

More than 350 described species occur in California, occupying every conceivable habitat, from seacoast dunes to timberline. A great many are small wasps, including members of genera not covered in the following examples.

◄ 678. YELLOW AND BLACK
MUD DAUBER *Sceliphron caementarium*
This is one of our commonest wasps.
ADULT: BL 14–28 mm; black with collar, portions of the thorax, legs, and the conspicuously thread-waisted abdomen yellow.
HABIT: Each female builds mud nests of about two to six cells, laid side by side in series, and these are covered by a continuous layer of mud. Nests are placed on undersides of rocks, under eaves, and the like, then provisioned with spiders, primarily crab-spiders and others that live on plants.
RANGE: Widely distributed at low to mid-elevations.

▶ **679. GOLDEN DIGGER WASP** *Sphex ichneumoneus*

ADULT: Large (BL 15–27 mm); thorax black and yellow with dense, crinkly pile of golden hair; abdomen bright reddish orange.

HABIT: This species usually constructs a simple burrow in heavy soil and provisions it with a single, large katydid nymph that has been paralyzed and dragged to the burrow along the ground by the backward-walking wasp.

RANGE: Widespread in arid parts of the state, including deserts, much of southern California, and the Central Valley.

▶ **680. THREAD-WAISTED DIGGER WASPS** *Ammophila* spp.

ADULT: BL 8–38 mm; very slender, abdomen formed into a long thread-waist with a small, oval enlargement at its tip; thorax usually black, marked with silver, the abdomen gray or silvery with the enlarged tip orange or reddish.

HABIT: This genus is of great interest because the whole range of simple to complex prey provisioning is shown. The nest always is a simple, vertical burrow with one cell, and during its provisioning the female uses a rock that exactly fits the entrance as a temporary door. At final closing she often holds the rock in her mandibles and tamps the fill with it. All species prey on caterpillars, some using large ones like sphinx moth larvae, providing one to a cell after laboriously dragging it from the point of capture to the nest. Other *Ammophila* provide several smaller caterpillars, such as inchworms, which they can carry in flight one at a time. Still others provision progressively; the mother decides each morning, based on the size of her offspring, how many prey to bring in. Individual females of some *Ammophila* even maintain two or three nests at once, each larva in a different stage of development.

RANGE: Widely distributed, especially in sandy areas. More than 20 species occur in the state.

▶ **681. GREEN CRICKET HUNTER** *Chlorion aerarium*

One of our most beautiful wasps.

ADULT: Large (BL 16–30 mm); slender with a thread-waist; metallic, bright blue-green or blue with dark, violet-tinged wings.

HABIT: This species flushes crickets from their daytime hiding places, subdues them, and buries them in a simple nest in the ground.

RANGE: Deserts and the Central Valley.

▶ **682. BLUE MUD WASP** *Chalybion californicum*

ADULT: BL 10–23 mm; metallic blue, blue green, or bluish black; slightly built but with a shorter thread-waist than in *Sceliphron*.

Hymenoptera

679. Golden Digger Wasp (*Sphex ichneumoneus*).

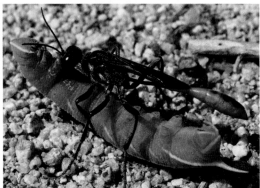

680. Thread-waisted Digger Wasp (*Ammophila* sp.) with Eyed Sphinx Caterpillar prey.

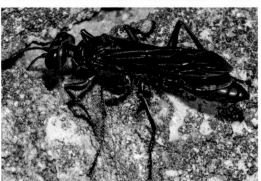

681. Green Cricket Hunter (*Chlorion aerarium*).

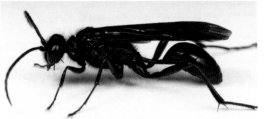

682. Blue Mud Wasp (*Chalybion californicum*).

HABIT: This wasp is in a sense a "poor relative" of the Yellow and Black Mud Dauber, for the female *Chalybion* uses abandoned cells of *Sceliphron*, carrying water to soften the old adobe for patching and sealing. She does not carry mud and seems unable to do her own architectural work. The Blue Mud Wasp hunts primarily on the ground, preying mainly on Black Widow spiders and other members of its family.

RANGE: Widespread in the state: the Sierra Nevada, the Coast Ranges, and the Central Valley to the desert margins.

Family Crabronidae

This family of wasps contains a complicated array of species, even more so than in the preceding sphecids; however, the species placed in the Crabronidae do not appear to be each other's closest relatives and the family assignments of its genera are in revision. Some crabonids are the closest living relatives of the bees, while others align with the sphecids. There is much we do not know about the diversity and relationships of these predators. Some species prey on adult Diptera that they hawk from the air with remarkable skill, while others gather more sedentary prey, like aphids, from vegetation, sometimes not even bothering to give a paralyzing sting before the victim is carried to its doom.

▶ **683. WESTERN CICADA KILLER** *Sphecius grandis*

One of the largest wasps in California, this species hunts big game, adult cicadas.

ADULT: BL 15–35 mm; robust, with a broad thorax and abdomen nearly as broad, without a thread-waist; thorax black, abdomen rust brown with yellow bands.

HABIT: The paralyzed victim is carried in flight, held beneath the wasp's body by the middle and hind legs, the latter specially modified to hold cicadas. Nests are dug in soft ground, are simple with one cell, and each is provisioned with one cicada. Females may need to drag their bulky victims up nearby trees and "jump" off to attain critical velocity for the load-bearing flight; occasionally the female wasp will sting a cicada that is too large to carry, resulting in a wasted meal.

RANGE: The Central Valley and deserts, including the Great Basin. The very similar looking Pacific Cicada Killer (*S. convallis*) occurs across the same regions but is restricted to lower elevations, thus the two species seem to occur at slightly different altitude zones and focus on different cicada species. *Sphecius convallis* lacks the yellow on the tip of the abdomen (fifth abdominal tergite) that is present in *S. grandis*.

▶ 684. SAND WASPS *Bembix* **spp.**

ADULT: BL 12–22 mm; stout-bodied, rather robust wasps with the abdomen appearing to be broadly attached to the thorax; gray or black with pale to bright yellow markings.

HABIT: Familiar to any naturalist interested in sand dunes, the industrious females of this genus are commonly seen rapidly kicking sand from their large tunnels, which are often aggregated in small colonies. Nests of some species are complex feats of architecture, with a great deal of variation from one species to another, often involving several cells. Females of some species progressively provision as the offspring grows. All *Bembix* hunt adult Diptera, which they evidently catch on the wing, and a variety of species of flies may be taken by a given female.

RANGE: Widespread, mostly at lower elevations in sandy areas, such as beach and desert dunes and riverbanks. More than a dozen species occur in California.

▶ 685. BEE WOLVES *Philanthus* **spp.**

ADULT: BL 14–15 mm; entire body covered with various patterns of black-and-yellow or white stripes and spots; head distinctly broad with very large sometimes greenish eyes and prominent mandibles; abdomen somewhat elongated.

HABIT: The 135 species in this genus (approximately ten in California) earned their name by hunting other insects, often of equal or greater size, especially bees, which the females use to provision their larvae. Despite the name, most bee wolf species can use a mix of bees and wasps or beetles. Although the genus is widespread in Europe, Africa, Asia, and North America, particular species can be very localized and subject to extinction. *Philanthus nasalis* was feared extinct when it disappeared from the Antioch Sand Dunes in Contra Costa County in 1959, but it was rediscovered 30 years later in a relict sand dune area in Santa Cruz County, apparently its last holdout.

RANGE: The genus is widespread in coastal, mountain, and desert regions, apparently preferring open country.

Subfamily Pemphredoninae

Members of this subfamily are small wasps, including tiny species (BL 2 mm) that are thought to be closely related to bees. They are the smallest members of the superfamily Apoidea and attack similarly minute prey, including aphids, leafhoppers, and other sternorrhynchans—and even Collembola (springtails)! These tiny hunters make repeated forays of even only a few yards to provision their nests with as many as 30 victims per

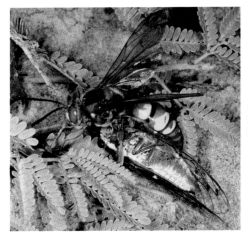

683. Western Cicada Killer (*Sphecius grandis*) with cicada prey.

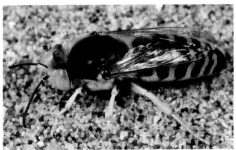

684. Sand Wasp (*Bembix* sp.).

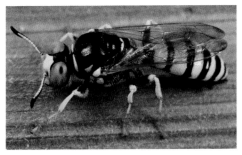

685. Bee Wolf (*Philanthus* sp.).

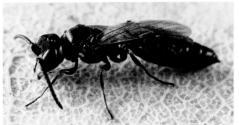

686. Aphid Hunter (*Passaloecus* sp.).

cell, with multiple cells making up each nest. Such voraciousness qualifies them as beneficial insects; without these wasps we might be up to our ankles in aphids. There are ground-nesting species as well as others that use cavities in twigs, galls, and abandoned burrows of other insects. More than 300 species are recorded from North America north of Mexico. Many more are undoubtedly undescribed and awaiting discovery.

◄ 686. APHID HUNTERS *Diodontus* spp.,
Passaloecus spp.

ADULT: BL 3.5–4.5 mm; tiny, black, stout body, broad head, typically with yellow legs; large jaws cause them to resemble ants when on the ground.
HABIT: These tiny wasps dig equally minute nests in soil and often reside colonially, with hundreds in a few square meters, making them conspicuous by their numbers, despite their small size. The females work independently, rapidly gathering aphids, often not bothering to give their prey an immobilizing sting before they are carried off. Each larva is provisioned with 20 to 30 aphids. But some of the wasps are also prey in their turn; there is a genus of tiny Velvet Ant (*Lomachaeta*) that attacks the aphid wasp's nests, plundering the prey the female wasp had intended for her young.
RANGE: Widespread, including interior parts of coastal counties, open areas, and Great Basin habitats. With more than 700 species worldwide, their diversity in California is only slightly understood.

Bees (Anthophila)

Bees are actually derived from a particular group of predatory wasps, and the gathering of pollen is a more recent evolutionary turn, which was evidently successful, given the diversity of bees. They are, essentially, a peculiar branch within the wasp family tree. When most people mention "bees," they are referring to domesticated **Honey Bees (707)**. There are, however, more than 1,000 species of native bees in California. Only a few are social, including the Honey Bee (an introduced species from the Old World) and bumble bees. Both of these are members of the family Apidae, while the vast majority of bee species are solitary in their habits and are members of several other families. Like wasps, most bees dig nests in the ground, some burrow into wood, soft stems, and the like, and a few construct nests of resin or mud. In contrast to wasps, bees collect pollen as provision for their larvae, and various specializations have been developed for pollen-carrying. Many bee species collect pollen from only one or a few plant species.

Bee larvae are legless, white grubs, living entirely within a cell, fed

pollen provided by the solitary mother, or in the case of social species, by the workers. A few genera have evolved a parasitic mode of life, laying their eggs in nests of other bees, in which the occupant larva is killed at an early stage and its food supply eaten. Compared to wasps, bees in general are more robust, hairy insects, having branched hairs, especially on the thorax. The abdomen is broadly joined to the thorax, and the hind legs are broadened in the fifth-from-last segment, rather than narrowed as in wasps.

Mining Bees (Family Andrenidae)

▶ 687. COMMON BURROWING BEES *Andrena* spp.
One of the largest genera of animals worldwide, *Andrena* is represented by more than 150 species in California.

ADULT: Small to medium-sized (BL 6–15 mm); thorax densely hairy; abdomen usually black or metallic blue, often with narrow, discrete pale hair bands; females with long hair brushes on the hind legs; males lack the brushes and have narrower, pointed abdomens.

HABIT: Burrows are made in the ground, usually consisting of a vertical tunnel with lateral branches to each cell. Most species fly in spring, visiting willow, and other early-flowering plants.

RANGE: Nearly throughout the state.

ORANGE-BANDED ANDRENA *Andrena prunorum*
One of the most abundant and widespread species in California, especially in the deserts and southern mountains.

ADULT: BL 8–15 mm; males slender with dense, whitish hair and a yellow face; females more robust with golden ochreous hair and variable yellow facial marks; wings in both sexes brown, shaded darker toward the front edge and tips; abdomen black with white hair bands, often the basal segments orange, superficially resembling the Honey Bee.

HABIT: Visits a wide variety of flowers.

GREEN BURROWING BEE *Andrena cuneilabris*
The Green Burrowing Bee is one of the commonest andrenids in central California. It is often seen in early spring visiting buttercups *(Ranunculus).*

ADULT: BL 9–12 mm; metallic bluish green with densely hairy head and thorax.

RANGE: Foothills of the Coast Ranges and the Sierra Nevada.

**BLACK BEES AND EVENING
PRIMROSE BEES** *Andrena (Onagrandrena)* **spp.**

Several species of this subgenus fly at dusk or before sunrise to gather pollen from evening primroses *(Oenothera)*; the females have specially modified hair brushes to accommodate the cobwebby pollen, and they are the only pollinators of some evening primrose species.

ADULT: Moderately large (BL 9–15 mm); entirely black, densely covered with black hair in the female; males are slender, black with white hair on the thorax in some species.

RANGE: Sandy areas of the deserts, the Central Valley, and seacoast dunes.

Leafcutting, Resin, and Mason Bees (Family Megachilidae)

Members of the family Megachilidae differ from all other bees in having the pollen-collecting brush on the underside of the abdomen, rather than on the legs. Most species cut out circular or oval discs from leaves or use other plant materials to build the walls of the nest cells but do not consume the foliage, relying wholly on pollen to feed their young. There are more than 250 species described in California.

▶ **688–689. MASON OR RESIN BEES** *Dianthidium* **spp. (688),**
Anthidium **spp.**

The rapid flight accompanied by a high-pitched whine makes bees of these and related genera distinctive.

ADULT: BL *Dianthidium* 6–12 mm **(688)**, BL *Anthidium* 8–12 mm **(689)**; stout, cylindrical, with the abdomen curled downward toward the tip; gray or black, marked with yellow spots, distinctively arranged in rows along the abdominal segments.

HABIT: They are solitary and build cells of plant resins, plant fibers, mud, or pebbles, cemented by resins. Many plants are used as pollen sources, but *Phacelia* and deerweed *(Acmispon)* are most commonly visited. Nests are constructed in abandoned insect or spider burrows in the ground or wood, and a few species dig burrows in sand. *Anthidium* females gather plant fibers with which they line the cells, while *Dianthidium* use fluffy down scraped from plants.

RANGE: The usually larger *Anthidium* are primarily montane, ranging along the Sierra Nevada (19 species including some restricted to high elevations) and the Coast Ranges, although a few are desert species; *Dianthidium* (13 species) tend to occur in more arid places, in the deserts and the Central Valley or foothills.

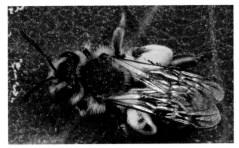

687. Common Burrowing Bee (*Andrena* sp.).

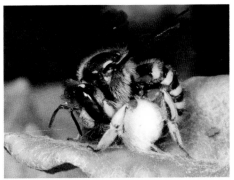

688. Mason Bee (*Dianthidium* sp.).

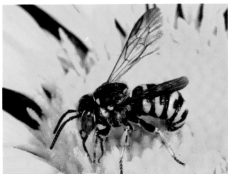

689. European Wool Carder Bee (*Anthidium manicatum*) female collecting fibers from leaf.

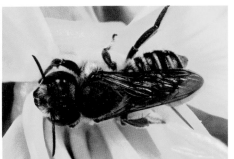

690. Silver-tailed Petalcutter (*Megachile montivaga*).

◄ **689. EUROPEAN WOOL CARDER BEE** *Anthidium manicatum*

ADULT: BL 11–17 mm; perhaps due to male territoriality, they are the larger sex in this species, which is unusual in most insects. Stout, rounded abdomen. Black body with prominent lateral yellow spots from head to abdomen. Covered in fine gray, brown, or yellow hairs. Legs are mostly yellow. Wings smoky gray.

HABIT: Yet another insect accidentally introduced from the Old World, where it is widespread. First collected in California in 2007, it occurs across the continent. Despite the name, this bee has nothing to do with sheep; females scrape plant fiber to line their nests in a way that is reminiscent of those who harvest wool. Males are highly territorial, staking out patches of flowers, mating with the females that visit, and aggressively driving off other males and unwary bystanders of all kinds. The last male to mate with a female before she lays an egg is the most likely to sire that offspring.

RANGE: Urban areas, the Central Valley, and the Coast Ranges. Still spreading. Unlikely in desert areas.

◄ **690. COMMON LEAFCUTTER BEES** *Megachile* **spp.**

ADULT: BL 7–17 mm; generally cylindrical, moderately robust, abdomen with a squared-off appearance; gray or black, usually with distinct, white hair bands around the abdomen.

HABIT: More than 60 species occur in California, many of them preferring flowers of the sunflower family for pollen. Nesting occurs in preexisting holes in the ground or wood.

Among this diversity are the Angelic Leafcutter Bee (*M. angelica*) one of our smallest at 7–8 mm long and the economically important Alfalfa Leafcutter Bee (*M. rotundata*) that was introduced from Europe and has been cultivated to pollinate alfalfa (which is not efficiently pollinated by Honey Bees). Producers of alfalfa seed are said to have increased yields approximately tenfold through use of this bee.

SILVER-TAILED PETALCUTTER *Megachile montivaga*

The **Silver-tailed Petalcutter (690)** is a medium-sized bee with its last abdominal segment covered in pale hairs. Rather than using leaves, as is typical in the genus, females collect flower petals for nest cell construction.

ADULTS: BL 7–11 mm; black with moderately distinct, thin, pale abdominal hair bands. It is common during summer throughout mountains and foothills from the Transverse Ranges northward, visiting a wide variety of flowers.

SHORT LEAFCUTTER BEE *Megachile brevis*

The Short Leafcutter Bee is a common native species.

ADULT: Small (BL 7–11 mm); black with thin, white or pale-yellow abdominal hair bands. Visits a diversity of flowers, especially sunflowers.

RANGE: Low to moderate elevations over most of the state except the deserts.

▶ 691–692. METALLIC LEAFCUTTER BEES *Osmia* spp.

The brightly colored members of this genus are among our most common mountain bees.

ADULT: BL 5–15 mm; stout, cylindrical with round abdomens; bright metallic green **(691)**, blue, nearly black **(692)**, or golden.

HABIT: They visit a wide range of flowers and nest in abandoned beetle burrows in logs or other holes.

RANGE: Throughout foothill and mountainous parts of the state. More than 75 species have been described from California, but their taxonomic relationships and natural histories are poorly known.

Sweat Bees (Family Halictidae)

▶ 693–694. ALKALI BEE *Nomia melanderi*

ADULT: **(693)** Moderately large (BL 9–14 mm); robust with smooth abdomen, having distinctive yellow or white bands, tinged with opalescence reminiscent of abalone shell colors. Females collect pollen from a variety of plants.

HABIT: Alkali bee females make nests in large aggregations on salt flats or in open patches of salty soils. Each nest has a network of tunnels leading to egg chambers. The female provisions each egg chamber with a large pollen ball on which the larva **(694)** feeds until it forms a pupa. The pupa overwinters, emerging as a new adult in the spring. The females prefer lowland, alkaline soils, such as fallow areas around alfalfa fields and, like the Alfalfa Leafcutter Bee, are more efficient pollinators of alfalfa than Honey Bees.

RANGE: Lower-elevation sites in the Central Valley south through the deserts.

▶ 695. METALLIC SWEAT BEES *Agapostemon* spp.

Bees of this genus resemble cuckoo wasps in their metallic green color, but lack the shiny, concave underside of the abdomen that characterizes chrysidids.

ADULT: BL 7–14 mm. Females have broad, pollen-collecting brushes (scopae) on the hind legs; entirely metallic green or with dark-banded abdomens. Males are slender; metallic green, abdomen yellow with black bands; hind legs lack brushes.

HABIT: A variety of flowers is visited by any given population.

RANGE: Throughout low to middle elevations of the state including the deserts. About six species occur in California.

▶ **696–697. SOCIAL SWEAT BEES** *Halictus* **spp. (696),** *Lasioglossum* **spp. (697)**

ADULT: Small to medium-sized (BL 3–13 mm); dull metallic gray, brown, or black, often with distinct, pale hair bands on the abdomen. In females the last visible abdominal segment is split longitudinally on the upper side. Many kinds of flowers are used by each colony.

HABIT: Sweat bees received their common name because they often are attracted to perspiring skin—for example, at swimming pools—and sometimes give a sharp but rather harmless sting if disturbed while extracting their drink from the unwary swimmer or hiker. These are among California's most common bees because there are more than 100 species, and many have social habits, producing a large number of reproducing worker females as well as queens. There is wide variation—from solitary species to highly organized social colonies in which the queen leaves the task of provisioning to her oldest progeny after the first brood. In some species workers may produce unfertilized eggs that result in males. The nests are complex burrows in the ground and, even in species that provision in a solitary fashion, many females may use the same entrance.

RANGE: Nearly throughout the state except at the highest elevations.

Plasterer Bees (Family Colletidae)

These bees smooth and waterproof the inside walls of the cells of their soil-burrow nest as if they are making drywall repairs, but they do this with fluids secreted from their mouths in combination with fluids from their abdomens, which the females then spread with their forked tongues. The concoction forms a sealant resembling plastic in its properties, protecting the cell and the larva's provisions from moisture and spoilage. They are solitary bees, in that they don't jointly make and inhabit nests, but they often aggregate in neighborhoods of many nests.

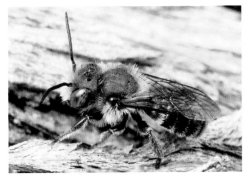

691. Metallic Leafcutter Bee (*Osmia* sp.).

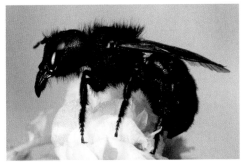

692. Metallic Leafcutter Bee (*Osmia* sp.).

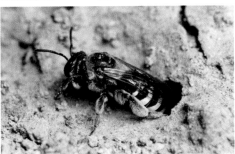

693. Alkali Bee (*Nomia melanderi*) adult.

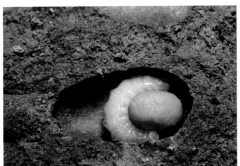

694. Alkali Bee (*Nomia melanderi*) larva in brood cell with pollen ball.

▶ 698. CELLOPHANE BEES
Colletes **spp.**

ADULT: BL 8–15 mm; fuzzy, especially the head and thorax, black bees, with light yellow to nearly white hair; triangular-shaped faces and typically strongly striped abdomens.

RANGE: Nearly everywhere in the state.

Family Apidae

▶ 699. SQUASH BEE
Peponapis pruinosa

ADULT: Males are medium-sized (BL 10–13 mm); gray with tan hair on thorax and in bands on the abdomen; females are more robust (BL 11–14 mm) with more extensive, ochreous hairiness.

HABIT: This species collects pollen only from plants of the squash family, and throughout most of California, pollination of gourds, squashes, and pumpkins is largely dependent upon this bee.

RANGE: Squash-growing areas of the state. Pollen-collecting takes place primarily before sunrise, when the blooms first open.

▶ 700. URBAN ANTHOPHORA
Anthophora urbana

This is one of the most common native solitary bees in California.

ADULT: Medium-sized (BL 10–13 mm); with distinct, pale gray hair bands on the abdomen.

RANGE: Widespread in foothills and middle elevations of the state; seen most often in late spring.

EDWARDS' ANTHOPHORA
Anthophora edwardsii

Another species, Edwards' Anthophora, is more prevalent in early spring when few other bees are flying. Many plants are visited, but early-flowering kinds such as manzanita *(Arctostaphylos)* are most often used.

ADULT: Large, robust (BL 12–18 mm); thorax covered with pale gray pile; abdomen black without pale hair bands; males with a white or yellow facial patch.

RANGE: Throughout lower elevations and foothills. More than 30 other species of *Anthophora* occur in California.

LONG-HORNED BEES
Eucera **spp.**

These bees are among the most commonly seen visiting spring wildflowers, especially fiddleneck (*Amsinckia*).

ADULT: Moderately large (BL 8–15 mm); stout with densely hairy thorax and shiny, round abdomen, sometimes with pale hair bands; males have

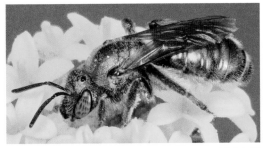

695. Metallic Sweat Bee (*Agapostemon* sp.).

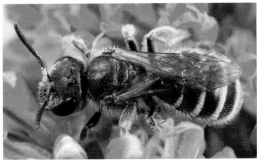

696. Social Sweat Bee (*Halictus* sp.).

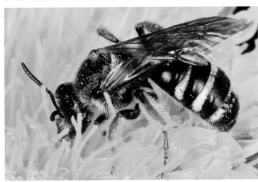

697. Social Sweat Bee (*Lasioglossum* sp.).

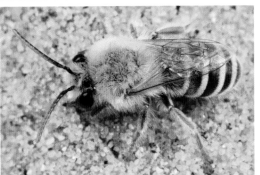

698. Cellophane Bee (*Colletes* sp.).

long antennae, nearly as long as the body, and a yellow patch on the face.

RANGE: Throughout coastal, foothill, and low-elevation areas of California.

▶ 701–702. CUCKOO BEES — *Nomada* spp.

The slender members of this genus resemble wasps. They are commonly seen hovering low over the ground in search of other bees' burrows (especially Andrenidae) in which the *Nomada* bee deposits her eggs.

ADULT: Slender-waisted with a globular thorax and pointed abdomen, which often is held upright; wings characteristically margined with brown.

RANGE: Throughout the state wherever their hosts are found.

▶ 701. EDWARDS' CUCKOO BEE — *Nomada edwardsii*

Edwards' Cuckoo Bee is a large (BL 9–12 mm), yellow-and-black species resembling a vespid wasp (compare **674** to **701**).

RANGE: In foothill and mid-elevation areas during late spring.

▶ 702. RED CUCKOO BEE — *Nomada angelarum*

The common Red Cuckoo Bee is most often seen early in the season, hovering around nest sites or visiting manzanita and other early spring flowers. It is a brick red species with darker thorax and brownish wings.

RANGE: It is common and widespread, but its biology and taxonomy are not well known, as is true of all the more than 60 species of *Nomada* described from California.

▶ 703–704. CARPENTER BEES — *Xylocopa* spp.

These are the largest bees in California.

ADULT: Large and robust (BL 12–26 mm); deep metallic blue, black, or blond in the males of some species; females have a dense brush of hairs on the hind legs for gathering pollen.

HABIT: Members of this genus construct long burrows in standing dead trees, structural timbers, fence posts, and the like. Each burrow consists of a linear series of cells partitioned with discs made of wood chips and provisioned with sizable, delicious, pollen balls. Although the bees congregate during nesting and a single entrance may lead to several burrows, there is no true social behavior.

RANGE: Throughout the state except at high elevations.

The Mountain Carpenter Bee (*X. tabaniformis*) is a small species (BL 12–18 mm); black in both sexes with variable amounts of yellow hair on the thorax of the male. It occurs in the Coast Ranges and the Sierra Nevada using dead incense cedar and redwood structural timbers for

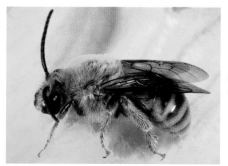

699. Squash Bee
(*Peponapis pruinosa*).

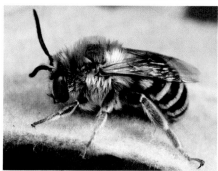

700. Urban Anthophora
(*Anthophora urbana*).

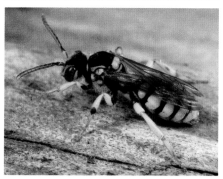

701. Edwards' Cuckoo Bee
(*Nomada edwardsii*).

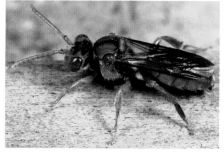

702. Red Cuckoo Bee
(*Nomada angelarum*).

nesting. The Valley Carpenter Bee *(X. varipuncta)* (BL 18–26 mm) has metallic black females **(703)** and pale buff males **(704)**. It is the common species in southern California and occurs northward through the Central Valley, using old hardwoods and telephone poles as burrow sites. The commonest species, the California Carpenter Bee *(X. californica)* (BL 17–26 mm), is shining blue or greenish blue with dark wings; it occurs in the deserts and southern mountains where it uses the dry stalks of Chaparral Yucca *(Hesperoyucca whipplei)* and agave for nesting. Northward, this bee occurs in the foothills and mountains and nests in incense cedar and redwood timbers.

▶ 705–706. BUMBLE BEES *Bombus* **spp.**

ADULT: Queens are large, workers resemble the queens but are smaller, and both have pollen baskets formed of broadened, concave, hind leg segments marginally fringed with long hairs. Most species are black with yellow hair bands, while some are largely yellow and some high-elevation species have a reddish abdominal band as well.

HABIT: This genus contains the familiar, medium-sized to large, densely hairy, yellow-and-black bees that are commonly seen in gardens, weedy areas, and natural habitats. They live in social communities consisting of reproductive females (queens), males (drones), and nonreproductive females (workers). The large queen overwinters and in spring seeks a secluded hollow such as an abandoned rodent's nest to begin the colony. She then gathers pollen and nectar and lays eggs. The resulting offspring are the much smaller workers that take over gathering of pollen and nectar and the construction of brood cells. In fall, males (from unfertilized eggs) as well as new queens are produced and mating takes place before the females hibernate; the males perish, their sole purpose accomplished. Many kinds of flowers are visited, but because of their size, bumble bees can use and pollinate clover, alfalfa, and other flowers that Honey Bees and other short-tongued bees cannot. Bumble bees, because they self-regulate their body temperature and are active at colder air temperatures, more efficiently use early spring and high-elevation plants, and are active early and late in the day and in cloudy weather.

RANGE: Throughout the state except in the deserts. The commonest species at lower elevations and around cities is the **Yellow-faced Bumble Bee** *(B. vosnesenskii)* **(705)**, which is black, with bright yellow face, thorax in front of the wings, and a narrow band on the rear of the abdomen; BL queens 15–22 mm, workers 10–17 mm. Queens of the Sonoran Bumble Bee *(B. sonorus)* are among the largest bumble bees in California (BL to 24 mm). They appear in early spring in southern California and the Central Valley and are densely covered with deep yellow pile, with a black band across the thorax, and the end of the abdomen black. Workers are

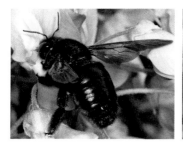

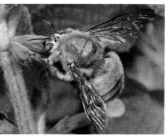

703. Valley Carpenter Bee
(*Xylocopa varipuncta*) female.

704. Valley Carpenter Bee
(*Xylocopa varipuncta*) male.

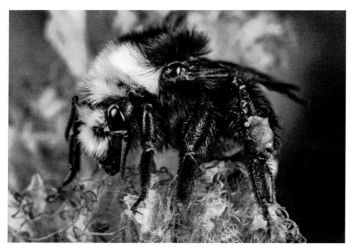

705. Yellow-faced Bumble Bee (*Bombus vosnesenskii*).

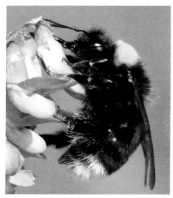

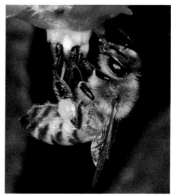

706. Western Bumble Bee
(*Bombus occidentalis*).

707. Honey Bee
(*Apis mellifera*).

similar but smaller, varying greatly in size (BL 10–20 mm). The **Western Bumble Bee (B. occidentalis) (706)** is a species of concern due to a rapid decline in its abundance in the 1990s, possibly caused in part by a fungal pathogen outbreak. It is similar in size and form to other *Bombus* species but has a distinctive white tip to its abdomen. Once common throughout the central and northern parts of the state, now sightings in California are rare and perhaps it is restricted to Shasta and Siskiyou Counties.

◀ 707. HONEY BEE — *Apis mellifera*

Probably the world's best known insect and, as a domesticated animal, like the cow of the insect world.

ADULT: BL workers 10–15 mm; drones are larger and stouter than workers, with very large eyes that meet at the top of the head. In all castes the thorax is hairy, brownish; the abdomen orange with variable extent of black banding.

HABIT: The Honey Bee is not native to North America. It was introduced into California about 1850 when hives were shipped all the way around Cape Horn of South America. It is now naturalized nearly everywhere. The morphology and habits of this insect have been studied from the Renaissance on. The social organization is highly developed with three forms: the queen, workers, and males or drones. The queen has a long abdomen, performs no nest functions other than egg-laying, and may live several seasons. There may be 50,000 or more workers in a colony, and each lives only a few weeks or months in the case of winter workers. When the population increases beyond the capacity of the hive, a new queen is produced by special feeding, and a swarm, consisting of the old queen and a large number of workers, is emitted to colonize elsewhere. The virgin queen takes a nuptial flight, followed by several males. Copulation occurs in midair, and the newly fertilized queen returns to the nest. At the end of summer, the workers eject the males from the nest since the colony will not develop swarms again until the following year; the males, with no further function in the life of the community, die. The honeycomb is the structural base of the colony. It is composed largely of hexagonal cells, placed back to back, and is constructed of wax produced by younger workers. The cells' sizes vary according to the caste destined to occupy them. Development requires about 16 days for workers and 24 days for drones; the larvae feed on a mixture of honey and digested pollen provided by the workers.

Honey Bees visit a wide variety of flowers. Communication among them has been extensively studied; workers carry out a complex dance on the comb to provide their sisters with cues as to direction and distance to nectar and pollen sources. A much more aggressive subspecies, the Africanized Honey Bee (*A. mellifera scutellata*), sometimes hyper-

bolically referred to as the "Killer Bee" in headlines was introduced into South America from Africa. It escaped captivity, replaced the European Honey Bee, and over many years slowly spread north, reaching Texas by about 1992. It has become established in California and occurs at least as far north as Kern County. Its swarming attacks may be fatal to pets or other small mammals, rarely to humans, and its replacement of the more docile European strain creates severe problems for beekeepers.

ACKNOWLEDGMENTS

We thank all the contributors that were listed in the first edition of this field guide. Their generous contributions of time and knowledge remain in the core of this second edition.

A new generation of our colleagues has supplied specialized information on particular groups as well as identifications from specimens and photos, provided or aided in locating specimens to photograph, helped in the field and with access to field sites, and offered feedback on sections of the text. These colleagues include Alice Abela, John Ascher, Cheryl Barr, Vassili Belov, Chris Borkent, Roberta and Bob Brett, John and Poody Brown, Margarethe Brummermann, Allan Cabrero, Bernadette Cardona, John F. Carr, John De Benedictis, Torsten Dikow, Bill Donahue, Diane M. Erwin, Art Evans, Brian Fisher, Steve Gaimari, Rosser Garrison, Philip Georgakakos, J. Kenneth Grace, Sziráki György, Mike Hamilton, April Hansen, Zachary Harlow, Martin Hauser, Dave Hawks, Casey Hubble, Paul Johnson, Leyla Kaufman, Dave Kavanaugh, Peter Kerr, Christopher Kilonzo, Lynn Kimsey, Ceal Klinger, Deborah Lage, Robert Lane, Jonathan Lee, Vernard Lewis, Owen Lonsdale, Cristiano Lopes-Andrade, Steve McElfresh, Patina Mendez, Pete Oboyski, Kendall Osborne, John Oswald, Kerry Padgett, Richard Peigler, Norm and Ana Penny, Mary Power, Cindy Preto, Brady Richards, Dave Ruiter, Aaron Schusteff, Bill Shepard, Michael Smith, Paul Smith, Peter Steel, Daniel Swanson, Andre Szejner-Sigal, James R. Tucker, Paul Tuskes, Natalia von Ellenrieder, David Wagner, Jane Walker, Andra Ward, Ralph Wells, Kevin Williams, Doug Yanega, Melissa Yoshimizu, Chen Young, Thomas Zavortink, and Robert Zuparko.

In addition, Barbara Roemer, Paul Johnson, Doug Yanega, Martin Hauser, Allan Cabrero, Bill Shepard, Ryan St. Laurent, Kendall Osborne, and Paul Rude read major portions of the manuscript and offered many important suggestions and corrections that improved the text. We thank all the people who generously provided their own photographs for inclusion. The photographers are listed in the credits. Sara Crews prepared the line drawings for the synopses of orders based on the figures in the first edition of this field guide.

We also thank the Angelo Coast Range Reserve, the Blue Oak Ranch

Reserve, the California State Park System, and the National Park System for access. Many others, wittingly, willingly, or otherwise, provided assistance during the process of preparing this second edition. There are many unnamed members of the broader online entomology community who contribute observations and images to such sites as BugGuide and iNaturalist who provided information and inspiration. We extend our gratitude to them.

Finally, we wish to give sincere gratitude to our families for varying levels of support and tolerance with trials ranging from time away in the field to escapees in the house during the long process that led to this book.

GLOSSARY

alate winged form.

annulation ringlike segment or division.

anterior towards front end.

apical end, tip, outermost point.

aposematic having warning signal, for example coloration that indicate an animal is dangerous or unpalatable

arista large, dorsal bristle on apical antennal segment of most Diptera, Cyclorrhapha.

basal near the base or point of attachment.

campodeiform shaped like a Dipluran, Campodeidae.

carrion flesh of dead vertebrate animal.

caste a form of adult in social insects.

caudal towards the tail end.

cercus (pl. cerci) one of a pair of appendages at the tail end of the abdomen.

chrysalis pupa of a butterfly.

collophore tubelike structure on the venter of the first abdominal segment in Collembola.

compound eye eye composed of many elements (ommatidia).

cornicles pair of tubular structures on the posterior part of aphid abdomen.

costa (costal) leading edge of the wing (pertaining to that area of the wing).

coxa (pl. coxae) basal segment of the leg.

crossvein wing vein connecting adjacent longitudinal veins.

diapause a delay in development.

distal towards the free end of an appendage, end farthest from the body.

diurnal active in the daytime.

dorsum (dorsal) the back or upperside (pertaining to topside).

ectoparasite parasitic insect which lives on the exterior of its host.

elytron (pl. elytra) one of the thickened, often hardened forewings in Coleoptera.

endoparasite parasite which lives inside its host.

epandrial lobes developments of the dorsal segments of abdomen in some male insects that form part of the genitalia complex.

femur (pl. femora) third leg segment, between the trochanter and tibia.

filiform threadlike.

frass excrement of insect.

frenulum in Lepidoptera, the spine and the bristles arising from the base of the costa of the hind wings.

furcula forked, springing apparatus in Collembola at end of the abdomen.

gall abnormal growth of plant tissues caused by insect or other agent such as mites.

globose spherical.

grub thick-bodied larva, blunt at both ends.

halter (pl. halteres) small, knobbed structure representing the hindwing in Diptera.

hellgrammites the aquatic larva of megalopterans.

hemelytron (pl. hemelytra) forewing of Hemiptera, Heteroptera.

hemimetabolous with incomplete metamorphosis, change in form (egg, nymph, adult).

holometabolous with complete metamorphosis, change in form (egg, larva, pupa, adult).

inquiline species that lives in the home (nest, burrow, gall) of another species.

instar stage between successive molts.

integument outer covering of insect body.

keel elevated ridge, often shaped like the keel of a boat.

labial palpus (pl. palpi) segmented, antennalike structure arising on each side of labium.

labium lower "lip" of the mouthparts.

labrum upper "lip" of mouthparts.

lanceolate spear-shaped, tapering to the tip.

larva (pl. larvae) immature, feeding stage between egg and pupa of holometabolous insects.

larviform shaped like a larva.

lateral referring to the side of the body or individual structure.

maggot legless, headless larva of Diptera, often carrot-shaped, blunt at the posterior end.

mandible one of lateral, opposed structures of mouthparts, usually adapted for biting.

mandibulate with mandibles.

maxilla (pl. maxillae) one of paired lateral mouthpart structures just behind the mandibles.

maxillary palpus (pl. palpi) segmented, antennalike structure arising from maxilla.

mesothorax middle segment of the thorax, bearing forewings in winged insects.

metathorax hind or third segment of thorax, bearing hindwings in winged insects.

miner larva living within plant leaves or in stems just under the epidermis.

monotypic a taxon such as a genus or family that includes only a single species.

morphology study of form or structures.

naiad aquatic, gill-breathing immature stage of Odonata, Plecoptera, and Ephemeroptera.

notum dorsal surface of a body segment.

nymph immature, feeding stage between the egg and adult in non-holometabolous insects.

obtect pupa with the appendages affixed to the body surface.

ocellus (pl. ocelli) simple eye, usually located behind the compound eye; in a group of three in some insects.

ommatidium single unit of a compound eye.

ovipositor egg-laying apparatus, modified as a sting in many Hymenoptera.

palpus (pl. palpi) segmented, antennalike process of labium or maxilla.

parasite species that feeds in or on another organism (its host) during all or part of its life but does not normally kill the host; in insects often refers also to parasitoid species.

parasitoid species that lives in another insect and kills it.

parthenogenesis egg development without fertilization

pecten comblike or rakelike structure.

petiole (pedicel) "stem" or narrow basal part of abdomen in Hymenoptera.

pheromone chemical given off by an individual, causing reaction in other individuals of the same species.

phytoplankton plants drifting in marine or fresh water.

plastron in aquatic insects, a film of air held on the outside of the body that provides an air-water interface for gas exchange.

plumose featherlike.

polymorphism the condition of having several forms

postclypeus upper portion of the clypeus or "face."

posterior referring to tail or terminal end.

prehensile adapted for grasping or holding.

proboscis tube-shaped process of the head; modified mouthparts of some insects.

process outgrowth or appendage of body wall or structure.

proleg abdominal "false legs" of larvae; shortened name for prothoracic legs of adults.

pronotum dorsal sclerite of prothorax, often enlarged, extending over mesothorax.

propodeum first abdominal segment in Hymenoptera, which is united with the thorax.

prothorax anterior or first thoracic segment.

pubescence (pubescent) covered with short, fine hairs.

pupa (pl. pupae) immature stage after the larva in which transformation to the adult stage occurs in holometabolous insect.

puparium case formed by hardening of the larval skin, in which pupation takes place in most Diptera, Cyclorrhapha.

raptorial modified for grasping prey.

reticulate like a network.

retinaculum a connecting or retaining band or structure

rostrum beak.

rugose with many wrinkles or small ridges.

sclerite hardened body wall plate.

sclerotized hardened by linking of protiens.

scutellum sclerite of the thoracic dorsum, usually the mesothoracic.

sister group the state of immediate common ancestory for two lineages, often sister species or sister taxa

species, sp. (singular), spp. (pl.) biologically recognized and typically formally named groups closely interrelated individuals

spiracle breathing pore, external opening of a trachea.

stria (pl. striae) thin groove or depressed line.

stridulate (stridulatory, stridulations) to make a noise by rubbing two surfaces together (referring to structure used for this purpose).

stylet needlelike structure, especially piercing structures of sucking mouthparts.

stylus (pl. styli) fingerlike process of abdomen.

subimago a sub-adult form, in Ephemeroptera, the winged developmental stage immediately preceding the reproductively mature adult.

tarsus (pl. tarsi) last or distal leg segment, consisting of one to five subdivisions or "segments."

tegmen (pl. tegmina) thickened, leatherlike forewing of an Orthopteran.

tibia (pl. tibiae) fourth leg segment, beyond the femur and just preceding the tarsus.

trochanter second segment of a leg, between the coxa and femur.

tubercle (tuberculate) knoblike or rounded process (with tubercles).

urogomphi in Coleoptera, more or less elongte paird processes at the terminal end of an insect larva.

venter (ventral) bottom or underside.

vestiture body covering of hairs or scales.

wing covers elytra.

wing pad precursor of adult wing in nymph.

xeric characterized by scanty moisture, referring or adapted to arid conditions.

BIBLIOGRAPHY

Information on Californian insects is distributed across thousands of technical and popular publications. The purpose of this bibliography, which is selected from sources old and new, is to provide the serious enthusiast a start to their own exploration of the literature.

General

Arnett, R. H., Jr. 2000. *American Insects: A Handbook of the Insects of America North of Mexico.* 2nd edition. ebook. Boca Raton, FL: Imprint CRC Press. 1024 pp. doi.org/10.1201/9781482273892.

Borror, D. J., and R. E. White. 1970. *A Field Guide to the Insects of America North of Mexico.* Boston: Houghton Mifflin Company.

Eiseman, C., and N. Charney. 2010. *Tracks and Sign of Insects and Other Invertebrates.* Mechanicsburg, PA: Stakepole Books. 592 pp.

Hogue, C., and J. Hogue. 2015. *Insects of the Los Angeles Basin.* 3rd edition. Los Angeles: Natural History Museum of Los Angeles County. 464 pp.

Marshall, S. A. 2017. *Insects: Their Natural History and Diversity: With a Photographic Guide to Insects of Eastern North America.* 2nd edition. Buffalo, NY: Firefly. 736 pp.

Merritt, R. W., and K. W. Cummins. 2019. *An Introduction to the Aquatic Insects of North America.* 5th edition. Dubuque, IA: Kendall/Hunt Pub Co.

Monroe, L., and G. Monroe. 2013. *Desert Insects and Kin of Southern California: A Photographic Survey and Natural History—Anza-Borrego Desert State Park.* Lyons, CO: Merryleaf Press. 768 pp.

Munz, P. A., and D. D. Keck. 1959. *A California Flora.* Published for the Rancho Santa Ana Botanic Garden. Berkeley: University of California Press. 1681 pp.

Peterson, M. A. 2018. *Pacific Northwest Insects.* Seattle, WA: Seattle Audubon Society. 528 pp.

Russo, R. 2007. *Field Guide to Plant Galls of California and Other Western States.* California Natural History Guides. Berkeley: University of California Press. 400 pp.

Sawyer, J. O., T. Keeler-Wolf, and J. M. Evens. 2009. *A Manual of California Vegetation.* 2nd edition. Sacramento: California Native Plant Society.

Stehr, F. W. 1991. *Immature Insects.* Vol. 1. Seattle, WA: Kendall Hunt Publishing. 768 pp.

———. 1998. *Immature Insects*. Vol. 2. Seattle, WA: Kendall Hunt Publishing. 992 pp.

Triplehorn, C. A., and N. F. Johnson. 2005. *Borror and Delong's Introduction to the Study of Insects*. 7th edition. Belmont, CA: Thompson Brooks/Cole, 2005. 864 pp.

Group Specific

PROTURA

Allen, R. T. 2007. "Studies on the North American Protura 1: Catalogue and Atlas of the Protura of North America; Description of New Species; Key to the Species of *Eosentomon*." *Proceedings of the Academy of Natural Sciences of Philadelphia* 156: 97–116.

DIPLURA

Allen, R. T. 2002. "A Synopsis of the Diplura of North America: Keys to Higher Taxa, Systematics, Distributions and Descriptions of New Taxa (Arthropoda: Insecta)." *Transactions of the American Entomological Society* 128 (4): 403–466.

COLLEMBOLA

Bellinger, P. F., K. A. Christiansen, and F. Janssens. 1996–2018. *Checklist of the Collembola of the World*. http://www.collembola.org.

ZYGENTOMA

Wygodzinsky, P. 1972. "A Revision of the Silverfish (Lepismatidae, Thysanura) of the United States and the Caribbean Area." *American Museum Novitates*, no. 2481: 26 pp.

EPHEMEROPTERA

Meyer, M. D., and W. P. McCafferty. 2008. "Mayflies (Ephemeroptera) of the Far Western United States. Part 3: California." *Transactions of the American Entomological Society* 134 (3/4): 337–430.

ODONATA

Biggs, K. 2009. *Common Dragonflies of California: A Beginner's Pocket Guide*. Sebastopol, CA: Azalea Creek Publishing. 128 pp.

Manolis, T. 2003. *Dragonflies and Damselflies of California*. California Natural History Guides. Berkeley: University of California Press. +201 pp.

Paulson, D. 2009. *Dragonflies and Damselflies of the West (Princeton Field Guides)*. Princeton, NJ: Princeton University Press. 536 pp.

PLECOPTERA

Jewett, S. G. 1960. "The Stoneflies (Plecoptera) of California." *California Insect Survey Bulletin* 6 (6): 125–177.

GRYLLOBLATTODEA

Schoville, S. D., and G. O. Graening. 2013. "Updated Checklist of the Ice-Crawlers (Insecta: Grylloblattodea: Grylloblattidae) of North America, with Notes on Their Natural History, Biogeography and Conservation." *Zootaxa* 3737: 351–378.

MANTODEA

Anderson, K. 2018. *Praying Mantises of the United States and Canada*. Independently published. 291 pp.

ORTHOPTERA

Capinera, J. L., R. D. Scott, and T. J. Walker. 2005. *Field Guide to Grasshoppers, Katydids, and Crickets of the United States*. Ithaca, NY: Cornell University Press. 280 pp.

PHASMIDA

Arment, C. 2006. *Stick Insects of the Continental United States and Canada*. Darke County, OH: Coachwhip Publications. 204 pp.

EMBIIDINA

Ross, E. S. 1957. "The Embioptera of California." *California Insect Survey Bulletin* (3): 51–58.

PSOCODEA

Mockford, E. L. 1993. *North American Psocoptera*. Boca Raton, FL: CRC Press LLC. 480 pp.

HEMIPTERA

Maw, H.E.L., R. G. Foottit, K.G.A. Hamilton, and G.G.E. Scudder. 2000. *Checklist of the Hemiptera of Canada and Alaska*. Ottawa, Canada: NRC Research Press.

THYSANOPTERA

Hoddle, M. S., L. A. Mound, and D. L. Paris. 2012. *Thrips of California. LUCID Key*. Queensland: CBIT Publishing.

MEGALOPTERA, RAPHIDIOPTERA, NEUROPTERA

Penny, N. D., P. A. Adams, and L. A. Stange. 1997. "Species Catalog of the Neuroptera, Megaloptera, and Raphidioptera of America North of Mexico." *Proceedings of the California Academy of Sciences* 50: 39–114.

COLEOPTERA

Arnett Jr., R. H., and M. C. Thomas, eds. 2000. *American Beetles, Volume 1: Archostemata, Myxophaga, Adephaga, Polyphaga: Staphyliniformia*. 1st edition. Boca Raton, FL: CRC Press LLC. 464 pp.

Arnett Jr., R. H., M. C. Thomas, P. E. Skelley, and H. J. Frank, eds. 2002. *American Beetles, Volume 2: Polyphaga: Scarabaeoidea through Curculionoidea.* 1st edition. Boca Raton, FL: CRC Press LLC. 880 pp.

Evans, A. V., and J. N. Hogue. 2004. *Introduction to Beetles of California.* California Natural History Guides. Volume 88. Berkeley: University of California Press. 299 pp.

———. 2006. *Field Guide to Beetles of California.* California Natural History Guides. Volume 88. Berkeley: University of California Press. 334 pp.

SIPHONAPTERA

Hubbard, C. 1947. *Fleas of Western North America: Their Relation to the Public Health.* Ames: Iowa State College Press. 533 pp.

DIPTERA

Cole, F. R. 1969. *The Flies of Western North America.* Berkeley: University of California Press. 693 pp.

Huckett, H. C. 1975. "The Muscidae of California Exclusive of the Muscinae and Stomoxyinae." *California Insect Survey Bulletin* 18. 148 pp.

James, M. T. 1955. "The Blowflies of California (Calliphoridae)." *California Insect Survey Bulletin* 4: 1–34.

McAlpine, J. F., B. V. Petersen, G. E. Shewell, H. J. Teskey, J. R. Vockeroth, and D. M. Wood. 1981. *Manual of Nearctic Diptera.* Volume 1. Research Branch Agriculture Canada. 674 pp.

———. 1987. *Manual of Nearctic Diptera.* Volume 2. Research Branch Agriculture Canada. 675–1332.

McAlpine, J. F., and D. M. Wood. 1989. *Manual of Nearctic Diptera.* Volume 3. Research Branch Agriculture Canada. 1333–1581.

Middlekauff, W. W., and R. S. Lane. 1980. "Adult and Immature Tabanidae of California." *California Insect Survey Bulletin* 22: 1–99.

TRICHOPTERA

Denning, D. G. 1956. "Trichoptera." In *Aquatic Insects of California*, edited by R. L. Usinger, 237–270. Berkeley: University of California Press.

Holzenthal, R. W., R. E. Thomson, and B. Ríos-Touma. 2015. "Order Trichoptera." In *Thorp and Covich's Freshwater Invertebrates: Ecology and General Biology.* 4th Edition. Edited by James H. Thorp and D. Christopher Rogers, 965–1002. Cambridge, MA: Academic Press.

Wiggins, G. B. 1977. *Larvae of the North American Caddisfly Genera (Trichoptera).* Toronto: University of Toronto Press. 401 pp.

LEPIDOPTERA

Holland, W. J. 1968. *The Moth Book: A Guide to the Moths of North America.* Reprint, New York: Dover Press. 479 pp.

Moths of America North of Mexico (MONA) Series. 1971–2018. Wedge Entomological Research Foundation, Inc. http://www.wedgefoundation.org/.

Opler, P. A. 1999. *Western Butterflies*. 2nd edition. Peterson Field Guides. Boston: Houghton Mifflin Company. 540 pp.

Powell, J. A., and P. A. Opler. 2009. *Moths of Western North America*. Berkeley: University of California Press. 369 pp.

Scott, J. A. 1992. *The Butterflies of North America: A Natural History and Field Guide*. Redwood City, CA: Stanford University Press. 585 pp.

Shapiro, A. 2007. *Field Guide to Butterflies of the San Francisco Bay and Sacramento Valley Regions*. Berkeley: University of California Press. 360 pp.

Tuskes, P. M., J. P. Tuttle, and M. M. Collins. 1996. *The Wild Silk Moths of North America: A Natural History of the Saturniidae of the United States and Canada*. Ithaca, NY: Cornell University Press. 250 pp.

Tuttle, J. P. 2007. *The Hawk Moths of North America. A Natural History Study of the Sphingidae of the United States and Canada*. Wedge Entomological Research Foundation. 253 pp.

HYMENOPTERA

Bohart, R. M., and R. C. Bechtel. 1957. "The Social Wasps of California." *California Insect Survey Bulletin* 4 (3): 73–102.

Fisher, B. L., and S. P. Cover. 2008. *Ants of North America: A Guide to the Genera*. Berkeley: University of California Press. 216 pp.

Frankie, G. G., R. W. Thorp, R. E. Coville, and B. Ertter. 2014. *California Bees and Blooms: A Guide for Gardeners and Naturalists*. In collaboration with the California Native Plant Society. Berkeley, CA: Heyday. 320 pp.

Goulet, H., and J. Huber, eds. 1993. "Hymenoptera of the World: An Identification Guide to Families." *Agriculture Canada Publication* 1894/E. 668 pp.

LeBuhn, G., and N. B. Pugh. 2013. *Field Guide to the Common Bees of California*. Berkeley: University of California Press. 192 pp.

Michener, C. D. 1974. *The Social Behavior of Bees: A Comparative Study*. Cambridge, MA: Belknap, Harvard University Press. 404 pp.

ONLINE RESOURCES

Art Shapiro's Butterfly Site. http://butterfly.ucdavis.edu. University of California, Davis.

BugGuide. https://bugguide.net. Iowa State University.

California Dragonflies & Damselflies aka California Odonata. http://bigs nest.powweb.com/southwestdragonflies/caphotos/.

California Beetle Database. http://www.sbcollections.org/cbp/cbpdatabase1 .aspx. Santa Barbara Museum of Natural History.

Essig Museum of Entomology Collections and Database. https://essigdb .berkeley.edu/. University of California, Berkeley.

The (new) Diptera Site. http://diptera.myspecies.info/.

iNaturalist. https://www.inaturalist.org/.

PHOTO CREDITS

John and Kendra Abbott / Abbott Nature Photography: 133, 141
Alice Abela: 88, 89, 90, 91, 96, 97, 101, 109, 194, 255, 431, 434, 435, 440, 442,
 443, 466, 527, 533, 534, 557, 569, 571, 576, 586, 599, 602, 605, 607, 608, 609,
 627, 637
James P. Bailey: 14, 594
Bavarian State Collection of Zoology (ZSM): 384, 385, 387
Matt Bertone: 1, 140
D. L. Blumfield: 539
Peter J. Bryant, University of California–Irvine: 628, 629
Annie Caires, University of Nevada, Global Water Center: 52
Catherine Chang: 108
Jack Kelly Clark, Courtesy University of California Statewide IPM Program:
 234, 235, 238, 449
Rollin Coville: 27, 28, 29, 33, 36, 37, 38, 39, 41, 42, 44, 201, 260, 453, 454, 556,
 562, 600, 616, 621, 625, 633, 641, 642, 643, 679, 681, 688, 689, 703, 704
Jillian Cowles: 683
J. Scott Cox: 501
Daniel J. Drew, Invertebrate Zoology, Yale Peabody Museum: 386
Brenda Dobbs: 564
Charley Eiseman (www.charleyeiseman.com): 521
David K. Faulkner: 253
James Gathany/CDC: 410, 414, 415
Jeremy Gatten: 706
Christopher C. Grinter, California Academy of Sciences: 606
Paul G. Johnson: 32, 579, 582, 592, 624
Gordon Johnston: 17
Jeffrey Weston Lotz, Florida Department of Agriculture: 229
Ted C. MacRae: 232
Blaine A. Mathison: 494
Gary McDonald: 360, 572
Joel Mills: 132
Beatriz Moisset: 545
Graham Montgomery: 160, 505
Matthew L. Niemiller: 40
Pudding4brains: 522
Daniela Raguth (flickr.com/photos/155780538@N08/): 142

Edward S. Ross†, Courtesy of Essig Museum of Entomology: 143, 259, 693, 694

Gilles San Martin: 139

Joachim Schmid: 217

AG Prof. Schmitz: 302

Katja Schulz: 458

Aaron Schusteff: 444, 617, 661

Rahul Singh Lamba: 457

Spencer Entomological Collection, Beaty Biodiversity Museum, University of British Columbia: 383

Lee Townsend: 137

Salvador Vitanza: 333

Dr. Vuk Vojisavljevic: 651

Robyn J. Waayers: 585

David Wagner: 553

Alex Wild/alexanderwild.com: 314

Kip Will: 135

Kirby Wolfe: 588

Barry Yates, Sussex Wildlife Trust: 493

All photos not listed above are by Joyce Gross.

INDEX

ABOUT THE AUTHORS

Kip Will is an entomologist, insect systematist, and former director of the Essig Museum of Entomology at the University of California, Berkeley.

Joyce Gross has been photographing California insects for 17 years and works as a computer programmer with the Berkeley Natural History Museums at the University of California, Berkeley.

Dan Rubinoff is a professor of entomology and director of the University of Hawaii Insect Museum; he grew up in California chasing insects and continues to work actively in the state.

Jerry A. Powell is professor of the Graduate School and former director of the Essig Museum of Entomology at the University of California, Berkeley.

PHOTO BY DIANE M. ERWIN

(left to right) Jerry A. Powell, Dan Rubinoff, Joyce Gross, and Kip Will

Founded in 1893,
UNIVERSITY OF CALIFORNIA PRESS
publishes bold, progressive books and journals
on topics in the arts, humanities, social sciences,
and natural sciences—with a focus on social
justice issues—that inspire thought and action
among readers worldwide.

The UC PRESS FOUNDATION
raises funds to uphold the press's vital role
as an independent, nonprofit publisher, and
receives philanthropic support from a wide
range of individuals and institutions—and from
committed readers like you. To learn more, visit
ucpress.edu/supportus.